BELLINI · GIORGIONE · TITIAN

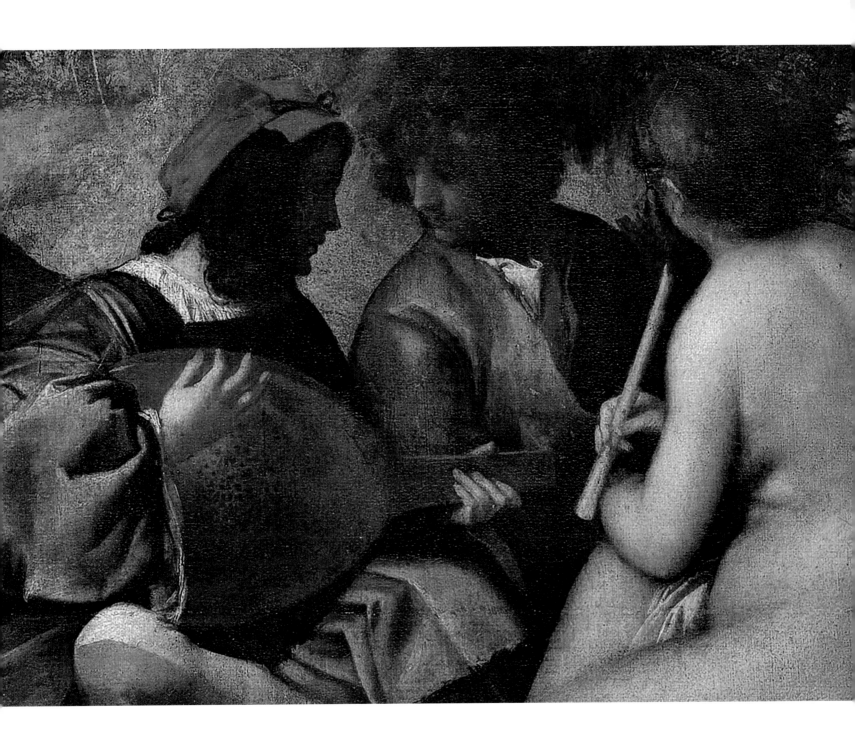

BELLINI · GIORGIONE · TITIAN

and the Renaissance of Venetian Painting

DAVID ALAN BROWN * SYLVIA FERINO-PAGDEN

with Jaynie Anderson, Deborah Howard,
Peter Humfrey, and Mauro Lucco
technical studies by Barbara H. Berrie, Louisa C. Matthew,
Elke Oberthaler, and Elizabeth Walmsley

NATIONAL GALLERY OF ART *Washington* * KUNSTHISTORISCHES MUSEUM *Vienna*

in association with YALE UNIVERSITY PRESS *New Haven and London*

This exhibition is made possible by Bracco, an international leader in diagnostic imaging.

The exhibition was organized by the National Gallery of Art, Washington, and the Kunsthistorisches Museum, Vienna.

The exhibition is supported by an indemnity from the Federal Council on the Arts and the Humanities.

Exhibition dates

National Gallery of Art
June 18–September 17, 2006

Kunsthistorisches Museum
October 17, 2006–January 7, 2007

Dimensions are cited in centimeters followed by inches in parentheses.

Library of Congress cataloguing-in-publication data

Brown, David Alan, 1942–
Bellini, Giorgione, Titian, and the Renaissance of Venetian painting / David Alan Brown, Sylvia Ferino-Pagden ; with Jaynie Anderson ... [et al.] ; technical studies by Barbara Berrie ... [et al.].

p. cm.

Issued in connection with an exhibition held June 18–Sept. 17, 2006, National Gallery of Art, Washington and Oct. 17, 2006–Jan. 7, 2007, Kunsthistorisches Museum, Vienna. Includes bibliographical references and index.

ISBN-13: 978-0-300-11677-9 (hardcover : alk. paper)

ISBN-10: 0-300-11677-2 (hardcover : alk. paper)

ISBN-13: 978-0-89468-332-9 (pbk. : alk. paper)

ISBN-10: 0-89468-332-2 (pbk. : alk. paper)

1. Painting, Italian—Italy—Venice—16th century—Exhibitions. 2. Painting, Renaissance—Italy—Venice—Exhibitions. I. Ferino-Pagden, Sylvia. II. Anderson, Jaynie. III. Berrie, Barbara. IV. National Gallery of Art (U.S.) v. Kunsthistorisches Museum Wien. VI. Title.

ND621.V5B76 2006
759.5'3107443613—dc22

2006005822

Produced by the Publishing Office, National Gallery of Art, Washington, *www.nga.gov*

Judy Metro, *Editor in chief*
Chris Vogel, *Production manager*
Margaret Bauer, *Design manager*
Julie Warnement, *Senior editor*
Evanthia Mantzavinos Granville, *Editorial assistant*

Designed by Margaret Bauer and edited by Julie Warnement

Translations by Linda Parshall (from German) and Susan Scott (from Italian), and production assistance by Nancy van Meter

Typeset in Aldus and Lucida Sans by Duke & Company, Devon, Pennsylvania

Printed on Gardapat Kiara by Conti Tipocolor, Florence

Hardcover edition published in 2006 by the National Gallery of Art, Washington, and the Kunsthistorisches Museum, Vienna, in association with Yale University Press, New Haven and London

Yale University Press
302 Temple Street
P.O. Box 209040
New Haven, CT 06520-9040
www.yalebooks.com

10 9 8 7 6 5 4 3 2 1

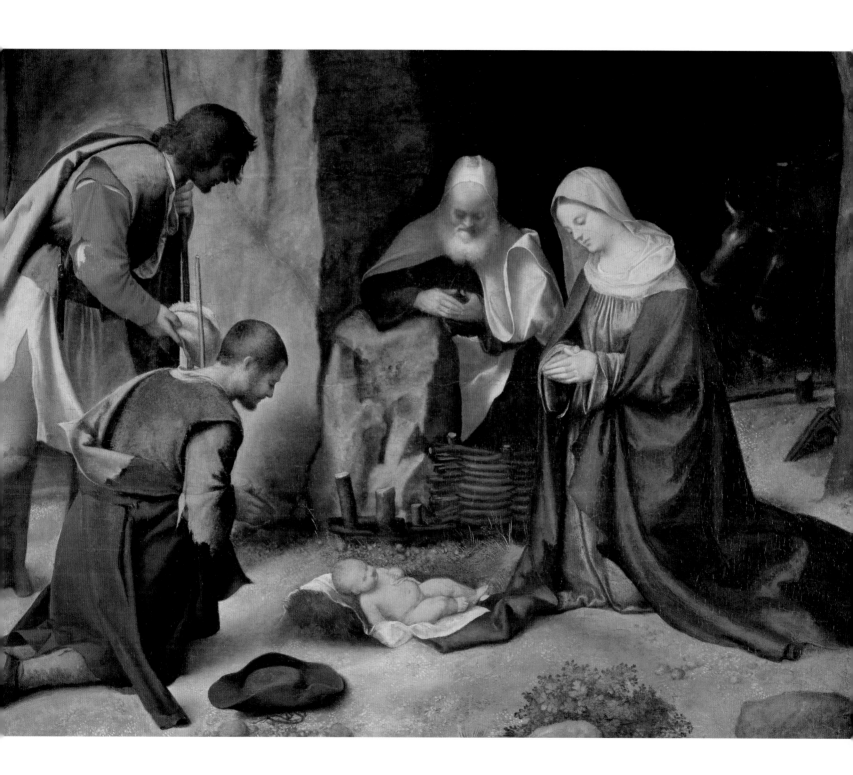

CONTENTS

SIXTEENTH-CENTURY Venetian art, from a period regarded as a Golden Age, has been the subject of numerous international loan exhibitions, most recently in London, Paris, Rome, Venice, and Edinburgh. Except for the show focusing on Titian's *Sacred and Profane Love* in Rome in 1995, these exhibitions were all large surveys, organized chronologically by medium and artist. This exhibition of Venetian art, organized by the National Gallery of Art, Washington, and the Kunsthistorisches Museum, Vienna, differs in important ways from the previous surveys. Our show is limited to paintings, the quintessential artistic medium of the school, and it concentrates on the period 1500–1530, which represents the most exciting phase of the Renaissance in Venice. Our exhibition also differs significantly from its predecessors in that, instead of dividing up the artists, it explores the relationships between them by comparing and contrasting their works. Consisting of nearly sixty pictures, the exhibition in Washington and Vienna provides an opportunity to see displayed together many of the greatest masterpieces of Venetian painting—Titian's *Pastoral Concert ("Concert Champêtre")* and *Man with a Glove* from the Louvre; Bellini and Titian's *Feast of the Gods* and Giorgione's *Adoration of the Shepherds* from the National Gallery of Art; Giorgione's *Laura* and *Three Philosophers* from the Kunsthistorisches Museum.

In an era when museums and collectors are increasingly hesitant to lend their treasures, the exhibition was made possible by close collaboration between the National Gallery of Art and the Kunsthistorisches Museum, both of whose Venetian holdings are among the finest in the world. The collection in Vienna is a historic one, formed by the Habsburg dynasty, particularly the archduke Leopold Wilhelm, and already complete or nearly so by the mid-seventeenth century.

Most of the Venetian paintings that Washington provided to the exhibition were brought together by two early twentieth-century collectors, Samuel H. Kress and Joseph Widener, whose art joined that of the Gallery's founder Andrew Mellon. Pooling their resources, the two institutions formed a nucleus of about one-third of the works in the show. To these were added outstanding loans from other institutions, including the National Gallery, London, the Uffizi in Florence, and the Prado in Madrid. The large majority of the works in the exhibition appear at both venues.

Two Bellini paintings in Washington—*Saint Jerome* and *Scipio*—together with Bartolomeo Veneto's *Gentleman*, were cleaned for the exhibition, as were Catena's *Man with a Book* and the anonymous *Christ Carrying the Cross* in Vienna. The cooperation of the lending institutions extended to conservation treatments of some of their loans as well: Titian's *Virgin and Child with Saints* from the Prado; the Giorgionesque *Double Portrait* and Savoldo's *Tobias and the Angel,* respectively from the Palazzo Venezia and the Borghese Gallery in Rome; Paris Bordone's *sacra conversazione* from a private collection; and Giovanni Agostino da Lodi's *Adoration of the Shepherds* from the Kress Collection at the Allentown Art Museum. In addition to highlighting recently cleaned pictures, the exhibition incorporates the findings of recent technical investigations into the artists' methods and materials. X-radiography, infrared reflectography, and cross sections of paint layers have brought forward new evidence about how the artists designed and painted their pictures.

The urge to innovate—clearly evident in the technique, as well as in the subject matter and style, of these works—makes Bracco the perfect sponsor for the Washington venue of the exhibition. This company is a global leader in all aspects of innovative diagnostic imaging, including magnetic

x resonance imaging (MRI), x-ray imaging, and ultrasound imaging. In effect, Bracco provides the most sophisticated methodologies to study the human body. Recently, infrared reflectography of Venetian paintings has helped to challenge previous assumptions that Venetian artists did not draw, for it has exposed the "underdrawings" beneath the paintings' surfaces. In a similar way, Bracco's groundbreaking solutions facilitate medical discoveries and the opportunity to interpret otherwise hidden medical data in a noninvasive fashion. In its commitment to promoting a "culture of values" through initiatives showcasing Italy's artistic legacy, Bracco is the ideal sponsor for the exhibition, and we are immensely grateful to Diana Bracco for her generous and enlightened support.

David Alan Brown, the Gallery's curator of Italian painting, conceived the idea for the exhibition and with Sylvia Ferino-Pagden, curator of Italian Renaissance painting at the Kunsthistorisches Museum, selected the works to be included. In organizing the exhibition, they were assisted by an outstanding group of specialists in Venetian Renaissance art: Jaynie Anderson, University of Melbourne; Miguel Falomir, Museo Nacional del Prado; Jean Habert, Musée du Louvre; Peter Humfrey, University of St Andrews; and Mauro Lucco, Università degli Studi di Bologna. Salvatore Settis of the Scuola Normale Superiore in Pisa also offered sage advice in the initial stages of planning the exhibition, while Deborah Howard of the University of Cambridge joined curators Brown and Ferino-Pagden and Professors Anderson, Humfrey, and Lucco in contributing to the catalogue. Because modern technologies have revolutionized our understanding of the methods of the Venetian painters, the exhibition and the catalogue both include a section on conservation studies by Elke Oberthaler of the Kunsthistorisches Museum and Elizabeth Walmsley of the National Gallery of Art. In the exhibition catalogue, National Gallery of Art conservation scientist Barbara H. Berrie and art historian Louisa C. Matthew of Union College present their research findings about the role of color sellers and the glass industry in creating the brilliant hues in Venetian painting. Early support for travel and research expenses incurred in planning the exhibition was provided by the Samuel H. Kress Foundation.

Italian government officials played an important role in facilitating the loan of paintings from Italy. We are indebted to the former Italian ambassador to the United States, Sergio Vento, and to his successor Giovanni Castellaneta, as well as to First Secretary and Cultural Attaché Silvia Limoncini, for their help. Our largest debt of gratitude goes to the directors of the lending institutions and private collectors, who have generously agreed to share their works.

Earl A. Powell III, National Gallery of Art
Wilfried Seipel, Kunsthistorisches Museum, Vienna

AN INTERNATIONAL LOAN exhibition like this one results from the contributions of numerous individuals and many National Gallery of Art departments. In the department of Italian paintings, Gretchen Hirschauer, associate curator, deserves thanks for her many efforts on behalf of our project. Elizabeth Concha, staff assistant, provided research and administrative support for the exhibition and its catalogue. A series of summer and academic-year interns and research associates, Christina Neilson, Daniela Cini, Marina Galvani, Kathleen Christian, and Christoph Brenner, assembled materials for the essays and entries and, in discussions, helped to refine the concepts underlying the exhibition. David Bull and Michael Swicklik diligently cleaned three Gallery pictures for the show. D. Dodge Thompson, chief of exhibitions, and Naomi Remes, exhibition officer, administered the loans. In the corporate relations department, Christine Myers, chief officer, and Jason Herrick, deputy, worked closely with Bracco, the exhibition's unstinting sponsor. Patricia Donovan coordinated the Kress Foundation's support for the organizers' travel for planning and research. Mervin Richard, deputy chief of conservation, advised on the condition and framing of several paintings, and Steve Wilcox, frame conservator, provided frames as needed. In the publishing office, Judy Metro, editor in chief, Julie Warnement, senior editor, and Evanthia Mantzavinos Granville, editorial assistant, spent countless hours producing the catalogue, which was beautifully designed by Margaret Bauer. Mariah Shay and Caroline Weaver completed the editorial team working on the book. Sara Sanders-Buell and Ira Bartfield, permissions coordinators, organized the photography, and Alan Newman, chief of imaging and visual services, Robert Grove, head of digital imaging, John Schwartz, specialist, and David Applegate, photographer, refined and improved

the color reproduction of images. Assisting with digital photography were Lorene Emerson, Ricardo Blanc, and Debbie Adenan. Neal Turtell, executive librarian, and his staff, particularly Lamia Doumato, put all the resources of the library at our disposal, while Gregory Most, chief of library image collections, and his staff, especially Missy Lemke, archivist, helped with image research.

Mark Leithauser, chief of design, Gordon Anson, head of exhibition production, Donna Kirk, senior architect, John Olson, production coordinator, Deborah Kirkpatrick, design coordinator, and Barbara Keyes, head of graphics, are responsible for the installation. The public attention the exhibition receives is due to the energetic campaign mounted by Deborah Ziska, press and public information officer, and Mary Jane McKinven, publicist. Susan Arensberg, head of exhibition programs, provided the wall texts and other educational materials, apart from those for the Barbari map, which were provided by Peter Parshall, curator of old master prints. Sally Freitag, chief registrar, and Michelle Fondas, registrar for exhibitions, planned the transportation of the objects.

Outside the Gallery, we are indebted to Linda Cena, public relations director at Bracco, for her unflagging support; to Federica Olivares of Edizioni Olivares for the early interest she took in the exhibition; to Professor Gerhard Wolf, director of the Kunsthistorisches Institut, Florence, who kindly provided working space and hospitality for the organizing committee; to Sybille Ebert-Schifferer, for access to the closed Bibliotheca Hertziana in Rome; to Daniel Mezler, who performed valuable bibliographic research; and to Linda Parshall, who expertly translated the "Pictures of Women" section of the catalogue. We are grateful, too, for support for our loan requests from the appropriate super-

xii

intendents in Italy: Antonio Paolucci of Florence; Ugo Soragni of Friuli Venezia Giulia; Maria Teresa Fiorio of Milan; Nicola Spinosa of Naples; Giovanna Damiani of Parma; Claudio Strinati of Rome; Giangiacomo Martines of Udine; and Giovanna Nepi Scirè of Venice. Above all, we owe a debt of gratitude to colleagues—museum directors and curators and other individuals—who assisted us in countless ways: Graham Allen, Luisa Arrigoni, Lisa Avagnina, Andrea Bayer, Duilio Bertani, Piero Boccardo, Mar Borobia, Don Alessandro Bortolan, David R. Brigham, Anna Maria Brignardello, G. Franca Carloni, Tullia Carratù, Rev. Prof. Carlo Chenis, Keith Christiansen, Sac. Remigio Clozza, Anna Coliva, Roberto Contini, Jean Pierre Cuzin, Wencke Deiters, Giuliano Doria, Nora Goldschmiedt Doria, Barbara Eble, Michael Eder, Martin Ellis, Hal Fischer, Roberto Fontanari, Lucia Fornari, Elisabetta Francescutti, Jane Glaubinger, Martina Grießer, Kristina Herrmann Fiore, Willard Holmes, Ingrid Hopfner, Sophie Jugie, Alastair Laing, Henri Loyrette, Manfredo Manfredi, Harald Marx, Catherine Metzger, Philippe de Montebello, Bruno Mottin, Antonio Natali, Anna Rosa Nicola, Serena Padovani, Richard Douglas Pennant, John Peterson, Mauro Piacenza, Simoni Tosini Piazzetti, Ruperta Pichler, Debra Pincus, Carol Plazzotta, Mons. Ovidio Poletto, Vincent Pomarède, Beatrice Provinciali, Gianfranco Ravasi, Elisabeth Ravaud, Katherine Lee Reid, Tom Ritter, Mons. Giuseppe Romanin, Martin Roth, Beatrice de Ruggieri, Ferdynand Ruszczyc, Mons. Virginio Sanson, Peter-Klaus Schuster, Maria Selene Sconci, Charles Saumarez Smith, Albertina Soavi, Guillermo Solana, Stephen Sommerville, Alessandra Sorrentino, Monika Strolz, Francesca del Torre, Giovanni Valagussa, Charles Venable, Gerhard Wiedmann, Elisabeth Wolfik, Eric Zafran, Willi Zavaritt, Stefan Zeisler, and Miguel Zugaza.

The exhibition in Washington does not stand alone but is accompanied by a variety of programs that are addressed, like the exhibition and its catalogue, to scholars and the general public alike. In particular, the Gallery's Center for Advanced Study in the Visual Arts will hold a curatorial / conservation colloquy for scholars in the field to discuss Venetian underdrawings. The colloquy, supported by funds from the Robert H. Smith grant, will take place at the time of the exhibition opening. Just before the closing of the exhibition, the Gallery will hold a public symposium entitled "Reconsidering Venetian Renaissance Painting." Organized in conjunction with the Solow Art and Architecture Foundation, it will feature illustrated lectures by noted scholars and a panel discussion with the exhibition organizers.

David Alan Brown and *Sylvia Ferino-Pagden*

Accademia Carrara di Belle
Arti, Bergamo

Allentown Art Museum

Birmingham Museums
& Art Gallery

Chiesa Concattedrale di San
Marco, Pordenone

Church of Santo Stefano, Vicenza

The Cleveland Museum of Art

Fondazione Magnani-Rocca, Parma

Fundación Colección Thyssen-
Bornemisza, Madrid

Galleria Borghese, Rome

Galleria degli Uffizi, Florence

Galleria di Palazzo Rosso, Genoa

Galleria Nazionale, Parma

Galleria Palatina, Florence

Gallerie dell'Accademia, Venice

Kunsthistorisches Museum, Vienna

The Metropolitan Museum
of Art, New York

Musée des Beaux-Arts, Dijon

Musée du Louvre, Paris

Museo e Gallerie Nazionali di
Capodimonte, Naples

Museo Nacional del Prado, Madrid

Muzeum Narodowe, Warsaw

The National Gallery, London

National Gallery of Art, Washington

The National Trust, Penrhyn
Castle, Wales

Palazzo di Venezia, Rome

Pinacoteca Ambrosiana, Milan

Pinacoteca di Brera, Milan

Private Collection

Staatliche Kunstsammlungen
Dresden

Staatliche Museen zu Berlin,
Gemäldegalerie

Timken Museum of Art,
San Diego

Wadsworth Atheneum Museum
of Art, Hartford

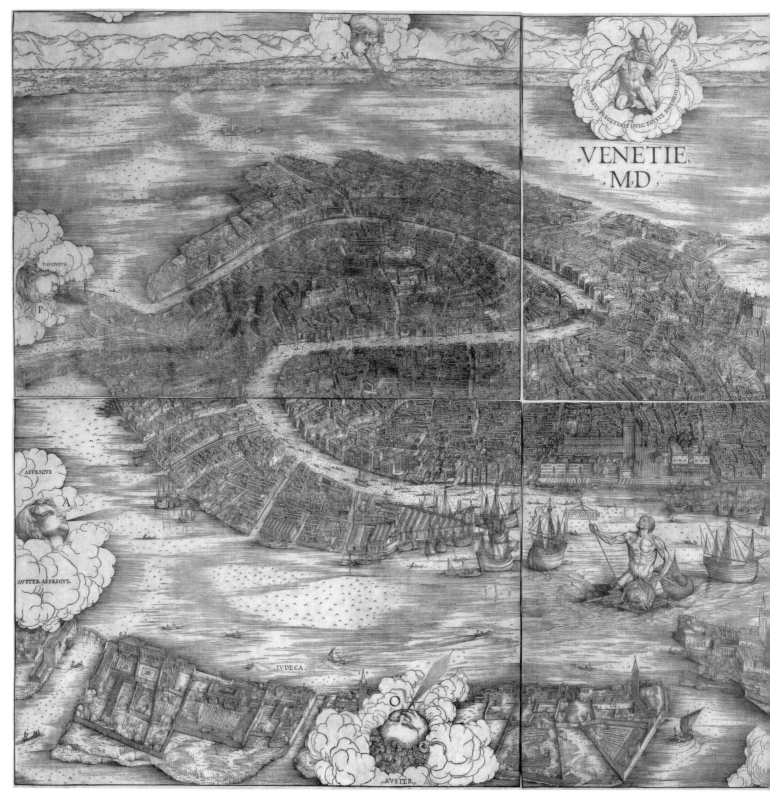

Jacopo de' Barbari, *View of
Venice*, 1500, woodcut from
six blocks on six sheets of
paper, The Cleveland Museum
of Art, Purchase from the J.H.
Wade Fund, 1949.565.4

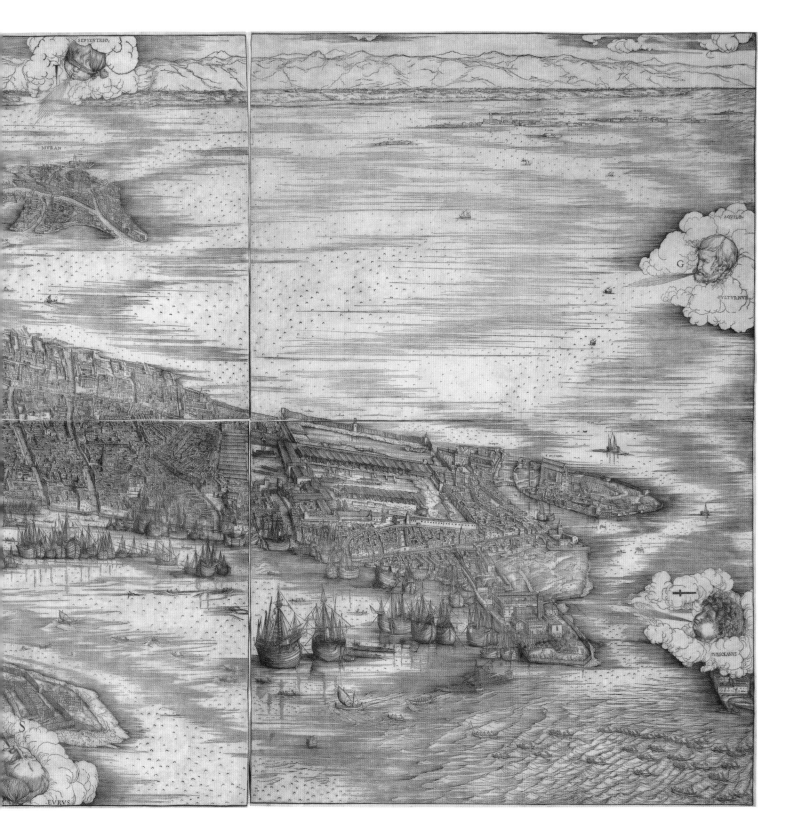

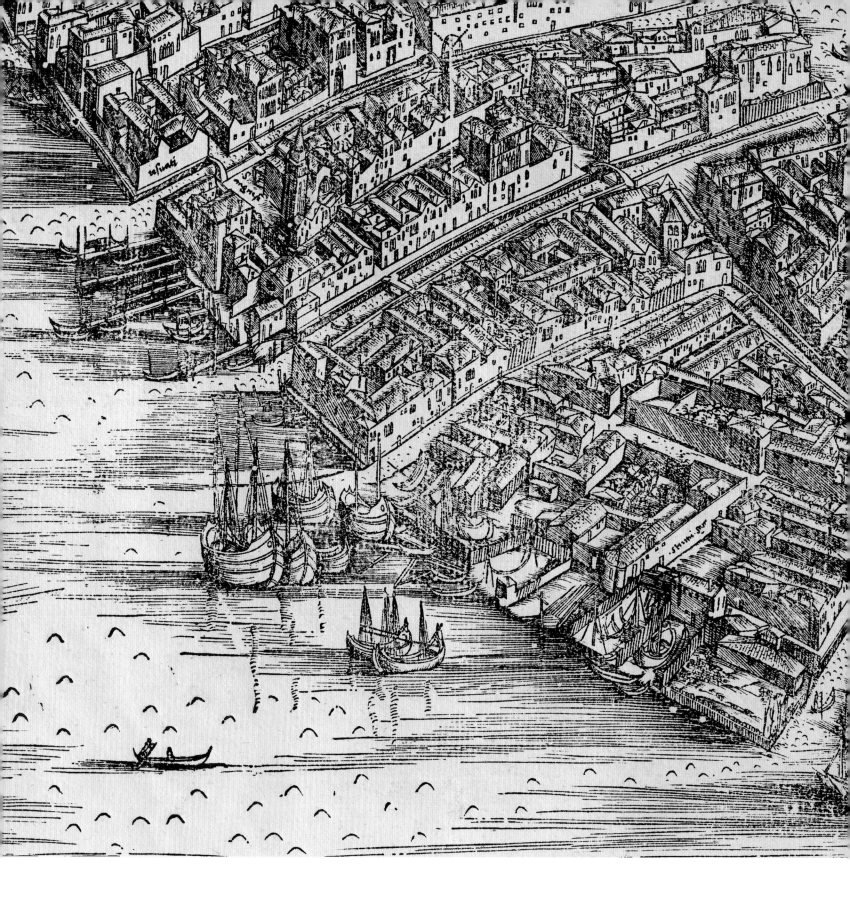

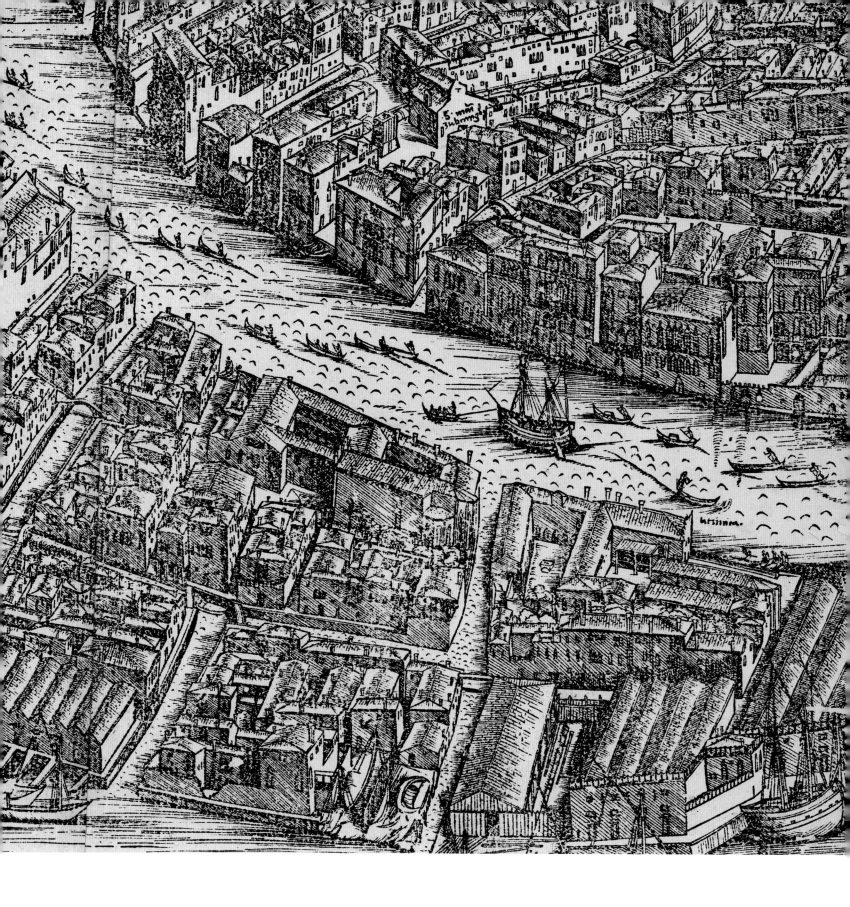

VENICE: SOCIETY AND CULTURE, 1500–1530 * *Deborah Howard*

IN 1500 THE QUINCENTENARY year was commemorated in Venice with the publication of Jacopo de' Barbari's huge bird's-eye view of the city (pages xiv–xv). Printed on six outsized sheets, this imposing woodcut committed to posterity the appearance of the world's most successful trading metropolis. In the map Mercury, god of trade, and Neptune, god of the sea, define the north-south axis running through the heart of the city, and assert the mercantile and maritime identity of the state. Myth and reality exist in perfect equilibrium. Artifice, though disguised by the virtuoso realism of the detail, massages the shape of the city into the streamlined profile of a dolphin.[1] As a familiar symbol of fortune and Christian redemption, the dolphin here proclaims the destiny and cultural identity of Venice.

Yet 1500 also marks the beginning of a catastrophic phase in Venetian history, on both land and sea, which seems hardly compatible with the artistic achievements of the same period. Since the loss of Lepanto in the previous year, the republic had been at war with the Ottoman Empire. In the ensuing peace treaty of 1503 Venice ceded the "eyes" of the Aegean, the strategically situated ports of Coron and Modon, to the Turks. Meanwhile on the mainland, Venice's daring conquests of the first half of the fifteenth century had caused alarm to rival powers. Since the Peace of Lodi in 1454, the Venetian *terraferma* had extended as far west as Bergamo and Brescia. In 1508 France, Emperor Maximilian, Ferdinand of Aragon, and the papacy, with their allies, Mantua and Ferrara, formed a powerful alliance known as the League of Cambrai to contain Venetian expansion. In the following year enemy troops inflicted a humiliating defeat over Venetian forces at the Battle of Agnadello.

Thus, in 1509, the Venetian Republic was very nearly wiped off the face of the map. The invasion overran the whole Venetian *terraferma* except Treviso, reaching as far as Mestre, from where the bombardment was audible in Venice itself. The period of recovery was slow, painful, and expensive. The city itself was protected—as ever—by its impregnable site in a shallow lagoon, but a formidable military effort had to be mounted to regain the principal subject cities of the Veneto. The Venetian diarist Marin Sanudo excitedly reported the spontaneous jubilation that followed the Venetian reentry into Verona in January 1517.[2] But it was not until the Peace of Bologna in 1529 that the conflict was finally settled by treaty.

Wars were not the only disasters to strike Venice in the first three decades of the sixteenth century. In 1505 the Fondaco dei Tedeschi, the German merchants' headquarters, burned to the ground, depriving Venice's oriental merchandise of its usual outlet. Although the Fondaco was quickly rebuilt, a second cataclysmic fire within less than a decade, in the exceptionally cold winter of 1514, destroyed almost the whole of the Rialto market on the opposite bank of the Grand Canal. The commercial center was not the only prominent site to be wrecked by fire. In 1512 the north side of Piazza San Marco was badly damaged in an alarming conflagration, initially blamed on sabotage but probably accidental. Meanwhile, recurrent plague outbreaks caused alarm in the city. The epidemic of 1503 to 1504 was followed by that of 1510, which may have killed Giorgione. A major pestilence in 1528 (probably typhoid) and catastrophic famines led to poverty and disease on a worrying scale, exacerbated by the new disease known as the *mal francese* (syphilis), the AIDS of the sixteenth century.

As a great world emporium, Venice relied for her prosperity on overseas trade. As Marin Sanudo remarked, "It is worthy of note that, just as they have been merchants from

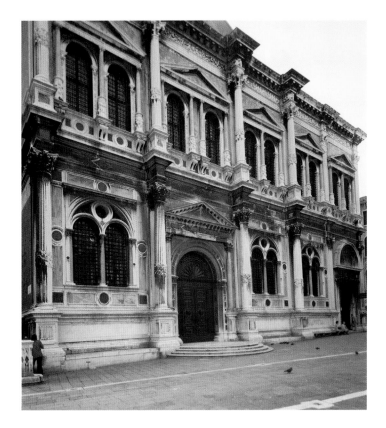

1.

Pietro Bon and Antonio
Scarpagnino, 1515–1541,
façade, Scuola Grande
di San Rocco, Venice

the beginning, so the Venetians continue to be from year to year."[3] Even with her expanding empire on land and sea, the Serenissima had few natural resources apart from specific commodities such as fish, white building stone from Istria, and sand for glassmaking. The ruling oligarchy of Venice was not a landed aristocracy of feudal origins, but a mercantile nobility with cosmopolitan horizons. Young Venetian patricians characteristically spent their formative years acquiring the skills of trade, many of them traveling to the eastern Mediterranean while still in their teens.

Trade, of course, was a gamble. Overseas voyages were prone to the dangers of war, shipwreck, and piracy. Commodity prices, then as now, rose and fell. Banks could suffer catastrophic collapses; indeed, a series of bank failures in 1499 and 1500 seriously threatened Venetian trade. After Vasco da Gama's discovery of the route to India around the Cape of Good Hope, Venetians were only gradually becoming aware of the real impact of Portuguese competition. They were even slower to wake up to the significance of the discovery of the New World. The "news on the Rialto,"

chronicled in exhaustive detail in Sanudo's copious diaries from 1496 to 1533, was full of gloom and despondency.

How could a Golden Age in painting emerge from such an unpropitious context? Of course, the relationship between culture and commerce is never simple. War and pestilence have never dampened artistic creativity, but one cannot divorce artistic output from the painful realities of day-to-day life. The very fragility of human existence often provokes patrons to commission religious works and to make major donations to charitable causes. It was during this war-torn period, for example, that one of the most lavish building projects of sixteenth-century Venice, the Scuola Grande di San Rocco, achieved its triumphal realization (fig. 1). Faced with the prospect of death, donors gave generously to the devotional confraternity dedicated to the very saint who was believed to offer protection against the plague. Saint Roch's body, brought to Venice in 1485, lay in a marble-inlaid shrine in the adjoining church, a powerful locus of devotion in this period of stress. Elaborately carved, infused with *all'antica* allusions, and inlaid with precious marbles, the façade of the Scuola di San Rocco was more impressive than any state building project of the time. Similarly, Titian's high altarpiece for the church of Santo Spirito (fig. 2) seems to invoke protection against disease, with the prominent depiction of the physician saints Cosmas and Damian on the left, the plague saints Roch and Sebastian on the right, and above the enthroned figure of Saint Mark overcast by a dark shadow of foreboding. But the fundamental question remains: what factors allowed Venetian culture to thrive so abundantly in such difficult conditions?

First of all, we must remember the overall size and wealth of the city. During the fifteenth century Venice's overriding dominance in Mediterranean trade, assisted by

the fruits of the *terraferma* conquests, had created an infra-structure of miraculous richness and beauty. The population, estimated at about 100,000 inhabitants, was growing rapidly. Jacopo de' Barbari's view shows the profusion of great Gothic palaces in 1500 (pages xiv–xv): indeed, in 1549 an English traveler, William Thomas, reported that Venice had "above 200 palaces able to lodge a king."[4] On the right-hand side of the map, the Arsenal, the greatest industrial complex in Europe, covers a vast area. In the foreground the outsized vessels spawned by the shipyard seem to have grown since they took to the waters. On their overseas voyages the huge *cogs* (round ships) carried bulk merchandise such as cotton or grain, while the smaller, maneuverable, hand-rowed galleys carried luxury goods, including spices, jewels, and rich textiles, in armed convoys. Venetian houses and churches were filled with treasures and works of art; capital was invested in government bonds, trading ventures, and real estate; and the city's religious institutions were generously endowed by centuries of charitable bequests. In other words, the underlying wealth of the city allowed it to survive the effects of a long and painful war.

Venice's trade routes stretched out like tentacles across the Mediterranean: to Egypt and Syria, and thence overland to central Asia and India; to Constantinople and the Black Sea; to North Africa, Spain, and northwestern Europe. The administration of overseas "colonies" or trading posts needed efficient communications, and postal services also penetrated the European mainland. Information gathering for diplomatic, commercial, and security reasons created channels for the importation of ideas and visual memories. Over the centuries, this network of communication had allowed the city to develop a remarkably eclectic mercantile culture, which permeated all aspects of life at home, from the Venetian

2.

Titian, *Saint Mark Enthroned with Saints Cosmas, Damian, Roch, and Sebastian*, c. 1510, Santa Maria della Salute, Venice

dialect infused with Arabic words to the exotic cuisine. Much of the information from overseas arrived in sensitive, secret documents, penetrating right to the heart of the Venetian ruling elite.

The fact that the trading destinations of the eastern Mediterranean coincided with the biblical world added an aura of sacred authenticity to imported cultural elements, even if these areas were now dominated by Muslims. Venetian galleys offered a package-tour facility for pilgrims, inclusive of guides to the holy sites, and as the first stage in this sacred itinerary Venice had to fashion herself as a pilgrim city. In 1494 the Milanese priest Canon Pietro Casola, en route for the Holy Land, remarked that he had "not found in any city so many beautiful and ornate churches as there are in Venice."[5] After Constantinople fell to the Ottomans in 1453, a revival of interest in Byzantine culture began to sweep through Venice, stimulated by the arrival of Greek refugees and the donation of the Greek Cardinal Bessarion's library, rich in Greek and Latin codices, to the republic in 1468. The gilded mosaics in some of Bellini's finest altarpieces, the revival of the Greek-cross plan for parish churches, and the use of lacy Byzantine capitals on the Arsenal gateway in 1460 all testify to this renewed interest in traditions of the Eastern Empire.

Venice's traditional cultural horizons were not indiscriminately broad. Lying at the intersection between the easiest trans-Alpine route to northern Europe, over the Brenner Pass, and the Adriatic route to the East, Venetian commerce had forged strong links with two very different but complementary cultures: the Gothic in the north, and the Islamic and Byzantine traditions of the East. In artistic terms, they shared a love of vegetal ornament, delicate low-relief carving, perforated traceries, pointed arches, elaborate skylines, glowing colors, and rich materials. From these very diverse, yet compatible influences, Venice's visual culture evolved its individuality and richness, ranging from the glittering mosaics of Saint Mark's to the Gothic-framed polyptychs of the Vivarini. Cultural contacts with northern Europe encouraged the introduction of oil painting into Venice. Although Vasari attributed the introduction of oil painting to the visit of Antonello da Messina from 1475 to 1476, painters such as Giovanni Bellini were already experimenting with the oil medium.[6] The rapid development of oil painting in late Quattrocento Venice laid the foundations for many of the innovations in the pictorial arts of the early sixteenth century.

It was through the German connection that Venice developed its printing industry, becoming one of the major centers of print culture by 1500. Like any sudden acceleration in communication, printing had a major impact on intellectual, religious, and artistic life. The virtuosity of Jacopo de' Barbari's huge woodcut map relied not only on surveying and draftsmanship, but also on revolutionary technology in paper manufacture and printing. The works printed in Venice in the early sixteenth century ranged from religious texts to the Greek and Roman classics, and from propaganda to fiction. Perhaps the most beautiful printed book to emerge from the early Venetian presses was Francesco Colonna's romance entitled the *Hypnerotomachia Poliphili*, published by Aldus Manutius in 1499, with its distinctive blend of humanist and medievalizing thought and imaginative woodcut illustrations. Printing allowed written knowledge to emerge from the confines of the courtly library and the monastery cell, and gave added authority to the texts through the consistency of a single print run. Some of the most celebrated scholars, writers, and humanists of the

sixteenth century were not nobles, but educated *cittadini* (middle classes). Yet printed texts were often intended to be hand-illuminated, to confer on them the value and conventions of a traditional manuscript. Venetian presses became celebrated for their polyglot output. The first printed text in Greek was published in Venice as early as 1471, and Greek classics became the specialty of the presses of Aldus Manutius—even the hero of Thomas More's *Utopia* had Aldine Greek volumes in his suitcase.[7] Books were published in Hebrew and Slavonic languages, as well as in translation from Spanish and Arabic. The existence of a mercantile public encouraged the growing demand for travel narratives and maps.

The cultural vitality of Venice was very different from that of neighboring courtly cities such as Ferrara, Urbino, and Mantua. By attempting to prevent the formation of dominant factions, the complex republican constitution ensured that no single dynasty could dominate. Voting rights in the Great Council were limited to the male nobility over the age of twenty-five; from this body of about two thousand members, the various councils and magistracies were elected, culminating in the office of doge at the apex of the constitutional pyramid. Two remarkable doges dominated the early sixteenth century: Doge Leonardo Loredan (1501–1521) and Doge Andrea Gritti (1523–1538), separated by the brief dogeship of the elderly Antonio Grimani, elected at the age of eighty-seven.

The constitution ensured that the doge was a figurehead rather than a ruler, but individual doges could impose cultural leadership, whether by the direct patronage of public and private works of art or through influence on other public bodies such as the Senate and the Procurators of Saint Mark's. Like popes, doges tended to be venerable figures: Doge Loredan was already sixty-five on his election in 1501. Soon afterwards his likeness was captured by Giovanni Bellini in a portrait, now in the National Gallery in London (fig. 3), in which hieratic dignity is combined with intense realism. Although the depiction of individuals in Piazza San Marco was officially forbidden, medallions with Loredan's profile appear on the three bronze standard bases decorated with reliefs by Alessandro Leopardi, erected in front of Saint Mark's in 1505. Doge Andrea Gritti, formerly a merchant in Constantinople and later a hero of the Cambrai Wars, was about sixty-eight when he became doge in 1523. Gritti, too, was a vigorous and powerful figure, although stout and prone to attacks of gout. Titian's portrait in the National Gallery in Washington disguises the doge's enormous girth (the leather belt is extended to the last possible hole) by drawing attention to his piercing gaze and determinedly pursed lips. Doge Gritti was renowned for his zealous patronage of music, literature, architecture, painting, and sculpture.

The class structure of Venice ostensibly discouraged social mobility, but its effects did not necessarily disadvantage the *cittadini*. The identity of the Venetian ruling class had been defined by the *serrata* (closure) of the nobility in 1297 (although in reality a series of further decrees later refined the original measures). In 1506, the Council of Ten decreed that every legitimate noble birth had to be officially registered, thereby initiating the famous *Libri d'oro* (Golden Books), which authenticated the membership of the ruling patriciate.[8] But if political power was restricted to the nobility, the *cittadini* were allowed a considerable amount of self-government through membership of the great confraternities known as the Scuole Grandi. Thanks to their prominent participation in state ceremonial, the Scuole Grandi were invested with

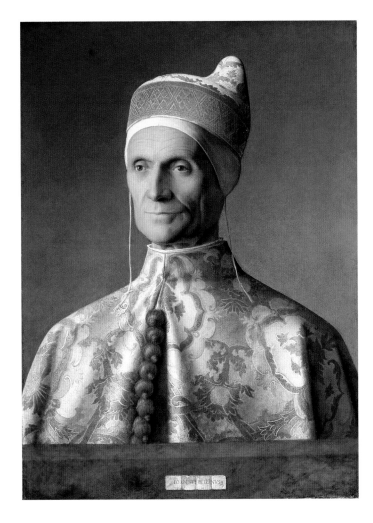

both status and visibility, and their institutions played a major part in the patronage of art, architecture, and music.

Membership of the nobility conferred privilege, but also required onerous duties. The fact that only the nobles were entitled to take part in the electoral processes of government obliged them to commit a considerable amount of time to politics and public service, which did not necessarily assist their material success. Nor could poor nobles replenish their fortunes by marrying the daughter of a wealthy *cittadino*, for the children of a marriage outside the nobility could not be entered in the *Libri d'oro*. The division of inheritance between the testator's surviving sons, combined with dowry inflation, was depleting many noble families' fortunes. *Cittadini* were often as wealthy as the less fortunate nobles. Only *cittadini* could occupy the posi-

tion of grand chancellor, one of the highest offices in the government, and many other posts in the chancery were reserved for citizens.

Thus, although the ruling oligarchy was an exclusive group sealed to outsiders, there was less economic and social division than might be expected. The possibilities for cultural diffusion between classes in Venice were considerable. Noble family palaces were dispersed throughout the city rather than concentrated in a particular high-class quarter. Since Venice was largely a pedestrian city, people met constantly in the street and observed one another from balconies, windows, and bridges. Although women's horizons tended to be defined by parish boundaries, their testaments reveal that they had interaction with the whole social range from slaves to nobles. Patricians and commoners alike owned family chapels in both monastic and parish churches, and endowed commemorative masses that perpetuated their memory. Anyone with capital to spare (including women and priests) could invest in trading voyages or in the purchase of real estate, whether property in the city or farmland on the *terraferma*, and could commission works of art and architecture.

Because immigrants from outside Venice were entitled to request the right of citizenship after long-term residence as taxpayers, the local culture was constantly enriched by outsiders, who ranged from Tuscan textile merchants to Lombard stonemasons. Surnames such as Gruato, Furlan, Schiavon, and Bossina indicate origins in Croatia, Friuli, Dalmatia, or Bosnia. There were important resident communities of Greeks, Armenians, Albanians, and Dalmatians, whose guilds (*scuole*) played a major role in patronage of the arts. Jews had been obliged to live in Mestre until the town was overrun in the Cambrai Wars, forcing them to flee to Venice. In 1516 the Venetian Senate established a residential

3.
Giovanni Bellini, *Doge Leonardo Loredan*, c. 1501, National Gallery, London

quarter specifically for the Jewish community on the island in Cannaregio known as the Ghetto Nuovo (named after the local iron foundry). According to the decree of 1516, Jews were to be confined to the Ghetto after sunset, and the access bridges guarded day and night.[9] As moneylenders, secondhand dealers, and medical doctors, the Jewish community played a vital role in the commercial and intellectual life of the city.

In other words, despite traumatic wars and natural disasters, Venice offered extraordinarily favorable conditions for artistic achievement in the first decades of the sixteenth century. The city's underlying wealth, cosmopolitan population, eclectic cultural traditions, international communications, and stable republican government all combined to foster enlightened patronage. During the very same years, papal Rome was also undergoing remarkable artistic development, under Pope Julius II (1503–1513) and the two Medici popes, Leo X (1513–1521) and Clement VII (1523–1534). Although Venice's artistic traditions were very different from those of the Holy City, the two should not be considered in isolation. One of the most striking underlying currents in the arts of early sixteenth-century Venice is a growing fascination with both ancient and modern Rome. Venice's self-identity, of course, had long depended on antique roots. Her legendary foundation in AD 421 by refugees from the barbarian invasions on the mainland justified continual recourse to the cultural precedents of antiquity. Before 1500, however, classical influence had usually been mediated through the legacy of Constantinople.

What stimulated the new interest in the *western* Roman tradition after 1500? The travails of the League of Cambrai intensified diplomatic contacts with Rome; as mentioned, diplomacy served as one of the most potent agencies of cultural transmission. A report of the Venetian envoy, Alvise Gradenigo, from Rome in 1523, for example, included a detailed and vivid description of the Pantheon, which he described as "the most beautiful temple in the world."[10] Those Venetian clans with ecclesiastical connections, such as the Grimani and the Corner, had regular contact with Rome through their family cardinals. In 1523, Cardinal Domenico Grimani, the son of the late doge, died, leaving his celebrated collection of classical sculpture to the republic. In parallel, Venetians were developing a growing pride in Roman antiquities preserved on their own territory, such as the impressive remains of Verona and Pula.

By tradition Venice zealously guarded her independence in religious affairs, and history is colored by many phases of poor relationship with Rome. Yet in the early sixteenth century, despite the hiatus of the Cambrai Wars, there were moments of intensely close and friendly contact. In 1511 the papal banker and enthusiastic patron of the arts, Agostino Chigi, visited Venice on a diplomatic mission and took Sebastiano del Piombo back to Rome with him. In the same year, the publication in Venice of Fra Giocondo's illustrated and learned edition of Vitruvius' *Ten Books on Architecture*, was prefaced by a dedication to Pope Julius II. The early years of Andrea Gritti's dogeship were marked by an exceptionally close rapport with the papacy, united by the menace of the increasingly powerful Emperor Charles V. Treaties of 1524 and 1525 formalized the alliance, culminating in the League of Cognac of 1526. When Rome was sacked by imperial troops in 1527, the reaction in Venice was not the jubilation of a cultural rival, as is sometimes suggested, but alarm and deep sympathy.

In the context of this growing openness to Roman civilization, both old and new, artists in Venice began to look

4.

Titian, *Saint Christopher*, c. 1523, Doge's Palace, Venice

5.

Palma Vecchio, *Saint Barbara*, central field of polyptych, 1523-1524, Santa Maria Formosa, Venice

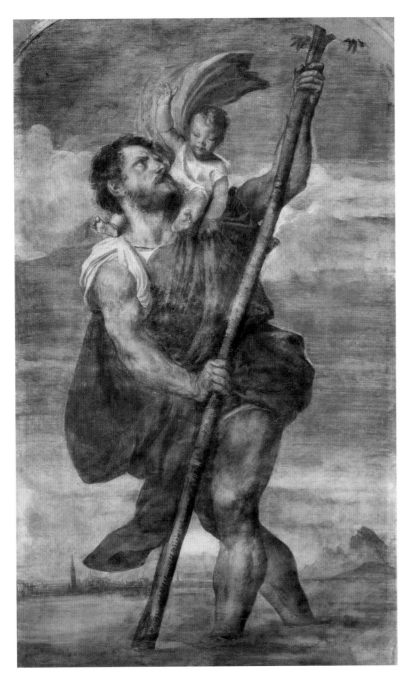

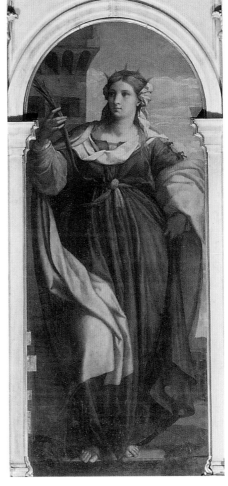

harder at what could be learned from ancient and modern Rome. Humanist studies, stimulated by the burgeoning printing industry, opened up unfamiliar mythological and classical themes, while a new monumentality began to characterize figure painting. The impact was not confined to elite circles. Mythological pictures were often small private commissions. Hieratic grandeur appears in works for a wide range of patrons, from Titian's colossal fresco of Saint Christopher (fig. 4) in the Cappella di San Niccolò, painted for Doge Gritti, to Palma Vecchio's Santa Barbara (fig. 5) for the altar of the Scuola dei Bombardieri in Santa Maria Formosa.

Finally, it should be noted that paintings were relatively inexpensive, in comparison with, say, tapestries or mosaics. It was far cheaper to fresco the exterior of a building such as the Fondaco dei Tedeschi, decorated by Giorgione and the young Titian from 1508 to 1510, than to face it with expensive marbles. A large altarpiece by a medium-rank painter, such as the *Coronation of Saint Catherine of Siena* by Francesco Bissolo, executed between 1513 and 1515, might cost only 40 ducats. Even one of Titian's masterpieces, the *Death of Saint Peter Martyr* for Santi Giovanni e Paolo, painted between 1526 and 1530 (but sadly destroyed by fire in 1867), cost as little as 100 ducats.[11] The traumas of war and disease—far from dampening this period of intense creativity—encouraged patrons to seek their own salvation in the afterlife through the commissioning of devotional works of art. Thus the cultural vitality, cosmopolitan horizons, and long-established prosperity of Venice provided the ideal conditions for artistic achievement in the eventful first three decades of the sixteenth century.

1. Deborah Howard, "Venice as a Dolphin: Further Investigations into Jacopo de' Barbari's View of Venice," *Artibus et Historiae* 35 (1997), 101–112.

2. Marin Sanudo, *I diarii*, R. Fulin et al., eds. 58 vols. (Venice, 1879–1903), 23: col. 477–493, 16–18 January 1517 (1516 Venetian style).

3. "Et è' da saper che Venetiani, cussì come sono stati nel principio mercadanti, cussì ogni anno seguono." Marin Sanudo, *De origine, situ et magistratibus urbis Venetae, ovvero la città di Venezia*, Angela Caracciolo Aricò, ed. (Milan, 1980), 28.

4. William Thomas, *The History of Italy*, G. B. Parks, ed. (Cornell, 1965), 65.

5. Margaret Newett, ed., *Canon Pietro Casola's Pilgrimage to Jerusalem in the Year 1494* (Manchester, 1907), 137.

6. See Milanesi 1878–1885, 2:568–572.

7. Martin Lowry, *The World of Aldus Manutius: Business and Scholarship in Renaissance Venice* (Oxford, 1979), 258.

8. David Chambers and Brian Pullan, eds., *Venice: A Documentary History 1450–1630* (Oxford, 1992), 244–246.

9. Chambers and Pullan 1992, 338–339.

10. Sanudo 1878–1903, 34: cols. 220–221.

11. Prices from Humfrey 1993, 154–155.

1494

Invasion of Italy by Charles VIII of France sets in motion four decades of warfare in the peninsula.

1496–1505

Correspondence between Isabella d'Este, Marchesa of Mantua, and her various agents in Venice concerning a picture commissioned by her from Giovanni Bellini.

1499

The Ottoman Turks advance westwards to threaten the Venetian province of Friuli.

Aldus Manutius publishes the *Hypnerotomachia Poliphili* by Francesco Colonna.

1500

Publication of Jacopo de' Barbari's woodcut bird's-eye *View of Venice*.

March · Leonardo da Vinci in Venice.

1501

Election of Doge Leonardo Loredan.

1502

Vittorio Carpaccio signs the *Calling of Matthew* and the *Funeral of Saint Jerome* in the Scuola di San Giorgio degli Schiavoni.

1503

Lotto recorded in Treviso.

1504

Giovanni Agostino da Lodi recorded in Venice.

1505

Aldus Manutius publishes *Gli Asolani* by Pietro Bembo.

Bellini signs the San Zaccaria (page 41, fig. 1) and Birmingham (cat. 5) altarpieces, and the *Saint Jerome* (cat. 22).

Date formerly inscribed on the reverse of Lotto's *Allegory of Virtue and Vice* (cat. 37).

January · Destruction by fire of the Fondaco dei Tedeschi.

September · By September Dürer is in Venice, where he stays until the end of October 1506.

1506

June · Inscription on the back of Giorgione's *"Laura"* (cat. 38).

Lotto signs the *Assumption of the Virgin with Saints Anthony Abbot and Louis of Toulouse* (Duomo, Asolo); date inscribed on his *Saint Jerome* (Louvre, Paris). Lotto settles the fee due for his recently completed *Saint Christina* altarpiece (Santa Cristina al Tiverone, parish church) and leaves the Veneto for the Marches.

1507

February · Death of Gentile Bellini.

March · Giovanni Bellini undertakes the completion of the *Saint Mark Preaching in Alexandria* (Brera, Milan) for the Scuola di San Marco, left unfinished by Gentile.

August · Giorgione is paid for a canvas in the Audience Chamber in the Doge's Palace; further payments follow in January and May 1508.

September · Bellini is urged to complete three canvases for the Sala del Maggior Consiglio (Hall of the Greater Council) in the Doge's Palace, and Carpaccio is taken on as his assistant there.

1508

March · Emperor Maximilian I invades Cadore in the northern Veneto.

Florentine painter Fra Bartolommeo visits Venice.

November · Giorgione requests a review of his payment for his frescoes on the Fondaco dei Tedeschi, which in December is undertaken by a committee of three painters nominated by Bellini.

December · Formation of anti-Venetian League of Cambrai by the papacy, the Holy Roman Empire, Spain, and France.

1509

May · Defeat of Venetian forces by the armies of the League of Cambrai at Agnadello.

July · The Venetians under Andrea Gritti recapture Padua from imperial forces.

Giovanni Cariani is recorded as a painter in Venice.

1510

Bellini signs the Brera *Virgin and Child* (cat. 1).

Carpaccio signs the *Portrait of a Knight* (Thyssen Collection, Madrid) and the *Presentation of Christ in the Temple* for San Giobbe (Accademia, Venice).

Sebastiano del Piombo signs the *Judith* (or *Salome*) (National Gallery, London).

Palma Vecchio is recorded living in Venice.

October · Before 25 October, Giorgione dies.

December · Titian undertakes to paint frescoes for the Scuola del Santo in Padua (page 47, fig. 7); he receives a series of five payments for his work there in April, May, July, and December 1511.

1511

Treaty between Venice and two former members of the League of Cambrai, France and the papacy.

Carpaccio signs the *Ordination of Saint Stephen* for the Scuola di San Stefano (Staatliche Museen, Berlin).

Date inscribed on Sebastiano del Piombo's *Wise Virgin* (cat. 40).

August · Sebastiano leaves Venice for Rome.

1513

May · Letter from Titian to the Council of Ten, offering to paint the *Battle of Spoleto* for the Hall of the Greater Council in the Doge's Palace.

Bellini signs the *Saint Jerome with Saints Christopher and Louis of Toulouse* (San Giovanni Crisostomo, Venice).

Carpaccio signs the *Disputation of Saint Stephen* for the Scuola di San Stefano (Brera, Milan).

1514

Destruction by fire of much of the Rialto market.

February · Palma Vecchio receives a payment for his *Assumption of the Virgin* (Accademia, Venice).

Bellini signs the *Feast of the Gods* (cat. 32); he receives his final payment in November.

1515

July · Bellini undertakes to paint the *Martyrdom of Saint Mark* (Accademia, Venice; signed by his assistant Vittore Belliniano, 1526) for the Scuola di San Marco.

Bellini signs the *Lady with a Mirror* (cat. 41).

1516

The Venetians recapture Brescia.

January–March · Titian in Ferrara.

August · Cima receives a part payment for his *Saint Peter Enthroned* altarpiece (cat. 6).

November · Death of Giovanni Bellini.

Carpaccio signs the *Lion of Saint Mark* for the Palazzo dei Camerlenghi (Doge's Palace, Venice).

1517

The recapture of Verona by the Venetians effectively ends war of Cambrai.

Giovanni Cariani is in Bergamo to undertake the commission for the *Saint Gotthard* altarpiece (Brera, Milan). Payments follow until 1521.

1517 or 1518

Death of Cima.

1518

Paris Bordone recorded as a painter in Venice.

May · Titian's *Assumption of the Virgin* is officially unveiled in the church of the Frari (page 48, fig. 8).

1519

Charles I, king of Spain, succeeds as Holy Roman Emperor Charles V.

Titian undertakes to paint the Ca' Pesaro altarpiece (page 49, fig. 9) for the church of the Frari, and completes it in 1526.

October · Titian takes the *Worship of Venus* (cat. 34), commissioned in the previous year, to Ferrara to complete.

1520

Titian signs the *Virgin and Child in Glory with Saints Francis and Blaise* (page 49, fig. 11).

1521

Death of Doge Loredan and election of Doge Antonio Grimani.

Giovanni Savoldo is in Treviso to complete the high altarpiece for San Niccolò begun by Fra Marco Pensaben (in situ).

October · Paris Bordone is paid for his *Story of Noah* fresco (lost) for the loggia of the Palazzo del Capitanio, Vicenza.

Titian paints *Judgment of Solomon*, also for the loggia.

1522

Titian signs the *Resurrection* polyptych (Sa nti Nazzaro e Celso, Brescia), which was already in progress in 1520.

August · The Council of Ten orders Titian to complete Bellini's unfinished *Humiliation of the Emperor Frederick Barbarossa* for the Doge's Palace by June of the following year.

1523

Death of Doge Grimani and election of Doge Andrea Gritti.

February · Titian in Ferrara to install the *Bacchus and Ariadne* (page 50, fig. 12), which was recorded in progress in 1522.

Cariani is recorded back in Venice from Bergamo.

1524

Savoldo in Pesaro to undertake the commission for the high altarpiece of San Domenico (Brera, Milan).

Titian spends two months in Ferrara at the end of the year.

1525

July · Palma Vecchio undertakes to paint the *Adoration of the Magi* (Brera, Milan) for Sant'Elena by Easter 1526.

December · Lotto returns to Venice after a nineteen-year absence in the Marches and Bergamo.

1525/1526

Death of Carpaccio.

1527

Sack of Rome. Arrival in Venice from Mantua of Pietro Aretino, and from Rome of Jacopo Sansovino.

Lotto signs the *Assumption of the Virgin* (Celana, parish church) and the *Andrea Odoni* (Hampton Court, Royal Collection).

1528

May · Pordenone is commissioned to fresco the chancel of San Rocco in Venice, and is paid for his work in March 1529.

Titian in Ferrara.

Cariani recorded back in Bergamo.

June–August · Sebastiano del Piombo recorded back in Venice.

Death of Palma Vecchio.

1529

Peace of Bologna confirms imperial and Spanish hegemony in Italy.

Lotto completes the *Saint Nicholas in Glory* (Santa Maria dei Carmini, Venice).

January–June · Titian is in Ferrara and Mantua. He paints the portrait of Federico Gonzaga (Prado, Madrid).

September–October · Michelangelo in Venice.

Titian meets Emperor Charles v.

1530

Charles v is crowned in Bologna by Pope Clement vii.

Titian completes the *Death of Saint Peter Martyr* (lost; see page 49, fig. 10) for Santi Giovanni e Paolo, Venice, which was begun in 1526.

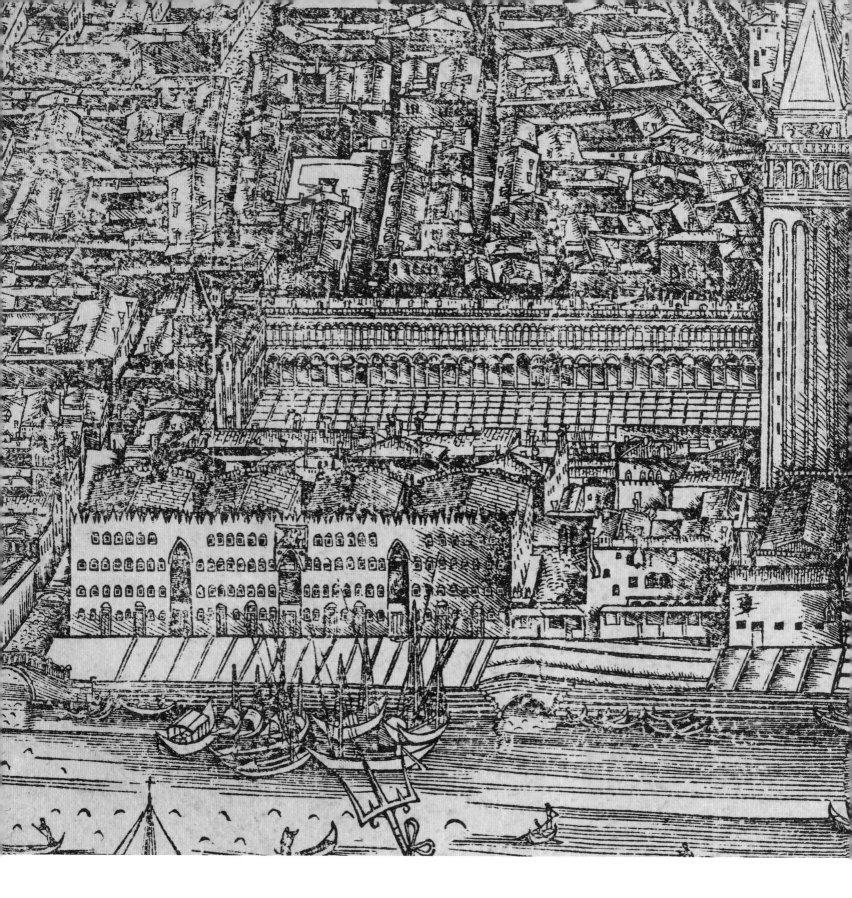

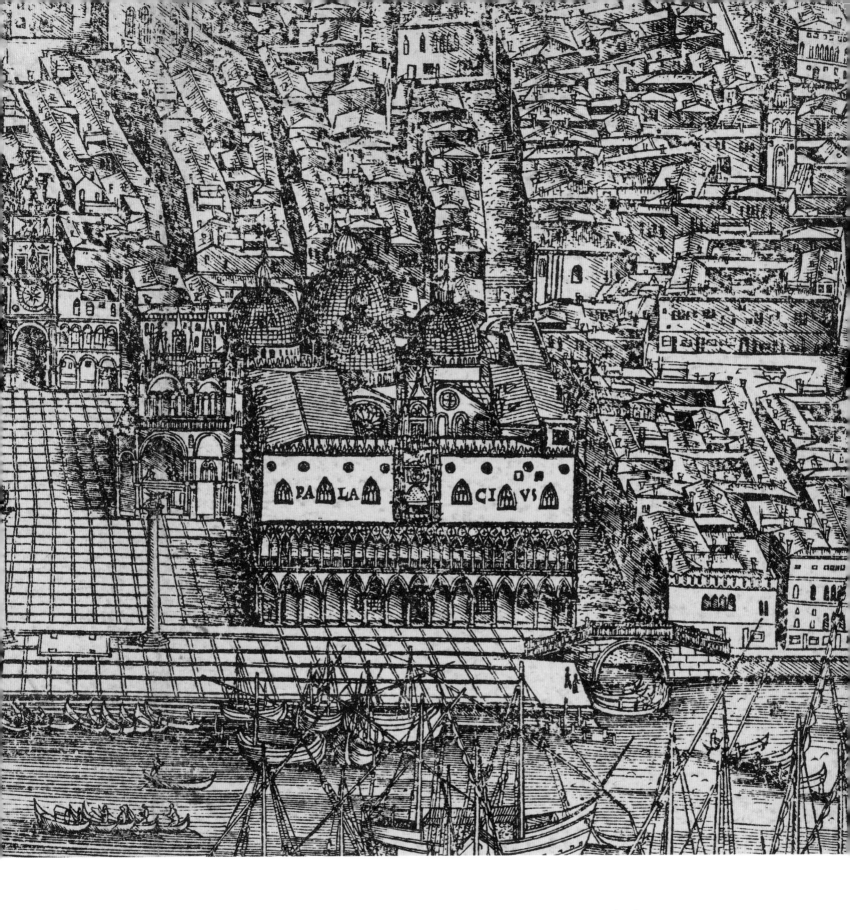

VENETIAN PAINTING AND THE INVENTION OF ART * *David Alan Brown*

LOVERS OF VENETIAN painting may not realize how little is actually known about the works brought together in this exhibition. Indeed, we probably know less about the origins of a famous masterpiece like the *Concert Champêtre* (cat. 31) than about any other climactic moment in the history of Western art. The artistic revolution that took place in Venice at the beginning of the sixteenth century did not go unremarked, of course. But it was mainly a private matter until the two leading innovators, Giorgione and Titian, undertook the exterior fresco decoration of the Fondaco dei Tedeschi in 1508–1509. Even afterwards, the Florentine Vasari, who visited Venice twice in advance of the 1550 and 1568 editions of the *Lives*, fails to mention a single picture in the exhibition, apart from a confused account of the Ferrara Bacchanals. Later art historians responded to the gap in knowledge by producing a vast and still growing literature on the subject. But without reliable evidence, the results have proved contradictory and inconclusive. Consulted more often than read, this literature deals primarily with two problems—attribution and iconography or identification of subject matter—neither of which is new. Giorgione's contemporaries, we are told, could not easily distinguish his own works from ones painted in his style. Fortunately, some guidance is offered by a few early sources, especially Marcantonio Michiel's notebooks, which briefly describe paintings by Giorgione in private collections. Several of these recorded works joined others indisputably by the master in the Giorgione exhibition held in Venice and Vienna in 2003–2004, forming a core production against which to measure hopeful attributions.[1] Likewise, another exhibition and two new lavishly illustrated monographs offer a chance to compare works by or ascribed to Titian and, in doing so, to agree or not about their authorship.[2] The result of these recent efforts is that some, if not all, of the attribution problems left unsolved when connoisseurship went out of fashion may now be approaching resolution. As for iconography, just as attributions are seldom based anymore on linking types or motifs that are the common currency of Giorgionesque painting, so too studies of subject matter increasingly favor a more synthetic approach over using a single element shared with a text as a key to unlocking the meaning of a picture.[3] The difficulty, in any case, is inherent in the art, which not only eludes simple explanation but seems to lend itself to multiple interpretations. Thus Michiel mistook the smartly dressed youth in Giorgione's *Tempest* (page 44, fig. 3) for a soldier, while Vasari failed to discover the subjects of the Fondaco frescoes.

Early sixteenth-century Venice was a crucible in which artists turned to new subjects drawn from classical antiquity and developed new styles and new techniques to represent them. Organized thematically rather than by artist, the exhibition traces the emergence of several new pictorial themes—the pastoral landscape, eroticism and the female nude, and the dramatic portrait. And it demonstrates how the artistic revolution transformed traditional religious painting, which still predominated. The exhibition also explores music, love, and the passage of time, overarching themes that cut across the categories in which the works are presented: sacred images, sacred stories, allegories and mythologies, pictures of women, and portraits of men. These genres were not rigid, however, and they overlapped, as the protagonists of sacred or secular pictures came to exhibit the kind of inner life we associate with portraiture, and portraits took on a narrative dimension. The present exhibition, it must be emphasized, is not about a theme—the courtesan or music—or themes per

se; rather it addresses artists' innovative treatments of a variety of subjects, new and old, during this crucially important period. The goal is to get visitors to the exhibition and readers of the catalogue to approach early sixteenth-century Venetian painting in a different way. By taking it out of the realm of scholarly debates over attribution and iconography and treating these works in a more integrated fashion, we hope to make what is special and significant about them accessible to a wider audience. Finally and appropriately for an exhibition, the show is about viewing and the responses that the paintings elicit from the observer.

The "Renaissance of Venetian Painting" of the exhibition title refers to the artistic renewal that occurred at the beginning of the sixteenth century. Historically, the term "Renaissance" alludes to the rebirth of antiquity, and it was during this period in Venice that humanist culture flourished as never before. To be sure, Venice had its own antique past, as Patricia Fortini Brown has demonstrated, but the kind of classicism associated with Florence and Rome came late to the Serenissima.[4] The complex relations between early sixteenth-century Venetian paintings and the intellectual and cultural climate in which they were made cannot be explored very well in an exhibition and have, in any case, been intensely studied by scholars.[5] The artists depicted subjects taken from Greek and Latin literature and philosophy; their interpretations were later called *poesie*. Artists and their patrons also took a new interest in the antiquities of Rome and in the classicizing work of the central Italian artists Raphael and Michelangelo. In 1523, for example, Cardinal Domenico Grimani bequeathed his celebrated collection of classical sculpture to the republic. In addition to its meaning as a revival *all'antica*, the "Renaissance of Venetian Painting" signifies that during this period the

earlier fifteenth-century renewal of painting in Venice was completely and utterly transformed. Giovanni Bellini had succeeded in assimilating the achievements of his brother-in-law Mantegna and of Donatello in nearby Padua, and he went on to absorb the Flemish-inspired style of Antonello da Messina, who sojourned in Venice in 1475–1476. This process of renewing the local tradition through contacts with outsiders was not typical of Florence, where an unbroken series of artistic innovations links Masaccio to Michelangelo. But it does describe Bellini's practice, and it also helps to explain the fundamental changes that took place in Venetian painting after the turn of the century.

The time span covered by the exhibition — the opening decades of the sixteenth century — was selected because most of the artists came to maturity about 1500 and were either deceased or absent by the 1530s. More important, this period represents, visually and intellectually, the most exciting phase of the Renaissance in Venice, when the old Bellini (d. 1516), Giorgione (d. 1510), young Titian, Sebastiano Luciani, later called del Piombo (active in the city until 1511), and Jacopo Negretti, known as Palma Vecchio (d. 1528), were all working side by side. The exhibition does not present a dialectic of styles approaching some kind of ideal norm; instead, a variety of individual expressions each contributed to a development whose outcome was unforeseen. In Venice in 1506, Dürer described Bellini as "still the best," but among the younger generation, Giorgione played the central role. Working for a new class of culturally sophisticated patrons, he invented a new type of painting that aimed to rival poetry in its evocative power. Combining secular subjects whose meanings are elusive with a softly atmospheric style and a dreamy introspective mood, Giorgione's art had a profound impact on contemporaries, who

quickly fell under his spell. But Giorgione died tragically at an early age, and it was left to the slightly younger Titian to reinvent the art of painting in ways that continue to the present day. To each of the genres represented in the exhibition, as in his paint handling, Titian brought a new energy and vitality. By 1518 he was recognized as Bellini's successor as the leading painter in the city, and art historians have rightly stressed his rise to greatness. But the exhibition also highlights Sebastiano, who at this time was working nearly as Titian's equal. Whether or not his seminal works are datable before those of Titian, Sebastiano remains a major protagonist. While he was notably successful at working on a large scale, it is Sebastiano's brilliantly executed smaller works that are featured in the exhibition. To judge from his output, Palma Vecchio's homogenizing version of the new manner was much appreciated; he is represented here in every category. While celebrating the achievements of these masters, the exhibition does not omit more conservative artists, like Cima da Conegliano (d. 1517 or 1518) and Vincenzo Catena (d. 1531), and it includes others like Lorenzo Lotto, Cariani, and Savoldo—who worked, though not exclusively, in Venice at this time—as well as the younger Paris Bordone and Bonifacio de' Pitati. The period may be said to close with Titian's (lost) *Death of Saint Peter Martyr,* completed in 1530 as the culmination of a series of innovative altarpieces. Beyond the purview of the exhibition lie the advent of Mannerism in Venice in the 1540s and the rise of a new generation of great masters, Jacopo Bassano, Tintoretto, and Veronese.

By the turn of the century, when he depicted Doge Loredan (page 7, fig. 3), Bellini had become the patriarch of Venetian painting and his art had gained canonical status. Younger artists flocked to his workshop, eager to master his exquisite distillation of visible reality. Like Venice itself, as seen in Jacopo de' Barbari's monumental bird's-eye view (pages xiv–xv) of 1500, Bellini's mature manner was a kind of self-contained realm, perfect in its own way. The map, introducing the exhibition, shows the unique geographical position of Venice as an island in a lagoon off the Adriatic Sea. As the center of a far-flung commercial empire, Venice was not isolated; it had a rich layered culture and was overflowing with artistic talent. But in 1500 the city was cut off from the most advanced artistic developments underway elsewhere in Italy and in northern Europe. As Deborah Howard explains in her essay (pages 1–10), the burst of creativity examined in this volume took place against a background of social, political, and military crises in which Venice's very existence was threatened, by catastrophic fires, by the plague that killed Giorgione in 1510, and by the war of the League of Cambrai (1508–1516).[6] Just as Venice was beset by enemies from abroad, so too the artistic culture was dramatically changed as a result of a series of "outside" influences. The role of these contacts in the artistic flowering of the early sixteenth century is only beginning to be fully appreciated. Their relevance as a catalyst for change arises from the fact that Bellini's achievement, however great, could not be developed further in its own terms except, as the exhibition demonstrates, by the master himself. The physical and emotional stasis of Bellini's work—the reticence that went hand in hand with its refinement—made it inadequate to represent the new content coming into Venetian art during this period. At the same time, artists outside Venice—Leonardo in Milan and Florence, Raphael and Michelangelo in Florence and Rome, and Dürer in northern Europe—were creating what Vasari, referring to the Italians, called the *maniera moderna.* Though most of the artists included here—Giorgione,

Titian, Sebastiano, Lotto, Palma, and Catena— studied with Bellini or took his work as a point of departure, the exhibition does not present his direct legacy, as the more enterprising of his pupils, unlike the faithful "Belliniani," were quick to see the limitations of his art and turned to new models. The horizons of the younger generation rapidly expanded, as Giorgione first sought inspiration in drawings that Leonardo brought to Venice during a brief sojourn early in 1500 (page 240, fig. 3).[7] Leonardo's impact involves a basic change in the conception of the human figure that can be traced, as a sense of heightened animation, right up to Titian's *Assumption* (page 48, fig. 8).[8] If Leonardo supplied the expressive dimension missing in Bellini, Dürer was a force through the intense realism of his prints, which circulated throughout Italy, and of the paintings he completed during his Venetian sojourn of 1505–1506. Dürer's engravings influenced the landscapes in Lotto's early allegories (cats. 37, 47), for example, and his *Feast of the Rose Garlands* (page 45, fig. 6), painted for the church of San Bartolomeo a Rialto, lies behind Lotto's early *sacra conversazione* (cat. 3) in Rome.[9] Lotto, whose originality often verges on the bizarre, forms a contrast to Titian, whose work superseded Giorgione's as the standard for the new painting. Recent scholarship, borne out by the exhibition, has clarified the debt young Titian owed indirectly to sources in Raphael and Michelangelo.[10] Long before his trip to Rome in 1545, prints and drawings recording their ideas offered Titian and his contemporaries the means to update their inheritance from Bellini and Giorgione. The revolution that produced some of the world's most glorious paintings thus seems to have been prompted to a considerable extent by works on paper.

Like the other new themes treated by Giorgione and his fellow artists, the pastoral landscape became a quintes-sentially Venetian mode of painting. The pastoral did not arise out of some new feeling for nature or the countryside. To the contrary, it depicts an imaginary world whose roots lie in ancient bucolic poetry then being revived in Venice.[11] More than Theocritus' *Idylls*, published by Aldus Manutius in the original Greek in 1495, it was the Latin pastoral of Virgil's *Eclogues* that was the primary model for the revival. Of even greater importance because it was in the vernacular, which could be read by artists and not just their learned patrons, was the Neapolitan poet Jacopo Sannazaro's *Arcadia*, published in an unauthorized edition in 1502 and again in 1504.[12] Frequently reissued, Sannazaro's prose and verse romance tells the story of a court poet who flees the cares of urban life to seek solace in nature. Playing the shepherd, Sannazaro's protagonist encounters an idyllic landscape— a *locus amoenus* (pleasant place)—populated by real shepherds, nymphs, and satyrs. The revived pastoral in literature unquestionably stimulated the rise of pastoral painting in Venice, as seen in the epitome of the genre— Titian's *Pastoral Concert* (cat. 31) in the Louvre. As in its literary precedents, the landscape setting in the picture plays a major role and is essential to its poetic effect. Also common to the visual and verbal pastoral are arcadian motifs, such as nymphs and the shady grove and gently rolling hills. But the key element is the shepherd, shown in his dual role as herdsman (the small figure tending his flock in the background) and as musician or poet. The latter concept predominates, as Giorgione's type of curly-haired youth (page 44, fig. 4) joins the gathering in the foreground. His bare foot and humble dress, contrasted with the resplendent costume of his male companion, point to the dialectic between city and country, cultured and rustic, art and nature, that lies at the heart of the pastoral idiom.

But aside from its shared imagery and values, Titian's painting differs significantly from the literary type. Quite unlike the classical architecture in the *Arcadia*, for example, the picturesque motif of rustic structures perched on a hillside derives from Dürer's prints and may serve to recall the city left behind. Titian's main focus, however, is the figures on the grassy knoll. As shown by technical investigation, their relation to one another changed during the course of execution. In the final version, the standing nude female turns away from the group, while her counterpart, seated with a recorder in hand, turns her back to the viewer and ignores the youths, who gaze intently at each other.[13] Nothing like this occurs in Sannazaro's poem, but a similar configuration appears in Titian's *Christ and the Adulteress* (page 102, fig. 2), in Glasgow, which may be dated just prior to the *Concert*, about 1509/1510.[14] The point is not that Titian was merely reusing his figural vocabulary but that the *Concert* is essentially an artistic invention with literary associations that recommended it to the patron. Also Titian's was the decision to depict the lute player not as a pretend shepherd but as a young patrician, whose contemporary dress would have encouraged the patron to project himself into the imaginary world of the painting.

The schema of an intimate group in a landscape was also used for paintings of religious subjects. The horizontal format of these works, going back to Bellini, lent itself to a pastoral treatment, nowhere more than in depictions of the Adoration of the Shepherds. Again like the *Concert* but earlier, Giorgione's version of the theme (cat. 17), in the National Gallery of Art, includes large-scale figures of shepherds adoring the infant Christ in the foreground and smaller ones with their flock in the middle distance. As Mauro Lucco explains (page 117), these are noble shepherds,

dressed poorly but dignified, almost courtly, in demeanor.[15] The later addition of an announcing angel in the upper left corner turned the pair resting under a tree into the conventional shepherds of the Gospel story. The Washington picture belongs to the so-called Allendale group, including the little *Holy Family* (fig. 1), also in the National Gallery of Art, and the *Adoration of the Magi* in the National Gallery, London, which are now generally regarded as early works by Giorgione.[16] The *Adoration of the Shepherds* may be compared in the exhibition with the *Sunset Landscape* ("Il Tramonto") (cat. 29), also widely attributed to Giorgione and a link with the *Tempest* and his other established secular works. As a highly innovative treatment of a familiar theme, the *Adoration of the Shepherds* inspired more copies and variants than did the *Tempest*; indeed it may have been Giorgione's most popular composition.[17] The exhibition includes three such imitations, one of them claimed to be an autograph replica. The unfinished version (cat. 18) of the *Adoration* in Vienna has often been attributed to Titian; recently Jaynie Anderson has connected the two works with Michiel's description of two pictures by Giorgione, one of which he judged superior to the other. In bringing the Washington and Vienna paintings together for the first time, the exhibition offers the chance to make just such a comparison.

Of course, Giorgione's contribution to the pastoral surpassed the *Adoration of the Shepherds*. In the *Tramonto* he inverted the usual relation between figures and setting, giving the landscape greater importance and featuring a sunset which, as in the *Tempest*, gives the picture its name. And in the *Three Philosophers* (cat. 30), he introduced an unaccustomed note of exoticism.[18] Behind the enigmatic figures, tall tree trunks and a cave frame a pastoral vista similar to that in the *Concert*. The use of such a framing

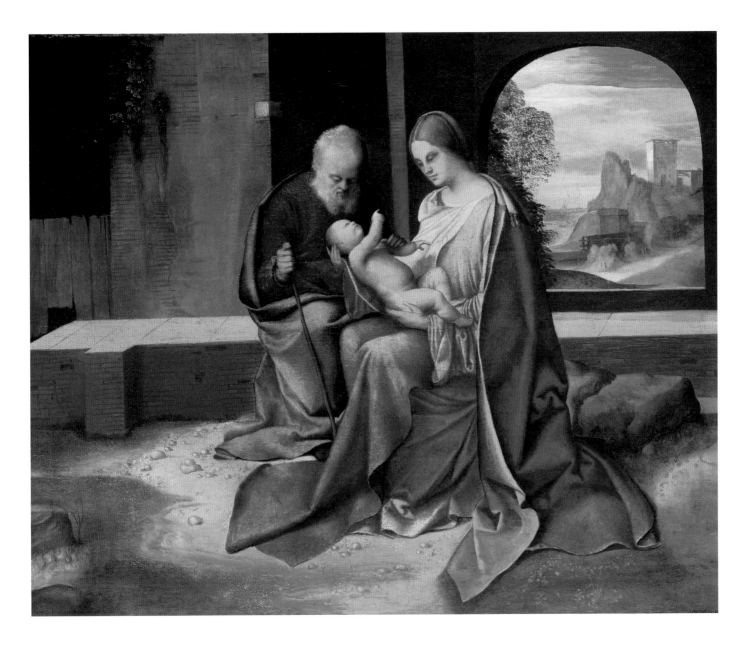

device extends beyond the Vienna picture to include the Allendale *Adoration* and even Bellini's *Saint Jerome Reading* (cat. 22) of 1505. The framing of a landscape is more explicit in Giorgione's Castelfranco altarpiece, in which two complementary pastoral scenes flank the enthroned Virgin and Child, and in his *Holy Family* (fig. 1), where an opening in a wall behind the figures encloses a vista that appears autonomous. The consistency of these views—the sunrise or sunset over blue mountains and rolling hills, the castle or other

rustic buildings, the tall tree or grove, the plain with tiny figures—further contributes to the effect of a picture within a picture. Artfully composed and framed, the pastoral vignettes in these works, as well as in the backgrounds of Sebastiano's portraits (cats. 43, 55), point toward the emergence of landscape as an independent genre.

The difference between the new pastoral landscape and the older type may be gauged by comparing Titian's *Gypsy Madonna* (cat. 2) with Bellini's *Virgin with the*

1.

Giorgione, *Holy Family*, National Gallery of Art, Washington, Samuel H. Kress Collection

Blessing Child (cat. 1) of the same date, in which the background is full of symbolic details and, continuing behind the figures, helps to balance the composition. Shifted to the right, Titian's cloth of honor asymmetrically frames the landscape (fig. 2), in which a soldier, rather than a shepherd, is seated beneath a tree. The x-radiograph reveals that the artist carefully adjusted the Arcadian motifs composing the view. They are repeated, in fact, from the left side of the distant landscape, framed by a rocky outcrop, in the *Sleeping Venus* (page 44, fig. 5), in Dresden, which, according to Michiel, Titian completed after Giorgione's untimely death in 1510.[19] The right side of the landscape in the *Venus*, with rustic buildings crowning a hill, also recurs on the right (fig. 3) in the *Noli Me Tangere* (cat. 21), and in other works by or attributed to Titian.[20] The repetition of the *Venus* landscape suggests that for the young Titian it was not a matter of self-borrowing but a pictorial strategy aimed at claiming

responsibility for the Dresden picture. Michiel and quite possibly others credited the invention of the *Venus* and the execution of the main figure to Giorgione—all the more reason, then, for Titian to attempt to put his stamp on it. Some scholars now believe that Titian did all of this epochal painting, not just the landscape (and a cupid overpainted on the right). He was responsible for the landscape, in any case, and the integration of the figures with the echoing forms of nature in the *Noli Me Tangere*, as Nicholas Penny has observed, marks a further advance in the history of landscape painting.[21] As for the pastoral, the idealized view of nature that it presents gradually changed to admit more of the harsh reality of country life, at first simply by including enough animals to make a real flock (cat. 25).[22]

If the pastoral landscape held out the vision of a carefree existence in nature, the second of the new, quintessentially Venetian themes—the nude or partially clad

2.

Titian, *Gypsy Madonna* (cat. 2), detail of landscape

3.

Titian, *Noli Me Tangere* (cat. 21), detail of background right

4.

Francesco Colonna, *Hypnerotomachia Poliphili* (Venice, 1499), detail of nymph and satyr

female nude in painting has become an artistic cliché to which we respond mainly in aesthetic terms. It is necessary to recall, therefore, how few female nudes there were in Venetian art before the *Sleeping Venus.* Significantly, the one most often cited as a prototype is not a painting but a woodcut. This little picture (fig. 4) of a slumbering nymph accosted by a lustful satyr illustrates one of the most famous books of the period, Francesco Colonna's *Hypnerotomachia Poliphili,* published by Aldus Manutius in Venice in 1499. Because of its rarity, this classically sanctioned nude had an influence disproportionate to its size. Giorgione's bold step was to transform the small graphic image into a large-scale picture that rendered the nude life size and in living color, and that cast the viewer in the satyr's role as voyeur. A later example of the genre, Palma's *Bathing Nymphs* (cat. 35) offered the connoisseur of female beauty not one but thirteen nudes posed in a variety of attitudes for his pleasure.

Though portrayals of women in this period were tempered by the Neoplatonic concept, then much in vogue, of love as an ascent, through stages, from sensuality to spiritual love of the divine,[23] the modern critical notion of the male gaze again offers some help in interpreting the related genre of half-length females depicted close to the viewer. Here, too, the problem is one of overfamiliarity. Giorgione's *Laura* (cat. 38) is so famous it is easy to forget that, at this time, such images of women were rare in Venetian painting. Even if Giorgione's subject was a wife and not a mistress or courtesan, as some scholars have argued, the way she removes what appears to be a male garment must have surprised and delighted viewers used to seeing women portrayed, if at all, like Lotto's respectable matron (cat. 36). Given the lack of realistic portraits of women in Venice, Titian's so-called *Schiavona* (cat. 45),

female—aroused fantasies of a different sort. More directly than the pastoral, early sixteenth-century depictions of women nude or in a provocative state of partial undress raise the issue, as new as the art itself, of how such images seek to communicate with the viewer. Here the problem is that, while the pastoral may still appear delightful, the recumbent

in London, is most remarkable for its size and complexity, explicitly raising, as it does in the woman's carved profile, the issue of the *paragone* (comparison) between painting and sculpture.

The x-radiograph (page 292, fig. 8) of the *Laura* reveals that the erotic motif of baring the breast was of particular concern to Giorgione as he worked on the picture. Like the artist's *Sleeping Venus,* the *Laura* launched a new genre in the history of art, including notably Titian's *Flora* (cat. 42), which is here juxtaposed with its prototype for the first time ever. Titian's celebration of female loveliness quickly superseded Giorgione's enigmatic image as a model for the *belle donne* of other artists, especially Palma, who specialized in the genre. As Sylvia Ferino-Pagden indicates (pages 189–235), the status of these works is still not entirely clear: are they idealized portraits of actual women or images of ideal female beauty? What they all have in common, aside from their seductiveness, is that the youthful beauty they portray was ephemeral. It seems fitting, therefore, that Giorgione's brutally realistic *La Vecchia* (cat. 39) should appear, arrestingly juxtaposed in their midst, as a reminder of the ravages of age. Like the hermit or intercessory saints or the teachers pictured in the exhibition, Giorgione's old woman offers an example of moral guidance. Her message, and theirs, is clear: with the passing of time (*col tempo*), youth turns into age, beauty fades, and love grows cold. Sensuous beauty and pleasure pervade the exhibition, but so, too, does a melancholy awareness of their transience.

No less than the pictures of women, male portraits of the period make a newly dramatic statement about the sitter that goes beyond his character or appearance. Lotto stressed his subjects' state of mind or aspirations through the use of symbols or emblems. But it was Giorgione and his circle who evolved a revolutionary type of idealized portraiture, in which an individual was shown in the guise of a lover, poet, musician, or soldier. Aptly called "action" portraits, these works depict young men acting out roles, as in a dramatic situation or narrative, and frequently turned toward the viewer. The epitome of this development is Titian's *Concert* (cat. 53) in Florence. In this and other group portraits, the format has been expanded to include additional figures, whose relation to the protagonist determines the content of the picture. Often such "allegorical" portraits have learning or music-making as a theme.[24] Music shared with painting the ability to convey what cannot be expressed in words. And it was believed to elevate the soul and reflect the harmony of the universe. The keyboard player in the *Concert,* accordingly, seeks inspiration, but his figure, contrasted with that of his flamboyant companion, already strikes a new note. In Titian's hands, poetic idealization increasingly gave way to a new realism and a sharper awareness of social distinctions, just as it had in the pastoral.

If the new subjects—the pastoral landscape, the erotic female, and the dramatic portrait—are particularly associated with Venice, the manner devised to represent them had much in common with what was occurring in Florence and Rome. The parallel is not surprising given that a knowledge of central Italian innovations, however indirect, was an essential factor in the transformation of Venetian painting. Most obviously, the change involved an increase in size and scale: paintings became larger, and the figures in them grew larger, too, in relation to the picture area. With this change came a change in function, as the works were mostly destined, it would seem, for fairly large spaces in the domestic setting of a palazzo, where their broader brushwork and selective detail provided a new sort of aesthetic satisfaction.

5.

Giovanni Bellini, *Virgin and Child with Saints Peter and Mark and a Donor* (cat. 5), detail of the center and right-hand side

6.

Titian, *Virgin and Child with Saints* (cat. 10), detail of the center and right-hand side

At the same time, a shift occurred toward a horizontal format, an oblong rectangle that allowed for other dramatis personae. As if stepping onto a larger stage, figures interact with one another and with the viewer. Though visible in every category in the exhibition, these dynamic structures may be seen best, as Peter Humfrey demonstrates (pages 56–63), in religious art where the basic subject matter remained more or less unchanged. We have seen that for the formal, strictly symmetrical scheme of Bellini's *Virgin* (cat. 1), Titian experimented with an arrangement (cat. 2) that shifted the figures and the cloth of honor behind them

off the central axis in favor of a landscape view. The offset view of landscape reappears, then, in Titian's *sacra conversazione* (cat. 10) in Parma. Bellini's earlier version of the theme (cat. 5) in Birmingham also depicts the figure of a kneeling donor, whose inclusion fails to alter the symmetrical composition and solemn mood (fig. 5). In Titian's more fluent grouping (fig. 6), the donor ardently presses forward and, with his patron saint, meets the Virgin's gaze, while the infant Christ turns toward Saint Catherine, featured as a *bella donna* on the left. The sloping contours of the landscape stress the piety of the patron and his pro-

tector. This kind of lively relation between figures, who seem to commune with nature as well as with each other, reached its culmination in works by Bonifacio de' Pitati (cat. 12) and Paris Bordone (cat. 13) that can truly be called holy conversations. Here on the Rest on the Flight into Egypt, the Holy Family encounters not only the little Saint John of the biblical account, but also Tobias and the angel and Saint Catherine, all in a lush pastoral landscape.

The stylistic development from static to dynamic outlined above correlates with analogous changes in painting technique. During this period Venetian painters' materials and methods were transformed, as canvas replaced wood panel as the preferred support, and as the oil medium, used alone or in combination with tempera in Venice since the 1470s, was increasingly exploited to obtain new pictorial effects. Oil paint continued to be employed, as it had been by Van Eyck a century earlier, to depict light and texture. Sebastiano's brush captured the reflections on polished metal in his *Man in Armor* (cat. 51) and the precise feel of fabric and fur in the so-called *Dorothea* (cat. 43). But oil paint could also help to portray new realms of feeling and vision. Lotto used it to convey the psychological nuances of sitters like the sensitive young man, surrounded by symbols expressing his state of mind, in Venice (cat. 57), while Titian's painting of creamy flesh and golden hair heightens Flora's erotic appeal (cat. 42). Beginning with Giorgione, the Venetians also utilized the transparency of the medium to represent sunset, twilight, and other transitory effects of light and atmosphere in landscape. New, too, were virtuosic displays of painterly skill, like the flourish of glowing yellow and orange drapery (fig. 7), featured between prayerful heads and hands, in the *Adoration of the Shepherds*. For Joseph's robe Giorgione employed one or both of the new mineral-based pigments,

7.
Giorgione, *Adoration of the Shepherds* (cat. 17), detail of Saint Joseph

8.
Titian, *Noli Me Tangere* (cat. 21), detail of hands and white drapery

orpiment and realgar, just coming into Venetian painting.[25] These colors became a hallmark of the new manner, but the brilliance and luminosity they exhibit could be achieved in other ways as well. The pioneering research of Louisa Matthew and Barbara Berrie (pages 301–309) has shown that painters obtained pigments of superior quality from *vendecolori* (color sellers), a specialty profession unique to Venice, and that they admixed unusual substances, like pulverized glass, to add vibrancy to their pictures. But the most far-reaching change occurred when Bellini's thin, smoothly applied paint layers were supplanted as a technical procedure by Titian's revolutionary method of applying paint freely and in complex layers. A prime example is the *Noli Me Tangere* (cat. 21), already cited for its pastoral landscape. Here the Resurrected Christ appears to the Magdalen (fig. 8) wearing a white shroud that winds around his nude body in loosely painted folds with impasto highlights. The visible brushwork in this passage, meant to stand out like Joseph's robe in the *Adoration*, initiates a career-long development in Titian's work leading up to the even more boldly painted loincloth in the late *Saint Sebastian* in the Hermitage, St. Petersburg.

Aside from fluid brushwork, other changes in the creative process also profoundly altered the course of Western art. Modern technologies, including x-radiography and infrared reflectography, have revolutionized our understanding of the methods of the Venetian painters. As Elke Oberthaler and Elizabeth Walmsley explain (pages 285–300), already in the 1930s, early sixteenth-century Venetian paintings were among the first to be studied using x-rays, which revealed pentimenti (changes of mind) as the artists worked out their compositions. More recently, infrared reflectography has exposed the underdrawings lying beneath the surfaces of these paintings and in doing so qualified Vasari's claim in the *Lives* that Venetian artists did not draw. Even allowing for the low survival rate for Venetian drawings, compared with the riches of Florentine draftsmanship, it seems clear that, instead of making numerous, detailed preliminary studies on paper, Venetian artists, beginning with Bellini, drew with the brush directly on the panel or canvas to be painted. The underdrawings, in a carbon material, range from slight indications of contours to fully worked-up sketches complete with hatchings for shadows. While in Bellini the underdrawing is mainly confined to the figures and becomes more abbreviated, Giorgione's underdrawings, made with a wider brush, are bolder and more varied and extend to the landscape. Significantly for the pastoral, Giorgione experimented with the size and profile of the cave, framing the distant landscape, in both the *Adoration of the Shepherds* and the *Three Philosophers*. The new infrared reflectogram (page 293, fig. 11) of the Vienna picture, published here for the first time, is particularly interesting, as a touchstone for Giorgione's draftsmanship and for what it reveals about his working methods. The reflectogram shows that the underdrawing is not uniform and consistent, in the manner of a finished drawing or cartoon on paper, but varies throughout the painting according to a specific purpose. The technical investigation further reveals that the protagonists' robes were first longer, as seen in the underdrawing, and then shorter, as in the x-radiograph, before reaching their present appearance. Combining the two investigative techniques leads to a better understanding of Giorgione's creative process, which did not involve two different versions of a composition, one drawn and the other painted, but a more complex method of continuous revision. Giorgione's practice of altering compositions while working on them was not lost on his "creati," as Vasari called Sebastiano and Titian.

In their works, too, the same process of experimentation ranged from simple contour adjustments to what seem to be changes in subject. The figure of Roch in Titian's *Virgin and Child with Saints* (cat. 7) in the Prado, for example, bends over from a formerly upright position to expose his plague sore to the gaze of the infant Christ.

The relation between the Venetians' iconographically unusual subjects and the innovative styles and techniques they used to represent them is difficult to determine exactly. For example, we have seen that before painting the *Tempest* Giorgione had already evolved the new creative procedures for representing the pastoral landscape. What is clear is that style and technique converge in artists' treatments of a given theme. Approached from this standpoint, Venetian paintings of the period demonstrate a heightened self-consciousness on the part of their creators. This artistic self-consciousness is manifested in various ways both in the works themselves and in the manner in which they address the viewer. Unlike their predecessors, early sixteenth-century Venetian painters seem to declare, or draw attention to, the status of their works as artistic creations. We can detect this kind of conscious artistry applied to all three of the new pictorial themes. The pastoral offers the fiction of an ideally beautiful landscape into which the city dweller might escape. But for all its links to literature, the visual pastoral is essentially an artistic invention relating in each case to the artist's other works. And the landscape is brought to the viewer's attention as an artistic construct both by its greater importance and by the way in which vistas are framed or featured within the larger picture. A key factor is the repetition of the type. Similarly, with the *belle donne,* the image of an ideally beautiful woman appears in various guises in both sacred and secular pictures. What mattered was not the ostensible sub-ject but the type (especially the long blond hair), which could be varied to suit the viewer or even radically altered, as in *La Vecchia,* to confound his (or her) expectations. Or, the viewer's pleasure could be doubled, as in Palma's *Bathing Nymphs,* in which the seductive female nude was multiplied and combined with a pastoral setting. In the portraiture of men, the subject could confront the viewer, by means of highly obvious but effective devices, like the turning pose and over-the-shoulder glance.

Self-conscious artfulness could be impressed on the observer in other ways, too, like displays of painterly skill. The kind of reflections on shiny metallic surfaces in Sebastiano's *Man in Armor* were a specialty of Giorgione's, according to Vasari and other early sources. Titian's bravura brushwork, featured next to the Magdalen's outstretched hand in the *Noli Me Tangere,* also solicited the viewer's admiration. If for the artists' contemporaries these comparisons and contrasts remained implicit, in the exhibition they resonate in telling juxtapositions and sequences. For example, we can follow the permutations of a type or motif throughout the show, as when musician angels abandon their places at the base of a throne (cats. 6, 9) and move outside (cat. 20), or become a handsome youth making music in a landscape (cat. 31) or a real-life singer and lutenist (cat. 54). Even in the area of subject matter, the painter's art became visible as his treatment of a theme deviated — deliberately it would seem in a *paragone* of painting and poetry — from the biblical or classical texts on which it was based. Of course, artists had always been obliged to add elements not found in literary sources and each one did so in his own particular style. It was the Venetian painters' approach to subject matter that was new, with the textual source or program indicated by the patron serving as a point of depar-

ture for an autonomous artistic invention that was meant to be admired for its own sake, as a distinctive or even deeper interpretation of a theme.[26]

The appearance of a new kind of painting created—and meant to be perceived—as a product of the artist's imagination is obviously connected with the larger issue of Renaissance notions of subjectivity and the self.[27] In the visual arts, the idea that a work of art reflected its creator was reinforced, in Venice, by the visits of Leonardo and Dürer at the beginning of the century. The presence of these two magnetic personalities, combined with their works, would have made a compelling case for artistic innovation. Leonardo showed off a portrait of Isabella d'Este, on which he was working, to a visitor in his studio.[28] And Dürer included his self-portrait, looking out at the viewer, in the *Feast of the Rose Garlands*, both as a proud declaration of authorship and as a challenge to the Venetians, who, he complained, were stealing his ideas.[29] Marcantonio Michiel's notebooks, already cited in connection with the *Allendale Nativity*, offer further evidence that the cultural climate in which Giorgione and his contemporaries were working had recently begun to prize personal invention and its visibility in works of art. In what is essentially a glorified list, dated 1521 to 1543 and preserved in the Biblioteca Marciana, Venice, Michiel describes works of art he had seen in public and in private collections to which he had access in Venice and elsewhere in northern Italy. A well-connected patrician and friend of the writers Sannazaro and Bembo and of the artists Bellini, Titian, Sebastiano, and Catena, Michiel had his own art collection—including, it would seem, a copy of Jacopo de' Barbari's *View of Venice*—and he had a collector's interest in the works he described.[30] Going beyond the superficial praise for lifelikeness found in much humanist

writing on art, he notes the medium and support of paintings, and he was alert to problems of attribution, quality, and condition, just as in a modern catalogue. His assertion that two of Giorgione's pictures, the *Three Philosophers* and the *Sleeping Venus*, were completed by Sebastiano and Titian, respectively, is remarkable for its time. But Michiel had no interest in the place of a work in an artist's oeuvre, and he made no distinction, as a modern art historian would, between period styles. Most of his entries are necessarily brief, but Michiel describes certain works in greater detail, indicating how he looked at them. He does not offer his personal reactions, so there is no projection or titillation or even admiration for Venetian color. Michiel aimed to record what he found characteristic about a painting, namely the artist's treatment of its subject, which he often fails to identify precisely. His list makes clear that Venetian collectors prized Flemish or Flemish-inspired panels, as well as classical sculpture, and that their holdings went far beyond the small devotional images and portraits that hitherto constituted the pictorial decoration of Venetian palazzi. Many works now had secular subjects, and among these Michiel notes iconographical novelties: a portrait sitter and a female nude by or after Giorgione were both "seen from the back," as was the donor in Titian's *Baptism* now in the Capitoline Museum, Rome. Michiel was also sensitive to landscape and not only in the *Tempest*, which he examined in the collection of the wealthy patrician Gabriele Vendramin and which he famously describes as a "small landscape, on canvas, with a storm and a gypsy and a soldier." Evidently Michiel discussed the objects with their owners—in other words, a conversation about art—and though more skilled as a connoisseur, his remarks may be taken to reflect their approach to art and art collecting as well. One of this new breed of

art lovers, Michele Contarini had a study of a nude in a landscape for a Giorgione painting owned by Michiel himself, and even made small copies after the masters. Two others each had a version of a "head of a young man holding an arrow" (page 44, fig. 4) by Giorgione, one of which Michiel believed to be a copy. Preliminary studies, paintings in the new manner, and copies after them, all displaying the artist's invention, were avidly collected.[31]

The premium placed on personal invention engendered rivalries between painters, who engaged in a competitive struggle for dominance on the Venetian scene. As Charles Hope has noted, "artistic rivalry, probably never before so intense or overt in Venice, must have been a major factor in the rapid development of Venetian painting in this period."[32] Striking out on their own, Bellini's former pupils competed both with him and with each other. In his essay entitled "Masters and Pupils, Colleagues and Rivals" (pages 39–53), Peter Humfrey tracks the shifting personal and professional relationships between these artists. The context for their rivalry was the *paragone* or debate over the superiority of painting, on the one hand, and poetry or sculpture, on the other. Leonardo lauded the painter's ability, through reflections, to make multiple views of a figure; unlike sculpture in the round, these could be perceived simultaneously.[33] The *paragone* was aired in print in the *Hypnerotomachia Poliphili* and in Luca Pacioli's *Divina Proportione* published in Venice, respectively, in 1499 and 1509. Above all, it was a courtly matter. In his *Il Cortegiano (Book of the Courtier)*, Baldassare Castiglione explains that "in painting Leonardo da Vinci, Mantegna, Raphael, Michelangelo, and Giorgio da Castelfranco are most excellent; and yet they are all unlike each other in their work: so that in his own manner no one of them appears to lack anything, since we recognize each to

be perfect in his own way."[34] We know that Castiglione's Mantuan patron, the marchesa Isabella d'Este, deliberately compared portraits for their artistic merits. In April 1498 she wrote to Cecilia Gallerani, mistress of Duke Lodovico Sforza, in Milan, asking her to send her portrait by Leonardo (the *Lady with the Ermine* in Cracow) so that she might compare it with examples by Bellini.[35] Recalling an earlier competition between Pisanello and Jacopo Bellini for her uncle Lionello d'Este, Isabella's *paragone* was not made for disinterested aesthetic reasons only, for shortly afterwards she commissioned the portrait of herself from Leonardo, evidently preferring his style to that of Bellini. Similarly, for the decoration of the *studiolo* (private study), where she displayed her collection, Isabella solicited works from the most renowned masters, who were expected to emulate the Mantuan court painter Mantegna. Here Isabella could, and did, compare Mantegna's *Parnassus* and *Expulsion of the Vices*, which initiated the series, with Perugino's *Battle of Love and Chastity* and with two allegories by Mantegna's successor, Lorenzo Costa. Isabella tried to obtain a contribution from Bellini as well, but without success. Even though she agreed that he might paint a picture "of his own invention" and "in his own way," in the end they settled on a *Nativity*, which is lost.[36] Judged worthy of comparison with Mantegna, Bellini's *Nativity* encouraged Isabella to try again—and again without success—for a secular work for her *studiolo*. The problem, Pietro Bembo explained in a letter to the marchesa of 1505, was that the artist was "accustomed as he says to wander at his will in his paintings."[37] Bellini was pitted against Mantegna once more in a commission from the Venetian Francesco Cornaro, who wished him to complete a cycle of four history pictures left unfinished at Mantegna's death in 1506. From the way it is painted, Bellini's

Continence of Scipio (cat. 28) appears to have offered a rejoinder to Mantegna's grisaille in the National Gallery, London.

The rivalry between Venetian painters extended to Bellini's pupils and went public with the exterior decoration of the headquarters of the German merchants, the Fondaco dei Tedeschi, recently rebuilt after a fire. Giorgione painted the canal façade in 1508, while Titian, probably in 1509, undertook the less important façade overlooking the street. The cycle, which featured large-scale allegorical figures, is preserved only in a few badly damaged fragments and in engraved copies. It is uncertain whether Titian began working as Giorgione's assistant—he claimed to have won the commission independently—but the two artists quickly became rivals. Both Lodovico Dolce in his *Aretino* of 1557 and Vasari report that Titian's contribution was held to have surpassed Giorgione's to the chagrin of the latter.[38] We have observed that a slightly later work, the *Pastoral Concert* (cat. 31), is more Giorgionesque than any other work by Titian; indeed, it is more Giorgionesque than is Giorgione. If it is not by Giorgione, as most critics now agree, why does the Louvre picture enter so deeply into his manner? It would be gratifying to believe that Titian's painting was a fond memorial to his recently deceased mentor. But in light of the Fondaco incident, it would seem that in the *Pastoral Concert* Titian was signaling that he had assumed leadership of the artistic revolution then underway. The painting is emblematic of the relation between the two artists in the sense that, no longer having to challenge Giorgione, Titian was now taking his place. The younger artist brought a new energy, vitality, and sensuality to Giorgione's lyricism. But, along with its visual poetry, there is something slightly unsettling about the Louvre picture, as if Titian had not only counterfeited Giorgione's style but also assumed his identity.

With Giorgione dead and Sebastiano departed for Rome, only the old Giovanni Bellini stood in Titian's way as an obstacle to advancement. As Humfrey recounts (page 47), in 1513, three years before Bellini's death, Titian staked his claim to succeed him as head of the Venetian school by offering to paint a "work which no other artist had been able to do"—a battle piece left unexecuted by Perugino (and presumably by Bellini) in the Sala del Maggior Consiglio in the Doge's Palace. Even earlier, Titian's votive picture of *Jacopo Pesaro Presented to Saint Peter* in Antwerp, together with a *sacra conversazione* recently attributed to him in the Prado, appears, like the *Gypsy Madonna*, less an imitation of Bellini than a challenge to his supremacy.[39] After Bellini died in 1516, the rivalry between the two artists became posthumous. Only two years before his death, Bellini completed the *Feast of the Gods* (cat. 32) for the *camerino* of Duke Alfonso d'Este in the castle at Ferrara. This work and the *Lady with a Mirror* (cat. 41) show that, late in life, Bellini reinvented himself once again. While stunningly beautiful and moving as a testament to his undiminished creative powers, these two paintings, brought together in the exhibition, represent a highly personal, ambivalent response to the current vogue for secular art. Like his sister Isabella's program of juxtaposing mythological pictures by different artists, Alfonso's *camerino* paired the *Feast* with three large mythological canvases by Titian—the *Worship of Venus* (cat. 34), the *Bacchanal of the Andrians* (cat. 33), both in the Prado, and the *Bacchus and Ariadne* in the National Gallery, London. The chronology and arrangement of the *camerino* pictures are still debated, even after the Titian exhibition of 2003 reunited them. But scholars agree that the *Worship of Venus* preceded Titian's other contributions and that the *Andrians* and the *Feast* hung side by side, with Titian's

picture on the left, as can be deduced in each case from the continuity in the landscape background. The *Worship of Venus* seems to have flanked Bellini's painting on the right. Beverly Brown has recently suggested that Titian may have taken the *Feast* into consideration when planning the *Worship of Venus,* as the towering trees from which putti gather fruit on the left echo those in Bellini's picture.[40] The issue is clearer with the *Andrians.* The composite x-radiograph of the *Feast* (page 289, fig. 4) shows that Titian repainted the landscape background (one that already covered Bellini's screen of trees) on the left, not only to harmonize that work better with the *Andrians* but also, perhaps, to facilitate a direct comparison between the two pictures. The exhibition provides a rare opportunity to view Bellini's and Titian's canvases as they were originally meant to be seen, side by side in a relatively narrow space, in a wooden enframement and raised to a considerable height approximating that of the original vantage point. The major difference between the two compositions lies in the scale of the figures, which are larger in the *Andrians* and closer to the viewer. The hedonistic mood of Titian's drunken, dancing revelers obviously differs too—a real bacchanal, we might say. But these differences cannot disguise the way in which Titian's canvas echoes Bellini's, not only in the sleeping females (figs. 9, 10) in the lower right and in the bare-backed males carrying jugs on the left but also in small details like the overturned cups. Some of the allusions are witty, too: Titian's vine-crowned, urinating boy substitutes for the infant Bacchus pouring wine from a cask, and his larger, tastier guinea fowl, perched in a tree, confronts Bellini's pheasant.[41]

The visual echoes meant to demonstrate Titian's superiority over Bellini were only part of the pictorial strategy employed in the *Andrians.* The younger artist also sought to

align himself and his picture with modern art. By "modern" the Renaissance meant classicizing, and Titian's painting, accordingly, alludes to both ancient and contemporary works not on view in the *camerino* but surely known to the artist's patron. For guidance in artistic matters, Alfonso d'Este looked to Rome. On a trip there in July 1512 to seek pardon for offenses against Pope Julius II, he climbed the scaffold to inspect the nearly completed ceiling decoration of the Sistine Chapel. After others in the party had left, an eyewitness reports that "Alfonso remained up there with Michelangelo, for he could not see enough of those figures, he flattered him copiously and…requested that he should make him a painting; and he made him discuss it, he offered money, and extracted a promise to do it."[42] Whether or not this work was for the *camerino* is unknown. On a subsequent visit to Rome for Pope Leo X's coronation in 1513, Alfonso was similarly said to "care only for commissioning pictures and seeing antiquities."[43] Titian, who began working for Alfonso in 1516, knew him as a discerning patron and shared his cultural ambitions. The borrowings from central Italian art in the *Andrians* are deliberate, not disguised, and were designed both to update the picture and to appeal to a patron captivated by Michelangelo and the antique. Already in the *Bacchus and Ariadne* Titian had conspicuously cited the famous *Laocoön* in the figure of a satyr struggling with snakes. The allusions to classical sculpture in the *Andrians* are even more appropriate, as that work aimed to evoke an ancient painting described in the literary source for the picture. What is particularly interesting about the derivations in the *Andrians* is that some of them involve the very same figures that Titian contrasted with Bellini's. Thus, the sleeping nymph with her arm raised in the lower right corner is based on the *Sleeping Ariadne* (fig. 11), then believed to represent Cleopatra, in

33

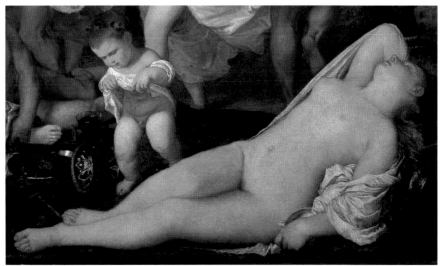

12.

the Vatican, as well as on similar reclining females on bacchic sarcophagi, known to Renaissance artists and collectors in the original or from drawings or engravings.[44] Likewise, the bearded man carrying a jar on the left in the *Andrians* derives from Agostino Veneziano's signed engraving of a Man carrying a Column Base or a similar type of nude male figure bearing a heavy burden.[45] But Titian's principal debt, as far as modern sources are concerned, was undoubtedly

Michelangelo's famous cartoon for the *Battle of Cascina*. The male nude reclining to the right of the woman raising her cup in the *Andrians* replicates a figure in Michelangelo's drawing, which, having been cut up, was known from fragments and various copies, including one (fig. 12) of the main composition.[46] In fact, Titian repeatedly quoted figures from the cartoon in a number of works dating to the second and third decades of the century.[47] Not just individual motifs but

the whole composition of the *Andrians* mimics the densely intertwined figures in the battle piece, and the lesson Titian learned from Michelangelo was no doubt a key factor in his success with Alfonso. But no one would mistake Titian's revelers for Florentine bathers responding to an alarm. The male nudes in the *Andrians* are only a chorus to the real star of the picture—the unabashedly sensual nymph, shown life size and at eye level, in the lower right. She precedes a series of provocatively posed female nudes that Titian painted for an ever-wider circle of princely patrons. In the same way, the extraordinary range, variety, and brilliance of color in the *Andrians* are, like the similar palette in the *Feast*, unmistakably Venetian. In the end, it was not just the pictorial strategies of early sixteenth-century Venetian painting but its beauty of color that formed a lasting legacy for Western art.

1. Ferino-Pagden and Nepi Scirè 2004; and Nepi Scirè and Rossi 2003. See also the review by Paul Holberton, "Giorgione: Myth and Enigma," *Apollo* (July 2004), 58–59.

2. For the monographs, see Joannides 2001 and Pedrocco 2001; for the exhibition, see *Titian* 2003 and Falomir 2003.

3. Stephen J. Campbell, "Giorgione's *Tempest, Studiolo* Culture, and the Renaissance Lucretius," *Renaissance Quarterly*, vol. 56 (2003), 299–332.

4. Patricia Fortini Brown, *Venice and Antiquity: the Venetian Sense of the Past* (New Haven and London, 1996).

5. To the older literature may be added the exhibition celebrating the quincentenary of Aldus Manutius' activity, held in Florence and Venice in 1994, together with *Aldus Manutius and Renaissance Culture*, Acts of the International Conference, Venice and Florence, 1994, D.S. Zeidberg, ed., with the assistance of Fiorella Gioffredi Suberbi (Florence, 1998).

6. Marin Sanudo recorded these and innumerable other events in his diaries, which chronicle a period (1496–1533) corresponding to that covered in the exhibition.

7. See *Leonardo and Venice* 1992.

8. The lesson of Leonardo apparently sank in during the opening decades of the century; though the comparison has gone unrecognized, the gesticulating apostles reacting to the miracle in Titian's *Assumption* are indebted to the new figurative language Leonardo developed for the *Last Supper* in Milan. Like Raphael, Titian ignored the idiosyncratic quality of Leonardo's work, its combination of beauty and strangeness, that appealed to Giorgione.

9. Compare Lotto's Saint Onophrius, with his long white mustache and beard, to a similar figure on the left in Dürer's altarpiece. The head of the infant Christ is nearly identical to that in Dürer's *Madonna* of 1506 in the Gemäldegalerie, Berlin.

10. Hochmann 2004, 193–242.

11. The fundamental study of Venetian pastoral paintings and drawings is David Rosand, "Giorgione, Venice, and the Pastoral Vision" (see Rosand 1988, 21–81). See also Luba Freedman, *The Classical Pastoral in the Visual Arts* (New York, 1989). About the pastoral in general, see the essays in *Pastoral* 1992.

12. Jacopo Sannazaro, *Arcadia and Piscatorial Eclogues*, Ralph Nash, trans. and intro. (Detroit, 1966).

36

13. With their facial expressions shadowed, the relation between the young men in the painting is ambiguous, by contrast to the ostensibly homoerotic pairings in two drawings of pastoral landscapes by Titian's associate Domenico Campagnola (W. R. Rearick, "From Arcady to the Barnyard," in *Pastoral* 1992, 148–149 and figs. 13 and 14).

14. The Glasgow *Adulteress* may be dated between Titian's Fondaco frescoes of 1509 and those he painted in 1510–1511 in the Scuola del Santo in Padua. About the painting, which includes a shepherd with his flock beside a shady grove in the background, see Peter Humfrey's entry in Peter Humfrey, Timothy Clifford, Aidan Weston-Lewis, and Michael Bury, *The Age of Titian: Venetian Renaissance Art from Scottish Collections* (exh. cat., National Gallery of Scotland), (Edinburgh, 2004), 80–82, nos. 13 and 14.

15. On the concept of the innately noble shepherd, as opposed to the peasant, whose poverty was scorned, see Patricia Emison, *Low and High in Italian Renaissance Art*, (New Haven and London, 1997), 37–89.

16. For the *Holy Family* see most recently David Alan Brown in Ferino-Pagden and Nepi-Scirè 2004, 170–172, no. 2.

17. For three of these, see Joannides 2001, figs. 30, 55, and 56.

18. Rosand 1988, 51.

19. Anderson 1997, 307–308.

20. Compare the *Sacred and Profane Love* in the Borghese Gallery, Rome, and the *Cupid* by a Titian follower in the Akademie, Vienna (Joannides 2001, 188–189 and fig. 158).

21. Nicholas Penny, in Penny 2003, 87–88, no. 7, hypothesizes that the group of buildings on the hill in the *Noli Me Tangere* may precede the same motif in the Dresden picture.

22. For the later type associated with Jacopo Bassano, see Rearick in *Pastoral* 1992, 154–157.

23. Pietro Bembo, *Gli Asolani*, Rudolf B. Gottfried, trans. (Bloomington, Indiana, 1954).

24. In addition to the publications of Augusto Gentili cited in the bibliography, see Ian Fenlon, "Music in Italian Renaissance paintings," in *Companion to Medieval and Renaissance Music*, Tess Knighton and David Fallows, eds. (New York, 1992), 189–209 (with bibliography).

25. About these pigments, which were used for the *Three Philosophers* and other pictures in the exhibition, see Lorenzo Lazzarini, "The Use of Color by Venetian painters 1480–1580: Materials and Techniques," in *Color and Technique in Renaissance Painting*, Marcia Hall, ed. (Locust Valley, New York, 1987), 117 (115–136); and Dunkerton 1994, 67 (63–74). The swirling orange drapery recurs in Titian's early *Circumcision* in the Yale University Art Gallery (Joannides 2001, fig. 77).

26. Giulio Campagnola's prints record pictorial ideas and types closely associated with Giorgione, much as Marcantonio's contemporary engravings after Raphael, Michelangelo, and others transmit their pictorial concepts. About Giulio's prints, see Konrad Oberhuber in Jay Levenson, Konrad Oberhuber, and Jacquelyn Sheehan, *Early Italian Engravings from the National Gallery of Art* (exh. cat., National Gallery of Art), (Washington, 1973), 390–413. About the graphic dissemination of artists' ideas, see David Landau and Peter Parshall, *The Renaissance Print 1470–1550* (New Haven and London, 1994), 116–161.

27. The seminal study is Stephen J. Greenblatt, *Renaissance Self-Fashioning: From More to Shakespeare* (Chicago, 1980).

28. About the cartoon for this work, in the Louvre, see most recently Françoise Viatte in *Léonard de Vinci. Dessins et manuscrits* (exh. cat., Musée du Louvre), (Paris, 2003), 185–189, no. 61.

29. For the altarpiece, see Peter Humfrey, "Dürer's *Feast of the Rosegarlands:* A Venetian altarpiece," *Bulletin of the Society for Renaissance Studies*, vol. 4, no. 1 (April 1986), 29–39; and about Dürer's independent self-portraits, see Joseph Leo Koerner, *The Moment of Self-Portraiture in German Renaissance Art* (Chicago, 1993), and the review by Peter Parshall in *The Art Bulletin* 76, no. 3 (September 1994), 537–539.

30. Jennifer Fletcher, "Marcantonio Michiel: His Friends and Collection," *The Burlington Magazine* 123, no. 941 (August 1981), 453–467; "Marcantonio Michiel, 'che ha veduto assai,'" in *The Burlington Magazine*, no. 943 (October 1981), 602–608.

31. For the present locations of these works, see Rosella Lauber, "Breviario per una Diaspora: In Quali Musei Sono Finiti i Dipinti Descritti da Michiel," in *Venezialtrove*, Fabio Isman, ed. (Venice, 2000), 46–83 (with English translation).

32. Hope 1980 (London ed., 1981), 27. For competition between artists in Venice and elsewhere, see Goffen 2002.

33. Claire J. Farago, *Leonardo da Vinci's Paragone* (Leiden, 1992). The reflection in Bellini's *Lady with a Mirror* (cat. 41) demonstrates this principle.

34. Baldassare Castiglione, *The Book of the Courtier*, Charles Singleton, trans., and Daniel Javitch, ed. (New York and London, 2002), 45. Though the book was not published until 1528, this passage was written before 1514.

35. David Alan Brown, "Leonardo and the Ladies with the Ermine and the Book." *Artibus et Historiae* 22, no. 11, (1980), 47–61.

36. On the negotiations with Bellini, Goffen 2002, 11–18.

37. Goffen 1989, 268: "vagare a sua voglia."

38. See Roskill 1968, 186–187; and Giorgio Vasari, Vita of Titian, in Francesco Valcanover, *Tiziano. I suoi penelli sempre partorirono espressioni di vita* (Florence, 1995), 133.

39. David Alan Brown, "Titian and Bellini: From Pupil to Rival," *Arte Cristiana* 93, no. 831, (November–December 2005), 425–442. The Prado picture is a close variant of Bellini's *Virgin and Child with Two Female Saints* in the Accademia, Venice. For the relation between the two artists, see David Alan Brown, "Bellini and Titian," in *Titian* 1990, 57–67.

40. Beverly Brown, Review of Titian 2003, in *Renaissance Studies* 18, no. 1 (March 2004), 117 (113–123). Titian would have seen Bellini's picture as the duke's guest at the castle in February–March 1516.

41. For the idea that the *Andrians* critiques the *Feast*, see cat. 33, note 3. The birds were aptly contrasted in Fehl 1957), 165, note 3.

42. About this incident, see John Shearman, "Alfonso d'Este's Camerino," in *"Il se rendit en Italie." Etudes offertes à André Chastel* (Rome and Paris, 1987), 250–251; and Goffen 2002, 270.

43. Shearman 1987, 250–251.

44. For the *Ariadne*, reproduced here in one of Marcantonio Raimondi's engraved copies, see Hans Hendrik Brummer, *The Statue Court in the Vatican Belvedere* (Stockholm, 1970), 153–184; and for the sarcopaghi, see Sheard 1993, 317–320, especially note 21, and 340.

45. About Agostino's engraving (B.XIV. 354.477) and one in reverse by Marcantonio Raimondi as well as similar figures by Raphael and in ancient sculpture, see Innis H. Shoemaker and Elizabeth Broun, *The Engravings of Marcantonio Raimondi* (exh. cat., Spencer Museum of Art), (Lawrence, Kansas, 1981), no. 41, 140–142.

46. About the debt of the *Andrians* to Michelangelo's cartoon, see most recently Goffen 2002, 284–285. For the copy of the composition, see Martin Kemp in *Circa 1492: Art in the Age of Exploration,* Jay A. Levenson, ed. (exh. cat., National Gallery of Art), (Washington, 1992), 266–268, no. 167; and for engraved copies of individual figures by Marcantonio Raimondi (B.XIV. 363.488 and B.XIV. 361.487), datable 1509 and 1510, see Shoemaker and Broun 1981, 90–92, no. 19. Landau and Parshall (1994, 143–144) note that one of these engravings cites Michelangelo as the inventor of the image, the first dated appearance in the history of printmaking of the term *invenit*. An engraved copy by Agostino Veneziano (B.XIV.363.423) of 1523 likewise bears Michelangelo's name. As the authors explain, the function of these and other prints after Michelangelo or Raphael was to disseminate their pictorial inventions for reproduction by other artists.

47. The number of these works, including the *Three Ages of Man* in Edinburgh, the *Baptism of Christ* in Rome, the *Triumph of Faith* woodcut, and the polyptych with the Resurrected Christ in Brescia, suggests that Michelangelo's art, or what Titian knew of it, struck him with the force of a revelation, analogous to Giorgione's response to Leonardo a decade or so earlier.

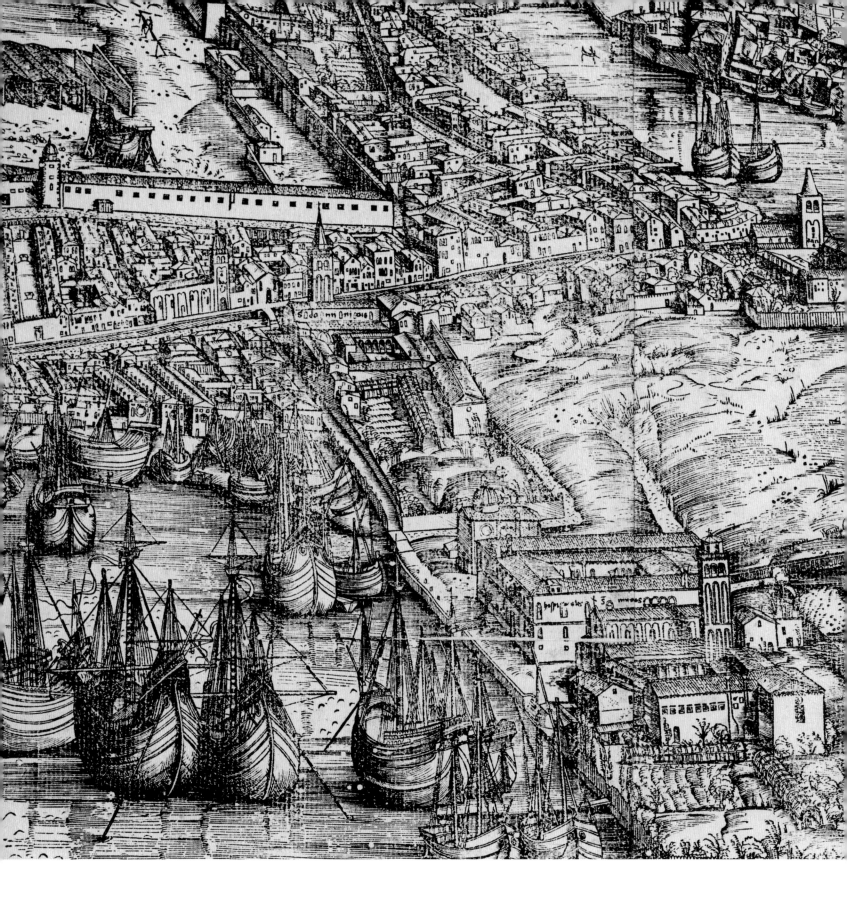

SVBSOLANVS

MASTERS AND PUPILS, COLLEAGUES AND RIVALS ∗ *Peter Humfrey*

THE FIRST THIRTY YEARS of the sixteenth century correspond to a phase in Venetian painting characterized by ceaseless innovation and extraordinary achievement. Within these three decades the pioneer of early Renaissance painting in Venice, Giovanni Bellini, executed his final works; the short-lived but highly inventive Giorgione spent his entire career; and the greatest Venetian painter of the century, Titian, rose to artistic maturity and embarked on an international career that was to take him well beyond the confines of the city. Working alongside these three great artists were numerous other, scarcely lesser figures, belonging to overlapping generations. And providing further stimulus to their creativity was the brief presence in Venice of a number of distinguished visitors: Leonardo da Vinci in 1500; Albrecht Dürer from 1505 to 1506; Fra Bartolommeo in 1508; Michelangelo in 1529.

As a period of intense ferment that was to make a permanent impact on the wider development of European painting, these three decades may be compared with other historic periods, such as the first thirty years of the twentieth century in Paris. Like their early twentieth-century successors, the Venetian painters whose works are displayed in the present exhibition would all have known one another personally, as masters and fellow pupils, as friends and rivals, and perhaps sometimes as enemies. They would have worked in close proximity, and would have striven to emulate one another's inventions, borrowing from them and varying certain elements, while rejecting others. In almost exactly the same years in Florence and Rome, another artistic analogy is provided by the fruitful interaction between Leonardo, Michelangelo, Raphael, and their contemporaries. The now somewhat unfashionable art-historical label traditionally applied to this phase in central Italian art is "High Renais-

sance." As long as this term is sufficiently flexible to accommodate the qualities of dynamism and rich variety, and is not understood to imply anything resembling stasis or uniformity, it may also continue to be applied—as it often has been in the past—to Venetian painting of the period.

This essay, in sketching a brief chronological overview of painting in Venice from 1500 to 1530, will focus where possible on the personal and professional relationships between the main protagonists.[1] By comparison with the well-documented history of painting in early twentieth-century Paris—and even with that of High Renaissance Florence and Rome—this exercise is fraught with difficulty. Particularly problematic is the first decade, the shape of which remains obscured by the mystery that still surrounds the short career of Giorgione. Although within a few years of his premature death in 1510 Giorgione was widely recognized as the great innovative genius of early sixteenth-century Venetian painting, a consensus about the definition of his oeuvre, and hence, too, of his chronology, has still not been reached by art historians. This attributional and chronological uncertainty inevitably also affects any attempt to reconstruct the early development of Giorgione's younger but scarcely less innovative contemporaries, Sebastiano del Piombo and Titian.

Such problems are much less acute in the case of leading members of the older generation, such as Giovanni Bellini, Cima da Conegliano, and Carpaccio. In 1500 Bellini still occupied the dominant position in Venetian painting that he had assumed some twenty years previously and that, despite the rise of Giorgione, he was to continue to occupy until his death at the age of about eighty in 1516. In part because of his near-monopoly of large-scale public commissions in Venice, Bellini's late career is reason-

1.

Giovanni Bellini, *Virgin and Child Enthroned with Saints*, church of San Zaccaria, Venice

Bellini would probably have retained official favor even if, like his elder brother Gentile, he had been content to perpetuate his fifteenth-century manner for the rest of his life. On the contrary, his late works show an extraordinary capacity to expand the boundaries of his art, in matters of subject, composition, style, and technique. In many ways, the innovations of his late career resemble those of his much younger contemporaries, and to some extent he may have been inspired by their example. Yet Bellini's own work of the last two decades of the fifteenth century had already provided a matrix for the inventions of the younger generation, and for the most part his late achievements may be interpreted as a natural continuation of an art that had never ceased to evolve in productive new directions. Bellini's works in this volume serve not merely to illustrate a point of departure for the younger generation, but also to show that the aged master remained an active participant in the artistic ferment of the period.

Because of his involvement in large-scale public projects—and also because of the huge demand for smaller religious works by him, such as half-length Madonnas—Bellini in his later years greatly expanded the size of his workshop, which as a result became a training ground for an entire generation of Venetian painters. Many of his pupils, generically known as Belliniani, remained close imitators of their master and were content to repeat variations of his compositions throughout their lives. In his early career Vincenzo Catena may be described as a Belliniano, although by the middle of the second decade he had begun to update his style in accordance with rapidly changing fashions. But according to Giorgio Vasari's *Lives of the Artists* (1550 and 1568), younger and much more original painters, including Giorgione, Sebastiano, and Titian, as well as Lorenzo Lotto, also underwent their initial training in Bellini's workshop.[3]

ably well documented. From 1479 onwards he was in charge of the most important artistic project of the entire Renaissance period in Venice: the decoration of the vast Hall of the Greater Council in the Doge's Palace with a cycle of narrative paintings (lost). He also played a leading role in another major narrative cycle, that of the Scuola Grande di San Marco, undertaking commissions there for monumental canvases in 1507 and 1515. He remained Venice's principal practitioner of altarpieces, and in 1505 he signed the great work still in the church of San Zaccaria (fig. 1). In 1514 he completed a highly prestigious commission for the head of a neighboring state: the *Feast of the Gods* (cat. 32) for Alfonso d'Este, Duke of Ferrara. The verdict expressed by Dürer in 1506 that Bellini was "still the best in painting" clearly continued to be fully shared by the Venetian establishment.[2]

Anton Maria Zanetti,
Etching after Giorgione's
Standing Nude on the
Fondaco dei Tedeschi

While it is true that the Florentine's account of Venetian painting in this period was subject to extensive oversimplification and distortion, his information in this instance is likely to be correct. There is no evidence that the other leading Venetian masters of the 1490s and early 1500s, such as Gentile Bellini, Alvise Vivarini, Carpaccio, and Cima, maintained workshops even remotely comparable to Bellini's in size or prestige. As a sort of patriarch of Venetian painting, he seems to have taken a paternal (or grandpaternal) interest in the independent careers of his former pupils. It may have been thanks to his recommendation, for example, that Giorgione was engaged to paint a canvas for the Audience Chamber of the Doge's Palace in 1507.[4] Certainly Dürer spoke with appreciation of Bellini's personal kindness to him as a visiting foreigner.[5]

The career of Giorgione, in complete contrast to that of Bellini, lasted no more than ten to fifteen years, and was supported mainly by a restricted circle of patrons and collectors. On the evidence of Vasari, he was born in 1477/1478, and so the beginning of his career may be dated to about 1497 or perhaps a couple of years earlier.[6] But he left no signed pictures, and only one — the Vienna *Laura* (cat. 38) — is inscribed with a reliable date (1506). Of only two documented works, one (the frescoes for the Grand Canal façade of the Fondaco dei Tedeschi, completed by October 1508)[7] survives as an almost entirely obliterated fragment (fig. 2), and the other (the painting for the Doge's Palace of 1507–1508) is lost without trace. The two principal sixteenth-century sources for Giorgione's work, Marcantonio Michiel's *Notes* (c. 1525–1543) and Vasari's *Lives*, are both in their different ways unreliable and inadequate, and each does little to confirm or clarify the information provided by the other.[8] Michiel's laconic notes on private art collections in

Venetian houses are crucial for establishing a small number of pictures, most notably the *Tempest* (fig. 3), the *Three Philosophers* (cat. 30), the *Boy with an Arrow* (fig. 4), and the *Sleeping Venus* (fig. 5), as key works by Giorgione.[9] But even in the case of these four, Michiel introduces a note of attributional doubt by commenting that the *Three Philosophers* was completed by Sebastiano, and that the landscape and the figure of Cupid (now overpainted) in the *Venus* were completed by Titian; and while most modern art historians have concluded that any role by Sebastiano in the *Three Philosophers* was minimal or nonexistent, there is a growing converse tendency to attribute the *Venus* to Titian in its entirety.[10] Vasari did not know Michiel's *Notes* or any of the pictures recorded there as by Giorgione; and as a foreigner he focused principally on the works on public view in Venice that were still associated with Giorgione's name forty years after his death. Several of these, such as the San Rocco *Christ Carrying the Cross* or the San Giovanni Crisostomo altarpiece, are arguably or certainly the work of other painters (in this case, of Titian and Sebastiano respectively).

On the basis of the inscribed *Laura* and the canonical handful of pictures mentioned by Michiel, scholars have constructed widely different versions of Giorgione's oeuvre, ranging from no more than ten or fifteen surviving works to forty or more. As regards his chronology, there is a similar lack of consensus, beyond the generally held view that devotional works such as the Washington *Adoration of the Shepherds* (cat. 17) are relatively early (about 1500/1504), that the *Tempest* and the *Three Philosophers* are close to the *Laura* of 1506, and that the scale of Giorgione's figures grew larger as he began to undertake large-scale public commissions in about 1507. There is general agreement that Giorgione was deeply responsive to the art of two great foreign artists who visited Venice in the first decade of the sixteenth century — the Florentine Leonardo and the German Dürer — but even the known dates of their visits do not provide firm anchor-points for the works that appear most closely to reflect their influence. Leonardo's brief visit in March 1500 was to advise the Venetian government on defending the province of Friuli against a possible attack by the Turks, and he is unlikely to have carried any of his paintings with him. He may, however, have brought drawings, and the very presence of so famous a figure is likely to have stimulated an interest in his work. Yet while some scholars have accordingly dated Giorgione's most explicitly Leonardesque works, such as the *Boy with an Arrow*, close to 1500, a majority — following Vasari's comment that Giorgione achieved a *maniera moderna* (modern style) approximating that of Leonardo in the year 1507 — have placed Leonardo's influence later. It has even been suggested that Leonardo made another, undocumented visit to Venice at about that time.[11]

Dürer's visit to Venice from 1505 to 1506 was much longer, and is documented by a series of letters he sent to his friend Wilibald Pirckheimer at home in Nuremberg. During his thirteen-month stay he painted a major altarpiece, the *Feast of the Rose Garlands* (fig. 6) for the church of San Bartolomeo di Rialto, and a number of smaller works. Dürer reported that the completed *Feast of the Rose Garlands* was greatly admired by the doge and patriarch of Venice,[12] and it clearly also made a deep impression on the younger generation of Venetian painters, including Sebastiano and Titian, and also Palma Vecchio. Plenty of evidence, however, indicates that woodcuts and engravings by Dürer had previously been circulating in Venice, which was a close trading partner of Nuremberg and an important center of the

44

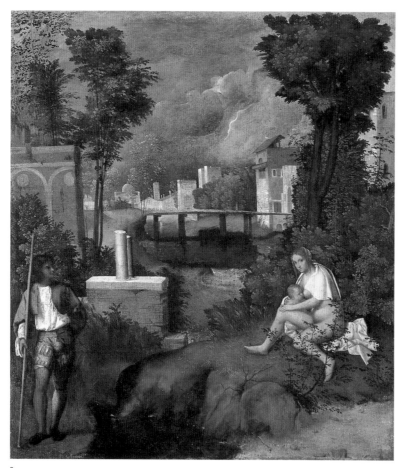

3

4

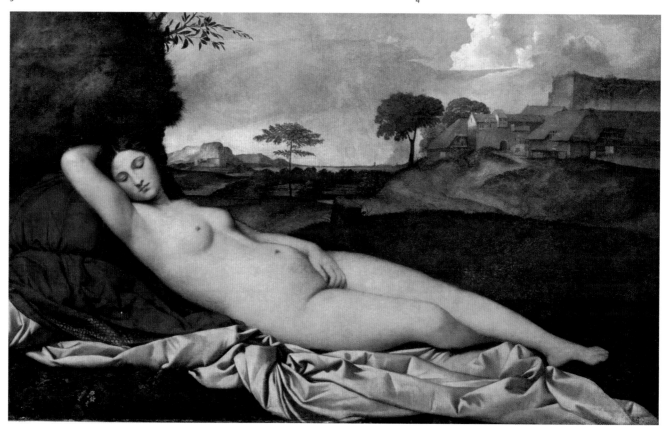

5

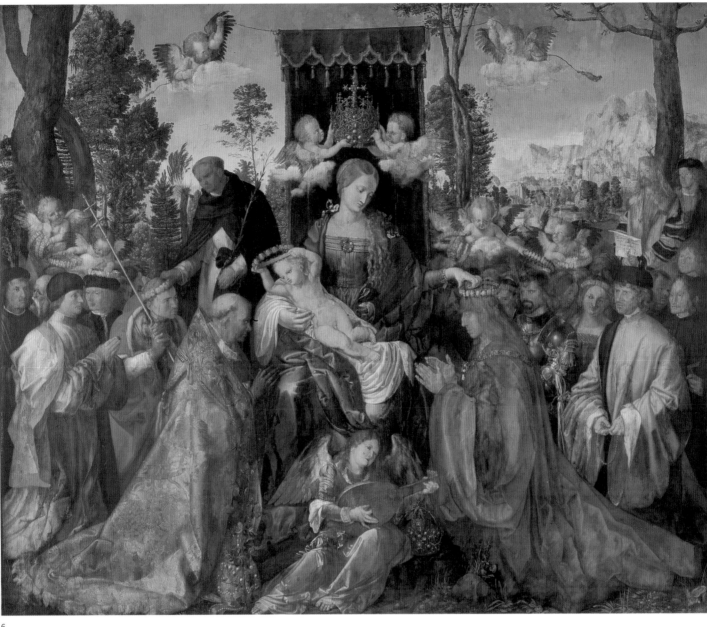

6

printing industry for at least ten years previously; and given the character of his own art, Giorgione is likely to have been less interested in a formal altarpiece than in the dynamic vision of landscape communicated by Dürer's prints.[13]

No less responsive to Dürer's prints than Giorgione, and arguably engaged by them somewhat earlier, was another probable former pupil of Bellini, Lorenzo Lotto.[14] In about 1503, soon after graduating as a master, Lotto left his native Venice to take up residence in the mainland city of Treviso; and only three years later he moved much further afield, to the city of Recanati in the Marches. Although Treviso is situated less than twenty miles from Venice, Lotto's residence there—as well as his highly independent, not to say idiosyncratic, personality—may account for the relative absence in his early work of the influence, so pervasive in the capital, of Giorgione. Yet within these three years, Lotto produced a number of variants on fifteenth-century compositional types that are as expressive and original as those of any Venetian painter of the first decade (see cat. 3).

Somewhat younger than Lotto were Sebastiano and Titian, whom Vasari called Giorgione's two "creati"—that is to say, his pupils.[15] This description is true in the sense that they both clearly pondered his works deeply and learned from them; and if Michiel was correct to report that they were both involved in the completion of his works, they must also have had a close professional contact with him. On the other hand, with his concentration until nearly the end of his life on relatively small, iconographically unusual pictures, Giorgione—in contrast to Bellini—is unlikely to have employed shop assistants or to have trained pupils. Further, to judge from the inscription on the reverse of the *Laura* (cat. 38), in which he is described as the *cholega* (colleague)

of Catena, Giorgione did not even own his own workshop (before 1506, at least), but apparently shared one with a painter who may have been a friend, but with whom he had very little in common stylistically.

From the evidence of Vasari, who knew him well in his later years in Rome, Sebastiano was born in about 1485/1486, and so would have graduated as an independent master by about 1505.[16] Like Lotto and unlike Giorgione and Titian, Sebastiano was a native Venetian; and also like Lotto, he chose to abandon Venice at an early date in search of new opportunities elsewhere. Thus in August 1511, less than a year after the death of Giorgione, Sebastiano accepted the invitation of the wealthy banker Agostino Chigi to accompany him back to Rome. Although the five or six years of Sebastiano's Venetian activity are not well documented, they include at least three works—among which is the high altarpiece of San Giovanni Crisostomo—that attest to the young painter's ambition to produce pictures on a large scale and for a public context. As early as Giorgione himself, therefore, Sebastiano was introducing Giorgione's stylistic and technical innovations to a wider Venetian audience. But even more distinctive of Sebastiano, and a natural corollary to his instinct to think big, was his early interest in classical sculpture, presumably inspired by statues that were already present in private collections in Venice and nearby Padua. This same interest, for which there was little precedent among Venetian painters, was soon to impel him into the immediate circle of Michelangelo in Rome.

The matter of Titian's birth date is notoriously problematic, since the sixteenth-century evidence is contradictory. According to a growing scholarly consensus, however, he was born between 1488 and 1490; in other words, he was slightly younger than Sebastiano, and his earliest works

Especially after the departure of Sebastiano in 1511, Titian became the natural heir to Giorgione, and throughout the second decade Titian continued to paint the kinds of pictures with which Giorgione had been associated: pastoral landscapes, poetic allegories, half-length figures (whether portraits of real people or ideal representations). At the same time, it is clear that from the beginning Titian also saw himself as the heir of Bellini, and in the elderly painter's final years his young colleague constantly sought to position himself to take Bellini's place the moment it was vacated. The most striking illustration of this ambition is provided by Titian's petition to the Venetian government in May 1513, in which he offered to paint the *Battle of Spoleto*, one of the projected scenes in the history cycle in the Doge's Palace.[18] With the offer Titian requested that he be employed on the same terms as Bellini: that is to say, as a salaried government official and not simply by piecework. Since the *Battle* had originally been allocated to the visiting central Italian painter Perugino, who would now clearly never return to execute it, the government accepted Titian's offer, and he set to work on the large canvas. The requested sinecure was also granted; and although it was then withdrawn a few months later, in response to the protest of other applicants for government salaries, Titian had clearly succeeded in establishing himself in the public eye as Bellini's heir. Significantly, Titian was commissioned to complete one of the history paintings left unfinished by Bellini, the *Humiliation of the Emperor Frederick Barbarossa by Pope Alexander III*, immediately after the latter's death at the end of 1516. Five years later Titian had made such slow progress that the government ordered him to fulfill the commission within ten months; and in June 1523 he was duly reinstated with his sinecure.[19]

are datable to only a year or two before 1510. His earliest documented paintings are the frescoes he painted in the Scuola del Santo in Padua in the first half of 1511 (fig. 7); but they were almost certainly preceded by his own contribution to the fresco decoration of the Fondaco dei Tedeschi, on a different façade than that painted by Giorgione. Confirmation that it was executed within Giorgione's lifetime is arguably provided by an anecdote recounted by Lodovico Dolce in 1557 (and later repeated by Vasari)— the older master is described as reacting with resentment to the public praise that greeted the unveiling of the young Titian's frescoes.[17]

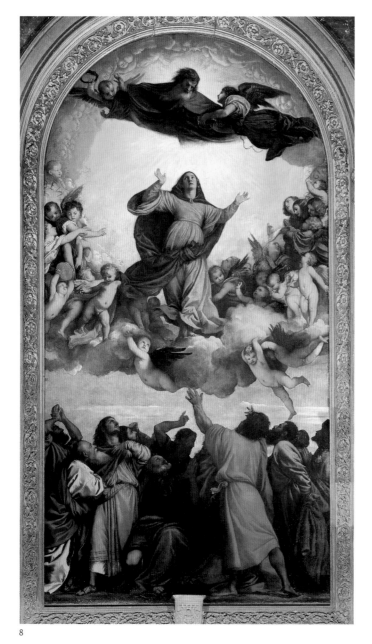

It is not difficult to guess that the main reason why Titian was so slow to meet his obligations in the Doge's Palace—he was not to complete the *Battle of Spoleto* until 1538—was the very comprehensiveness of his success in promoting himself as Bellini's heir in all major types of commission. Probably in 1515, and possibly even likewise as a result of an audacious offer, Titian was commissioned to paint the largest altarpiece ever seen in Venice (some seven by three and a half meters) for one of the most conspicuous sites in the city: the *Assumption of the Virgin* for the high altar of the huge Gothic church of the Frari (fig. 8). Despite his relatively limited experience to date as a painter of altarpieces, he succeeded triumphantly in his task, and the official unveiling of the completed work in May 1518 confirmed Titian's position not just as the dominant personality in Venetian painting, but as one of the leading artists in all Italy. The success of the *Assumption* naturally led to a string of further commissions for altarpieces during the course of the 1520s, both from within Venice and from outside. Among the most important Venetian commissions were the Ca' Pesaro altarpiece of 1519 to 1526 (fig. 9) and the *Death of Saint Peter Martyr* of 1528 to 1530 (fig. 10); among the most important sent to outside destinations were the Ancona altarpiece of 1520 (fig. 11) and the *Resurrection* polyptych of 1519 to 1522 for Brescia.[20]

Meanwhile Titian also followed in Bellini's footsteps—and indeed, quickly outdistanced him—as an international court painter. Bellini's *Feast of the Gods*, dated 1514 (cat. 32) was conceived by its patron the Duke of Ferrara as a part of a cycle of large-scale mythologies that was originally also meant to include contributions by leading central Italian painters such as Michelangelo, Raphael, and Fra Bartolommeo. Titian was first invited to Ferrara by the duke early in 1516,

8.

Titian, *Assumption of the Virgin*, church of the Frari, Venice

9.

Titian, Ca' Pesaro *Virgin and Child with Saints*, church of the Frari, Venice

10.

Martino Rota, Engraving after Titian's *Death of Saint Peter Martyr*

11.

Titian, *Virgin and Child with Saints Francis and Blaise*, Pinacoteca Civica, Ancona

9

10

11

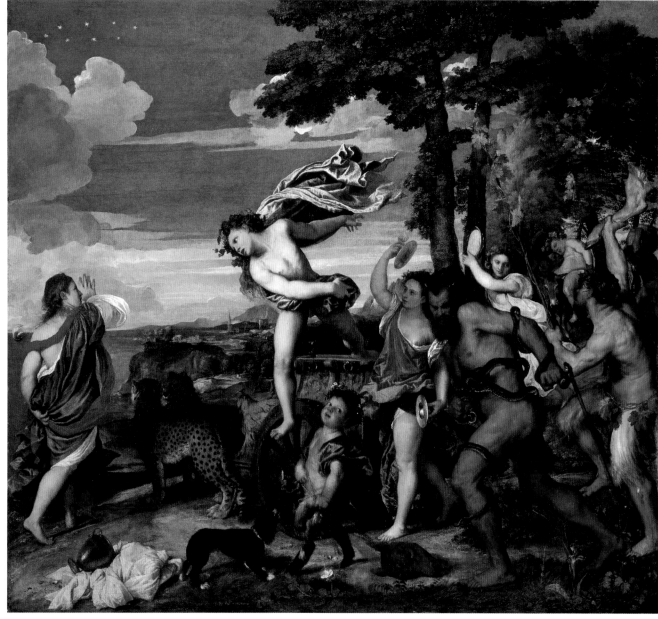

12.

Titian, *Bacchus and Ariadne*, National Gallery, London

but in connection with small-scale commissions such as the *Tribute Money* (Gemäldegalerie, Dresden) and not yet for the cycle of mythologies. But when the central Italians for various reasons failed to deliver, Titian was on hand to meet the duke's needs. Between about 1518 and 1525 he contributed three great bacchanalian subjects to the duke's apartment—the *Worship of Venus* (cat. 34), the *Bacchanal of the Andrians* (cat. 33), and the *Bacchus and Ariadne* (fig. 12)—and then, probably in 1529, he repainted the background of his former master's *Feast of the Gods,* in order to integrate it better stylistically and compositionally with his own canvases. Although the opportunity to paint such an ambitious cycle of mythologies did not recur until three decades later, when Titian was in the employment of King Philip of Spain, the Ferrara Bacchanals clearly won him great celebrity throughout Italy as a painter of sensuously erotic subjects, resulting in an immediate expansion of his princely clientele. On his various visits to Ferrara in the 1520s in connection with the Bacchanals, Titian also painted the life-size portraits of the duke and his mistress Laura Eustochia[21]— works that similarly inaugurated his future and highly successful career as a painter of courtly portraits.

In keeping with contemporary practice, Titian would from the beginning of his career have made regular use of studio assistance. Already in his petition to the Venetian government of 1513 he mentions two young men who would assist him with the large *Battle*. Later, as in the workshop of Bellini, Titian employed assistants to produce replicas and variants of his most successful compositions. But Vasari reports that one of his early pupils, Paris Bordone (born in 1500), was disappointed to find that Titian was not a conscientious teacher;[22] and indeed, Paris was one of the very few important artists who emerged from Titian's workshop.

A more typical pupil was the mediocre but compliant Girolamo Dente, who witnessed Titian's marriage in 1525 and forty years later still worked as his assistant.[23] In contrast, then, to that of Bellini, Titian's studio did not provide a major training ground for Venetian painters of the following generation; and in this respect, a more important role seems to have been played in the next decade by Bonifacio de' Pitati, who counted among his pupils painters of the stature of Jacopo Bassano, Tintoretto, and Schiavone.

Partly, perhaps, as a consequence of the particular character of his studio, Titian did not dominate Venetian painting in the 1520s to the extent of homogenizing it or of eliminating all competition. He derived enormous prestige from his position as quasi-official painter of the Venetian Republic and from his employment by the Duke of Ferrara; and his style and repertory of compositions represented inescapable points of reference for his contemporaries. But also working in Venice in this decade were a number of painters with quite distinctive artistic personalities, who were able to offer Venetian patrons a rich variety of alternatives to the art of Titian. Settled in Venice since the first decade, for example, were two distinguished painters of Bergamasque origin, Palma Vecchio and Cariani. A close associate of Palma, at least from the early 1520s, was the Veronese Bonifacio. About this time, too, Savoldo arrived from Brescia, and Paris Bordone set up an independent shop. In 1525 Lorenzo Lotto, after an absence of nineteen years in the Marches and Bergamo, returned to Venice. In 1528 the Friulian Pordenone is recorded in the city; and perhaps, if one is to believe the story in the early sources that he competed with Titian for the commission for the *Death of Saint Peter Martyr,* he was already present in 1526. Pordenone certainly engaged in active rivalry with Titian in

the following decade; but already in the 1520s all of these painters, albeit less aggressively, must have been offering similar competition to Titian's supremacy in their own areas of strength.[24]

During the execution of the *Death of Saint Peter Martyr,* two leading representatives of the central Italian High Renaissance made brief visits to Venice. The first was Sebastiano del Piombo, who following the calamitous Sack of Rome in the previous year is recorded in his native city as present at his sister's wedding in the summer of 1528.[25] Witness to the marriage contract was Vincenzo Catena, another former pupil of Bellini and associate of Giorgione, with whom Sebastiano had evidently maintained contact during the seventeen years since he had left Venice. The other visitor, a year later, was Michelangelo, who had fled from Florence during the political upheavals following the expulsion of the Medici. Michelangelo's stay, like that of Sebastiano, lasted less than two months, and did not result in any artistic commission.[26] It is difficult to believe, however, that the great Florentine did not find time to make contact with the presiding genius of Venetian art; and if he did, the experience must have stimulated Titian, whose *Death of Saint Peter Martyr* already incorporated borrowings from the heroic figure style of both Michelangelo and Raphael, to continue to enrich his art by actively engaging with that of central Italy.

It is precisely the growing internationalization of Venetian painting after about 1530, particularly its closer contacts with the art of Florence and Rome,[27] that separates this later phase from the first three decades of the sixteenth century. In the years just before and after 1530 three of the major players in Venetian painting of the 1520s quitted the scene: Palma Vecchio died prematurely in 1528; Catena died in 1531; and Lotto returned to the Marches in 1533. At about the same time, the work of Cariani began to decline into a repetitive provincialism. Paris Bordone, by contrast, was to respond positively to the growing contacts with central Italian art and even enjoyed a modest success, in imitation of Titian, as an international court painter. Decisive for the new tenor of Venetian art was the presence in the city from 1527 of another refugee from the Sack of Rome: the distinguished Florentine architect-sculptor Jacopo Sansovino. Unlike Sebastiano and Michelangelo, Sansovino adopted Venice as his permanent home; and his architectural transformation of the Piazza San Marco, while showing deep respect for the centuries-old Venetian tradition, also set new standards of classical correctness. Symptomatic of the changed climate after 1530 was the formation of a new artistic establishment in Venice, consisting of Titian, Sansovino, and another new friend from Tuscany, the writer Pietro Aretino.

1. Recent surveys of the period include the relevant sections in Huse and Wolters 1986; *Le Siècle de Titien* 1993; Humfrey 1995; Lucco 1996–1999; Romanelli 1997. For a survey focusing on the Venetian interest in contemporary developments in Florence and Rome: Hochmann 2004, 193–242. Recent monographs and exhibition catalogues on the three painters whose names appear in the title of the present catalogue include the following —Bellini: Goffen 1989, Tempestini 1999, Humfrey 2004; Giorgione: Lucco 1995, Anderson 1997, Pignatti and Pedrocco 1999, Ferino-Pagden and Nepi Scirè 2004; Titian: *Titian, Prince of Painters* 1990, Joannides 2001, *Titian* 2003, Falomir 2003.

2. "Noch der pest jm gemoll," Letter to Pirckheimer, 7 February 1506. In Rupprich 1956, 44.

3. For Vasari 1568, see Bettarini and Barocchi 1966–1987.

4. For the documents, see Anderson 1997, 361; Perissa Torrini 2004, 24–25.

5. Letter to Pirckheimer, 7 February 1506. In Rupprich 1956, 43–44.

6. Charles Hope, however, argues that Vasari's date is not necessarily trustworthy, and Giorgione may have been born some years later (Hope 1993, 195; Hope 2004, 41–42).

7. Documents in Anderson 1997, 362; Perissa Torrini 2004, 25.

8. Frimmel 1888. For the limitations, as well as the value of Michiel and Vasari as sources for Giorgione, see Anderson 1997, 53–68.

9. Frimmel 1888: for the *Three Philosophers*, see pages 86, 88; for the *Sleeping Venus*, see page 88; for *Boy with an Arrow*, see page 104; and for the *Tempest*, see page 106.

10. See, for example, Alessandro Ballarin in *Le Siècle de Titien* 1993, 310; Lucco 1995, 138; Joannides 2001, 179–185.

11. Pedretti 1978, 84. For Leonardo and Venetian painting in general, see *Leonardo and Venice* 1992.

12. Letter to Pirckheimer, 8 September 1506. In Rupprich 1956, 55.

13. Pignatti 1973. For Dürer and Venice, see most recently Koreny 1999; Schütz 2004.

14. For Lotto, see most recently Humfrey 1997; Brown, Humfrey, and Lucco 1997; Gentili 2000.

15. Vasari 1568. See Bettarini and Barocchi 1966–1987, 4 (1976), 47.

16. For Sebastiano, see Lucco 1980; Hirst 1981.

17. Dolce 1557; see Roskill 1968, 186–187. Vasari 1568; see Bettarini and Barocchi 1966–1987, 6 (1987), 157.

18. Wethey 1969, 10–11; Wethey 1975, 47–52, 225–232.

19. Wethey 1969, 11–12; Wethey 1975, 233.

20. For these altarpieces, see Wethey 1969, respectively 74–76, 101–102, 153–155, 109–110, 357–358; Humfrey 1993, 357–360, with references.

21. The portrait of the duke is lost, but is recorded in a seventeenth-century copy in the Metropolitan Museum of Art, New York. For the *Laura* portrait (Kisters Collection, Kreuzlingen), see most recently Bestor 2003.

22. Vasari 1568; see Bettarini and Barocchi 1966–1987, 6 (1987), 170.

23. For Dente, see Claut 1986.

24. Recent monographs and exhibition catalogues on these painters include the following—Palma: Rylands 1992; Cariani: Pallucchini and Rossi 1983; Bonifacio: Cottrell 2000; Savoldo: *Giovanni Gerolamo Savoldo* 1990, Frangi 1992; Paris Bordone: Fossaluzza and Manzato 1987; Pordenone: Furlan 1988, Cohen 1996.

25. Hirst 1981, 3.

26. For this episode and its implications, see Joannides 2004.

27. See Hochmann 2004, 245–292.

SACRED IMAGES ✳ *Peter Humfrey*

DESPITE THE DRAMATIC RISE of a new range of secular, poetic subject matter in Venetian painting of the early sixteenth century, the overwhelming majority of works remained, as in previous centuries, religious in content. Of this religious majority, an increasing number of paintings depicted narratives: that is to say, episodes from the Bible or legends of the saints. Most religious pictures, however, still consisted of timeless images of holy figures, especially of the Virgin Mary with the Christ Child, but often also of a selection of saints. This is true both of large-scale paintings for churches, such as altarpieces, and of smaller pictures for the more private surroundings of the home. In the case of altarpieces, an array of holy figures provided a much-needed focus for the devotions of the worshiper during the celebration of Mass. By displaying the images of a number of powerful but sympathetic advocates in the court of heaven, the painting above the altar helped channel heavenwards the prayers of the worshiper for supernatural assistance in this world and the next. But timeless representations of the Virgin and saints were scarcely less in demand in pictures for devotion in private. Placed in reception rooms, studies, or bedrooms, smaller devotional images served equally as vehicles of prayer and to reassure their owners of the protective presence of divine intercessors with Christ.

The centrality of the Christian faith to the lives of ordinary people in the Renaissance period clearly explains the continuing high demand for sacred images. It cannot, however, adequately account for the accelerated tempo of formal and expressive innovation that took place in the decades after 1500. The Venetians who commissioned religious pictures from Bellini, Giorgione, Titian, and the other leading painters were no doubt sincerely pious, but they would have been concerned above all to acquire paintings that represented traditional subjects in ways that were novel, striking, and beautiful. The painters themselves would have sought both to meet and to stimulate further this demand by inventing a whole range of compositional variations on traditional types of images, experimenting, for example, with the ways in which the holy figures interacted with one another and with the viewer, or varying the types of architectural or landscape setting.

An unavoidable point of departure for all the painters of altarpieces in our period was provided by the series of monumental representations of the Virgin and Child enthroned with saints painted by Bellini from the 1470s.[1] Bellini's own greatest altarpiece of his final years—that completed for the church of San Zaccaria in 1505 and still in situ above its altar (page 41, fig. 1)—still adheres in its essential formal composition to one that he had devised some thirty-five years earlier. The life-size figures form a pyramidal grouping, with the Virgin on her tall throne at the apex and an angel musician seated at its foot. Space for the participants in the *sacra conversazione* is created by the chapel-like architecture, which opens at both sides to offer glimpses of landscape and sky. The strictness of the symmetry about the central vertical axis enhances the effect of timeless grandeur and quiet meditation. Although the saints are deep in their own thoughts and only the child angel makes eye contact with the viewer, the composition is oriented with diagrammatic clarity towards the worshipers at the altar below, as if inviting them to invoke the holy figures with their prayers.

Already before 1500 some of Bellini's younger contemporaries, most notably Cima, were actively seeking novel ways of varying the Bellinesque scheme. In Cima's *Virgin and Child with Saints Michael and Andrew* (Galleria Nazionale, Parma) of about 1496 to 1498, for example, the architectural

foreground is no longer centralized round the vertical axis but is shifted to the right, allowing an enticingly detailed view of a hilltop city to the left. Cima was also interested in conveying a greater sense of communication between the figures: in other words, in making the *sacra conversazione* into a true conversation. These innovations were developed much more radically in the new century by the young Sebastiano and Titian. In his only altarpiece for a Venetian church, that of about 1508 for the high altar of San Giovanni Crisostomo (fig. 1), Sebastiano placed three saints on either side of a seventh, enthroned saint, but grouped the figures with much greater freedom and gave at least one of them—that of Saint John the Baptist—an unprecedentedly athletic pose. Furthermore, the central bishop is shown not frontally but in profile, adding further to the effect of mobility and informality. As with Cima, the background combines architecture seen in oblique perspective on one side with a view of distant landscape on the other.

Similar experiments by Titian in his *Saint Mark* altarpiece of about 1511 (Santa Maria della Salute, Venice) reached a climax in the Ca' Pesaro altarpiece of 1519 to 1526 (page 49, fig. 9), in which the Virgin on her tall throne has been shifted well to the right of the vertical axis and the figures engage in animated interaction. These more or less radical departures from Bellinesque precedent have resulted in a composition that is much less obviously worshiper-oriented than that of the San Zaccaria altarpiece. In compensation, however, Titian's expression of religious sentiment has become more overt; and the physical drama of the Ca' Pesaro altarpiece, heightened by the bold contrasts of color and of light and shade, would certainly have been calculated to play on the emotions of the pious viewer.

In its composition and in the rhetorical flavor of its

1.

———

Sebastiano del Piombo,
San Giovanni Crisostomo
altarpiece, church of
San Giovanni Crisostomo,
Venice

piety, the Ca' Pesaro altarpiece was to become an inspirational model for numerous representations of the Virgin and Child with saints of the Counter-Reformation era, both in Venice and far beyond. The same is even more true of another altarpiece painted by Titian at exactly the same time: the *Virgin and Child with Saints Francis and Blaise* for San Francesco ad Alto in Ancona, dated 1520 (page 49, fig. 11). Here Titian returned the Madonna group to the central axis,

but apparently stimulated by his own recent Frari *Assumption* (page 48, fig. 8), he rendered the Virgin floating in glory surrounded by jubilant angels while the saints gaze up at her ecstatically from the ground. Less emphasized than the vertical axis are the powerful intersecting diagonals that unify earth and heaven, and create an even more dynamic equilibrium of forces than in the Ca' Pesaro altarpiece. In both these seminal works, the intrinsically static subject of the Virgin and Child accompanied by a selection of anachronistic saints is transformed into a vividly dramatic and inspiring event.

During the first three decades of the sixteenth century, the Madonna and saints picture painted for the rather different context of private devotion followed a course closely parallel to that of the altarpiece. In the long career of Bellini, the principal domestic counterpart to the grandiose, full-length *sacra conversazione* was the half-length Virgin and Child. In the innumerable examples painted by Bellini and his workshop between about 1460 and 1500, the figures were customarily shown behind a marble ledge in the foreground, so that the Virgin was visible from her waist or thigh upwards, and in front of a cloth of honor or a curtain.[2] In a domestic context, the half-length format had the obvious advantage of presenting the holy figures close-up, creating a greater sense of intimacy and allowing a more active emotional involvement on the part of the devotee. The type may be illustrated by one of the finest painted by Bellini in his midcareer, the so-called *Madonna of the Pear* (fig. 2) of about 1485. The picture is characteristically painted on a wooden panel of a vertical format; the figures are at once touchingly human and imbued with a deep sense of spiritual gravity; and a complementary sense of divine presence pervades the vistas of luminous landscape to either side. The very prominence of the pear placed on the foreground ledge helps underline its symbolic significance, alluding to the fruit of the Garden of Eden and hence also to the redemption of mankind by Christ as the new Adam and the Virgin as the new Eve. Thanks to the powerful example of Bellini, the half-length Virgin and Child also became a central theme for members of the younger generation of fifteenth-century painters, such as Cima.

After about 1500 Bellini painted markedly fewer representations of the Virgin and Child alone, while at the same time introducing a number of significant variations on his previous compositional type. One of the most striking of these was the introduction of a horizontal format, allowing the narrow bands of landscape in the vertical *Madonna of the Pear* to be expanded laterally. As its popular nickname indicates, the *Madonna of the Meadow* (fig. 3) of about 1505 shows a much more extensive panorama than the earlier work; and the marble ledge and the cloth of honor have both been abolished to allow the Virgin to be shown seated in the landscape. In the grandiose *Virgin with the Blessing Child* (cat. 1) of 1510, the cloth has been retained, but the broad picture field similarly allows for the inclusion of a more expansive vision of nature than was possible before and with it a greater density of symbolic detail. The broad format was also adopted by the young Titian in his own various early Madonnas, including the *Gypsy Madonna* (cat. 2) of about 1511 and the Madonnas in Bergamo (Pinacoteca dell' Accademia Carrara) and New York (The Metropolitan Museum of Art).

By about this date, however, the theme of the Virgin and Child alone was becoming less favored than another type popularized by Bellini: that of the Virgin and Child accompanied by saints, likewise seen in half length. In his earliest

2.

Giovanni Bellini, *Madonna of the Pear*, Pinacoteca dell'Accademia Carrara, Bergamo

3.

Giovanni Bellini, *Madonna of the Meadow*, National Gallery, London

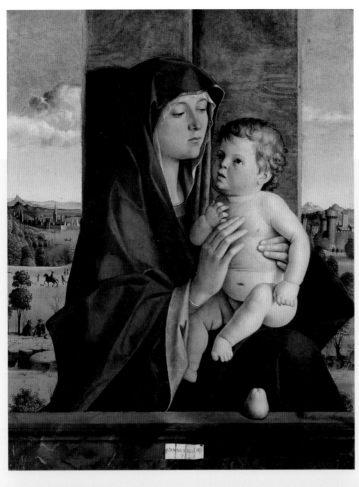

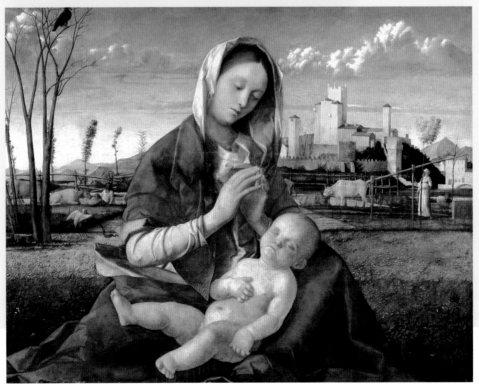

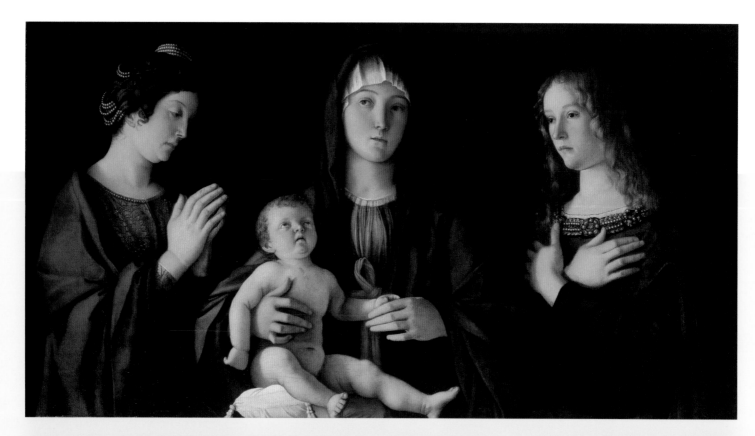

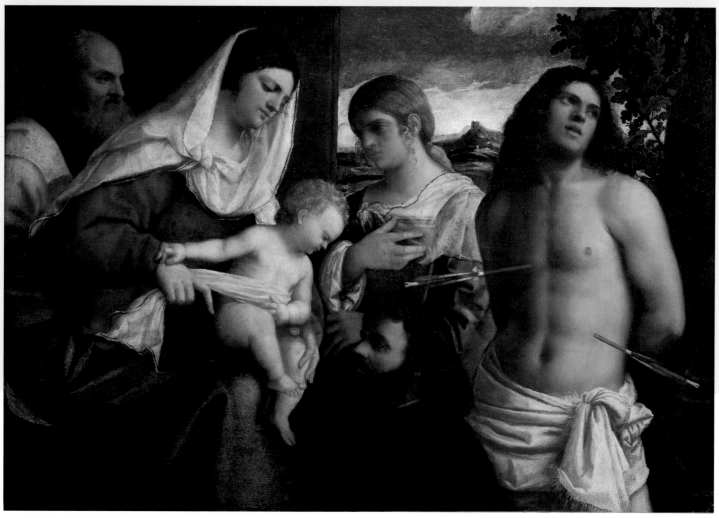

representations of this subject, for instance the *Virgin and Child with Saints Peter and Sebastian* of about 1480 (Musée du Louvre, Paris), Bellini retained the vertical format and simply squeezed in the saints at the sides. By about 1485/1490, however, as in the *Virgin and Child with Two Female Saints* (fig. 4), he had adopted instead a horizontal format, giving the saints more ample space and making the composition less cramped. This type became widely diffused by Bellini's many pupils and followers, some of whom doubled or even tripled the number of flanking saints.[3]

As in the case of large-scale altarpieces, painters of the fifteenth-century generation tended to adhere in their Madonna and saints compositions to a fairly strict symmetry, which was only slightly mitigated by the rhythms set up by the differing poses and gestures of the saints. Bellini, indeed, as in the San Zaccaria altarpiece, made a positive virtue of placing the Virgin and Child on the central vertical axis as a way of enhancing the grandeur of the Virgin in her role as Mother of God. With the gradual introduction into the type of kneeling donor portraits, symmetry could remain as long as both husband and wife were included; but if, as often happened, a single male donor was represented, it became natural to shift the Madonna group to one side and to show the holy figures greeting or blessing the devotee approaching from the other. A similar asymmetry might be created if one of the saints, for example a Saint Catherine receiving a ring in token of her Mystic Marriage with the Christ Child, became more actively involved with the Madonna group. But again, as in *sacra conversazione* altarpieces, by the early years of the sixteenth century members of the younger generation of Venetian painters no longer shared Bellini's respect for axiality, and most experimented with a looser, more dynamic grouping of the figures, as well as with more active gestures. Characteristic of this tendency is Sebastiano's *Virgin and Child with Saints Joseph, Catherine, Sebastian, and a Donor* of about 1506 to 1508 (fig. 5), in which the asymmetrical arrangement of the saints is further energized by the uneven subdivision of the background into areas of red curtain, distant landscape, and foreground tree. Titian continued to produce exciting variants on this type of composition during the second decade of the century, in such works as the *Virgin and Child with Saints George and Dorothy* of about 1520 (Museo Nacional del Prado, Madrid). Soon afterwards, however, he must have decided that the potential for further development of the type, like that of the single Madonna, was limited, and he largely abandoned it.

Compensating for the decline in interest in the devotional image among the most inventive painters in the second decade was the rise of another type: that of the full-length Virgin and Child seated informally with saints in a landscape.[4] Characteristic features of the type, as illustrated by Titian's *Holy Family with Saint John the Baptist* of about 1517 to 1520 (fig. 6), include the horizontal "landscape" format and the mood of domestic intimacy, as the saint on the right, probably identifiable as Joseph, reaches out to take the Christ Child in his arms. Although the figures are represented in full length, they are shown kneeling, or seated on or close to the ground, thus ensuring that the emphasis remains on their heads and upper bodies. The formal panoply of architecture and curtains has given way to trees and bushes as a foil for the figures in the foreground, and to a view over rolling, sunlit pastures to distant hills in the background.

In a sense this type may be seen as a natural development of a composition such as Bellini's *Madonna of the*

4.

Giovanni Bellini, *Virgin and Child with Two Female Saints*, Gallerie dell'Accademia, Venice

5.

Sebastiano del Piombo, *Virgin and Child with Saints Joseph, Catherine, Sebastian, and a Donor*, Musée du Louvre, Paris

Meadow of about a decade earlier (fig. 3), in which the Virgin is already seen sitting in a landscape, and beyond that, of the late medieval iconography of the Madonna of Humility. The inclusion, however, of other figures also links the type to narrative scenes from Christ's infancy, such as the Adoration of the Shepherds or the Rest on the Flight into Egypt. This linkage is evident from slightly earlier works by Titian such as the *Holy Family with a Shepherd* of about 1512 (fig. 7), the subject of which hovers ambiguously between that of a Nativity and an ideal, anachronistic grouping such as that of the *Holy Family with Saint John the Baptist*. Similarly, Titian's *Rest* of about 1510 (Marquess of Bath, Longleat) already contains all the essential ingredients of the timeless type and merely awaits the arrival of a non-historical saint or two. Finally, the popularity of the type in the second and third decades was evidently also closely related to the contemporary taste for pastoral poetry and to the parallel popularity in secular painting of subjects showing figures sitting or reclining at their ease in serene and fertile

landscapes dotted with shepherds and sheep, as in Titian's *Concert Champêtre* (cat. 31) and his *Three Ages of Man* of about 1513 (National Gallery of Scotland, Edinburgh, Sutherland Loan).

During the 1520s gatherings of the Virgin and Child with saints in a landscape became one of the most popular subjects in Venetian painting. Despite the pioneering examples by Titian (cat. 10), the principal practitioner of the type was Palma Vecchio (cat. 11), whose placid temperament was ideally suited to representing holy figures relaxing in the countryside, unburdened by any hint of tension, drama, or tragedy. In one of his earlier and most lyrical variations on the theme, the *Virgin and Child with Saints* in the Thyssen collection (fig. 8), probably dating from about 1516 to 1518, Palma gave the Virgin a rustic throne and hinted at the traditional cloth of honor in the foil of foliage behind her, while also preserving the effect of a close and loving family circle. The type also became a favorite of Palma's close follower Bonifacio (cat. 12) and of Titian's former pupil Paris Bordone (cat. 13), both of whom perpetuated it into the 1530s and beyond.

1. For the Venetian altarpiece in the period 1450 to 1530, see Humfrey 1993.

2. For Bellini's Madonnas, see Goffen 1989, 23–66.

3. For this pictorial type, see Tempestini 1996–1999, vol. 3.

4. For this type, see Rylands 1992, 67–70.

6.

Titian, *Holy Family with Saint John the Baptist*, National Gallery of Scotland, Edinburgh, Sutherland Loan

7.

Titian, *Holy Family with a Shepherd*, National Gallery, London

8.

Palma Vecchio, *Virgin and Child with Saints*, Museo Thyssen-Bornemisza, Madrid

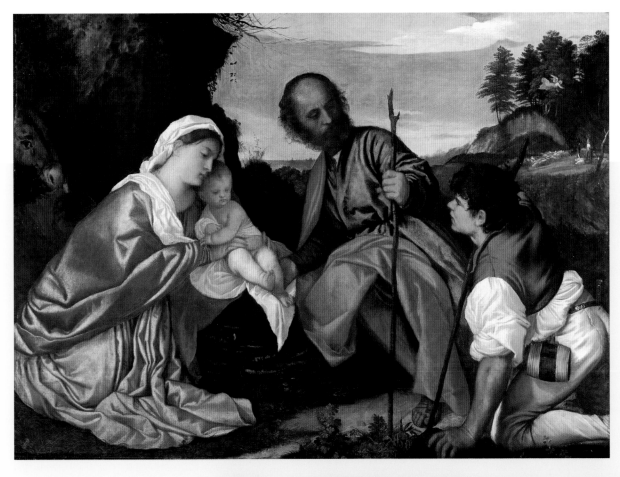

1

Giovanni Bellini

VIRGIN WITH THE
BLESSING CHILD

1510, oil on canvas,
transferred from panel
85 × 115 (33 7/16 × 45 ¼)
Pinacoteca di Brera, Milan

signed: IOANNES /
BELLINVS / MDX

•

Washington only

By 1510 Giovanni Bellini had been painting half-length devotional images of the Virgin and Child for half a century, and in terms both of its majesty gravity and its imposing scale, this work marks a fitting climax to what had been a central concern throughout his long career. Compared with his many Madonnas painted before 1500 (see page 59, fig. 2), the picture field has been broadened to accommodate an extensive landscape on either side of the figure group, and the foreground parapet has been removed to allow the seated Virgin to be represented in three-quarter length. In some ways, the expansion of the field helps convey a greater naturalism: the figures are less tightly confined within their frame, and the background offers a beautiful evocation of the countryside north of Venice, where the foothills of the Dolomites meet the plain. Yet thanks to the strict formality of the composition, the Virgin is no ordinary mother with her child, but remains unmistakably the Queen of Heaven. The figure group, with the standing, blessing Child, reverts to the traditional, hieratic Byzantine Hodegetria scheme; the green silk cloth of honor has no naturalistic means of support; the two trees in the middle ground are arranged with formal symmetry on either side; and the grandeur of the figure group is further enhanced by its relationship with the repeating triangular forms in the landscape, and especially with the wedges of hillside that rise to an apex in the head of the Virgin.

The religious message is further underscored by many of the details in the background, which Renaissance viewers would have been encouraged to interpret symbolically.[1] The tree on the right, for example, set up as a bird trap with lined streamers and a tethered decoy, probably alludes to Psalm 124, verse 7 ("Our soul is escaped as a bird out of the snare of the fowlers: the snare is broken, and we are escaped"), traditionally interpreted in terms of the Christian soul escaping from the temptations of the world. Similarly, the sleeping shepherd at the lower right recalls the condemnation by Isaiah (Isa. 57:10–11) of ignorant and lazy shepherds, who fail to care for their flocks; while the leopard on the altar to the left—a motif Bellini borrowed from his father Jacopo's *Book of Drawings* (British Museum, London, f. 89v), which he had recently inherited from his elder brother Gentile—refers to sinful humanity, spotted with evil.[2] However, identifying the boundary between symbolism and pure naturalism in Bellini's landscapes is not always easy; and in the present case, he is unlikely to have invested the clusters of farmhouses, or the two figures under the tree on the left, or the horseman on the right, with any deeper significance.

Painted in the year of Giorgione's death, the Brera *Virgin and Child* may be seen as fully participating in the technical and stylistic revolution that took place in Venetian painting in the first decade of the sixteenth century. Infrared reflectography has revealed an underdrawing that is remarkably summary by the standards of Bellini's earlier career, with outlines limited to the principal forms and no indication of internal modeling.[3] Similarly, Bellini exploits the oil medium to lend a warm mellowness to the colors and a melting softness to the tonal transitions.

1. Gentili 1991, 51–57; Gentili 2004, 178–180; Grave 2004, 79–80.

2. Tempestini 1992, 282–283.

3. *Giovanni Bellini a Milano* 1986, 20–29; Dunkerton 2004, 189–190.

Provenance: Palazzo Monti, Bologna (by c. 1769); Giacomo Sannazzari, Milan; bequeathed by him to the Ospedale Maggione, Milan, 1804; acquired for the Accademia di Belle Arti, 1806.

Selected References: Oretti (18th-century manuscript, 1984 ed.), 37; Crowe and Cavalcaselle 1871, 1:152 note 6; Fry 1900, 45; Venturi 1907, 389; Malaguzzi Valeri 1908, 124–125; Robertson 1968, 122–123; Huse 1972, 98–99; Wilde 1974, 46; *Giovanni Bellini a Milano* 1986, 20–29; Goffen 1989, 63–66; Humfrey 1990, 84–86; Humfrey in *Pinacoteca di Brera* 1990, 56–58; Gentili 1991, 51–57; Tempestini 1992, 282–283; Dunkerton 2004, 189–190; Gentili 2004, 178–180; Grave 2004, 79–80; Tempestini 2004, 260.

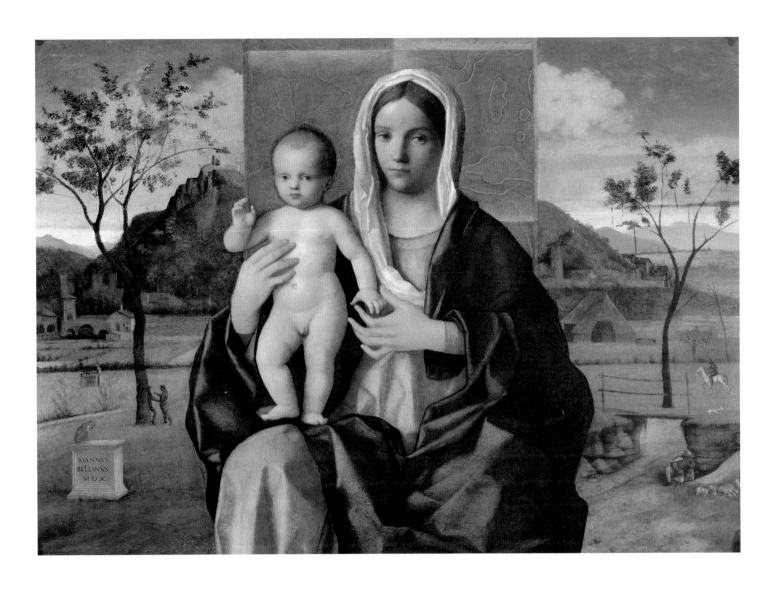

2

Titian

VIRGIN AND CHILD
("GYPSY MADONNA")

c. 1511, oil on panel
65.8 × 83.5 (25 7/8 × 32 7/8)
Kunsthistorisches Museum,
Gemäldegalerie, Vienna

Although not signed or dated, this imposing image of the Virgin and Child is universally recognized as a characteristically vital and sensuous work by the young Titian. The half-length composition, with the foreground ledge and the hanging cloth of honor, pays obvious homage to a pictorial type closely associated with Giovanni Bellini and, in particular, to recent examples in a horizontal format such as a Madonna of 1509 in the Detroit Institute of Arts and the Brera Madonna of 1510 (cat. 1). At the same time, the picture may be interpreted as an explicit critique of Bellini in its adoption of more ample and robust figure types, and in the freer, more generalized handling of the landscape.

Technical investigation of the picture by infrared reflectography (see page 297, fig. 14) has revealed the extent to which Titian had already departed from the practice by Bellini—and even on occasion by Giorgione—of preparing the composition with an outline underdrawing of all the major forms. In a way that foreshadows the painter's mature practice, underdrawing is mainly restricted to rapidly and boldly sketched indications of the Virgin's face, hand, and the Child's shoulders, and it was subject to constant modification during the process of execution.[1] Even more revealing of his revolutionary technique are the x-radiographs, which document the actual process of Titian's revision of his Bellinesque model (page 298, fig. 15).[2] They show that Titian's underpainting originally bore a much closer resemblance to the design of Bellini's Detroit Madonna,

with the two figures conceived more separately from each other, the Child facing outwards towards the spectator and the Virgin's fingers outstretched rather than clasping a voluminous bunch of drapery. The figures' features were originally more delicate and their proportions slimmer; by enlarging the heads, and by giving the limbs and draperies greater physical weight, Titian succeeded in investing them with a greater effect of both fleshy naturalism and classical grandeur. The grandiose effect of the pyramidal figure group is further heightened—despite the relatively small scale of the picture field—by its tight integration with the grid of verticals and horizontals formed by the ledge, wall, and curtain.

Repetitions of shape and especially of color similarly unify the foreground with the background, with its vision of rolling pastures bathed in evening sunlight receding to distant blue hills. This kind of landscape is very different from that portrayed by Giovanni Bellini, and is clearly inspired by the example of Giorgione, whose Castelfranco altarpiece already included the picturesque motif of relaxing soldiers. An even closer possible link with Giorgione is provided by the flat-topped mountain with the castle in front of it, a motif that exactly repeats one in the Dresden Venus (page 44, fig. 5). The status of the latter work remains highly controversial, however; and while as yet only a minority of critics attribute it in its entirety to the young Titian, a majority, following the testimony of Marcantonio Michiel, accept that Titian was responsible for providing Giorgione's reclining nude with its background, including the entire landscape.

In either case Titian would have painted the background of the Venus soon after Giorgione's death in 1510; and a similar date of about 1511 is usually now accepted for the Virgin and Child. Such a dating implies that the Bellinesque characteristics of the work should be interpreted less as an immediate reflection of Titian's training in Bellini's workshop (perhaps completed as early as about 1506) than as a self-conscious challenge to Bellini's continuing supremacy in the Venetian artistic establishment. Indeed, Titian was to mount such a challenge on a monumental scale in May 1513, when he requested permission from the Venetian government to paint the Battle of Spoleto for the Hall of the Greater Council of the Doge's Palace. Consistent with this ambition is the greater formal discipline of the Virgin and Child as compared with slightly earlier works such as the Christ and the Adulteress of about 1509 (page 102, fig. 2) or the Virgin and Child in the Accademia Carrara, Bergamo, of about the same date.[3] Further confirmation of a dating to about 1511 is provided by the stylistic similarity of the present work to the documented Padua frescoes of that year.

The *Virgin and Child* already carried an attribution to Titian when in the collection of the Archduke Leopold Wilhelm in 1659, and the name TITIANVS is inscribed both on the engraving by Jan Meyssen (1612–1670) and on an apparently early copy in the Accademia dei Concordi, Rovigo. The popular and convenient nickname "Gypsy Madonna," referring to the Virgin's dark skin, eyes, and hair (especially striking in comparison with the slightly later *Madonna of the Cherries*, likewise in Vienna), is first recorded in Engerth's gallery catalogue of 1881.

1. Hope and Van Asperen de Boer 1991, 131. See also the detailed discussion by Elizabeth Walmsley and Elke Oberthaler in the present volume.

2. Wilde 1932, 151–154.

3. Joannides 2001, 141–144.

Provenance: Collection of the Archduke Leopold Wilhelm of Austria, Brussels, by 1659; bequeathed by him to the Austrian imperial collection.

Selected References: *Inventarium* 1659 (1883 ed.), C no. 235; Storffer 1733, 3: fol. 34, no. 127; Mechel 1783, 24; Krafft 1854, 27–28; Crowe and Cavalaselle 1877, 1:54–56; Engerth 1881, 340–343; Rothschild 1932; Wilde 1932, 151–154; Pallucchini 1969, 27, 243–244; Valcanover 1969, 95; Wethey 1969, 8, 98–99; Wilde 1974, 113–115; Freedberg 1975, 145; Hope 1980, 22–23; Brown in *Titian* 1990, 62; Hope and Van Asperen de Boer 1991, 131; Joannides 2001, 141–144; C. Campbell in *Titian* 2003, 74.

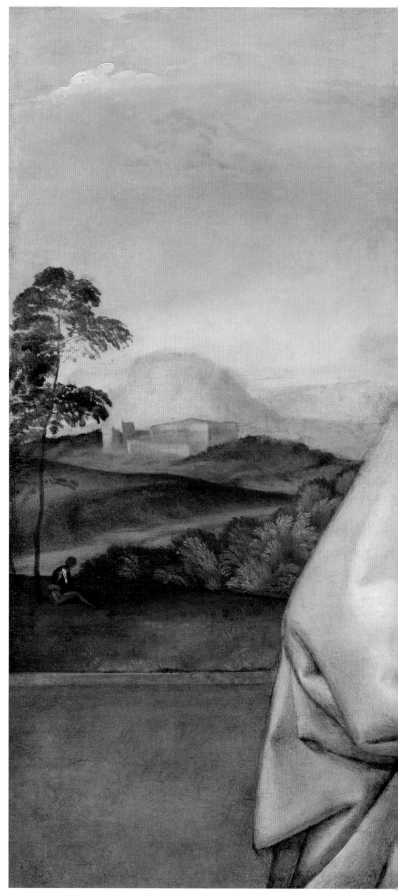

2

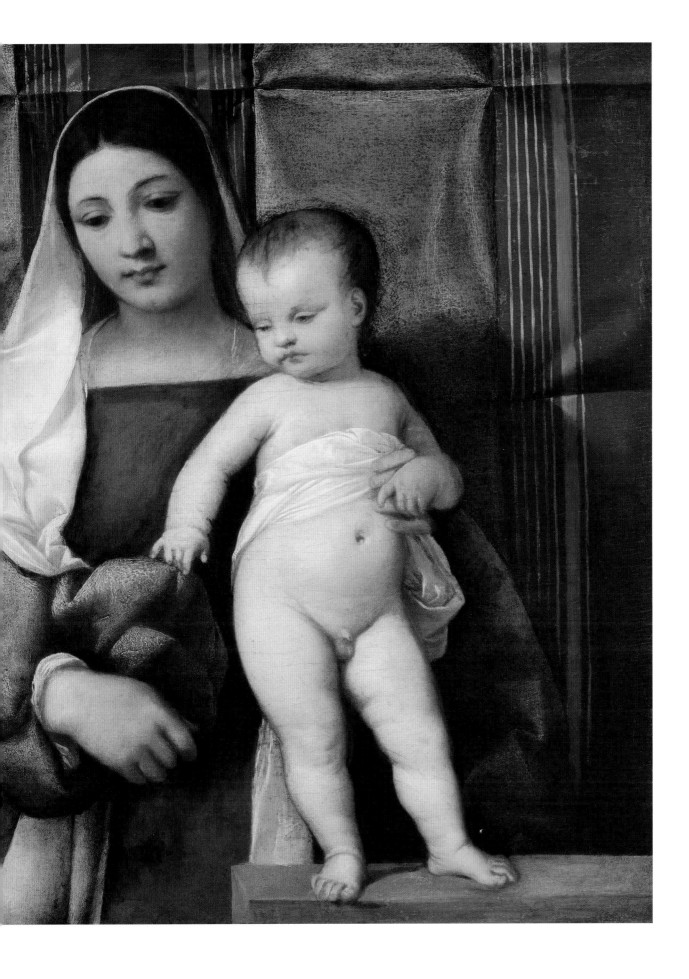

1.

Albrecht Dürer, *Christ
among the Scholars*,
Museo Thyssen-
Bornemisza, Madrid

3

Lorenzo Lotto

VIRGIN AND CHILD
WITH SAINTS
IGNATIUS OF ANTIOCH
AND ONOPHRIUS

1508, oil on panel
51 × 65 (20 1/16 × 25 9/16)
Galleria Borghese, Rome

signed and dated:
.LAVRENT.LOTVS.M.D.VIII.

The half-naked, hirsute saint on the right is easily recognizable as Onophrius, the fourth-century anchorite, who lived for sixty years alone in the desert, covered only with hair and leaves. In the past the bishop saint has been called Louis or Flavian; but as pointed out by Ekserdjian,[1] he must be Ignatius Theophorus, a disciple of Saint John the Evangelist and bishop of Antioch, who was martyred in Rome under the emperor Trajan. The name "Theophorus" signifies that he carried God inside him, and after his death the name of Jesus was accordingly found inscribed on his heart. Lotto's painting clearly refers to this legend in the interaction between the saint and the Christ Child.

In composition, the picture derives ultimately from works by Giovanni Bellini such as the *Virgin and Child with Two Female Saints* of about 1485 to 1490 (page 60, fig. 4), where the half-length holy figures are similarly placed against a dark, neutral background. Lotto's previous experiments with the type, such as the *Virgin and Child with Saints* of about 1505 (National Gallery of Scotland, Edinburgh), are also strongly Bellinesque in style. As is generally recognized, however, the style of the Borghese picture has shifted dramatically towards that of the German Albrecht Dürer. This new direction is especially evident in the physiognomies, which are expressive to the point of ugliness; but scarcely less Düreresque

are the heightened sense of animation and the use of bright, metallic color—so different from the softly luminous color planes of Bellini. In this connection it is worth noting that the now badly faded color of the Virgin's headdress would originally have been an intense yellow.

Lotto may well have met Dürer during the latter's stay in Venice from 1505 to 1506; he certainly would have known his great altarpiece, the *Feast of the Rose Garlands* (page 45, fig. 6), as well as engravings such as the *Witch Riding Backwards on a Goat*, or the *Three Putti with Shield and Helmet*, both of about 1500. As pointed out by Dal Pozzolo,[2] Lotto's Christ Child is very similar to the chubby infants in Dürer's prints, in his physical type and vehement gesture. The work by Dürer that seems to have made the greatest impact on Lotto,

however, is the *Christ among the Scholars* of 1506 (fig. 1), with its expressive crowding of upper bodies and heads, and the placing of the elderly figure with the long walrus moustache on the right. There is some debate among Dürer scholars about whether this strange and powerful work was painted in Venice or Rome, but in either case Lotto could have seen it: either before he moved from Treviso to the Marches in October 1506; or when he arrived in Rome, probably in the late summer of 1508.

In support of the conclusion that Lotto painted the Borghese picture in Rome towards the end of 1508 (rather than a few months earlier in the Marches) is the fact that both saints were the objects of flourishing

cults in the papal capital. It may seem paradoxical that on arrival in Rome Lotto should have immediately turned his attention, not towards the art of classical antiquity, nor even to the epoch-making frescoes by Michelangelo and Raphael in progress in the Vatican, but to an idiosyncratic work by a visiting German. But Lotto had already sensed a temperamental affinity with the art of Dürer; and although he was subsequently to draw a certain inspiration from the art of Raphael, he was never to be deeply attracted to the classical ideal of beauty.

1. Ekserdjian 1997.

2. E. M. Dal Pozzolo in Aikema and Brown 1999, 300, no. 54.

Provenance: Collection of Scipione Borghese (died 1633).

Selected References: Berenson 1895, 14–15; Banti and Boschetto 1953, 12, 68; Zampetti 1953, 44, no. 25; Della Pergola 1955, 1:117; Mariani Canova 1975, 91; Lattanzi in Gentili 1985, 155–161; Ekserdjian 1997; Humfrey 1997, 30–32; Dal Pozzolo in Aikema and Brown 1999, 300, no. 54; Heimbürger 1999, 221–222.

3

4

Palma Vecchio

VIRGIN AND CHILD
WITH SAINTS
JOHN THE BAPTIST
AND MARY
MAGDALENE

c. 1516–1518, oil on panel
71 × 108 (28 × 42 ½)
Musei di Strada Nuova,
Palazzo Rosso, Genoa

In what is arguably Palma's most beautiful contribution to the Bellinesque type of the half-length Virgin and Child with saints (compare to page 60, fig. 4), there is a suggestion that, as in the *Madonna of the Meadow* (page 59, fig. 3), the figures are sitting or kneeling on the ground, where they commune with nature as well as with one another. Unlike in other variations on the type by the younger generation of Venetian painters (page 60, fig. 5), including Palma himself (*Virgin and Child with Saints John the Baptist and Sebastian* [Muzeum Naradowe, Poznan]), the composition here remains centered on the Madonna group. At the same time, Palma updated the Bellinesque scheme with the greater amplitude of his figure types, especially with the introduction of a much greater degree of rhythmical fluency, based on diagonals, reciprocal movements, and sweeping curves. The landscape, with its shepherd and sheep, farm buildings and rustic church, is of the idyllically pastoral type so popular in Venetian painting of the second and third decades of the sixteenth century. And the Magdalen has been secularized in the manner of the ideal representations of beautiful women (cat. 44) in which Palma specialized.

Palma's chronology is notoriously difficult to plot, and the picture has been seen both as an early work of about 1508 to 1510,[1] and as a mature work of about 1520 or later.[2] Here an intermediate date of about 1516 to 1518

may be suggested: that is to say, a date close to the *Virgin and Child with Saints* in the Thyssen collection (page 63, fig. 8), with its similar use of undulating rhythms across the picture surface and its relative delicacy of touch, but well before the grander harmonies of late works such as the *Virgin and Child with Saints* from Penrhyn Castle (cat. 11).

First mentioned in print by C.G. Ratti in 1766 in the collection of Marcello Durazzo in Genoa, the picture is almost certainly identical with one recorded a century earlier in the posthumous inventory (1658) of Giovanni Battista Balbi and described as "Nostra Signora S. Gio. Batta et una santa vergine del Palma vecchio."[3]

1. Gombosi 1937, 10; Rowlands 1966, 374.

2. Spahn 1932; Rylands 1992, 81, 93–94.

3. Boccardo and Magnani 1987, 51.

Provenance: Giovanni Battista Balbi, Genoa (died 1657); by inheritance to the Durazzo family, and later to the Brignole-Sale family, Palazzo Rosso, Genoa; bequeathed by Duchessa di Galliera to the city of Genoa, 1890.

Selected References: Ratti 1766, 187; Tassi 1793, 106; Crowe and Cavalcaselle 1871, 2:492; Frizzoni 1890, 123; Jacobsen 1896, 122; Spahn 1932; Gombosi 1937, 10; Rowlands 1966, 374; Mariacher 1968, 98; Boccardo and Magnani 1987, 51; Rylands 1992, 81, 93–94; Rylands in *Bergamo* 2001, 190.

5

Giovanni Bellini

VIRGIN AND CHILD
WITH SAINTS
PETER AND MARK
AND A DONOR

———————

1505, oil on panel
91.4 × 81.3 (36 × 32)
Birmingham Museums
and Art Gallery

signed and dated:
IOANNES BELLINVS
MCCCCCV
(on *cartellino*)

Dated to 1505, the same year as Bellini's grandiose altarpiece for the church of San Zaccaria (page 41, fig. 1), this more modestly scaled work similarly shows the Virgin and Child enthroned with saints, with a tiled marble pavement in the foreground giving way to a luminous landscape beyond. Unusually for a Venetian altarpiece, however, the holy figures are accompanied by the full-length portrait of a donor, kneeling in prayer. As a result, the figures communicate with one another more directly than in the San Zaccaria altarpiece; and while the Virgin and Child turn their attention to the donor, his patron saint, probably Saint Mark, presses forwards towards the Madonna group, as if actively interceding on behalf of his devotee. The effect of gentle activity rather than of motionless, inward meditation is further enhanced by light asymmetries in the composition. Thus while the perspective construction, the Virgin's throne, and the *cartellino* with the painter's signature are all aligned on the same vertical axis, it is shifted to the left of center, as if to compensate for the bulky form of the donor on the right.

Nothing certain is known of the identity of the donor, or of the original setting of the picture. It is usually identified with a work recorded by Carlo Ridolfi in 1648 in the Muselli collection in Verona: "Among the many possessions collected by their father, Cristoforo and Francesco Muselli of Verona have two very beautiful paintings by this master [Giovanni Bellini]. One of these, in the form of an altarpiece, shows the Queen of Heaven with Saints Peter and Paul at the sides, and below, a portrait of someone wearing a costume of former times. On the cover are depicted Saints Francis and Vincent Ferrer."[1] This description, together with one by Bartolomeo dal Pozzo of 1718 (by which time the work had entered another collection in Verona), is probably sufficiently circumstantial to confirm that Ridolfi was referring to the Birmingham picture.[2] As pointed out by Cannon-Brookes, however, Ridolfi was almost certainly mistaken in his identification of the saint on the right.[3] Although the figure lacks an attribute, with his short beard he corresponds in type to Mark rather than Paul; and although his cloak is now dark green, it is likely originally to have been blue. More perplexing is Ridolfi's mention of the two saints "on the cover"—described in a Muselli inventory of 1662 as "shutters."[4] Winged triptychs of the Netherlandish type were not adopted by Venetian painters; and in any case, the pairing of the founder of the Franciscan order with the Dominican Vincent Ferrer would be anomalous. It may be that the saints on the cover were misidentified. Or, these panels may originally have had nothing to do with the main panel, but were merely associated with them in the Muselli collection. Certainly, they had disappeared by the time that the Birmingham picture is first definitely recorded in England in 1801.

The inclusion of donor portraits was much more common on the Venetian mainland than in Venice itself; and given the presence of Saint Mark and the resemblance of the composition to that of official votive pictures, it is tempting to speculate that the work was commissioned by some provincial governor, perhaps even by a Venetian patrician posted to Verona. Yet the costume worn by the donor—with sleeves tight at the wrist and a cloak of the purplish color known as *pavonazzo*—does not correspond to Venetian official dress. Another possibility, argued in detail by Douglas-Scott, is that the work corresponds with one bequeathed in 1528 to the church of the Madonna dell'Orto in Venice by the Venetian citizen Hieronimo Olivier and described as "the picture of Our Lady made by the hand of Giovanni Bellini, which has the portrait of the blessed memory of the deceased Marco who was my brother."[5] Olivier wished it to be placed on an altar in the church, "in place of an altarpiece" (*in luogo de Palla*), implying that it had previously served the needs of private devotion in the family home, but that it was now to be adapted to a new function. According to Douglas-Scott's thesis, the portrait of Marco Olivier would be posthumous, immediately postdating his death in 1504; *pavonazzo* would be appropriate as a color of mourning; and Mark would be included primarily as the donor's name saint, rather than as the patron saint of Venice. For some reason,

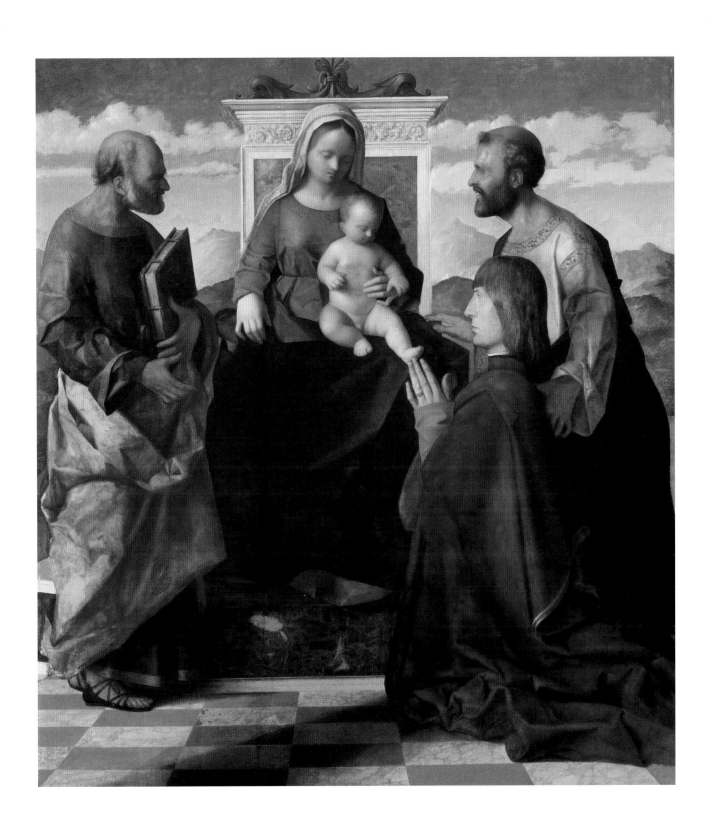

however—perhaps because the clergy did not wish to display the portrait of a donor with no connection with the church—the work was never installed in the Madonna dell'Orto, and must eventually have been sold on the art market.

The authorship of the painting has been the subject of some art-historical debate, with some critics declaring it to be entirely autograph and others dismissing it as a shop production. There are indeed disturbing discrepancies of scale in the various heads, and the Madonna group appears weaker in quality than the vigorous and expressive saints. Particularly fine is the head of Saint Mark, which, as Robertson observed, is apparently inspired by a classical model, in particular, by Roman imperial portrait busts of the celebrated Greek orator Demosthenes.[6] Significantly, x-radiography has revealed that— whereas the Madonna group exactly follows incised contour lines, as if an assistant were mechanically executing his master's design—the saints show a number of pentimenti, reflecting Bellini's own creative process.[7] The head of the donor appears to have been repainted at a later date, perhaps because the original was damaged. The panel also appears to have been trimmed along all four edges, most conspicuously at the top, where the cresting of the throne is truncated.

The history of the picture's ownership in nineteenth-century England is traced in detail by Cannon-Brookes.

1. "Li Signori Christoforo e Francesco Museli in Verona hanno, trà le molte cose raccolte del già Padre loro, di questo Autore due rarissime Pitture, l'una in forma d'altare continente la Regina de i Cieli, hà dalle parti i Santi Pietro e Paolo e vi è un ritratto à piedi vestito all'antica, e nella coperta San Francesco e San Vicenzo Ferrerio." Ridolfi 1648, 72.

2. Dal Pozzo 1718, 283.

3. Cannon-Brookes 1977.

4. Campori 1870, 182.

5. "el quadro de nostra dona fatto per man de zuan Bellini che ha el retratto de la bona memoria del quondam misser Marcho fo mio fradello." Douglas-Scott 1996.

6. Robertson 1979.

7. Tempestini 1992, 258–260.

Provenance: Probably collection of Cristoforo and Francesco Muselli, Verona (by 1648), and collection of Counts Sareghi, Verona (by 1718); possibly in the Pembroke collection, England; John Purling sale, London, 1801; Edward Coxe sale, London, 1807; John Humble sale, London, 1812; collection of Dawson Turner, Great Yarmouth from 1814; to his sale, London, 1852; Earls of Ashburnam, London (by 1878); acquired from the 5th earl by Vernon James Watney, London and Cornbury Park, Oxfordshire, 1899; acquired from the Watney collection by the Birmingham Art Gallery, 1977.

Selected References: Ridolfi 1648 (1914 ed.), 72; Dal Pozzo 1718, 283; Campori 1870, 182; Robertson 1968, 117–118; Freedberg 1975, 168; Cannon-Brookes 1977; Robertson 1979; Tempestini 1992, 258–260; Douglas-Scott 1996; Tempestini 1999, 77–80, 227.

6

Cima da Conegliano

SAINT PETER
ENTHRONED
WITH SAINTS JOHN
THE BAPTIST
AND PAUL

1516, oil on canvas,
transferred from panel
156 × 146 (61 7/16 × 57 1/2)
Pinacoteca di Brera,
Milan

signed:
JOAN(N)IS BAPTISTE...
(on *cartellino*)

Peter, as the first supreme head of the Christian church, is represented in full pontificals, with the keys of heaven at his feet; he is accompanied by his fellow apostle and cofounder of the church, Paul, and by the youthful John the Baptist. The inscription on the Baptist's banderole (EGO VOX CLAMANTIS) is a quotation from the saint's own claim to be the precursor of the Messiah (John 1:23, "I *am* the voice of one crying in the wilderness...").

This painting is Cima's last recorded work, painted in 1516 only a year or two before his death, for the Franciscan nunnery of Santa Maria Mater Domini in his native town of Conegliano. By the eighteenth century, it was hanging in the nuns' refectory,[1] but presumably it had been commissioned for an altar dedicated to Peter in the neighboring church. Some influence of the Giorgionism prevalent among his younger contemporaries is apparent in the mellow, late-afternoon lighting, and perhaps also in the figure of the Baptist, with his romantically tousled curls, his face thrown half into shadow, and his yearning expression. But in most other respects—in striking contrast to Titian's Prado altarpiece (cat. 7) and Pordenone's *Madonna of Mercy* (cat. 8), both of which precede it— Cima's composition follows the pattern established by Giovanni Bellini for *sacra conversazione* altarpieces in the last decades of the fifteenth century: in this strictly symmetrical formal arrangement, the central saint is placed on a raised throne with an angel musician at its base, and the figures are set beneath an architectural canopy (see page 41, fig. 1).

There is no record of the original frame, but it was probably of the customary architectonic type, with its forms matching those of the painted architecture. The frame would then have resembled a window opening out to a loggia containing the holy figures, with a view of landscape beyond. The architectural style of the painted piers, with their tall, slender proportions and their finely chiseled foliage *all'antica*, also harks back to the 1470s and 1480s, especially to Pietro Lombardo's carvings in the Venetian churches of San Giobbe and Santa Maria dei Miracoli. Peter's throne, with its sumptuous display of colored marbles and its semidome revetted in gold mosaic, reveals the artist's indebtedness to an even older Venetian tradition, as represented by the Byzantine church of San Marco. The painting was damaged during its journey from Conegliano to Milan in 1806, and soon after it was acquired by the newly founded Brera Gallery it was transferred from panel to canvas. Originally the effect of material richness and glowing color would have appeared even more striking than it does now.

1. Malvolti 1774.

Provenance: Santa Maria Mater Domini, Conegliano; transferred to Milan, 1806; acquired by the Pinacoteca di Brera, 1811.

Selected References: Ridolfi 1648 (1914 ed.), 77; Malvolti 1774 (1964 ed.), 12; Federici 1803, 1:223; Crowe and Cavalcaselle 1871, 1:245 note 3; Botteon and Aliprandi 1893, 100–101, 203–204; Burckhardt 1905, 78–80; Malaguzzi Valeri 1908, 93–94; Coletti 1959, 17; Menegazzi 1962, 65; Menegazzi 1981, 53–54, 132–133; Humfrey 1983, 48, 119–120, 206–207; Humfrey in *Pinacoteca di Brera* 1990, 118–119.

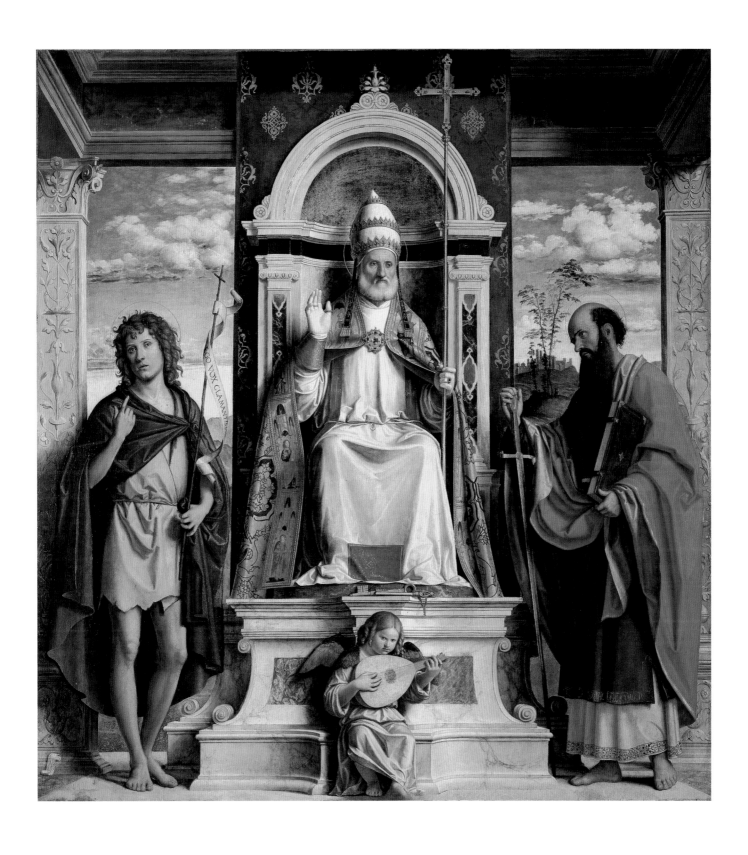

7

Titian

VIRGIN AND CHILD
WITH SAINTS
ANTHONY OF PADUA
AND ROCH

c. 1508, oil on canvas
92 × 133 (36 ¼ × 52 ⅜)
Museo Nacional
del Prado, Madrid

Probably painted as a small altarpiece, the picture shows the Virgin and Child in the company of two saints who enjoyed great popularity in Renaissance Venice, particularly in Franciscan circles. Standing in the place of honor to the Virgin's right, Saint Anthony of Padua is identified by his gray habit and attributes of a book and flowering lily. He was the most prominent saint of the order after Francis himself, and his shrine in nearby Padua was one of the most favored pilgrimage destinations in all Italy. A lay confraternity dedicated to him, the Scuola di Sant'Antonio, existed next to the church of the Frari. Saint Roch, identified by his pilgrim's costume and the bubo on his exposed thigh, was regularly invoked as a protector against the plague. His own shrine was housed in the recently built church of San Rocco, situated immediately behind the Frari and consecrated in 1508. Nothing is known of the original destination of the picture, but it is possible that it was painted for a chapel or oratory in the same neighborhood, perhaps even the meetinghouse of the Scuola di Sant'Antonio.

In the nineteenth century the picture bore an obviously impossible attribution to Pordenone, and then for about half a century after 1880 a majority of critics considered it to be by Giorgione.[1] The basis for this idea was the obvious similarity of type between the figure of the Virgin and her counterpart in Giorgione's Castelfranco altarpiece, in which her ideally oval head likewise sinks demurely downwards; very similar, too, is the introspective languor of Saint Anthony. As early as 1904, however, an alter-

native attribution to the young Titian was proposed, which has become generally accepted.[2] There remain dissenting voices to this near consensus: it has been argued, for instance, that the resemblance of the Madonna group to that in Domenico Mancini's fragmentary polyptych, signed and dated 1511 (Lendinara, Duomo), suggests that the present picture is also by this obscure master;[3] or that it cannot be by Titian because it does not sufficiently resemble the *Gypsy Madonna* (cat. 2).[4] But another argument used to reject the attribution—that the name of Titian was never associated with the picture before 1904[5]—is disproved by the recent convincing proposal to identify it with one by Titian acquired for the Spanish monarchy in 1654. Indeed, the thick, apparently padded or interlined draperies closely resemble those not only of the *Gypsy Madonna* but also of other works generally accepted as by the young Titian, such as the *Pastoral Concert* (cat. 31) and the *Christ and the Adulteress* (page 102, fig. 2). The pose of Roch is also very similar to that of the man leading in the adulteress in the latter work.

Compared with these other early works and with the *Saint Mark Enthroned with Saints* altarpiece (page 4, fig. 2), likewise usually seen as contemporaneous with the documented Padua frescoes of 1511 (page 47, fig. 7), the present picture appears relatively archaic in its compositional stasis and in the strictness of its symmetry. It remains closer, in other words, in composition—and mood—to Giorgione's Castelfranco altarpiece, and even to Bellini's San Zaccaria altarpiece of 1505 (page 41, fig. 1). As is evident from its recent cleaning

(2005) and from a recent infrared image (fig. 1), the painting also resembles Bellini in its technique: now clearly visible to the naked eye is the underdrawn modeling of the Virgin's cloak, consisting of fine parallel hatchings; and all the major forms and drapery folds are indicated with clear outlines. For all these reasons, the picture may be seen as one of Titian's very earliest independent works, dating perhaps from about 1508. An explanation for the contrast between the fine-boned Madonna and the considerably more fleshy version in the *Gypsy Madonna* would then be that the one was painted some three years earlier than the other. This early dating conflicts with the attractive suggestion that the picture was painted during Titian's stay in Padua in 1511;[6] but as has been mentioned, the popularity of the cult of Anthony was by no means limited to Padua.

Although some areas of the painting, for instance the silk cloth of honor and the figure of Roch, are fully resolved, other areas—notably the background landscape—remain incomplete. The Virgin's cloak (certainly meant to be blue and not green) and the green curtain, both of which have been heavily overpainted, were probably also left incomplete by the painter. The x-radiographs reveal a number of pentimenti, notably in the head of the Child, which originally faced downwards to the right, towards Roch's exposed bubo.

The first certain mention of the picture occurs in 1657, when it was recorded in the sacristy of the Spanish royal palace-monastery of the Esco-

rial by Fray Francisco de los Santos with an attribution to "Bordonon." It was placed on the north entrance wall of the sacristy, and is clearly visible in the mirror image of the room included in Claudio Coello's altarpiece, known as the *Sagrada Forma* (c. 1690). It has traditionally been inferred from De los Santos' text that the author claimed that the picture had been presented to Philip IV by the Duke of Medina de las Torres, but a closer reading does not necessarily support this inference.[7] Rather, as has recently been suggested, the picture should be identified with one bought in Amsterdam for the king in 1654 from the estate of the recently deceased Countess of Arundel by the former Spanish ambassador to London, Alonso de Cárdenas.[8] In his memorandum of 1659 it is described as "Another large picture on canvas, with Our Lord, Saint Anthony of Padua and Saint Roch, with life-size figures, by the hand of Titian."[9] The exactness of this description leaves little room for doubt about the identification; and it may be assumed,

therefore, that the countess, together with or independently of her husband, acquired it when in Venice in 1613 or 1622. (In this connection it may be noted that, by contrast, the Duke of Medina de las Torres acquired his Italian pictures from Naples and Sicily.) Immediately after the picture arrived in Spain, its attribution was evidently changed from Titian to "Bordonon"—a curious amalgam of Giorgione, Pordenone, and Paris Bordone—presumably on the advice of Velázquez, who from 1652 onwards had responsibility for the hanging of the pictures in the sacristy, and whose idea of Titian would have been based on the generally much later works by him in the Spanish royal collection.

1. See, for example, Morelli 1880, 216; Justi 1908, 108, 140–141; Richter 1937, 228–229; Wethey 1969, 174.

2. Schmidt 1904, 160; and followed, for example, by Venturi 1913, 134–135; Suida 1933, 21–22; Pallucchini 1969, 11–12; Valcanover 1969, 93–94; Ballarin in *Le Siècle de Titien* 1993, 349–351; Joannides 2001, 125–127; Falomir 2003, 141–143.

3. Holberton 1993, 257.

4. Hope 1980, 40; Hope 2003, 740.

5. Hope 2003, 740.

6. Rearick 1984, 64; Joannides 2001, 125–127.

7. This information was kindly provided by Miguel Falomir.

8. Brown 2002, 66–67.

9. "Ítem otro quadro grande en tela, de Nuestro Señor, San Antonio de Padua y San Roque, figuras al natural, de mano del Tiziano." *Sale of the Century* 2002, 292; Falomir 2003, 142–143.

Provenance: Probably Earl and Countess of Arundel, London (by 1622); probably acquired from her estate by Alonso de Cárdenas, 1654, and donated to Philip IV of Spain; transferred from the Escorial to the Prado, 1839.

Selected References: Santos 1657, 46v; Morelli 1880 (1893 ed.), 216; Schmidt 1904, 160; Justi 1908, 108, 140–141; Venturi 1913, 134–135; Suida 1933, 21–22, 151; Richter 1937, 228–229; Pallucchini 1969, 11–12; Valcanover 1969, 93–94; Wethey 1969, 174; Wilde 1974, 118; Freedberg 1975, 146; Hope 1980, 40; Richardson in *Genius of Venice* 1983, 168–169; Rearick 1984, 64; Ballarin in *Le Siècle de Titien* 1993, 349–351; Holberton 1993, 257; Anderson 1997, 331–332; Joannides 2001, 125–127; Brown 2002, 66–67; *Sale of the Century* 2002, 292; Falomir 2003, 142–143; Hope 2003, 740; Brown 2005.

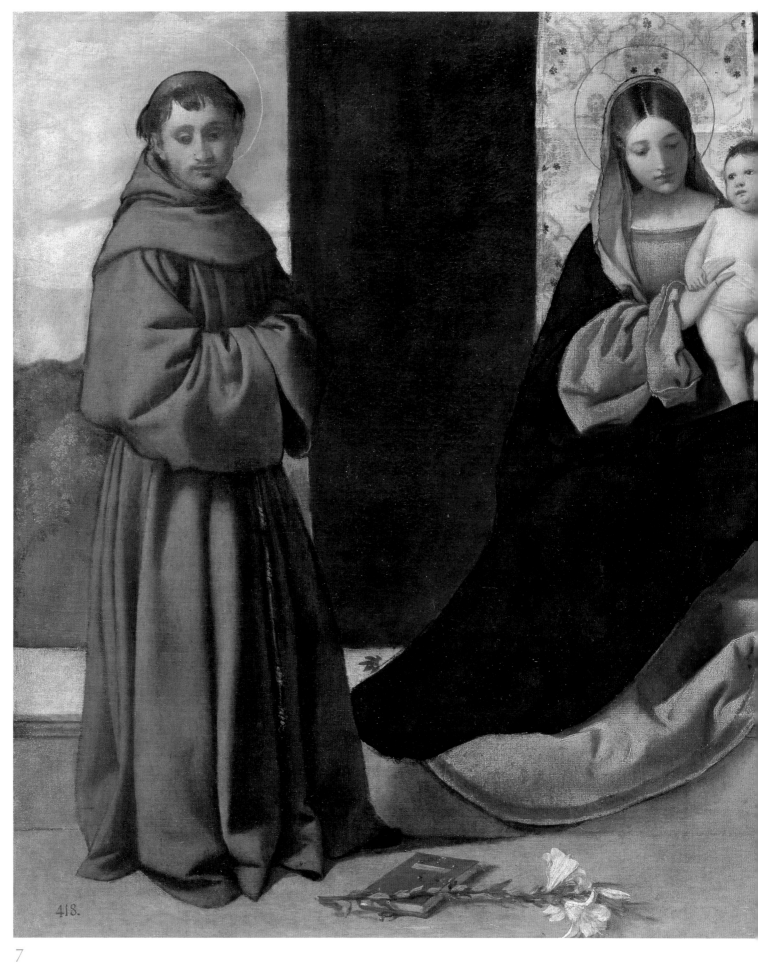

418.

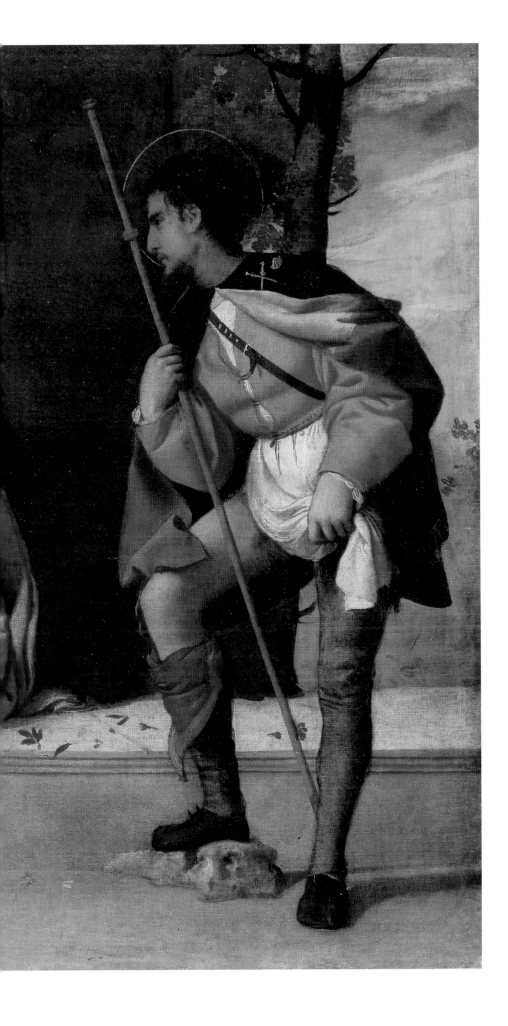

8

Pordenone

MADONNA OF MERCY
WITH
SAINTS CHRISTOPHER
AND JOSEPH

1515, oil on canvas
288 × 174 (113 ⅜ × 68 ½)
Concattedrale di
San Marco, Pordenone

The altarpiece remains in the church for which it was painted, above the first altar on the right, in the painter's native city in the province of Friuli. Three documents record the circumstances of the commission. In his will of 15 December 1514, one Giovanni Francesco da Tiezzo, called Cargnelutto, required his heirs to commission, "from a good painter," an altarpiece for the altar of the Misericordia in the church of San Marco. The painting was to represent "the Virgin Mary in the guise of the Madonna of Mercy,"[1] together with saints Joseph and Christopher, and its frame was to be carved and gilded. On 8 May 1515, Cargnelutto himself commissioned the altarpiece from Pordenone, according to an agreed design; the work was to be completed by the following Easter for a fee of 47 ducats, on which Pordenone was given an advance in the form of a plot of land. On 25 June the painter received another partial payment of 11 ducats.[2] The documents do not record whether Pordenone met his deadline of Easter 1516; but in view of the dramatic development of his pictorial style during the course of that year, most critics agree that the altarpiece is likely to have been completed before the end of 1515.[3]

The subject matter of the altarpiece exactly follows the patron's instructions. At the center is the figure of the Madonna of Mercy who, in keeping with traditional iconography, is shown standing and protectively shielding the diminutive figures of kneeling donors with her cloak. Presumably these figures portray Cargnelutto in the immediate foreground with various members of his family. To the left, the gigantic figure of Christopher ferries the Christ Child over a river, and to the right, Joseph also holds the Child as an identifying attribute. Christ's earthly father was the object of an intense cult in early sixteenth-century Friuli,[4] while Christopher— like the Madonna of Mercy—was constantly invoked as a protector against disaster and sudden death.

Pordenone's painting shows a strange but compelling blend of the modern, the archaic, and the idiosyncratic. Strikingly up-to-date with the most recent artistic developments in Venice are the muscular and dynamic figure of Christopher, and the background landscape. The Christopher has been compared with his counterpart in Titian's *Triumph of Faith* woodcut and with the engravings of the *Standard-Bearer*, based on Raphael, by Agostino Veneziano and Marcantonio Raimondi. Pordenone's figure cannot have been inspired by these prints, since it has been convincingly argued that they date from 1516 or later.[5] The resemblance, in any case, is only very general; yet it is sufficient to illustrate the self-conscious modernity of Pordenone's figure style. Similarly the landscape, with its vignette of shep-

herds and sheep, its castles and farmhouses, and its atmospheric distances, shows full awareness of the pastoral mode currently fashionable in Venice— although with characteristic originality, Pordenone showed not the idyllic sunlit scenery favored by Titian and Palma Vecchio in this period, but one subject to blustery winds and storms.

This modernity contrasts oddly, however, with the archaically small scale of the donors, and with a figure composition that treats the three saints as separate entities, as if they still belonged to the traditional format of a triptych. Christopher's river does not extend beyond his own immediate area, and the spaces surrounding the saints are not coherently linked either to one another or to the landscape background. Attributable rather to personal idiosyncrasy is the way in which the painting reverses the traditional compositional structure of altarpieces by showing the central Virgin lower in height and smaller in scale than the flanking saints; and similarly offending against traditional decorum is the surprising double inclusion of the Christ Child. The playful antics of the Child on the right and the expression of quizzical amusement on the face of Joseph further contribute to an effect that is at once quirky and highly engaging.[6]

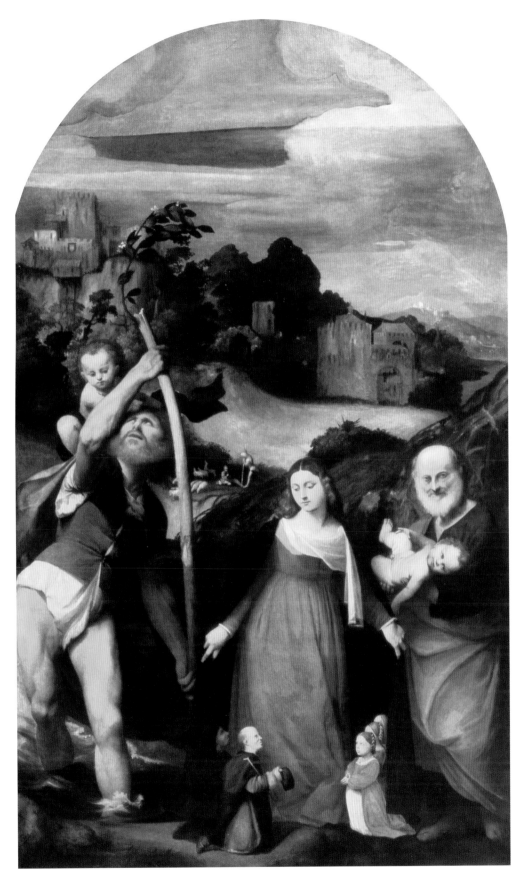

1. "unam divinam Mariam in formam Matris Misericordiae."

2. P. Goi in Furlan 1988, 355; Cohen 1996, 536, 755–756.

3. Pattanaro 1993, 384–385; Cohen 1996, 87–90.

4. Wilson 2001, 16.

5. See Bury, 1989.

6. Cohen has tentatively suggested that a landscape drawing with houses in the Biblioteca Ambrosiana, Milan, may have been made in preparation for the landscape background (cod F. 271 inf. No. 30 recto; Cohen 1980, 96–97). The same scholar regards the replica of the figure of Christopher in the Kress Collection at Indiana University as a good sixteenth-century copy (K1106; Cohen 1996, 356); Furlan suggests that the copy could have been made in Pordenone's shop, perhaps by the young Pompeo Amalteo (Furlan 1988, 331).

Provenance: Church of San Marco, before the end of 1515.

Selected References: Ridolfi 1648 (1914 ed.), 117; Altan 1772, 20; De Rinaldis 1798, 27–28; Lanzi 1808 (1970 ed.), 2:58; Di Maniago 1819, 42, 133, 218; Crowe and Cavalcaselle 1871, 2:250–251; Fiocco 1939, 42, 136, 159; Freedberg 1975, 292; Lucco 1975, 22; Cohen 1980, 96–97; Furlan in *Il Pordenone* 1984, 92–93; Furlan 1988, 18–19, 74–78; Pattanaro in *Le Siècle de Titien* 1993, 384–385; Cohen 1996, 87–90, 536–537; Wilson 2001, 78, 93.

9

Palma Vecchio

VIRGIN AND CHILD
WITH SAINTS
GEORGE AND LUCY

c. 1518–1520, oil on canvas
310 × 208 (122 1/16 × 81 7/8)
Church of
Santo Stefano, Vicenza

The altarpiece remains above the altar for which it was painted, that dedicated to the Virgin in the left transept of Santo Stefano in Vicenza. Although the work is not documented, it was almost certainly commissioned by the Vicentine nobleman Girolamo di Giorgio Capra, who owned rights to the chapel.[1] As name saint of the patron's father, George accordingly occupies the position of honor to the Virgin's right. Lucy is identifiable by her attribute of a pair of eyes in a crystal dish, alluding to her readiness to sacrifice her sight and her beauty to Christ.

In terms of its composition, the work remains conservative for a painter of Palma's generation, especially by comparison with the radically experimental contemporary altarpieces by Titian (see page 49, figs. 8, 9, 11). The essential ingredients—the central placing of the Virgin and Child on a tall throne in front of a brocade cloth of honor, the musician angel seated below, the saints arranged symmetrically on either side—were already to be found in the altarpieces of Giovanni Bellini and Antonello da Messina in the 1470s. Furthermore, George in his suit of gleaming armor had already appeared in a similar position in the left foreground in Antonello's San Cassiano altarpiece of 1475 to 1476 (surviving fragment in the Kunsthistorisches Museum, Vienna). Characteristically modern, however, are the greater physical scale of the figures in relation to their surroundings and the latent dynamism of their poses. These effects are further enhanced, as in Pordenone's probably only slightly earlier

Madonna of Mercy (cat. 8), by the asymmetry of the pastoral landscape and by the constantly alternating contrasts of light and shade. An even greater contribution to the visual drama of the image is created by the fragmentation of the foreground draperies into variegated planes of scintillating color.

The painting has usually been seen as a late work by Palma, only shortly predating his early death in July 1528. Rylands has suggested that it was commissioned in 1527, on the grounds that in September of that year Girolamo Capra married Lucia Angaran, and that this event would explain the inclusion of Saint Lucy.[2] This suggestion, however, has been convincingly rejected by Lucco, for reasons both circumstantial (Palma is unlikely to have been able to execute the work in a mere nine months) and stylistic.[3] Lucco argues that the style of the altarpiece is close to that of the *Adoration of the Shepherds* (Musée du Louvre, Paris), datable to about 1518 to 1520, and points to a number of elements that may be related closely to developments in Venetian painting in the phase from about 1505 to 1515. They include the Giorgionesque play of reflections on George's armor; the motif of the sculpted ram's head at the base of the throne, characteristic of the Venetian works of Sebastiano del Piombo; and the wooded and rocky landscape in the right background, evidently inspired by Titian's *Sacrifice of Abraham* woodcut of 1515. To these considerations may be added the fact that the long hair sported by Saint George, so favored by young men in the years around 1510, was no longer fashionable after 1520.[4]

1. Rumor 1907.

2. Rylands 1992, 58–62.

3. Lucco in *Le Ceneri* 2004.

4. A sheet of drapery studies (Gabinetto Nazionale delle Stampe, Rome), executed in black chalk, was recognized by Meijer as preparatory for the sleeves and skirt of Lucy (inv. F. C. 125746; Meijer 1976, 768). A study of a female head (Musée du Louvre, Paris) bears a generic likeness to the head of the saint but, as pointed out by Rylands, is more likely to have been made in preparation for the earlier *Christ and the Adulteress* in the Hermitage, St. Petersburg (no. 482; Rylands 1992, 238–239). The pictorial technique has been analyzed by Avagnina and Girotto in relation to the recent cleaning and conservation of the work (Avagnina and Girotto 1996).

Provenance: Church of Santo Stefano, Vicenza, probably by 1520.

Selected References: Ridolfi 1648 (1914 ed.), 139; Boschini 1676, 66; Bertotti Scamozzi 1761, 117; Baldarini et al. 1761, 122; Tassi 1793, 102; Crowe and Cavalcaselle 1871, 2:469; Morelli 1880, 296–297; Rumor 1907; Venturi 1913, 169–170; Spahn 1932, 74; Suida 1934–1935, 88; Gombosi 1937, xxiii, 96; Robertson 1954, 33, 61; Arslan 1956, 164; Mantese 1964, 947; Mariacher 1968, 63–64; Freedberg 1975, 335; Meijer 1976, 768; Rylands 1992, 58–62, 238–239; Avagnina and Girotto 1996; Lucco in *Le Ceneri* 2004, 114–117.

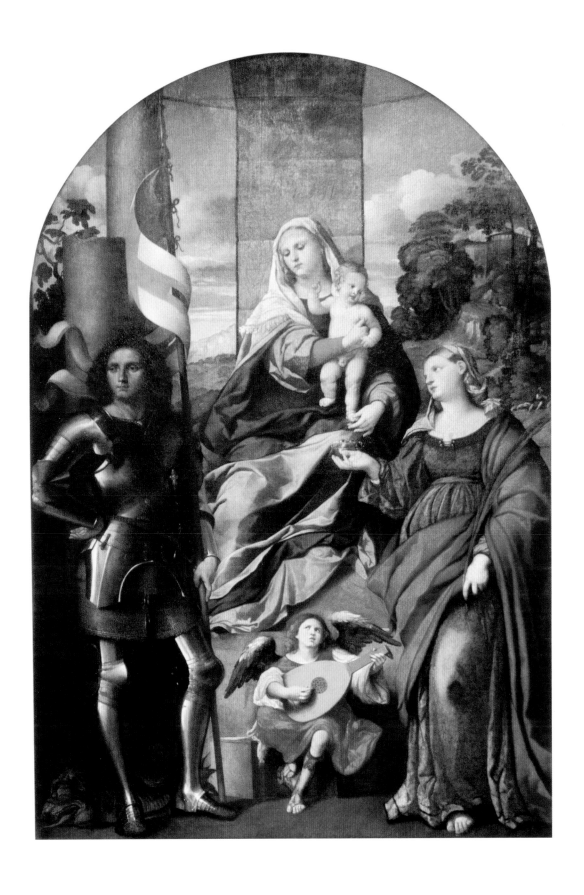

10

Titian

VIRGIN AND CHILD
WITH SAINTS
CATHERINE OF
ALEXANDRIA AND
DOMINIC
AND A DONOR

c. 1513–1514, oil on canvas
137 × 184 (53 15/16 × 72 7/16)
Fondazione
Magnani-Rocca, Parma

Washington only

Catherine, identifiable by her attributes of sword and broken wheel, sits on a fragment of antique architecture on the left; the Dominican saint on the right has no attribute apart from his distinctive black and white habit, and so is probably Dominic himself. The identity of the kneeling donor is not known, but his black toga conforms to the dress code of the Venetian ruling classes. He may have chosen Dominic to intercede for him with the Virgin and Child as his name saint, or perhaps because he had some particular interest in the order.

Although in the past the picture was sometimes placed as late as about 1520, scholars now agree that it dates from the phase of about 1511 to 1515, with some stressing its stylistic relationship with the Padua frescoes of 1511[1] and others seeing it as closer to the slightly later *Noli Me Tangere* (cat. 21) and *Sacred and Profane Love*.[2] The compositional device of bisecting the background into a dark, neutral foil on one side and a bright, luminous landscape and sky on the other was much favored by Titian in this early period; but here he used it most effectively, placing the restrained blacks and whites of Dominic and the donor against the light, and the large planes of intense color in the women's draperies against the dark. And although the various parts are not yet, perhaps, fully coordinated, the composition has a new fluency and the twisting poses of the Virgin and Child have a new classicizing ambition that seem to mark a clear advance on the works of about 1511.[3]

Typologically the picture may be seen as an imaginative hybrid of the Venetian votive tradition, as represented, for example, by Giovanni Bellini's *Virgin and Child with Saints* (cat. 5) of 1505 in Birmingham, and quasi-narrative subjects with landscape settings, such as the Adoration of the Shepherds or the Rest on the Flight into Egypt. As in Bellini's picture, a kneeling donor is presented by his patron saint to a fairly central full-length Virgin and Child. But as well as greatly enhancing the incipient effect of movement in Bellini's composition with much more fervently active poses, Titian abolished the tiled pavement and the Virgin's throne, and had the landscape invade the foreground. In this way, the picture must have served as a major source of inspiration for Palma Vecchio's painting of about 1516 to 1518 in the Thyssen collection (page 63, fig. 8), and for the many other subsequent representations of the Virgin and Child seated with saints in pure landscapes (see cats. 11–13; and pages 62, 63, figs. 6, 8). No less influential on Palma, and no less important for the very different genre of the ideal female beauty, is the figure of Catherine, with her diaphanous veil and her long golden tresses curling sensuously round her bare shoulders.

The first certain record of the picture occurs in 1761, when it was in the Balbi collection in Genoa. By this date it may already have been in the city for a century or more; there is no good reason, however, to suppose that the unknown donor represents a member of the completely unrelated Balbi family of Venice. The figure composition and details of three of the heads are recorded by Van Dyck in his Italian Sketchbook (British Museum, London).[4] Although Van Dyck could have seen the original in either Venice or Genoa, the fact that his sketches are in reverse implies, as pointed out by Wethey,[5] that they were based on a print. This print cannot, however, have been the modest engraving signed by Frans van den Wyngaerde (1614–1679) indicated by Wethey:[6] apart from the fact that Van Dyck's heads are closer to the original than to the engraving, Wyngaerde was still a child when Van Dyck was in Italy, and never went there himself. Presumably, then, both Van Dyck and Wyngaerde were following a print of which no impression survives.

1. Valcanover in *Titian* 1990, 162–164; Lucco 1996–1999, 1:68, 120.

2. Romani in *Le Siècle de Titien* 1993, 360–361; Joannides 2001, 157–159.

3. Joannides 2001, 157–159.

4. Ff. 10v–11, 45v.

5. Wethey 1969, 106.

6. Adam Bartsch, *Le Peintre Graveur*, vol. 16 (Leipzig, 1870), 97–98. An impression in the Albertina, Vienna, is illustrated in Gert Adriani, *Anton Van Dyck. Italienisches Skizzenbuch* (Vienna, 1940), fig. 6.

Provenance: Palazzo Balbi di Piovera, Genoa (by 1761); acquired from the Balbi family by Luigi Magnani, Reggio Emilia, c. 1952.

Selected References: Ratti 1766 (1761 ed.), 167; Alizeri 1847, 75; Crowe and Cavalcaselle 1877, 2:417; Morassi 1946a; Pallucchini 1969, 27–28, 244; Wethey 1969, 106; Freedberg 1975, 146–147; Hope 1980, 34; Valcanover in *Titian* 1990, 162–164; Romani in *Le Siècle de Titien* 1993, 360–361; Lucco 1996–1999, 1:68, 120; Joannides 2001, 157–159; Vittorio Sgarbi in Tosini Pizzetti 2001, 103–105; Campbell and Jaffé in *Titian* 2003, 90–91; Fornari Schianchi 2005.

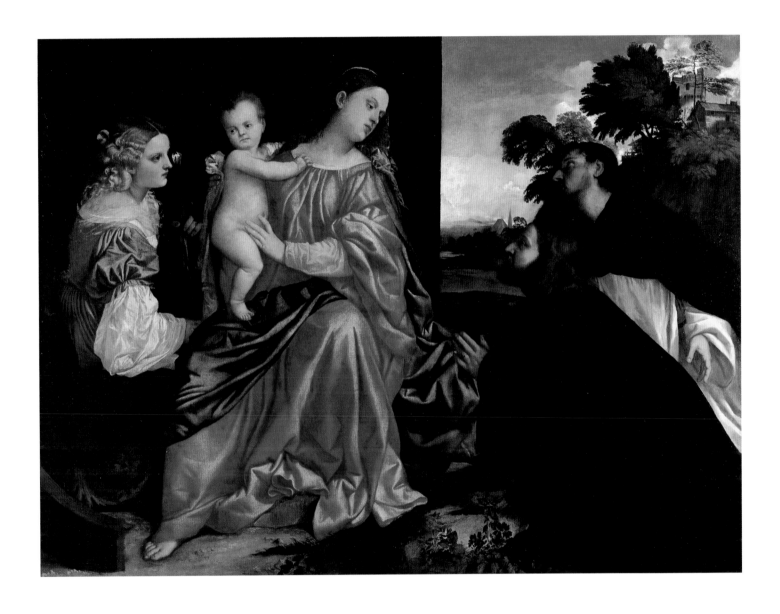

11

Palma Vecchio

VIRGIN AND CHILD
WITH SAINTS JEROME,
JUSTINA, URSULA,
AND BERNARDINO

c. 1526, oil on canvas
90 × 157.5 (35 ½ × 62)
Penrhyn Castle,
The Douglas Pennant
Collection, accepted in lieu
of tax by H. M. Treasury
and transferred
to the National Trust
in 2005

In one of the grandest and most mature of Palma's many variations on the subject, the Virgin and Child are shown seated with Saints Jerome (with his attributes of lion, crucifix, and Bible), Justina (with her martyr's palm and dagger in her chest), Ursula (with her banner and model ship), and Bernardino (with his monogram of the Name of Jesus encircled by golden flames). Unusually, Bernardino's attribute takes the form of a metal plate, which becomes the object of a touching physical and psychological interaction between the saint and the Christ Child. The lush background landscape offers enticing views of hilltop cities, distant mountains, and a coastline, with the white sails of ships on the sea. The vignette on the right with a shepherd and sheep reflects the pastoral inspiration behind this subject.

When in the collection of the king of the Netherlands in the early nineteenth century, the picture was attributed to Palma's great-nephew Palma Giovane, a not uncommon confusion of the period. Although sold to Lord Penrhyn in the 1850s as by Palma Vecchio, it acquired an attribution to the Ferrarese painter Garofalo before the obviously correct attribution to Palma was reaffirmed as late as the 1980s.[1] A copy was recorded in the nineteenth century in the collection of the Marchese Alessandro Pallavicino, Genoa.[2]

Despite the difficulties of dating Palma's works, comparison with the superficially similar *Virgin and Child with Saints* in the Thyssen collection (page 63, fig. 8), usually accepted as dating from the mid-to-late teens,

indicates that the present work must be considerably later. The planar figure composition of the Thyssen picture has become semicircular, the forms have acquired greater weight, shadows are deeper, a more assertive realism is evident in the heads of the male saints, and the patterning of the trees against the sky has become simpler and bolder. Hitherto, the only date for the present picture has been from about 1522 to 1524, but it may be later still: perhaps about 1526, close to the grandiose *Adoration of the Magi* (Pinacoteca di Brera, Milan), documented to 1525/1526, not long before the premature end of Palma's life.[3]

1. Laing 1995, 122–123.

2. Rylands 1992, 203–204.

3. Rylands 1992, 81.

Provenance: Acquired by Prince Willem of Orange (from 1840 King Willem II of the Netherlands), 1838; bought from his heirs by L. J. Nieuwenhuys, 1855, and sold by C. J. Nieuwenhuys to Colonel Hon. Edward Douglas-Pennant (later 1st Baron Penrhyn of Llandegai), Penrhyn Castle; by descent to the late Lady Janet Douglas Pennant.

Selected References: Nieuwenhuys 1843, 206–207; Douglas-Pennant 1902, no. 42; Rylands 1992, 81, 203–204; Laing 1995, 122–123.

12

Bonifacio Veronese
(Bonifacio de' Pitati)

HOLY FAMILY
WITH THE
CHILD BAPTIST
AND TOBIAS
AND THE ANGEL

c. 1527, oil on canvas
116 × 152 (45 11/16 × 59 13/16)
Pinacoteca
Ambrosiana, Milan

Bonifacio's picture provides a perfect illustration of the almost inextricable fusion of image and narrative so often found in Venetian devotional painting of the period. The subject here has sometimes been described as a Rest on the Flight into Egypt; and it is true that several of the essential elements relating to this popular apocryphal story are present: the seated Holy Family; the landscape surroundings; even the child Baptist, who according to some versions of the story met up with the Holy Family as it journeyed to Egypt to escape the wrath of Herod. On the other hand, there is no sign of the usual donkey or other traveling equipment, while the Archangel Raphael and the boy Tobias, with his attributes of a fish and a dog, have nothing to do with the Flight story. On balance, the subject is best interpreted as a timeless gathering of holy figures, like that in Palma's *Virgin and Child with Saints* pictures in the Thyssen collection (page 63, fig. 8) and from Penrhyn (cat. 11), as well as in numerous other examples by Bonifacio. Joseph is by no means an essential participant in such gatherings, and his inclusion here—where he is given the exceptionally privileged task of holding the Christ Child—certainly reflects some special devotion to him on the part of the unknown patron.[1] Similarly, some of the apparently naturalistic details have a symbolic rather than narrative significance. The apple proffered to the Child by the Virgin, for example, alludes to her role as the New Eve, helping to redeem mankind from the sin committed in the Garden of Eden, while the prominent fig tree would have carried a complementary messianic significance.

The work is first recorded in 1607, in a lengthy codicil to the will of Cardinal Federico Borromeo, Archbishop of Milan (1564–1631), in which he itemizes his important collection of sacred pictures: "Another picture by Titian, two braccia high by two and a half wide, showing six figures, including Our Lady, Our Lord in the arms of Joseph, and the Angel with Tobias, in a gilded frame."[2] Although Borromeo's chief interest in his pictures was for their devotional and didactic value, he was also concerned with connoisseurship, and in his act of donation of his collection to the newly founded Ambrosiana museum and library in 1618, he reattributed the work to "Giorgione, Master of Titian."[3] Seven years later, in his guide to the museum he oscillated between the two attributions: "If one looks at the excellence of the design, one would say that it was a work of Giorgione, not Titian; but the power of the color suggests Titian, not Giorgione."[4] Later in the seventeenth century, the picture was given instead to Palma,[5] and it was not until 1880 that it received its present, unanimously accepted attribution to Bonifacio.[6]

Despite the lack of certain dates in Bonifacio's Madonna and saints pictures, there is general agreement among critics that the present work is relatively early, and is datable to the period of the painter's closest artistic relationship with Palma Vecchio in the later 1520s.[7] Comparisons have often also been drawn between the beautiful figure of the angel, with his blonde curls and silhouetted wings, and similar figures in the work of Lotto in these years, as in the *Virgin and Child with Saints* of about 1528 to 1530 in Vienna. Bonifacio is indeed likely to have been inspired by this and similar figures by Lotto, but no relationship is so precise as to establish a definite terminus post quem for the present work. An uncharacteristic

interest in Pordenone is also evident in the quizzically eccentric figure of Joseph, who strongly recalls his counterpart in the former's *Madonna of Mercy* altarpiece of 1515 (cat. 8); while the processional impetus of the child Baptist, the angel, and Tobias unmistakably echoes that of the figures in the right foreground of Titian's *Bacchus and Ariadne* of 1520 to 1523 (page 50, fig. 12).[8]

1. Wilson 2004, 306.

2. "Un altro quadro di Titiano di altezza di due braccia et di lunghezza di due et mezo con sei figure cioè una Nostra donna Nostro Signore in braccio a San Giuseppe e l'Angelo con Tobia con cornice profilate d'oro" (Jones 1993, 41–43, 429).

3. Falchetti 1969, 260, 291; Jones 1993, 41–43, 429.

4. "Se si guarda all'eccellenza del disegno, si direbbe opera di Giorgione, non di Titiano; se ala potenza del colorire, di Titiano, non di Giorgione" (Borromeo 1625, 10–11; Rossi and Rovetta 1997, 55).

5. Santagostino 1671, 73.

6. Morelli 1880, 245.

7. Westphal 1931, 28–31; Simonetti 1986, 97–98; Cottrell 2000, 41–43.

8. Cottrell 2000, 429.

Provenance: Acquired by Cardinal Federico Borromeo, Archbishop of Milan, by 1607, and donated by him to the Ambrosiana, Milan, 1618.

Selected References: Borromeo 1625, 10–11; Santagostino 1671 (1980 ed.), 73; Morelli 1880 (1893 ed.), 245; Westphal 1931, 28–31; Falchetti 1969, 260, 291; Simonetti 1986, 97–98; Dell'Acqua 1992, 309–310; Jones 1993, 52, 230, 338, 349; Rossi and Rovetta 1997, 55; Cottrell 2000, 41–43, 429; Wilson 2004, 306.

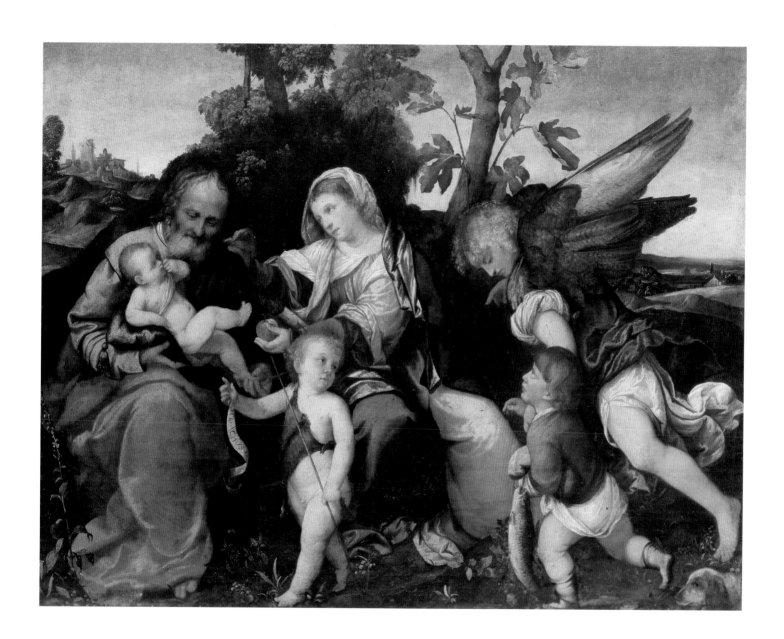

13

Paris Bordone

MYSTIC MARRIAGE OF
SAINT CATHERINE

c. 1524–1527, oil on canvas
149 × 260 (58 11/16 × 102 3/8)
Private Collection

This canvas is the largest and perhaps the finest in a series of variations on the theme of the Virgin and Child with saints in a landscape painted by Paris Bordone in the first decade of his career. On the right, Saint Catherine of Alexandria, with her attribute of a wheel, is encouraged by Joseph to advance towards the Christ Child, who holds out a ring in token of their Mystic Marriage; while on the left, the Virgin lends a guiding hand to the child Baptist, with his attributes of a prophet's scroll, reed cross, and lamb. The picture was presumably painted for a patron with a particular devotion to both Catherine and Joseph, who, in a break from medieval tradition, is shown as young and virile, with a muscular bare leg, instead of as a frail and slightly foolish old man.[1] Despite the anachronistic presence of Catherine, the scene carries strong echoes of the apocryphal Gospel episodes of the Rest on the Flight into Egypt, and of the meeting on the journey between the Holy Family and the child Baptist. In keeping with this iconography is the serenely pastoral landscape, dotted with grazing sheep and goats, and including a picturesque castle. The curtain slung from a rustic pole at the left, while doubling as a casually extemporized cloth of honor, similarly evokes the Rest by suggesting a tent or shelter for the Holy Family.

The picture is not dated, but the poses and proportions of the figures are more self-consciously heroic than in Paris' earliest experiments with this type of subject, such as those formerly in the Barlow collection, London, and in Glasgow, datable to about 1520 to 1522. The active, twisting poses of the Virgin and Child are clearly dependent on their counterparts in recent altarpieces by Paris' master Titian, such as the Ancona altarpiece of 1520 (page 49, fig. 11) and the Ca' Pesaro altarpiece of 1519 to 1526 (page 49, fig. 9). The close stylistic resemblance of the picture to Paris' Manfron altarpiece (Galleria dell'Accademia Tadini, Lovere), datable on external grounds to about 1524 to 1527, confirms the dating suggested by Canova to the same phase of the painter's development.[2] Rearick has pointed out that a drawing of a leg with drapery (Victoria and Albert Museum, London) was used by Paris not just for the figure of Joseph in the present work, but also for his counterpart in an earlier version of the same subject (Hermitage State Museum, St. Petersburg) and for an apostle in the *Pentecost* (Pinacoteca di Brera, Milan), likewise of about 1525 to 1526.[3]

The original canvas, undergoing treatment at the time of writing, has been enlarged by about six centimeters at the right, and by narrower strips at the left and below. An early copy in the Museum of Fine Arts, Boston, shows the composition without these additions.

The picture is probably identical with one recorded in 1648 by Carlo Ridolfi in the collection of Cardinal Leopoldo de' Medici in Florence: "Saint Catherine Martyr being married to Our Lord as a Child, who leaning away from his Mother offers the ring in marriage, while the Virgin takes the little Baptist by the hand. In this work the painter's style approximates that of Palma Vecchio."[4] In that case, the picture is likely to have been acquired for Cardinal Leopoldo, like so many high-quality Venetian pictures, by his agent in Venice from 1640, Paolo del Sera. The picture was certainly acquired by Clemente Doria (1666–1736) from another Genoese collection in 1707,[5] but the circumstances of its presumed passage from Florence to Genoa are unknown.

1. Wilson 2004, 85, 305.

2. Canova 1964, 7, 101.

3. Rearick 1987, 48.

4. "Santa Caterina martire si sposa à Nostro Signore bambino che spiccandosi dalla Madre le porge l'anello per farsela sposa, e San Giovanni pargoletto è preso per mano dalla Vergine, nella qual opera pare che si approssimasse alla maniera del vecchio Palma" (Ridolfi 1648, 233).

5. This information was kindly provided by Piero Boccardo.

Provenance: Probably Cardinal Leopoldo de' Medici, Florence, by 1648; acquired in 1707 by Clemente Doria, Genoa, from another Genoese collection; by descent to the present owner.

Selected References: Ridolfi 1648 (1914 ed.), 233; Alizeri 1847, 442; Morassi 1946, 9; Bonicatti 1964, 250; Canova 1964, 7, 101; Mariani Canova in *Genius of Venice* 1983, 32; Mariani Canova in *Paris Bordon* 1984, 32; Rearick 1987, 48; Wilson 2004, 85, 305.

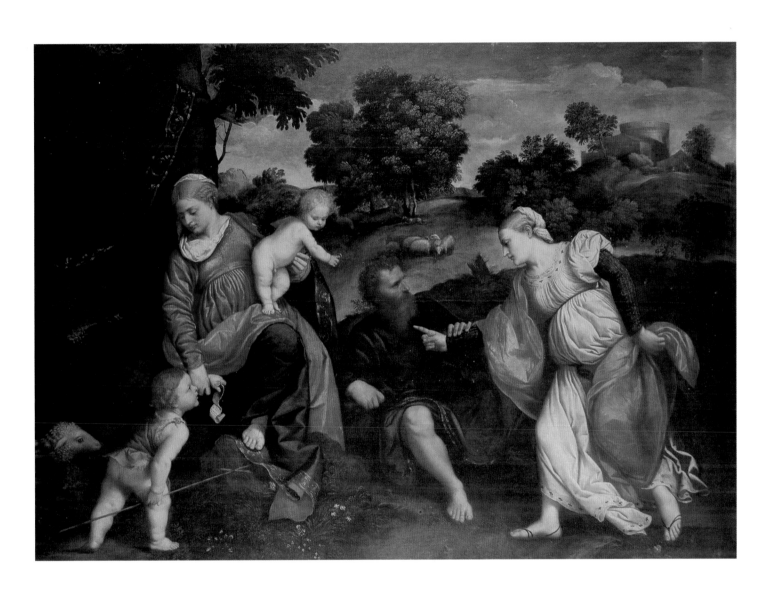

SACRED STORIES * *Mauro Lucco*

IN 1474, THE VENETIAN government decided to commission from the brothers Gentile and Giovanni Bellini a series of paintings on canvas illustrating salient episodes from the myth-entwined history of Venice to replace the fresco decoration of the Hall of the Greater Council in the Doge's Palace. Unfortunately, the newer cycle was destroyed in the fire that badly damaged the palace in 1577, and today the original subjects of the decoration, not specifically religious but intended to communicate the idea of the sacred mission of the Venetian state, can be read only through late sixteenth-century and early seventeenth-century "copies." Alongside this category of state painting, whose main purpose was political propaganda, were history paintings, commissioned by the semipublic charitable organizations called *scuole*. These works usually had as their subjects the life of the *scuola*'s patron saint. The genre had a relatively long tradition, and even though most of these cycles are now lost, we can see vestiges of them in a few canvases and in the works, which happily do survive, of Vittore Carpaccio. We can also observe some general characteristics in this material and compare it to what was produced elsewhere. If in Florence or in Venice's neighbor Padua, for example, the stories from the life of Christ, the Virgin, or the saints were recounted in frescoes arranged in horizontal bands one above the other, the Venetian narrative cycles were painted on canvas and were customarily organized in an unbroken flow on one register. This arrangement meant a drastic reduction in the total number of episodes that could be represented. On the other hand, it allowed a much larger paint surface to be given over to each episode and even the possibility of including several episodes in one picture: for instance, the thirty-three moments into which the history of Venice was divided in the Palazzo Ducale were depicted on twenty-two large canvases.

Moreover, it appears that the Venetian painters concentrated not on the dramatic or psychological core of the story per se but sought to impart a perceptible realism in the costumes and in the places portrayed, as if to verify the "objective truth" of the story itself.

Whether it was fortunate miracles or brutal martyrdoms, transfigured passivity or emotional violence, the scenes were treated by the Venetians as a serene, detached chronicle in which the eye could grasp the immense variety of the world. A good example of this approach to narrative is the *Departure of Saint Ursula* (fig. 1), painted by Carpaccio in 1490 for the Scuola di Sant'Orsola and now in the Gallerie dell'Accademia, Venice. This scene of the engaged couple leaving their parents is recounted as a great civic holiday, with crowds lining the banks of the canal, trumpeters, banners waving in the wind, ships, and beautiful architecture. Deeply loved in Venice, Saint Ursula probably never existed, giving the artist ample freedom to imagine a severe, semi-barbaric England in contrast to the festive, multicolored, civilized Brittany. When the story to be told involved Venice, the painter had less freedom, and little or no freedom at all when the events were more recent, occurring in the city itself and concerning civic matters, as was the case with the *Miracle of the Relic of the True Cross* painted for the Scuola Grande di San Giovanni Evangelista, for the most part between 1494 and 1500.

The decoration of the Scuola Grande di San Marco, though set in the past, also falls into the last category. The cycle had a rather tortured history, due both to the *scuola*'s economic problems and to the death of some of those involved: begun in 1504, it was not finished until 1534. The recounting of the life of Saint Mark the Evangelist, patron saint of the Venetian state, respects all the painting conven-

1.

Vittore Carpaccio,
Departure of Saint Ursula,
Gallerie dell' Accademia,
Venice

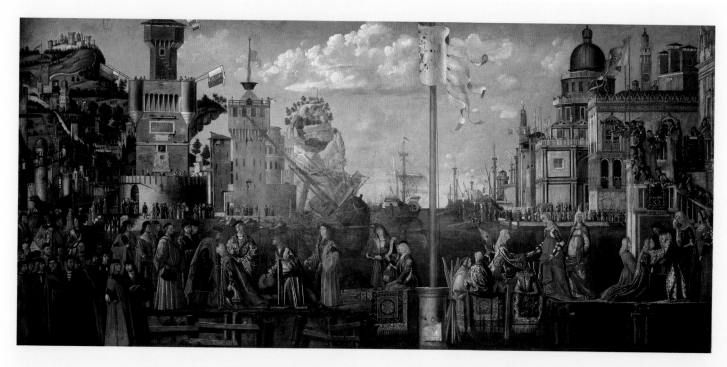

tions used in the Palazzo Ducale to precisely identify places and costumes and offer an "eyewitness" account.[1] Accordingly, first-century Alexandria is recognizable not so much by actual buildings as by its exotic Middle Eastern aspect, by the Egyptian costumes (drawn from Erhard Reeuwich's illustrations to the well-known book by Bernhard von Breydenbach), and by the emphasis on the symbols of the Mamluk dynasty, then reigning in Egypt but nonexistent during the time of Saint Mark.[2] In other words, the current scene was the lens through which a fifteen-hundred-year-old story was read and reconstructed. For the saint's final moments, which took place in Venice, the necessary identification was more easily established by the water, the architecture, the clothing, and the presence of the doge himself.

These criteria, adhered to by artists like Mansueti and Vittore Belliniano in virtually complete isolation from the contemporary style, could be ignored in moments of creative fervor, as, for example, Titian did for his share of the decoration of the Scuola del Santo in Padua, underway from 1508 to about 1520. The miracles of the Franciscan from Portugal who became identified with Padua are illustrated, with one exception, against simple landscape backdrops, suspended in time, and without any relation to places that could easily have been portrayed in recognizable form. In Titian's three frescoes of 1511, the dominant elements are a great craggy rock, a sunset over a distant town, and an ancient building with a statue of Caesar Augustus. The events themselves assume a sort of heroic status above any specific historical

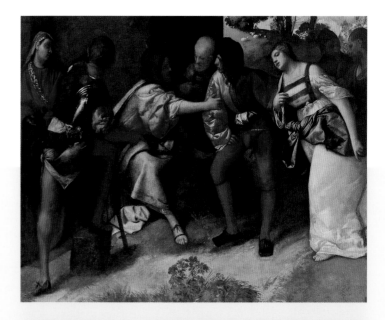

epoch, allowing the figures to be shown in modern dress. Not coincidentally at this time, Titian painted an analogue to the frescoes in his canvas *Christ and the Adulteress* (fig. 2), now in Glasgow. Titian's subject was new, having just been introduced, and it ran its course and was practically abandoned within the space of less than twenty years. His large-scale depiction reinterpreted the Bible story as a current moral conflict, rendering it suitable for a secular setting in a private house rather than a church and opening the way for the *quadri da portego* (hallway pictures), which we shall consider shortly.

The boundary between the iconicity suited to an altarpiece, on the one hand, and narrative, on the other, was often difficult, and in some cases nearly impossible, to define. The representation of certain episodes from the life of Christ, for example, even if destined to go above an altar, could not avoid a certain amount of episodic narrative, as is evident in Giovanni Bellini's *Resurrection*, painted between 1475 and 1479, and now in the Gemäldegalerie, Berlin, and in his *Transfiguration* of 1480 for Vicenza cathedral (Capodimonte, Naples). Similarly, smaller pictures for private devotion could fluctuate between icon and narrative, as in the theme of Christ Blessing. Cima da Conegliano's *Christ among the Scholars* (cat. 16) in the National Museum, Warsaw, is organized, despite the narrative theme, like an iconic, timeless *sacra conversazione* (sacred conversation). Cima's picture differs from the panel of the same subject (page 70, fig. 1) that Dürer painted in Rome in 1506, in which the entire figure composition swirls and gathers like a whirlpool around the dramatic eddy of hands in the center. The theme of Christ Carrying the Cross also lent itself to treatment either as an icon or as a narrative. Appearing first in Milan about 1480, it immediately took on a canonical form all over northern Italy by presenting the figure parallel to the picture plane and seen from the side, when not actually in profile. But in the early years of the second decade of the sixteenth century, Titian transformed the subject in a canvas (fig. 3) for the church of San Rocco (now the Scuola di San Rocco), Venice, showing Christ without the cross, but with an executioner dragging him along by a rope. Here the story acquires a strongly dramatic air, with an unprecedented emotional charge in the contrast between the bestial ferocity and ugliness of the executioner and the innocence and beauty of

2.
———
Titian, *Christ and the Adulteress*, Kelvingrove Museum, Glasgow

3.
———
Titian, *Christ Carrying the Cross*, Scuola di San Rocco, Venice

4.
———
Lorenzo Lotto, *The Penitent Saint Jerome*, The National Brukenthal Museum of Sibiu

the martyred Savior. Lorenzo Lotto reached the apex in the dramatic treatment of this theme, in his painting, signed and dated 1526, now in the Louvre.

The lives of the saints, especially those most distant in time and space, had been narrated against fabulous backdrops and with poetic candor in one of the great "best sellers" in the history of Western culture, the *Golden Legend* by Jacobus de Voragine. Written in the second half of the thirteenth century and circulated widely in manuscript form and in print, the book was at the peak of its popularity about 1500, though soon to be set aside by the more skeptical secular rationalism of the new century. Nonetheless, in paintings for private patrons, the stories of these long-ago saints, so deeply imprinted in the collective imagination, demanded a visual treatment parallel or equivalent to the written narrative, especially if the saint had led his life in nature in an untamed state, as for example with Saint Jerome. In the early fifteenth century, Jerome had usually been represented as a scholar in his study; but starting about 1460, in Giovanni Bellini's painting now in the Barber Institute, Birmingham, he began to be presented as a hermit in the desert. Bellini would go on to paint three other versions of the subject, on vertical panels now in Florence, London, and Washington (cat. 22), showing the saint in a calm and austerely meditative pose. In this case, it was Lorenzo Lotto, rather than Titian, who furnished a more intense version of the saint's penitential mortification, marked by his dramatically unsteady posture, in the artist's painting (fig. 4) of about 1513 in the Brukenthal Museum of Sibiu. With time, the landscape surrounding the saint gained in importance, either in terms of the painting's overall structure, as in Paris Bordone's treatment of the theme dating from about 1525, in the Johnson Collection, Philadelphia, or in effects of luminous

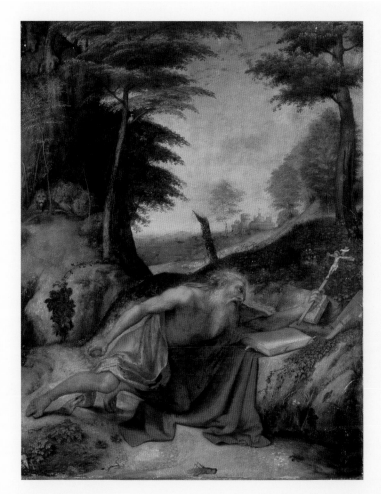

magic, as in Savoldo's canvas of about 1530, in the National Gallery, London, both of which have a horizontal format. Perhaps because of the chance it offered to contrast an inferno with a beautiful landscape, a new category of paintings of fires arose in the early Cinquecento. Horizontal in format, these works, like Savoldo's Anthony Abbot (cat. 23), often associated a saint's trials or temptations, as the work of the devil, with the idea of the flames of hell, following the example of Hieronymus Bosch's bonfires and monsters, which were well known in Venice.

A crucial factor in this new way of viewing the world—a view that brought landscape to the forefront—was the lyric poetry of the time, especially love lyrics, by Serafino Aquilano to Tebaldeo, Poliziano and Pontano to Sannazaro, whose *Arcadia* was published in Venice in 1502, and on to Pietro Bembo's *Gli Asolani* of 1505. In the late fifteenth century, poetry had already taken on a bucolic air in Venice, with the work of Filenio Gallo, Giovanni Badoer, and Pizio da Montevarchi.[3] The enveloping sensuality of this poetry, with a tendency to place love and languor against a background of virginal nature, provided the intellectual instrument for interpreting landscape not in a rational aspect that the viewer could grasp at first glance, but as a pastoral, emphasizing its emotional connotations as a place of refuge and peace. In the Quattrocento, for example, Giovanni Bellini always viewed landscape as anthropocentric, concerned with man's agricultural activities and the economic interdependence of city and countryside, organized into roads and paths, villages and towns.[4] Bellini captured this relationship with detached lucidity in extraordinary works for private devotion, like the *Saint Francis* in the Frick Collection, New York, or the much later *Virgin and Child* (cat. 1) of 1510, in the Brera, Milan. He shows no sign of perceiving the

beauty of nature untamed or untouched by human presence, because, like all men of his time, he was aware of the discomfort and peril lurking in a world that had not been colonized by human labor. For Bellini, the countryside is the obverse of urban space, an appendage to the city. No matter how extraordinarily realistic the details may be, his overall landscape is constructed like a select anthology of elements that he has "learned about" and not "felt."

For Giorgione, on the other hand, the rural poetry of the landscape is, in his earliest work, a prime concern that can even take precedence over a realistic representation and must involve the viewer emotionally. If, as seems probable, the Allendale *Adoration* (cat. 17) in the National Gallery of Art is the painting owned by Vittore Beccaro that whetted Isabella d'Este's collecting appetite in 1510, the term she used to describe it shows that, among connoisseurs, Giorgione's landscapes had taken on a pastoral character, colonizing the territory of the sacred. Without ever having seen the picture, she called it a *nocte* (night scene), evidently indicating a precise category of subject: her agent Taddeo Albano had no doubt about what he had to look for or the result of his search.[5]

As Coletti has suggested, Giorgione cultivated his own special "poetic feeling of distance," and the shepherds in the background of the *Adoration* seem in effect to vibrate and penetrate the airy depths of space. This is a landscape in many ways more "constructed" than Giovanni Bellini's, but rendered visually in a more persuasive, apparently real way, owing to Giorgione's renunciation of symbolic elements, his affectionate dwelling on intensely observed details, and his disregard of the human presence and its "products," first and foremost the town. Giorgione's peacefully bucolic world is a magical dream of escape from daily life, a restful universe in which all stories can be set, whether sacred or profane,

5.
Sebastiano del Piombo,
The Judgment of Solomon,
Kingston Lacy (Wimborne), Bankes collection
(National Trust)

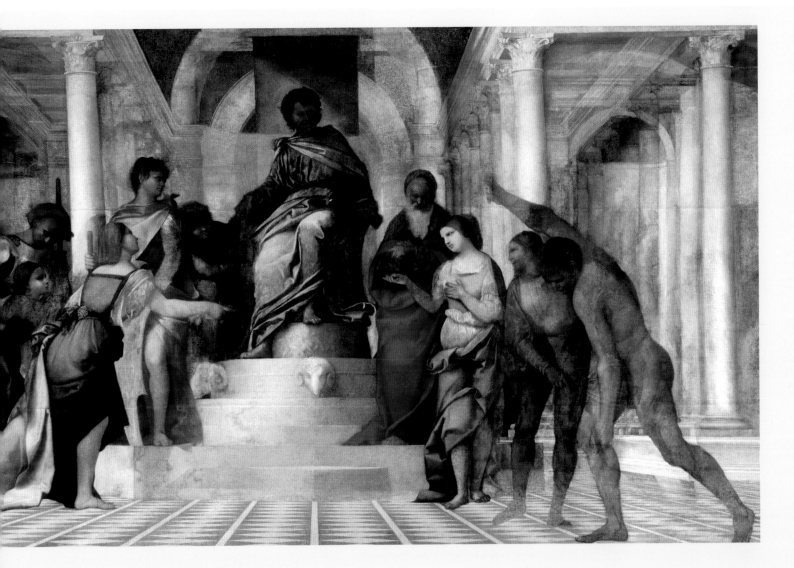

clearly spelled out or mysteriously allusive. For less revolutionary artists, this marvelous backdrop of an archaic, happy age lent itself to the staging of sacred stories; the satyrs and nymphs would come later, in keeping with a vocation for conservatism that was characteristic of Venetian society.

Until the early Cinquecento, paintings for private rooms, whether representing iconic images or narratives, were relatively small; we can gain an idea of them from the pictures of Madonnas hanging on the walls in paintings like Carpaccio's *Arrival of the English Ambassadors* or his *Dream of Saint Ursula* (both, Accademia, Venice). But the taste of that era changed with astonishing speed. At various points in his notes, Marcantonio Michiel explicitly uses the term *tela grande* (large canvas) in opposition to *quadro* (picture) or *quadretto* (little picture).[6] The reasons for this increase in size are probably more social than artistic; the new palace architecture furnished a different kind of space for a display of paintings that was no longer just a private passion but a method for semipublic self-aggrandizement. The large number of small pictures in a *studiolo* (small private study), to which practically no one had access, was now making way for large paintings displayed in parts of the house like the *portego* (large ground-floor hall connecting the water entrance with a door on the land side), which all visitors could enter. In fact, one of the largest canvases in all Venetian painting, Sebastiano del Piombo's *Judgment of Solomon* (fig. 5), now at Kingston Lacy, comes from Palazzo Loredan, where it may have had as its pendant in the same room the *Rest on the Flight into Egypt* (Hermitage, St. Petersburg), which Titian is now widely believed to have painted about 1512.[7] Titian's painting, which is even a few centimeters larger than Sebastiano's, marks a fundamental advance in the affirmation of landscape as the real protagonist of a picture: the Holy Family,

guided by an angel, seems to disappear into the luxuriant vegetation of a prospect in which resting shepherds constitute the only human presence and sheep and other animals live in peace and harmony, as in the mythical Golden Age.

As opposed to public history painting, these new *portego* canvases (a term that should not be taken as indicative of a well-defined artistic category, since it blends and often merges with contemporary *sacre conversazioni*), stress aspects that delight the eye and mind, providing an escape from the everyday, like the invented landscapes in Virgil's *Eclogues* or the *Arcadia*. Also, characters and crowds are significantly thinned out, reduced to two or three protagonists shown larger than life size. A fundamental step in this direction was made by Palma Vecchio, about 1516. Seeking not to dramatize but to clarify the story of Jacob and Rachel in his Dresden canvas (cat. 25), he narrated the biblical tale, depicting only the two protagonists and two secondary figures of shepherds. Palma's shepherds, like those that Giovanni Agostino da Lodi had represented some years earlier in his painting (cat. 20) in Allentown, have nothing to do with the ragged shepherds devastated by hunger and pinched by poverty that Ruzante, more or less in the same years, placed on stage in his visceral anti-Arcadia; Palma's are clearly part of a culture of escape, not of reality. The pastoral landscape always remained close to the heart of Venetians as a "place of delight," but its decline as a background for paintings was rapid.[8] Perhaps owing to the growing importance of the theater, architectural backdrops were chosen more and more frequently, and beginning in the 1540s artists like Paris Bordone called themselves "painters of architecture." Times were changing, and the dream of beauty bringing new life to the world grew dim in an age of conflict.

1. P. Fortini Brown, *Venetian Narrative Painting in the Age of Carpaccio* (New York and London, 1988), especially 60–66, 125–132.

2. Bernhard von Breydenbach, *Opusculum Sanctarum Peregrinationum ad sepulcrum Christi venerandum* (Mainz, 1486).

3. M.A. Grignai, "Badoer, Filenio, Pizio: Un trio bucolico a Venezia," in *Studi di filologia e di letteratura italiana offerti a Carlo Dionisotti* (Milan and Naples, 1973), 77–115; C. Dionisotti, "Giorgione e la letteratura di corte," in *Appunti su arti e lettere* (Milan, 1995), 116.

4. G. Romano, *Studi sul paesaggio* (Turin, 1978), 61–67; P. Camporesti, *Le belle contrade. Nascita del paesaggio italiano* (Milan, 1992), 34–36; G. Folena, *Il linguaggio del Caos. Studi sul plurilinguismo rinascimentale* (Turin, 1991), 275–279.

5. H. Tietze and E. Tietze-Conrat, "The Allendale *Nativity*," *Art Bulletin* 31 (1949), 11–20.

6. M.A. Michiel, *Notizia d'opere del disegno*, C. De Benedictis, ed. (Florence, 2000), 51, 53, 56.

7. We do not know, however, if this was its original provenance, because the palace, designed and built by Mauro Codussi, was only finished in 1509, and the painting appears on stylistic grounds to date a few years earlier. The scene, moreover, is set in an interior, making it, perhaps, an unlikely counterpart to Titian's canvas.

8. R. Cafritz, L. Gowing, D. Rosand, *Places of Delight: The Pastoral Landscape* (Washington, 1988); Holberton 1993, 245–262.

14

Marco Basaiti
CHRIST BLESSING

1517, oil on panel
40 × 34 (15 ¾ × 13 ⅜)
Accademia Carrara,
Bergamo

signed: M.DXVII /
M. BAXAITI. F.

This panel, which represents Christ granting his redeeming grace to the viewer, draws on the iconography of the Salvator Mundi, whose transformations have been ably investigated by Sixten Ringbom.[1] In the climate of the *devotio moderna* (modern piety) that spread throughout northern Europe, the type slowly lost its narrative connotations and became autonomous. A fundamental milestone in this development was undoubtedly a *Holy Face* by Jan van Eyck (lost but known from copies), which finds a parallel in Fra Angelico's extraordinary painting of the same theme in the Museo Fattori in Livorno. Around the middle of the Quattrocento, in the so-called Braque triptych in the Louvre, Rogier van der Weyden showed Christ (surrounded by other figures) blessing with his right hand and holding the globe of the world in his left. Not long after that, about 1475 to 1480, the type of Christ Blessing as an isolated figure was definitively established in a painting by Antonello da Messina in the National Gallery, London, which, if we read its date as 1475, should be understood as probably painted in Venice, and in one by Hans Memling now in the Galleria di Palazzo Bianco, Genoa, replicated by Domenico Ghirlandaio in a work in the Johnson Collection, Philadelphia.[2] From that moment on, the success of the image was ensured, finding fertile ground in northern Italy, above all in the work of Leonardo and his circle in Milan.

Another major turning point in the development of the type occurred when Marchesa Isabella d'Este asked Leonardo, in a letter dated 25 May 1504, to paint her a "Christ as a young boy about twelve years old, which would be his age when he debated in

the temple, and done with the sweetness and gentleness that you have to an excellent degree because of your special skill."[3] If and how Leonardo satisfied the marchesa's desire is unknown, but ideas for this work were circulating in northern Italy, as testified by some paintings that appear to fulfill her wishes and that could therefore derive from a prototype by Leonardo. Basaiti's panel, too, with its sensitivity and soft treatment of color, appears related to Leonardo's ideas, perhaps absorbed through the teachings of Giorgione. The slight inclination of the head, full of pathos, the eyes fixing the viewer as though to establish a dialogue, and the mouth open and perhaps about to speak, as well as the treatment of the pearly background, saturated by shadows, all hark back to Giorgione, to whom Basaiti paid keener attention from 1515 onward. But he did so with a nostalgic eye; the Giorgione who interested him was not the fiery late artist of the *maniera moderna* (modern style), but the still vaguely protoclassical Giorgione of the first five years of the sixteenth century, inspired by Leonardo and intent on experimenting with the representation of light and atmosphere.

The process of idealization to which the figure was subjected, making it more an *Andachtsbild* (painting for private devotion) than an image that synthetically tells a story, does not, however, render it distant and abstract. A sweetness of feeling brings the subject closer to the viewer and makes it more human than the hieratic types of Giovanni Bellini, from which the picture also draws some inspiration. These very characteristics have sparked a marked disparity of opinion among those who see the work as the culmination of Basaiti's

Quattrocento manner and those who view it in the Cinquecento tradition.[4] The comparison made by some scholars, beginning with Bonario, of this painting and the head in the *Risen Christ* in the Pinacoteca Ambrosiana, Milan, demonstrates clearly that the emphasis on volume in the latter differs sharply from the atmospheric softness of the Bergamo panel, which can thus be placed squarely in the Cinquecento.[5]

1. Ringbom 1965, 1984.

2. Previtali 1980, 27–34.

3. "Uno Christo giovenetto de anni circa duodeci, che serie di quella età che l'haveva quando disputò nel tempio, et facto cum quella dolceza et suavità de aiere che aveti per arte peculiare in excellentia." Venturi 1888, 45–46.

4. Morelli 1891; Van Marle 1935.

5. Bonario 1974.

Provenance: The painting came into the Accademia in 1796, a legacy from Count Giacomo Carrara, who had bought it in Milan on 27 September 1791.

Selected References: Crowe and Cavalcaselle 1871, 1:265; Morelli 1890, 370; Morelli 1891, 20; Berenson 1894, 82; Morelli 1897, 288; Crowe and Cavalcaselle 1912, 1:269; Venturi 1915, 619; Berenson 1932, 52; Van Marle 1935, 7:505–506; Berenson 1936, 45; Berenson 1957, 13; Heinemann, 1962, 1:269; Bonario 1974, 39, 121–123; Lucco 1974, 2:96–97; Lucco 1988b, 638; Rossi 1988, 21; Morelli (Anderson ed.) 1991, 299; Lucco 1993, 6–7; Momesso 1997, 30; Lucco 1999, 1268; Paccanelli 1999, 253, 274, 310.

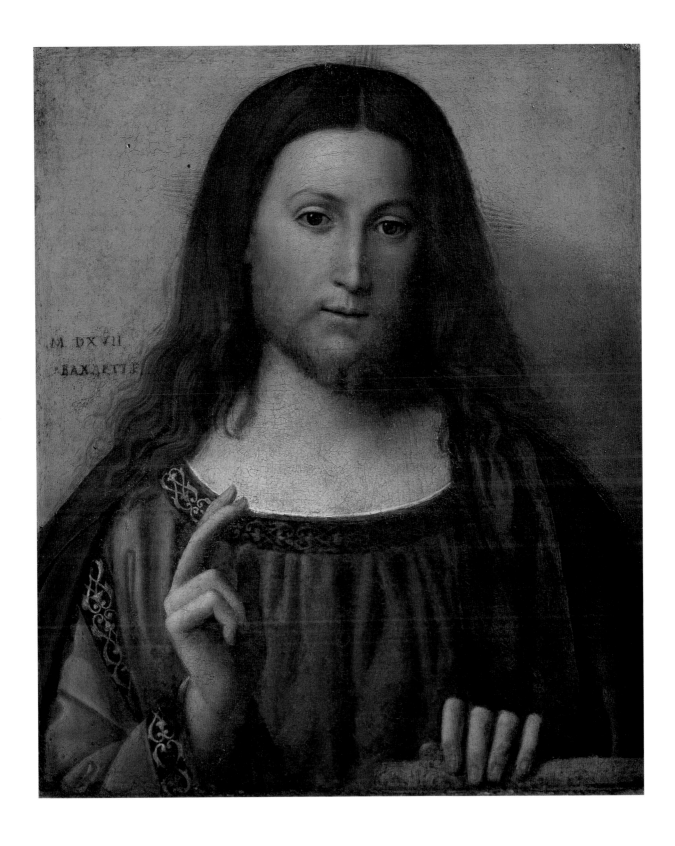

15

Venetian 16th century
(Pordenone?)

CHRIST CARRYING
THE CROSS

c. 1515, oil on panel
63 × 46 (24 ¹³⁄₁₆ × 18 ⅛)
Kunsthistorisches Museum,
Gemäldegalerie, Vienna

This painting, labeled "Venetian School" by the museum, is an attributional conundrum.[1] Carlo Volpe first proposed the authorship of Pordenone, and he dated the panel close to 1515–1516.[2] Volpe's opinion was accepted by Rizzi, by the compiler of this entry, and by Furlan, but not by Cohen, who thought the psychological tone of the painting and its surface and execution were foreign to Pordenone.[3] On the basis of information provided by the museum catalogues, scholars from Volpe to Cohen have claimed that the picture was painted on parchment glued to a wood support, but the recent restoration demonstrates that there is no such element between the paint film and the panel. In favor of an attribution to Pordenone, it should be observed that the face of Christ here resembles those of Saint Roch frescoed on a pillar in Pordenone cathedral, of Saint Roch in the altarpiece in Vallenoncello, of the protagonists in the *Two Saints* in Raleigh, or of Saint John the Baptist in the altarpiece in Susegana — all works belonging to Pordenone's youthful period, between 1513 and about 1515. It remains true, however, that the Vienna picture also seems stylistically in harmony with works by Palma Vecchio, like the *sacra conversazione* in Penrhyn Castle (cat. 11).

By this time, the theme of Christ Carrying the Cross, with the Savior shown as a half-length figure isolated from any narrative context, already had a substantial history and was enjoying extraordinary success all over northern Italy. Appearing for the first time in the area of Milan in the period about 1480 to 1490, the theme was enthusiastically adopted by the circle of Leonardo, who himself experimented with it in the beautiful

drawing of about 1490 in the Accademia, Venice.[4] Gianfrancesco Maineri and especially Andrea Solario produced their own new versions. The theme then spread to the circle of Mantegna in Mantua. Giovanni Bellini and his workshop produced some memorable examples (now in Toledo, Ohio; Boston; and Rovigo), copied by Palmezzano. The young Titian, soon after 1510, expanded the theme to include the narrative dimension, in the canvas now in the Scuola Grande di San Rocco (page 102, fig. 3). And it was further articulated by Sebastiano del Piombo in Rome about or soon after 1515, in his painting now in the Prado, Madrid.

The complex history of this iconographical type lies outside the scope of this entry. Suffice it to say that we would have some difficulty in calling the Vienna panel simply an *Andachtsbild* (a picture for private devotion). In effect, what is innovative about this image — that is, its break with respect to the established way of representing the theme — is the secularization of the subject. Volpe pointed out that the painting is "almost shamelessly beautiful, considerably less pathetic than was traditionally held proper for this subject...more like a fine Roman portrait by someone in Raphael's or Sebastiano del Piombo's circle than any contemporary Venetian version; and it may not seem exaggerated to find it closer, let us say, to *Bindo Altoviti* than to Titian's *Christ Carrying the Cross* in San Rocco, all works done in the same years. Perhaps it was this foreign air...which made the parchment painting in Vienna undecipherable or ambiguous...in the array of Venetian material around 1515."[5]

The viewer's emotional participation in Christ's suffering was an integral part of the history of the theme. Here, conversely, the Savior does not seem to be suffering at all, but appears, in front of one of the gates of Jerusalem, distracted by an observer outside the picture plane, as in the Leonardesque type, elaborated by Giorgione, of the "figure seen from behind."[6] It is as though the viewer has exceeded the limits of his role, disturbing and interrupting a social rite. For this reason, the intense fixity of Christ's eyes trained on the beholder is terrible in a somewhat provocative way, as Furlan has acutely noted.[7] The characterization of the face, the vigorous, elastic pose of the figure, and the athletic body demonstrate unequivocally that the model for this painting was the *Young Man in a Fur Coat* in Munich, which is attributed to Giorgione or Palma but which the compiler believes is by Sebastiano del Piombo, even down to the detail of the visible right hand, which in Munich is holding the sitter's gloves and here rests on the cross.[8] It is on the basis of this portrait type, rather than the figurative tradition of Christ Carrying the Cross, that Pordenone worked out his image, demonstrating yet again the great freedom with which iconographic themes were approached in Venice and on the mainland.

1. The picture traditionally bore an attribution to Correggio. Berenson (1894) first thought it was a work by Cariani; despite the fact that he later changed his mind, this attribution was adopted by Gallina (1954), while Suida (1931) considered the painting to be by Palma Vecchio, connecting it with the *Young Man in a Fur Coat* in the Alte Pinakothek in Munich. His opinion persuaded Berenson (1932), but already Wilde (1933), feeling sure about the strong iconographical tie with the painting in

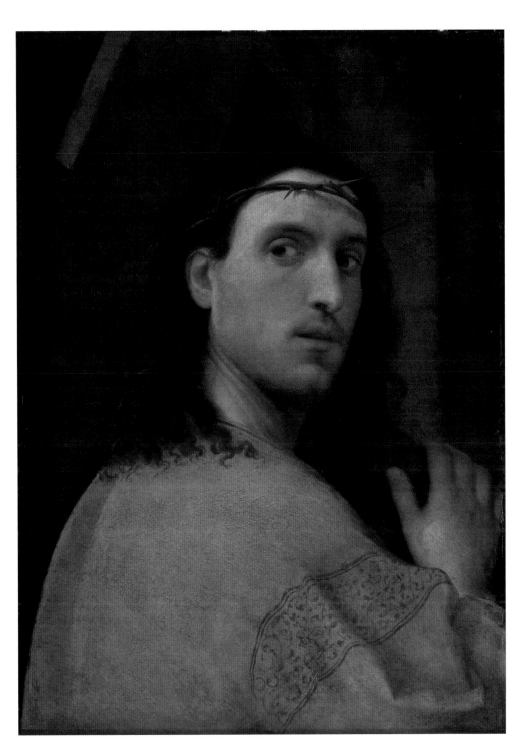

Munich, proposed as its author an anonymous "Master of the Self-Portraits" in the orbit of Domenico Mancini and Palma Vecchio, who would have painted, besides the two works already mentioned, the so-called *Bravo* and the *Man Holding a Lyre*, both also in Vienna. Gombosi (1937) also adhered to this idea, while Heinemann (1962) assigned the painting to the "Master of the Three Ages" in the Pitti, a fictional personality created by Berenson, who in the meantime reabsorbed it into the corpus of Giorgione (1957). However, since the painting could not be clearly assigned to either Palma or Cariani, many scholars have simply called it "Venetian, circa 1515."

2. Volpe 1975.

3. Rizzi 1978; Lucco 1981; Furlan 1988; Cohen 1996.

4. Ringbom 1965 (1983 ed.), 147–155; Brown 1987, 86–88.

5. Volpe 1975.

6. Pedretti 1978, 181–185.

7. Furlan 1988.

8. The x-rays made during the present restoration show that it was a last-minute addition by the artist.

Provenance: The painting came into the Austrian imperial collections in 1785 from the collection of Count Althmann, and from there entered the Kunsthistorisches Museum.

Selected References: Berenson 1894, 95; Suida 1931, 139; Berenson 1932, 411; Wilde 1933, 121; Suida 1934–1937, 92; Berenson 1936, 354; Gombosi 1937, 129; Gallina 1954, 120; Berenson 1957, 126; Baldass 1961, 80; Heinemann 1962, 202; Mariacher 1968, 112; Volpe 1975, 100–103; Lucco 1981, 40; Hörnig 1987, 120–121; Furlan 1988, 63–68; Rylands 1988, 299; *Gemälde-galerie* 1991, 129, pl. 23; Rylands 1992, 312; Lucco 1994, 33; Cohen 1996, 112, 493, 495, 500–501; Lucco 1996, 76, 125.

16

Cima da Conegliano

CHRIST AMONG
THE SCHOLARS

c. 1504, tempera on panel
54.6 × 84.4 (20 ½ × 16 ¼)
Muzeum Narodowe, Warsaw

signed: JOANNES BAPTISTE
CONEGLANĒSIS / OPUS
(cartouche, bottom center)

In 1829, when this painting was purchased by the Counts Potocki, it was claimed for Giovanni Bellini, owing to a repainting of the cartouche with a false signature. Cima's authorship, occasionally affirmed in the past despite the false signature, has, since the 1978 restoration revealed the original inscription, been universally accepted. Much effort has been devoted to establishing the relationship between this painting and one of the same theme (page 70, fig. 1) by Albrecht Dürer now in the Thyssen collection in Madrid, a work that, according to the inscription on the cartouche, was finished in five days in 1506. Since this date places Dürer's painting squarely within the period of his stay in Venice, many scholars, including Berenson, Pallucchini, Ringbom, and Anzelewsky, have maintained that it preceded Cima's and was its direct source. Others, from Wölfflin to Panofsky, Bialostocki, Coletti, Menegazzi, and Humfrey, believe, on the contrary, that Cima painted his panel about 1504 and that Dürer borrowed from him. Though this vexed question of the relationship between Cima and Dürer is often described as still open or is resolved by reference to a hypothetical shared prototype by Giovanni Bellini, the problem has effectively been closed since the publication by Arnolds of some early copies of Dürer's painting, which state that it was made in Rome ("Romae").[1] Traces of the letters making up this word are still legible in the Thyssen picture. Therefore, if Dürer painted his picture in Rome, having come there from

Venice, he could very well have known the panel now in Warsaw, whereas Cima never went to the Eternal City. Furthermore, the suggestion of a possible Bellini prototype has been seriously weakened by Humfrey's publication of another, smaller version of the Warsaw painting that belonged to the Venetian Francesco Algarotti, in whose 1776 inventory it was listed with the name of Cima da Conegliano.[2] Another hypothesis pointing to the existence of a prototype by Leonardo of 1504, supposedly reflected by a painting by Luini in the National Gallery, London, likewise has no basis in fact, and "there seems no reason, according to Humfrey, to assume any dependence by Cima on Leonardo."[3]

With Bellini and Leonardo eliminated, there can be no reasonable doubt that the proper derivation is Dürer from Cima, not Cima from Dürer. As many scholars, beginning with Ringbom, have noted, Cima must have followed the Venetian tradition of the devotional narrative picture with half-length figures, such as the now lost *Presentation in the Temple* by Giovanni Bellini, which is known from some thirty or so copies or derivations.[4] Ringbom indicated that the Warsaw painting had no specific precedent in Italian painting, thus bestowing on Cima the merit for having initiated a new iconographical type.[5] In reality, there are a few earlier representations of Christ among the Scholars in northern Italy, from the fresco by Giusto de' Menabuoi in the Baptistery in Padua to a small panel by Butinone (National Gallery of Scotland, Edinburgh), painted soon after 1480. Cima's innovation lies in having detached the theme from the

narrative context of stories from the life of the Virgin Mary or of Christ, as in Giusto or Butinone. He gave the subject an autonomous dignity and, eliminating its narrative characteristics, charged it with symbolic meaning.[6]

Specifically, the artist did away with the figures of Mary and Joseph — who, anxiously searching for their lost twelve-year-old son, are key protagonists of the story (Luke 2:41–50) — in order to focus instead on the theological discussion. The adolescent Christ is shown in the typical pose of enumerating his arguments with the *computus digitalis* (counting off on his fingers) characteristic of medieval Scholastics. Cima also lent special emphasis to Christ, who, even though physically smaller than the other participants in the scene, is seated on a high stool, so as to attract their gaze. In this way Christ constitutes the unmistakable focal point of the composition. Conveyed by gestures laden with meaning, the true subject of the picture is thus the revelation of Divine Knowledge through the human nature of Christ, who presents himself as the beginning and end of history, the Alpha and Omega. There is a clear opposition, for example, between the figures on the far left and right. The left-hand figure, dressed as a Hebrew, seems to rip out sections of the book of the law placed on his lap and should thus be recognized as standing for the Old Testament, which was superseded by the coming of Christ. The figure on the right, with bared head (contravening Jewish custom) and a cope, symbolizes the New

Testament. That the Christian message is valid for all mankind is shown by the variety of costumes worn by the other figures surrounding Christ, including the one on the right whose head is covered by a Muslim turban and the other bearded man on the left with a yellow veil over his head, who should be understood as representing a Hebrew scholar. Given the opportunity to observe visitors in Venice from the Near and Far East, it is likely that Cima's contemporaries could quite easily have identified the headgear.[7] Although Cima's subject is apparently that of a narrative painting, in reality his picture is constructed as an ensemble of iconic symbols; decoding their interrelated meanings presupposes some involvement and background knowledge on the part of the observer.[8]

1. Arnolds 1959.

2. Humfrey 1986.

3. Thausing 1876, 265; Clark 1958 ed., 118; Ringbom 1965, 183–184; and Humfrey 1983, 165.

4. Ringbom 1965.

5. Ringbom 1965, 185.

6. Ziemba 2004, 80–81.

7. Fortini Brown 1988.

8. Eva Manikowska in a detailed iconological analysis of the painting (1999) has noted that on the right and the left, half-hidden by the other figures, are two heads wearing laurel crowns, indicating that they are poets; the one on the right, because of his aquiline nose and headgear typical of the popular image of Dante, would be the great Florentine poet, while the other figure, on the left, would be Virgil, usually associated with Dante and with him a major protagonist of *The Divine Comedy*. These two presences, in light of the integration between poetry

and theology widespread in Quattrocento thought, further reinforce the reading of the picture as a contrast between the Old and New Testaments. Nevertheless, these two heads, though they appear also in the other version of the painting published by Humfrey (1986), do not seem stylistically consistent with the rest of the painting and are painted on top of the black background. They are completely invisible in the x-radiographs of the painting made for the 1999 exhibition and they appear to the author to be later additions to Cima's work.

Provenance: Purchased in Venice by Counts Artur and Zofia Potocki of Krzeszowice from the painter Natale Schiavoni in 1829; taken in 1830 to the Baranami Palace, near Krakow; in 1946 by the Polish Public Security Services and given to the National Museum in Warsaw.

Selected References: Fiocco 1947, 277; Białostocki 1952, 10–15; Białostocki and Walicki 1955, no. 76; Berenson 1957, 68; Arnolds 1959, 187–190; Białostocki 1959, 27–34; Coletti 1959, 42, 50, 85; Levey 1961, 512–513; *Cima* 1962, 46–47; Heinemann 1962, 318; Pallucchini 1962, 226; Marini 1963, 158; Ringbom 1965, 184–185, 187–188, 190; Winzinger 1966, 283–287; Anzelewsky 1971, 202–205; Białostocki and Skubiszewska 1979, 59–61; Menegazzi 1981, 44–45, 119; Humfrey 1983, 164–165; Ringbom 1984, 183–188; Humfrey 1986, 154–155; Boesten Stengel 1990, 54; Sponza 1994, 130–136; Heimbürger 1999, 28; Martin and Manikowska 1999, 294–295; *Serenissima* 1999, 118–129; Kilian 2004, 92–93; Ziemba 2004, 80–81.

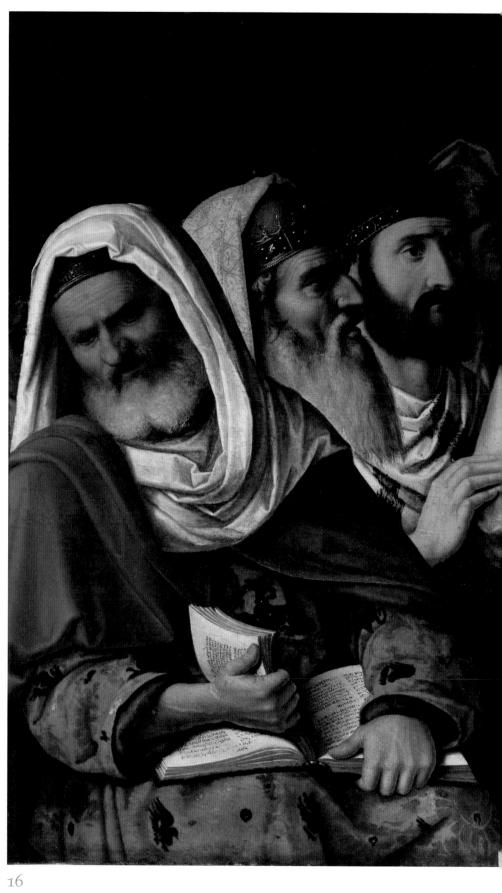

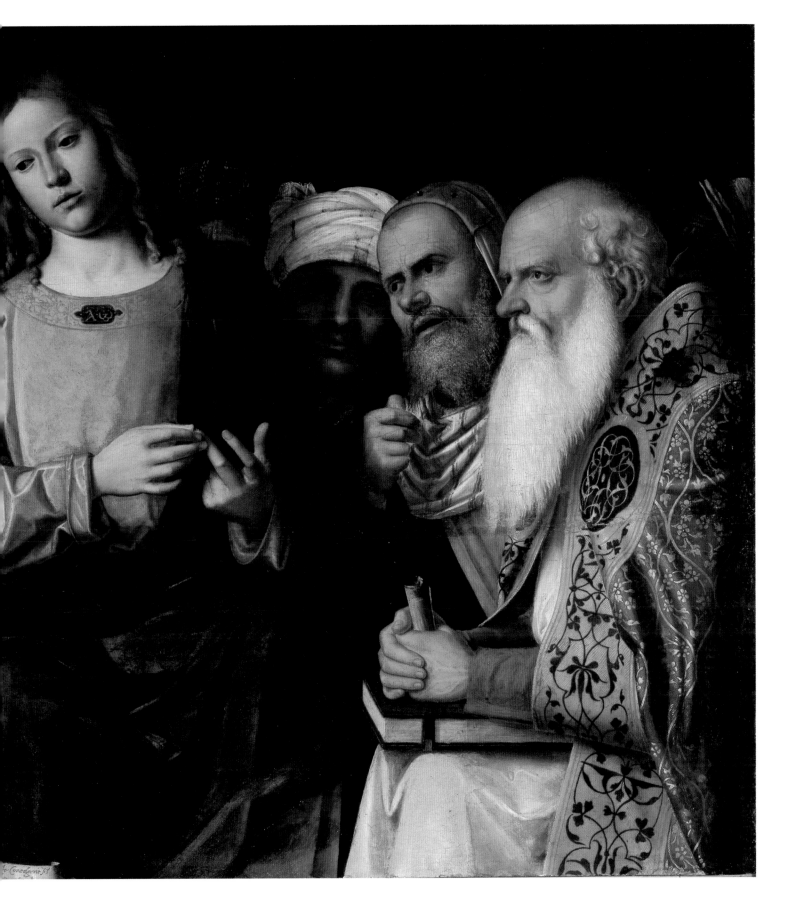

Giorgione

ADORATION
OF THE SHEPHERDS
("ALLENDALE
NATIVITY")

c. 1500, oil on panel
90.8 × 110.5 (35 ¾ × 43 ½)
National Gallery
of Art, Washington,
Samuel H.
Kress Collection

The majority of scholars, with an accord that today approaches unanimity, have assigned this painting to Giorgione, usually at a fairly early date in his short career, around or immediately after 1500.[1] Naturally, this attribution would take on greater weight if it could be proven that this panel is the painting referred to in a letter by Taddeo Albano, dated 8 November 1510, in response to one from Isabella d'Este of 25 October.[2] Isabella, having heard the news of Giorgione's death, expressed to Albano her wish to own "a picture of a night, very beautiful and unusual," which, it appeared, was "among the belongings and estate of the painter Giorgio of Castelfranco."[3] Albano, after verifying the matter, answered that, in fact, this painting was not among the items left by the artist, but that he had painted two *nocti* (nights), one for Taddeo Contarini that "is not very well-finished" (*non è molto perfecta*) and another for Vittore Beccaro, "of better design and better finished than Contarini's," but that neither of them was for sale at any price.[4] Since there exists another version of the painting discussed here in the Kunsthistorisches Museum, Vienna (cat. 18), which is not completely finished—the only such case in Giorgione's *oeuvre*—the identification of the Washington panel as the one painted for Vittore Beccaro has seemed distinctly plausible to some scholars.[5] The Venetian provenance of the Vienna picture, registered in the 1636 inventory of Bartolomeo della Nave's collection, relatively close to the date of Albano's letter, is another element in favor of this theory.[6]

There is, therefore, much to recommend the hypothesis identifying the Washington painting with the one made for Vittore Beccaro, the more finished of the two, although conclusive proof is lacking. Less likely is the identification of the panel with "a picture of a crèche by the hand of Giorgio of Castelfranco" belonging to the heirs of Antonio Grimani and evaluated by Paris Bordone, in connection with the Grimani inheritance, on 15 July 1553.[7] In effect, it is only the subject that suggests the picture. Anderson maintains, moreover, that the citation refers to Giorgione's *Holy Family*, now also in the National Gallery of Art, Washington. Similarly, it is impossible to be sure about the proposed identification with a "Madonna with the shepherds coming to worship, by Giorgione," recorded in the inventory of the paintings belonging to James II of England in the latter half of the seventeenth century.[8]

A comparison of the scientific analysis of the Washington painting, made during its conservation treatment by David Bull in 1990–1991, with that of the version in Vienna also seems to support the Beccaro hypothesis.[9] Everything in the Vienna painting points to a certain simplification of the one in Washington, which must be acknowledged therefore as having been created first; in the same vein, it seems logical to think that Vittore Beccaro's picture, "of better design and better finished," was the prototype for the "not very well finished" replica made for Taddeo Contarini. Anderson's observations, made on the basis of Bull's analyses and those by Jill Dunkerton, indicate that the painting technique in the Washington

panel is the same as that used for the *Tempest* in Venice; once this connection is accepted, the attribution to Giorgione in his early phase seems beyond dispute. Pignatti's observation that this landscape inspired the one in Lorenzo Lotto's Asolo altarpiece, signed and dated 1506, helps to support the early date for the Washington painting.[10]

The Birth of Christ—including its variant, the Adoration of the Shepherds—is one of the most common iconographical themes for altarpieces throughout the Italian Quattrocento. Its representation generally involves an enclosed space just beyond the figures or a stable, with a very small section of landscape. In contrast to the splendid Adoration of the Magi, where luxurious costumes and exotic animals are displayed, the Adoration of the Shepherds represents a more intimate, meditative moment, with a simple, familiar grace, rooted in the life of the poor. In the earlier Venetian tradition, the terrain for this theme was exclusively the "public" sphere of polyptychs or predellas. Giorgione's first great innovation is to have transformed a subject widely identified with a specific category of painting, with its own rules, into one suitable for a picture for domestic devotion. The relatively small size of the panel ensures that it was never placed above an altar. Equally important, the subject chosen was only the pretext for a completely new narrative treatment: the rustic log hut is here replaced by a cave, where the heads of the ox and the ass are barely visible in the darkness. Beyond the cave lies

a vast landscape, rich in fantastic details, whose distance in time and space from the everyday life of a city renders it full of charm—a place of dreams. Vegetation of every sort, a succession of inlets alongside a river, a mill, a little cascade of crystalline, transparent water, the shepherds, the low rays of the setting sun on a tower, the fire flickering in a courtyard, and the sky lit with a yellowish effect are fundamental to how we experience the narrative. These elements are the fruit of literary suggestion. They derive from the long line of poems exalting the beauty of nature and the pastoral world, from works by Filenio Gallo and Giovanni Badoer to Pizio da Montevarchi, from the *Hypnerotomachia Poliphili* to Sannazaro's *Arcadia*, which came out in Venice in 1502 in an unauthorized edition (a sign that it had long circulated in manuscript form).[11] And yet, the rusticity of this pastoral life is completely fictional and is, in fact, its opposite, the product of cultural sophistication. What could appear in some way as naive in the execution of the work is the fruit of this sophistication. No other Italian painting of the early Cinquecento can boast such a vast and varied representation of nature, which is no longer just a background for the figures but a *locus amoenus* whose enveloping beauty and serenity also help to define the emotions of the Holy Family and the shepherds.

In order to make room for the new protagonist of the picture—nature—Giorgione adopted another idea revolutionary for his time: setting aside the fifteenth-century concept of hierarchy, he moved the narrative core

of the image all the way to the right. Never before have we seen the story's main character, the Christ Child, shifted from the place assigned him by the norms of decorum, that is, the center of the composition. In a highly meaningful inversion, the center is occupied by the shepherds, with the result that the least dignified supporting actors have been given the leading role, just as happened in the pastoral literature of the time. This literary background, in which the knowledge and choices of the artist himself come into play and not just those of a patron who asks an artisan to give them expression, reveals clearly that the shepherds represent persons for whom grace, cultivated manners, gentility of mind, and elegance of stance are a natural habit—they become princes in shepherds' garb. On no common mortal would clothes and hair fall in such soft, slow curves.

———

1. Considering this panel to be part of a group that also includes the so-called Benson *Holy Family* in the National Gallery of Art, Washington, and the *Adoration of the Shepherds* by Vincenzo Catena in The Metropolitan Museum of Art, New York (cat. 19), Morelli (1880), Lionello Venturi (1913), and Gronau (1908) attributed it to Catena. Berenson (1894) at first agreed, then later changed his mind, leaving the attribution unsettled. In the early 1930s, he felt that it was a very early work by Titian, still closely bound to the workshop of Giorgione, which, twenty years before he published the view in 1957, led to the rupture of his long-standing association with Joseph Duveen. In the meantime, Phillips (1909) coined the name of "Master of the Allendale Nativity,"

later adopting in 1937 the idea that the painting was really by Giorgione (the landscape) and a painter trained by Bellini (the figures). The hypothesis of Gronau (1921) and Richter (1937), followed by the Tietzes (1944, 1949) and more recently Heinemann (1962) and Gibbons (1978), that the painting was made in the workshop of Giovanni Bellini by one or more students of the master, was relatively short-lived. Berenson's idea of a very young Titian making his debut, following a landscape scheme that is still Giorgionesque, became with Shapley (1955, 1979) that of a late painting by Giorgione, finished and transformed by Titian. The attribution to Titian still seems to have a following in the United States, having long been reiterated and defended by Freedberg (1971, 1975, 1988) and Rearick (1979), with the support also of Sir Ellis Waterhouse (1974).

2. Luzio 1888.

3. "Una pictura de una nocte, molto bella et singulare in le cose et heredità de Zorzo da Castelfrancho pictore."

4. "È de meglior desegnio et meglio finitta che non è quella del Contarini."

5. Pignatti 1969, 1971; Anderson 1996, 2004; Pignatti-Pedrocco 1999; Lucco 1995.

6. Richter warned in 1937 that *nocte* should be understood not in the sense of a nocturne but of a "holy night," or "Christmas eve," and he also pointed out that the painting in Vienna is described in Leopold Wilhelm's inventory in Brussels of 1659 as a *Nachtstuckh* (night piece), in other words, a Nativity. Tietze and Tietze-Conrat (1949) objected that in the early sixteenth century the term *nocte* did not yet indicate a Nativity. No nocturne can be found in painting before our picture, though Giorgione, toward the end of his life, painted at least one, *Orpheus by Moonlight,* known from a small painting on copper by David Teniers, formerly in the Suida-Manning collection in New

York, and by an engraving by Lucas Vosterman in the *Theatrum Pictorium* (1659). Another such nocturne, a "Saint Jerome nude, seated in a desert by moonlight… portrayed on canvas by Giorgio of Castelfranco," is cited in 1532 by Marcantonio Michiel in the house of Andrea Odoni, but this painting, too, has been lost.

7. "Uno quadro de uno prexepio de man de Zorzi da Castel Francho."

8. Richter 1937.

9. Anderson 1997; Dunkerton 2002; Anderson 2004a. Along the left side of the Vienna painting, for example, a tree with a fuller, rounded crown of foliage, identical in shape to the one in Washington, has been painted over and replaced with two slender saplings. Other minor details of the painting also differ: in Vienna, for example, the standing figure originally planned for the center of the panel in Washington is missing.

10. Pignatti 1969, 1978.

11. Dionisotti 1987, 15.

Provenance: Collection of Cardinal Fesch in Rome, by 1841; sold 1845 to Claudius Tarral, Paris; Thomas Wentworth Beaumont, Yorkshire, in 1847; by descent to Wentworth Blackett Beaumont, the first Lord Allendale; bought by Duveen in 1937. Sold 1938 to Samuel H. Kress; 1939 by gift to National Gallery of Art.

Selected References: Berenson 1894, 103; Cook 1900, 20–25, 53, 128; Gronau 1908, 508; Justi 1908, 118–125; Phillips 1909, 331–337; Venturi 1913, 230, 383–384; Phillips 1937, 5, 37–42, 113; Richter 1937, 256–258; Tietze-Conrat 1944, 175–176; Tietze and Tietze-Conrat 1949, 11–20; Shapley 1955, 383–390; Berenson 1957, 85; Heinemann 1962, 25; Pignatti 1969, 98; Freedberg 1971, 87, 100; Waterhouse 1974, 13–15; Wilde 1974, 89–93; Tschmelitsch 1975, 87–94; Gibbons 1978, 23–34; Mucchi 1978, 30–31; Shapley 1979, 208–211; Hörnig 1987, 191–193; Freedberg 1988, 153; Rearick 1992, 139–141; Rosand 1992, 164–165; Freedberg 1993, 51–71; Perissa Torrini 1993, 32–35; Freedberg 1994, 324, 327–332; Lucco 1995, 18, 20, 58–63; Anderson 1997, 109–114, 294–295; Heimbürger 1999, 75–78; Pignatti-Pedrocco 1999, 50–51, 116–119, 192; Dunkerton 2002, 138–143; Anderson 2004a, 173–175; Brown 2004, 170–172.

17

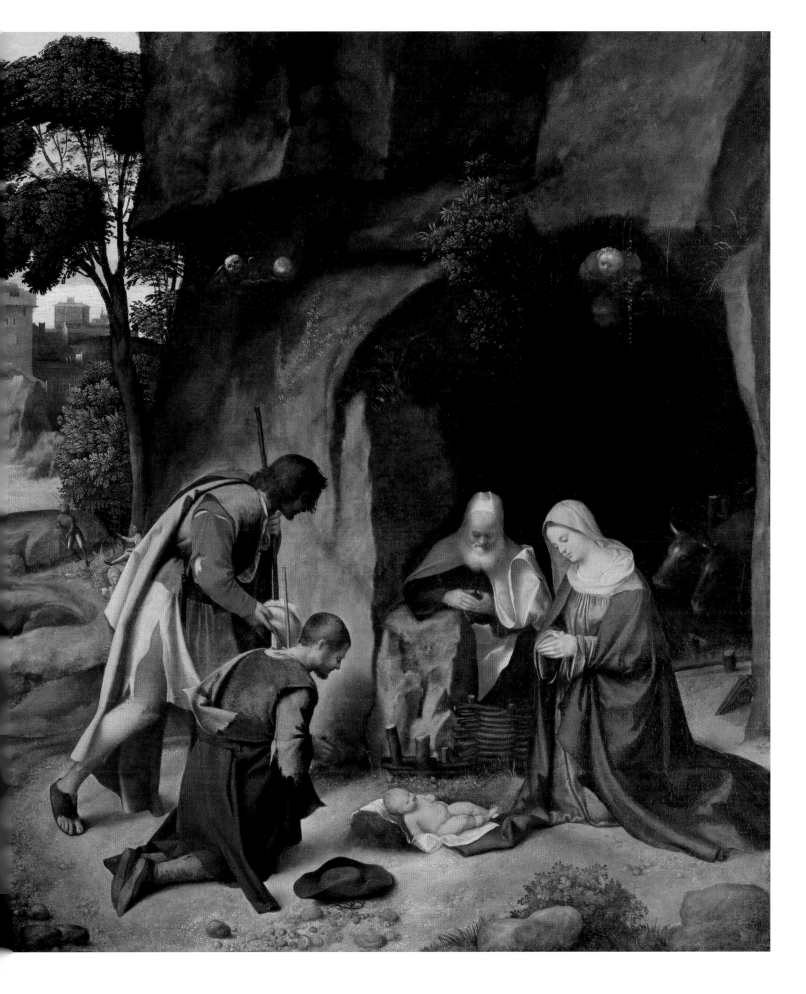

18

Giorgione (?)

ADORATION
OF THE SHEPHERDS

c. 1505–1510 or later,
oil on panel
92 × 115 (36 ¼ × 45 ¼)
Kunsthistorisches Museum,
Gemäldegalerie, Vienna

•

Vienna only

As early as 1932, Berenson proposed that this version of the so-called *Allendale Nativity* (cat. 17) was a copy after the young Titian, to whom he ascribed the Washington picture.[1] Given the generally credited attribution of the *Allendale Nativity* to Giorgione and the known relationship between Giorgione and Titian, the hypothesis that the Vienna version was a copy after Giorgione by Titian met with considerable success.[2] An alternate idea that the Vienna picture was a copy of the one in Washington made by someone other than Titian has also found wide support. Subsequently changing his mind, for example, Berenson spoke of a "Flemish" copy of the ex-Allendale painting, while Tietze and Tietze-Conrat, Della Pergola, Pallucchini, Wethey, and the compiler of this entry are all on record that the Vienna picture is a copy, pure and simple.[3] The fact that this painting is unfinished has led Anderson to see it as the panel belonging to Taddeo Contarini mentioned in Taddeo Albano's letter to Isabella d'Este of 8 November 1510, as "not very well-finished" (*non è molto perfecta*).

The general relationship between the Washington and Vienna paintings is easy to ascertain: the latter is indeed a copy of the former, though a somewhat unusual one. As was explained in the preceding entry, the panel in Vienna borrows from the one in Washington even those details which in that work were more fully worked out. After taking over the composition, the author of the Vienna version then went on to rework it, as in the case of the tree with a rounded top on the left, which has been transformed

in the copy into two slender, insubstantial saplings. Thus, there can be no doubt that the Vienna version comes *after* the Washington one and imitates it, though it has been difficult up to now to establish how much time separates the two. Scientific analysis carried out in connection with the Giorgione exhibition in Vienna in 2004 suggested to Anderson, however, that the manner of execution was precisely the same as in the Allendale painting and in Giorgione's *Adoration of the Magi* in the National Gallery, London, and that the same hand painted all three.[4] If the works do, in fact, share the same technique, the relative agreement on the name of Giorgione for the panels in Washington and London would also make this attribution relevant to the one in Vienna. The marked difference in surface and the apparently lower quality of the painting in Vienna would thus be due to the fact that it is only the skeleton of a painting, a basic sketch that still required extensive work in order to reach a final state. The interpretation of the work as a deliberately darker expression, closer to the idea of a *nocte,* would also appear to have no sound basis. Rather, the dark chromatic base would have enabled the artist to render atmospheric effects more successfully. The recently gathered technical information has been taken to support the identification of the Vienna painting as the one, "not very well-finished," in the possession of Taddeo Contarini in 1510. Indeed, Anderson posits that Contarini may have bought it from Giorgione's workshop, where it had remained unfinished for reasons we do not know, immediately after the death of the master and several days before Isabella d'Este's request to purchase it.[5]

1. Berenson 1932, 576.

2. Baldass 1957, 109; Baldass and Heinz 1965; Pignatti 1969a, 137, and Pignatti 1978, 143; Pignatti-Pedrocco 1999.

3. Berenson 1957, 109.

4. Anderson 2004a, 173–175.

5. Anderson 2004a, 173.

Provenance: Collection of Bartolomeo della Nave, Venice. Sold 1636, to Sir Basil Fielding; Joint property of Fielding and the Duke of Hamilton until 1649; Archduke Leopold William 1659 as a *Nachtstuckh* (night piece) by Giorgione, and from there it came into the Kunsthistorisches Museum in Vienna.

Selected References: Cook 1900, 21, 24–25, 122, 125; Crowe and Cavalcaselle (Borenius ed.) 1912, 3:20; Borenius 1913, 173–174; Venturi 1913, 230; Holmes 1923, 230; Berenson 1932, 576; Berenson 1936, 495; Richter 1937, 257; Fiocco 1941, 18–19; Morassi 1942, 69; Tietze and Tietze-Conrat 1949, 13; Coletti 1955, 64; Pallucchini 1955, 5; Zampetti 1955a, 18–20; Baldass 1957, 109; Berenson 1957, 85; Della Pergola 1957, 29; Baldass and Heinz 1965, 118, 120, 175; Zampetti 1968, 88–89; Pallucchini 1969, 5; Pignatti 1969a, 137; Wethey 1969, 168; Pignatti 1978, 143; Anderson 1979, 83–90; Perissa Torrini 1993, 118; Lucco 1995, 152; Anderson 1996, 295–296; Pignatti-Pedrocco 1999, 210–211; Anderson 2004a, 173–175.

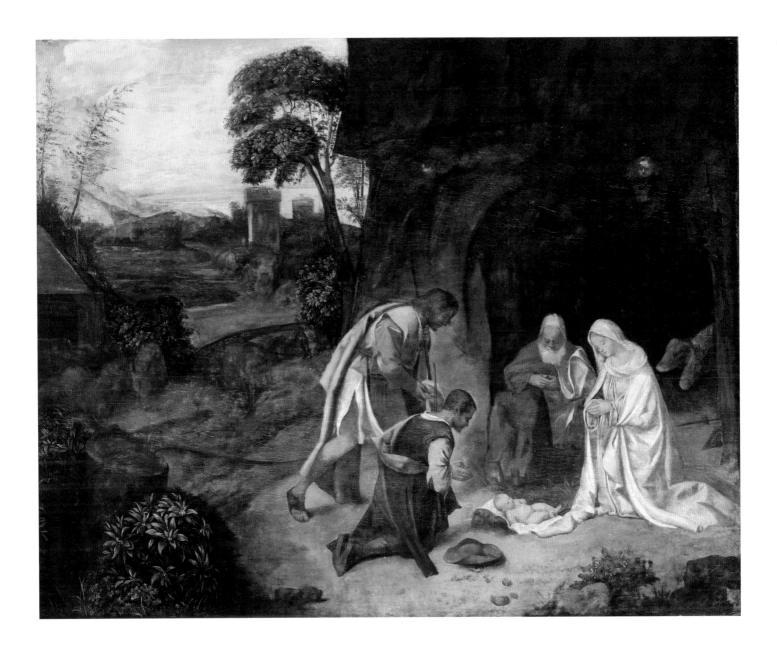

19

Vincenzo Catena

ADORATION
OF THE SHEPHERDS

c. 1520–1522, oil on canvas
125.7 × 207.6 (49 ½ × 81 ¾)
Lent by
The Metropolitan
Museum of Art,
Purchase, Mrs. Charles S.
Payson Gift,
Gwynne Andrews Fund,
special funds, and
other gifts and bequests

Long attributed to Giovanni Bellini and exhibited under his name in London several times between 1879 and 1912, this work was the object of significant attention in the late nineteenth and early twentieth centuries. In 1893 it was attributed for the first time to Vincenzo Catena by Claude Phillips, followed by Berenson, who noted echoes of Giorgione.[1] Borenius was the first to observe a close connection with the so-called *Allendale Nativity* (cat. 17), which he thought was by Cariani.[2] Curiously, this indication, which highlighted the quality of Catena's picture, ended up working to its detriment, when Venturi maintained that it was by an anonymous follower of the artist influenced by Giorgione.[3] Once the link with Catena was broken, other scholars gave the painting to Palma Vecchio, until Catena's authorship was reasserted in the 1940s.[4] Since then that attribution and the influence of the *Allendale Nativity* have never been placed in doubt.

Robertson's identification of the painting's numerous figurative sources has enabled scholars to date it shortly after 1520, the year inscribed on the marble altar containing Catena's *Vision of Saint Catherine* in the church of Santa Maria Mater Domini in Venice. The greyhound in the *Adoration* is a hybrid of the two in Dürer's engraving of the Vision of Saint Eustace from the earliest years of the Cinquecento; the flying angel in the upper left also appears in Catena's *Virgin and Child*, datable between 1515 and 1520, in Philadelphia; the figure of the sleeping Child recurs in two *sacre conversazioni* by the artist, in Berlin and St. Petersburg, datable to the same period; and the kneeling shepherd with a basket of eggs lying

next to him was inspired (in reverse) by Cima's altarpiece for the Carmelites, of about 1509–1510.[5] The reference Catena's Joseph makes to the same saint in Giorgione's *Allendale Nativity* is beyond debate. To this we might also add the obvious derivation of the towers and walls on the hilltop from the identical structures in the background of Giovanni Bellini's Barbarigo votive banner in the church of San Pietro Martire, Murano. The central perspective of the stable meanwhile takes up a long-standing Venetian tradition that may have originated in a Flemish prototype. Finally, as Federico Zeri has pointed out, the leafy branches of the trees and bushes in the background resemble the foliage painted and engraved by Dürer.[6]

This, then, is a picture that draws on a wide range of suggestions, but the way the various motifs are assembled reflects in essence the mentality of an artist whose formation was still Quattrocentesque. Zeri has noted, too, that the Giorgionesque qualities of the painting diminished with the cleaning performed when the picture entered the Metropolitan's collection.[7] This change does not, however, negate any connection with Giorgione. As is known, the inscription on the back of the *Laura* in Vienna identifies its author, Giorgione, as the "cholega de maestro Vizenzo Chaena." Whatever meaning we wish to give to the word "colleague," it is clear that it suggests at least an easy access on Catena's part to Giorgione's compositions, and, in fact, his work has been substantially read in this key. Starting about 1515 and continuing up to his death in 1531, his paintings take on a new breadth and a fusion of color and atmosphere that cannot be called anything but Giorgionesque. Nonetheless,

as Laclotte acutely observed, this phenomenon in Catena has the flavor of a revival.[8] Faithful to the graphic rigor and plastic clarity of Bellini, Catena merely clothed his images in the intense color adopted by Giorgione at the beginning of his career. In other words, about 1520, in an artistic world already dominated by the swirling movement and deep sonorities of Titian's *Assumption* in the Frari, Catena returned to Giorgione's delicate painting style of about 1500. Borrowing from the *Allendale Nativity*, which he must have known, Catena in his own version of the subject shifted the focal point of the scene from the right to the left side but still made the beautiful head of a shepherd the center of the painting.

This contrast with the times in which he was working is just what gives Catena's painting its enchanting air of Arcadian peace. Here the same lovingly precise eye caresses the newborn Savior and the wicker basket of eggs, the birds brought as a gift and the flowers in the foreground, the greyhound and the rocks, the beams and gate made of rough planks, the leafy branches and the grazing animals, and the solemn silence of the dawn rising just beyond the walls of the rustic courtyard. The aristocratic grace of the shepherd's jacket, with its sartorial cut, indicates that Catena was measuring himself against an ideal vision of a glorious past, rather than the all too real poverty of the rural classes. There is, we may feel, a joy here in the artist's ability to transfigure the story, regardless of the world in which he found himself. And it is this joy that constitutes the special charm of Catena's art.

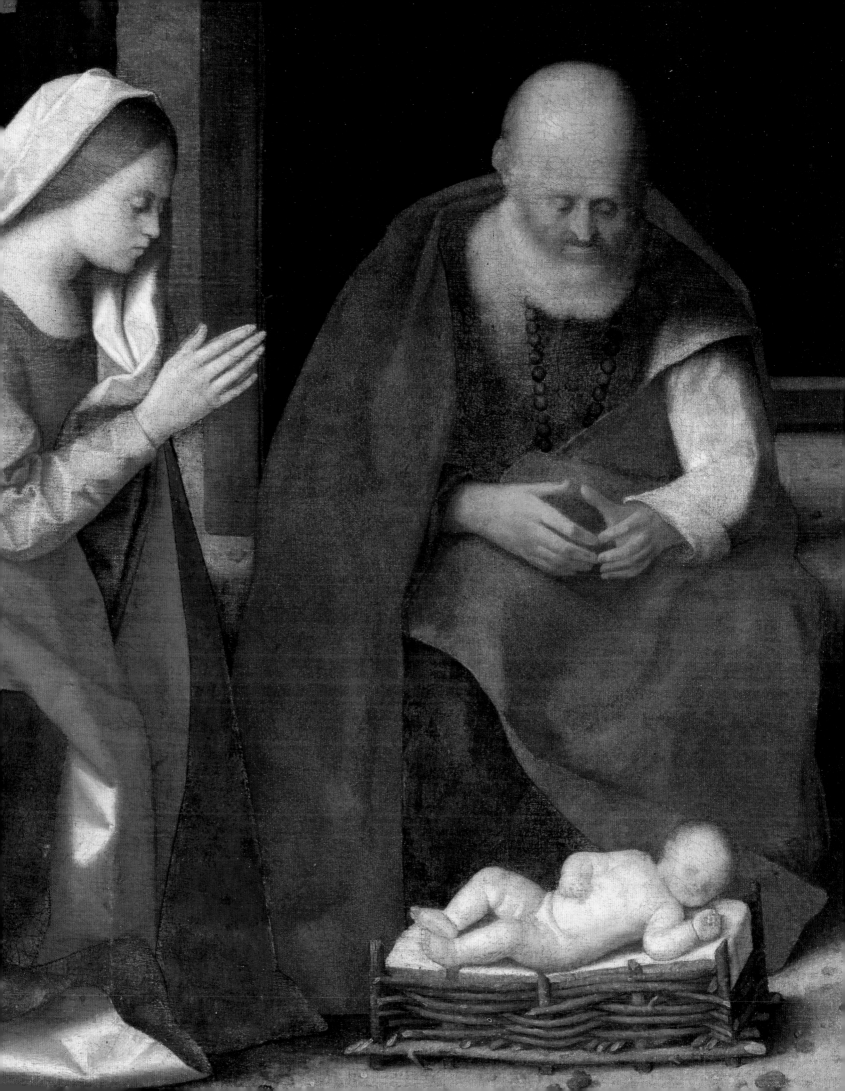

1. Berenson 1894, 96, and Berenson 1901.

2. Borenius 1913, 35.

3. Venturi 1915.

4. Fiocco 1941, 21.

5. Robertson 1954.

6. Zeri 1973.

7. Zeri 1973.

8. Laclotte 1993, 274.

Provenance: Giustiniani de' Vescovi collection, Venice, by 1790. Sir Abraham Hume, London 1791; by descent in 1838 to Viscount Alford; in 1851 to the 2nd and 3rd Lords Brownlow; by descent until 1921. Unsold at the 1923 auction of that collection; immediately bought by Count Alessandro Contini Bonacossi, Florence; The Metropolitan Museum of Art purchased it from his heir in 1969.

Selected References: Phillips 1893, 227; Berenson 1894, 96; Borenius 1913, 35; Venturi 1915, 578–579; Venturi 1928, 60–62; Berenson 1932, 138; Fiocco 1941, 18; Robertson 1954, 32–33, 60–61; Zampetti 1955, 146–147; Berenson 1957, 62; Freedberg 1971 (1979 ed.), 172, 683; Zeri 1973; Robertson 1983, 167; Freedberg 1988, 193; Ballarin 1993, 294; Laclotte 1993, 274; Lucco 1996, 127; Joannides 2001, 29; Lucco 2004a, 264.

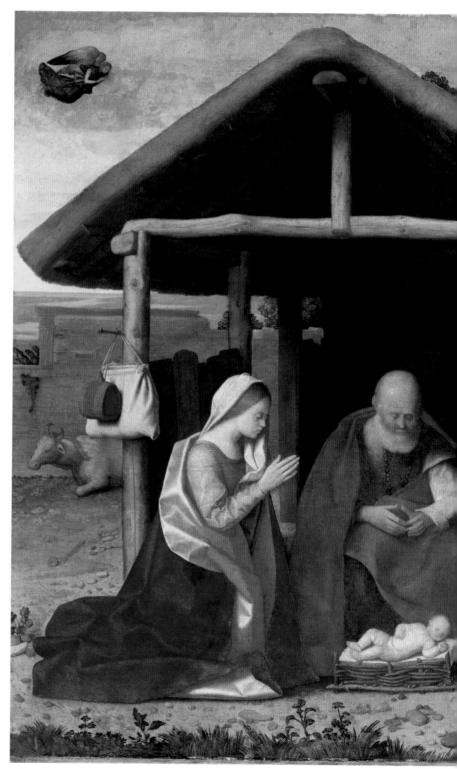

19

20

Giovanni Agostino da Lodi

ADORATION
OF THE SHEPHERDS

c. 1505, oil on panel
101 × 86.4 (39 ¾ × 34)
Allentown Art Museum,
Samuel H. Kress
Collection

Washington only

This painting displays the great variety of styles and stylistic influences possible in Venice in the first decade of the sixteenth century. It was published for the first time by Suida, who attributed it to "Pseudo-Boccaccino," the artist correctly identified as Giovanni Agostino da Lodi, and assigned it a date of about 1505.[1] Except for Shapley, who placed the picture after 1510, Suida's dating has been accepted by later scholars.[2] Giovanni Agostino da Lodi, who arrived in Venice shortly before the mid-1490s, has been the object of new critical attention in the past twenty-five years, which has not only significantly added to his oeuvre but also focused on his key role in bringing to Venice the stylistic innovations developed by Leonardo and Bramante in Milan. Suida, Shapley, and other scholars have all noticed, in addition to the picture's basic Leonardesque quality, its specific relation to the *Adoration of the Shepherds* (cat. 17) by Giorgione in the National Gallery of Art, Washington: in both cases a cave replaces the stable frequently found in Quattrocento art, and the Child lies on the ground on a small cloth with his head resting on a little mound of dirt and grass.

In an unpublished lecture of 1988 (cited by Ballarin 1995), the author of this entry pointed out that the two shepherds, especially the one on the right with the long staff resting against his shoulder, belong to a repertory that, widespread as it was in northern Italy, enjoyed a particular vogue in Bologna, as seen in the altarpiece, now in the Brera, that Francia painted in 1499 for the church of the Misericordia on commission from Anton Galeazzo Bentivoglio.[3] The

shepherd on the right corresponds quite closely to the figure of Bentivoglio, dressed as a shepherd, in the altarpiece; also, the composition is semicircular in each work, suggesting a direct relationship between the Allentown painting and the one in Bologna. Giovanni Agostino, in the earliest years of the sixteenth century, must have had some knowledge of Bolognese painting, acquired either from prints or engravings or as a result of a visit to the city. Significantly, Gioseffi identified the "Agostino of the perspectives," whom Dürer traveled to Bologna to meet in 1506, as Giovanni Agostino, and indeed the date assigned to the Allentown painting, about 1505, is very close to the time of Dürer's visit.[4] Giovanni Agostino could have been in Bologna at about that time, as the only fixed points in his career are his presence in Venice in December 1504 and in Milan on 7 September 1510 and 13 May 1511, when, as reported by two documents, he received payments for a picture.

The painting's attention to music — above all, to the lute, the "universal instrument" of the Renaissance — fits perfectly into the new climate of heightened sensitivities, which were nourished by discussions on the nature of love, by the observation of natural beauty, and by a graceful code for expressing love and beauty, to which the terms "protoclassical taste" and "courtly culture" have been applied.[5] The relationship with the Bentivoglio altarpiece indicates that Giovanni Agostino was involved in this broad cultural phenomenon — one marked by a harmony expressed in rhythmic curved lines, a love of symmetry, and an ecstatic, timeless calm, which Perugino helped to make

widespread throughout northern Italy in the late Quattrocento. This propensity is clearly demonstrated in the Allentown picture by the sinuous flow of the Virgin's garments and by the carefully calibrated relationships of the various figures.

At the same time, the variety of individual physiognomies and expressions (note the Leonardesque expressivity of Joseph's face) points us once more in the direction of Giorgione's *Adoration*. Despite their torn clothing, it is clear that shepherds like these are not real. Rather, as with Giorgione and the Arcadian taste his picture represents, they are nobles dressed in clothing not their own. The adoration of the Christ Child involves not prostrating oneself at his feet, but rather maintaining a sort of respectful, meditative silence, resembling a court ritual. And yet if Arcadia supplied the basic material for expression, the Allentown panel presents us with a kind of betrayal of these principles: Giorgione inserted his figures into a vast landscape receding into the distance toward faraway mountains, while here the horizon is closed off immediately behind the figures, lending the scene a more intimate feeling. While Giorgione was careful not to mix the human and the divine (the cherubs' heads in the Washington picture remain suspended in the air), Giovanni Agostino did not hesitate to bring the angel, with his beautiful curly hair, down among the other characters in the story. It is as though the Lombard artist, to construct his narrative, reinterpreted a Quattrocento *sacra conversazione* with a secular eye, offering the patron not only an impulse to devotion but also a delight for the eyes.

1. Von Bode 1890; Malaguzzi Valeri 1912, 99–100; Suida 1956.

2. Shapley 1960, and Shapley 1968, 20.

3. Ballarin 1995, 13.

4. Gioseffi 1979, following Schlosser 1924.

5. Sachs 1940, Italian ed. 1996, 406.

Provenance: Casa Soranzo in Venice, in the early twentieth century; bought in the 1930s by Alessandro Contini Bonacossi, who sold it in 1939 to Samuel H. Kress. Displayed from 1941 to 1956 in the National Gallery of Art, since 1960 in the Allentown Museum of Art.

Selected References: *Preliminary Catalogue* 1941, 25; Suida 1956, 89–93; Hirsch and Shapley 1960, 54–55; Berenson 1968, 172; Shapley 1968, 20; Fredericksen and Zeri 1972, 125, 270, 551, 664; Lucco 1988a, 14; Moro 1989, 25, 38; Moro 1992, 52–57; Ballarin 1995, 13; Lucco 1995, 20; Bora 1998, 261–262; Simonetto 2001, 274; Quattrini 2002, 33.

21

Titian

NOLI ME TANGERE

c. 1514, oil on canvas
109 × 91 (42 $^{15}/_{16}$ × 35 $^{13}/_{16}$)
The National Gallery,
London

•

Washington only

Since it first came to light, this paint-
ing has been attributed to Titian,
either as its sole creator or as finishing
a work begun by Giorgione.[1] A greater
disparity of opinion has surrounded
its date, which ranges from about 1506
to 1515, depending on differing views
of Titian's early development.[2] Yet
with few exceptions, art historians
substantially agree that the work was
painted during a stylistic phase that
also includes the artist's *Baptism of
Christ* in the Capitoline Museums in
Rome, the so-called *Three Ages of
Man* in the National Gallery of Scot-
land in Edinburgh, and the *Sacred and
Profane Love* in the Borghese Gallery
in Rome. This period began immedi-
ately after the Padua frescoes of 1511
and lasted until 1514, the date pre-
sumed for the *Sacred and Profane
Love*. These works all display a fasci-
nating gentleness combined with a
bold touch and an astounding ability
to make visible the veil of atmosphere
over the painted scene. Among mod-
ern scholars, the date of 1511/1512,
argued at length by Ballarin, is now
commonly held for the London pic-
ture.[3] Nevertheless, the recognition
by Joannides that the *Three Ages* in
Edinburgh is the picture that Vasari
says Titian painted for the father-in-
law of Giovanni da Castelbolognese,
identified as the goldsmith Emiliano
Targone, upon the artist's return from
his first stay in Ferrara in August
1516, suggests that a new chronology
is possible. Vasari's testimony, unless
contradicted by other evidence, ought
to be credited; and since the canvas
in question appears to slightly precede
the *Three Ages* in style, it should be
dated to about 1514.

The extraordinary pose of Christ,
twisting in a spiral motion, has been
connected with the works of Fra Bar-
tolommeo, who was present in Venice
in the summer of 1508. More likely,
as the compiler has suggested, it was
borrowed, in reverse, from the figure
of Saint John the Baptist in Sebas-
tiano del Piombo's altarpiece in the
church of San Giovanni Crisostomo,
which though it had already been in
place for years must have still reso-
nated as one of the most modern pic-
tures to be seen in Venice.[4] X-rays
of the London painting (fig. 1) show
that the pose of Christ underwent

significant changes as it was being
worked out, from that of a stiff,
wooden figure moving toward the
left to the dynamic one we see now.[5]
A precedent for the idea of the trans-
parent white fabric of Christ's loin-
cloth and cloak and of Mary Magda-
lene's sleeve lies in Saint Sebastian's
white drape on one of Sebastiano
del Piombo's organ shutters for the
church of San Bartolomeo di Rialto
of about 1510. The rustic buildings
on the right recur, reversed, in the

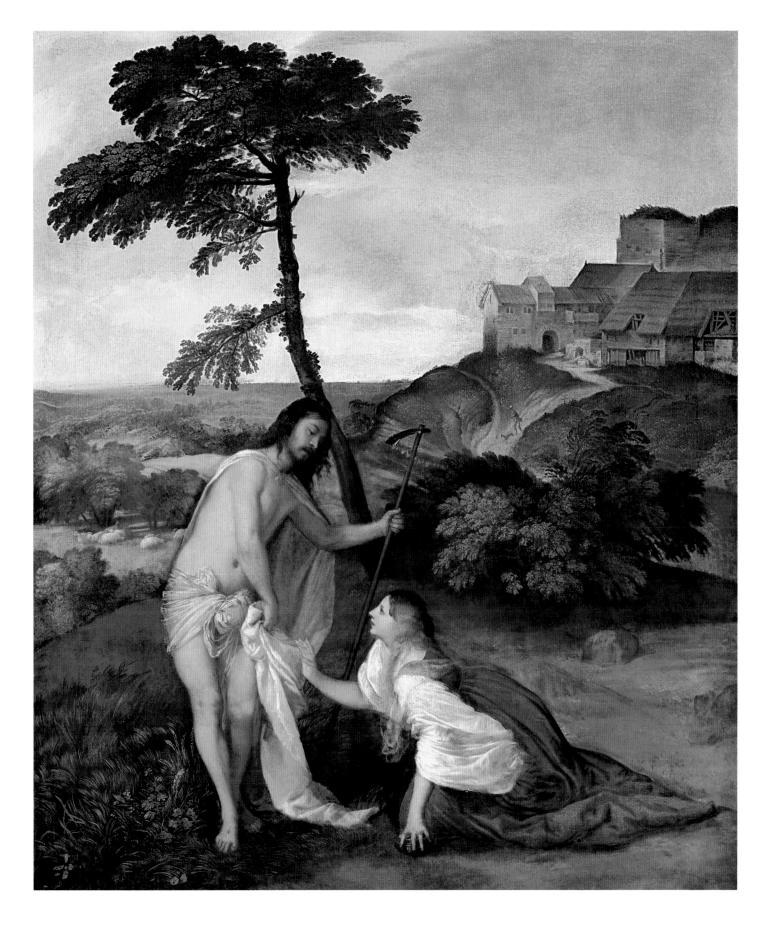

Sacred and Profane Love, a repetition that likewise argues in favor of the later date of about 1514 for the London painting.[6]

The subject of the *Noli Me Tangere* was rare in Venice and on the mainland in this period. Much more frequently represented in the fourteenth century, it seems to have more or less disappeared over the course of the Quattrocento. Like Vincenzo Catena's painting of the same subject, in the Brera, of about 1520, the London canvas is too small ever to have been above an altar; its place was in a private *cabinet d'amateur.* Penny posits that the picture may have been Titian's own personal idea, not a commissioned work, which he painted merely to explore his capacity for expression, or that it might have been commissioned by someone so completely in harmony with the artist that he left him ample room for experimentation.[7] In the choice of the subject there was already, in embryo, a vast range of narrative solutions: in the Gospel of John, for example, the encounter between the risen Christ and Mary Magdalene takes place on Easter morning in a garden, where Mary mistakes the Savior for a gardener. But it is the integration of the protagonists and their setting—in which the landscape forms echo those of the figures, emphasizing the gazes of Christ and the Magdalen or echoing their movements—that makes this painting one of Titian's greatest achievements. With an almost untamed touch of the brush, he seems uninterested in any preceding icono-graphical solution or even in a measured placement of the planes. Rather, he indulged his freedom to invent a space that pulsates with effects aimed at emphasizing the depth of feeling of the figures. Seen as if from a height, the far-off plain is made blue by the air. Because of this new and revolutionary relationship between figures and space, Penny has quite rightly spoken of a first step in the creation of the heroic landscape.[8] A masterpiece like this could not be easily digested, and, in fact, Titian's picture is a unique case in Venetian painting of the time. It is equally clear that such bold and boundless freedom could have happened only in a situation in which Titian no longer felt constrained by other artists, the very one in which he found himself with Giorgione's death, with Giovanni Bellini's advanced age, and with Sebastiano's departure from Rome in a move that turned out to be definitive.

1. Hetzer 1920, 1926; Richter 1934; Tietze 1936.

2. Morassi 1942, 1954, 1964; Hope 1980; Wilde 1974; Joannides 1994, 2001.

3. Ricketts 1910; Ballarin 1993.

4. Richter 1937; Hope 1980; Wilde 1974; Joannides 2001; Ballarin 1993; Lucco 1996; Gilbert 1980, 36–75.

5. Gould 1957; Dunkerton and Penny 1995.

6. Penny 2003, 86–87. X-rays clearly show that Titian initially planned to place the buildings on the left and later moved them to the right; he also replaced a slender tree with another, larger one of a different shape.

7. Dunkerton and Penny 1995.

8. Penny 1995.

Provenance: Christoforo and Francesco Muselli, Verona, by 1648; Marquis de Seignelay, d. 1690; Pierre-Vincent Bertin, d. 1711; Orléans collection, sold 1792 to "Walkuers," and sold again to Laborde de Méréville; Jeremiah Harman, London; Duke of Bridgewater and Lords Carlisle and Gower; sold 1802 by Gower and Duke of Bedford; Arthur Champer house sale, 1820, bought by Samuel Rogers; his bequest to the National Gallery, 1856.

Selected References: Ridolfi 1648 (Hadeln ed. 1914), 198; Cavalcaselle and Crowe 1877–1878, 1:176–178; Hourticq 1919, 16, 18, 110–111; Richter 1934, 4–16; Tietze 1936, 1:84–85, 2:292; Tietze 1950, 12, 376; Pallucchini 1953, 66–69; Baldass 1957, 128–130; Gould 1958, 44–48; Gould 1959, 109–111; Valcanover 1960, 17–18, 51; Pallucchini 1969, 23–24, 240–241; Valcanover 1969, 94; Freedberg 1971, 94; Wilde 1974, 122; Gould 1975, 275–278; Wethey 1975, 269; Hope 1980, 17–21; Freedberg 1988, 162–163; Joannides 1990, 25–26; Ballarin 1993, 407–411 (with complete bibliography to date); Steinberg 1993, 207–211; Dunkerton and Penny 1995, 364–367; Guarino 1995, 364–367; Lucco 1996, 68, 119; Heimbürger 1999, 100–101; Hills 1999, 122–125; Joannides 2001, 175–176; Pedrocco 2001, 84; Dunkerton and Plazzota 2002, 78; Dunkerton 2003, 50–51; Penny 2003, 86–87 (Spanish ed.), 148–149.

22

Giovanni Bellini

SAINT JEROME
READING

1505, oil on panel
48.9 × 39.5 (19 ¼ × 15 ⁹⁄₁₆)
National Gallery
of Art, Washington,
Samuel H. Kress
Collection

signed: [BELLINV]S
MCCCCCV (lower left)

Examination by x-ray and infrared reflectography carried out by the Gallery shows unequivocally that the date inscribed on the painting is 1505 and that there are no signs of discontinuity in its execution, which would scarcely be credible in the case of such a small painting. In other words, despite proposals to the contrary, this is a picture painted entirely by Giovanni Bellini in 1505.[1] An extensive literature treats the rise of the theme of Saint Jerome in Italian painting, beginning in the second half of the Trecento, its relation to the spread of the congregation of Hieronymites, and the various ways of representing Jerome, initially as an intellectual in his study and then, from about 1400, as a penitent in the desert.[2] The subject was a favorite in the Veneto region; in Giovanni Bellini's immediate circle, his father Jacopo had depicted Jerome as a penitent on at least three sheets in his album in the British Museum, London, and on a panel in the Museo del Castelvecchio, Verona. Interest in Saint Jerome seems to have increased greatly as a result of the publication in the Venetian Republic between 1475 and 1498 of at least fourteen editions of his biography, the *Vita et transitus Sancti Hieronymi* (Life and Passing of Saint Jerome), of which at least twelve were in the vernacular.[3]

In the painting examined here, the treatment of the subject is peculiarly Venetian.[4] Perhaps the first known version of this type is another poetic drawing by Jacopo Bellini in his album in the Louvre. In this drawing

and in the Washington painting, Jerome is shown not as a penitent but absorbed in reading in his desert hermitage. Strictly speaking, this scene is appropriate for a different, later moment in his life, when, withdrawn from the world but in a convent, he devoted himself to the study and translation of the Holy Scriptures. The story should thus be set in an interior. But here the idea of a retreat from the world is echoed visually by the saint's withdrawal to the lower right corner of the painting, heightening the contrast between the restricted space of his eremitic life, its aspect as a closed microcosm, and the immensity of the world around him. This shrinking of the figure and expansion of nature go hand in hand with contemporaneous developments in Giorgione's work. Bellini's treatment may not derive specifically from Giorgione, but here, as elsewhere in his oeuvre, the range of the elder artist's curiosity and his capacity for grasping the artistic changes taking place around him are remarkable. As opposed to Bellini's earlier characterizations of the subject, this wizened figure of Jerome, his back bent and his penance paralleled by his harsh environment, appears to be a touching meditation by the artist on old age — even his own; the body's decay is counterbalanced by the energy of the saint's mind, still intact and capable of distilling Christian doctrine. While absorbed in his reading, Jerome's intense gaze takes in all the minute details of his world — the gritty pebbles, the lead-bound stones of the pool, the lizard, the ivy, the slender fig tree — but he seems to have no interest in venturing beyond the rocky bank toward the soft grass or

distant buildings. His lion is there, like an aging pet, to protect him from intruders.

Scholars have been strongly tempted to read the scene as a moralizing landscape, in which every object, animal, or plant alludes to some aspect of the multifaceted personality of the saint. Thus, the bird of prey, perhaps a hawk, in the upper center of the painting could allude to magnanimity or to an excess of this trait, which transforms nobility of spirit into haughtiness and pride — vices to be eradicated from Jerome's soul. Or the bird could be an emblem of death.[5] The two rabbits might be examples of the Christian meekness and reserve practiced by the saint as a means to salvation.[6] Or are they emblems of the unbridled lasciviousness against which the saint tried to defend himself during his retreat?[7] The squirrel, tenacious in its search for food and thus an emblem of resistance in the face of adversity, could symbolize the fierce struggle with temptation that Jerome overcame by severe fasting and penance, or, given the ambivalence of symbols, it could also represent the sin of intellectual pride.[8] Just as the nuances of Saint Jerome's character are countless, so too are the meanings revealed by the symbols, which are by their very nature polysemic. While the painting seems to lend itself to a symbolic or allusive reading, the details do not necessarily have a source in a text; they can clearly be read in the context of an overall visual meaning, without recourse to boundless erudition.[9]

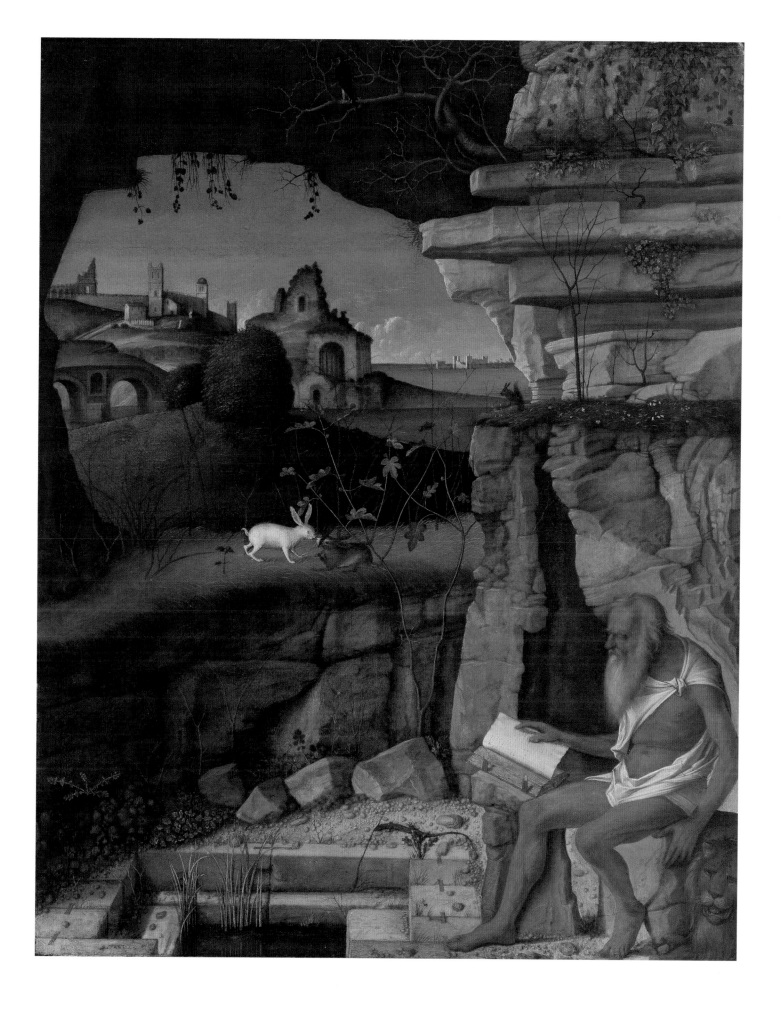

If practically identical rabbits appear in completely different contexts in three other works by Bellini, we must wonder whether any real hermeneutical significance can be attributed to compositional elements and motifs that can represent one thing or its opposite according to the context. In short, the animals and plants scattered throughout the picture seem like "attributes" of the landscape. Just as a saint is characterized by an object alluding to a moment in his life or by the instruments of his martyrdom, so the vastness and richness of the visible world is indicated by a lizard, a squirrel, two rabbits, and a bird of prey. To be sure, Giovanni Bellini would have had his own ideas and preconceptions about each of these elements, but their proper placement in their environment, and not in impossible or absurd juxtapositions, seems to speak clearly in favor of a reading that is not strictly symbolic.

1. For the debate over the picture's precise attribution and date, see Brown 2003, 70–74.

2. Friedmann 1980; Rice 1985; Russo 1987; Echols 1994.

3. Russo 1987, 175.

4. Russo, 1987, 221.

5. Friedmann 1980; Lattanzi 1983; Gentili 1985; Echols 1994.

6. Friedmann 1980.

7. Gentili 1985.

8. Friedmann 1980; Gentili 1985.

9. Brown 2003, 70–74; Echols 1994.

Provenance: Collection of Baron Monson, England, early nineteenth century; Sold in London in 1888; Bought in 1891 by Robert and Evelyn Benson, London, held until 1927. In 1929 passed to Clarence H. MacKay, Roslyn, New York; Sold 1936 through Duveen's to the Samuel H. Kress Collection; Given to the National Gallery of Art in 1939.

Selected References: Berenson 1894, 82; Borenius 1914, 143–144; Gronau 1928, 20, 24; Gronau 1930, 215; Berenson 1932, 71; Berenson 1936, 61; Dussler 1949, 100; Pallucchini 1949, 139; Berenson 1957, 36; Pallucchini 1959, 102, 153–154; Heinemann 1962, 67; Robertson 1968, 77–78, 115; Shapley 1979, 35–36; *San Girolamo* 1983, 86, 90–93; Gentili 1985, 164–166; Pujmanová 1987, 47; Rosand 1988, 58, 65; Goffen 1989, 260, 290; Olivari 1990, 47; Humfrey 1991, 109; Tempestini 1992, 256–257; Dunkerton 1994, 64; Echols 1994, 48, 58, 61; Paris 1995, 234, 237–238; Tempestini 1997, 226–227; Christiansen 1998, 51–52; Tempestini 1998, 39; Brown 1999, 454–455; Dunkerton 1999, 99; Tempestini 2000, 182; Brown 2003, 70–74; Christiansen 2004, 40–41, 56 (Italian ed.), 141; Tempestini 2004, 94; Wilson 2004a, 104.

detail, cat. 22

23

Giovanni Girolamo Savoldo

THE TORMENTS
OF SAINT ANTHONY

c. 1512, oil on panel
69.5 × 119.2 (27 3/8 × 47 15/16)
The Putnam
Foundation, Timken
Museum of Art,
San Diego

Since it was first published by Boschetto, this painting has been universally accepted as Savoldo's. It has also always been associated with another work by the artist, often held to represent the same subject, in the Pushkin Museum, Moscow.[1] Though the two panels have generally been dated to about 1530, Mina Gregori preferred to place both of them in the second decade of the sixteenth century.[2] Frangi likewise pointed out that the San Diego painting preceded Savoldo's *Two Hermits* in the Gallerie dell' Accademia, Venice, by a few years, and his view was seconded by Ebert-Schifferer, who further noted that the monk shown running away derives from the one in Giovanni Bellini's *Martyrdom of Saint Peter Martyr* in the Courtauld Gallery, which at one time bore the date 1509 on the back.[3] The compiler of this entry then added that the rotating head of the saint reflects that of the man behind Saint Anthony in Titian's fresco of the Miracle of the Restored Foot in the Scuola del Santo, of 1511.[4] The cultural mix of Leonardo, Giorgione, and Titian that can be discerned in the San Diego panel has slightly older roots than the markedly Raphaelesque influence visible in the one in Moscow. Thus the correct chronological order of the two paintings seems to be the San Diego panel, among Savoldo's very earliest works, followed by the picture in Moscow, datable between 1515 and 1520.

Jacobsen identified the source for some of the monstrous creatures on the right in the triptych of the *Last Judgment,* attributed to Hieronymus Bosch, in the Groeninge Museum in Bruges. As nothing is known about its earlier history, Jacobsen hypothesized

that Bosch's painting may originally have been in Italy, where Savoldo could have seen it.[5] Conversely, Savoldo could have traveled to Flanders, the birthplace of his wife. Or, such motifs could have been transmitted through engravings. But we should not forget, at least in terms of general inspiration, the vast group of Flemish works present in Venetian collections. Beverly Brown has noted that at least two paintings of the Temptations of Saint Anthony, attributed to Bosch and now lost, were in the 1520s in the collection of Cardinal Domenico Grimani, well known as a connoisseur of Flemish painting, not to mention the three works by Bosch that are now in Palazzo Ducale in Venice.[6] Bosch's great success at the time was connected with his representation of fires; he was considered a specialist, a model who was impossible to ignore. Noting that Saint Anthony Abbot is also dressed as a Carmelite in Squarcione's polyptych painted for the church of the Carmine and now in the Museo Civico, Padua, Brown plausibly suggested that the Timken painting could have been commissioned for a building belonging to that order.[7]

The method of constructing the narrative in the San Diego picture is characteristic of Venetian painting in the early decades of the Cinquecento. The story is staged with no literal correspondence to the successive moments of the torments as they are narrated by Saint Athanasius or Jacobus de Voragine. In the entire written history, at no time does the saint ever flee from his demons, who either tempt him with lust, nostalgia for the world, gold, and silver, or else beat him harshly, make terrible noises, and appear to him in the guise of

reptiles or wild beasts. Unflinching, Anthony stands firm in his story as narrated by the sources. There is no escape from temptation or a place of evil to one of salvation, from a world of darkness and fire to one of comforting natural safety.[8] Savoldo's setting conforms instead to the canons of the moralizing landscape, with on the right a malevolent, infernal scene representing the diabolical nature of temptation contrasted with a friendly, optically true environment on the left including a church and a monastery enclosed by walls—an oasis of tranquility and peace.

Nonetheless, the fire does not necessarily represent temptation, except indirectly in the sense that demons live among the flames. But fire is traditionally connected with Anthony, perhaps because of norm 54 of the saint's rule ("When you pray and think about God, let your habit be like wings to fly above the sea of fire"). He also became the protector against the viral illness (shingles) known as "Saint Anthony's fire."[9] In the folk tradition of the Venetian mainland, it was the custom on the eve of the saint's feast day on 17 January to build an enormous pile of wood called "Saint Anthony's bonfire." Savoldo thus transformed an attribute of the saint into a narrative element and an imaginary place in which to tell his story, clarifying it by opposing the fire as a metaphor for hell with the serene "desert" of remote places, with no respect for chronological order, for the essential unity of place in the written text, or even for a consistent history. Anthony's struggle with the demons is in effect a physical and moral struggle that does not take place solely in the mind or the imagi-

nation. This lack of straightforward adherence to the written text in favor of a few, highly significant elements, chosen so that the story can be grasped, emphatically and at a glance, is fully consistent with the new secular narrative genre that was emerging in Venice in the early years of the Cinquecento. Indeed, this painting may represent one of the earliest examples of the application of the type to a sacred story.

1. Boschetto 1963, 38–39.

2. Gregori 1988, 12.

3. Frangi 1988, 176; Ebert-Schifferer 1990, 71.

4. Lucco 1990, 91.

5. Jacobsen 1974, 532–534.

6. Brown 1999, 444.

7. Brown 1999.

8. See Athanasius 1989, 5–14.

9. Athanasius 1989, 18–19.

Provenance: Collection of Dr. William Dean, England; Sold, Sotheby's London, 27 April 1960, to the Timken Museum of Art.

Selected References: Boschetto 1963, 38–39 and pls. 13–18; Bossaglia 1963, 1032; Waltham 1963, 23–24; Jacobsen 1974, 532–534; Gilbert 1986, 521; Frangi 1988, 176; Gregori 1988, 12; Begni Redona 1990, 154; Ebert-Schifferer 1990, 71; Joannides 1990, 57; Lucco 1990, 91; Panazza 1990, 30, 32; Penny 1990, 32; Frangi 1992, 11–12, 38–39; Lucco 1996, 119; *Timken* 1996, 53–57; Sricchia Santoro 1998, 58; Brown 1999, 438, 444–445; Cottrell (PhD diss.) 2000, 55; Gilbert 2003, 291.

detail, cat. 23

24

Giovanni Girolamo Savoldo

TOBIAS
AND THE ANGEL

c. 1522/1525,
oil on canvas
96 × 126 (37 $^{13}/_{16}$ × 49 $^{5}/_{8}$)
Galleria Borghese,
Rome

Scholars have long attributed this striking picture to Savoldo but disagree about its dating, which ranges between 1522 and 1540.[1] There is a growing consensus, however, that any date after 1525 is precluded for stylistic reasons. Gilbert hypothesized that the Borghese canvas was one of the "four pictures of night and fires, very beautiful" that were cited in the Mint in Milan by Vasari.[2] According to Gilbert, another painting from this same group was Savoldo's *Saint Matthew and the Angel* in the Metropolitan Museum, illuminated by candlelight with figures in the background warming themselves by a fireplace. Christiansen, nevertheless, pointed out the impossibility of considering as pendants one work in which smaller full-length figures are shown by twilight and another in which half-length figures are depicted in artificial light; later scholars, including Gilbert, have accordingly abandoned the hypothesis that the painting in question was one of those belonging to the Mint.[3]

Though generally depicted as a narrative, the subject of Tobias and the Angel has many symbolic meanings, beginning with the fish and the dog, which, as attributes, enable us to recognize Tobias and to identify the Archangel Raphael. The other meanings are hidden in the circumstances of each individual commission, including this one, about which we are completely in the dark. Gombrich pointed out that the majority of depictions are concentrated in Florence in the years between 1425 and 1475.[4] As an isolated theme, Tobias and the Angel is quite rare in Venice, though it was there that Scorel painted his

panel, now in the Kunstmuseum, Düsseldorf. More or less at the same time Moretto completed his version in the Viezzoli collection, Genoa, attributed by Longhi to the young Savoldo.[5] Titian, too, had painted a Tobias and the Angel for the church of Santa Caterina, now in the Gallerie dell'Accademia, Venice (as well as the one, outside the chronological limits of this exhibition, still in San Marcilian); Palma Vecchio interpreted the subject in a little panel in the museum in Stuttgart; and another artist, more likely Domenico Campagnola than Palma, painted the panel formerly in the Schatzker collection in Vienna.

The emphasis in the Borghese picture, as opposed to these and other works (cat. 12), is not on the journey of the two figures shown walking side by side, but on a moment of rest on the bank of the Tigris—an Arcadian vision of nature, in which, according to Paolo Pino, Savoldo was an even greater specialist than the Flemish masters.[6] The attitude of the Archangel Raphael is not the pedagogical stance of a guide, but rather of one who gives orders, albeit kindly. The fish shown emerging from the water is much larger than in any other representation, in Venice or elsewhere; its size here is closer to the fish in the biblical narrative.[7] And finally, Tobias is not a child, as in other pictures of the story, but a vigorous youth, sunburned and accustomed to hard work. Although set in the majestic calm of the evening, as clouds gather in the sky and a silvery light shows off the monumental figures against the backdrop of trees, Savoldo's narrative has an unprecedented liveliness, as if he wanted to give visual form to the pause after the first phase of the journey. The tired puppy curls up to sleep, the

watchful angel points out Tobias' course, and the young man, at first frightened by the apparition of the monstrous fish but now reassured and confident, kneels almost as though obeying an order. This divergence from the standard type of narrative treatment—along with the artist's capacity for a psychological rendering of feelings and his cool light, charged with atmospheric verity—is what gives Savoldo's painting its persistent charm and its position as a signature piece in his oeuvre.

1. Opinion about the proper dating of the work varies from between 1527 and 1533 proposed by Longhi (1927) and accepted by Venturi (1928), Suida (1935), and Bossaglia (1963), to well after 1535 proposed by Gilbert (1945) and adopted by Della Pergola (1955). An even earlier date of 1521/1522 was indicated first by Capelli (1951) and Boschetto (1963). Gilbert (1983) later moved the date back to the early 1520s. Ballarin (1966), who had initially thought the date was about 1527, in a talk at the Savoldo conference in Brescia in 1990 proposed 1522 or 1523, a chronological position that this author also advanced in that same period (1990). Frangi sees a close relation with the *Adoration of the Shepherds* in Turin and with the Pesaro altarpiece, as does Joannides (1990).

2. Gilbert 1945, 1955, 1983, 1986; "quattro quadri di notte e di fuochi, molto belli... nelle dette case della Zecca"; Milanesi 1878–1885, 6:50.

3. Christiansen 1985, 85; Gilbert 1991, 37.

4. Gombrich 1948 (1978 ed.), 39–45.

5. Longhi 1946, 63.

6. Pino 1548 (1954 ed.), 69–70.

7. Tobit 6:2.

8. D'Achiardi 1912.

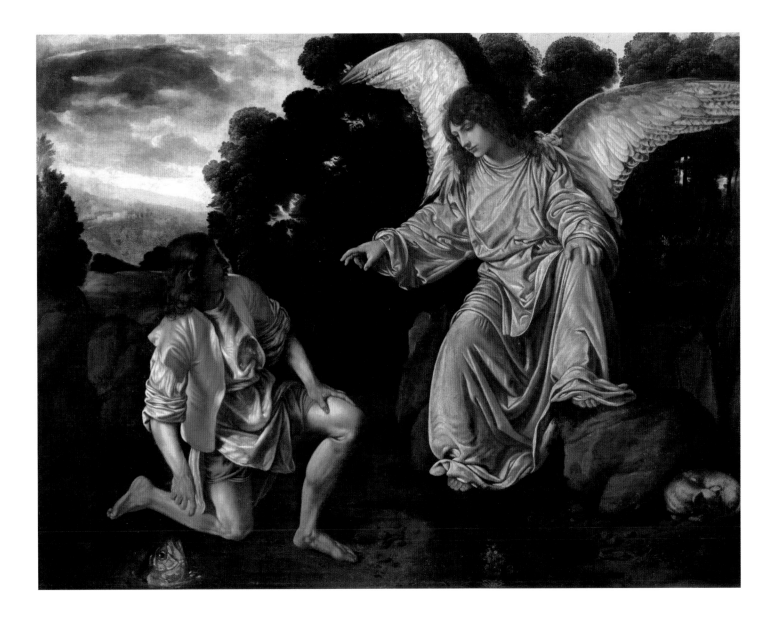

Provenance: Seen by Giulio Cantala-messa in 1910 in the possession of Riccardo Pompili in Tivoli; purchased in 1912 by the Galleria Borghese, Rome. There is no confirmation of the presumed provenance, stated by D'Achiardi, of Palazzo Alfani (or Alfani-Florenzi) in Perugia.[8]

Selected References: Longhi 1927, 72, 75 (1967 ed.), 153; Venturi 1928, 771–773; Suida 1935, 511; Pallucchini 1944a, xli; Gilbert 1945, 130–131, 136; Capelli 1951, 17, 18, 20, 24; Gilbert 1952, 151–152; Della Pergola 1955, 128; Zampetti 1955, 232–233; Boschetto 1963, pls. 33–35; Bossaglia 1963, 1018, 1021, 1024, 1030–1033; Ballarin 1966, pls. VI–VII; Gilbert 1983, 204; Sgarbi 1984, 67; Bossaglia 1985, 11; Christiansen 1985, 85; Panazza 1985, 181; Frangi 1986, 171, 181; Gilbert 1986, 184–185, 370–371, 376–377, 440–444, 520, 548–551; Gregori 1986, 13, 14; Begni Redona 1990, 160, 162; Joannides 1990, 57; Lucco 1990, 91; Nova 1990, 432; Frangi 1992, 12–13, 48–51; Papetti 1992, 141–146; Frangi 1993, 449–450; Lucco 1996, 83; Sricchia Santoro 1998, 58; Finocchi Ghersi 2003, 62.

25

Palma Vecchio

THE MEETING
OF JACOB
AND RACHEL

c. 1515, oil on canvas
146.5 × 250.5 (57 11/16 × 98 5/8)
Gemäldegalerie, Dresden

Vienna only

Traditionally attributed to Giorgione, this large and imposing canvas was first given to Palma Vecchio by Morelli, who dated it toward 1520; virtually all later scholars subscribe to this view.[1] For the compiler, too, the picture represents one of the final products of a phase—situated around 1515—in which Palma adopted the young Titian's system of placing light, bright colors next to each other in broad flat areas, almost without shadows.[2] While the slender tree on the right in the Dresden canvas, with its sparse foliage set like a web against the sky, recalls similar ideas by Fra Bartolommeo, who was in Venice in the summer of 1508, it also recurs in Palma's *Assumption of the Virgin*, documented as having been painted between 1512 and 1514, in the Gallerie Veneziane. The well-rounded volumes of Jacob's legs find a counterpart, again, in the *Assumption* in Venice. The poses of the two shepherds on the left seem to refer quite precisely to motifs used by Michelangelo and Raphael: the seated shepherd echoes the nude on the left above the Persian Sibyl on the Sistine ceiling, uncovered completely in 1512; and the one pouring water repeats the so-called Aeneas and Anchises group in Raphael's *Fire in the Borgo* fresco, about 1514 or 1515, of which an engraving reached Venice almost immediately. Here Palma seems to have combined the two figures, applying to the legs of one the torso and arms of the other. Also supporting a dating of about 1515 is the detail of the landscape on the right, with three luxuriant trees shading the road uphill to the town gate and the rustic buildings

whose arrangement shows clearly that they were inspired by the woodcut made from a drawing by Titian of the *Sacrifice of Isaac*, published in February 1515; the buildings as painted are simply a reassembly of those in the print.[3]

Given its large size, Rylands has proposed that this work is a *quadro da portego* (hallway painting), suitable for hanging in the largest reception room of a typical Venetian house— the vast corridor linking the water entrance with the door on the land side.[4] This idea, however, is derived from the supposed provenance of the work from Palazzo Malipiero and loses a large part of its validity if the painting comes instead from the convent of nuns in Treviso, where it seems to have been in 1684. Although *quadri da portego* are not precisely a genre, with specific rules, it can be said nonetheless that their subjects, because of their large size, were always narrative, as in the present case.

Palma's subject has almost always been identified as the meeting between Jacob and Rachel, narrated in the Bible.[5] Rylands observes that the painting approaches a genre scene in its proliferation of shepherds and especially of herds and dogs, just as Mariacher wrote of a pre-Bassano air to the canvas, in which Molmenti had seen a "bucolic simplicity of composition reminiscent of the valleys of Bergamo, the mountains sprinkled with meadows and crowned by eremitic little churches."[6] In short, the Dresden picture may be viewed as an almost "real" topographic illustration of the locale where Palma was born, populated more by animals than human beings. There are strict iconographical

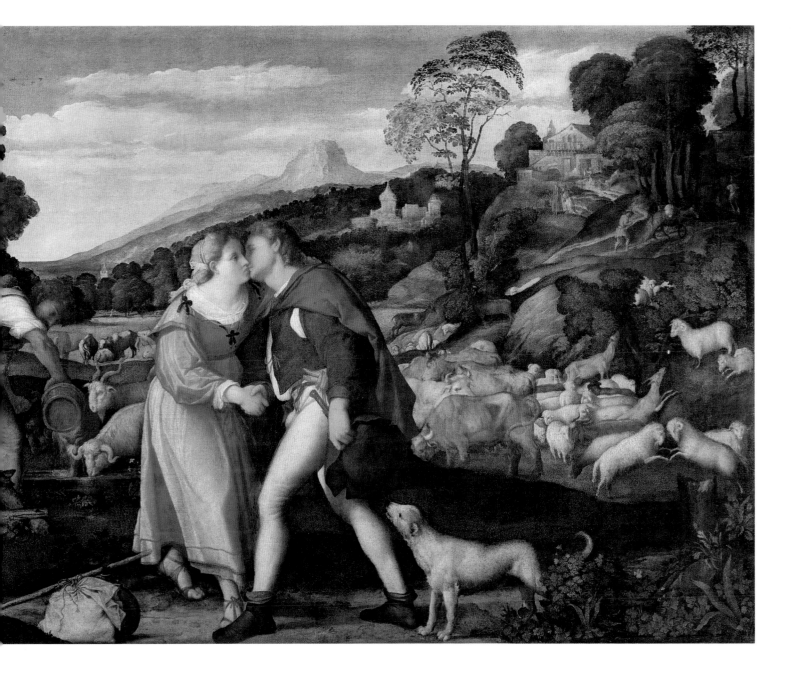

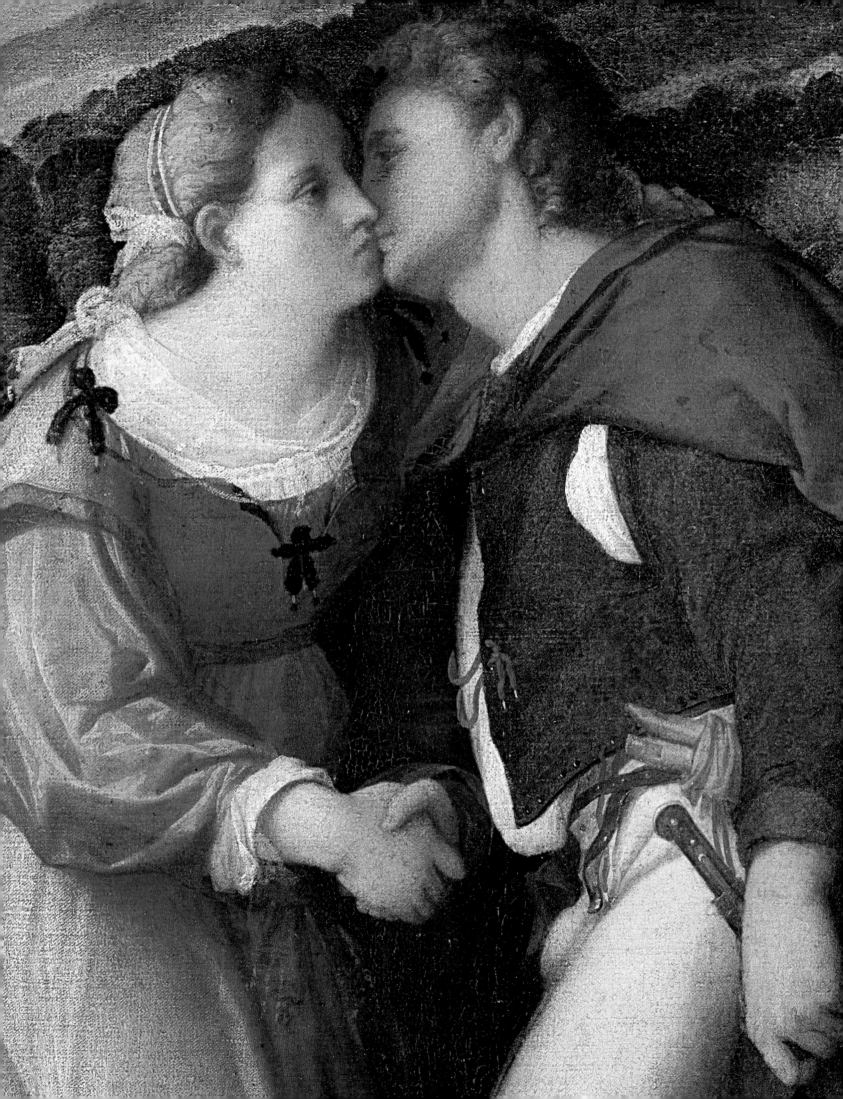

reasons for a pastoral, but not Arcadian, setting, as Burckhardt noted in 1898, since the biblical text reports that, at the moment of Jacob's encounter with Rachel, four flocks of sheep were gathered nearby. Also, the depiction of the two shepherds watering their animals and replacing the stone over the mouth of the well corresponds exactly with the *consecutio temporum* in the Bible, where the revelation of the protagonists' kinship and their kiss come after the animals have been cared for.

Although the two main figures stand out strongly in the foreground, reflecting a late-Quattrocento idea, the high horizon formed by the hills above their heads serves to integrate the protagonists and the landscape. With a long visual sweep moving diagonally back toward the horizon, following the shape of the valley, the setting here is much vaster and more open than is usually the case in pastoral representations. The freshness of the wide open spaces thus tones down any heightened reverberation of feeling. And Jacob's kiss, the prelude to his falling in love with Rachel and their subsequent marriage, is as chaste as any seen in the history of painting. Palma seems to have preferred representing the spectacular beauty of the visible world rather than exploring the emotions attendant on the story. As further evidenced by the lovers' handshake, his approach to the subject is simple and straightforward, attempting only to bring the scene and costumes up to date. Nonetheless, in this large painting, which seems to have been made more for aesthetic than for religious reasons, the artist succeeds in adapting the pastoral ideal to the theme of sacred history. In inventing

the genre of "religious pastoral," he produced a clear, crystalline narrative in which the literary convention is transformed by poetically imagined details of the kind found in Dürer's engravings and woodcuts.

1. Morelli 1880 (1886 ed.), 153–154.

2. Lucco 1996, 75.

3. Daniel Rosand and Michelangelo Muraro, *Titian and the Venetian Woodcut* (Washington, 1976), 55–96, nos. 3a and b.

4. Rylands 1988; and 1992.

5. Genesis 29:1–12.

6. Rylands 1988 and 1992; Mariacher 1968; Molmenti 1927–1929.

Provenance: Convent of nuns in Treviso, by 22 July 1684; Palazzo Malipiero, Venice; purchased for the Elector of Saxony, in whose inventory it appears from 1747.

Selected References: Crowe and Cavalcaselle 1871, 2:554–555; Morelli 1880 (1886 ed.), 153–154; Woermann 1887, 96–97; Burckhardt 1898 (Ghelardi-Müller ed. 1995), 125; Crowe and Cavalcaselle (Borenius ed.) 1912, 3:387; Schubring 1916, 28–34; Molmenti 1927–1229, 2:132–133; Venturi 1928, 401–402, 435, 436; Spahn 1932, 84–86, 156–157; Gombosi 1937, 136, pls. 66–67; Ballarin 1968a, 252; Mariacher 1968, 67–68; Menz 1968, 87–92; Walther 1968, 76–77; Mariacher 1975, 209; Mascherpa 1981, 18, 21; Pallucchini and Rossi 1983, 350; Rylands 1988, 97–99, 240; Rylands 1992, 83, 218; Attardi 1993, 433–434; Lucco 1994, 32; Humfrey 1995, 165–166; Lucco 1996, 75; Finocchi Ghersi 2003, 61; Hope 2004, 44.

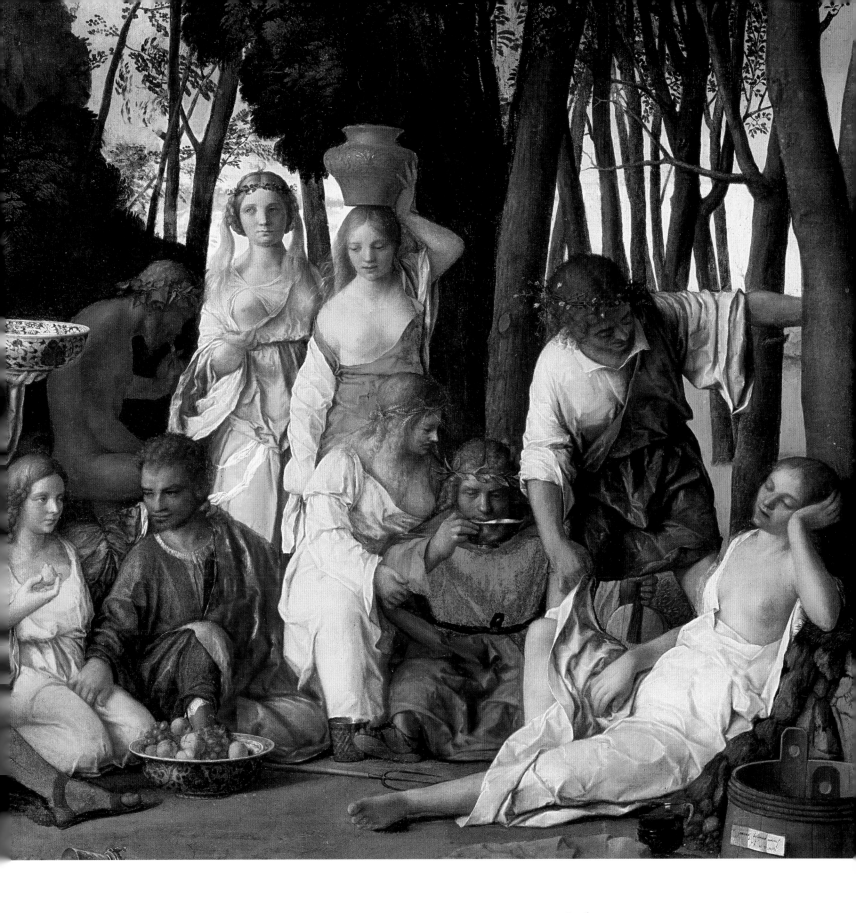

ALLEGORIES AND MYTHOLOGIES * *Jaynie Anderson*

AT THE BEGINNING of the sixteenth century Venetian artists turned to the countryside and nature in search of a landscape in which to place their visions of antiquity. Although the physical beauty of Venice was one of the most magical of all urban settings, the countryside offered the promise of la dolce vita. Even more important, the landscape setting was hospitable to ideas of the ancient world, whether about love, philosophy, or music. All of the allegorical and mythological paintings in this section were commissioned by enlightened patrons, most of whom we can identify, who chose to acquire these and other works of art representing the gods and goddesses of antiquity. The subjects they chose reveal a great love for the classics and for the rediscovery of texts, which seemed to hold the promise of how to re-create the ancient world they wished to see portrayed.

The section opens with two small circular furniture paintings, uncharacteristic mythologies, by one of the most captivating pupils of Giovanni Bellini, Cima da Conegliano (cats. 26, 27). The gods of antiquity first romped into the Venetian Renaissance on such pictures, occasionally on the pretext that they re-created lost works, to be shown in intimate spaces reserved for contemplation by a patrician, a prince or princess, and their friends. When Cima painted one of the most beautiful youths known to the classical world, Endymion, his visual imagination was triggered by a literary source, an allegorical painting described in a racy dialogue between Aphrodite and the goddess of the moon, Selene. Written by the Greek author Lucian, the conversation of these two lascivious women gazing at a sleeping Endymion presents a provocative, irreverent view of the gods and goddesses. Aphrodite opens the dialogue by teasing Selene about her obsession with the sleeping youth and asking "Is Endymion good looking?" Selene replies, "I think that he is very

good looking, Aphrodite, especially when he sleeps with his cloak under him on the rock, with his javelins just slipping out of his left hand as he holds them, and his right hand bent upwards round his head and framing his face makes a charming picture, while he's relaxed in sleep and breathing in the sweetest way imaginable...there's no need to tell you what happens next. You must remember I'm dying of love."[1]

Whether addressed to a patrician in Venice or to the court culture of Parma or Ferrara, the imagery of these two little allegories was created to provoke sophisticated and witty intellectual debate. Pictures like Cima's enjoyed a privileged existence in beautiful rooms, where a patrician or a prince might escape at his leisure, to imagine a classical past, where discourse about love, music, and philosophy were especially valued. Descriptions of ancient paintings were sought in ancient sources, and one in particular, the *Imagines* of Philostratus, a Greek writer, appealed to Isabella and Alfonso d'Este, the brother and sister who each commissioned works based on that text. Although at least three translations of Philostratus existed in the fifteenth century, Isabella commissioned a new one from Demetrius Moschus.[2]

Perugino's *Battle of Love and Chastity* (fig. 1) was the first Renaissance painting we know to quote from Philostratus: in the picture's background are cupids riding swans, a singular motif only to be found in the lengthy description in the *Imagines* (1.9) of a painting of a marsh. The motif is described in the detailed instructions prepared for the artist by Paride da Ceresara, an agent of Isabella d'Este, in 1503.[3] Either Paride or Isabella could have been responsible for the choice of this detail. The singularity of d'Este patronage may obscure the fact that the impact of Philostratus on Renaissance art was fairly limited to them. It is really Alfonso

1.

Perugino, *Battle of Love and Chastity*, Musée du Louvre, Paris

d'Este who had a predilection for the text. Alfonso commissioned at least three re-creations of ancient paintings, two by Titian (cats. 33, 34) and another by Dosso Dossi, *Hercules and the Pygmies* (Landesmuseum Joanneum, Graz). Of the sixty-five pictures described by Philostratus, only six were utilized by Renaissance artists, and of these the most popular was the "Cupids." In the history of Renaissance art, much is written about the rivalry between artists, but the rivalry between patrons is an equally rewarding way of conceptualizing the past.

The culture of the court was not dissimilar to the tastes of Venetian patricians, although we know less about the Venetian nobility because of the lack of confessional literature in that city. Patient research in the Venetian archives and genealogies has resulted in the creation of brief biographies for those fortunate men who commissioned works by Giorgione, such as Taddeo Contarini, who owned Giorgione's *Three Philosophers* (cat. 30). His collection was described by Marcantonio Michiel, but others' were not. Michiel's brief and fragmentary descriptions reveal only the tip of the iceberg.

A patrician family such as the Cornaro was not dissimilar in its ambitions and aspirations to the d'Este. After all, the only queen to come from Venice, a society that forbade royalty, was Caterina Cornaro. Giovanni Bellini's newly cleaned *Continence of Scipio* (cat. 28) was commissioned in 1505 by Caterina's brother, Francesco Cornaro. The scene chosen celebrates their ancestry, which they believed could be traced back directly to ancient Rome, to the Cornelii, and to Scipio himself. Bellini inherited the commission from his brother-in-law Mantegna, who had begun the cycle with the *Introduction of the Cult of Cybele to Rome*, now in the National Gallery, London (page 156, fig. 1), depicting Scipio receiving an ancient statue that would save Italy. Together the two pictures would have decorated the cornice of a Cornaro palace. Both artists imitated a sculpted frieze of plain marble figures in relief against a background veneered with colored marble. The decoration that Mantegna and Bellini created for the Cornaro in Venice would have been impossible without the precedent of Isabella d'Este. When Titian went to Ferrara to stay with Alfonso in November 1519, it is recorded that the court artist Dosso Dossi took him to Mantua to admire the collections of Isabella d'Este, especially her works by Mantegna.[4] Patrons as well as artists were in a competitive dialogue with one another.

Of all the allegories in the exhibition it is the *Pastoral Concert* (cat. 31) that remains the most mysterious. Was it made for an Emilian court or for a patrician palace in Venice? One clue as to the origin of the patron might be adduced by the presence in the painting of a member of the elite patrician festival organizers, known as the Compagni della Calza (Companions of the Order of the Stocking), prominently represented in the form of the urban lute player. He is garbed with exquisite luxury: not only does he wear the bicolored

stockings from which the organization took its name, every other detail of his costume also relates to the way the members of this most exclusive society dressed. Most Italian towns had associations of young men, but in Venice this society took a particular form. The festivities they organized were usually associated with Carnival or with aristocratic marriages between distinguished families. For example, Isabella d'Este's husband, Francesco Gonzaga, was a *compagno* (companion) and his confraternity, the Reali, arranged their marriage.[5]

A letter from a member of the Contarini family records that on 16 February 1441, for the marriage of Jacopo Foscari, son of Doge Francesco, with Lucrezia Contarini, eighteen members of a company organized four days of nuptial celebrations.[6] According to this letter, written by the bride's brother, all eighteen members not only wore the famous stockings and berets, but were also dressed in garments of crimson velvet with open sleeves and fur lining. In every detail of his costume, the lute player in the *Concert* is characterized as belonging to this very exclusive and wealthy club of patricians, from whose ranks members of the middle classes (*cittadini*) were excluded. What are we to make of the presence of a member of such an elitist group at the center of the painting? Do the figures — chaste muses accompanied by poets — represent the imaginative world of a *compagno*, who creates and commissions music and poetry for festivities to celebrate a wedding?

Young men like these, dressed with such refined elegance, were conspicuous on the Venetian scene. Carpaccio included several in the crowd scenes of the *Miracle of the Relic of the True Cross*, for the Scuola di San Giovanni Evangelista, showing them with their backs turned to the spectator, as personages of mysterious luxury like the lute

2.

Vittorie Carpaccio,
*Miracle of the Relic of
the True Cross*, detail of
the *compagno*, Gallerie
dell'Accademia, Venice

player in the *Pastoral Concert*. Carpaccio's image of a *compagno* (fig. 2), together with his elegant long-haired page, was later transposed by Cesare Vecellio, Titian's nephew, as the quintessential image of the Compagni della Calza in his famous book on costume (*Degli abiti antichi et moderni*, 1590). Carpaccio's young men with long blonde hair and splendid costumes are the trendsetters of the Venetian scene. Guaranteeing magnificence and creating fashion, their elegance is mirrored by the gondoliers and other passing youths seen at Rialto Bridge.

The diarist Marin Sanudo was frequently drawn to recording the prominent social activities of those who belonged to these thirty-four elite clubs, some of which had pastoral names such as Zardinieri (Gardeners). In many ways they might be described as superior event managers. For these events the Compagni commissioned plays, intermezzi, music, and much more besides. As Chojnacki has shown, their activities were not just social but had a political significance.[7] In December 1506, the Council of Ten, the most powerful body of government, passed a law regulating their attendance at dinner parties. Banquets and electioneering have a long history, and it seems that such events as the

Compagni organized could be construed as a means to buy political favors. Within a history of young people in the West, the Compagni occupy a unique position.

Renaissance princes and patricians commissioned mythological and allegorical pictures drawing on a variety of literary sources, which their artists elaborated upon, whether these were *ekphrases* or moral texts. Alfonso d'Este's understanding of Philostratus was rather idiosyncratic, but Titian could elaborate upon the ancient text in an equally exceptional manner. The fragmentary correspondence between Alfonso's agents and Titian suggests a complex and mutually satisfying negotiation of meaning. Having received the canvas and a letter of instruction, presumably for the *Worship of Venus*, Titian wrote to the duke on 1 April 1518. Praising him for his way of eliciting works of art, Titian described the duke's patronage as enlightened, *tanto bella et ingeniosa* (very beautiful and ingenious).[8] What more fitting epitaph could be found than Titian's words to conclude this discussion of the reciprocal role and relation between Venetian painters and their patrons.

1. Lucian, *The Works of Lucian. Dialogi deorum*, M.D. Macleod, trans. (Harvard, 1969), 329, 331.

2. The original manuscript is in the University Library, Cambridge, Add. 6007.

3. Webb 1992, 160.

4. Menegatti 2002, 446.

5. Muraro 1976–1986, 319.

6. Muraro 1976–1986, 324. See also Chojnacki 2003.

7. Chojnacki 2003.

8. Menegatti 2002, 444–445.

1.

Pinturicchio, *Selene
with Endymion*, fresco,
Piccolomini Library,
Siena cathedral

26

Cima da Conegliano
ENDYMION ASLEEP

c. 1506, oil on panel
diameter: 24 (9 7/16)
Galleria Nazionale,
Parma

When the goddess of the moon Selene fell in love with the young Endymion, Jupiter granted him his wish for immortality, eternal sleep, and perpetual youth. Ancient writers describe Endymion as one of the most beautiful young men in the world, on a par with Adonis and Ganymede. His sleeping presence inspired extraordinary fantasies, not the least with his beloved Selene. One of the classic texts describing their encounter is the twentieth *Idyll* of Theocritus, quoted here in Sir John Davies translation of 1588:

Who was Endymion? Was he not a
 Neatherd? Yet the moon
Did love this Neatherd so, that, from the
 heavens descending soon,
She came to Latmos grove where with
 the dainty lad she lay.[1]

In this earliest known representation of the subject in the Italian Renaissance, Cima da Conegliano places the sleeping Endymion in a landscape lit, or metaphorically kissed, by a heavy quarter moon resting low in the sky. Endymion is dressed as a warrior, but behaves like a shepherd, whose "flock" demonstrates the irresistible power of sleep that he emanates, as well as the various ways in which animals slumber.[2] Endymion's faithful dog echoes his master's repose. The cow, a symbol of negligence, is comatose, as free of care as the vice he represents. Hares are known to sleep with their eyes open. The cranes, symbols of vigilance when poised on one leg, here stand on two legs, their way of sleeping. It is as if Cima enjoyed representing different forms of sleep found

among fauna. As Humfrey has suggested, another idea for a third lost or unexecuted tondo in the series that included *Endymion* and the *Judgment of Midas* (cat. 27) may be represented by Cima's drawing of *Orpheus Taming Animals*, in the Galleria degli Uffizi, Florence, in which case, the roundels would all have offered differing representations of the power of gods over the animal kingdom.[3]

Pinturicchio's fresco of *Selene with Endymion* (fig. 1) on the ceiling of the Piccolomini Library, in Siena Cathedral, is a representation comparable to, but independent from, Cima's tondo of about the same date.[4] On the Piccolomini ceiling Diana is depicted in female form descending from her chariot, a motif that Pinturicchio appropriated from an ancient sarcophagus, perhaps the celebrated Endymion sarcophagus in the Palazzo Rospigliosi, Rome. Pinturicchio, like Cima, clothes Endymion, ignoring the supine nude figure of Endymion on the Roman sarcophagus. Yet unlike Cima, Pinturicchio represented Endymion clothed as a shepherd, not as a soldier. Other near contemporary representations of Endymion in prints (Bartsch, 8.279.56; 14.205.252) by Marcantonio Raimondi

depict Endymion nude, much as he appears on the ancient relief of the sleeping youth in the Musei Capitolini, Rome. Given these available traditions from antiquity, with which he was familiar, it is unlikely that Cima dressed Endymion as a sleeping knight from ignorance, as has been supposed. Languid knights sleeping or at rest, such as the dreaming Scipio, are often portrayed in cases where young men exercise judgment, in association with good fortune. Out of prudery, or for other reasons, the patron may have suggested clothing Endymion.

When Cima represented Endymion in the first decade of the sixteenth century, he may have known the best-selling book of poetry by the Catalan, Benedetto Gareth, known as Il Chariteo, especially his book on Endymion and the Moon (*Libro inscripto Endimione a la Luna*). This volume was published in 1506 at Naples, where Chariteo was official poet to the Aragonese court, and was later expanded in a new edition in 1509, *Libro di sonetti et canzoni di Chariteo intitulato Endimione*, in which the poet again identifies with Endymion. It is notoriously difficult to date it and Cima's other mythologies accurately, but the date of Chariteo's publications may indicate that they should be placed in the second half of the first decade of the sixteenth century. Other famous Italian writers, such as Pietro Bembo and Jacopo Sannazaro, took Endymion as their poetic role model, as may have been the case with the patron who commissioned the roundels.

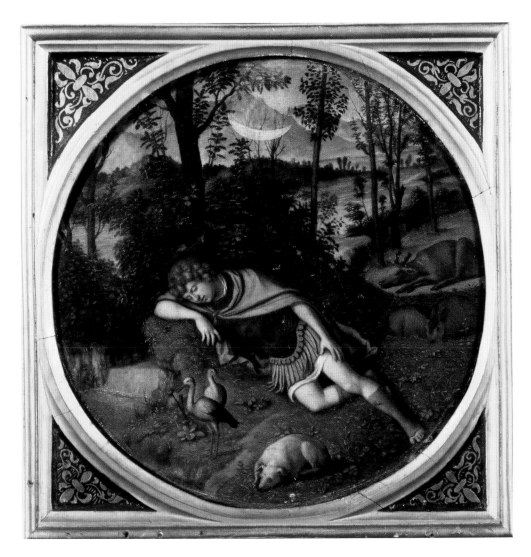

1. Theocritus, *Six Idilia, that is six small, or petty, poems, or Aeglogues, chosen out of the right famous Sicilian Poet Theocritus*, Sir John Davis, trans. (Oxford, 1588).

2. Natalia Agapiou, "Endymion au Carrefour. La fortune littéraire et artistique du mythe d'Endymion à l'aube de l'ère moderne," in *Ikonographische Repertorien zur Rezeption des antiken Mythos in Europa* (Berlin, 2005), 4:78–81.

3. Humfrey 1982, 35–46.

4. Settis and Toracca 1998, 268–271.

5. The two tondi by Cima are included in a Prati family inventory published by Giancarla Periti (Periti 2005). The jurist Bartolomeo Prati (b. 1471) was a sophisticated collector and patron, Correggio's *Ecce Homo*, now in the National Gallery, London, being the gem of his painting collection.

Provenance: Commissioned by Bartolomeo Prati, Parma, and bequeathed by the Dalla Rosa Prati family to the Galleria Nazionale, Parma, in 1851.[5]

Selected References: Battisti 1962, 25–30; Meller 1962, 10–24; Humfrey 1982, 35–46; Humfrey 1983, 139–140; Van der Smam 1986, 197–203; Fornari Schianchi 1997, no. 128; Settis and Toracca 1998, 268–271; Agapiou 2005, 72–82; Periti 2005.

27

Cima da Conegliano

JUDGMENT OF MIDAS

c. 1506, oil on panel
diameter: 24 (9 7/16)
Galleria Nazionale,
Parma

In his second roundel apparently made for the same piece of furniture, Cima da Conegliano depicted the famous competition between a god and a satyr, Apollo versus Pan, as to who is the better musician. Taken from book 11 of Ovid's *Metamorphoses*, the story is a pejorative account of the greed of Midas, whose foolish wish that everything he touched might turn to gold led to predictable disaster. When the king's wish was rescinded, as Midas had grown to hate wealth, he then spent his time in the woods with Pan. In the story that follows in Ovid's text, the judge and arbiter of the music contest is Tmolus, the deity of the mountain, alluded to by Cima in the background landscape. In the roundel, in which Pan and Apollo contend for superiority, Midas, appointed judge of the competition by Tmolus, prefers Pan and is accordingly punished by being given the ears of an ass.

Cima chose to depict the moment of artistic judgment in the classical story, showing King Midas, wearing a crown, but with the animal's long ears already growing from his head, and pronouncing on who is the better musician. Midas is portrayed in rustic dress, like a peasant rather than a king, indicating his lack of wisdom and the time he has spent and will continue to spend with Pan in the woods. Apollo appears as a beautiful youth, in stark contrast to the smaller stunted Pan. Like Ovid, Cima condemns Midas for his ignorance and

slights Pan as an inferior hybrid. Scholars have accepted the suggestion of Battisti that the tondo is an allegory of the competition between two kinds of Renaissance poetry, the classical and the rustic, the latter being implicitly condemned.[1] And in a larger sense the painting is an allegory of the contrast between two registers, high and low, in artistic discourse. Both Midas and Endymion, shown in the accompanying panel, wished for impossible things and were granted their wishes, the consequences of which they had to endure.

Burckhardt has convincingly suggested that Cima's composition was based on a Renaissance plaquette, *Orpheus, Eurydice, and Pluto* in the Museo Correr, Venice.[2] Aside from the fact that the painting, like the plaquette, is round, Cima closely modeled the elegant classical figure of Apollo on the nude figure of Orpheus, in stance and hand gestures, and he rather amusingly appropriated the devilish Pluto, who accompanies Eurydice, for the figure of Midas, while Pan assumes the place of Eurydice.

Art historians have always noticed a certain naivete in the form and the characterization of the protagonists in Cima's panels. Similar observations might be made about another version of the myth by Cima in the Statens Museum for Kunst, Copenhagen, which is without a pendant. Like the Parma tondo, the square painting in Copenhagen once decorated a piece of furniture. It is also based literally on Ovid's *Metamorphoses* (11.147–187), but is less of a caricature. Midas is seated on a broken tree trunk, dressed in rustic attire, while Apollo and Pan are depicted as of equivalent physical stature. The mountain deity Tmolus is shown as a figure listening, rather than as a mountain.

Mythologies by Cima are rare, as are roundels in Venetian Renaissance art, so their function has aroused much speculation with the probability that they decorated either a wedding chest (*cassone*) or a case for a spinet or other musical instrument. Both hypotheses are plausible given that the subject matter is appropriate to both contexts. It has often been remarked, too, that Cima's works were not in the collections described by Marcantonio Michiel in Venice and the Veneto in the 1520s and 1530s, and Humfrey's hypothesis of a distinguished humanist patron in Parma has recently been confirmed.[3] Otherwise, Cima's work is almost entirely ecclesiastical, altarpieces and religious commissions, which, while disseminating Bellini's

inventions, failed to appeal to the sophisticated Venetian patricians, who preferred Giorgione and Titian. The unusual nature and relatively late date of these works in Cima's oeuvre might imply that he here wished to rival the newly emerging style and subject matter of Giorgione, an artist who specialized in secular paintings of little figures in landscapes. Whatever Cima's ambition, they represent Venetian taste after it had been radically transformed by the novelty of Giorgione. Whatever the case, it was an Emilian, not a Venetian, patron who stimulated Cima to produce such unusual and beautiful creations.

1. Battisti 1962, 25–30.

2. Burckhardt 1905, 86.

3. Humfrey 1982, 35–46. The two tondi by Cima are included in a Prati family inventory published by Giancarla Periti (Periti 2005).

Provenance: Commissioned by Bartolomeo Prati, Parma, and bequeathed by the Dalla Rosa Prati family, to the Galleria Nazionale, Parma, in 1851.

Selected References: Burckhardt 1905, 86; Battisti 1962, 25–30; Meller 1962, 10–24; Humfrey 1982, 35–46; Humfrey 1983, 139–140; Van der Smam 1986, 197–203; Fornari Schianchi 1997, no. 128; Agapiou 2005, 72–82; Periti 2005.

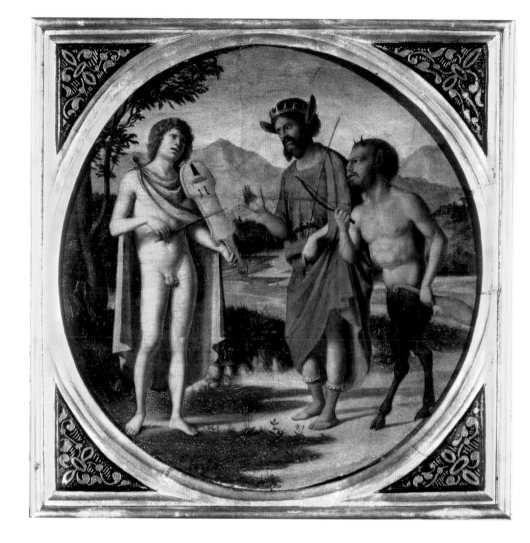

1.

Mantegna, *Introduction
of the Cult of Cybele
to Rome*, 1505–1506,
National Gallery, London

28

Giovanni Bellini

THE CONTINENCE
OF PUBLIUS
CORNELIUS SCIPIO

1506, oil on canvas
74.8 × 356.2 (29 ⅜ × 140 ¼)
National Gallery
of Art, Washington,
Samuel H. Kress Collection

inscribed: TVRPIVS /
IMPER / VENERE / Q. AR /
MIS VINCI[1]

It is surprising that within Giovanni Bellini's oeuvre this marvelous grisaille is the first large-scale example of a classical subject, executed when he was about seventy years old. The commission, inherited after his brother-in-law Andrea Mantegna's death, provided a considerable challenge, to which Bellini responded with wit and originality. In 1505 Francesco Cornaro, a Venetian nobleman who claimed descent from the ancient Roman clan of the Cornelii, commissioned a painted frieze of four pictures to decorate a room celebrating the family's genealogy. Mantegna's *Introduction of the Cult of Cybele to Rome* (fig. 1), now in the National Gallery, London, is the first scene, imagined as a simulated sculpted relief of plain marble figures against a background of colored marble. The London grisaille depicts a significant historical event in which Italy was saved from a barbarian invasion. After Hannibal conquered almost all the Italian peninsula in 204 BC, the Romans sought salvation, consulting the Sibylline books and seeking advice from the Delphic oracle. In the hope that Hannibal might be overcome, the Roman

Senate, following the Sibylline prophecy, ordered the statue of the goddess Cybele to be brought to Rome. Mantegna imaginatively combined several accounts of the story as found in Ovid (*Fasti* 4.179–349), Livy (*History of Rome* 29.10, 11, 14) and Appian (*The Civil Wars*, 7.9, 56). To fulfill the ancient prophecy, the statue of the goddess had to be received by the most worthy living Roman, who was commonly agreed to be Publius Scipio. When the ship carrying the miraculous image of Cybele reached Rome, the goddess gave the first sign of her power by revealing the innocence of a Roman matron, Claudia Quinta, who had been wrongfully accused of unchaste behavior. Cybele (who fell to earth as a meteor) appears twice in Mantegna's monochrome, both as a stone and as a bust with a crown. Shown kneeling before her statue, Claudia Quinta is the emotional center of Mantegna's composition.

The cycle is well documented, for on 15 March 1505 Cardinal Marco Cornaro wrote to Mantegna's patron, the Marchese Francesco Gonzaga in Mantua, to secure the commission from his brother Francesco.[2] The messenger chosen was Niccolò Bellini, who, like Giovanni, was Mantegna's brother-

in-law. Mantegna began work shortly thereafter, for Pietro Bembo wrote to Isabella d'Este Gonzaga on 1 January 1506 that the artist wanted more than the 150 ducats agreed upon for the canvases. On 31 January Isabella replied that Mantegna was ill and unable to work. Other letters show that Mantegna prepared four canvases for the commission but finished only one. Scholars have tried to identify the additional canvases with Mantegna's *Vestal Virgin Tuccia* and *Sophonisba*, both in the National Gallery, London, but as Christiansen has argued, their attempts to associate these two *bronzi finti* with the Cornaro commission are unconvincing.[3] The much larger rectangular pictures by Mantegna in London and Bellini in Washington are in a different medium, oil and possibly tempera on canvas; they simulate marble relief rather than bronze; and they are to be viewed from below, whereas the small simulated bronzes are made to be seen straight on. Finally, the documentation reveals that Mantegna finished only one work.

What was it that Mantegna was imitating in the ancient world? His style resembles ancient reliefs, including

cameos, but no such stone or painted relief with a colored background survives from the period. Perhaps Mantegna could have seen pictures in *opus sectile* (stone marquetry used by the Romans in wall and floor decorations). Whatever the source, Giovanni Bellini adopted a similarly classicizing style in several preliminary gouache drawings on red grounds (Institut Néerlandais, Paris; British Museum, London; Kromericz; and another in a private collection), which show Bellini experimenting with the positions of the men in the procession.

Throughout history Scipio has retained his reputation, and in the Renaissance he was one of the most frequently represented men from antiquity, a national hero who embodied multiple virtues. The Washington panel represents the related scene of the Continence of Scipio, again a subject that celebrates the virtue of self-restraint as emphasized by the inscription on the wall tablet, which reads in translation, "It is more shameful to be ruled by Love than to be conquered by War." The composition is divided by the central figure of Scipio seated on a throne near the plaque, the one borrowing from an ancient object, whose form was taken from the base of a candelabrum in the Grimani collection. The steps of Scipio's throne are decorated with classical reliefs, a prototype for Saint Mark's throne in Titian's Antwerp altarpiece. Behind Scipio his troops stand at ease in poses that are both relaxed and distinguished, while on the right-hand side, the procession accompanying the captive princess is much more lively and animated, awaiting the moment of Scipio's decision.

detail, cat. 28

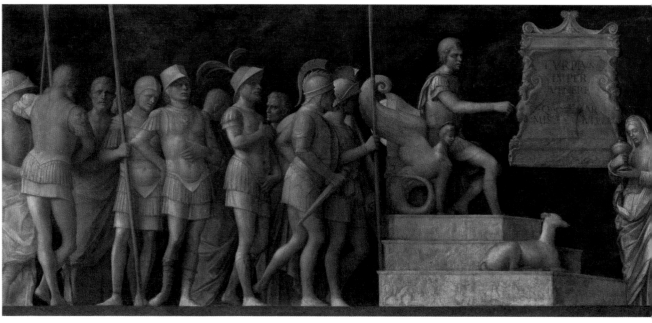

28

The Continence of Scipio is frequently represented on Renaissance wedding chests (cassoni) like one by Apollonio di Giovanni in the Art Institute of Chicago.[4] For fifteenth-century Italians Scipio represented an ideal marriage broker, an exemplary model for bride and groom. According to several sources—Livy (History of Rome 26.50), Valerius Maximus (Deeds of Famous Men 4.3), and Silius Italicus (Punic War 15.268)—the soldiers brought to Scipio a young virginal captive, a princess of exquisite beauty. Scipio learnt that she was betrothed to Allucius, a young prince of Celtiberi. Scipio returned the woman to Allucius unharmed and refused to accept the ransom offered by her parents, swearing that she had been treated with as much respect as if she had been with her own family. Only one reward was requested, friendship with the Roman people. For Knox, the subject in Bellini's interpre-

tation is the lesser-known episode in which Scipio addressed the Iberian hostages after the fall of Cartagena.[5] Knox identifies the elderly woman near the throne as the wife of Mandonius, who pleads with Scipio to protect the younger women's virginity. Alternatively the complex procession could be read as one merely of bringing gorgeous and valuable gifts to Scipio— loot that contrasts with his chaste and magnanimous nature. Amid all the seriousness, a lighter note is struck by the figures holding up jars, not unlike a satyr in Bellini's Feast of the Gods (cat. 32).

The Washington painting has recently undergone conservation treatment, providing opportunities for new observations about the artist's technical procedures. Dunkerton has determined that the cusping on the original fabric for Mantegna's Cybele in London is exactly the same as that on Bellini's Scipio in Washington—

confirmation perhaps that Bellini was given the canvas by Mantegna's heirs.[6] Infrared reflectography has brought to light an underdrawing with a number of pentimenti, of which the most significant was the repositioning of the rider with the helmet. The painting is brought to a different level of completion for the figures on the left than for those on the right, which are less elaborate. There are considerable damages throughout, which may explain negative judgments made about the authorship and execution of the grisaille in the past.[7] Responding to his brother-in-law must have been a considerable challenge for Bellini. Instead of the ponderous figures of Mantegna, he conceived of an antiquity peopled by delicate and sensitive figures, reenacting the fables of an ancient age from a sixteenth-century Venetian perspective.

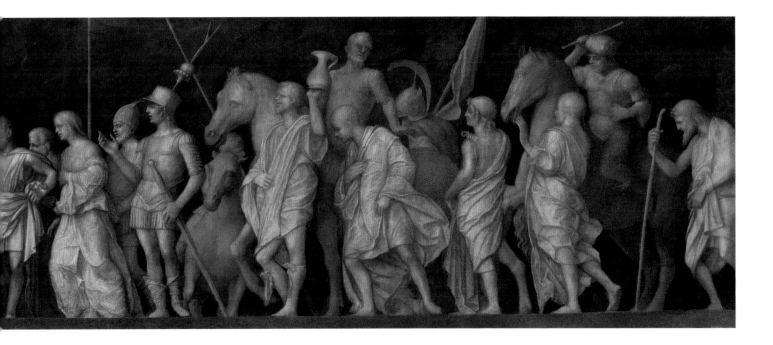

1. During the recent conservation treatment of the painting by Michael Swicklik at the National Gallery of Art, the inscription emerged in a somewhat different form from what was previously published. The compiler thanks Dr. K.O. Chong-Gossard at the University of Melbourne for his new transcription and translation: TVRPIVS IMPER(ARI) VENERE Q(VAM) ARMIS VINCI (It is more shameful to be governed by Venus than to be conquered by arms); or, more simply (It is more shameful to be ruled by Love than to be conquered by War).

2. The documentary sources are discussed by Brown 1974, 101–103.

3. Keith Christiansen in *Andrea Mantegna,* Jane Marineau, ed. (London and New York, 1992), 412–416. Braham 1974.

4. A survey of representations of Scipio in the Renaissance is given in Cristelle Baskins, "(In)Famous Men: The Continence of Scipio and Formations of Masculinity in Fifteenth-Century Tuscan Domestic Painting," *Studies in Iconography* 23 (2002), 109–136.

5. Knox 1978, 79–84.

6. Unpublished report in the National Gallery of Art files.

7. In an unpublished letter from Roberto Longhi, December 1948, preserved in the Archive of Villa I Tatti, Florence, he called for a more detailed evaluation of the *camerino* of Francesco Cornaro and initiated a new positive approach to the interpretation of the painting.

Provenance: Probably commissioned by Francesco Cornaro, Venice; Sir John Charles Robinson, London; sold 1873 to Sir Francis Cook, 1st Bt., Richmond, Surrey; by descent to Sir Francis Ferdinand Maurice Cook, 4th Bt.; sold February 1948 to Count Alessandro Contini-Bonacossi, Florence; sold March 1949 to the Samuel H. Kress Foundation, New York; given in 1952 to the National Gallery of Art.

Selected References: Brockwell 1932, no. 133; Shapley 1968, 42; Robertson 1968, pl. cviiib, 118, 132–133; Brown 1974, 101–103; Knox, 1978, 79–84; Washington 1985, 42; Goffen 1989, 238–240, fig. 174; Tempestini 1992, 265–267, no. 94; Tressider 1992, 660–662; Goffen 2002, 18–19; Pincus 2004, 122–142; Laclotte 2005, 76.

29

Giorgione

SUNSET LANDSCAPE
("IL TRAMONTO")

c. 1507, oil on canvas
73.3 × 91.5 (28⅞ × 36)
The National
Gallery, London

The title "Il Tramonto" (The Sunset), by which this enigmatic religious painting is known, was invented by Longhi in recognition of the fact that the sunset at dusk was the principal subject, while the activities of the saints who inhabit the landscape are seemingly of secondary importance.[1] A good proportion of Giorgione's few celebrated paintings, such as the *Tempest* and the *Three Philosophers*, are concerned with the depiction of transitory effects of light—a thunderstorm, a sunrise, a sunset, or the blue hazy distance seen in atmospheric perspective. According to Pliny in his *Natural History* (book 35), for an artist in the ancient world these subjects were the most difficult to represent. Giorgione took up this challenge, and nearly all of his works evince a determination to depict in painting what the ancient world found possible to represent or imagine successfully only in words.

The landscape framing the sunset is inhabited by four tiny figures and a number of strange animals, and it was evidently Giorgione's intention to provoke the spectator to consider the relationships between them. Lurking in a crevice in the right-hand background is Anthony, a tiny bearded hermit, and in a watery cave below him, his faithful pig. Not far from Saint Anthony in the middle distance is Saint George, engaged in his battle with the dragon. Larger than the others and more prominently represented in the foreground are two figures engaged in a compassionate act of healing: a mature man tenderly attends to the leg of a young boy. The older man is sometimes identified as

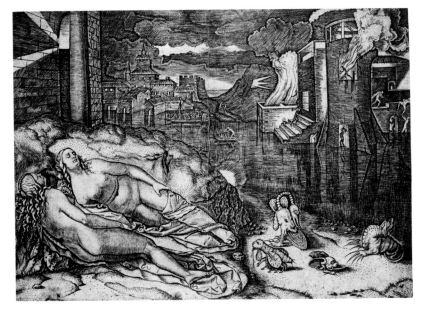

Saint Roch, who was associated with healing as a consequence of the plagues that frequently occurred. Yet he has none of the traditional attributes of Roch, notably, the conspicuous sore found on the saint's upper leg. There is, however, a casket of wine, perhaps a reference to the saint's healing with wine and vinegar of a disease (ergotism) known as Saint Anthony's fire (see also cat. 23).[2]

Scarcely of lesser importance are the fantastic hybrid animals. The swimming bird, with a viciously open beak, gazes at the act of healing taking place. Nearby, a dark creature shaped like a rhinoceros lurks in the water. Even the traditional pig is given a sinister presence, resembling a rat on the water's edge. These monsters have always been construed as references to the imagery of Hieronymus Bosch, whose works were found in several Venetian collections known to Giorgione, principally that of Cardinal Domenico Grimani, who owned two

versions of the northern artist's *Temptations of Saint Anthony.* The Grimani family were patrons of the Antonite hospice in Venice from the fourteenth century until its dissolution in 1807. Sufferers from ergotism often experienced hallucinations of the kind that may be reflected in the suggestive monsters in the landscape. Among Giorgione's works, the London picture is unique in representing northern fantasies and dream imagery. A single comparative example, said to represent a lost composition by Giorgione, is an engraving by Marcantonio Raimondi known as the *Dream of Raphael* (fig. 1). In the print, two slumbering female figures, of Giorgionesque proportions, dream in a way that only Bosch could have imagined.

162 The combination of Saints Anthony and George in Italian Renaissance painting is equally rare. A Pisanello panel, in the National Gallery, London, is the only other configuration of these saints, conceived as a symbolic victory of the spirit over the devil. In the present work, Giorgione combined two kinds of landscape as if to signify the triumph of Saints Anthony and George over infernal powers. The upper part of the picture represents in blue monochrome a distant hamlet and the plain of a Veneto landscape. To the right of this scene is a view of a country town resembling that in Giorgione's *Adoration of the Shepherds* (cat. 17) as well as the underdrawn landscape in the central part of the Dresden *Venus.* In contrast with the calm Venetian hinterland, the lower watery section consists of strange natural forms that echo those of the animals: the contours of rocks are bearded with tussocks of grass, the gnarled roots of a large tree are exposed, a cliff is murky, jagged, and spiky. Above all, the extraordinary sunset makes the landscape vibrate with the magic of an Antonite miracle. The extraordinarily inventive composition of *Il Tramonto* can be compared for its unconventionality only with Giovanni Bellini's *Sacred Allegory* in the Uffizi, Florence. Though ostensibly a religious picture, Giorgione's painting has, even more than Bellini's, the qualities associated with profane allegories of the period.

1. Longhi 1934 (1956 ed.), 179.

2. Anderson 1997, 181–184.

Provenance: Discovered by Giulio Lorenzetti in 1933 at the Villa Garzoni, Pontecasale; collection of Vitale Bloch 1934–1957; acquired by the National Gallery via Colnaghi's in 1961.

Selected References: Sangiorgi 1933, 789; Longhi 1934 (1956 ed.), 179; Zampetti 1968, no. 18; Gentile 1981, 12–25; Ballarin 1993, 307–309 (with full bibliography); Anderson 1997, 181–184, 301.

29

30

Giorgione

THREE PHILOSOPHERS

c. 1506, oil on canvas
123 × 144 (48 7/16 × 56 11/16)
Kunsthistorisches Museum,
Gemäldegalerie, Vienna

This masterpiece by Giorgione has an exceptionally well-documented beginning, when the Venetian patrician and connoisseur Marcantonio Michiel described it in the collection of his friend Taddeo Contarini in 1525 as: "The canvas in oil of Three Philosophers in a Landscape, two standing and another seated, who contemplates the rays of the sun, with a painted rock that is miraculously rendered. It was begun by Zorzo da Castelfranco and finished by Sebastiano the Venetian." Though Michiel did not give the figures specific identities, Giorgione, to judge from the way he differentiated them in his painting, intended to depict particular philosophers. In subsequent inventories, however, Michiel's description was forgotten, and the protagonists were described simply as "figures," as in Dario Contarini's will (1545), or as "geometers and mathematicians" (1638), or as the "Three Magi" (1783) in the first inventory of the Kunsthistorisches Museum in Vienna.[1]

The main theme of the painting has always been recognized as the contrast between light and darkness, which is evaluated by three philosophers representing the three ages of man. Before the painting was cut on the left, the metaphor of light and dark would have been more evident, as the dark rocky face would have occupied at least half the surface of the painting.[2] The young philosopher contemplates the darkness, the mature eastern philosopher contemplates our world, while the oldest philosopher holds up a diagram with calculations and appears almost blind. On the old philosopher's piece of parchment are a quarter moon, a circular disc with

spokes, and the numbers one to seven, reminiscent of astronomical diagrams of lunar computation. The spoked disc may be a lunar volvelle, a rotating disc made from parchment or wood that was used to calculate the occurrence of a lunar eclipse. Such lunar volvelles are frequently found in astronomical manuscripts from the mid-fourteenth to the late fifteenth centuries. Beneath the philosopher's hand some have seen a Greek word, while others read the date 1505. The emphasis on light and darkness in relation to philosophy has suggested one of the most credible interpretations of the painting, originally proposed by Meller, who argues that it represents the education of philosophers, as described in book 7 of Plato's *Republic*, whose famous allegory concerns the cave, the sun, and the dividing of the line.[3]

Giorgione's patron, Taddeo Contarini, was one of the richest men in Renaissance Venice and brother-in-law of Gabriele Vendramin, the owner of Giorgione's celebrated *Tempest*. Plato's myth, which was an artistic subject in the Renaissance, would have appealed to the intellectual interests of the patron, who was also a reader of ancient manuscripts of astronomy and philosophy, which he borrowed from Cardinal Bessarion's library, which formed the basis of the Marciana Library, Venice. Contarini was not only rich and erudite, but also a serious collector. And he must have been a judge of quality in art, for he possessed one of the most magical pictures Giovanni Bellini ever painted, *Saint Francis in the Desert*, now in the

Frick Collection, New York. Contarini was particularly fond of Giorgione and possessed other works by him, all with classical subjects, and all now lost, including his *Finding of the Infant Paris, Hell with Aeneas and Anchises*, and the late *Night*, which had appealed to Isabella d'Este (see cat. 17).

In the twentieth century the significance of the *Three Philosophers* was colored by Wilde's misinterpretation of the first x-ray taken of the painting, in 1932. Writers following Wilde regarded Giorgione's figures as the Three Wise Men on the grounds that one of them may have been black.[4] After Anderson argued in 1979 that x-radiographic evidence cannot determine underlying color, the view that the Three Philosophers were Magi has not been repeated.[5] Further to the x-radiographs, the new infrared reflectogram made in 2004, and published here for the first time (see page 293, fig. 11), reveals an even more complex pictorial development than previously supposed. In the landscape, the horizon was originally placed lower, there was a castle to the left, and the sky was more open with fewer trees. The seated philosopher wore a head covering, while the philosopher depicted on the right was in profile and somewhat thinner, wore an amazing solar headdress, and held a different object, not the chart. The middle philosopher had a shorter dress and his right hand was repositioned. The new infrared reflectogram lends no support to the theory that Sebastiano del Piombo may have intervened in the execution of the picture. Indeed, we may doubt Michiel's testimony that Sebastiano made any significant contribution to the work,

except as an assistant in preparing Giorgione's colors. The more we know about the painting's underdrawing, the more it appears to be the work of one hand. These newly revealed pentimenti show how carefully Giorgione devised and refined the composition, particularly the figures. That the picture represents philosophy in the Renaissance should not be doubted, but it may always remain a matter of speculation as to which philosophers are represented.

1. Dario Contarini's will of 14 November 1545 was first published by Anderson 1997, 148–150.

2. The painting was considerably cut on the left-hand side, at least as much as 17.5 centimeters.

3. Meller 1981, 227–247.

4. Wilde 1932, 141–154.

5. Jaynie Anderson, "L'année Giorgione," *Revue de l'art* 43 (1979), 83–90.

Provenance: Collection of Taddeo Contarini, Venice; by descent to Dario Contarini; Bartolomeo della Nave, 1638; bought by Lord Basil Fielding, 2nd Earl of Denbeigh for his brother-in-law, James Hamilton, 3rd Marquis of Hamilton, 1639; collection of Archduke Leopold Wilhelm, 1659; Kunsthistorisches Museum, Vienna, by 1783.

Selected References: Wilde 1932, 141–154; Pignatti 1969, 105–106; Wind 1969, 4–7; Battilotti and Franco 1978, 58–61; Settis 1978, 19–45; Meller 1981, 227–247; Hope and Van Asperen de Boer 1991, 129–131; Torrini 1993, 86–93; Anderson 1997, 57–58, 86–90, 152–157; Nepi Sciré and Rossi 2003, 124–133, no. 4; Ferino-Pagden and Nepi Sciré 2004, no. 5.

30

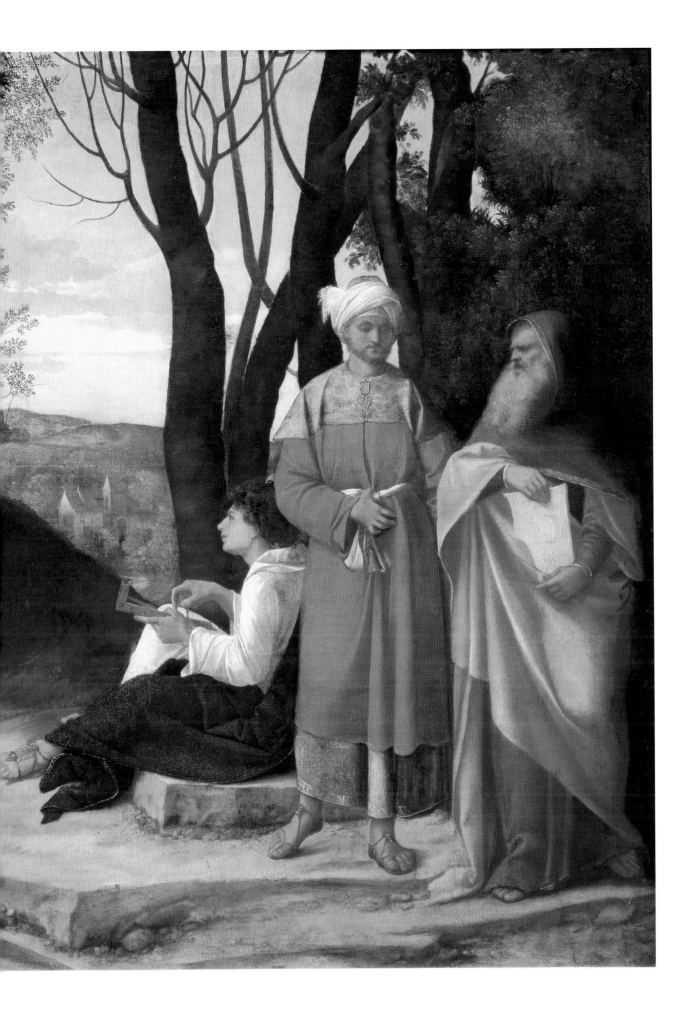

1.

Titian, *Concert
Champêtre*, infrared
reflectogram of
the lute

2.

Titian, *Concert
Champêtre*, infrared
reflectogram of
the standing Muse

31

Titian

PASTORAL CONCERT
("CONCERT
CHAMPÊTRE")

c. 1510, oil on canvas
105 × 136.5 (41 5/16 × 53 ¾)
Musée du Louvre,
Departement des Peintures,
Paris

The genre title, *Concert Champêtre*, which Lépicié, in his 1754 catalogue of the French royal collection, casually gave to this, the greatest erotic masterpiece in the history of Western painting, has always obscured its Renaissance meaning. Until the twentieth century the picture was traditionally attributed to Giorgione, on the grounds that such a work belonged to the biography of an artist characterized in Vasari's *Lives* as a musician who played the lute for patricians and continually enjoyed the pleasures of love.[1]

The patron for whom the picture was painted remains unknown. Famous names have been suggested, like that of Isabella d'Este.[2] And it has been identified as the *bagno* commissioned for Isabella's brother, Alfonso d'Este, or a bath scene in Lord Arundel's collection in the seventeenth century.[3] But a *bagno* would better describe Palma Vecchio's painting of nymphs (cat. 35) than this meditative allegory on the creation of poetry. A century and a half after it was painted, the *Concert Champêtre* emerged in the collection of Eberhard Jabach, a naturalized French banker of German origin, who served as director of the East India Company in Paris. An indebted Jabach was forced to sell his collection, which Jean-Baptist Colbert bought for Louis XIV.

Writers entranced by the painting have felt compelled to account for the strange configuration of two handsome young males, clothed and making music, accompanied by two nude women. Once before in the history of art such a configuration of a clothed man with a nude woman

had occurred, in Giorgione's *Tempest* in the Accademia, Venice. Another detail links the *Tempest* with the *Concert:* the protagonists in both works wear the bicolored hose of the Compagni della Calza (Companions of the Order of the Stocking), an elite patrician group of young people who arranged special events for Carnival or for notable patrician marriages.[4] The three protagonists on the right form an inward looking group, their backs turned, immersed in their own emotional world. On the left a woman pours water back into a fountain in a seemingly unmotivated gesture and, unlike her companions, faces the external world. The men and the women are characterized by contrasting urban and rustic life styles. The lute player, holding an expensive musical instrument and wearing an

elegant red velvet beret, a finely embroidered shirt, and a black overgarment with red bouffant sleeves, is an urban libertine, while the singing shepherd is a barefoot peasant. The seated nude likewise bears the marks of aristocratic luxury: her chignon, tied with white silk, falls lightly on her shoulders, while her counterpart appears more like a disheveled robust country nymph.

That the *Concert* is simply a bucolic encounter between two couples on a warm afternoon is obviously too simple an explanation of the meaning of the work. A persistent view has been that this is a representation of a poem by Theocritus about Daphnis, a shepherd who invented bucolic poetry. Daphnis was blinded by a nymph to

whom he had sworn fidelity. Similarly the picture has been related to passages in Virgil's *Eclogues* (2. 28–34, 45–50, 60–62), as when the shepherd Cordon, the unhappy lover of the beautiful Alexis, seeks to attract her favors by showing his talent as a musician. A third theory points to Sannazaro's *Arcadia* (first printed in 1502 and frequently reissued), whose narrator Sincero is in dialogue with the shepherd Carino, a motif that might be illustrated by the two male figures in the *Concert Champêtre.* Each interpretation seeks to locate the meaning of the painting as an illustration of a pastoral poem from antiquity or the Renaissance.

There are two contributions to unraveling the iconography of the *Concert Champêtre* that every scholar concerned with the picture has to assess.[5] In 1957, Fehl observed that the women were invisible to the men and represent Muses. Fehl also noted the lack of emotional engagement between the couples; to him the psychological interaction between men and women in nineteenth-century French adaptations of the painting, like Manet's *Déjeuner sur l'herbe,* did not exist in the Venetian prototype.[6] In 1959 Egan noted that the gestures of the two women—one holding a flute and the other pouring water back into the fountain—correspond to the attributes of the single figure of Poetry (Poesia) as depicted on playing cards called *tarocchi.*[7] So compelling are the associations of poetry and music with the Muses that most subsequent scholars have accepted both of these observations, though sometimes with qualifications or modifications.

In May 2005 the *Concert* was reexamined and new infrared images were produced.[8] From these we learn that the artist began by conceiving the figures on the right as turned away from the spectator even more than they are in the final version. The lute player's face was first drawn in *profil perdu,* his features a shadowy outline; but in the final version he was turned towards the spectator by the addition of a nose. Originally the lute player played a smaller instrument, his right hand strumming its chords (fig. 1), before the instrument grew larger and his hand came to rest on it in repose. In rethinking the composition, the artist depicted the silence of music in this meditative, poetic picture.

In 1949, x-radiography revealed the figure of another woman beneath the standing muse. The new scientific evidence clearly indicates that this first version of the female figure is unfinished (fig. 2) and represented frontally, with legs parallel and face turned towards her companions. Her silhouette resembles *La Primavera,* an engraving dated 1508 by Marcantonio Raimondi, said to be after a lost work by Giorgione. For the second position of the standing figure the artist used an unusual grid system of vertical and double horizontal lines. Drawn over her body, but not her head and left hand, the grid is realized in fine black chalk. Her first hand holding the carafe was positioned closer to the left edge of the composition, and the well was first conceived as a circular shape, perhaps representing a vase, decorated with curved, alternating bands. In the history of the attribution of the painting it has sometimes been argued that the changes to the standing female figure, first noted in 1949, are the work of another artist, Titian, for instance, completing a picture by Giorgione.[9] Now, as the recent technical investigation has established, the changes occur so frequently throughout the painting that they appear to be the work of one hand and mind. The attribution to Titian was first made by Schlegel, who saw the painting being conserved in 1803. Yet, for most of the nineteenth century, Morelli's attribution to Giorgione prevailed, until Hourticq, in one of the most important books ever written on the young Titian, gave the *Concert* to that artist with extensive comparisons to his early works.[10] In 1976 the museum officially designated the picture as Titian's, reflecting growing scholarly opinion in his favor. By the time of Ballarin's exhaustive review of the critical fortune of the picture in 1993, the Titian attribution predominated, and it is now nearly universal.[11]

1. Quoted in Anderson 1997, 364.

2. Isabella's ownership was first questioned by Egan 1959.

3. Greater credence has been given to the Arundel provenance than to others. See Anderson 1997, 308–309.

4. See the statutes of the Compagni confraternity in David Chambers and Brian Pullan, *Venice. A Documentary History 1450–1630* (Oxford, 2003), 378–380. For further accounts of the Compagni, see Chojnacki 2003 and Muraro 1976–1986.

5. For some recent iconographic interpretations, see Francis Broun, "The Louvre 'Concert Champêtre': A Neoplatonic Interpretation," in *Ficino and Renaissance Neoplatonism*, Konrad Eisenbichler and Olga Zorzi Pugliese, eds. (Toronto, 1986), 29–38; Elhanan Motzkin, "The Meaning of Titian's *Concert Champêtre* in the Louvre," *Gazette des Beaux-Arts* 116 (1990), 51–66; Patricia Emison, "The 'Concert Champêtre' and Gilding the Lily," *The Burlington Magazine* 133, no. 1056 (March 1991), 195–196; and Ross S. Kilpatrick, "Horatian Landscape in the Louvre's "Concert Champêtre," *Artibus et Historiae* 21, no. 41 (2000), 123–131.

6. Fehl 1957, 153–168.

7. Egan 1959.

8. The compiler thanks Bruno Mottin and Jean Habert for their generosity in sharing the results of their investigations with her and with the readers of this catalogue.

9. Wethey 1975, 10–15, 167–169; and Joost-Gaugier 1999, 1–13.

10. Hourticq 1919, 9–21.

11. Ballarin 1993, 392–400. See also Freedberg 1993, 62–63; Valcanover 1999, 16–17; Pignatti and Pedrocco 1999, 207; Pedrocco 2001, 82–83; and Joannides 2001, 98–105. The writer of this entry continues to believe, nevertheless, that the *Concert* is by Giorgione rather than Titian. To the evidence proffered in her monograph on Giorgione (1997), she would contrast the newly discovered underdrawing with a drawing on paper in the British museum, always associated with the Louvre picture and frequently attributed to Titian (Harold E. Wethey, *Titian and His Drawings* [Princeton, 1987], no. 35, 153–154 and fig. 69), which shows a different graphic style.

Provenance: Collection of Eberhard Jabach, Paris; sold to Louis XIV, 1671; Duc d'Antin, son of Madame de Montespan, Paris; from 1736 in the reserve collection at Versailles; transferred in 1792 to the Musée du Louvre, Paris.

Selected References: Lépicié 1754, 2, 46; Hourticq 1919, 1–31; Fehl 1957, 135–159; Egan 1959, 103–113; Klein 1967, 199–206; Haskell 1971, 543–555; Fischer 1974, 71–77; Krumrine 1981, 5–10; Benzi 1982, 183–187; Ballarin 1993, 340–348; Freedberg 1993, 62–63; Holberton 1993, 245–262; Hope 1993, 22–25; Jaubert 1994; Anderson 1997, 76–79, 87–90, 135–136, 285–286, 307–308; Joost-Gaugièr 1999, 1–13; Pignatti and Pedrocco 1999, 207; Valcanover 1999, 16–17; Joannides 2001, 98–105; Pedrocco 2001, 82–83; Volle 2005.

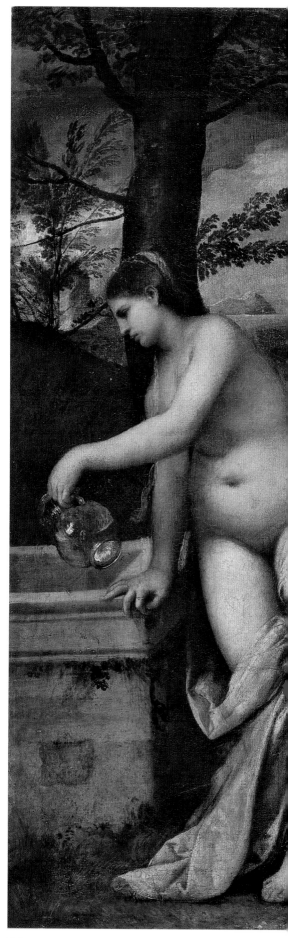

31

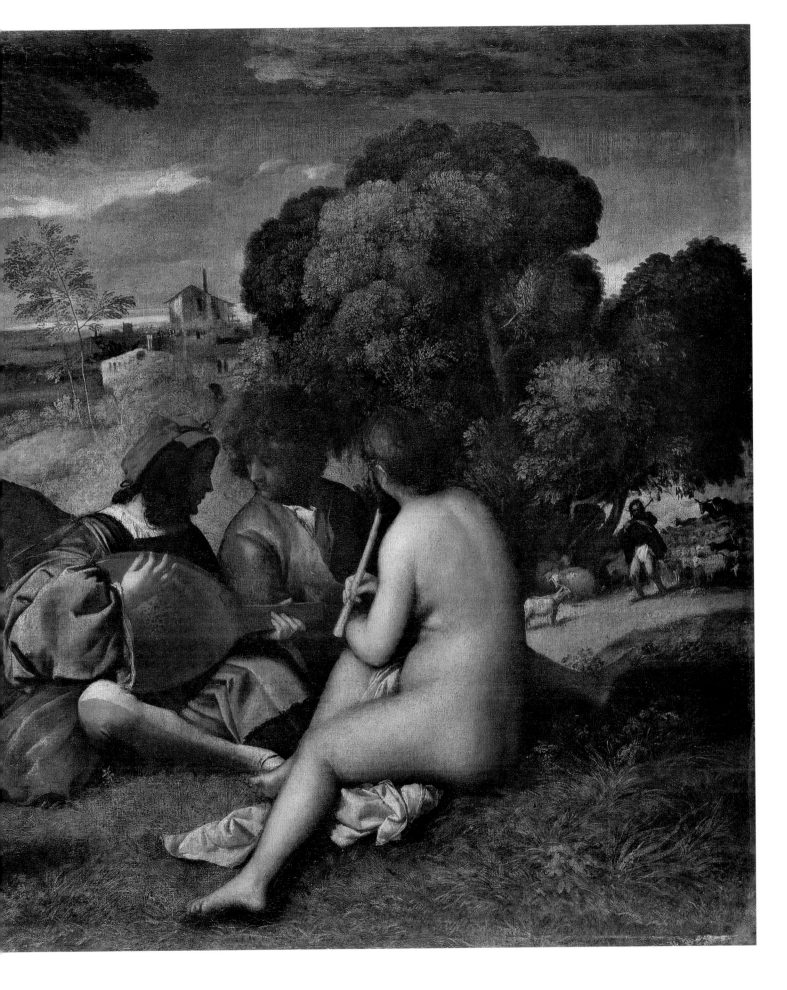

32

Giovanni Bellini and Titian

FEAST OF THE GODS

1514 and 1529, oil on canvas
170.2 × 188 (67 × 74)
National Gallery of Art,
Washington, Widener
Collection

signed: jovannes bellinus
venetus / p. MDXIIII

On 14 November 1514 Giovanni Bellini received 85 golden ducats from Alfonso d'Este in payment for the painting that we now know as the *Feast of the Gods*. It was the duke's first commissioned work for the most beautiful room in Renaissance Italy, known as the Alabaster Room (*camerino d'alabastro*), located in a covered passageway linking the castle and palace at Ferrara. That Alfonso chose Bellini for this task above all other Italian artists reveals how highly the painter was esteemed in the last years of his life. Bellini prominently signed and dated the painting on a *cartellino* (piece of paper) wittily placed on the wine cask in the lower right corner.

The classical subject of the gods of antiquity at a bacchic festival was recounted by Ovid in several passages in his poem *Fasti* (1.391–440; 6.319–348). In Bellini's interpretation Mercury is seated at the center of the painting wearing his famous cap at an angle and looking a bit befuddled from too much wine, as do his companions. The main protagonists, from left to right, are Silenus, a woodland diety accompanied by his donkey; the infant Bacchus in blue; the ancient god of the forest Silvanus wearing his wreath; Mercury, leaning on a barrel with his caduceus; Jupiter drinking with his eagle; Persephone (also identified as Amphitrite) eating fruit next to a dark-skinned Pluto (also identified as Neptune), who fondles her thigh in a familiar manner. Ceres, goddess of agriculture, is represented kneeling to assist her companion Apollo, who is drinking intemperately, his body so slumped that he has to clutch a *lira da braccio* for support. All of these figures form a circle around an exquisitely beautiful young

woman, who is sleeping on the right-hand side of the picture. A young man, in a state of some sexual excitement, is lifting her dress. In 1948 Wind recognized him as Priapus, god of the vineyards, attempting to rape the nymph Lotis.[1] His attempt was foiled by the ass, which in Ovid's account brayed and awakened the startled nymph. All the gods laughed at Priapus, who took his revenge by demanding the annual sacrifice of a donkey.

Bellini's late masterpiece is unparalleled in the Renaissance for the humor, both affectionate and erotic, with which he retells an ancient story and presents the foibles of the gods and goddesses. When the painting was in the Camuccini collection in Rome in the eighteenth century, it was appropriately thought to represent the ancient proverb "Sine Cerere et Baccho friget Venus" (Lovemaking is cold without food and wine). Every detail of the composition contains a suggestive innuendo, which Alfonso and his friends must have enjoyed. Indeed, Alfonso's libertine personality was in harmony with the explicit sexual imagery that Bellini created.[2]

After Bellini's death in 1516, the *Feast of the Gods* was substantially reworked by two artists, at different times, presumably to make it align with pictures that they themselves later painted in the same room. These alterations, whatever their merits as painting, have obscured the dramatic and emotional intensity of Bellini's composition. X-radiographs (see page 289, fig. 4) show that Bellini originally placed the gods before a continuous band of trees, just as one sees in his painting of the *Death of Saint Peter Martyr* at the National Gallery, London.[3] Bellini's conception of the subject was to isolate the company

in a grove, with the sun streaming between the trees. If his picture had not been altered, the silhouettes of some of the seemingly marginal figures would have been clearer, like that of the satyr on the left-hand side of the painting, who merrily dances with a phallic jar on his head, or the satyr, to the left of the middle of the picture, who provocatively balances a precious porcelain vessel on his head.

The first modifications to Bellini's composition are attributed to the Ferrarese court artist Dosso Dossi, who provided for the same room both a bacchanal and a frieze of ten paintings, one of which, *Aeneas and Anchises on the Libyan Coast*, of about 1520, is also in the National Gallery in Washington. The similarities between Dosso's picture and the repainting of Bellini's, both in style and in the pigments chosen, notably the vivid idiosyncratic green, confirm that Dosso was responsible. The first modifications were to the left-hand side of the painting and disturbed Bellini's carefully articulated silhouette of the tipsy satyric background figures. Dosso added buildings on a hill and painted over Bellini's enclosed woodland grove. He may also have added the extraordinary pheasant placed on the tall tree on the right-hand side. The reverence with which this additional detail was maintained is significant, as is the differing color of the leaves just above the bird.

Titian visited Ferrara on several occasions, but it is believed that his alterations date from 1529, when he stayed for three months. That he was asked to rework the picture suggests that the earlier changes, to which Alfonso must have consented, were hardly

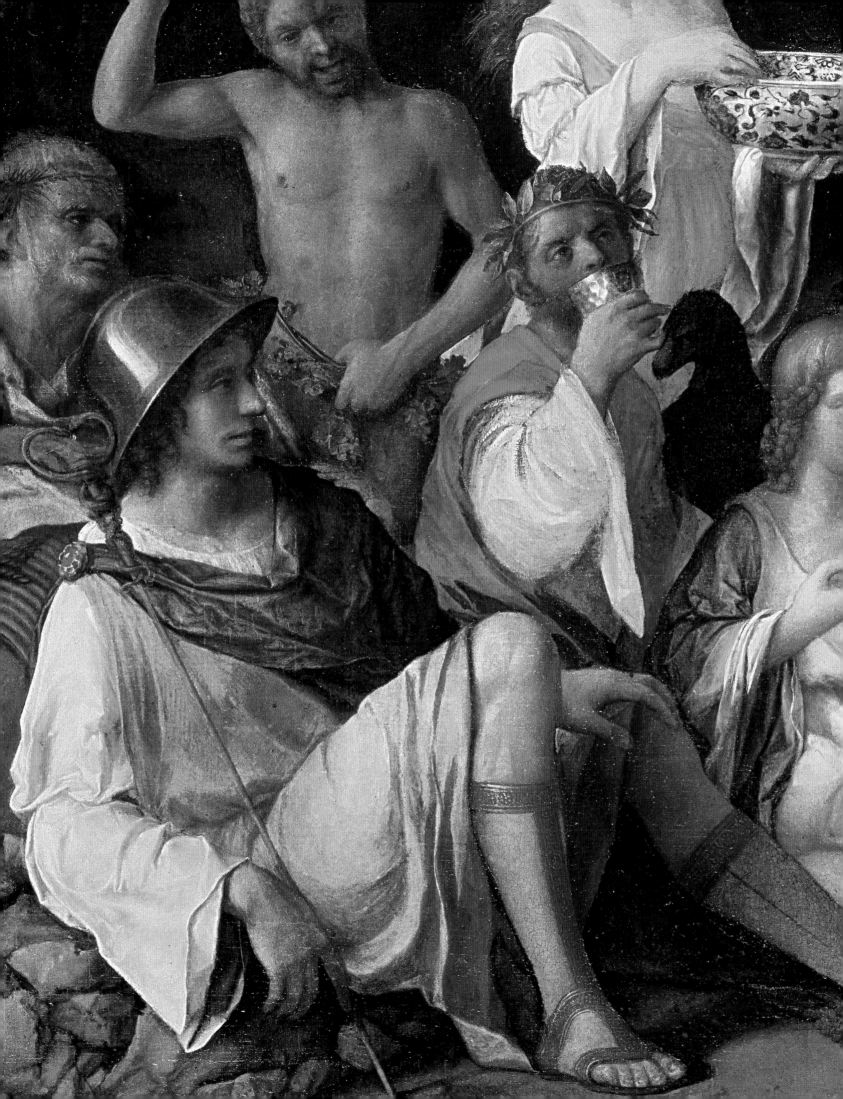

satisfactory. Titian's contribution consists principally of the steep mountain, where his brushwork may be detected in the landscape forms and in details such as the two drunken satyrs and the hunting hound chasing a stag. With these additional layers, the paint surface here is much thicker. Titian, who was Alfonso's fifth choice to paint in the *camerino* (contributions were also solicited, unsuccessfully, from Raphael and Fra Bartolommeo), must have been challenged by the authority of his former master Bellini, but his changes show that he was scarcely reverential.

The substantial and radical reworkings of the painting, for which there was no technical reason, have contributed to making its conservation history one of the most complex in the history of art. The literature presents a series of misconceptions, beginning with Giorgio Vasari's statement that the picture was left unfinished by Bellini and completed by Titian. Was Vasari misinformed by Titian? Bellini signed and dated the picture, indicating that he believed he had completed it. Only one detail appears unfinished: perhaps the standing nymph's outstretched hand should have held an object. The publication of the conservation treatment conducted between 1989 and 1993, by Bull and Plesters, modified John Walker's monograph on the *Feast of the Gods* of 1956, by revealing that the erotic revisions of the draperies and attitudes of the figures were entirely due to Bellini and not to Dosso or Titian, as Walker and others had supposed.[4] The critical reception of the *Feast of the Gods*, both in its own time and afterwards, is highly illuminating and has contributed to a deepening awareness of the complexity of Giovanni Bellini's artistic personality.

1. Wind 1948, 28–29.

2. Manca 1993, 305–307.

3. Bull and Plesters 1990; Brown 1993, 289–299.

4. John Walker, *Bellini and Titian at Ferrara* (London and New York, 1956).

Provenance: Painted in 1514 for Alfonso I d'Este, Duke of Ferrara; confiscated in 1598 by Cardinal Pietro Aldobrandini, Rome; by descent to Giovan Battista Borghese Aldobrandini; acquired 1797 by Vincenzo Camuccini; by descent to Giovanni Battista Camuccini, 1853; sold 1855 to Algernon Percy, 4th Duke of Northumberland, Alnwick Castle; sold by the 7th Duke of Northumberland to Agnew's in 1916; bought by Arthur J. Sulley & Co. London, 1917; collection Carl W. Hamilton, 1920; London, Agnew's, until 1921; collection of Joseph E. Widener, Lynnewood Hall, Elkins Park, Pennsylvania, from 1922; bequeathed to the National Gallery of Art, 1942.

Selected References: Valentiner 1923; Wind 1948; Walker 1956; Fehl 1974, 42–55; Shapley 1979; Goffen 1989, 240–247; Bull and Plesters 1990; Colantuono 1991; Anderson 1993, 264–287; Brown 1993, 288–299; Bull 1993, 366–373; Manca 1993, 303–313; Plesters 1993, 375–391; Sheard 1993, 315–357; Falomir 2003, 168–169, 361, no. 13; Jaffe and Carey in *Titian* 2003, 108–109, no. 15.

32

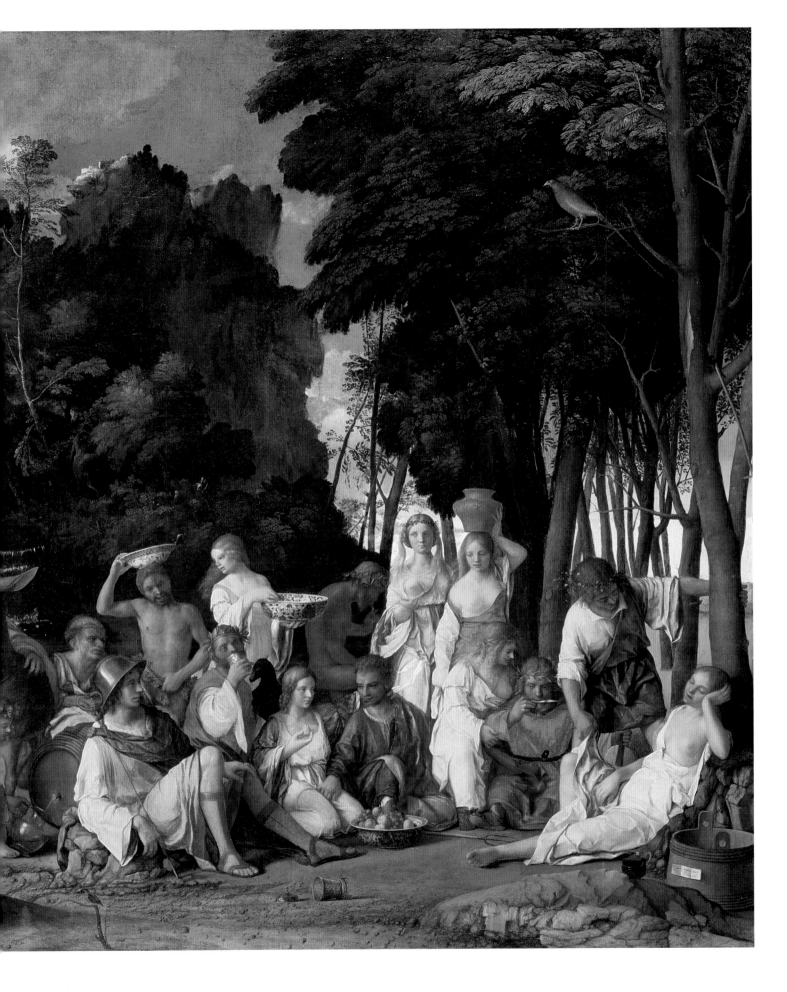

33

Titian

BACCHANAL
OF THE ANDRIANS

1522–1524, oil on canvas
175 × 193 (68 7/8 × 76)
Museo Nacional del Prado,
Madrid

signed: Ticianus F

·

Washington only

After Giovanni Bellini's *Feast of the Gods* (cat. 32) was delivered in 1514, Duke Alfonso d'Este turned to central Italian painters for the decoration of his *camerino*, a small rectangular room in the castle at Ferrara. Emulating his sister Isabella d'Este's project to unite works by the greatest living masters in her *studiolo* in Mantua, Alfonso solicited contributions from the Florentine Fra Bartolommeo and from Raphael. Both artists produced only preliminary drawings, however, and after their deaths, respectively, in 1517 and 1520, the duke transferred the commissions to Titian, whose Frari *Assunta* of 1516–1518 established him as Bellini's successor in Venice. In addition to a now lost work by the Ferrarese court painter Dosso Dossi, Alfonso obtained from Titian a series of three large mythological canvases —the *Worship of Venus* (cat. 34) in the Prado, the *Bacchus and Ariadne* in the National Gallery, London, and the *Bacchanal of the Andrians*. Executed between about 1518 and 1525, these works all draw on ancient literary sources and combine male and female nudes with figures in contemporary and classical dress.

For the first time since Alfonso's *camerino* was deprived of its pictorial decoration in 1598, Bellini's and Titian's paintings were reunited in the Titian exhibition held at the National Gallery, London, in 2003. The sequence of pictures proposed there—with the *Bacchus* on an end wall to the left, the *Andrians* and the *Feast* (followed by a space for the missing Dosso) on the long wall, and the *Venus Worship* on the end wall to the right—was criticized and rectified in the subsequent installation of three of the *camerino* paintings in the Prado venue of the Titian exhibition, with the *Andrians*

and the *Venus* flanking the *Feast,* in the center of the same wall.[1] The *Venus* was the first canvas to be delivered, in 1519, but the order in which Titian painted the *Bacchus* and the *Andrians* is disputed. Most scholars believe that the *Andrians* was the last in the series, though the pertinence of the surviving documentation to that work or to the *Bacchus* is not entirely clear. A letter of 14 October 1522, from Jacopo Tebaldi, Alfonso's agent in Venice, to the duke, appears to refer to the *Andrians* and to changes in that composition. It is preceded by a series of letters in which Titian is asked to finish the picture. In one, Tebaldi recounts that he caught Titian in his studio, who excused himself for his tardiness, as he said he had to repaint two nude figures, one of them presumably the nymph, the other the figure pouring from a jug. Titian is reported as saying that although the duke wishes for him to come to Ferrara to complete the heads and other little things, it would not be a good idea, as in Venice (unlike Ferrara) he has the availability of female prostitutes and men who will pose for him in the nude.[2]

The painter did not always sign his works, unlike Bellini, but in the *Andrians* he wrote his name in black on the edge of a handkerchief, tucked into the blouse, just above the breast of the woman dressed in red in the foreground. His intention was evidently to surpass his master, whose own signature was placed on the wine vat in the *Feast of the Gods*. Titian visually linked the two bacchanals when, probably in 1529, he repainted the background in Bellini's canvas so that it conjoined the hilly contour on

the right in the *Andrians*. Both pictures contain rivers meandering through the landscape, and comparison further reveals a number of echoes of Bellini's figure motifs and groupings, from the men bearing vessels on the left to the female nudes shown asleep in the lower right corner of each composition.[3] Titian's reclining nymph actually seems to invite comparison with Bellini's Lotis: the near life-size figure in the *Andrians* exhibits the new larger scale now considered appropriate for mythologies, as well as an air of sensual abandon that pervades the entire picture.

The musical score in the foreground of the *Andrians* is said to be by Adriaen Willaert and related to the text: "Chi boyt et ne reboyt / il ne seet ue boyre soit" (He who drinks and does not drink again / does not know what drinking is).[4] As with Bellini's painting, the literary source for Titian's canvas has been identified, in this case, in a description of an ancient work purportedly decorating a villa outside Naples, in the *Imagines* (1.25) of the Elder Philostratus. The Andrians inhabit an island, Andros, where a river perpetually flows with wine. The effect on the inhabitants is described ironically by Philostratus, who writes that wine "makes men rich, dominant, generous to their friends, handsome, and four cubits high." The short text challenged Titian to invent details for his composition:

Consider, however, what is to be seen in the painting: The river lies on a couch of grape-clusters, pouring out its stream, a river undiluted and of agitated appearance; thyrsi grow about it like reeds about bodies of water, and if one goes along past the land and these drinking groups on it, he comes at length on Tritons at the river's

mouth, who are dipping up the wine in sea-shells. Some of it they drink, some they blow out in streams, and of the Tritons some are drunken and dancing. Dionysus also sails to the revels of Andros and, his ship now moored in the harbour, he leads a mixed throng of Satyrs and Bacchantes and all the Seileni. He leads Laughter and Revel, two spirits most gay and most fond of the drinking-bout, that with the greatest delight he may reap the river's harvest.[5]

If both the *Feast* and the *Andrians* have ancient literary sources, Titian's picture is also classicizing in style and in the visual sources it employs to create an authentic evocation of the imaginary work described by Philostratus. The *Andrians* is replete with allusions to classical sculpture; the recumbent nymph recalls the famous *Sleeping Ariadne*, then believed to represent Cleopatra, in the Vatican.[6] And at least one of the nude male figures is based on those in Michelangelo's famous cartoon for the *Battle of Cascina* (page 34, fig. 12), known to Titian perhaps through copies. Indeed, the whole frieze-like arrangement of interlocking figures, viewed close-up to the picture plane, echoes both the cartoon and classical sarcophagi. Recent technical investigation at the Prado throws light on the genesis of the picture, which may be explained partly by the brief nature of the literary text, as well as Titian's efforts to outshine his former master's contribution displayed immediately to the right of his own. Many figures in the underdrawing, revealed by infrared reflectography, were not executed. Fine outlines were painted to define

the placement of the heads and figures. A pot between the dancing couple subsequently disappeared. The figure of the recumbent female was considerably changed and may even have been oriented in the opposite direction. The urinating Cupid does not appear to have been part of Titian's original conception for the picture, as no space was left for him. The most significant pentimento is the couple dancing the tarantella on the right-hand side. The female was first represented looking at her male companion, then her dress was lifted and his clothes made more spare.[7] Titian is said to have painted the figures nude, then dressed them; here he would appear to be undressing them again.

1. Peter Humfrey, Review of *Titian* 2003, *The Burlington Magazine* 145, no. 1201 (April 2003), 304–305 (304–306); and Beverly Louise Brown, Review of *Titian* 2003, and *Tiziano* (Falomir 2003), in *Renaissance Studies* 18, no. 1 (March 2004), 117–118 (113–123). Alfonso's *camerino* has now been exhaustively restudied by Alessandro Ballarin, who includes in his reconstruction of its pictorial decoration a *Bacchus* in Bombay, attributed by him to Dosso. See Ballarin 2002.

2. The full text of this letter, together with all the other documentation, is given by Maria Lucia Menegatti, "Documenti per la Storia dei Camerini di Alfonso I (1471–1634) Regesto Generale," in Ballarin 2002, 193, 3–340.

3. For the idea that Titian deliberately echoed Bellini's picture, see Hope 1980, 60; Goffen 1997, 121–126; and Falomir 2003, 166–167, 359–361, no. 12.

4. Edward Lowinsky, "Music in Titian's *Bacchanal of the Andrians*: Origin and History of the *Canon per tonos*," in *Titian: His World and His Legacy*, David Rosand, ed. (New York, 1982), 191–282.

5. Philostratus the Elder, *Imagines*, Arthur Fairbanks, trans. (Cambridge, Mass., 1960), 96–99.

6. See Bober and Rubinstein 1986, 113–114.

7. The compiler wishes to thank Miguel Falomir and his colleagues at the Prado for sharing the results of their technical examination with her and with readers of the catalogue.

Provenance: Commissioned by Alfonso I d'Este, for his *camerino*, Ferrara; confiscated in 1598 by Cardinal Pietro Aldobrandini, Rome; Cardinal Ludovico Ludovisi, Rome, 1623; Olimpia Aldobrandini, 1626; Prince Niccolò Ludovisi, Rome, 1633; in August 1633, given to the viceroy of Naples, Manuel de Açevedo y Zuñiga; February 1638, given to King Philip IV of Spain; by descent to the Museo del Prado, Madrid.

Selected References: Crowe and Cavalcaselle 1877, 1:170–196, 226–233; Gould 1969; Pallucchini 1969, 1: 50–52. 253–254; Panofsky 1969, 96–102; Freedberg 1975 (1971 ed.), 102–104; Hope 1971, 641–650; Hope 1971a, 712–721; Murutes 1973, 518–525; Fehl 1974, 37–96; Wethey 1975, 37–41, 151–153; Gentili 1980, 87–90; Holberton 1987, 57–66; Hope 1987, 25–42; Marek 1987, 67–72; Perez Sanchez 1987, 27–36; Gentili 1988, 138–145; Webb 1992, 180–185; Goffen 1997, 121–126; Pedrocco 2001, 140–141; Ballarin 2002, 1:395–396, 455; Falomir 2003, 166–167, 359–361; *Titian* 2003, 106–107, no. 14.

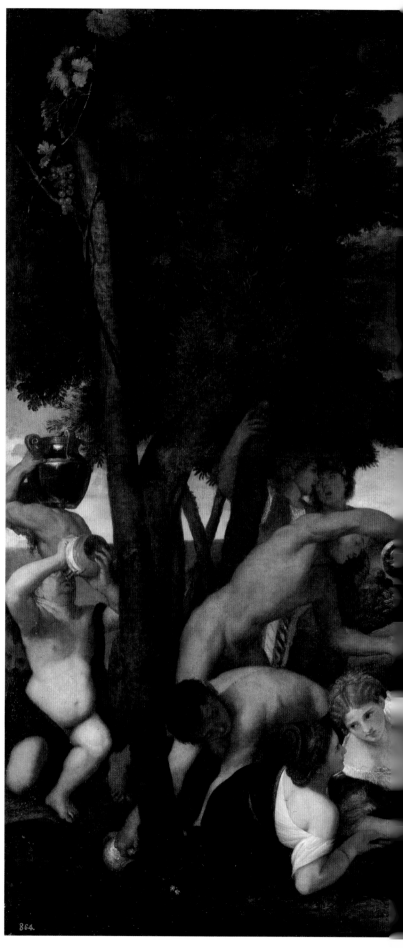

864.

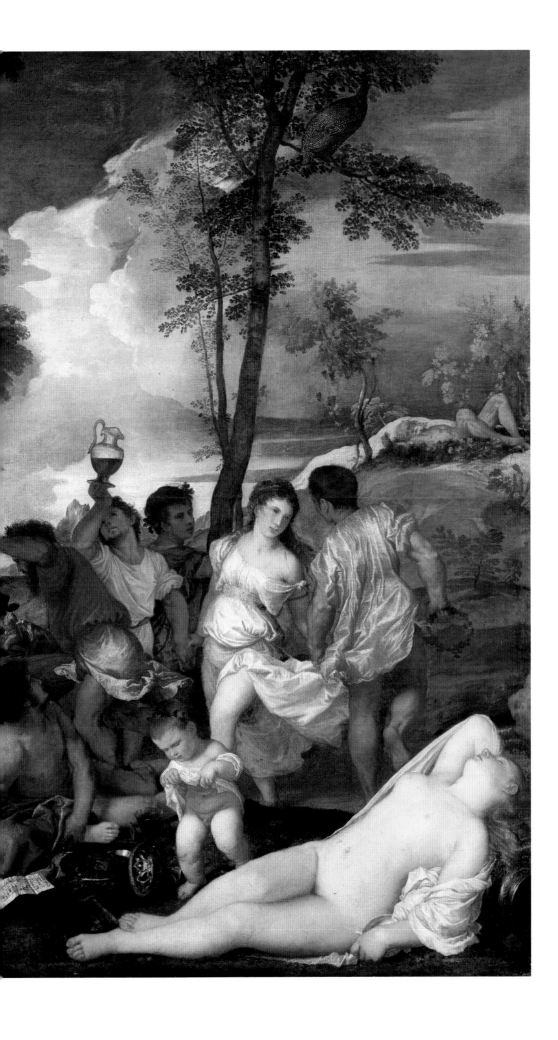

34

Titian

WORSHIP OF VENUS

1518–1519, oil on canvas
175 × 175 (68⅞ × 68⅞)
Museo Nacional
del Prado, Madrid

•

Vienna only

In his attempt to commission for his *camerino* the most significant paintings from the best artists in Italy, Alfonso d'Este first ordered the *Worship of Venus* from Fra Bartolommeo when the Florentine painter was in Ferrara in March 1516.[1] On 14 June 1517, Fra Bartolommeo wrote to Alfonso that he had not yet begun the mythology, and was leaving it to a more tranquil time in the future. Ironically for his expectations about the picture, the artist died in October of that year, and only a drawing (fig. 1) records his first idea, which, to judge from its relation to the Prado painting, Titian must have seen. On 15 February 1518, Titian sent Alfonso his own detailed drawing of the composition, and in the flurry of correspondence that followed there are mentions of additional sheets bearing annotated instructions from Alfonso to Titian. On 9 March 1518, Titian was sent the canvas to be painted, together with a set of written instructions, which do not survive. Though the correspondence is fragmentary, we learn from a letter from Alfonso's agent Jacopo Tebaldi, of 1 April 1518, that Titian was enthusiastic about the subject. At that time the artist requested information about the disposition of the paintings in the *camerino*, and in particular where his own contribution was to be placed on the long wall. A year later, on 17 October 1519, Titian left Venice to install the nearly finished painting at Ferrara. It is probable that he had to rework the varnish and to complete a section of the picture involving the color blue in Ferrara, as mentioned in Tebaldi's letter to Alfonso of 28 May 1520.

The subject of the painting was inspired by an ancient text by Philostratus the Elder (*Imagines* 1.6), that had been translated for Alfonso's sister Isabella d'Este.[2] The Greek author provided lengthy individual accounts of pictures in the gallery of an ancient villa at Naples. One of the paintings was about cupids in an apple orchard, simply entitled "Cupids." The description with which Titian had to work is in the form of a dialogue between an older visitor to the gallery and the collector's ten-year-old son. At a crucial point the older man remarks: "It is a beautiful riddle; come, let us see if perchance I can guess the painter's meaning. This is friendship, my boy, and yearning of one for the other. For the cupids who play ball with the apple are beginning to fall in love, and so the one kisses the apple before he throws it, and the other holds out his hands to catch it, evidently intending to kiss it in his turn if he catches it and then to throw it back; but the pair of archers are confirming a love that

is already present. In a word, the first pair in their play are intent on falling in love, while the second pair are shooting arrows that they may not cease from desire."

Titian was presented with the text in the form of a translation by the humanist Moschus. Among the many possibilities offered, it was the amorous theme that triggered his imagination. This was the first classical subject that he had ever painted on such a large scale, and he kept reasonably close to the text, despite the difficulties of visualizing an *ekphrasis*. How could he convey the delicious smell of an apple orchard? One detail Titian altered: the presence of Venus is merely evoked by Philostratus, who limits himself to referring to objects at her shrine. But Fra Bartolommeo and Titian following him embodied her presence as a statue. In Titian's

case, Falomir has shown that he appropriated an ancient sculpture in the Grimani collection, now in the Museo Archeologico, Venice.[3] There are considerable paint losses in the face of the statue of Venus, which may make Padovanino's copy of the composition in the Accademia Carrara, Bergamo, a more accurate representation of Titian's original conception.

For Titian, as for Philostratus, the principal subject was the lively infants, who mimic adult sexuality with a charming ingenuousness. With wings "dark blue and purple and in some cases golden," they enjoy themselves with apples in every possible way, eating them, throwing them like balls, and pelting one another with them. But the cupids were not the only elements in the text that Titian elaborated. Philostratus described the jeweled baskets in which the apples are gathered in some detail, and the artist rendered them with exquisite care in the left-hand corner. At the base of the statue of Venus, two putti cuddle and kiss, while on the right two nymphs run onto the scene, one holding the silver mirror mentioned by Philostratus. In visualizing the subject, Titian rivaled and surpassed the earlier composition by Fra Bartolommeo, and in doing so made himself indispensable to Alfonso. It was a brilliant beginning.

1. For a new complete edition of the documents relating to the *camerino*, see Menegatti in Ballarin 2002, 3:3–340.

2. Koortbojian and Webb 1993.

3. Falomir 2003.

Provenance: Commissioned by Alfonso I d'Este, for his *camerino*; confiscated in 1598 by Cardinal Pietro Aldobrandini, Rome; Cardinal Ludovico Ludovisi, Rome, 1623; Olimpia Aldobrandini, 1626; Prince Niccolò Ludovisi, Rome, 1633; in August 1633, given to the viceroy of Naples, Manuel de Açevedo y Zuñiga; February 1638, given to King Philip IV of Spain; by descent to the Museo del Prado, Madrid.

Selected References: Wethey 1975, 34–35, 146–148, no. 13; Holberton 1987, 57–66; Marek 1987, 67–72; Pérez Sanchez 1987; Webb 1992; Goffen 1997, 111–117; Pedrocco 2001, 118–119, no. 54; Ballarin 2002; Falomir 2003, 162–165, 358–359, no. 11; *Titian* 2003, 110–111, no. 16.

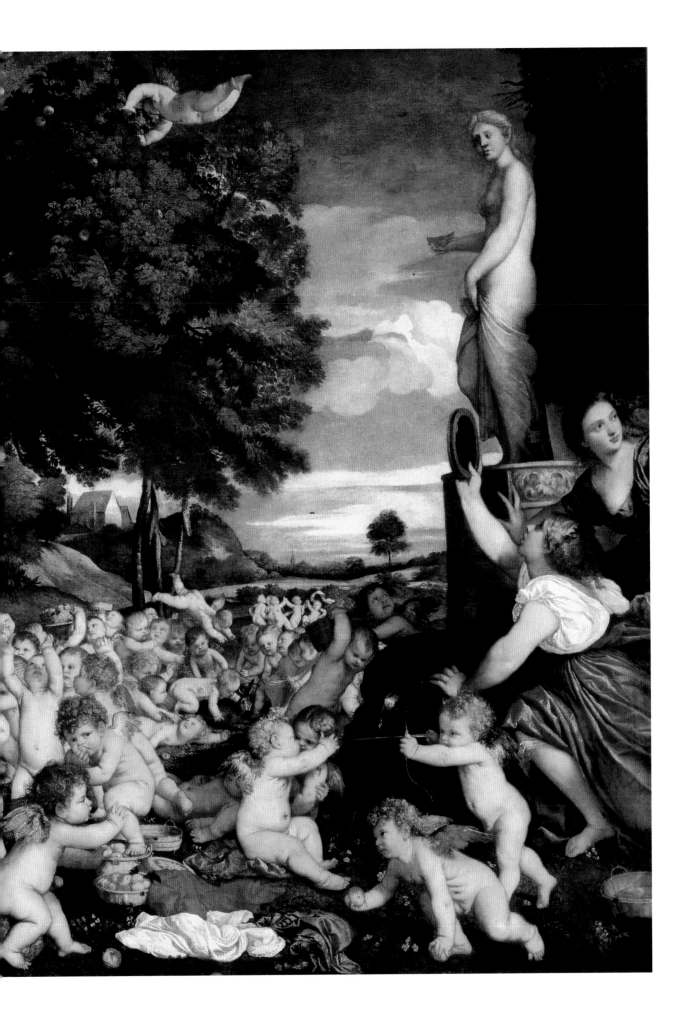

1.

Albrecht Dürer,
*Drawing of a Nude
Woman*, Albertina,
Vienna

35

Palma Vecchio

BATHING NYMPHS

c. 1525, oil on canvas
mounted on panel
77.5 × 124 (30 ½ × 48 ¹³/₁₆)
Kunsthistorisches
Museum, Gemäldegalerie,
Vienna

Thirteen female figures relax around a pool at the base of a wooded hillside, with a castle on a mountain in the distance. An old inventory describes the painting when it was in the collection of Bartolomeo della Nave as "A bath with 14 figures washing themselves at a fountain in a faire Landsckip." Yet the figures of red satyrs romping in a line along the left background might suggest a classical subject, either Diana discovering Callisto's pregnancy or Diana bathing. The nude woman on the left-hand side has taken off her robe to reveal a round stomach, indicative perhaps of Callisto's pregnancy. But many of the women have protuberant bellies, rather like those of Aristide Malliol, and there are no further attributes, like a crescent moon, to confirm the identity of any of them as Diana.

The theme of the picture may be merely that of a group of women bathing in a landscape, for a *bagno* (bath scene) is a genre both in northern and southern Europe in the Renaissance. Albrecht Dürer made a famous woodcut of a bathhouse for men and a drawing of a female bath. In his correspondence with Federico Gonzaga, Titian refers to a bathing scene that he had painted, while Dosso Dossi's painting in the Castel Sant'Angelo, Rome, has always been recognized as a bath without any reference to classical mythology. The word *bagno* in Italian can sometimes be a metaphor for a brothel, but that hardly seems appropriate in this context.

The seemingly casual appearance of the women belies the complexity of the painting, which makes numerous references to ancient sculpture. Almost every figure in the composition has been shown to have a distinguished sculptural precedent. The standing figure in the left foreground has assumed the pose of *Aphrodite Kallipygos,* and the nude figure on the right adopts the stance of *Aphrodite of Melos,* while the nymph combing her hair imitates the pose of Syrinx in the print of *Pan and Syrinx* by Marcantonio Raimondi, said to be after Raphael. The women in the middle distance assume the poses of the Florentine soldiers in Michelangelo's often copied but lost *Battle of Cascina* (see page 34, fig. 12). The two women in the right foreground resemble the figures in Jacopo de' Barbari's engraving of *Victory and Fame.* The languid figure in the central foreground resembles many a nude woman at rest in Renaissance art, like those found in Domenico Cam-

pagnola's print of that subject of 1517 or in Albrecht Dürer's engraving *Das Meerwunder* of 1498 or, more precisely, in Dürer's drawing in the Graphische Sammlung, Albertina (fig. 1). It has recently been argued that Palma's recumbent female resembles a lost Venus painted by Titian for Charles V, which was famous and frequently quoted by Renaissance artists.[1]

If we ask why there are so many quotations from classical sculpture and from engravings after Raphael and Michelangelo, the answer must lie in the fact that Palma was ambitiously engaging with the *paragone,* that Renaissance debate over the respective merits of painting and sculpture, in which painting, for its advocates, demonstrates its superiority by appropriating sculptural prototypes and portraying them with even greater skill.[2] The reference to Michelangelo

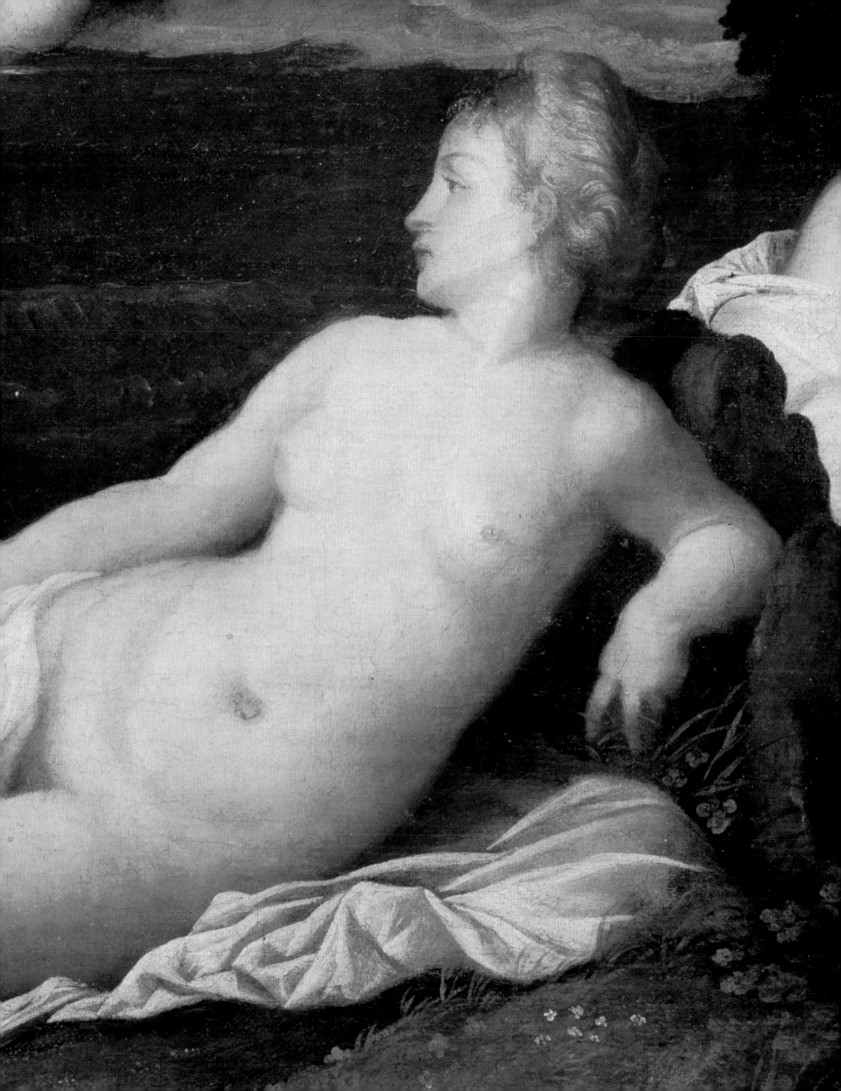

186

conjures up his great cartoon of Floren-tine soldiers bathing in a river while resting from battle. It was a parti-cularly Venetian triumph to demon-strate the excellence of painting by reference to the female rather than the male body, and to portray female forms in a fluid painterly manner. The variety of poses chosen by Palma shows female beauty from as many different angles as possible; at times two figures illustrate the same pose.

In his writings Leonardo da Vinci was the first artist to make frequent reference to the *paragone*, which he invoked to demonstrate a personal conviction that painting was superior to sculpture. In Venice this intellec-tual debate was taken up and given visual form by Giorgione.[3] Literary sources refer to demonstration pieces by Giorgione, in which he surrounded a single figure with reflecting mirrors in order to demonstrate that painting could show multiple views at a single glance. Paolo Pino, for example, refers to a figure of Saint George, reflected from six viewpoints in a series of mir-rors. Giorgione's experiments reso-nated among his contemporaries, so that Pino and the other texts describ-ing them have also been related to Savoldo's *Self-Portrait* in the Louvre, which demonstrates simultaneity as a manifestation of the artist's identity. Titian's *Portrait of a Woman*, called "La Schiavona" (cat. 45), in the National Gallery, London, further demonstrates that painting can rep-resent not only a painted likeness but also a profile likeness in sculpted relief. Palma's picture extends this

conceit beyond the realm of portrai-ture of the single figure to become a tour de force of the new genre of the erotic female nude, here multiplied in an eye-catching demonstration of the painter's superior ability.

1. Gabriele Gofriller, "Tizian an der staffelei: eine zeitgenössische Bildquelle zur verlorenen *Venus* für Kaiser Karl v," *Münchner Jahrbuch der bildenden Kunst* 52 (2001), 59–88, reference to drawing on 76–77.

2. Rylands 1988, 228.

3. Anderson 1997, 44–45.

Provenance: Collection of Bartolomeo della Nave, Venice, by 1637; Hamilton Collection, 1638; Collection of Arch-duke Leopold Wilhelm by 1659; trans-ferred to the Kunsthistorisches Museum, Vienna, in 1930.

Selected References: Teniers 1660, pl. 207; Wilde 1930, 248–249; Rylands 1988, 228; Gruber 2004.

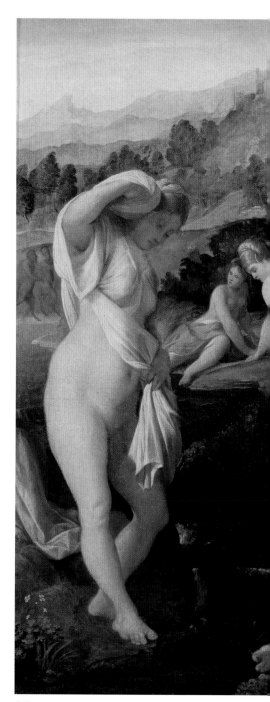

35

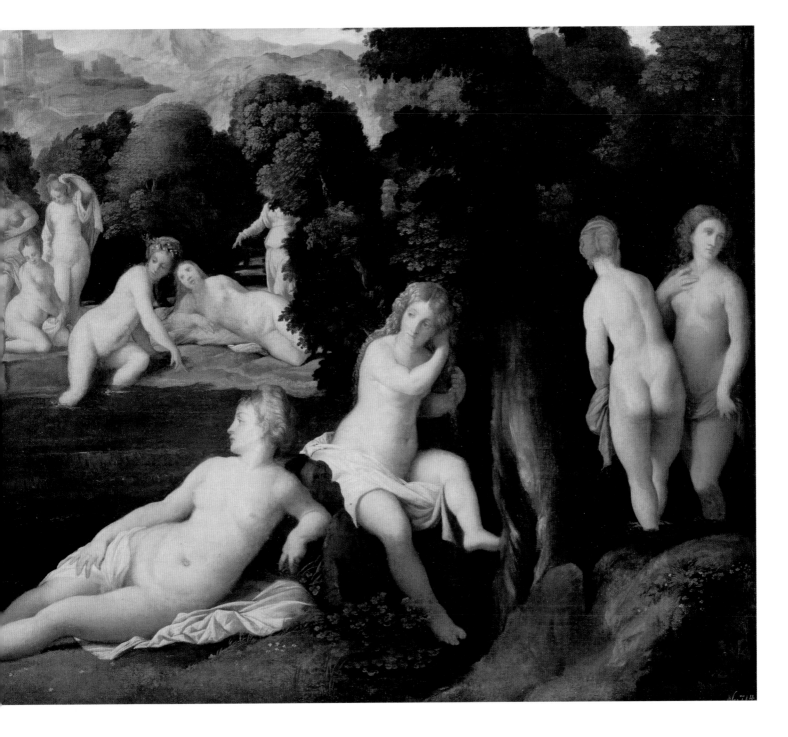

PICTURES OF WOMEN — PICTURES OF LOVE * *Sylvia Ferino-Pagden*

THE EROTICIZED, HALF-LENGTH female portrait was an innovation developed in the first third of the sixteenth century by Venetian artists of the highest rank. These rich and varied idealizations, many of them still extant, introduced a portrait type that enjoyed continued success throughout European painting for centuries to follow. Realistic Venetian portraits of women have a different history, for there are surprisingly few by important artists. The most significant examples are included in the present exhibition: Lorenzo Lotto's early *Portrait of a Woman* from Treviso (cat. 36) and Titian's *La Schiavona* (cat. 45), also more likely from the mainland than from Venice itself. We are led to wonder whether the new idealized paintings may have supplanted conventional portraiture and eventually superseded it. A comparison of Titian's *Flora* (cat. 42) with a solidly realistic portrait (fig. 1) now attributed to Marco Basaiti in the Worcester Art Museum seems to support this notion merely on the basis of the incomparably greater pleasure we take in looking at the sensuous beauty of Titian's creation.[1]

Yet the historical circumstances are much more complex. Of the portraits still extant from this period, those of men far exceed in number those of women, leading some to conclude that women's portraits were simply not being commissioned. Even pictures of the wives of doges survive only sporadically, most from after midcentury when female portraits appear in greater number. Some scholars have found an explanation in the Venetian oligarchy, which unlike a dynastic system, excluded women from a visible role in government.[2] By contrast, magnificent portraits of women from other cities have come down to us—Raphael's *Maddalena Doni,* a Florentine banker's wife, or *Donna Velata,* painted in Rome; or Sebastiano's portraits of Vittoria Colonna, for example. Indeed, female portraiture was of great

significance in dynastically structured city-states, for such pictures served to endorse the claim to inherited power. From the second half of the century we find whole "galleries of beautiful women" displaying historical portraits of the wives of various ruling houses. The gallery of Archduke Ferdinand of Tirol in Ambras Castle is a case in point.[3] And in the 1510s Isabella d'Este, a unique exemplar of female patronage, declared herself so weary of sitting for portraits that henceforth artists were told to model such works on existing paintings.[4]

Since 1422 the Republic of Venice, in order to maintain its oligarchy, had itself been issuing decrees that were increasingly addressed to the benefit of women from noble families. In order to guarantee the purity of a ruling patriciate, Venice also further secured the material needs of women through new inheritance laws.[5] Their consequent social power and lavish splendor were expressed through grand celebrations—family events including baptisms, marriages, and spectacular balls lasting several nights—all of which entailed an exorbitant display of jewelry and attire.[6] Husbands began neglecting their professional obligations in the mercantile or political arena in order to indulge in an idleness subsidized by their wives' dowries. This social trend became progressively more worrisome to local statesmen and political theoreticians and led the doge Andrea Gritti (ruled 1523–1538) to call for a *renovatio urbis*.[7] Yet how is it possible that, amidst such excess, no one was moved to commission a portrait of a daughter, a future bride, or an affluent wife?

Venetian inventories and other documents do include references to what were probably female portraits. For example, Marcantonio Michiel's notes describe pictures of women, and paintings of *gentildonne* by Titian are mentioned in the 1552 inventory of Gabriele Vendramin's collection in

DEL PALMA.

Santa Fosca.[8] The 1601 inventory of the same collection lists quite a few works as a *quadro* or a *quadretto de retratto de una donna* (picture or small picture with the portrait of a woman).[9] Yet even if we assume that *retratto* need not imply a naturalistic rendering, we can reasonably distinguish between real and ideal portraits in the 1627 illustrated inventory of Andrea Vendramin's collection. This listing is surprisingly rich in female portraiture, some attributed by inscription to painters such as Giovanni Bellini and Palma Vecchio (fig. 2), and others shown without attribution. In one prominent example ascribed to Palma, the background is formed by laurel leaves as in Giorgione's *Laura* (cat. 38). Yet there are no portraits attributed to Titian. A large number of works are included that, on the basis of the sitters' sensuous appeal and revealing attire, we would describe as idealizations. Although only a few of these paintings have been identified with extant works, there are enough to suggest that the others illustrated also existed at one time.[10] In addition, a significant number of female portraits survive

1.

Venetian School, *Portrait of a Woman*, Worcester Art Museum, Museum Purchase

2.

After Palma Vecchio, *Portrait of a Woman* (Vendramin Collection), British Library, London

that are now attributed to such followers of Bellini as Francesco Bissolo, Marco Bello, and Pietro degli Ingannati. Still largely in private collections or, because of their lesser quality, consigned to museum storerooms, these works have not yet been brought into the discussion of Venetian portraiture and its social context.[11]

The lack of portraits of Venetian *nobildonne* by significant artists is more than offset by the large number of idealized, eroticized portraits that survives. Venetian painters seem to have recognized that this picture type allowed them the greatest variety of form and content in their celebration of female beauty. The ideal portrait, not encumbered with the requirements of naturalistic portraiture, aligned itself naturally with traditional understandings of the role of art as the creator of beauty.[12] These images vary widely. Some have attributes associating their subjects with biblical heroines, temptresses like Judith or Salome (see page 216, fig. 1), or ancient heroines such as Lucretia; or they represent figures from classical mythology such as the goddesses Flora (cat. 42) and Venus. In such cases as the woman with an incense burner (cat. 40), scholars disagree as to whether the figure represents the Magdalen or a wise virgin from the parable. Other paintings simply depict lovely young women at their toilet (cat. 41), with a musical instrument, in bridal array (cat. 43), or as courtesans. Many scholars also see moralizing connotations— *vanitas*, *prudentia*, or *veritas*—in some of these pictures (cat. 38). Any allegorical allusions, however, are increasingly eroticized, and it becomes clear that a nontraditional reading with a different purpose is what is actually being offered. The more ambiguous idealizations have also been designated *belle donne*, a term that encapsulates the characteristic they all share.[13]

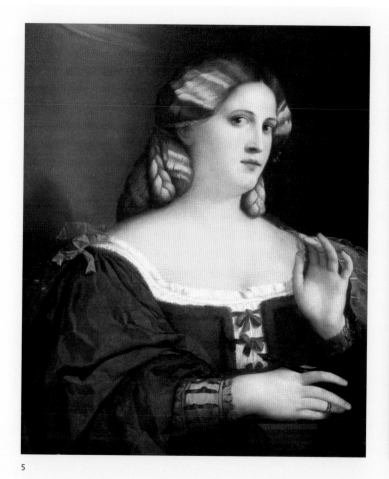

5

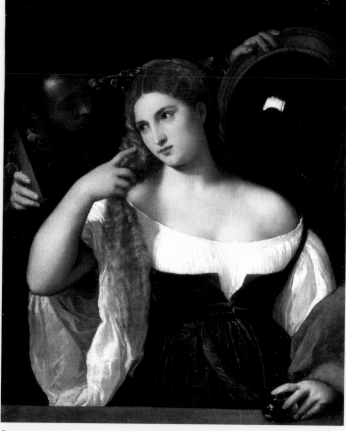

6

We are struck not just by the beauty and charm of these half-length pictures but by their sensuality as well: loosened, often disorderly hair, a provocative décolletage (fig. 3); a bared breast; a flirtatious glance (fig. 4); a floral offering (cat. 42); the presence of jewelry boxes and other cosmetic paraphernalia (fig. 5); or the figure's seeming absorption in her toilet (fig. 6). In all of these pictures the conventions of real portraiture are either subdued or inverted, although individual features might well be included at the request of a patron. Even Jacob Burckhardt, whose essay on portraiture excluded the Venetian *belle*, recognized their proximity to portraits and admitted that they sometimes recalled their models quite specifically.[14] Sebastiano del Piombo's *Dorothea* (cat. 43) and even Palma Vecchio's *Bella* (cat. 44) seem to be based on traditional portraiture. Leonardo's influence is conspicuous here: he

3.

Titian, *Vanitas*, Alte Pinakothek, Munich

4.

Palma Vecchio, *Young Woman in Profile*, Kunsthistoriches Museum, Vienna

5.

Palma Vecchio, *Young Woman in Blue*, Kunsthistoriches Museum, Vienna

6.

Titian, *Woman at Her Toilet*, Musée du Louvre, Paris

was the first to require that a portrait present the sitter's emotions, as made visible through external appearance.[15] A sitter's sensibility and inherent virtue were expressed through graceful gestures, refined postures, and inclinations of the head, with the torso shown in profile or from behind. Mimesis was subordinated in pursuit of a higher, ideal statement, and symbolic, emblematic, or allegorical attributes were included to help us read the character or "soul" of the woman depicted.

Leonardo successfully countered the prejudices of poets, writers, epigrammatists, and rhetoricians who, since antiquity, considered the painted portrait of a beloved to be inferior to a written description. For these wordsmiths an inanimate image, incapable of speech, could never enter into a true relationship with the viewer. Yet Leonardo, in his writings and especially in his portraits, endeavored to demonstrate that the image was more powerful than the word. The *Mona Lisa* addresses the viewer as no previous picture ever had. She invites a dialogue; she is enlivened by our gaze and lives through us. In pushing the boundaries of mimetic individuality to such an extant that the portrait could be taken for an ideal image, the *Mona Lisa* makes us aware that the distinction between actual and ideal remains much more problematic for representations of women than men. Another of Leonardo's idealized female portraits, the *Mona Vanna*, known only through copies, inspired many variants among his followers, mainly dating from the second decade of the sixteenth century onward.[16] Indeed, all of his pictures of women, whether realistic or idealized, influenced artists throughout Italy, especially in Venice. We can almost trace the progression of female allure as it challenges the traditions of portraiture and is heightened through symbolic, emblematic, and above all allegorical meaning. Here, it is Giorgione who consummated the progression from the mimetic to the allegorical portrait, a process well illustrated in this section of the volume.[17]

Meanwhile, Lorenzo Lotto's *Portrait of a Woman* from Treviso (cat. 36), which adheres most closely to the strict conventions of the fifteenth century, may be taken as an actual portrait, allegorical references being relegated to the separate cover (cat. 37). Titian's *Schiavona* (cat. 45), on the other hand, painted just eight to ten years later, is totally new and unique in its format and self-presentation, and—with the inclusion of the bas-relief profile—can be read as an allegory of *memoria* and the various ways it can be represented in a painting. Furthermore, the pose conveys a totally new and unmatched female conception of self.[18]

Giorgione's *La Vecchia* (cat. 39) is the most hyperrealistic portrait of the sixteenth century. A merciless rendering of a woman destroyed by age, the subject is allegorized by the *cartellino* inscribed *col tempo* (with time). *La Vecchia* extends the boundaries of female portraiture in the sixteenth century and lends a new dimension to the symbolic potential of the genre. What was the motivation behind the exacting portrayal of this particular old woman, whose unappealing features betray the ravages of time? *La Vecchia* might well be seen as an allegory of the portrait itself.[19]

In Giorgione's *Laura* (cat. 38), the very prototype of the erotic Venetian *bella donna*, naturalism and idealism intersect in an unsettling way. The face is rather unidealized and somewhat plump, and the rather stiff, upright pose and sternly directed gaze still correspond to the realistic portrait type in three-quarter turn. Yet the eroticism unleashed by the bared breast helps to turn it into an idealized picture, as if there were an implicit sense that sensuality and the real were antithetical: the more sensuous or revealing

a woman's depiction, the more idealized it should be, which would explain why Palma's *Bella* or Sebastiano's *Dorothea* appear more portraitlike than Titian's *Flora*.

In Titian's works, lovely, individual figures of women seem elevated to a level of ideal beauty. We find this, for instance, with the sitter who appears in several of his pictures, including the *Woman in a Blue Dress*, commissioned by the Duke of Urbino and now in the Pitti Gallery, Florence.[20] We know from letters that Titian very likely employed women of easy virtue as models for his nudes, and in the seventeenth century, appealing female half-lengths, like *Flora*, were believed without exception to be Titian's mistresses.[21] For example, the painting of a young woman shown at her toilet along with a young man has long been titled "Titian and His Mistress" (fig. 6).[22]

In the prudish Victorian age some of the *belle donne veneziane* were regarded as portraits of particular courtesans, Venice being famous for these and other providers of sexual services.[23] Cesare Vecellio and Giacomo Franco illustrated the costumes and appearance of various ladies of the trade, from the lowly *puttana* to the *corteggiana honesta*.[24] There were more than ten thousand prostitutes in sixteenth-century Venice, not including the procurers, servants, and others who depended on the commerce. The authorities kept careful watch over these women, and their overseers, the *provveditori delle pompe*, continually issued decrees intended to restrict or at least regulate their activities.[25] Widespread rumors held that the Serenissima managed to fund projects from the construction of the arsenal to the equipping of entire fleets with the taxes imposed on courtesans. In the second half of the sixteenth century, through their education and talent, some courtesans acquired considerable wealth and fame; the renowned poet Veronica Franco, for instance,

is supposed to have had a semiofficial contract linking her to the French king Henri III.[26] Free of the obligations of marriage and above all autonomous, they can be regarded as early champions of the prerogatives of the modern woman. Courtesans have been intensively studied from this perspective, especially by feminists bringing new insight to the subjects of the Venetian *belle donne* portraits.[27] For only prostitutes would have been able to disregard the expectations of chastity and modesty and allow themselves to be so permissively presented. It is clear from the courtesan Julia Lombardo's 1569 testament that her luxuriously furnished apartment was decorated with paintings and included a *studiolo* made into a curiosity cabinet, and that a *retratto de donna con soaze di nogera* (female portrait with a walnut frame), identified as her own portrait, hung in her bedroom.[28] A rather unpleasant portrait by Bernardo Licinio, dated about 1530, may be a similar case. Although clearly depicting a prostitute, it is exceptional for a work of the sixteenth century.

Repeated decrees restricting the extravagance of courtesans clearly indicate that the clothing and jewelry of the *meretrici* were so magnificent as to make them indistinguishable from the *gentildonne*.[29] They, on the other hand, increasingly insisted on revealing their décolletages, so that they, too, provoked comments by foreign visitors. Repeated attempts to rein in such luxury were unsuccessful.[30]

In view of the rapprochement in appearance of the legitimate and illegitimate—that is, between the *gentildonne* and the courtesans—it seems justified to assume that both were conforming to a paradigm shaped by male fantasy. As a result, exactly those features of courtesan portraiture that seem to refer to Venus—erotic dishabille, seductive

glances, jewelry, rings, pearls, roses, and myrtle—have been taken as evidence that these figures represent not courtesans but brides and were commissioned to serve as initiation and inspiration to the sensual relationship expected of a new wife.[31] Gentili had no doubt that they were portraits of individual women, ordered by their bridegrooms. According to this thesis, propagated mainly by male scholars, such paintings show that in Venice married life was no longer constructed around the classical, purely platonic love advocated until then, but rather strove for legitimate sensual fulfillment, a desire already expressed in contemporary literature. Hence, the baring of the breast need not imply unchasteness; after all, even personifications of the virtues or the arts were traditionally represented half-naked. These arguments further suggest that a bosom thus presented was poetically offered to the bridegroom's love.[32] And the obvious "V" formed by the elegantly splayed index and middle fingers of many of these women, earlier seen as an allusion to "Venus," has been most recently interpreted as a reference to *virtus*. On the other hand, this gesture may symbolize nothing more than grace and refinement. And these images might best be viewed as poetic idealizations of women and not simply as representations of brides or prostitutes.[33]

In any case, the dream of a bride or wife who is at once chaste and the object of erotic desire is rooted in the love poetry introduced into Venetian culture by Pietro Bembo, not only through his new edition of Petrarch's sonnets in 1501 but also through *Gli Asolani* published in 1505, a dialogue that was revolutionary in its treatment of erotic love. It was also Bembo who reinvigorated the *paragone* or contest between poetry and painting that had been inaugurated by Petrarch and Simone Martini: Bembo

wrote a poem to Giovanni Bellini's real or fictitious portrait of the poet's mistress (Maria Savorgnan?).[34] This literary description of a painted portrait of a beloved or admired woman was inspired by Lucian and other classical writers, and it offered a new and exciting possibility for contemporary authors like Trissino, whose literary portrait of Isabella d'Este in his dialogue "Li retratti" won him great fame.[35]

Likewise, Venetian painters created idealized portraits in accord with the canon of female beauty formulated in poetic and literary tracts: blond locks; broad, smooth forehead; wonderfully balanced, arched eyebrows; starlike eyes; well-formed cheeks; and so forth. These paintings in turn stimulated new poems and treatises on female beauty and love.[36]

While painters like Palma Vecchio, Cariani, and Licinio managed to capture the ambiguity of these *belle* with a sense of the uncertain boundary between proper and illicit love, Titian's female portraits elude such a categorization. And perhaps it is exactly his deeply felt realization of the indivisible essence of a woman that allows us to understand the climate that created these *belle donne*, no longer a matter of courtesan or bride, but a valid celebration of woman as the most magnificent embodiment of life, love, and art altogether. A comparison of the *Schiavona* with the idealized *Flora* reveals Titian's particular recognition of a woman as individual and ideal, whatever her costume (cats. 45, 42). The same is true of his so-called *Vanitas* (fig. 3), the *Woman at Her Toilet* (fig. 6), and *Violante*, not to mention his later portraits of the *bella* in the Pitti Palace or the *Lady with a Fur* in Vienna, and many others. Sperone Speroni's *Dialogo d'Amore*, published in 1537, treats love and painting as equals. No doubt he had already seen some of Titian's female portraits,[37] for in his claim,

"Lo amante (…) è propriamente un ritratto di quella cosa che egli ama" (A lover is actually a reflection of that which he loves), he named Titian as the painter who best visualized this concept.

If we now return to the question of why there appear to have been so few actual portraits and so many idealized images from this period in Venice, we should recall the discourse touched upon in Paolo Pino's *Dialogo di Pittura*, which gives clear preference to imagined over present beauty.[38] Translated into Vincenzo Danti's terms, the real beauty of the *retratto*, its concreteness, contrasts with *imitazione*, which records things not as they are but as they ought to be. Thus the portrait is to the ideal image as history is to poetry.[39] And the painter pursuing imitation is indubitably nobler than the strict portraitist, just as the poet is nobler than the historian. Hence we can scarcely be surprised that in the search for the female image, the Venetians declared themselves for poetry and, by analogy with the poetry of love, for the "picture of love."

1. Mauro Lucco, "Venezia 1500–1540," in Lucco 1996, 13–146; 47, no. 51; Beverly Louise Brown in Aikema and Brown 1999 (Italian ed.), 328–329.

2. Anderson 1979b, 153–158.

3. See Michael Wenzel, *Heldinnengalerie Schönheitsgalerie, Studien zu Genese und Funktion weiblicher Bildnisgalerien 1470–1715* (Heidelberg, 2001).

4. Sylvia Ferino-Pagden, *"La prima donna del mondo." Isabella D'Este Fürstin und Mäzenatin der Renaissance*, Sylvia Ferino-Pagden, ed. (exh. cat., Vienna) (Vienna, 1994), 95.

5. Stanley Chojnacki, "Marriage Legislation and Patrician Society in Fifteenth Century Venice," in *Law, Custom and the Social Fabric in Medieval Europe*, Essays in Honor of Bryce Lyon, S. Bachrach and D. Nicholas, eds. (Kalamazoo, 1990), 163–184; Stanley Chojnacki, "Kinship, Ties and Young Patricians in Fifteenth Century Venice," *Renaissance Quarterly*, 38 (1985), 240–270; Stanley Chojnacki, "'The most Serious Duty': Motherhood, Gender, and Patrician Culture in Renaissance Venice," in *The Italian Renaissance*, Paola Findlen, ed. (Oxford and Malden, 2002), 172–191; Stanley Chojnacki, "Marriage Regulation in Venice 1420–1535," in Chojnacki 2000, 53–75.

6. Stanley Chojnacki, "La posizione della donna a Venezia nel Cinquecento," in *Tiziano e Venezia: Atti del Convegno Internazionale di Studi (Venice, 1976)*, (Vicenza, 1980), 65–70.

198

7. Chojnacki, "Marriage Regulation in Venice 1420–1535," in Chojnacki 2000, 53–75, 71–73.

8. Frimmel 1888, 8; Ravà 1920, 77–78; 155–179; Santore 2000, 16–21, no. 3.

9. Anderson 1979a, 639–648.

10. Borenius 1923. See Palma's woman in Berlin (Rylands 1988, 212, no. 35).

11. Heinemann 1991, vols. 1–2, ill. 354–358; vol. 3, ill. 79, 80, 130–134, and 183.

12. Cropper 1986, 175–190 and 335–359.

13. See Junkerman 1988; Junkerman 1993, 49–58; Santore 1990.

14. Burckhardt 1898 (2000), vol. 6, 260.

15. Frank Zöllner, "The 'Motions of the Mind' in Renaissance Portraits: The Spiritual Dimension of Portraiture," *Zeitschrift*

für Kunstgeschichte, 1 (2005), 23–40; Shearman 1992, 108–148; Beyer 2002, esp. 61–72, 137–144, 150–157; Giovanni Pozzi, "Il ritratto della donna nella poesia d'inizio cinquecento e la pittura di Giorgione," in Pallucchini 1981, vol. 1; Quondam 1989, 9–44; Cropper 1986, 175–190.

16. David Alan Brown and Konrad Oberhuber, "Mona Vanna and Fornarina: Leonardo and Raphael in Rome," in *Essays Presented to Myron P. Gilmore*, Sergio Bertelli and Gloria Ramakus, eds. (Florence, 1978), 25–86.

17. Anderson 1979b, 153–158.

18. Harry Berger Jr., "The Fictions of the Pose, Facing the Gaze of Early Modern Portraiture," *Representations*, 46 (1994), 87–120; Harry Berger Jr., *The Fictions of the Pose, Rembrandt against the Italian Renaissance* (Stanford, 2000).

19. Cranston 2000, 61.

20. Patricia Simons, "Portraiture, Portrayal and Idealization: Ambigous Individualism in Representations of Renaissance Women," in *Language and Images of Renaissance Italy*, Alison Brown, ed. (Oxford, 1995), 263–311, 288–290.

21. Campori 1874, 581–620.

22. Santore 1990, 102–104.

23. The literature on courtesans is immense. Most recently, see *Le cortigiane di Venezia dal Trecento al Settecento: il gioco dell'amore* (exh. cat.,

Casinò Municipale Ca'Vendramim Calergi, Venice), (Milan, 1990); Lynne Lawner, *Lives of the Courtesans, Portraits of the Renaissance* (New York, 1987); Barzaghi 1980; Monica Kurzel-Runtscheiner, *Töchter der Venus: die Kurtisanen Roms im 16. Jahrhundert* (Munich, 1995), 348. Ingenhoff-Danhäuser 1984, 53–55.

24. Cesare Vecellio, *Habiti antichi et moderni di tutto il mondo* (Venice, 1590); and Giacomo Franco, *Habiti delle donne venetiane* (Venice, 1628).

25. Giovanni Scarabello, "Le 'Signore' della Republica," in *Il gioco dell'amore* 1990, 11–35. See also Casagrande di Villaviera 1968.

26. Rosenthal 1992, 102–104.

27. Junkerman 1988; Santore 1990.

28. Santore 1988, 44–83.

29. Chambers and Pullan 1992, 126–127.

30. Chojnacki 1980, 67; P. G. Molmenti, *La Storia di Venezia nella vita privata* (Torino, 1885), 261. Dürer was moved as early as 1497 to record this low-cut attire in a drawing. See Anderson 1997, fig. 134, 135.

31. Gentili 1995, 82–105; Sergio Bertelli, "Cortigiane sfacciate e sposi voyeurs," *Paragone* 48/13 (1997), 3–33.

32. Dal Pozzolo 1993, 257–292.

33. Fiorenza 2001, 63–87, 73–75.

34. Mary Rogers, "Sonnets on Female Portraits from the Renaissance," *Word & Image* 2 (1986), 291–305.

35. See most recently Rogers 1988, 47–86.

36. Pozzi 1981, 309–341; Quondam 1989, 9–44; Elisabeth Cropper, "On Beautiful Women, Parmigianino, 'Petrarchism' and the Vernacular Style," *The Art Bulletin* (1976), 3, 374–394; Rogers 1988; Cropper 1995; Giuseppe Zonta, *Trattati del Cinquecento sulla Donna* (Bari, 1913).

37. Sperone Speroni, *Dialogo d'Amore* (Venice, 1537), in Sperone Speroni, *Opere*, Mario Pozzi, ed. (Rome, 1989), 1:31, note 8; see Quondam 1995, 65–81, 65–66.

38. Quondam 1989, 9–44, 26–27; Paolo Pino, *Dialogo di pittura di Messer Paolo Pino, Trattati d'arte del Cinquecento fra Manierismo e Controriforma*, Paola Barocchi, ed. (Bari, 1960), 1:97–98.

39. Vincenzo Danti, "Trattato delle perfette proporzioni," in *Scritti d'arte del Cinquecento*, vol. 7, Paola Barocchi, ed. (Torino, 1979), 1570–1572.

36

Lorenzo Lotto

PORTRAIT OF
A WOMAN

c. 1502–1505, oil on panel
36 × 28 (14 ¼ × 11)
Musée des Beaux-Arts,
Dijon

In the layout of this, his earliest female portrait, Lotto conformed to the traditional bust-length format still popular in Venice and northern Italy, as seen in paintings by Giovanni Bellini and his circle. Models for this alternative to the profile portrait also lay in works by Netherlandish artists from Jan van Eyck to Hans Memling, where the sitter is turned fully or in three-quarter view so as to gaze directly at the onlooker. The influence of these works spread quickly throughout Italy and is reflected in the distinctive portraits (of men only) by Antonello da Messina, a Sicilian painter working in Venice, and in subsequent examples by Giovanni Bellini. In these works a parapet or balustrade both established a distance between viewer and sitter and underscored the memorial aspect of the portrait by including a chiseled or painted inscription, bearing the name of the artist or sitter or some other text. Here, however, the absence of such a parapet lends a heightened presence to the impressive figure set before soft folds of dark green drapery. With a slightly swollen, somewhat columnar neck, she presents herself in an alert upright pose as if she were intent on communicating with the viewer. Yet the sitter's gaze does not engage us, and the slightly pinched mouth beneath her long nose suggests a kind of passive resistance to becoming the subject of a portrait. Her reddish hair is held by an austere, transparent coif and a netlike decorative cap. Her black dress is restrained and without ornament; the only traces of animation are in the gathered folds of the white chemise showing between her bodice

and sleeves and in the transparent pinkish veil. Daylight enters from the lower left as if through an opening, touching the figure unevenly and starkly over-illuminating parts of her face.

These elements create the impression of a straightforwardly realistic portrayal, which encouraged nineteenth-century scholars to attribute the picture to Hans Holbein the Elder and which led to the theory that Lotto's early work was influenced by northern European painting, in particular that of Albrecht Dürer, who sojourned in Venice in 1505–1506.[1] An especially common comparison was with Dürer's *Portrait of a Young Venetian Woman*, completed during his Venetian visit or shortly thereafter.[2] A general receptiveness to the achievements of trans-Alpine painters can be traced throughout Lotto's career, and a knowledge of northern prints, especially Dürer's, may have enriched the compositions and subject matter, if not the style, of his pictures. In this case, the deliberately plain presentation of the sitter recalls the conventions of contemporary German portraiture, as does her erect, strong, and unbeautified presence. The woman wears no jewelry, which may indicate that she was a widow at the time. And yet, in spite of her sober demeanor and attire, she compels the observer's attention. It is not an expression that captivates us but rather the unfocused quality of her gaze, simultaneously directed toward and unaware of the viewer, much as if we were observing her pose and her reaction to her own portrayal. The artist has thus introduced a completely new dimension, one which, as Sheard notes, can be found again only in the nineteenth century.[3]

The sitter's identification as Giovanna de' Rossi, sister of Bernardo de' Rossi, bishop of Treviso, was first proposed by Liberali and adopted by most scholars including Dülberg and Gentili.[4] As early as 1493 Giovanna was documented in her brother's house in Belluno as the widow of Giovanni Battista Malaspina, and she was subsequently recorded in Treviso. A 1505 portrait of the bishop, also by Lotto (cat. 46), is very similar in style, and Lotto made protective sliding covers (cats. 37, 47) for both portraits, each of which depicts a romantically idyllic yet moralizing allegory referring to the sitter (fig. 1). However, Giovanna de' Rossi had already died by 29 October 1502. Liberali and Gentili do not rule out the possibility that her portrait might have been done before that of her brother, and Gentili goes so far as to suggest that the artist tried out his original idea of a portrait with sliding cover in a smaller format for Giovanna before producing a more monumental and considered version of this extraordinary ensemble for Bernardo.[5] The majority of scholars, however, believe the female portrait should be dated after that of the bishop, about 1505–1506.[6] If the portrait does depict the recently deceased Giovanna de' Rossi, then it seems reasonable to suppose that the commission came from her brother. Yet neither this painting nor its cover appears in the bishop's inventory drawn up in 1510 and 1511, although we do find his own portrait there

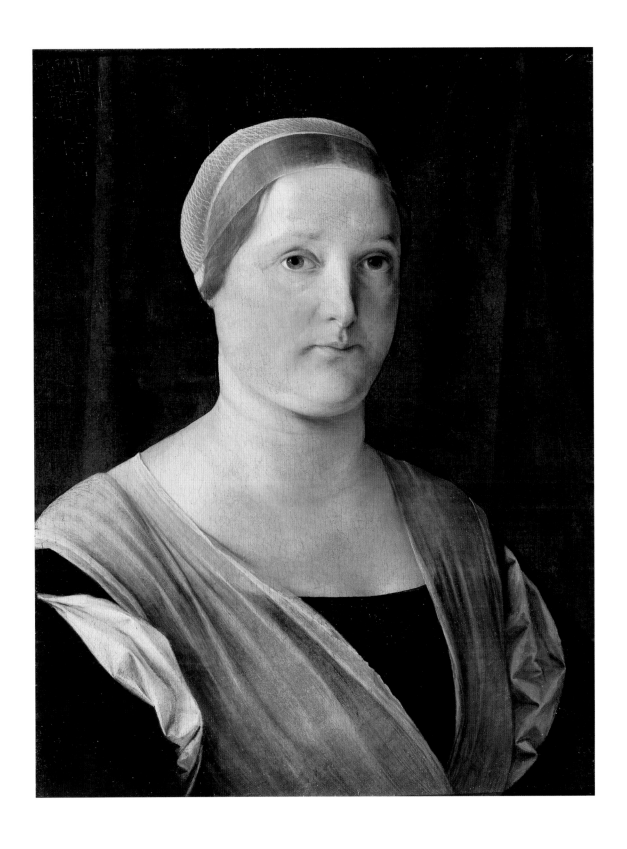

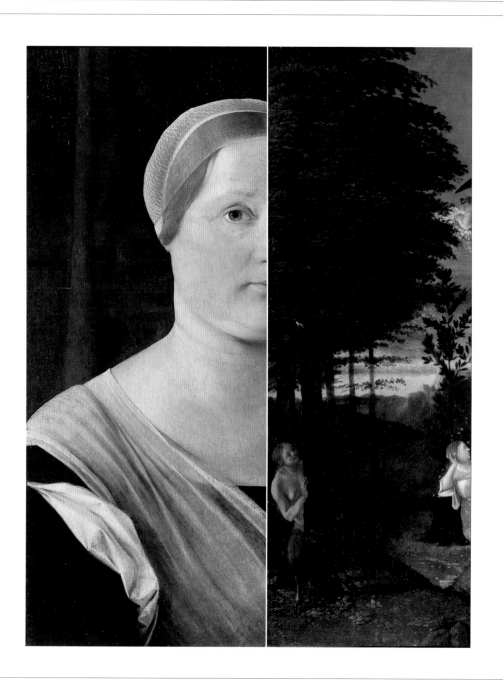

1.

Lotto's *Allegory of
Chastity* shown as a
sliding cover for his
Portrait of a Woman

along with other works he commissioned. Meanwhile, Giovanna had named her brother as heir, which displeased her husband's family.[7] Thus, if we consider Rossi an unlikely client, her Malaspina relatives are even less so.

One could surmise from the sitter's distant gaze that Lotto did not, in fact, know her at all but was following a painted prototype. Ample examples document this practice in the Renaissance, above all works by Titian. That artist's *Portrait of Isabella d'Este in Black* in the Kunsthistorisches Museum, Vienna, was painted after a model, and it shows a similarly upright pose, distanced expression, and absent gaze, although Titian did portray Isabella as a far more attractive person. In Veronese's so-called *Belle Nanni* in the Louvre, the sitter also looks out of the picture without focusing on or betraying any awareness of the viewer. We should not dismiss the possibility, therefore, that we are dealing with a convention in which a lady from the higher levels of society does not acknowledge the viewer but presents herself as attentive to loftier issues. The high degree of idealization in the Titian and Veronese portraits is in keeping with the Renaissance concept of beauty. By contrast, the realistic presentation of Lotto's sitter would lead us to assume that he was painting her from life. If Giovanna commissioned it herself, this portrait, together with the allegory decorating its cover, would be among the painter's earliest works executed in Treviso, and Lotto would have launched his career with a commission from a woman.

1. Marguerite Guillaume, *Catalogue raisonné du Musée des Beaux-Arts de Dijon: Peintures Italiennes* (Dijon, 1980), 43–44; Berenson 1957, 1:19–20.

2. Kunsthistorisches Museum, Vienna. See Brown 1997, 82–83, no. 4; Isolde Lübbeke in *Rinascimento* 1999, 330, no. 68.

3. Sheard 1997, 43.

4. On Bernardo de' Rossi see most recently Francesca Cortesi Bosco, "La Madonna col Bambino e i Santi Pietro Martire e Giovanni Battista di Capodimonte: devozione o 'damnatio memoriae'?" *Venezia Cinquecento* 19 (2000), 71–132.

5. Gentili 1985, 89–91.

6. Brown 1997, 81–83, no. 4.

7. Liberali 1981, 73–92; especially 75.

Provenance: Anthelme Trimolet (c. 1866); bequeathed 1878 by his widow Edma to the Musée des Beaux-Arts, Dijon.

Selected References: Berenson 1957, 1:102; Brizio 1964, col. 707; Mariani Canova 1975, 89, no. 16; Guillaume 1980, 43–44, no. 68; Béguin 1981, 99; Liberali 1981, 75; Gentili 1985, 89–93; Dülberg 1990, 144–145, 293, no. 329; Béguin 1993, 275; Goffen 1993, 121; Bonnet 1996, 24–25, no. 4; Brown 1997, 81–83, no. 4; Humfrey 1997, 10–11; Sheard 1997, 43.

37

Lorenzo Lotto

ALLEGORY OF
CHASTITY
("MAIDEN'S DREAM")

c. 1502–1505, oil on panel
42.9 × 33.7 (16⅞ × 13¼)
National Gallery
of Art, Washington,
Samuel H. Kress
Collection

The lyric mood of the sunset landscape in this panel relates both in content and style to the *Allegory of Virtue and Vice* (cat. 47) that once served as a cover for the portrait of *Bishop Bernardo de' Rossi* (cat. 46). This small painting probably served a similar function and, despite a slight discrepancy in size, was intended to protect Lotto's *Portrait of a Woman* (cat. 36).[1] However, unlike Bernardo's portrait cover, where the coat of arms points unmistakably to the de' Rossi family, this work makes no overt reference to the sitter's origins.

At the center of the picture is the figure of a young woman attired in glowing white and gold, colors symbolizing purity. Leaning against a tree trunk next to a clear spring, she seems absorbed in twilight dreams and transported by the fragrance of the blossoms raining down. The laurel tree rising behind her also refers to chastity: first by alluding to the nymph Daphne (Greek, laurel), who chose to be transformed into a laurel tree rather than submit to Apollo; and second and even more pertinently, by alluding to Petrarch's poems to Laura (Latin, laurel). In canzone 126 entitled "Clear, fresh, sweet waters" (Chiare fresche e dolci acque), the poet describes his beloved beside a river and next to a tree whose blossoms fall over her.[2] In the painting they are scattered by a winged putto who, lit from below, wears a fluttering veil that reveals more than it conceals. In the *Allegory of Virtue and Vice* we find a similar, albeit smaller, putto ascending the rocky path of virtue. With regard to who might have com-

missioned this work, it is interesting to note that Bernardo de' Rossi's extensive library contained a copy of Petrarch's *sonetti e canzoni*,[3] and the patron of the picture, or more likely its recipient, might have borne the name of Laura. However, the chaste young woman lost in noble thoughts is not alone but flanked left and right by creatures engaged in more earthly pursuits. On the left a small female satyr peeks lasciviously from behind a tree trunk in search of her male counterpart, who pours wine from a carafe and seems to take no notice of her.

Early interpreters of the painting looked for mythological sources, such as the golden shower of Danaë, here transformed into flowers, or the nymph Rhodos, wife of the sun god Helios, whom Plutus showered with gold.[4] It has also been suggested that the picture illustrates the *anima rationale*, the stages of love from the bestial to the divine, the subject of a painting that Lotto attempted to sell in Ancona in 1550.[5] More recent scholarship, however, points, partly by analogy with the de' Rossi allegory, to the general theme of *virtus* and *voluptas*, the victory of chastity over physical desires, and to an iconography drawn from a variety of sources.[6]

Since Berenson, reference has repeatedly been made to the similarity between the woman's pose and that of a female nude in a drawing by Dürer (page 184, fig. 1) in Vienna.[7] Yet there is no need to see this work as a direct antecedent. A drawing by Timoteo Viti, in the British Museum, London, shows a similar figure of a youth reclining in a landscape,

identified as Orpheus because of the stringed instruments next to him.[8] And the youth in the Giorgionesque *Young Lover and His Servant* (cat. 50), likewise lost in thought with his head on his hand, appears equally consumed by love's yearnings. The topicality of such a poetically melancholic mood, and of the dream of love itself, is demonstrated not only by the appearance of a new edition of Petrarch's sonnets and songs in 1501, but also by contemporary literary works from the Treviso region, particularly the *Hypnerotomachia Poliphili* (1499), in which the title itself refers to this subject. Bernardo de' Rossi's secretary owned a copy of this work, which was, therefore, most likely known to the artist. Here, too, we find the ideas of *virtus* and *voluptas* illustrated by similar protagonists.[9]

X-ray and infrared examination of the panel has revealed an earlier landscape composition, rotated 180 degrees, with a seated youth asleep with his head propped on his hand in a similar pose (fig. 1). As David Brown has shown, this pose is an almost exact reflection of the central figure in a comparable subject much beloved in the Renaissance, namely, the Dream of Hercules or Hercules at the Crossroads often found on *cassone* panels, like one attributed to Giacomo Pacchiarotto in the Museum of Fine Arts, Budapest.[10] If we accept the smaller Washington panel as a cover for a female portrait like that in Dijon, it would be reasonable to see a relationship between the dream of Hercules and the dream of the young woman painted over it. It is further tempting to assume that either the

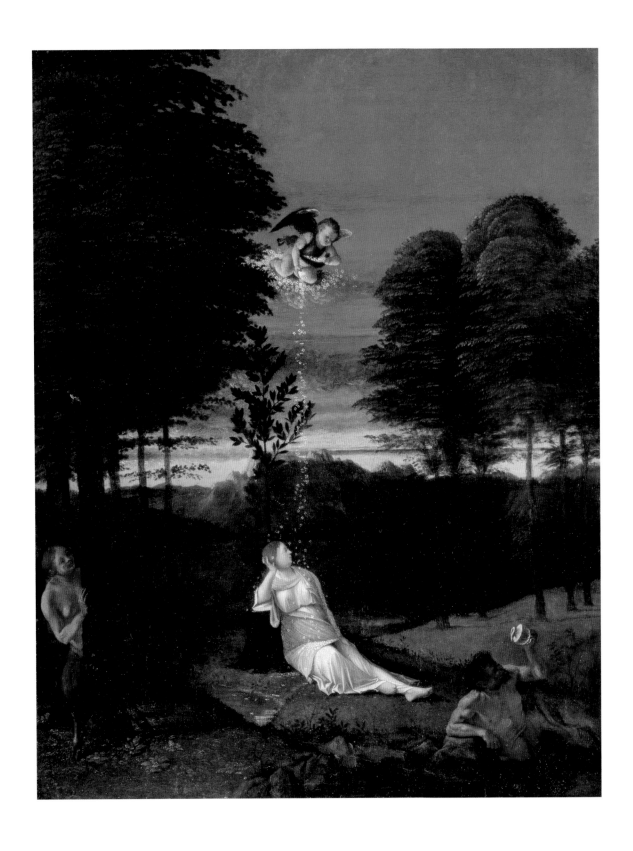

1.

Infrared reflectogram of
the painting

torial discourse on love and its various expressions. An important topic in the early sixteenth century, love was treated in Leone Ebreo's *Dialoghi d'Amore* and in other writings, like Pietro Bembo's *Asolani,* though Lotto's small panel specifically reflects contemporary humanism in Treviso, as seen in the works of Aurelio Augurello of Rimini, whom Dal Pozzolo names as the inventor of its literary *concetto.*[13]

The evening light in the Washington picture, with its long shadows and dark woods set off against the luminous, pink-tinged horizon, almost anticipates nineteenth-century plein-air painting. The sky glows deep blue toward the heavens, creating a kind of fairy-tale backdrop. The painting's solemn quiescence (*quies*) is reminiscent of the landscape backgrounds in Giovanni Bellini's religious works, like the *Sacred Allegory* in the Uffizi and the small scenes making up the so-called *Restrello* (mirror) that once belonged to the painter Catena and are now in the Accademia, Venice. Given these relationships, expressed not so much in detail as in an openness to the world of nature, we can conclude that Lotto must have been trained in Bellini's workshop. It is also clear that he is closer to the master in this work than in the de' Rossi *Allegory,* which should consequently be dated later.[14] Such a chronology, giving priority to the female allegory, would mean that Lotto's landscape idyll preceded Giorgione's *Tempest,* a work celebrated as the first autonomous landscape but hardly datable before 1506.

patron or the artist himself found this classically male subject inappropriate to cover a female portrait. Hence the scene was reconceived as a woman's dream. The new solution seems to be an original blend of subjects, primarily Petrarch's unrequited love for the ever chaste "Laura" and the same poet's treatment of Hercules' choice between *virtus* and *voluptas.*[11] Daniel Arasse has pointed out that a woman confronted with these options would not have had a choice. Only through sublimation, through striving for higher, spiritual qualities, might she overcome the sensuality embodied in the lustful female satyr.[12]

Whatever course Lotto may have taken in his choice of composition and content, he succeeded in creating a topical poetic testament to woman as exemplar of chastity and divine love. Indeed, his work might serve as a pic-

1. The connection was first established by Galis (1977, 212–215); see also Humfrey 1997, 12–14; differing opinions are listed in Brown 1997, 84–87, no. 5.

2. Pochat 1973, 384–387; Dal Pozzolo 1992, 109; the poem begins: "Chiare fresche e dolci acque / ove le belle membra / pose colei che sola a me par donna, / gentil ramo ove piacque / (con sospir mi rimembra) / a lei di fare al bel fianco colonna (verses 1–6)…Da' be' rami scendea / (dolce ne la memoria) / una pioggia di fior sovra 'l suo grembo (verses 40–42)…" (Clear, fresh, sweet waters, where she who alone seems lady to me rested her lovely body, gentle branch where it pleased her [with sighing I remember] to make a column for her lovely side…From the lovely branches was descending [sweet in memory] a rain of flowers over her bosom). Original Italian and English translation from *Petrarch's Lyric Poems. The* Rime Sparse *and Other Lyrics*, Robert M. Durling, trans. and ed. (Cambridge, Mass., 1976), 244–247.

3. Liberali 1981, 88. A new edition was published in 1501 by Aldo Manuzio.

4. On these interpretations see Shapley 1968, 158–160 and 1979, 275–277.

5. Cortesi Bosco 1992, 25–94.

6. Mariani Canova 1975, 88, no. 10; Gentili 1980, 65–68; 1981, 415–424. In a painting in the National Gallery of Art, Washington, attributed to Pietro degli Ingannati, elements of the de' Rossi *Allegory* are combined with a sleeping nymph, which has led to the assumption that the artist knew both of Lotto's allegories. See Brown 1997, 79, fig. 1 and 85–86.

7. Humfrey 1997, 15, fig. 18.

8. Popham and Pouncey 1950, no. 256, pl. 238.

9. Humfrey 1997, 15, fig. 19.

10. On the Hercules at the Crossroads subject and its popularity in the fifteenth and sixteenth century, see Erwin Panofsky, *Hercules am Scheidewege* (Berlin and Leipzig, 1930); also Mezzatesta 1975–1976, 17–19. For the Pacchiarotto painting, see Brown 1997, 87, fig. 3. Lotto somewhat later gave the same pose to a sleeping Apollo in a painting in the Museum of Fine Arts, Budapest, showing how artists continue throughout their lives to draw upon their own figural inventions.

11. Mommsen 1953, 178–192.

12. Arasse 1981, 370–376.

13. Dal Pozzolo 1992, 99–120.

14. This chronology was suggested by Gentili on iconographic grounds (1985), 87–91.

15. Anderson 1997.

Provenance: Probably not the "painting on panel by Giorgione, with a seated woman looking toward heaven and holding a veil in her hand, representing Danae in the shower of gold" (con una dona seduta che guarda il cielo tiene un drappo nelle mani qual sono Danae in piogia d'oro), cited in a Medici sale in Florence in 1681;[15] Castelbarco collection, Milan; (Anonymous dealer, Milan); sold 1887 as Hans Rottenhammer to Sir William Martin Conway, Allington Castle, Kent, England; (Count Alessandro Contini-Bonacossi, Florence and Rome); sold 4 October 1934 to the Samuel H. Kress Foundation, New York; gift 1939 to National Gallery of Art.

Selected References: Berenson 1894, 115; *Exhibition* 1894–1895, 16, no. 80; Berenson 1895, 1–3, 49–50; Ffoulkes 1895, 82–84; Coletti 1953, 292; Morassi 1953, 292; Pignatti 1953, 21–22; Pochat 1973, 384–385, 386–387; Caroli 1975, 106–107; Mariani Canova 1975, 6, 88, no. 10; Galis 1977, 35, 203–217, 435–446, no. 83; Sgarbi 1977, 45, 49; Brown 1979, 16, no. 21; Shapley 1979, 1:275–277; Brown 1980, 1:98–99; Gentili 1980, 65–66; Mascherpa 1980, 15, 22–23; Arasse 1981, 370–377; Pignatti 1983, 180–181; Gentili 1985, 87–91; Pochat 1985, 3–15; Baranski 1988, 1:209–210; Gentili 1988, 101–103; Rosand 1988, 69, 74–76, 258; Dülberg 1990, 144–145, 293, no. 329; Lippincott 1990, 74–75; Cortesi Bosco 1992, 25–49; Dal Pozzolo 1992, 103–127; Ballarin 1993, 309; Wood 1993, 50–51; Anderson 1997, 79; Humfrey 1997, 12, 168, no. 21–22.

38

Giorgione

PORTRAIT
OF A WOMAN
("LAURA")

1506, oil on canvas
mounted on panel
41 × 33.6 (16⅛ × 13¼)
Kunsthistorisches Museum,
Gemäldegalerie, Vienna

inscribed: 1506 adi primo
zugno fo fatto questo
de ma[no] de maistro Zorzi
da chastel fr[anco]
cholega de maistro vizenzo
chaena ad instanzia de
mis[ser] giac[omo] [...]
(reverse, wooden mount)

Giorgione's *Laura* of 1506 is considered the epitome of the modern female portrait of the Venetian Renaissance, the prototype of the idealized *belle donne*. Generally interpreted in more recent scholarship as portraits of courtesans, this picture type enjoyed great currency in Venice during subsequent decades.[1] Yet *Laura* is distinguished from these later works by the traditional three-quarter pose and a greater individualization of the facial features, suggesting that it must represent a specific young woman. Since the portrait was commissioned by a certain "Misser Giacomo," as gleaned from the early inscription on the reverse, we may presume that it depicts his wife, perhaps a bride, or even a mistress. The young woman's total disregard of the viewer seems only to increase her

allure. She gazes straight ahead with a modest expression, putting us in the position of voyeurs, and bares her right breast circled by a transparent veil. It is unclear whether she has just drawn back the luxurious, glowing red cloak, or whether she is on the verge of covering her breast with its soft fur trim. In spite of her innocent expression, the sitter's revealing pose might lead us to interpret her as a courtesan, rather than a virtuous bride or a wife, for whom chastity was the principal requirement.[2] Any interpretation is further complicated by the laurel that branches out so effectively against the black background, for the laurel can be variously interpreted, depending on the context. In Palma Vecchio's *Portrait of a Poet* (cat. 52), for example, the same motif has generally served to identify the figure's occupation, although the laurel in itself is insufficient evidence that he represents Ariosto, at that time

often celebrated as Apollo.[3] We know that the laurel was sacred to Apollo from the heartbreaking story of the beautiful Daphne (Greek, laurel), a chaste nymph who chose to be transformed into a laurel tree rather than submit to the god consumed by love for her. That our picture might allude to Daphne is ruled out merely on the basis of her bared breast.[4] Here the laurel more likely suggests a poet, perhaps one with the name of Laura or Daphne. The ample cloak has in fact been identified as a male garment and thus an indication that the sitter was engaged in a pursuit hitherto dominated by men, that of poetry.[5] From her décolletage we might infer her to be one of the poet-courtesans who achieved fame in the sixteenth century, such as Tullia d'Aragona or later Veronica Franco. However, no contemporary portraits of such women with breast bared have yet been identified.[6]

In a religious context the laurel stands for chastity, typically appearing as a backdrop for the Madonna in a painting ascribed to Palma or Cariani in the National Gallery, London, or in Giovanni Agostino da Lodi's *Madonna and Child with Two Donors* at Capodimonte in Naples. More generally it symbolizes *virtus* (virtue), as in Mantegna's famous engraving *Virtus Combusta et Virtus Deserta*.[7] In connection with weddings it takes on yet another meaning: Lorenzo Lotto's famous marriage picture *Marsilio Cassotti and His Bride Faustina*, in the Prado, Madrid (fig. 1), shows a laurel-crowned putto joining the couple with

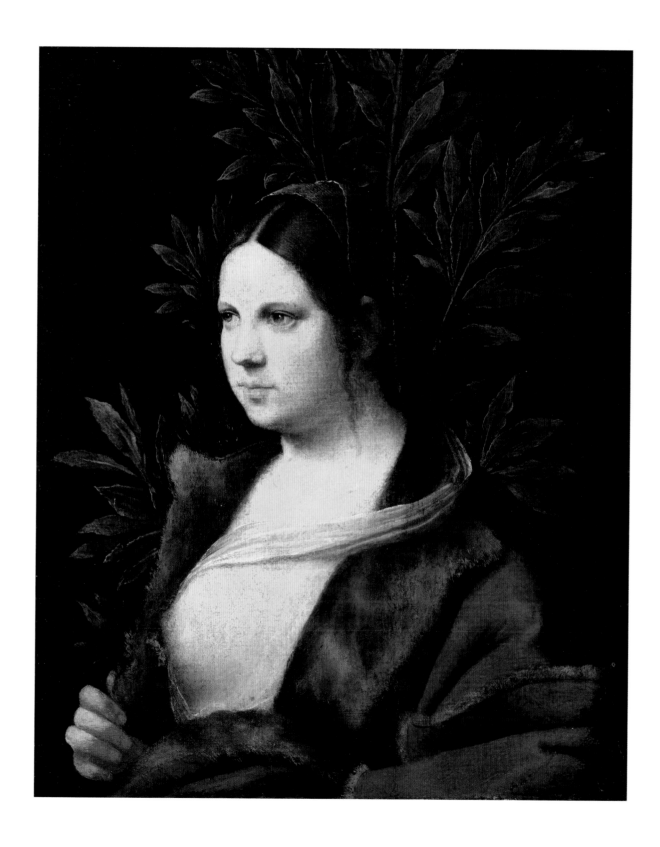

a yoke cut from laurel wood, its distinctive leaves resting on the shoulders of the bridal pair.[8] The marriage yoke was said to derive power from the laurel, making *coniuges* (spouses) of the couple and guaranteeing the longevity of the union. The laurel stands as marriage symbol on the reverse of a portrait by Jacometto Veneziano in the National Gallery, London, where two bound branches bear an inscription from an Horatian ode: FELICES TER ET AMPLIUS / QUOS IRRUPTA TENET COPULA (Thrice Happy and More are Those Bound Together).[9] The white veil that falls from the head and around the breast in the *Laura* is a familiar symbol of a married woman and would support this interpretation.

In the infrared reflectogram of the Vienna picture (see page 291, fig. 7) one can see that the cloak covering the woman's left breast was at first narrower and pushed aside. Rich folds of drapery are detectable, suggesting that Giorgione may originally have intended to display Laura's undergarment, a richly pleated chemise (*camicia*) of soft fabric of the kind worn in Titian's *Flora* (cat. 42). Now the mantle conceals nearly all of this, and the veil's continuation is merely suggested.[10] The motif of one covered and one bared breast has been read as implying the antithesis of *pudicitia* (chastity) and *voluptas* (delight), both essential for a harmonious marriage.[11] If so, the work may have been planned as a double portrait, its now lost male pendant perhaps showing the Misser Giacomo of the inscription.[12] Gentili believes that nearly all half-length portraits of erotic, partially dressed women are brides, not courtesans, and in them he finds that "the integration of emphatic, proffered, and lived eroticism is represented alongside tempered, monitored, and regularized eroticism," an integration only possible in marriage.[13] Thus he sees Laura as embodying the chastity symbolized by the laurel, the fertility suggested by the modestly exposed breast, and a demure willingness; the only possible audience for this picture, both socially and figuratively, would be her bridegroom.[14] Dal Pozzolo collected literary references dating from before and after this painting in which a woman's breast was considered the gate of the soul, bared so that the heart might receive something of beauty, such as the bridegroom's love. In his view, it was Giorgione's genius that elevated a modest portrait into an allegory of marriage, by eroticizing the bared breast.[15] On the basis of this overt sensuality, recent scholarship has read the portrait as a *paragone* in which painting is victorious over poetry, eroticism being more directly experienced through vision than language.[16] Thus *Laura* would become the allegory of *Pictura* per se. Petrarch's poems were once again enjoying wide popularity, and our portrait is often viewed as a rendering of the poet's cherished addressee. Yet if Giorgione had truly intended to represent Petrarch's Laura, it was not without a whiff of irony: Petrarch's beautiful ideal, blond and demure, opposed his carnal desire and remained forever unreachable; the painter's *Laura*, by contrast, is plump, dark-haired, and sensual.[17]

In keeping with Vasari, scholars have looked to Leonardo da Vinci, then staying in Venice, to explain Giorgione's new painting technique and with it the renewal of Venetian painting through the introduction of sfumato and chiaroscuro. This thesis has recently been questioned and, for the *Laura* portrait, disproven.[18] There is no trace here of these techniques. And in their innovative handling of texture, pictures such as the *Laura* or the *Tempest* are as different from the works of Giorgione's Venetian predecessors as they are from those of Leonardo and his school. By careful observation of the natural world, above all of light, Giorgione seems to have developed a distinctive technique that allowed him to capture the charged humidity of the atmospheric landscape in the *Tempest* or the almost palpable sensuality of *Laura*.

Technical investigation has revealed that the laurel branches were painted with a backdrop of sky or landscape, an even more direct testimony to a conceptual relationship with Leonardo's *Ginevra de' Benci* (National Gallery of Art, Washington), which, with its sitter framed by juniper leaves, has been regarded as the inspiration for *Laura*.[19] Even more surprising, the infrared reflectogram reveals an intermediate stage, with laurel branches only at the top and right sides. This solution would have concentrated the picture's directionality even more toward the left, an indication that the artist may, in fact, have considered adding a pendant (see pages 291–292; figs. 7, 8, 9).[20]

1. Junkerman 1988, 378–380; Junkerman 1993, 49–51; Götz-Mohr 1987, 45–47, 60–62; Gentili 1995, 95–103.

2. See the 1523 tract by Juan Luis Vives, *De Institutione Feminae Christianae*, not published in Venice until 1545. Italian translation by Ludovico Dolce, *Dialogo della Istitutione delle Donne*. Junkerman 1993, 49–58.

3. Verheyen 1968, 222 (220–227).

4. Richter 1937, 251.

5. Junkermann 1988, 378–397, and 1993, 49–58, attached considerable importance to this. Anderson (1997) also sees Laura as a poet-courtesan.

6. See the chapter on (female poets) in Ferino-Pagden 1997, 205–227.

7. R. Lightbown, *Mantegna* (Oxford, 1986), ill. 239 a and b, no. 220.

8. Lucco in Brown, Humfrey, and Lucco 1997, 134–137, no. 21.

9. See Brown 2001, no. 20.

10. For an account of the picture's condition and restoration history, see most recently Ferino-Pagden and Nepi Scirè 2004, 197–200, no. 8, and Oberthaler 2004, 267–269.

11. Verheyen 1968, 220–227. Dal Pozzolo 1993, 257–291

12. Noë 1960, 1–35.

13. "Ma compresenza di erotismo enunciato, offerto, vissuto ed erotismo moderato, sorvegliato, regolato." Gentili 2000a, 358.

14. Likely Misser Giacomo; Gentili 2000a, 358.

15. Dal Pozzolo 1993, 275–277.

16. See Holberton 2003, 40–42. In the inventory of Bartolomeo della Nave's collection of 1638, the picture is described as "Petrarcas Laura."

17. Dal Pozzolo 1993, 257–259, fig. 2–4.

18. Paul Holberton, "Giorgione's sfumato," in *Giorgione* 2006, 44.

19. Oberthaler 2004, 268–269.

20. This thesis has been proposed by Hirst 1981, 96, note 25; and most recently by Schleier 1998, 371.

21. See Ferino-Pagden and Nepi Scirè 2004, 282.

Provenance: Bartolomeo della Nave collection, 1638, no. 50; c. 1650–1651 in the collection of the Archduke Leopold Wilhelm; inventory of the collections of Archduke Leopold Wilhelm 1659, no. 176; thereafter in the imperial collection.[21]

Selected References: Mechel 1783, 19, no. 13; Krafft 1849, 11; Engerth 1881, 281, no. 393; Justi 1908, 262–263; Wilde 1931a, 91–100; Wilde 1934, 206–212; Richter 1937, 53, 251–252, no. 91, 322; Waterhouse 1952, 1–23; Noë 1960, 1–35; Baldass and Heinz 1964, 16, 29, 130–131, no. 9; Morassi 1967, 198, 200; Verheyen 1968, 220–227; Mellencamp 1969, 117, note 17; Pallucchini 1969, 1:6; Pignatti 1969, 58–59, 99–100, no. 10; Battisti 1970, 211; Calvesi 1970, 203–204; Wilde 1974, 70–72, 85; Roskill 1976, 88–90; Anderson 1978, 72; Mucchi 1978, 40; Pignatti 1978a, 54, 103, no. 11; Pignatti 1978b, 12–13; Anderson 1979a, 154, 156; Klauner 1979, 264–267; Ballarin 1980, 493–499; Ballarin 1981a, 26; Hirst 1981, 96, note 25; Pignatti 1981a, 143–144; Pozzi 1981, 334–335; Cropper 1986; Hornig 1987, 55, 70, 208–209, no. 21; Götz-Mohr 1987, 59–64; Junkerman 1988, 378–397; Fletcher 1989, 813; Haskell 1989, 208, 218; Pedrocco 1990, 82; Ballarin 1993, 332–337; Dal Pozzolo 1993, 257–291; Junkerman 1993, 49–58; Perissa Torrini 1993, 76; Gentili 1995, 95–103; Humfrey 1995, 126; Lucco 1995, 116; Lucco 1996, 42–44; Luchs 1995, 91–92; Anderson 1997, 208–217; 299–300; Helke 1999, 12–35; Pignatti and Pedrocco 1999, 138; Gentili 2000a, 358; Belting 2001, 48; Radar 2001, 91–93; Holberton 2003, 40–42; Ferino-Pagden and Nepi Scirè 2004, 197–201, no. 8 (Ital. ed. 2003, 144–149, no. 6); Holberton 2006, 44.

Giorgione

OLD WOMAN
("LA VECCHIA" OR
"COL TEMPO")

c. 1510, tempera and
oil on canvas,
transferred from canvas
68 × 59 (26¾ × 23¼)
unframed; 96 × 87.5
(37¾ × 34⁷⁄₁₆)
with original frame
Gallerie dell'Accademia,
Venice
·
Washington only

This image speaks of time and the process of aging—from the paper inscribed "Col Tempo" (with time), held by the old woman as she points to her breast, to her wrinkled face and dull hair, stumps of teeth, and above all her tired gaze, more woeful than accusing. The subject would seem to be an allegory of transience, and so has she been interpreted by the majority of scholars, though naturally with differing emphases. According to Suida, the picture is a straightforward *vanitas;* Panofsky interpreted it as an allegory of aging (*memento senescere*); Vescovo, as a personification of old age itself.[1] Calvesi detected the influence of Leone Ebreo, whose *Dialoghi d'Amore* describes how an old mother could, as *Mater Materia* or *Materia Prima,* allude to the "continua generazione e corruzione" (continuous procreation and corruption) of all things.[2] Del Bravo cites Aristotle's musings on transience as the procreator and corruptor of all things: "with time one becomes neither young nor beautiful."[3] The subject of time and its passing was popular with early sixteenth-century poets such as Panfilo Sasso and Cesare Nappi.[4] One of Filenio Gallo's poems repeats "col tempo" in every verse.[5] Cesare Nappi counsels with the words: "Bisogna ne sapiamo confortare / col tempo, e navicar questo van mondo, Ch'altro che dio non ce ne po' aiutare."[6] Ballarin inverts the customary reading of the inscription, claiming it is not, as Panofsky stated, a reference to the transitoriness of the body but to a moment of catharsis, the cleansing of youthful desires. Thus, as confirmed by the hand that holds the note and points to the heart, the old woman turns toward the all-embracing love of God.[7]

The blunt realism of the depiction surely presupposes an actual model, and x-radiographs and infrared reflectograms reveal a complex process leading from the model to the finished portrait; the woman's garment, for example, was originally cut lower, and the parapet was absent.[8] We can therefore conceive of this work as the picture of an old woman, and we find it listed as a portrait of the artist's mother in the Vendramin inventory of 1567–1569: "retrato della madre di Zorzon de man di Zorzon con suo fornimento depento con l'arma de Chà Vendramin" (Portrait of Giorgione's mother by the hand of Giorgione, with the frame painted with the crest of the house of Vendramin).[9] In Lucco's opinion, Giorgione was deliberately competing with Protogenes, the famous ancient painter who, according to Pliny, painted a portrait of his own mother.[10]

Elsewhere the work is listed simply as the portrait of an old woman, as for instance in the inventory of the Vendramin collection of 1601, although there it is described as having a protective cover bearing the painted portrait of a man wearing a black fur or pelt: "a painting of an old woman with a frame of painted walnut, approximately five-and-one-half *quarte* high and five *quarte* wide, with the Vendramin coat of arms on the frame, the cover of said picture painted with a man wearing a garment of black leather."[11] Aikema, following Cranston, inverts this arrangement, instead regarding the "Vecchia" as the cover for the lost male likeness. Citing works from north of the Alps—particularly Albrecht Dürer's *Avarice,* which decorates the verso of a male portrait—he suggests that we read the old woman as a comic

figure like the *tronies* or "amusing heads" of sixteenth-century Netherlandish art. By this account Giorgione would have been inspired by Leonardo's famous caricatures of old men.[12] Yet associating *La Vecchia* with the *ars comica* seems to contradict the picture's message, as the figure is not at all comical. Furthermore, the splendid original frame, once decorated with the Vendramin coats of arms (attached perhaps to some other material loosely applied to the wood), is still on the picture and is clearly described in all inventories. This makes it even less likely that *La Vecchia* was planned as a cover or that it later served such a function. Although the picture was often cited in inventories and letters, it is mentioned in connection with a portrait cover only in 1601. In Settis' view, even if the cover cited in the inventory was by Giorgione, the artist inverted the conventional relationship between portrait and cover, perhaps by mutual agreement with the patron. Normally a cover includes elements that refer to the sitter, such as coats of arms, symbols of transience, or a moralizing allegory (see Lotto's portraits, cats. 36, 46). In the present case, however, the portrait of a young man would have served as the cover for his own "device," here expressed as an allegory of time, an admonition representing the foundation for all his thoughts and actions: act responsibly and always consider the future.[13]

Gentili, on the other hand, points out that the prominent white cap and the equally bright shawl resemble the work clothes of wet-nurses found in paintings (fig. 1) from the fifteenth to the eighteenth century. He suggests that the hand pointing to the breast is

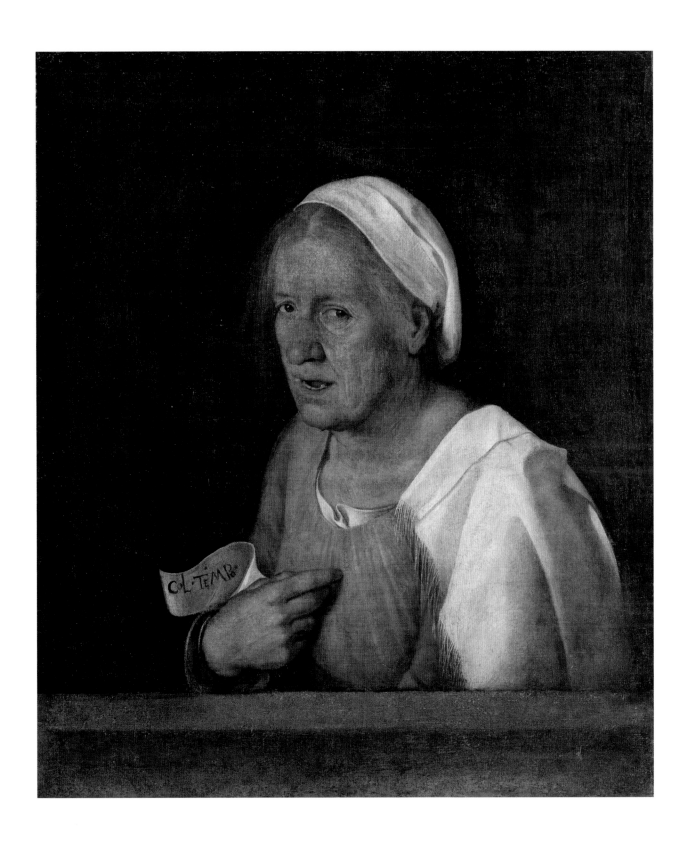

Vittore Carpaccio, *Arrival
of the English Ambassa-
dors to the Court of
King Maurus of Brittany*
(detail), Gallerie dell'
Accademia, Venice

214

another reference to this iconographic type, and that only the inscribed slip of paper, which he sees as a belated addition, serves to turn this disturbingly realistic portrait of a wet-nurse into an allegory.[14] Giovanna Nepi Scirè still prefers to see *La Vecchia* first and foremost as a portrait, recognizing it as one of Giorgione's most extraordinary and highly personal achievements.[15] In a recent analysis, the painting's allegorical character has been stressed anew but with a different emphasis: since the main purpose of a portrait is to reflect a moment in time, *La Vecchia*, evidencing the passage of time, should be considered an allegory of portraiture.[16]

1. Suida 1935a, 86–87; Panofsky 1969, 90–91; Vescovo 1992, 47–61.

2. Calvesi 1970, 220; Kodera 2003, 481–517.

3. Del Bravo 1987, 243.

4. Nepi Scirè 2003, 164–167; Ferino-Pagden and Nepi Scirè 2004, 220; Settis 2006, forthcoming.

5. Col tempo el villanel al giogo mena / el tor, sì fiero e sì crudo animale; / col tempo el falcon si usa a menar l'ale / e ritornar a te chiamato a pena. / Col tempo si domestica in catena /col tempo l'aqua, che è sì molle e frale, / rompe el dur sasso come el fusse arena. / Col tempo ogni robusto arbore cade, / col tempo ogni alto monte si fa basso: / et io, col tempo, non posso a pietade / mover un cor d'ogni dolcezza casso, / onde avanza di orgoglio e crudeltade / orso, toro, leon, falcone e sasso. (son. 19). "With time pass the years, and months, and hours, / with time the riches, rule, and reign, / with time youth and beauty die, / with time dies every plant and flower, / with time every tree turns to dry wood, / with time passes jest, injury, and disdain, / with time every sadness leaves and disappears." English translation from Cranston 2000, 31.ß

6. Battisti 1960, 156, note 1. (We must know how to be content with time and how to navigate this world of vanity, for only God can help us).

7. Ballarin 1979, 235–236; Ballarin 1993, 320–324.

8. Illustrated in Nepi Scirè and Rossi 2003, 205; Ferino-Pagden and Nepi Scirè 2004, 264.

9. Most recently, see Nepi Scirè 2003, 162; Nepi Scirè 2004, 219.

10. Lucco 1995, 27.

11. "Un quadro de una Donna Vechia con le sue soaze de noghera depente, alto quarte cinque e meza e largo quarte cinque incirca con l'arma Vendramin nelle soaze, il coperto del detto quadro depento con un'homo con una veste de pelle negra." Nepi Scirè 2003, 162; Nepi Scirè 2004, 219; Anderson 1979a, 647.

12. Aikema 2003, 79–80; Aikema 2004, 93.

13. Settis 2006, 27–41.

14. Gentili 2006, 93–104.

15. Nepi Scirè 2003, 167; Nepi Scirè 2004, 221–222.

16. Cranston 2000, 61.

17. Mason 2003, 69; Mason 2004, 37–38.

Provenance: Gabriele Vendramin Collection; by 1657 it appeared in the Zen collection; thereafter Cristoforo Orsetti from Bergamo, cited in inventories of 1664 and 1680.[17] Sold by Giovanni Battista Orsetti's heir. In the Manfrin collection at the end of the eighteenth century, then by descent to Bortolina Plattis-Sardagna. Acquired 1856 by Emperor Franz Josef.

Selected References: Suida 1935a, 86–87; Battisti 1960, 155, 156 n.; Moschini Marconi 1962, 124–125, no. 199; Baldass and Heinz 1965 (1964 ed., 36, 159–160); Pope-Hennessy 1966, 228; Panofsky 1969, 90–91; Pignatti 1969, 67–71, 111, no. 29; Calvesi 1970, 184, 220; Moschini Marconi 1978, 143–147; Anderson 1979a, 156; Anderson 1979b, 643, 647; Ballarin 1979, 235–236; Meller 1979, 9–18; Ballarin 1980, 493, Anm. 3; Ballarin 1981, 26; Pignatti 1981, 152–153; Ballarin 1983, 498, 506–507, 520; Pallucchini and Rossi 1983, 368, no. V.83; Nepi Scirè and Valcanover 1985, 121; Del Bravo 1987, 1:243; Hornig 1987, 205–208, no. 20; Nepi Scirè 1987, 22–29; Brown 1992, 93; Cogliati Arano 1992, 326; Nepi Scirè 1992, 328–329, no. 63, 351; Vescovo 1992, 47–61; Ballarin 1993, 320–324; Perissa Torrini 1993, 80–82; Lucco 1995, 44, 114; Anderson 1997, 172–174, 193–195, 302–303; Nepi Scirè 1998, 61; 154, 156, 262–263; Pignatti and Pedrocco 1999, 182–184; Cranston 2000, 17–61 and passim; Gentili 2000a, 357; Radar 2001, 90a–92; Borean and Mason 2002, 137, 139–147; Lauber 2002, 46–53; Aikema 2003, 73–89; Aikema 2004, 85–103; Nepi Scirè in Nepi Scirè and Rossi 2003, 162–167, no. 9; Nepi Scirè in Ferino-Pagden and Nepi Scirè 2004, 219–223, no. 14; Mason 2003, 63–71; Mason 2004, 33–39; Gentili, 2006, 97–102; Settis 2006, 28–33.

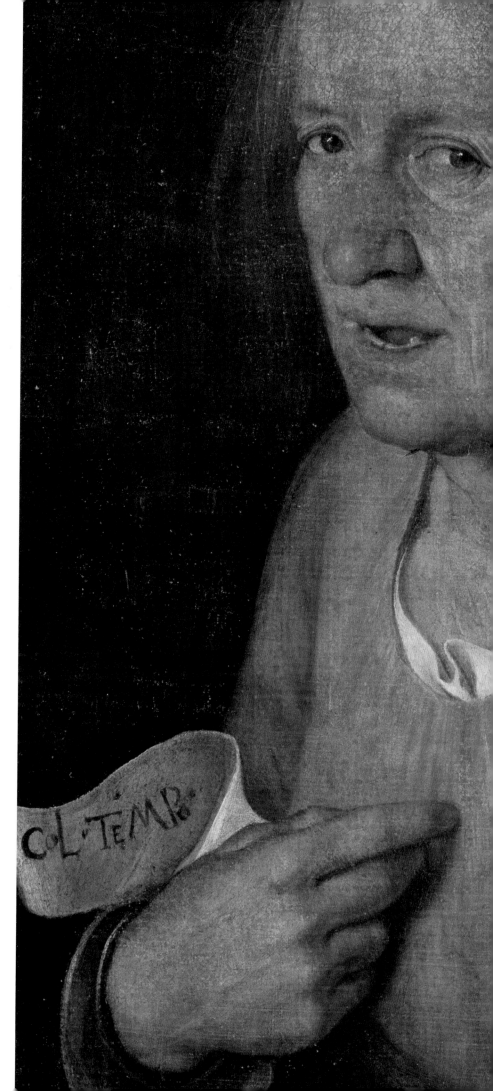

detail, cat. 39

40

Sebastiano del Piombo

WOMAN AS
A WISE VIRGIN

c. 1510, oil on
hardboard, transferred
from panel
53.4 × 46.2 (21 × 18⅛)
National Gallery
of Art, Washington,
Samuel H. Kress
Collection

inscribed:
V. (C)OLONNA (below
woman's hand)

The female portraits that Sebastiano painted while still in Venice already exhibit some of the expansiveness and monumentality that characterize the works he would do in Rome after 1511. The early group includes this glowing young woman, with cool, velvety skin and glistening ice-blue dress before a dark background; the *Portrait of a Girl* in the Museum of Fine Arts, Budapest, dated 1506; and the *Salome* in the National Gallery, London, dated 1510 (fig. 1). The Washington and London figures wear the same blue dress with sleeves pushed up to reveal a white chemise and may represent the same woman. The compositions of the two works further suggest that they were painted about the same time. Yet the messages could hardly be more different. Whereas the young woman in the Washington picture, with her innocent yet seductive and challenging glance, awakens a positive response in the viewer, the knowing, triumphant gaze of her counterpart in London and the decapitated head she bears elicit a shudder. The latter's bold expression has led to the suggestion that she may represent not the weak yet sensuously enticing Salome acting under her mother's influence, but rather the conscientious Judith, who committed murder in order to free her people.[1] Since conventional iconography places the head of John the Baptist, but not that of Holofernes, on a platter, the latter reading is possible only if we presume an intentional blurring on the artist's part, a deliberately ambiguous interpretation of his heroine.[2]

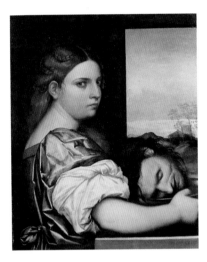

The Washington picture may contain a similarly premeditated equivocation. The young woman's *contrapposto* and the sharp glance from the corners of her eyes, focusing outside the picture, are reminiscent of the mix of seduction and coquettishness that we find in some portraits identified as courtesans, like one by Bernardo Licinio in a private collection.[3] Yet the gaze of Sebastiano's young woman appears purer and more innocent. In the past this mixture of blamelessness and enticement has led some to identify the figure as Mary Magdalene and her attribute as an ointment jar.[4] Yet once it was established that the object she carries is made of metal and has a conical top with openings and a small flame, the identifying attribute was recognized as an incense burner or an oil lamp.[5]

The inscription "V. COLONNA" (in an old but not contemporary script) and the date 1511, clearly visible on the pedestal, have usually been judged to be later additions and linked to a 1650 engraving by Wenzel Hollar of the famous poet Vittoria Colonna.[6] The

print includes no inscription on the pedestal, but scholars made reference to an engraving allegedly done after the painted portrait by Enea Vico, later in the sixteenth century. Though Vico did, in fact, engrave a portrait of Vittoria Colonna, it is not modeled on Sebastiano's picture, for it shows the poet wearing a widow's veil.[7] In line with Hollar's engraving, Sebastiano's young woman adorned the frontispieces of a number of later editions of Vittoria's poems.[8] Shapley, arguing that the inscription was contemporary with the painting and wrongly assuming that Vittoria was born in 1492 instead of 1490, maintained that the picture was a presentation portrait of Vittoria Colonna, aged nineteen, when she was preparing for her marriage to Ferrante d'Avalos. Since the attire of the sinful Magdalen would hardly have been appropriate for such an event, Shapley saw the sitter in the guise of a "wise virgin."[9] Ironically, Vittoria Colonna subsequently paid special attention to the penitent Magdalen by commissioning the most famous Italian painters—including Titian and Michelangelo—to represent her.[10]

Today scarcely anyone accepts this work as a portrait of the poet. It seems too idealized to be a likeness, and it would also be difficult to explain how Sebastiano, then little-known outside Venice, could have been commissioned to paint a relatively unknown young woman from Naples or the island of Ischia. Only after he had moved to Rome, and especially in the 1520s and 1530s, would Sebastiano have found adequate opportunity to

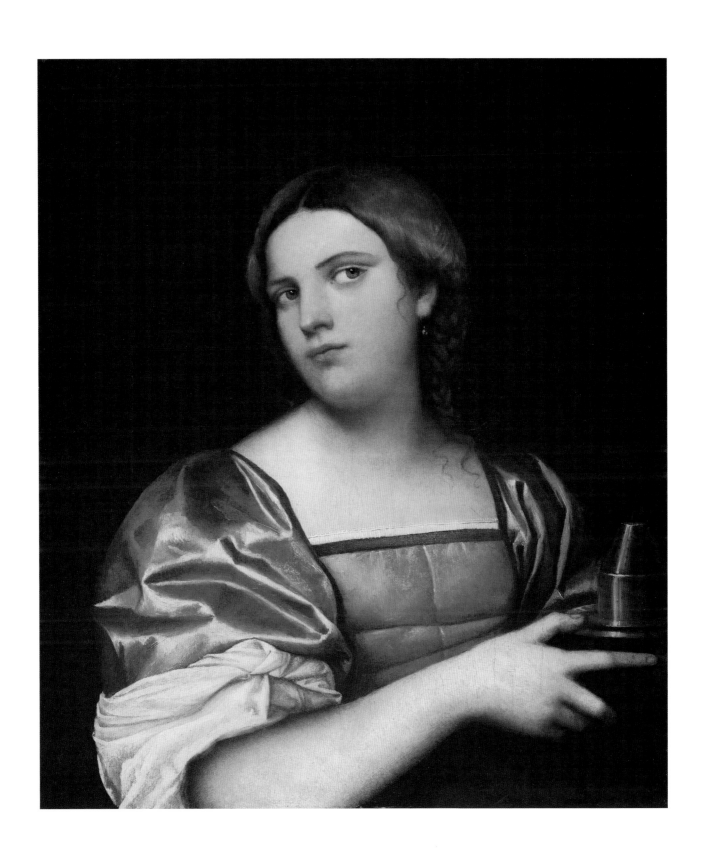

portray the then-famous poet.[11] The conclusion seems inevitable that the identification as Vittoria Colonna is a seventeenth-century invention. Most scholars now identify the figure as a "wise virgin," based on a reading of her attribute as an oil lamp and perhaps also on her innocent gaze. Yet to have chosen just one of the ten virgins of the parable, and to depict her in half-length, was an extraordinary idea, one never repeated in the history of art. Consequently, some scholars still regard the young woman as the courtesan Mary Magdalene.[12] In the context of idealized Venetian female figures of this period, considered brides rather than courtesans by a number of scholars, the subtle ambiguity of this seductive but innocent "virgin" may represent an admonition to a bride—whether in anticipation of Christ or a bridegroom— never to let her flame be extinguished.

1. Joannides 1992, 163–170.

2. Reinecke 2003, 196–197.

3. Hirst 1981, 94, note 18; Sander 2004, 319; Luchs 1995, 76.

4. See the literature listed in Shapley 1979, 421, note 1; Ffoulkes 1895, 254–256.

5. Borenius 1913, no. 140, as *Portrait of a Lady Holding a Censer.*

6. See most recently Ferino-Pagden 1997, 126–129.

7. Ferino-Pagden 1997, 137–38.

8. Ferino-Pagden 1997, 129.

9. Shapley, 1979, 420–421.

10. On Titian's *Magdalen* painted for Vittoria Colonna see most recently Agosti 2005, 71–81; Hirst and Mayr 1997, 335–344.

11. Ragionieri 2005, 43–59, no. 10–11; Ferino-Pagden 1997, 133–135.

12. For the parable see Matthew 25:1–13. Representations are more common north of the Alps. Parmigianino's frescoes in the vault of Santa Maria della Steccata, Parma, include just six virgins, all in full figure. See also Ingenhoff-Danhäuser 1984, 42.

Provenance: John and Jacobus van Veerle Antwerp, by 1650. Edward White, London, by 1870; (probably his sale, Christie's, London, 5 April 1872); purchased by (Colnaghi's London and New York) for Sir Francis Cook, 1st Bt [1817–1901], Doughty House, Richmond, Surrey; by descent to Sir Francis Ferdinand Maurice Cook, 4th Bt [1907–1978], Doughty House, and Cothay Manor, Somerset; (Francis A. Drey, London); sold February 1947 to the Samuel H. Kress Foundation, New York; gift 1952 to National Gallery of Art.

Selected References: London Old Masters 1870, no. 149; Ffoulkes 1895, 254–256; Benkard 1907, 27–28; D'Achiardi 1908, 46–47; Borenius 1913, no. 140; Dussler 1942, 16, 138; Pallucchini 1944; 15; Suida 1951, 102; Shapley 1979, 420–421, no. 301; Volpe and Lucco 1980, 96, no. 18; Hirst 1981, 4, 30–31, 93, pl. 29; Ingenhoff-Danhäuser 1984, 42; Joannides 1992, 167–168; Aikema 1994, 48–59; Luchs 1995, 76; Lucco 1996a, 331–336; Ferino-Pagden 1997, 126–128, no. I. 46.

41

Giovanni Bellini

LADY
WITH A MIRROR

1515, oil on panel
2 × 79 (24 7/16 × 31 1/8)
Kunsthistorisches
Museum, Gemäldegalerie,
Vienna

inscribed:
annes bellinus faciebat
M.D.X.V. (on paper)

Among idealized female portraits, the *belle donne* of Venetian art, Bellini's *Lady with a Mirror* is considered the purest embodiment of ideal nudity. Yet there is something poetic and timeless about this figure, perhaps because she is the creation of a painter nearly eighty-five years old. Otto Pächt dubbed the picture an "apotheosis of seeing," and Rona Goffen claimed that its actual subject was "sight."[1]

The woman's lovely body, posed on a carpet-covered bench, represents what is probably the first Venetian nude without any biblical, mythological, or moral motivation. She is bound in a play of spatial illusions—the dark green wall close behind her to the right and the distant landscape through an opening to the left where our gaze is drawn back in a sequence of horizontal landscape elements. Her upper body transects these boundaries above the frame that cuts across her legs.

Holding a hand mirror to see the back of her head in a round wall mirror, she arranges her hair in a pearl-trimmed net of sumptuous blue-green patterned brocade, its color picking up the storm clouds above the landscape. We, too, look into the mirror and see the slightly muted image of a red appliqué and pearls as well as part of her raised arm. Ever since Jan van Eyck's famous painting of a woman at her toilet became known in Italy, the subject of mirrors and reflections was very popular in Italian painting, above all in connection with the *paragone* of the arts.[2] The painted reflection makes multiple views possible from one vantage point, whereas we

must walk around a sculpture in order to see all of its sides.[3] Yet competing with sculpture was hardly Bellini's concern, as is often claimed; he seems to have been equally uninterested in the various meanings that can be associated with mirrors. Even though he captured that moment when the young woman, in arranging her hair, loses herself in contemplation of her own beauty, it must remain an open question whether he had in mind Narcissus and the invention of painting, or an allusion to *Prudentia* and *Veritas*, or the theme of transience. Some scholars, however, have wanted to see this figure as a "secularized" Vanitas.[4]

Certainly the play with the mirror made it possible for the artist to heighten the scene's erotic and poetic appeal by granting the viewer an undisturbed view of an undressed woman who is herself caught up in her own reflection. Holding the mirror in her right hand she performs the movement of a *Venus pudica* (chaste Venus) and partly covers her breasts. Goffen's suggestion that the raised left arm may allude to the classical *Venus Anadyomene* (Venus emerging from the sea, usually shown twisting her wet hair) is appealing, especially if we accept it as the stimulus for the entire composition.[5] Gentile Bellini, Giovanni's brother, had inherited the torso of a classical statue of Venus, and Jennifer Fletcher proposes that the way the red cloth cuts across the figure's arm is an allusion to this antique torso.[6] And yet, in spite of the almost alabaster appearance of her body, this woman is quite unlike the carved Aphrodites of the classical era who take such pleasure in their nudity. Rather we have become voyeurs at the toilet of a sixteenth-

century Venetian lady. For sculptural comparisons we would have to look at contemporary works such as those by Tullio Lombardo. His relief of *Bacchus and Ariadne* of about 1505 (Kunsthistorisches Museum, Vienna) may have offered a model for the figure type, especially for the headdress.[7] The mood of both works is similarly dreamy and entranced, like a fairy tale. The woman's idealized features can also be found in Bellini's representations of saints, such as the *Sacra Conversazione Giovanelli* (Accademia, Venice), making its subject less likely to have been the portrait of an individual.

According to Goffen, Bellini's picture assimilates the subject of Titian's *Sacred and Profane Love* into a single figure, an idealized portrait of a recently married woman; here she represents the various tasks of a wife: socially dictated demureness along with sexual submissiveness. As one can see in a workshop copy, the drapery was originally deep red,[8] a color, symbolic of love, used for bridal gowns in sixteenth-century Venice.[9] In Cesare Vecellio's costume book of 1590, *Degli abiti antichi et moderni*, brides of the twelfth century are given similar hairnets (*reticelle*), which are still found in wedding pictures of the sixteenth century; for example, Faustina Cassotti wears one in Lotto's double portrait *Marsilio Cassotti and His Bride Faustina* (see page 208, fig. 1) in the Prado, Madrid. Only unmarried women were allowed to wear their hair loose; its restraint under a net symbolized the yoke of marriage.

220

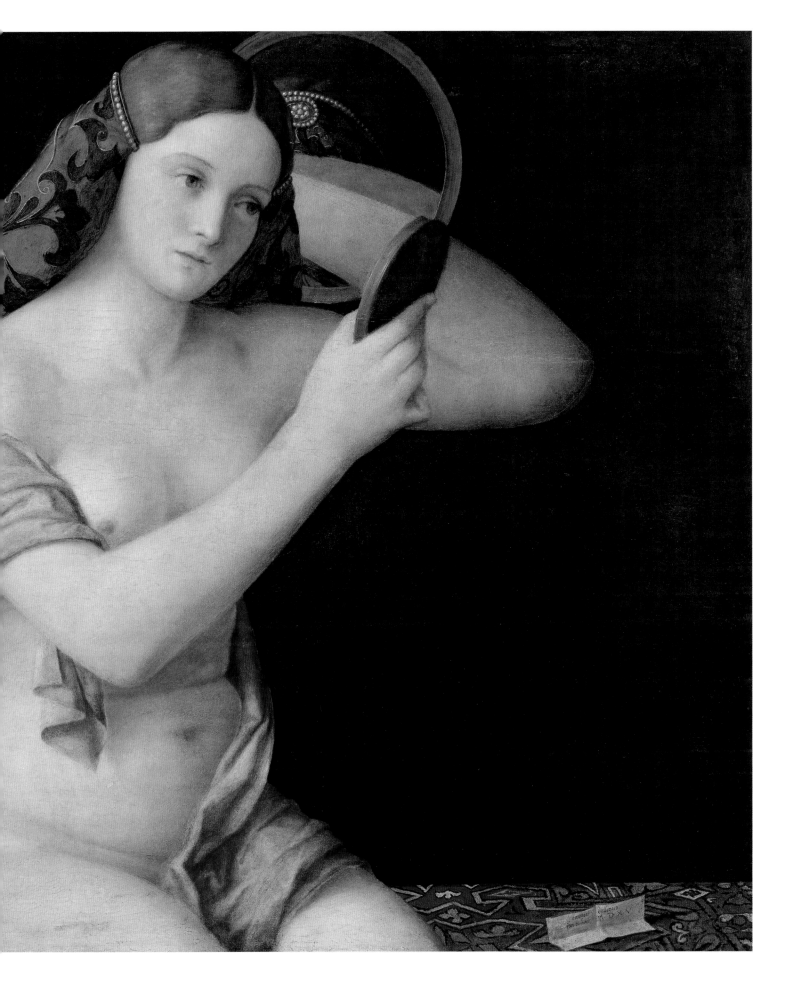

Our picture is unique within Bellini's extant oeuvre. Yet we know from reports and letters that he very likely painted a number of once famous works of this type. In 1525 Marcantonio Michiel referred to "a little panel by the hand of Zuan Bellini with a portrait of a lady 'al naturale' down to her shoulders" in the house of Taddeo Contarini.[10] Bellini earned special fame for his portrait of Pietro Bembo's mistress,[11] considered the counterpart to Simone Martini's painting of Petrarch's *Laura*. According to Michiel, Bembo also had a copy of Simone's portrait in his collection.[12] Although Bembo thanks Bellini for the painting in his famous sonnet (*Rime* 15): "O Imagine mia celeste e pura" (Oh, my heavenly and pure image), the work remains unknown, and Shearman doubts whether it ever existed.[13] Vasari mentions the portrait in both editions of his life of Bellini, as does Ridolfi somewhat later; and Burckhardt suggests that it might have been our *Lady with a Mirror*.[14] In contrast with the well-known type of Simone Martini's *Laura*, however, we know almost nothing about this lost portrait.[15] Yet the testimony that Bellini did paint female portraits also informs us of their poetic context. Goodman-Soellner insists that every element of the composition transposes Petrarch's verse into painting—from Laura's window in "Quella fenestra ove l'un sol si vede" (This window where one sun can be seen: *Canz.* 100) to the landscape in "Chi vuol veder quantunque pò natura" (Whoever wishes to see all that Nature…can do: *Canz.* 248). Whether we agree or not, there is no doubt that here Bellini has painted "silent poetry" in the sense of Horace's *ut pictura poesis*.[16]

According to Schäpers, Bellini used the subject of a young woman at her toilet not just to achieve a complex ambiguity but also to include various genres in a unique manner: female nude, idealized portrait, "secular devotional image," genre picture, interior, and landscape.[17] Most artists who subsequently adopted the subject developed just some of these aspects. Only Titian painted a comparable scene at the time, but he depicted both mirrors being held by a suitor or lover (page 193, fig. 6). Titian, with his customary deftness, activated Bellini's poetically rapt icon of seeing, and in doing so included yet another poetic topos: the lover's envy of the mirror, to which the beloved gives more attention than she does to him.[18] Bellini's light, his choice of color, and the exquisite rendering of the whole are poetic in the deepest sense, as, too, are individual details. Some of the household utensils are displayed with an almost still-life quality: the finely patterned carpet or the transparent glass vessel and sponge (*sponzarol*), an indispensable item of beauty care and a testament to intimacy absent in the contemporary copy of the painting. These elements also show how much Bellini was indebted to Netherlandish painting.[19]

Bellini's signature, like his distinctive calligraphy in the slightly earlier *Feast of the Gods*,[20] appears on a piece of paper that seems carelessly dropped onto the carpet, as if it were a love letter tossed aside: "Joannes bellinus faciebat M.D.X.V." The use of "faciebat" in the imperfect tense rather than the conventional "fecit" was commented on by Pliny in relation to the ancient masters Apelles and Polyclitus. Pliny states that these artists considered their work to be constantly in process and incapable of resolution. In this

sense the almost eighty-five-year-old Bellini created a picture that, like his other extraordinary late work, the *Drunkenness of Noah* (Musée des Beaux-Arts, Besançon), is finally to be understood in the deepest sense as a personal reference to his entire oeuvre, a poetic summa of his life's art.[21]

1. Pächt 2002, 246–247; Goffen 1989, 252.

2. Hammer-Tugendhat 1989, 78–99, esp. 89. On the *paragone* dispute in connection with mirrors, see Martin 1995, 40–42.

3. On the Venetian variation on the *paragone* debate, see Goffen 1991. On the Van Eyck painting, see Schäpers 1997, 61–63 and fig. 36.

4. Hartlaub 1951, 82–83; Panofsky 1969, 94; Schäpers 1997, 77, note 33; 91–95, Pächt 2002, 246–247.

5. Goffen 1991, 185–199, 190.

6. Fletcher 1990, 173.

7. Luchs 1995, 76, 269, fig. 119.

8. Most recently illustrated in *Tiziano Rubens. Venus ante el espejo* (exh. cat., Museo Thyssen-Bornemisza, Madrid), (Madrid, 2003), no. 5 as Giovanni Bellini and Vincenzo Catena; see also Bernardini 1995, no. 3 under "Bottega di Giovanni Bellini (Vicenzo Catena?)."

9. Goffen 1997, 75.

10. "El quadretto della donna retratta al naturale insino alle spalle fo de mano de Zuan Bellino." Frimmel 1888, 88; there are several female portraits attributed to Bellini in the Vendramin inventory of 1627, which shows drawings of the paintings in the collection. See Borenius 1923, pl. 3, 16, 17; Heinemann 1991, 2: fig. 178, 179, 185.

11. Scholars do not agree as to whether Bellini's picture represented Maria Savorgnan or a girl named Elena.

12. Burckhardt (1898) 2000, 208, note 2; Schäpers 1997, 101–102, Frimmel 1888, 22.

13. Shearman 1992, 142–143.

14. Vasari 1568 (Milanesi 1878–1885, 3:169); Ridolfi 1648, 1:73; Gamba 1937; Schäpers 1997, 75. Burckhardt (1898) 2000, 208, note 2.

15. Dal Pozzolo 1993, 257–291, esp. 260–264.

16. Goodman-Soellner 1983, 427–430.

17. Schäpers 1997, 236.

18. Goodman-Soellner 1983, 436–437.

19. Hammer-Tugendhat 1989, 89.

20. Walker 1956, 96–97.

21. Arasse 1991, 170. This signature alone nips in the bud any doubts about his authorship, which is discussed in Tempestini 1992, 296.

Provenance: About 1650 the work was acquired by Archduke Leopold Wilhelm as part of the Hamilton collection, 1659 inventory, no. 251.

Selected References: Mechel 1783, 13, no. 46; Krafft, 1854, 7–8; Crowe and Cavalcaselle 1871; Engerth 1881, no. 60; Gronau 1930, 217 and fig. 176; Walker 1956, 95–96; Pallucchini 1959, 11–112; Bottari 1963, 2: pl. 156; Robertson 1968, 152, pl. cxviii; Pignatti 1969a, no. 210; Wilde 1974, 51–53; Hornig 1975, 454; Wethey 1975, 2, 26, 144, pl. 28; Goodman-Soellner 1983, 426–442; Goffen 1989, 252; Hammer-Tugendhat 1989, 89; De Vecchi 1990, 67–68; Fletcher 1990, 173; Arasse 1991, 168–170; Goffen 1991, 185–199; Shearman 1992, 142–143; Tempestini 1992, 296, no. 104; Rogers 1994, 80–81; Martin 1995, 56–57, Schäpers 1997; Hills 1999, 130–131, fig. 160–161; Wilson 2004, 100–101.

detail, cat. 41

42

Titian

FLORA

c. 1520, oil on canvas
79 × 63 (31 1/8 × 24 13/16)
Galleria degli Uffizi,
Florence

Titian's *Flora* is rightly considered the finest and most successful of all sensuous half-length female figures in sixteenth-century Venetian painting. Radiantly beautiful and intoxicatingly sensual, the young woman appears in a relaxed, naturally graceful pose at the very front of the picture plane. Flora's voluminous body, nearly filling the pictorial space, provokes admiration and desire in the viewer, while her wavy reddish blond hair interlaced with a ribbon, her perfectly formed face with its earnest expression and penetrating gaze, and the flawless luminosity of her velvety skin make her a goddess of beauty. The figure's Venus-like sensuousness is heightened by her revealing décolletage: the white chemise slips down, baring her left breast, and the glistening, luxurious, pink brocade robe, loosely wrapped around her body, leaves her left shoulder bare.

The floral offering of roses, jasmine, and violets in the subject's right hand provides a key to interpreting her. She was first identified as Flora in Sandrart's engraving of 1640, which includes the following verses: "In Springtime, warmed and nourished by soft showers, / When Zephyr's gentle breeze brings forth sweet flowers, / Then Flora, in the mantle of the Spring, / Enamours Titian, and tempts others' hearts to sing."[1] And it was as Flora that Titian's picture entered the scholarly literature. In writings by classical authors, we find a wide range of interpretations of Flora.[2] Her most ancient pedigree is as a goddess. As *Flora Mater* she represented flowering, fertility, and conception. In Ovid's *Fasti* (5.183ff)

we hear of her as the nymph Chloris who, although initially raped by Zephyrus, the wind, became his wife and was named goddess of flowers. Hence her dress was adorned with many colors, and flowers tumbled from her hair. In the literature and art of the Middle Ages and Renaissance she appears as the goddess of springtime, an especially famous example being Botticelli's *Primavera*. From the sixteenth century on she was celebrated both in Netherlandish and Italian graphic art as a goddess of fertility related to the cultivation of gardens and plants. Yet Flora's divinity was questioned in the early Christian period by Lactantius and other scholars. He relates the tale of a famous Roman courtesan by this name who bequeathed to the Roman people the enormous wealth she had amassed through her profession, with the understanding that annual games be held in her honor. The Senate validated the courtesan's proposal by elevating her to a goddess, citing the authority of Ovid's legend of Chloris. The story was adopted and embellished by Boccaccio in his *De Claris*

Mulieribus, and from there found its way into later literature and art. The use of Flora as a preferred name for courtesans, though, may date back to antiquity.

If it was Titian's intention here to depict Flora, was he thinking of Ovid's goddess or Boccaccio's courtesan? Or is his portrait an artistic blending of the two? Titian was capable of granting not just beauty and charm but also dignity to every female figure he painted, including a courtesan; yet his *Flora* has more the demeanor of a goddess. There is a divine superiority and solemnity in the way her lack of attention to the viewer makes him aware of his own insignificance. Judging from the not fully legible x-radiographs (fig. 1), it seems that though Flora's head was originally inclined as we see it today, it may have been turned more toward the observer so that she would meet his gaze. This change suggests that Titian may have transformed his Flora *meretrix* into a classical goddess as the painting evolved.[3]

Renaissance literature refers to a classical statue of the goddess Flora by none other than Praxiteles, yet no such sculpture has ever been found; instead the torsos of female statues, such as the famous *Farnese Flora* of Guglielmo della Porta, were reconstituted as Floras. Titian's "re-creation" of the classical goddess, however, lacks any reference to antiquity, even in the drapery. According to Mellencamp, Flora's chemise—usually seen merely peeking out from under a gown at the neck and sleeves but here

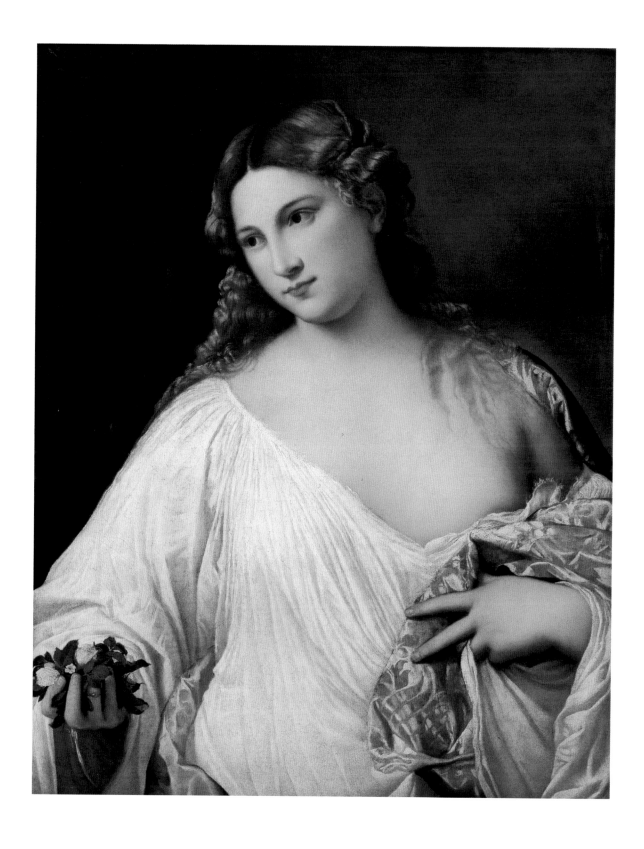

serving as her main article of clothing overlain by a cloth of brocade or damask—does not correspond to that of any classical figure and certainly not a Venetian bride, as Burckhardt had suggested.[4] Since Mellencamp identified the costume as one used in the contemporary theater to identify actors as nymphs and goddesses, we may conclude that, although archaeologically incorrect, it was the manner Titian chose to represent the nymph turned goddess.[5]

Many twentieth-century art historians, including Held, who wrote the first study of the Flora phenomenon, saw Titian's figure as the supreme representation of an early sixteenth-century Venetian courtesan.[6] But this idea—that in early sixteenth-century Venice the courtesan's profession not only found its way into paintings but was also celebrated by the most important artists—has been decisively rejected by Gentili.[7] He interprets the sensuality of such a figure's fully or half-exposed breast and the gesture of the hand pointing toward the lower body as allusions to an upcoming marriage, thereby seeing all, or almost all, of these paintings as bridal pictures that are both stimulating and instructive about the woman's role as future spouse and guarantor of the progeny of the male line. In Gentili's opinion, such paintings were commissioned by the bridegroom and intended to be seen only by the married couple.

In a recent discussion of Bartolomeo Veneto's famous *Flora* in the Städelisches Kunstinstitut, Frankfurt, Sander has suggested that the gaze of the figure can be a key in distinguishing between portraits of brides and courtesans: if the *bella donna* makes eye contact with the beholder, she is offering an invitation and is thus a courtesan.[8] Panofsky had already interpreted the Frankfurt *Flora*, in which the sideways gaze is directed sharply at the viewer, as a bridal portrait because of her obvious youth, her exposed though small and virginal breast, and her jewelry and veil.[9] Sander, however, compares her to Licinio's *Portrait of a Young Woman*, likewise with a bared breast, who gazes invitingly at the viewer and who seems clearly identified as a courtesan by the bordello scene visible in the mirror. Yet this very comparison makes the Frankfurt *Flora* seem more a bride, or even an innocent creature from a fairy tale, or, better still, an allegory of Poetry.

The gaze of Titian's Flora is concentrated on someone outside the boundary of the picture to whom she proffers her flowers. Inaccessible to the observer, she is, as a goddess, also rendered impersonal for the patron of the painting—whether bridegroom or lover.[10] It is therefore a moot question whether she represents the ideal bride whose sensuality guarantees love and thus fertility in marriage, or whether she represents a courtesan who awakens unimagined desires. Titian has transported this erotic woman into myth. Still open to debate, however, is whether or not the conspicuous V-shape formed by the two fingers of her left hand alludes to *virtus* and thus to the poetic topos "Virtutem forma decorat," as Fiorenza has recently suggested.[11] In spite of the divinely perfect beauty of Titian's *Flora*, the search for a specific model has not been abandoned. Sandrart

saw her as Titian's "beloved," invoking the classical topos of the painter intent on possessing beauty, as in the story of Apelles and Campaspe. Rembrandt further developed this thought, painting his wife Saskia as Flora no less than three times.[12] Because Titian's *Flora* also resembles the female figures in his Bacchanals for Alfonso d'Este, it has been thought that she might represent Cecilia, Titian's then mistress who had borne him two sons by the time they married in 1525.

The painting has been variously dated between 1514 and 1520, yet it seems more mature than comparable half-length figures such as the *Vanitas* in Munich, the *Woman at her Toilet* in the Louvre, or especially the female figures in the famous *Sacred and Profane Love* in the Galleria Borghese, Rome. Given that the figure so effectively yet so casually occupies the space, she may be identical with the "figura di donna" begun for Alfonso d'Este and mentioned in a letter by Tebaldi dated 1522.[13] We do not actually know who commissioned the Uffizi picture; indeed, its provenance is obscure until 1641 when it was sold in Paris from the collection of the Spaniard Alfonso Lopez.[14] The widely held assumption that it was acquired by Archduke Leopold Wilhelm is unconfirmed by his inventory of 1659 or by the *Theatrum Pictorium*, David Teniers the Younger's 1660 publication of the most prominent paintings in the archduke's collection. The painting is first recorded in eighteenth-century miniatures and engravings of the imperial collections, and it figures in

Christian von Mechel's catalogue of 1781 as a possible portrait of Palma Vecchio's daughter Violante.[15] It was later moved to Florence where, especially in the nineteenth century, it won high praise from the literati and was so often copied by painters that a decree was issued allowing no more than four copyists to work from it at the same time.[16]

1. "Vere viret tellus, placido perfusa liquore / A Zephyro, et blando turgida flore viget: / Flora modo veris, Titiani pectus amore / Implet, et huic similes, illaqueare parat." Agostini and Allegri 1978, 341. English translation from Julia Lloyd Williams, in *Rembrandt's Women* (exh. cat., National Gallery of Scotland, Edinburgh), (Edinburgh, 2001), 208.

2. Held 1961, 208–213.

3. My thanks to Antonio Natali for supplying the x-radiographs and for the valuable discussion of what is still discernible there. Judging from seventeenth-century engravings, Titian's *Flora* was cropped on all sides, especially by about 5 to 10 centimeters at the lower border. Yet we should not assume that seventeenth-century reproductions were particularly true to the original in questions of format.

4. Burckhardt 1860, note 718, 327; Romani 1993, 416.

5. Mellencamp 1969, 174–177.

6. Tietze 1950, 14.

7. Gentili, 1995, 82–105, esp. 97–98.

8. Sander 2004, 319.

9. Panofsky 1969, 137–138. The author also cites the myrtle, symbolizing marriage, encircling the woman's head; Pagnotta 1997, 39–47.

10. Goffen 1997, 75.

11. Fiorenza 2001, 84, note 65.

12. Williams 2001, 208.

13. Campori 1874, 596; Wethey 1975, 154, refers to a suggestion communicated verbally by Charles Hope.

14. Meijer 1999, 516.

15. Ferdinand Storffer, *Neu Eingerichtetes Inventarium der Kays.-Bilder Gallerie in der Stallburg…*, (Vienna, 1720), 1: fol. 55; Anton Joseph von Prenner, *Theatrum artis pictoriae in quo tabulae…*, (Vienna, 1728); *Prodromus oder Vor-Licht des eröffneten Schau- und Wunder-Prachtes aller deren an dem Kaiserl. Hof…Carl des Sechsten…*, Frans van Stampart and Anton Joseph von Prenner, eds. (Vienna 1735); Mechel 1783, 29, no. 55.

16. Agostini and Allegri 1978, 342–344.

Provenance: Sold in Paris in 1641 by Alfonso Lopez. In 1781 in the new installation of the imperial paintings in the Belvedere, Vienna. It was subsequently moved to Florence in 1793 as part of the exchange of pictures between the brothers Emperor Franz/Francis II and Grand Duke Ferdinand of Tuscany.

Selected References: Mechel 1783, 29, no. 55; Burckhardt 1860, note 718, 327; Held 1961, 201–218; Pallucchini 1969, 30, 247, pl. XIV; Mellencamp 1969, 174–177; Wethey 1975, 154; Agostini and Allegri 1978, 341–344; Hope 1980, 62, 81; Romani 1993, 415–417; Goffen 1993, 124–125; Holberton 1994, 31–41; Bernardini 1995, 249, no. 13; Goffen 1997, 72–77; Pagnotta 1997, 39–47; Meijer 1999, 516; Pedrocco 2000, 104, no. 40; Fiorenza 2001, 84–85 note; Joannides 2001, 264–265; Jaffé 2003, no. 11; Sander 2004, 319.

43

Sebastiano del Piombo

PORTRAIT OF A
WOMAN
("DOROTHEA")

c. 1513, oil on panel
78 × 61 (30 11/16 × 24)
Staatliche Museen zu Berlin,
Gemäldegalerie

Sebastiano's so-called *Dorothea* is undoubtedly one of his most captivating female portraits, successfully merging his Venetian training in the circle of Giorgione with his earliest responses to Roman art, primarily to Raphael's portraiture. It is not surprising that there are early copies, and in the eighteenth and early nineteenth centuries the picture corresponded so closely to the contemporary notion of Raphael's portraits that it was considered to be his work.[1] Only in 1837 did Waagen attribute it to Sebastiano del Piombo.[2]

A lovely young woman is posed in an interior, before a dark background that opens beside her onto a deep landscape vista. Her right hand gestures gracefully across her breast and in her left she holds a basket. Her left arm seems to rest on an invisible parapet, closing the composition horizontally. Auto-radiography reveals that a laurel hedge once stood behind the sitter, as in Giorgione's *Laura* (cat. 38) and Raphael's later *Fornarina* (Palazzo Barberini, Rome), and was later replaced by the architectural background with a landscape.[3] The sitter is a Roman type with a dark complexion, wide, low forehead, and thick hair parted in the middle, also found in Raphael's Roman portraits. Extraordinary attention has been devoted to her attire, which is less magnificent but more festive than Raphael's *Donna Velata* (Pitti Gallery, Florence). On her head is a white scarf with complex folds; and over a white, pleated chemise, visible below her sleeves, she wears a gold-edged gown of iridescent violet, probably origi-

nally painted in madder lake. Casually draped over her shoulders is a heavy velvet cloak of ruby red trimmed in sumptuous lynx.

In Sebastiano's *Wise Virgin* (cat. 40), painted in Venice about 1510, one is struck more by a tendency toward abstraction of the large forms than by a careful differentiation of illuminated surfaces. Here as in his other early Roman works the painter seems intent on emphasizing the latter characteristic. He captured the various textures of the sitter's clothing with more sophistication than in his so-called *Fornarina* in the Uffizi: we can almost feel the gentle softness of the fur, and we sense the weight of the richly lined cloak in its austere folds of fiery red velvet. The basket's disorderly jumble of fruit and flowers provides a certain contrast, just as a cloudy sky threatens the Venetian-like structures in the landscape. The cool atmosphere of an autumnal evening pervades the composition, touching the woman's skin, which glows against the dark background.

Sebastiano's creations—whether portraits, narratives, or devotional images—always give the impression of carefully considered compositions, and this quality would increase in his Roman works. The artist's care in working out compositions changed only when he fell thoroughly under the influence of Michelangelo, who supplied him with sketches and then recruited him in the competition against their common rival Raphael. The *Dorothea* has been dated between 1511 and 1515, usually about 1513.[4] Comparison with an early Leonardesque copy reminds us that the

graceful turn of the head was originally Leonardo's invention (the angel on the right in the *Madonna of the Rocks*). The influence of this pose extended to the younger generation of Venetian painters, including Giorgione and Titian, as well as to Sebastiano, who employed it in reverse in his *Salome* (page 216, fig. 1) of 1510, and later, and more successfully, in his *Violin Player* in the Rothschild collection in Paris.[5] In the Berlin picture, the turn seems more natural, fluid, and dynamic.

The basket of flowers has led scholars to interpret the figure as Saint Dorothea, and the early copy of the portrait was identified as such.[6] Yet there is no halo or martyr's palm to identify her as a saint. Hence, it is most likely a portrait. Hirst recognized a reference to bridal dress in the red cloak and the quinces in the basket. Drawing an analogy with Giorgione's *Laura* (cat. 38), he concluded that this panel might have been part of a diptych paired with a now lost male portrait.[7] Schleier believed, again with reference to Giorgione, that the original laurel backdrop pointed to an epithalamic content, further emphasized by the gesture toward the heart. A similar gesture is found in Raphael's *Donna Velata* and in a portrait from the School of Raphael in Strasbourg.[8] The V-shaped position of the fingers, standing for Venus or *virtus*, reinforces this hypothesis.[9] It remains to be determined whether Sebastiano's portrait represents a bride, a mistress, or even a woman called Dorothea.

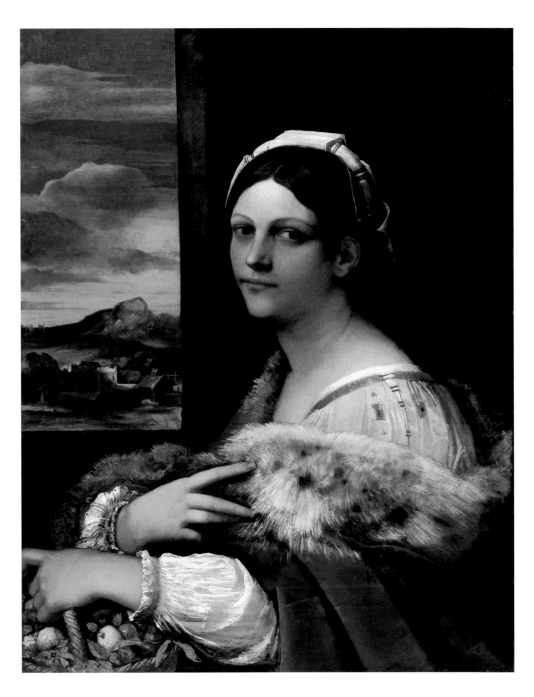

1. In a private collection (Schleier 1998, 371) and in Verona, Museo di Castelvecchio (Volpe and Lucco 1980, 103, fig. 38).

2. Waagen 1838, 2:40. Passavant 1833, 174, had already rejected the attribution to Raphael.

3. Schleier 1998, 371.

4. For the various suggested dates, see Volpe and Lucco 1980, 103, no. 38.

5. Hirst 1981, 100, fig. 71.

6. The Verona copy (see note 1, above) was listed as "Dorothea" in Scanelli's *Microcosmo* of 1657. See Meyer 1886, 58.

7. Hirst 1981, 96, note 25.

8. *Raphael dans les collections francaises* (exh. cat., Grand Palais), (Paris, 1983–1984), 32, no. 16.

9. Anderson 1997, 297; Fiorenza 2001, 84 and fig. 13.

10. "Una femmina con abito romano, che è in casa di Luca Torrigiani," Vasari 1568, Milanesi 1878–1885, 5:5, 574.

Provenance: According to Vasari (1568) in Luca Torregiani's house in Rome.[10] Between 1756 and 1885 in the collection of the Dukes of Marlborough, as a work by Raphael. Since 1885 in the Gemäldegalerie, Berlin.

Selected References: Passavant 1833, 174; Waagen 1837–1839, 2:40; Meyer 1886, 58ff; Lermolieff 1890, 53, 56; Lermolieff 1893, 85ff; Propping 1892, 44ff; *Beschreibendes Verzeichnis* 1904, 297, no. 209 B; D'Achiardi 1908, 155f; Dussler 1942, 38, 128 no. 4, fig. 31; Pallucchini 1944 and 1966; Schleier 1975, 322; Volpe and Lucco 1980, 103–104, no. 38, pl. XXXI; Hirst 1981, 96–97, fig. 66; Schleier 1998, 370–371; Fiorenza 2001, 84, fig. 13.

44

Palma Vecchio

PORTRAIT OF A
WOMAN
("LA BELLA")

c. 1518–1520, oil on canvas
95 × 80 (37 3/8 × 31 1/2)
Museo Thyssen-
Bornemisza, Madrid

inscribed: AMB / ND
(on parapet)

Vienna only

Jacopo Palma is one of the most celebrated painters of beautiful women of his era. He painted many variations of landscapes with naked goddesses or nymphs (cat. 35), and his repertoire of half-length figures was equally broad, including actual portraits as well as classical heroines like Lucretia or Judith. He may also have been the most prolific painter of eroticized *belle donne veneziane*, whom he rendered with varying degrees of idealization. In one of his paintings (Gemäldegalerie, Dresden) no fewer than three of these lovely women appear together. Some of his blond figures are shown parting their clothing or baring a breast, usually the left. Even his female saints, such as the Magdalen in the *Virgin and Child with Saints John the Baptist and Mary Magdalene* (cat. 4) in the Palazzo Rosso, Genoa, have an erotic charge. An unfinished painting of a young woman (page 192, fig. 4) turning away with a provocative look back over her shoulder, in the Kunsthistorisches Museum, Vienna, is both coquettish and psychologically profound. Other figures, fully and superbly attired, captivate us through a mysterious sidelong glance or a flirtatious gesture, perhaps toying with their hair or a veil. Palma's *Woman in Blue* (page 193, fig. 5), also in the Kunsthistorisches Museum, Vienna, falls into this category, as does the elegant *Portrait of a Woman* in Madrid. In the nineteenth century the subject was known as the "Bella di Tiziano," and the canvas was attributed to that artist until 1853, when Passavant first recognized Palma as its author.[1] In her majestic elegance and the sense of remove augmented by the parapet, she seems to anticipate aristocratic portraits of later centuries. For this reason the "ND" of the still undeciphered inscription has often been interpreted as *nobildonna*.[2]

Certainly an aura of nobility is imparted by the pilaster looming diagonally amidst the palatial architecture visible in the dark matt background, as well as by the figure of a knight carved in low relief, which still awaits a satisfactory interpretation.[3] The sitter's attire is appropriately noble too: the splendidly embroidered sleeves are visible over the traditional, finely pleated chemise (*camicia*), while a costly mantle of red silk taffeta is draped over her shoulders and falls in plush folds, its shiny blue lining enhancing the impression of luxury. Given this sartorial extravagance, we can understand why Venice was anxious to impose sumptuary laws. It is surprising, however, that the woman wears no jewelry—her rings and necklace of gold or pearls were omitted, perhaps, to emphasize her physical charms.

Palma's portrait is reminiscent of poetic *concetti* of the beautiful, inaccessible woman, a trope first captured in Petrarch's Laura. In addition, the sitter reflects the elements of female beauty promulgated by sixteenth-century poets and cognoscenti: golden locks, a smooth, broad forehead, ivory skin, sparkling eyes, and so on. In this respect she embodies the male dream of the ideal woman, whether it be a mistress or bride. Among all of Palma's beautiful and inventive female portraits, *La Bella* is one of the few that may represent an actual person, an argument supported by the presence of the parapet, often found in unambiguous portraits. Preoccupied with her hair and a jewel case, the woman seems surprised by the approach of an observer—perhaps her bridegroom or lover. Her glance, fleeting and spontaneous, provocative and reserved, enhances her fascination and attractiveness and lends the picture a sense of immediacy and

with it the hint of a narrative. As she is about to put on her jewels, a golden chain slides out of jewel case, an item sometimes given by a groom to his bride on the day of their wedding.[4]

Several aspects of the portrait are reminiscent, in reverse, of Titian's *Violante* (Kunsthistorisches Museum, Vienna), completed several years earlier: the three-quarter turn toward the viewer; the way the figure, seen from below, recedes into the pictorial space; the décolletage; and the carriage of the head atop a slender neck. Because of these similarities the *Violante* has often been misattributed to Palma Vecchio. In comparing these works, we can almost follow the energetic competition between the two artists as each attempts to outdo the other.

1. Passavant 1833, 163. The compiler would like to thank Roberto Contini for valuable information.

2. Rylands 2001, 188.

3. Attardi 1993, no. 57.

4. Gentili 1995, 100–101, suggests, however, that the box is a sewing kit.

Provenance: Rome, Sciarra Colonna collection; Paris, Eduard de Rothschild collection; acquired 1959 by Baron Heinrich von Thyssen-Bornemisza from Baron Guye de Rothschild.

Selected References: Passavant 1833, 163 note; Hendy 1964, 83; Mariacher 1968, 74–75, no. 51; Ekserdjian 1988, 96, no. 36; Rylands 1988, 115, 217, no. 45, 110, with bibliography; Pita Andrade and Borobia Guerrero 1992, 192; Gentili 1995, 100–101; Goffen 1997, 33ff.; Rylands 2001, 188, no. V.2.

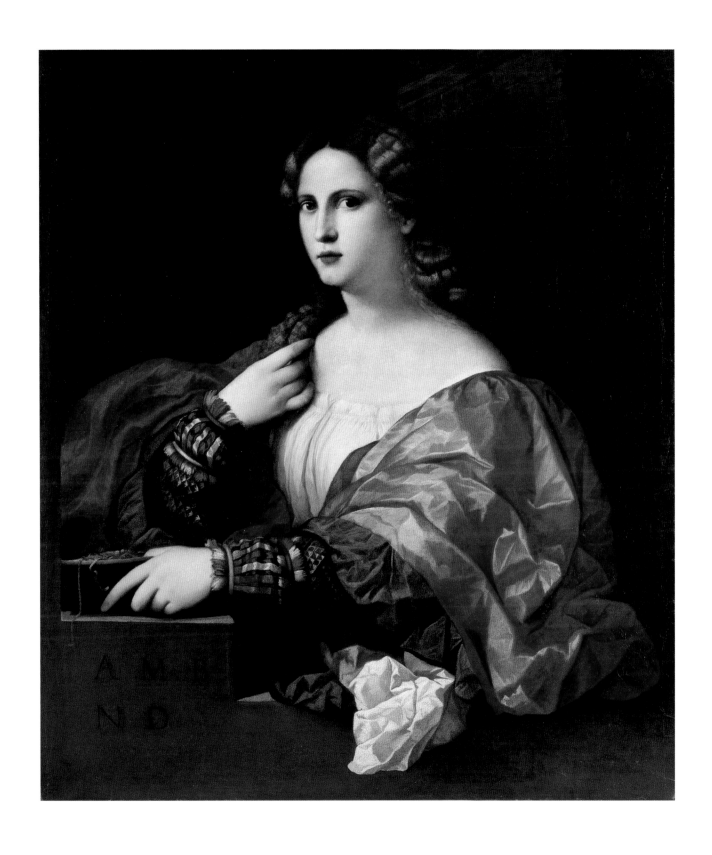

45

Titian

PORTRAIT OF A
WOMAN
("LA SCHIAVONA")

c. 1511–1512, oil on canvas
119.2 × 100.4
(46 15/16 × 39 ½)
The National Gallery,
London, Presented
through the National Art
Collections Fund by
Sir Francis Cook, BT.,
in memory of his father,
Sir Herbert Cook, BT.

signed: .T. .V.
(on parapet)

Vienna only

Not only is Titian's earliest female portrait unusually large for the period, especially compared with Lotto's portrait of only a few years earlier (cat. 36), but it is remarkably monumental as well. The emphatically asymmetric placement of the three-quarter length figure is also striking, as are the frontal pose and low viewpoint, almost as though the woman were looking down at us. The most impressive aspect, however, is her vividness and supreme composure in expression and appearance. Serene and self-possessed, she inspires our confidence, gazing directly at the viewer with the hint of a smile. La Schiavona inclines her head slightly, as if posing in front of a camera. Her dress of lightly iridescent purple, painted in costly madder lake, is elegantly simple, its slit sleeves reveal her white chemise and its folds are gathered in the finely patterned sash. A hairnet interwoven with gold adorns her head, small golden chains encircle her neck, and a transparent veil rests on her shoulders. Everything unfolds expansively: face, bust, dress, and parapet.

If Renaissance literati and theorists saw the creation of beauty as the primary role of art and considered this task perfectly fulfilled in the painting of a beautiful woman, then Titian failed here.[1] For in a conventional sense this stout figure with a double chin can hardly be called beautiful, and clearly neither artist nor sitter was intent on conforming to the Renaissance image of ideal beauty. As an individual she is timeless and humanly moving in her physicality.

Although certainly of an elevated social rank, she hardly accords with our notions of the demeanor and public aspect of the patrician ladies of Venice whom we imagine as more dazzling and also more distanced, rather in the manner of Titian's later presentations of Isabella d'Este or Eleonora Gonzaga. In the self-awareness of her portrayal, La Schiavona is more reminiscent of an independent, modern-day woman than of a reserved aristocrat of the Renaissance.

It is customary to bemoan the dearth of female portraits from the first half of the sixteenth century in Venice, an absence typically attributed to the status of women within the patriarchal social structure of La Serenissima's oligarchic regime.[2] Hence this painting is even more extraordinary, and one understands the repeated efforts to identify the sitter and thus learn

something concrete about the so vividly rendered self-esteem of a Venetian woman of the period. In the early nineteenth century, for example, the sitter's confident disposition and elegantly restrained attire led the picture's owners to identify her as Caterina Cornaro, the famous queen of Cypress who, until her death in 1510, held court in Asolo, where humanists such as Pietro Bembo often sojourned.[3] A later owner, Herbert Cook, invoked this idea again and even attributed the painting to Giorgione who, according to Vasari, had done a portrait of the queen.[4] Yet our figure does not at all resemble the queen's documented likeness by Gentile Bellini.[5]

The figure most closely related to *La Schiavona*, perhaps inspired by her double portrayal *en face* and in profile, is the woman shown on the right in voluminous profile in Titian's *Miracle of the Speaking Babe* (fig. 1), one of his Paduan frescoes of 1511. Yet we cannot conclude from this that our sitter came from the Venetian mainland. The name Schiavona—Slav, or woman from Dalmatia—first appears in relation to the painting in a letter of 1640: "un quadro di pittura detto la Schiavona."[6] Many scholars now regard the different views of female faces in the Paduan fresco as a successful attempt to show painting in competition with sculpture, the sister art that claimed superiority because of its multiple perspectives.[7] And they see Titian's ingenious idea of depicting La Schiavona twice. As both a

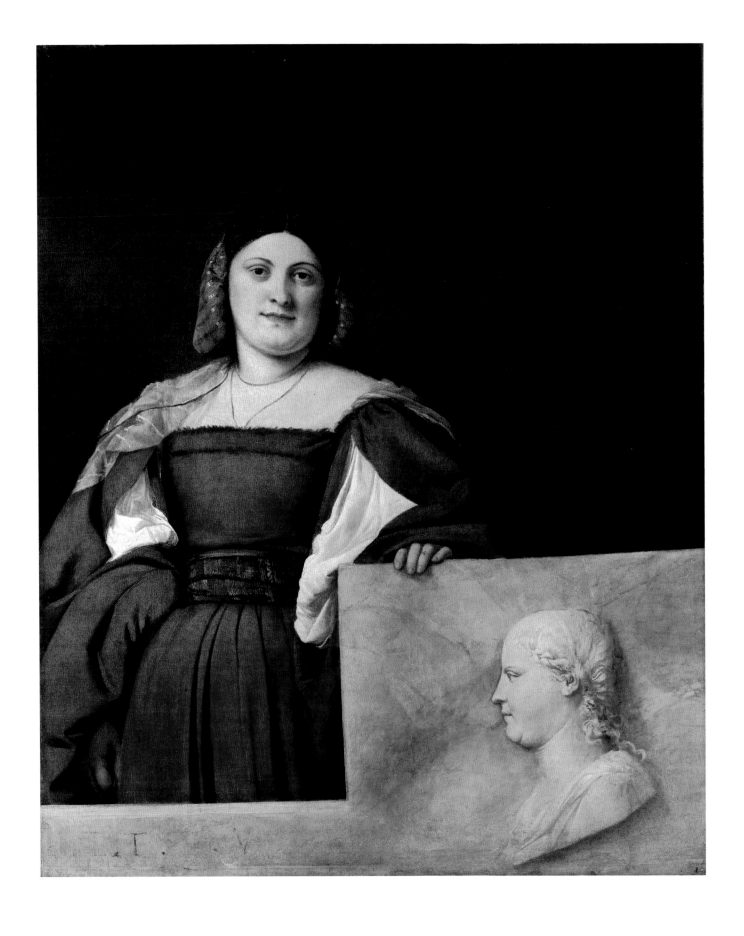

234

Tullio Lombardo, who had written a letter emphasizing the superiority of surviving classical sculpture over the transitory art of painting. Yet in *La Schiavona*, Titian inventively turned the discourse to the advantage of painting.[10] At the same time he made the changing importance of mimetic likeness a central theme, by reproducing individual traits exactly in paint and generalizing them in stone. It has been suggested that the *all'antica* bust—its coiffure and design conceivably inspired by antique, perhaps Augustan, gems or coins—may refer to the Roman origins of the portrait genre or, possibly, to the antiquity of the sitter's own genealogy.[11]

The initials "TV" are still visible today below the figure where the artist "engraved" them into the painted stone. Another large "V" shows through directly to the left of the profile bust. Titian has self-confidently placed his own initials here, whereas in contemporary portraits by other artists a "VVO" or "VV" stands for *vivus vivens* or *virtus vincit omnia*,[12] or for *virtus et veritas*, as has recently been suggested.[13]

painted portrait and a relief bust *all'antica*, she becomes a double victory for the art of painting, once over sculpture and once over classical art. This seemingly realistic portrait thus becomes a theoretical manifesto.[8]

The painting's primary focus, however, was not as an element in the *paragone* dispute, but as a work of *memoria*.[9] And here Titian's approach seems especially original, for he has confronted the *hic et nunc*—realistically portrayed in paint as flesh and

blood—with the idealized simulacrum transposed into the timelessness of stone; the momentary today is combined with the eternal, the present with the future. In *Il Cortegiano* Castiglione recorded the then current conviction that statues not only were more durable than paintings but also possessed more dignity; this alone made them more successful memorials. Titian was familiar with works by contemporary sculptors, especially

In view of this superb and conceptually sophisticated composition, it is surprising to find that the x-radiographs reveal a confused process of construction (fig. 2).[14] The figure's asymmetrical placement may have been occasioned by an opening at the upper right that was first rectangular, then round, and then completely painted out. And in place of the parapet with the relief bust we can discern a round form, a sort of bowl, that some have thought might have been held by a child. We can only speculate whether

the death of the child or the sitter occasioned the addition of the parapet.[15] However, we should recall that the provocative compositional alterations visible in the x-radiographs of many of Titian's paintings are better explained by his own creative furor than by outside influences, as may well be the explanation here. And as long as the sitter is unidentified and no comparable portraits appear, this extraordinary painting must be considered an invention of the artist. Such is the judgment of Nicholas Penny, who finds it possible that the portrait was not a commission but rather a depiction of a member of Titian's household intended as an example for clients who might then engage him to portray their wives.[16] Yet this interpretation would mean that the first portrait of a modern woman in Venetian painting is a pure fiction on the part of the artist and, as a document of the role of women in early modern society, no more than a fantasy.

1. Cropper 1986, 175–190.

2. Chojancki 2000.

3. Bonomi 1886, 13.

4. Cook 1900, 133–134; Cook 1915; Caroselli 1983, no. 1–2, 47–57; Gould 1975, 290, note 5. In 1897 Berenson attributed the portrait to Licinio (Berenson 1897a, 278–282); in 1903 he called it a copy after Giorgione.

5. Illustrated in Pächt 2002, color pl. 13.

6. Gould 1975, 289.

7. Luchs 1995, 76, 269, fig. 117.

8. Jaffé 2003, 80.

9. Freedman 1987, 31–40. Nova 2003, 183–202.

10. Rosand 1983, 105–107; Luchs 1995, 76, 269, fig. 117; Caroselli 1983, 56.

11. Brendel 1955, 116.

12. de Grummond 1975; Holberton 2003, 44.

13. Fiorenza 2001, 83 and fig. 10; Penny in *Titian* 2003, no. 4.

14. The compiler is grateful to Carol Plazzotta for her help in arranging for the loan of this picture and for providing the x-radiograph. On its interpretation see Gould 1961, 335–340.

15. Rosand 1983, 107.

16. Penny in *Titian* 2003, 144–145.

Provenance: 1641, the collection of Count Alessandro Martinengo in Brescia. 1900 in the Crespi gallery in Milan. Sold to Wildenstein in 1911/ 1912, where Herbert Cook acquired it in 1914. His son, Sir Francis Cook, bequeathed the portrait to the National Gallery in 1942.

Selected References: Bonomi 1886; Cook 1900; 74–81; Brendel 1955, 113–125; Gould 1961, 335–340; Pallucchini 1969, 1:238; Wethey 1971, 139; Gould 1975, 287–290; Rosand 1983, 91–129; Freedman 1987, 31–40; Luchs 1995, 76, 269, fig. 117; Goffen 1997, 45–65; Hills 1999, 192–195, 212–215; Fiorenza 2001, 63–87; Iamurri 2001, 49–55; Joannides 2001, 212–215; Holberton 2003, 29–47; Penny in Falomir 2003, no. 5; Penny in Titian 2003, no. 4.

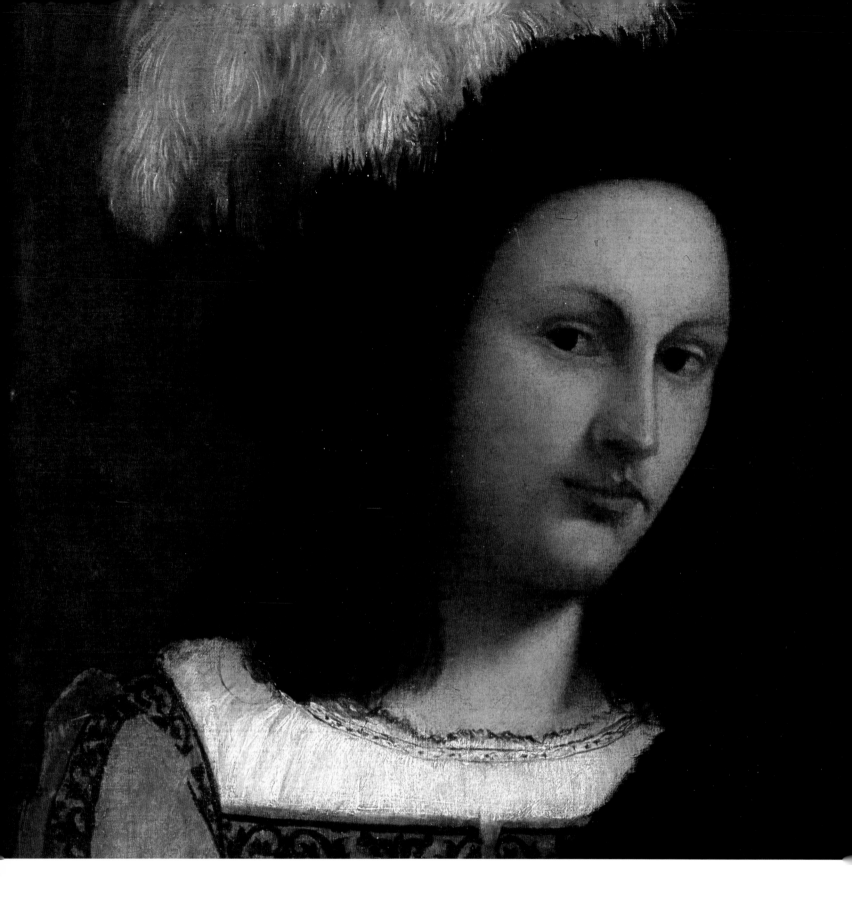

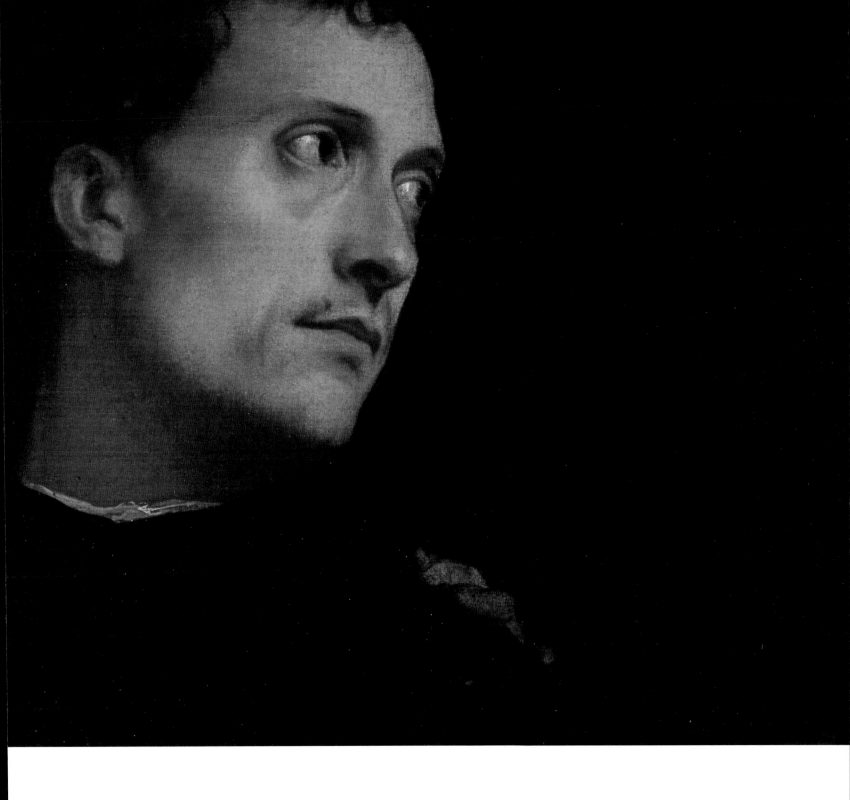

PORTRAITS OF MEN ✳ *David Alan Brown*

NOT SO LONG AGO, Renaissance portraits were viewed simply as realistic representations of individuals. Now there is a greater awareness of artistic conventions used to portray sitters and of the patron's role in determining his or her image. At a deeper level, the question of what a portrait seeks to convey about its subject also involves changing notions of personal or social identity. This section treats these issues as they concern independent portraits of men, not donors in religious paintings, bystanders in history pictures, or effigies of doges.[1] Portraits of private individuals were uncommon in Venice until the last quarter of the fifteenth century. In his *Lives of the Artists,* Vasari wrote that it then became fashionable for important men to have their portraits painted by Giovanni Bellini or one of his contemporaries.[2] Bellini's portraits created such a demand that likenesses of several generations were often found in a single household. Vasari's claim is confirmed by a fairly large group of portraits of young and middle-aged men attributable to Bellini or his shop. The rise of autonomous portraiture in late fifteenth-century Venice probably also reflects the taste for Flemish art. Painters from Van Eyck to Memling typically represented portrait sitters bust-length and in three-quarter view. Bellini's use of this schema was reinforced by Antonello da Messina's visit to Venice in 1475–1476. Antonello, too, adopted the head-and-shoulders type, which he may have encountered during his formation or on a possible trip to the Netherlands, but what was new about his portraits (fig. 1) was their powerful physical and psychological presence achieved through a strongly volumetric rendering of the head, set off against a dark background, and an intense focus on the expressive features of the eyes and mouth. Where Bellini's portraits differ from Antonello's is chiefly in the reserve of the sitters, who do not engage the viewer by means of a direct, outward glance, as

in Antonello, but avert their gaze. Though characteristic of his art in general, the emotional reticence of Bellini's portrait subjects also had a social significance: downplaying their individuality, it stressed instead their communal devotion to the state.[3] The impersonality of Bellini's portraits—accurate in capturing a likeness but lacking in a sense of character or emotion—contrasts with the vivacity of Antonello's, which made a lasting impression on later artists.[4]

Despite their convincing realism, late Quattrocento Venetian portraits were not a springboard for those created in the new century. Bellini's likenesses offered no clues to the sitter's character, while Antonello's were limited in their emotional range. Based on a notion of identity as fixed and permanent, these portraits display a uniformity that contrasts sharply with the variety of the later ones. But in one respect there was a continuity: among the works in this section, only two of the sitters, both churchmen, can be identified today, thanks to inscriptions. Beginning with Giorgione, we witness a progressive increase in size and scale: the sitters tend to be shown life size, as the portrait bust grew to half- and three-quarter length. At the same time, the format expanded laterally, with an oblong rectangle accommodating two, three, or more figures. Along with these changes, sitters' hands appear, at first tentatively, and come to play an increasingly active role, as do their gazes directed at the viewer or at each other. A first step towards the fully developed Cinquecento type is Giorgione's *Young Man* (fig. 2) of about 1500, in Berlin, which adopts the new larger format allowing for the inclusion of the sitter's hand, or rather fingers, shown resting on a stepped parapet.[5] The simple stone ledge in Bellini's portraits bears the artist's signature; here the parapet is inscribed with the mysterious and much-discussed letters "VV," referring to the unnamed sitter.[6] If

1.

Antonello da Messina, *Portrait of a Man called "Il Condottiere,"* Musée du Louvre, Paris

2.

Giorgione, *Young Man,* Gemäldegalerie, Staatliche Museen, Berlin

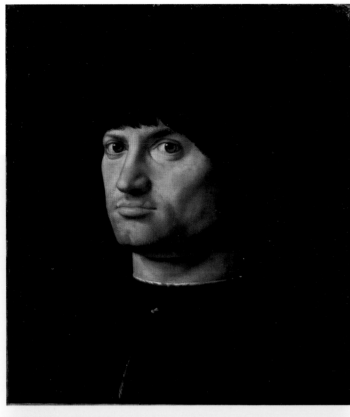

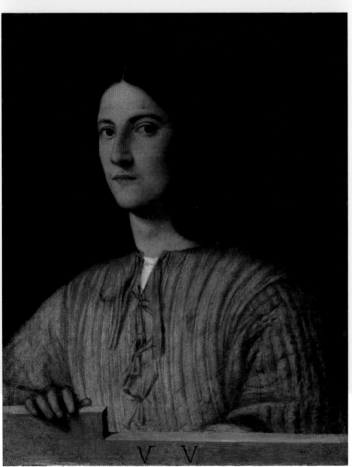

Giorgione looked back to Antonello for his treatment of the young man's face and gaze, the hand, however timid, suggests that the younger artist was also aware of the imposing portrait of Francesco delle Opere, which Perugino appears to have painted in Venice in 1494.[7] Perugino's model in turn was Memling, whose *Portrait of a Man* in the Accademia, Venice, includes a foreshortened hand much like Giorgione's.[8] Another innovation is the young man's pink quilted jacket, which gives him a fashionable air. Though the Berlin portrait only begins to explore the possibilities of the half-length format, it implicitly rejects the Bellinian portrayal of the sitter as a purely social being in favor of a more individual statement.

The decade ending with Giorgione's death in 1510 saw the emergence of new ways in which cultivated Venetian aristocrats saw themselves and wished to be seen by others. This new concept of identity involved a shift in the relation between the individual and the state and in personal relationships that is reflected in both literature and art. Alessandro Ballarin has sketched the context for Giorgione's portraiture in poetic and philosophical notions about love and friendship advanced by contemporary writers, especially Pietro Bembo (1470–1547), whose dialogue on love was published as *Gli Asolani* in Venice in 1505.[9] Giorgione's portraits, Ballarin and others have argued, express the same interests and aspirations as the writers—the yearning for friendship, the desire for amorous love, the pursuit of learning, and concerns over spiritual welfare. Poet, lover, courtier, and cardinal, Bembo was the chief representative of the cultural and intellectual climate, but scholarship has also drawn attention to two other humanists, Gasparo Contarini (1483–1542) and the teacher Giovanni Battista Egnacio (1478–1553), a close friend of Giorgione's partner, Vincenzo Catena.[10] These men,

together with the religious reformer Tommaso Giustiniani (1476–1528), Vincenzo Quirini (c. 1479–1514), Tifone Gabriele (1470–1548), known as the "Venetian Socrates," and Niccolò Tiepolo (d. 1551), belonged to a close circle for whom lifelong learning had as its goal not only knowledge but virtue. Shirking their civic duties, these and other young Venetian patricians sought a life of personal fulfillment, ranging from the enjoyment of music and the arts to study, contemplation, and prayer, in the setting of a country villa, princely court, school, or monastery. At the core of their program were books and the bonds of friendship, as we find them in several of the portraits included here.

Attuned to these new ideals and aware of the inadequacy of traditional Venetian portraiture to express them, Giorgione rejected the Bellinian schema and sought inspiration in the work of a series of visitors to Venice, not only Antonello and Perugino but also Leonardo da Vinci.[11] For about two or three months early in 1500, Leonardo sojourned in Venice, where he was employed as a military engineer. Despite the brevity of his stay, the idea that the Florentine master had a decisive impact on his Venetian contemporaries goes back to Vasari, who claimed in the second edition of the *Lives* that Giorgione was struck by some works by Leonardo that he had seen in the city and learned from them how to paint in the modern manner.[12] For Vasari it was Leonardo's oil paintings, with their soft handling and deep shadows, which Giorgione imitated. But the visual evidence to support that view is scant and contradictory. More likely, it would seem, Leonardo brought with him from Milan to Venice a number of drawings that, together with studies by his pupils, served to demonstrate the new pictorial language of pose, gesture, and expression he had evolved for the dramatic narrative of the *Last Supper*.[13] One such drawing may have been

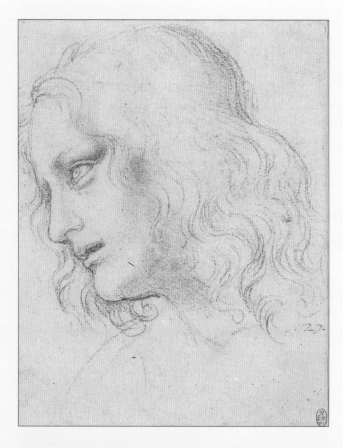

a preparatory study for Leonardo's youthful Saint Philip in the *Cenacolo*. The surviving study (fig. 3), at Windsor, is in black chalk, which enhances the softness and delicacy lent to the subject by his long wavy hair and dreamy expression. This drawing is for the head alone, but other lost sheets by Leonardo must lie behind the figure in the mural, with the hands held to the chest in a gesture of heartfelt devotion, and one or another of these may have been available in Venice.[14] Long after Leonardo left the city, his drawings would have continued to circulate in painters' workshops, in the original

3.

Leonardo da Vinci, *Study for the Head of Saint Philip*, Royal Collection, Windsor Castle

4.

Giorgione, *Man in Armor*, Kunsthistorisches Museum, Vienna

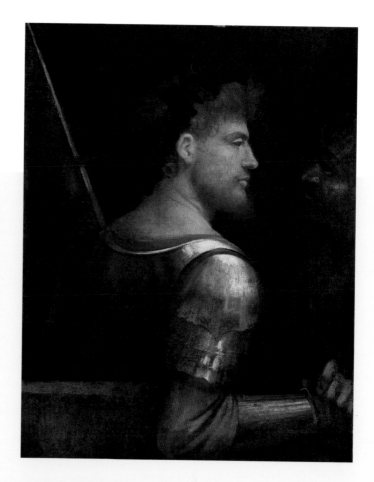

or in the form of copies, and as they were adopted and assi-milated by Venetian artists, their influence expanded beyond Giorgione to other members of the younger generation.

Having altered the tradition of Venetian portraiture in his *Young Man* in Berlin, Giorgione went on to transform it in a series of brilliantly inventive portraits, most of which are unfortunately lost or damaged.[15] In this process, in which the half-length format with hands became standard, the artist found in Leonardo's legacy in Venice the ideal means to express his sitters' desire for self-realization. Among Leonardo's Milanese pupils, an ephebic type of beauty had recently been applied to the portraiture of young men.[16] Then, just as the idealized portrait went out of fashion in Milan, the typology of the ideally beautiful male associated with Leonardo surfaced in Venice, as we have seen, and there it was again applied to portraiture in the work of Giorgione and his circle.[17] With the element of likeness almost totally suppressed, we cannot be sure whether Giorgione's *Boy with an Arrow* (page 44, fig. 4) is a portrait or not. Similarly, Leonardo's studies for narra-tive compositions—like that of Christ Carrying the Cross, in which the Savior's turning pose and outward glance, seen close-up, implicate the spectator in his suffering—had the effect of animating the Venetian portrait.[18] Leonardo's drawings appear to lie behind a number of newly expres-sive portraits by Giorgione and his followers, which do not specify the sitter's appearance or character but show him in a particular guise or role, as a scholar, poet, musician, lover, or warrior—not psychologically nuanced, as in Antonello, but suffused with emotion. It is not Giorgione's sitters that are individualized, but his portraits, which draw attention to their status as artistic creations. Light and shade are used in these works for expressive purposes to illuminate the subject's state of mind. In Giorgione's *Self-Portrait as the Victorious David* in Braunschweig, the painter displays a troubled expression taken as a sign of the melancholy asso-ciated with the artistic temperament.[19] An engraving that reproduces the composition before it was cut down shows that Giorgione's self-image as the biblical hero, wearing armor and holding the head of Goliath, inspired Sebastiano del Piombo's *Man in Armor* (cat. 51). Another source for Sebastiano's striking portrait is Giorgione's *Man in Armor* (fig. 4) in the Kunsthistorisches Museum, Vienna. Though this work survives in a damaged state, it is emblematic of the revolution in Venetian portraiture: the element of phy-siognomic contrast, borrowed directly from a Leonardo drawing, enhances the noble profile of the main subject, who confronts an ignoble companion.[20] Three male portraits included here are of this type, double portraits in which one figure is subordinated to the other.[21]

242 Other double or group portraits show the sitters as equals and record relationships between them that must have been of special significance. By contrast to the portraits with secondary figures, these works are oblong, not upright, in format. The so-called *Three Ages of Man* (fig. 5), plausibly attributed to Giorgione, in the Pitti Gallery, Florence, belongs to a series of such half-length compositions that combine the theme of music-making with pedagogy or moral instruction and, after women were introduced into the company, seduction and sensual pleasure.[22] The prototype for the series was Giorgione's *Giovanni Borgherini and His Tutor* (National Gallery of Art, Washington), which, because it was repainted by another hand, has not been given the scholarly attention it deserves.[23] The pairing of the young Florentine with his Paduan teacher here provided a model for the right-hand group in the Pitti picture, in which the lesson depicted has become a music lesson. The master on the right points to a sheet of music held by his young pupil in the center, while an old man on the left turns to look out at the observer as if to emphasize the lofty ideal of music as transporting both the performer and the listener/viewer. While the composition may go back to Bellini's half-length treatments of the Virgin and Child with saints, the *Music Lesson*, as we may call it, betrays a whole new dynamic, in which the figures, two engaged in an action and another looking at the spectator, and the physiognomic contrast between them derive from Leonardo.

At the time he joined Giorgione in decorating the Fondaco dei Tedeschi in 1509, Titian experimented briefly with the idealized portrait in his *Shepherd* at Hampton Court. But as the musician in the Pitti *Concert* (cat. 53) demonstrates, the younger artist quickly rejected the Giorgionesque type in favor of a newly realistic portraiture that better suited his

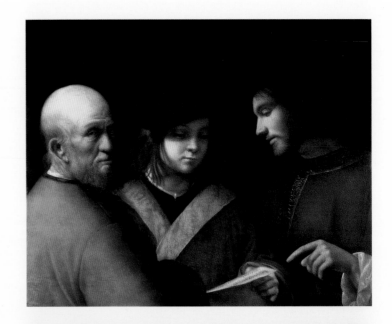

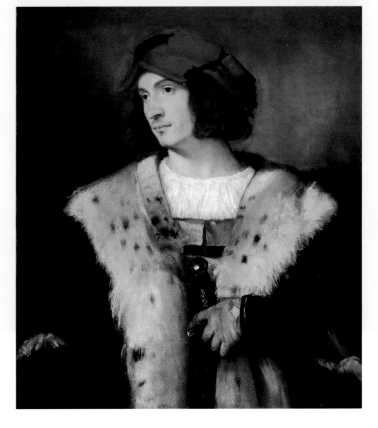

5.
―――――
Giorgione, *Three Ages of Man*, Galleria Palatina, Palazzo Pitti, Florence

6.
―――――
Titian, *Man in a Red Cap*, Frick Collection, New York

own temperament and the needs of his clients.[24] Sebastiano del Piombo, who, like Titian, was called Giorgione's "creato" by Vasari, and Palma Vecchio also painted Giorgionesque portraits (cats. 51, 52) before they, too, abandoned the type. Giorgione's portraiture continued to find adherents, but to the leading members of the younger generation, a figure like the youth languishing for love in the so-called "Ludovisi *Double Portrait*" (cat. 50) would have seemed contrived and artificial. Though the romantic aura of Giorgione's portraits doubtless reflects his own sensibility, the poetic conceits they embody became clichéd through repetition. Equally problematic, the Giorgionesque portrayal of a sitter enacting a role diminished his individuality by stressing one aspect of his character at the expense of others. Titian, aware of these limitations, returned to the tradition of Giorgione's predecessors, recapturing the dignity of Bellini's portraits and the psychological acuity of Antonello's but with a vast new range of pictorial resources. In a series of male portraits, beginning with the *Man with a Blue Sleeve* of about 1510, in the National Gallery, London, Titian increasingly departed from the half-length portrait with a parapet favored by Giorgione. Likewise eschewing the symbols or emblems that invite consideration in Lotto's portraits (cat. 57), Titian attempted to convey personality through pose and expression. Indeed, he is famous for his ability to capture the sitter's character and to communicate it to the viewer. Whether Titian—or any artist—can succeed in this goal is debatable, but if psychological interpretations of his portraits vary, they all affirm the sitter's individuality. Among his youthful efforts, the *Man in a Red Cap* (fig. 6) in the Frick Collection, New York, is datable to about 1512/1514, after the completion of the frescoes in the Scuola del Santo in

Padua. The unidentified young man wearing a magnificent fur-lined cloak and red hat, which gives the picture its name, holds a sword in his gloved left hand. Though still echoing Giorgione in his wistful expression, the sitter betrays an altogether new sense of inner life and movement that seem to expand to fill the canvas. The realistic rendering of his physiognomy and costume evidently respond to a renewed demand for a recognizable likeness and for a portraiture more reflective of the sitter's social and economic status. Titian's realism likewise gives the man a palpably human presence, recalling Antonello, who pioneered the use of the oil technique to lend immediacy to his subjects. The artist's role here is less obvious than in Giorgione, as the young man appears to present himself to the viewer's inspection. He keeps his distance, however, and fails to meet the spectator's glance, as if to underscore his superiority. Without sacrificing the sitter's individuality, Titian presents him as a member of the social elite in an equilibrium that would eventually make the artist the most respected and sought-after portraitist of the century.

244

1. Beginning in the mid-1300s, an official portrait of each newly elected doge was hung in the Sala del Maggior Consiglio in the Doge's Palace. A century later Venetian *scuole* (confraternities), commissioned narrative or processional pictures filled with portraits of their leading members. Donor portraits figure commonly in Venetian painting (cat. 10).

2. Milanesi 1878–1885, 3 (1878): 168–169.

3. Goffen 1989, 197–221.

4. Michiel (Frimmel 1888, 80) admired two Antonello portraits he saw in a Venetian collection in 1532 for their "great power and vivacity, especially in the eyes."

5. Ballarin (in *Le Siècle de Titien* 1993, 297–298, no. 16) dates the painting, which measures 57.5 × 45.5 centimeters, as early as 1497, but Anderson (Anderson 1997, 296–297) more convincingly places it among the works Giorgione completed after the turn of the century. See also Francesca Del Torre Scheuch in *Giorgione. Myth and Enigma* (Ferino-Pagden and Nepi Scirè 2004, 176–178, no. 4). The attempt occasionally made to attribute the Berlin portrait to the young Titian is excluded by the sitter's hand, which is a virtual signature of Giorgione.

6. David Rosand connects the parapet in early sixteenth-century Venetian portraits with ancient funerary symbolism in his "The Portrait, the Courtier, and Death," in *Castiglione. The Ideal and the Real in Renaissance Culture*, Rosand and Robert W. Henning, eds.

(New Haven, 1983), 97–102. The letters "VV" on the front of the parapet, in their present form at least, are not original to the Berlin portrait. For this and related portrait inscriptions, see most recently Giancarlo Fiorenza, "Pandolfo Collenuccio's *Specchio d'Esopo* and the Portrait of the Courtier," in *I Tatti Studies. Essays in the Renaissance*, vol. 9 (Florence, 2001), 63–87.

7. About Perugino's portrait in the Uffizi, Florence, see Pietro Scarpellini, *Perugino*, (Milan, 1984), 88, no. 60; and for a detailed comparison with the Berlin portrait, Wendy Sheard, "Giorgione's Portrait Inventions," in *Reconsidering the Renaissance*, Mario A. di Cesare, ed. (Binghamton, N.Y.,

1992), 171–176 and figs. 12, 13 (141–176). In 1494 and 1495 the Umbrian artist is documented in Venice, where the sitter, a Florentine, died in 1496. If Perugino's portrait was known to Giorgione, might not the left hand holding a scroll also be a source for the same motif in Lotto's *Bernardo Rossi* (cat. 46)?

8. About Memling's small panel, which has a Venetian provenance, see most recently Bernard Aikema in Aikema and Brown 1999, 194–195, no. 6.

9. Ballarin, in *Storia dell' arte italiana*, vol. 1, part 2, Federico Zeri, ed. (Turin, 1983), 479–541.

10. James Bruce Ross, "Gasparo Contarini and His Friends," *Studies in the Renaissance* 17 (1970), 192–232; and by the same author, "Venetian Schools and Teachers Fourteenth to Early

Sixteenth Century: A Survey and a Study of Giovanni Battista Egnazio," *Renaissance Quarterly* 29, no. 4 (Winter 1976), 521–566. In the conflict between secular and spiritual values, Giustiniani's call to withdraw from both the responsibilities and the pleasures of the world into an ascetic life of prayer and study was difficult or impossible to accept for most of his comrades, who affirmed instead the ideal of a good life led in society. This group, who in their "diverse forms of turning away from public commitments, express a common longing for a private life of spiritual and intellectual satisfaction, preferably in the company of kindred spirits" (Ross, 1970, 201), overlapped with Giorgione's patrons

Gabriele Vendramin, Taddeo Contarini, Gerolamo Marcello, and the mysterious "Giacomo," who ordered the *Laura*, and with the circle around the great Venetian printer Aldus Manutius (d. 1518).

11. The possible impact of the portraits that Dürer painted in Venice in 1505–1506 —especially those of donors and others, including the artist's self-portrait in the *Feast of the Rose Garlands*—is difficult to determine, given the fragmentary nature of Giorgione's oeuvre.

12. Milanesi 1878–1885, 4 (1879), 92–93.

13. In addition to Anderson in *Giorgione* 1979, 154–155, Anderson 1997, 31–39, and Ballarin in *Giorgione* 1979, 227–252, see Carlo Pedretti, "Ancora sul rapporto Giorgione–Leonardo e l'origine del ritratto di spalla," in *Giorgione* 1979, 181–185; David Alan Brown, "The

Cenacolo in Venice: the Initial Phase of its Reception," in *Venice 1992*, 85–96; and Sheard in *Reconsidering the Renaissance, 1992*, 141–176.

14. About the drawing in the Royal Library, Windsor Castle, and its importance for Venetian artists, see Brown in *Venice 1992*, 85–86, and 336, no. 65.

15. Though some of the male portraits assigned to Giorgione, like the so-called Broccardo portrait in Budapest or the *"Gattamelata"* in the Uffizi, can now be eliminated from his oeuvre after the 2004 Vienna exhibition, in which they could be compared with his autograph production, he must still be understood as the moving force behind these and other Giorgio-nesque works by his followers.

16. David Alan Brown, "Leonardo and the Ide-alized Portrait in Milan," *Arte Lom-barda* 67 (1983–1984), 102–116.

17. Anderson (Ander-son 1997, 34–36) notes the presence of two heads, one with a gar-land and the other the head of a youth, listed as by Leonardo in the 1528 inventory of Domenico Grimani's collection, but these are presumably pupils' works that were not necessarily in Venice during Giorgione's lifetime.

18. Anderson 1997, 32, 36.

19. Sheard in *Recon-sidering the Renais-sance, 1992*, 151–154.

20. About the paint-ings and their relation to Leonardo, see Fer-ino Pagden in Ferino-Pagden and Nepi Scirè 2004, 212–214, no. 12; and David Alan Brown in *Giorgione 2006*.

21. About Venetian double portraits of men, see Cecil Gould, "Lorenzo Lotto and the Double Portrait," *Saggi e Memorie di Storia dell' Arte* 5 (1966), 44–51; and Jaynie Anderson, "Bittersweet Love: Giorgione's Portraits of Masculine Friend-ship," in *The Italians in Australia: Studies in Renaissance and Baroque Art* (Florence, 2004), 87–94; and by the same author, "The Giorgionesque Portrait II: Representa-tions of Homosociality or the importance of friendship," in *Giorgione 2006*, 143–161. Anderson allows for the possibility of a homoerotic element in some of these works. On this point see also Pat Simons, "Homo-sociality and erotics

in Italian Renaissance portraiture," in *Por-traiture. Facing the Subject*, Joanna Wood-all, ed. (Manchester, N.Y., 1997), 44–45 (29–51).

22. The growing con-sensus in favor of the attribution to Gior-gione found new sup-port after the 1989 cleaning of the panel, which revealed its high quality, despite considerable damage. With the aid of infra-red reflectography, a sketch for a Nativity appeared beneath the paint layer. See Mauro Lucco, *'Le tre età dell'uomo' delle Galleria Palatina* (Florence, 1989), 11–28.

23. See, however, Anderson 1997, 140–146.

24. About Titian's portraiture of this period, see most recently Joannides 2001, 202–235.

46

Lorenzo Lotto

BISHOP BERNARDO
DE' ROSSI

1505, oil on panel
54.7 × 41.3 (21 9/16 × 16 1/4)
Museo Nazionale di
Capodimonte, Naples

Among the artists represented in this volume, Titian's only real rival for the variety and inventiveness of his portraits was Lorenzo Lotto. Unlike his contemporaries, Lotto did not experiment with the Giorgionesque mode of portrayal, choosing instead to individualize his subjects. At his best, he created hauntingly communicative images of his sitters that seem to transcend the period and circumstances in which they were made. Lotto's first major patron was Bishop Bernardo de' Rossi of Treviso, near Venice. Working for this newly appointed prelate and his circle, Lotto would naturally have painted his patron's portrait. Happily, both the portrait, now in Naples, and its original protective cover (cat. 47), in the National Gallery of Art, Washington, survive and are reunited in the exhibition. Dressed in a rose-colored mozzetta (elbow-length cape) and a black beret, Rossi wears a signet ring that bears (in reverse) his coat of arms, a lion rampant to the left, which also appears on the portrait cover. Lotto's portrayal of this high ecclesiastical official clearly echoes Bellini's great portrait of Doge Loredan (page 7, fig. 3) of about 1501, in the National Gallery, London, both in the realistic treatment of the features and costume and in the sitter's air of authority. The candid, literally "warts-and-all" naturalism of Lotto's portrait must be based on life studies of the kind that have frequently been attributed to the younger artist.

More than just a likeness, Lotto's portrait also displays the artist's overriding concern with characterization. The striking physical and psychological presence of the sitter accounts for the old attribution of the panel to Holbein the Younger and for the comparison often made to Dürer. The source for this aspect of Lotto's portraiture, however, is Antonello da Messina and his tradition. Like Antonello, in Venice in 1475–1476, Lotto posed his sitter in three-quarter view to the left, with the eyes turned to gaze intently at the beholder. But whereas Antonello had concentrated on the head, setting it off against a dark background, Lotto here adopted his favorite motif of a bright green curtain, and he included the sitter's hand. The expanded format of the Naples painting, vis-à-vis Antonello, links it in turn to a group of late fifteenth-century portraits by Alvise Vivarini, Andrea Solario, and other artists active in Venice. The larger scale of these works permitted their authors in each case to include one or both of the sitter's hands and to vary the background. The model for the amplified portrait type was evidently Perugino's *Francesco delle Opere* (Galleria degli Uffizi, Florence) of 1494; having been painted in Venice, it would seem, where the Umbrian artist and his Florentine sitter were both living, this work or one derived from it may well have been familiar to Lotto.[1]

Not just the structure but also the smallest details in Lotto's painting serve to characterize the sitter. Thus, the folds of the green curtain frame Rossi's head, focusing attention on the penetrating glance of his cold blue eyes. And the buttons of his cape

lead to the hand holding the scroll. The clenched fist in particular lends the sitter a resolute quality, which accords perfectly with what we know about the circumstances of his life. As an outsider from Parma, Rossi quickly came into conflict with the local authorities and with Girolamo Contarini, the Venetian *podestà* (governor) of Treviso. The reforms he instituted undermined their control of ecclesiastical affairs, to the extent that disgruntled members of the Onigo family, in league with the governor, tried to assassinate the bishop in September 1503. Rossi survived this attempt on his life, but the hostility provoked by his combative personality and policies forced him to flee Treviso in 1510.

1. David Alan Brown, *Andrea Solario* (Milan, 1997), 41–42, and figs. 20–22.

Provenance: Bishop Bernardo de' Rossi, Treviso and Parma, to 1527; Farnese Collection, Parma, before 1680, and Naples, 1734.

Selected References: Humfrey 1995, 138; Brown 1997, 73–75, no. 2 (with full bibliography); Humfrey 1997, 9–10; Aikema and Brown 1999, 190–191, no. 4.

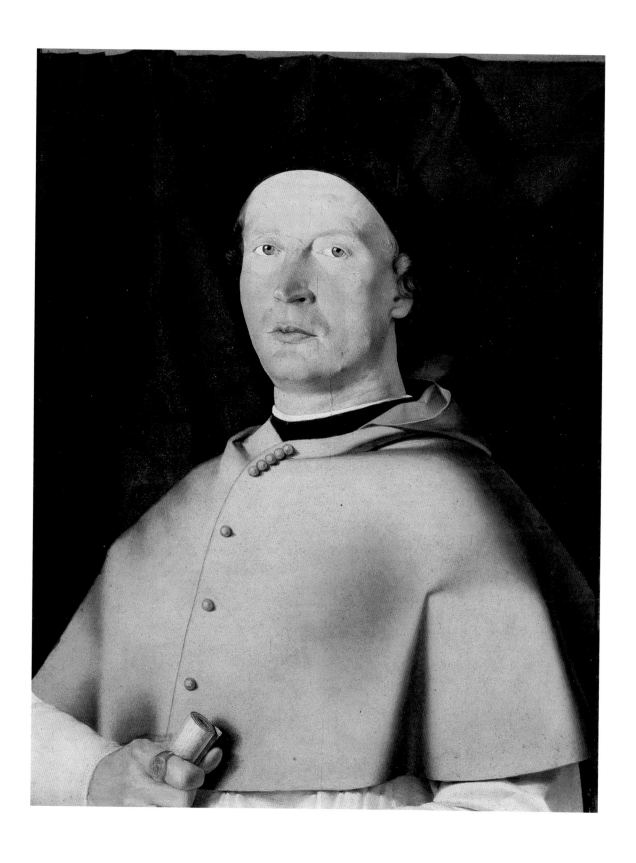

47

Lorenzo Lotto

ALLEGORY OF
VIRTUE
AND VICE

1505, oil on panel
56.5 × 42.2 (22 ¼ × 16 ⅝)
National Gallery
of Art, Washington,
Samuel H. Kress
Collection

Lotto painted the *Allegory of Virtue and Vice* for his first patron, Bernardo de' Rossi, bishop of Treviso, whose coat of arms—a white lion rampant to the left—adorns the shield in the center of the composition. The panel was formerly inscribed on the reverse with Rossi's name, title, and exact age (thirty-six years, ten months, and five days) at the time that Lotto, also named in the inscription, completed the painting on 1 July 1505. The panel now in Washington originally served as a cover for Lotto's portrait of the bishop (cat. 46), at Capodimonte in Naples, whose dimensions it approximates. Though painted covers for portraits may once have been fairly common, Lotto's *Allegory*, together with another similar work by the artist (cat. 37), is one of the few that survive. The cover was evidently of the sliding type: it slipped in and out of a groove in the frame, concealing, then revealing the underlying portrait—an arrangement similar to that in Dürer's *Hieronymous Holzschuher* in Berlin, where both the portrait and its sliding cover are intact.[1] Lotto's painted cover not only protected the panel underneath but also allowed the artist to amplify the likeness function of the portrait by means of an elaborate symbolic depiction of the sitter's character and ideals. The cover can be admired for its own sake apart from its intended function, and the temptation to treat it as an independent work of art, or in other words to remove it, must have been great. Not surprisingly, the *Allegory* is listed separately in early inventories, and it may have been detached shortly after it was painted.[2]

Although the iconography of the picture is complex and specific interpretations differ, scholars agree that it presents a moral choice between virtue and vice. In Lotto's bipartite scheme, a dead tree, sprouting a living branch, divides the composition in half. On the right, a drunken satyr peers into a pitcher of wine, while other vessels nearby spill their contents. The setting is lush and green, but in the background a storm has arisen, and a ship sinks beneath the waves. On the left, where Rossi's coat of arms appears, a putto occupies himself with a variety of mathematical and musical instruments. Here, by contrast, the terrain is rocky. In the distance, the same infant, endowed with wings, climbs a steep path toward a brilliant light emerging from the clouds. The moral lesson is that Rossi, who had only recently survived an assassination attempt when Lotto painted his portrait, would prevail over his enemies and, through study and steadfast virtue, attain intellectual and spiritual enlightenment. Lotto's allegorical portrait cover offers early evidence of both his lifelong fascination with symbols and emblems and his outstanding gifts as a landscape painter. Giorgione's *Tempest* of about 1506 (page 44, fig. 3), in the Accademia, Venice, may postdate the Washington picture, but Lotto was clearly aware of the new type of pastoral landscape that Giorgione was in the course of formulating. Indeed, the *Allegory* deconstructs the pastoral, separating the verdant meadow in the lower right from the luminous vista in the upper left; each element confronts its opposite across the picture and in depth. Another impulse behind Lotto's landscape, particularly the treatment of the rocks and trees, is

Dürer's prints, one of which also informs the landscape view in Bartolomeo Veneto's *Portrait of a Gentleman* (cat. 48).

1. On portrait covers and the problems of identifying and interpreting them, see Angelica Dülberg, *Privatporträts: Geschichte und Ikonologie einer Gattung im 15. und 16. Jahrhundert* (Berlin, 1990). The author distinguishes between the kind of fabric "trimpano," cited in Lotto's account book (pages 45–46), and wooden portrait covers that were sliding or hinged (pages 190–191, no. 47; 238–239, no. 187; and 293, no. 329).

2. Brown 1997, 77, no. 3.

Provenance: Bernardo de' Rossi, Treviso and Parma, 1505–1527; Antonio Bertioli, Parma, by 1791; Giacomo Gritti, Bergamo, by 1889; sold Sotheby's, London, 9 May 1934, lot. no. 129; Contini Bonacossi, Florence; sold to the Samuel H. Kress Foundation, 1935, and donated to the National Gallery of Art, 1939.

Selected References: Humfrey 1995, 138–140; Brown 1997, 76–80, no. 3 (with full bibliography); Humfrey 1997, 10–12; Aikema and Brown 1999, 400–401, no. 99.

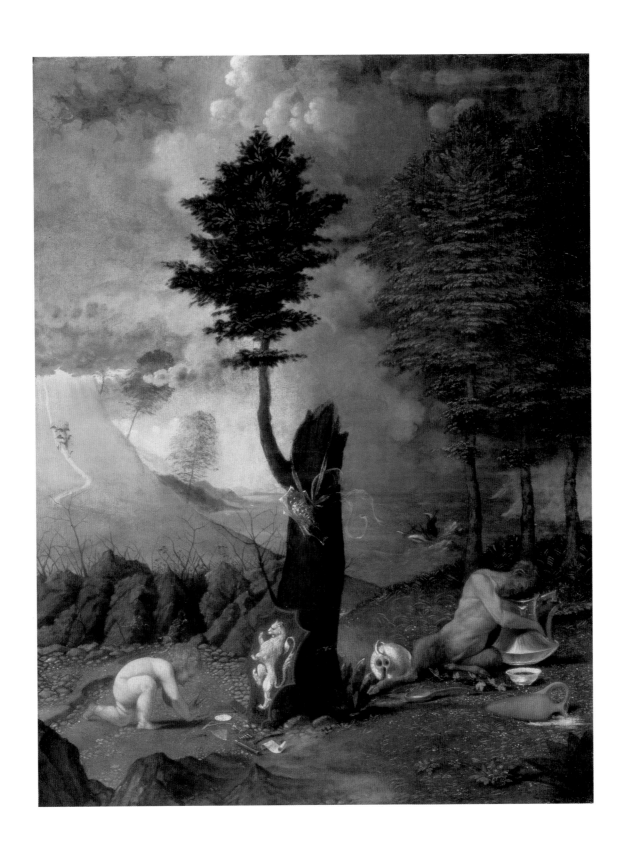

48

Bartolomeo Veneto

PORTRAIT OF A GENTLEMAN

c. 1515–1520, oil on canvas,
transferred from panel
76.8 × 58.4 (30 ¼ × 23)
National Gallery
of Art, Washington,
Samuel H. Kress
Collection

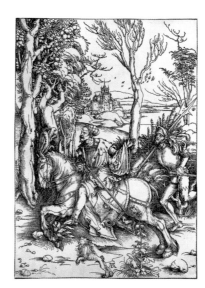

1.

Albrecht Dürer, *Knight
on Horseback and the
Lansquenet,* woodcut,
National Gallery of Art,
Washington, Gift of
W. G. Russell Allen

Besides reviving the artist's brilliant colors, recent cleaning of the picture has demonstrated that the parapet below the sitter is damaged with the result that the artist's signature presumably inscribed on the *cartellino* is missing. Even so, the painting has been correctly attributed to Bartolomeo Veneto for over a century. Because he specialized in portraits for private clients and did not receive public commissions, Bartolomeo was practically unknown before connoisseurs rediscovered his works. Often, his portrait sitters were fancifully identified: the unknown subject of the Washington painting was called Duke Massimiliano Sforza (1493–1530) of Milan. This unfounded hypothesis was quickly abandoned, but the sitter may well have been a Lombard nobleman, as suggested by the Milanese provenance of this and other works by Bartolomeo. The stylistic coordinates proposed for the painting—Leonardo da Vinci, Andrea Solario, Lorenzo Lotto, Holbein the Younger, all masters to whom Bartolomeo's portraits were once ascribed—fail to account for its archaic character, which harks back to his beginnings as an artist. Bartolomeo usually signed himself "Venetus," indicating the lasting importance of his training in the workshops of Gentile and Giovanni Bellini. Two early Madonnas by him are variants of compositions by Giovanni, and in the Washington picture the sitter's unfocused gaze and the parapet with the *cartellino* likewise recall Bellini's example.[1] Another source is Dürer, whose work strongly influenced Venetian painters during and after his sojourn in the city in 1505–1506. The realistic bias Bartolomeo acquired in Venice was reinforced

after he transferred his activity to Milan in the second decade of the sixteenth century. Like other painters active in both Venice and Lombardy—Giovanni Agostino da Lodi, Cariani, and Lotto, to name only three represented in this volume—Bartolomeo's work exhibits the pronounced naturalism characteristic of Lombard art.

The Washington picture has been repeatedly grouped with two other closely related half-length portraits by Bartolomeo depicting fashionably dressed young men turned to the left. The three portraits can be placed in sequence on the basis of their increasing complexity. The first, in the Museum of Fine Arts, Houston, bears a date, now illegible, that has been read as 1512 or 1520.[2] The second would seem to be the exhibited *Portrait of a Gentleman;* and the third, in which the sitter is turned into the picture space, is in the Galleria Nazionale d'Arte Antica, Palazzo Barberini, Rome.[3] The paintings in Washington and Rome both balance a red curtain against a landscape viewed through a window, in which the motif of a horseman followed

by a foot soldier is clearly derived from Dürer's woodcut (fig. 1) of the same subject.[4] But it is the life-size sitter's sumptuous attire that captures the viewer's attention and offers a contrast to the more subdued dress elsewhere portrayed in the exhibition. The pose in the Washington picture, with the torso nearly frontal, displays the luxurious costume to maximum effect—the white embroidered shirt, close-fitting black and gold striped jacket, and fur-lined black coat decorated with gold bands. The sitter is further adorned with a gold ring and chain, as well as a circular gold and enameled cap badge with an image of the martyred Saint Catherine with her attributes of the wheel and the palm. The fashion for cap badges bearing personal devices was introduced into Italy at the end of the fifteenth century. In this case the connection between the sitter and the female saint remains unexplained. The idea that Bartolomeo himself might have designed the badge "to suit the circumstances of his sitter" is not implausible in light of its similarity to other such ornaments in his work.[5] And the suggestion might be taken further in view of the sartorial resemblance among his male portraits. Instead of advising his clients about what to wear for their portraits, is it possible that the badges or other elements of their dress might be pure invention on the artist's part and not actual items worn by his subjects? Especially in Bartolomeo's *Portrait of a Gentleman* in the Fitzwilliam Museum, Cambridge, the elaborate symbolism of the man's attire verges on the fantastic.[6] Conceivably, in this and certain other portraits by the artist, the only part of the painting

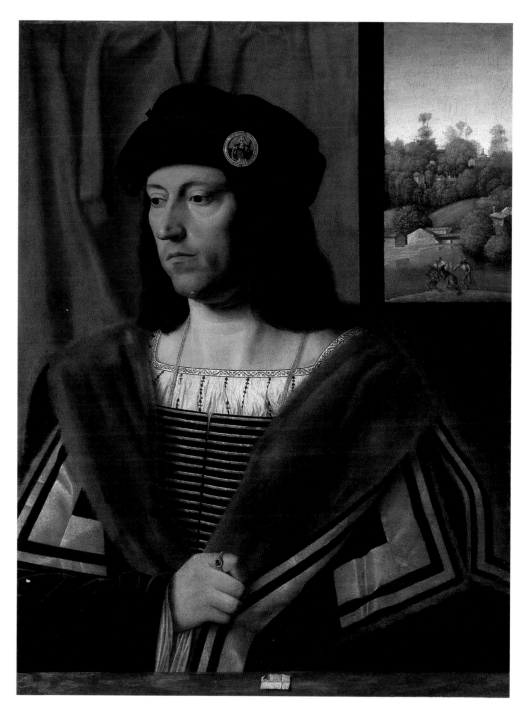

that is proper to the sitter is his head, based, it would seem, on a life drawing. Whatever the case, Bartolomeo, like Titian, evolved a successful formula for aristocratic portraiture that resonated with his clientele outside Venice.

251

1. For the Bellinesque Madonnas of 1502 and 1505, see Pagnotta 1997, 156–157, no. 2; and 162–163, no. 5. In a third *Madonna* (160–161, no. 4), the artist signed himself as a "scholaro di Ze[ntil] Be[llini]."

2. Pagnotta 1997, 232–235, no. 31; and Pagnotta 2002, 65–66, no. 5 and pl. 6.

3. Pagnotta 1997, 96–98, 238–241, no. 5, and pl. xvii; and Pagnotta 2002, 25 and pl. 10. Another male portrait (Pagnotta 1997, 208–209, no. 25, and pl. xiii), often grouped with the three cited here, differs in style and format and may be Ferrarese.

4. Bartsch 131. The borrowing was first pointed out by F. Hermanin, "Bartolomeo Veneto e Alberto Dürer," *L'Arte* 3 (1900), 155–157.

5. See Yvonne Hackenbroch, *Enseignes* (Florence, 1996), 101, and for Bartolomeo's other badges, 101–117.

6. Pagnotta 1997, 194–195, no. 18, and pl. vii.

Provenance: Casa Perego, Milan, by 1871; Benigno Crespi, Milan, by 1900; probably owned jointly by Wildenstein's and Gimpel's, Paris, c. 1911–1919; Henry Goldman, New York; Duveen Brothers, New York; Samuel H. Kress Foundation, 1937; donated 1939 to the National Gallery of Art.

Selected References: Shapley 1979, 1:27–29, no. 368; Pagnotta 1997, 91–92 and 210–212, no. 26 (with full bibliography); Pagnotta 2002, 24 and 63–64, no. 4.

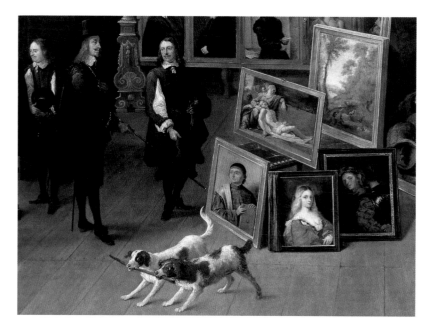

49

Vincenzo Catena

MAN WITH A BOOK

c. 1515, oil on panel
79 × 59.5 (31 ⅛ × 23 ⁷⁄₁₆)
Kunsthistorisches
Museum, Gemäldegalerie,
Vienna

inscribed:
VINCENTIUS CATENA
PINXIT

This signed portrait has long been admired as one of the artist's finest works. In the depiction of the Archduke Leopold Wilhelm in his Gallery in Brussels (fig. 1), in the Kunsthistorisches Museum, Vienna, the collector points out Catena's painting to the artist Teniers. The archducal inventory of 1659 gives larger dimensions for the picture (no. 16), and the engraving after it in Teniers' *Theatrum Pictorium* (1660) shows (in reverse) more space around the figure and a complete book. The inventory gives framed measurements, however, and the print is apparently a visual enlargement of the original. The panel, newly cleaned for the exhibition, has a ten-centimeter-wide margin at the bottom (perhaps left unfinished by the artist and repainted to match the rest of the picture), whose shape and location suggest that it may have been intended as a parapet that the artist omitted to accommodate the book. Another pentimento, revealed by x-radiography, concerns the present head, which was painted over an additional preparatory layer.

Half a century ago Giles Robertson, in what is still the only monograph on Catena, characterized his style as a "thoughtful blending of old and new."[1] Early portraits by the artist depict young men bust length against a cloud-filled sky in the manner of Bellini, while his so-called *Venetian Senator* of about 1525, in the Metropolitan Museum of Art, New York, is closer to Titian in the amply proportioned figure turned into the picture space.[2] The *Man with a Book* occupies an intermediate place in Catena's oeuvre, and Robertson dated it, accord-

ingly, to about 1515.[3] In the Vienna picture, the sitter is portrayed frontally, with the head turned slightly to the left. The shallow space and simple geometric forms parallel to the picture plane appear decidedly old fashioned compared with the innovations of the younger generation. Catena's picture looks back to Giovanni Bellini for its smooth brushwork and broadly colored shapes and to Giorgione for the half-length format and atmospheric softening of contours. Catena owned and restored works by Giovanni Bellini and may have been his pupil, and he was closely associated with Giorgione, who is described in an inscription of 1 June 1506 on the reverse of the *Laura* (cat. 38) as his *cholega*, probably meaning that they shared a studio.[4] The sitter's carefully observed facial features — his wrinkles and jowls — are evidently based on a life drawing of the sort that survives in many examples from the period.

Vasari devotes a brief passage in his biography of Carpaccio to Catena, whose portraits the writer particularly admired.[5] Among his contemporaries, too, Catena seems to have enjoyed a considerable reputation as a portraitist. He depicted two doges, as well as the Venetian collectors Francesco Zio and Giovanni Ram in works that are lost or unidentified.[6] His portrait of Palladio's first patron, Giangiorgio Trissino, is in the Louvre.[7] Catena was independently wealthy and, unusually for an artist, had a large number of friends and acquaintances among the Venetian intellectual elite. Though his surviving works, apart from portraits, all have religious subjects, he is said to have painted a "head of Apollo," which would have appealed to the new classical taste.[8] A series of wills and codicils drawn up by Catena in the years

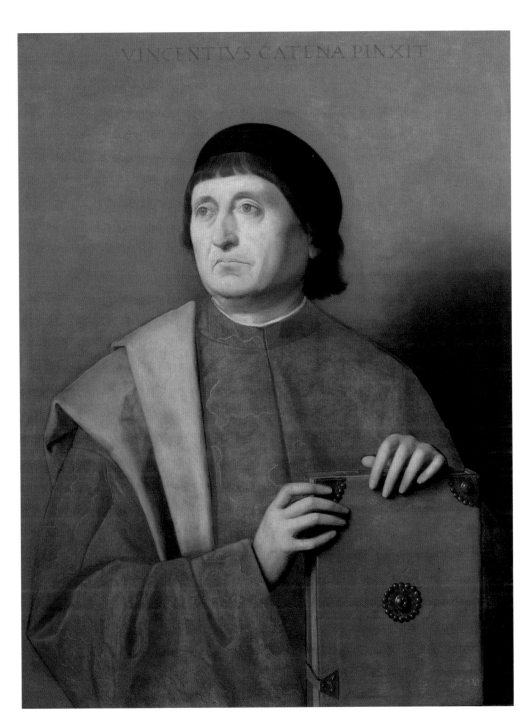

VINCENTIVS CATENA PINXIT

between 1515 and 1531 name as the artist's executors Antonio Marsilio (1486–1556), a distinguished notary with humanist interests, and Giovanni Battista Egnacio (c. 1478–1553), a teacher-scholar who became prior of the Ospedale di San Marco in 1511. Catena bequeathed works of art, including some terracotta nudes in relief, to both men, who were obviously close friends. Catena is also mentioned in letters written by Marcantonio Michiel to Marsilio, facetiously likening the painter to the recently dead Raphael, in 1520, and by Pietro Bembo in 1525.[9]

The middle-aged sitter of Catena's portrait was identified in early catalogues of the Vienna collection as a *Domherr* (cathedral canon), and Robertson, followed by Schmitter, likewise calls him a canon or parish priest.[10] Other authors refer to the man portrayed as a senator, however.[11] The discrepancy derives from the sitter's elegant dress, consisting of a long blue silk gown with ample sleeves, a pink stole worn over the shoulder, and a black cap: a similarly clad figure appears as one of the ducal councilors in the *Consignment of the Ring to the Doge*, completed by Paris Bordone for the Scuola di San Marco in 1534.[12] Whatever his social status, noble or not, the book upheld by the sitter clearly identifies him as a scholar. In Catena's portrait of Trissino, the scholar similarly holds a book, and another such figure is the tutor on the left in Cariani's *Concert* (cat. 54). All three examples conform to depictions of scholars, ancient or modern, widely disseminated in various media, including book illustrations. In the case of the Vienna picture, the man's

hands characterize him as the probable author of the book and in control of the knowledge it contains. The portrait should be compared with Catena's versions of Saint Jerome in His Study from the same period, in London and Frankfurt, which evoke the life of learning to which the Vienna man was devoted.[13] Catena's sitter would seem to be a gentleman scholar whose identity might be revealed by further research.[14] His facial features suggest that he was in his fifties in about 1515, the date convincingly assigned to the picture by Robertson. The fact that the Vienna painting is the only extant portrait signed by Catena, together with the unusual prominence of the signature, suggests that the artist took considerable pride in linking himself with this as yet unidentified man of letters.

1. Robertson 1954, 32.

2. Robertson 1954, 46–47, nos. 12 and 13; and 66, no. 45.

3. Robertson 1954, 25–26, and 53 as "not long after 1515" and "substantially before 1520."

4. A Madonna composition associated with Catena underlies Giorgione's *Self-Portrait as David with the Head of Goliath,* in Braunschweig, as revealed by x-radiography.

5. Milanesi 1878–1885, 3:643–644: "molto più si adoperò in fare ritratto di naturale, che in alcuna altra sorte di pitture: ed in vero alcuni, che si veggiano di sua mano, sono maravigliosi...."

6. Frimmel 1888, 86 and 104.

7. See Giles Robertson in *The Genius of Venice 1500–1600.* Jane Martineau and Charles Hope, eds. (New York, 1983), 167, no. 33; and Michel Laclotte in *Le Siècle de Titien* 1993, 274, no. 7.

8. Frimmel 1888, 104.

9. On Catena's documented relationship with contemporary humanists and writers, see Robertson 1954, 5–12.

10. Robertson 1954, 53; Schmitter 1997, 102, and Schmitter 2004, 935, note 99.

11. Von Hadeln 1908, 1,084; and Venturi 1915, 568.

12. Giovanna Nepi Sciré, *Gallerie dell'Accademia. I teleri della Sala dell'Albergo nella Scuola di San Marco* (Venice, 1984), 48–52.

13. Robertson 1954, 50–51, nos. 21–22.

14. Jennifer Fletcher (Fletcher 1973, 384 note 25) tentatively identified the sitter as Catena's heir and executor Egnacio (c. 1478–1553); about Egnacio, see also James Bruce Ross, "Venetian Schools and Teachers Fourteenth to Early Sixteenth Century: A Survey and a Study of Giovanni Battista Egnacio," *Renaissance Quarterly* 29, no. 4 (Winter 1976), 521–566.

Provenance: Bartolomeo Della Nave, Venice, 1636; Basil Fielding; Duke of Hamilton, to 1639; Archduke Leopold Wilhelm, Brussels and Vienna, 1659.

Selected References: Milanesi 1878–1885, 643–644; Von Hadeln 1908, 1,084; Venturi 1915, 568; Robertson 1954, 25–26 and 52–53, no. 25; Fletcher 1973, 384 note 25; Schmitter 1997, 102–103; Schmitter 2004, 935–938.

50

Follower of Giorgione

YOUNG LOVER AND
HIS SERVANT

c. 1510–1520,
oil on canvas
80 × 67.5 (31 ½ × 26 ⁹⁄₁₆)
Museo Nazionale
del Palazzo di Venezia,
Rome

Featured in surveys of Renaissance portraiture, this fascinating picture epitomizes the Giorgionesque mode of portrayal. The canvas is often called the "Ludovisi *Double Portrait*" after its seventeenth-century Roman owners, who believed it to be by Giorgione.[1] Soon after it came to light about 1920, Longhi likewise gave the painting to Giorgione, and he was followed, half a century later, by Ballarin and Lucco.[2] But since the *Double Portrait* does not correspond stylistically to other images of young men credibly ascribed to Giorgione, like the *Young Man* in Berlin or the *Boy with an Arrow* in Vienna, the Giorgione attribution has never found a consensus. Nor have the other candidates proposed as authors of the painting—Sebastiano del Piombo, Domenico Mancini, and the Veronese Francesco Torbido—proved persuasive.[3] The alternative view, namely, that the picture is by an anonymous follower of Giorgione, has found support from the recent cleaning, which failed to confirm or reveal the painter's identity.[4]

The authorship of the *Double Portrait* remains elusive, therefore, but its conception is clearly indebted to contemporary Venetian literary culture. These links have been explored, above all, by Ballarin, who in a series of publications from 1979 to 1993, examined the parallelism between the *Double Portrait*, for him an authentic Giorgione of about 1502, and Pietro Bembo's influential love treatise pub-

lished as *Gli Asolani* in Venice in 1505.[5] Ballarin's argument was sharpened by his discovery that the fruit held by the handsome young man was a *melangolo* (bittersweet orange), symbolizing the lover's plight.[6] Though too narrowly tied to the specifics of Bembo's text, perhaps, Ballarin's analysis seems essentially correct: the young man resting his head in his hand experiences the pangs of love, unlike his earthy companion. As Ballarin observed and as the recent cleaning has emphasized, there are two different lighting methods in the picture, which underscore the contrast between the two young men and their viewpoints—one spotlights the iconographically important gestures of the principal figure and casts his eyes in the shadow, and the other falls directly on the secondary figure's head. Indeed, it could be said that two realities are depicted, one poetic and dreamlike and the other brutally frank.[7]

The main subject of the Palazzo Venezia portrait rests his right arm on a stepped parapet and cradles his head in his hand; he gazes pensively into the distance as if absorbed in thought or in the grip of a powerful emotion, identified by the fruit he holds as amorous love. The youth's glance and gestures are not unique to the picture but recall the conventions of love and desire in Petrarch's sonnets, called the *Canzoniere*, and the Petrarchan tradition: here the lover does not weep or lament but quietly suffers the painful absence of his beloved.[8] Though ostensibly an individual, the man has been idealized to approximate the type of youthful male beauty associ-

ated with Giorgione. His long hair, fine features, and elegant attire contrast with the plebian character of his companion. The latter's round, coarsely featured face and modest garb identify him has a servant who, approaching from the right, intrudes upon the scene.[9] Like Bembo's *Asolani*, therefore, the *Double Portrait* offers conflicting views on the nature and experience of love, one courtly and refined, the other sensual and vulgar. Significantly, however, it is the servant, not the love-struck youth, who engages the viewer. Over his master's shoulder, he casts a knowing glance that makes the lover's despondency seem affected. Datable to the decade after Giorgione's death in 1510, the Giorgionesque *Double Portrait* thus seems to embody an implicit criticism of, or challenge to, the master's visual poetry as rarefied and unreal.

1. Klára Garas, "The Ludovisi Collection of Pictures in 1663," *The Burlington Magazine* 109 (1967), pt. 1, 289 (287–289), and pt. 2, 343 (339–348).

2. Roberto Longhi, "Cartellina Tizianesca," *Vita Artistica* 1 (1927), 133–138. Reprinted in *Opere complete di Roberto Longhi*, 14 vols. (Florence and Milan, 1956–2000); vol. 2 (1967), *Saggi e Ricerche 1925–1928*, 244 note 15 (233–244). Ballarin 1979, 234–235, 252; Ballarin 1983, 479–541; Ballarin 1993, 316–320, no. 23; and Lucco 1980, 138–139, no. 218. See also Lucco 1995, 96.

3. For the critical fortune of the *Double Portrait*, see Ballarin 1993, 316–320, no. 23. Anderson first rejected the Giorgione attribution (Anderson 1997, 340–341), then after further studying the picture, accepted it as his work (Anderson 2004, 89–91).

4. Pignatti 1971, 136, no. A50, as Giorgione circle.

5. Ballarin 1979, 234–235, 252; Ballarin 1983, 479–541; and Ballarin 1993, 316–320, no. 23.

6. Already described as a *melangolo* in the Ludovisi inventory, the fruit was sacred to Venus and symbolized bittersweet love, according to Andrea Alciati's *Emblemata* (1st ed., 1531), cited in Mirella Levi D'Ancona, *The Garden of the Renaissance. Botanical Symbolism in Italian Painting* (Florence, 1977), 275.

7. The treatment and technical investigation further revealed that blue sky in the upper right may originally have continued to the left side of the picture, under the present gray wall, and that the principal figure's sleeve originally had a larger opening.

8. Francesco Petrarca, *The Canzioniere*, Mark Musa, trans. and ed. (Bloomington and Indianapolis, 1996).

9. A similar, though more muted, contrast differentiates the patrician lute player from his rustic companion in Titian's early *Concert Champêtre* (cat. 31) of about 1510.

Provenance: Ludovisi Collection, Rome, 1663; Ruffo Collection, Ferrara, 1734; donated to the Palazzo Venezia, Rome, in 1919.

Selected References: Pope-Hennessy 1966, 132, 137; Pignatti 1971, 136, no. A50; Ballarin 1979, 234–235, 252; Lucco 1980, 138–139, no. 218; Ballarin 1983, 479–541; Huse 1990, 241; Ballarin 1993, 316–320, no. 23 (with full bibliography); Torrini 1993, 126, no. 8A; Lucco 1995, 96; Anderson 1997, 340–341; Carratù 2001, 68–69, no. 9; Anderson 2004, 89–91.

51

Sebastiano del Piombo

MAN IN ARMOR

c. 1511/1512, oil on canvas
87.5 × 66.5 (34 7/16 × 26 3/16)
Wadsworth Atheneum
Museum of Art, Hartford,
The Ella Gallup Sumner
and Mary Catlin Sumner
Collection Fund

Illustrated in André Chastel's *The Crisis of the Renaissance*, Sebastiano del Piombo's *Man in Armor* vividly evokes the period of military strife in Italy culminating in the Sack of Rome in 1527.[1] At this time, when the superiority of pursuing arms over letters was hotly debated and when the warrior emerged as a distinct cultural type, there arose in Venice a new genre of portraits of men in armor of which the Hartford picture is an outstanding example. The new pictorial type seems to have been invented by Giorgione soon after the turn of the century, in the form of his damaged and fragmentary *Self-Portrait as David* in Braunschweig. This work, frequently cited as a source for Sebastiano's portrait, depicted, in its original format, the victorious young David holding the head of Goliath on a parapet.[2] The facial expressions may differ — David appears troubled, while Sebastiano's warrior casts a menacing glance at the viewer — but both convey the subject's mental state. The Hartford painting deftly characterizes the sitter as potentially aggressive: his jutting shoulder, encased in armor, and his hand grasping the weapon are countered by the position of his arm shown resting on the parapet, parallel to the picture plane. The warrior's armor was also probably inspired by that of the military saint, usually identified as Liberale, in Giorgione's Castelfranco altarpiece. Like Giorgione, Sebastiano carefully depicted what appears to be an actual suit of armor, one that may or may not have belonged to the sitter, which experts agree in describing as that of a knight

of the heavy cavalry.[3] Complete with neck-guards and a lance-rest, the suit resembles the armor produced in Milan and elsewhere in northern Italy during the second half of the fifteenth century.[4] Similar armor is worn by Duke Federigo in Piero della Francesca's Montefeltro altarpiece in the Brera. But it is not only the accuracy of the armor that is indebted to Giorgione. Like mirrors and other polished metal surfaces, dark gleaming armor of the kind depicted by Sebastiano offered the opportunity for a virtuoso display of the artist's skill in handling the medium of oil paint. Giorgione was famous for his ability to depict metallic sheen and reflections in the manner of Jan van Eyck and his followers.[5]

When the Hartford picture was cleaned in 1982, the head of a page was revealed, laid in by the artist with the dark underpaint and subsequently covered by the green adopted for the background. The painted-out head, looking up at the warrior, is just visible on the left in the x-radiographs and on the surface in natural light.[6] Why Sebastiano chose to eliminate the page is a matter for speculation, but the original idea of including a secondary figure, like so much else in the Hartford painting, goes back to Giorgione.[7] Anderson relates the *Man in Armor* to Giorgione's *Portrait of Gerolamo Marcello*, which Marcantonio Michiel recorded in his diary and which has been connected with the artist's damaged but autograph *Man in Armor* in the Kunsthistorisches Museum, Vienna.[8] Michiel noted that Marcello, in armor, was shown half-length in a turning pose. Another distinctive feature of the Vienna painting, not mentioned by Michiel, is the

inclusion of a secondary figure, a grotesque hook-nosed supplicant on the right, recently identified as the *servus publicus* (slave), who figures in ancient triumphal processions.[9] Sebastiano could easily have turned Giorgione's slave into a page. Or the older master himself may have created a double portrait of a knight and page, now lost, that would be reflected in the so-called *Gattamelata* in the Uffizi. This canvas, which bears striking analogies in size, composition, and detail to the Hartford picture, figured in the recent Giorgione exhibition in Vienna, where, in the context of works universally accepted as the master's, it was shown to be a Giorgionesque imitation of the highest quality.[10]

In August 1511 Sebastiano, as perhaps the best available painter in Venice, accompanied the Sienese banker Agostino Chigi to Rome, where the artist embarked on a new career. Though Roman in date, if not in style or conception, the *Man in Armor* has antecedents in Sebastiano's early Venetian period. One is the figure of a halberdier in a painting of a woman and child seated in a landscape, on loan from a private collection to the Fogg Art Museum, Cambridge, Massachusetts. This little pastoral idyll, which has also been attributed to Titian, was clearly inspired by Giorgione's *Tempest*.[11] Closer in scale and spirit to the Hartford sitter is the figure of a saint, endowed with a portrait-like individuality, in Sebastiano's San Giovanni Crisostomo altarpiece of 1510–1511.

But the closest analogies lie in the murals with Ovidian scenes that Sebastiano painted for the loggia of Chigi's villa, later called the Farnesina, in Rome in 1511–1512. Scholars have tended to date the *Man in Armor* near in time to the fresco cycle; indeed, they appear to be contemporary.[12] Numerous parallels can be found among the frescoes, especially that of the giant Polyphemus, for not only the physical type but also the massive proportions of the portrait sitter.[13] The novelty of Sebastiano's demonstration of the Giorgionesque manner in Rome had a considerable impact, according to Vasari, not least on Raphael, who was working alongside the Venetian in the Farnesina decoration.[14] An echo of the new Giorgionesque type of pastoral landscape has been detected in Raphael's *Madonna of Foligno* in the Vatican Pinacoteca, of 1512, and the treatment of the Baptist on the left in the altarpiece, with his dark bushy hair and beard and dense modeling, likewise seems to recall the *Man in Armor*.[15] In yet another work by Raphael from this time, the *Portrait of Bindo Altoviti* in the National Gallery of Art, Washington, the chiaroscuro and dynamic pose of the sitter, turning toward the spectator before a green background, may also have been inspired by the Hartford picture, in which the dark gray underlayer was used in modeling the forms.[16]

1. André Chastel, *The Crisis of the Renaissance 1500–1600* (Geneva, 1968), repro. on 29.

2. For Sebastiano's debt to Giorgione's *Self-Portrait*, in the Herzog Anton-Ulrich Museum, Braunschweig, see most recently Sylvia Ferino-Pagden in Ferino-Pagden and Nepi Scirè 2004, 234–236, no. 18; and for the print reproducing the original composition, Francesca Del Torre Scheuch, 237, no. 19.

3. Hirst 1981, 97 note 28; and Cadogan 1991, 198 note 12. For the proposal to identify the portrait with one of an armed man that Vasari saw in Florence, see Cadogan 1991, 198 note 3.

4. Aldo Mario Aroldi, *Armi e Armature Italiane fine al XVIII secolo* (Milan, 1961), 519 and figs. 93–94.

5. Anderson 1997, 48–49.

6. The x-radiographs also reveal, aside from a few changes in the armor, that the sitter originally wore a cape around his neck that descended over his proper right shoulder. Stephen Kornhauser of the Atheneum and Claire Barry and Elise Effman of the Kimbell Museum kindly provided this information.

7. Wendy Sheard hypothesized that the page, who is not black, as sometimes stated in the literature, was deleted from the picture to suppress its supposed erotic overtones ("Giorgione's Portrait Inventions," in *Reconsidering the Renaissance* [Birmingham, N.Y., 1992], 148–149; and Review of *Le Siècle de Titien* 1993, in *Art Journal* [Spring 1994], 87 [86–89]).

8. Jaynie Anderson, "The Giorgionesque Portrait: from Likeness to Allegory," in *Giorgione* 1979, 155 (153–158).

9. See Sylvia Ferino-Pagden in Ferino-Pagden and Nepi Scirè 2004, 212–214, no. 12; and David Alan Brown in *Giorgione* 2006.

10. See Ferino-Pagden in Ferino-Pagden and Nepi Scirè 2004, 208–211, no. 11.

11. For the attribution, see Lucco 1980, 91, no. 3; and Joannides 2001, 78–82. In adapting Giorgione's prototype, Sebastiano turned the youth loosely described by Michiel as a *soldato* into a real armor-clad soldier, as noted by John Hale, "Michiel and the *Tempesta:* the Soldier in a Landscape as a Motif in Venetian Painting," in *Florence and Italy. Renaissance Studies in Honor of Nicolai Rubinstein*, Peter Denley and Caroline Elam, eds. (London, 1988), 415–416 (405–418).

12. Traditionally attributed to Giorgione, the Hartford picture, from the time it was first recognized as Sebastiano's, has been dated progressively earlier in his Roman period, from c. 1516–1518 (Dussler 1942, 134–135), c. 1515 (Pallucchini 1944, 160), and c. 1514 (Freedberg 1961, 370, 608), to c. 1512 (Lucco 1980, 104, no. 39; and Cadogan 1991, 198).

13. Compare in Lucco 1980, plates XVIII–XXIII. A related early Roman picture, *The Death of Adonis* in the Uffizi (Lucco 1980, plates XXV–XXVII), also bears comparison with the portrait, particularly the powerful arm and the way it cuts across the body, of the bearded male figure on the right. The figural scale in all three works, including the *Man in Armor*, evinces the artist's awareness of Michelangelo's Sistine Ceiling frescoes before they were publicly unveiled in October 1512.

14. Vasari (Milanesi 1878–1885, 5, [1880]: 567) specifies that it was the Giorgionesque character of Sebastiano's oil paintings that impressed his Roman audience.

15. At this moment of close contact between the two artists, the influence was mutually beneficial: in a drawing (Hirst 1981, fig. 179) in the British Museum, Sebastiano copied the pose of Raphael's Virgin and Child in the *Madonna of Foligno,* borrowed in turn from Leonardo.

16. For the Sebastiano connection, see David Alan Brown and Jane Van Nimmen, *Raphael and the Beautiful Banker: The Story of the Bindo Altoviti Portrait* (New Haven and London, 2005), 23–24.

Provenance: James Brydges, Duke of Chandos, by 1723 to 1747; Sir Thomas Sebright by 1857, and by descent to Sir Giles Sebright, Beechwood Park; Christie's, London, 2 July 1937, lot no. 118; Kleinberger, New York, sold to the museum in 1960.

Selected References: Dussler 1942, 41, and 134–135, no. 30; Pallucchini 1944, 40–41 and 160; Freedberg 1961, 1:370, 608; Pignatti 1979, 56–57, no. 12, 159; Lucco 1980, 104, no. 39; Hirst 1981, 97; Cadogan 1991, 197–200; Pattanaro 1993, 355–356, no. 39; Bowron 2004, 42, no. 2.

detail, cat. 51

52

Palma Vecchio

PORTRAIT OF A POET

c. 1520, oil on canvas
mounted on panel,
transferred from panel
83.8 × 63.5 (33 × 25)
The National Gallery,
London

As an artist, Palma Vecchio was uneven, painting a number of routine pictures that rise above the level of competence to approach greatness when he emulated Giorgione, Titian, and Sebastiano. But in doing so, Palma often looked to acknowledged masterpieces, not the latest novelties, for inspiration. The central figure in his altarpiece in Santa Maria Formosa, for example, goes back to the Virgin in Titian's Frari *Assumption*. Likewise, his *Portrait of a Poet*, which has been dated stylistically between 1515 and 1525, recalls Giorgione well after the master's death in 1510.[1] To some extent Palma was a specialist in two genres: wide-format depictions of the Virgin and Child with saints in a landscape; and half-lengths, all more or less erotic, of idealized women with blond hair. He painted relatively few portraits, strictly speaking, and of these the London *Poet* is acknowledged to be the finest. Aside from his *Man in a Fur Coat* in the Alte Pinakothek, Munich, which was singled out for praise by Vasari, Palma's other male portraits in St. Petersburg, Venice, Madrid, and elsewhere, are more conventional.[2] By contrast to these, the elements that distinguish the London portrait are also found in Palma's religious paintings and representations of women. The pose of the sitter with one arm held up, resting on a support (here a book, elsewhere a ledge) and holding an object (here beads, there drapery folds), was a favorite of Palma's and appears repeatedly in his work.[3] The figures posed in this manner are occasionally shown against a foliate background, as in the *Poet*.[4]

Though the London picture is by no means perfectly preserved, the face, hands, and much of the costume are in quite good condition. The paint has been extended about an inch at the bottom edge, so the parapet on which the arm and the book rest is only implied. The *Poet* is exceptional in Palma's oeuvre not only for its formal complexity but also in its characterization. Apparently in his late twenties or early thirties, the subject is splendidly dressed in a white shirt, close-fitting jacket, deep rose-red in color and with blue stripes and puffed sleeves, and a brown fur cape. He wears thin gold chains and the gloves of a gentleman, one of which he has removed in order to finger a string of dark rosary beads. The gloves form part of the logic of the pose, and so do the sitter's other garments, which have fallen down, exposing the white shirt and a bit of bare shoulder in a way that recalls Palma's provocatively disheveled women (cat. 44). In this case, the sartorial disarray suggests that the man has turned abruptly to the left as if distracted. Two of the attributes—the laurel branches and the book—identify the sitter as a poet who, like the youth languishing for love in the *Double Portrait* (cat. 50), is lost in thought. Palma's source for the motif of the laurel behind the figure has been identified in Giorgione's *Laura* (cat. 38) of 1506, in which the plant alludes to Petrarch's famous beloved "Laura."[5] In the London painting, the laurel framing the sitter's head combines with the book to suggest that he was a published poet of some renown. Unlike Catena's older and more dignified scholar (cat. 49), Palma's subject carries his learning lightly. The role of the rosary beads in this context is unclear.[6]

Is the sitter in the London portrait some love poet in the Petrarchan tradition? No such claim has been made for the picture, but another celebrated writer has often been proposed as its subject—Ludovico Ariosto, court poet to Duke Alfonso d'Este of Ferrara and author of the chivalric epic *Orlando Furioso*, first published in Venice in 1516. The London portrait was once identified with a portrait of Ariosto by Titian recorded by Ridolfi (1648) in the house of the painter Nicolas Régnier in Venice.[7] As Rylands has explained, the issues of attribution and identification are intertwined, for when connoisseurs recognized the painting as Palma's, Ariosto's name was dropped along with Titian's.[8] The compiler of the London National Gallery catalogue, while maintaining Palma's authorship, attempted to revive the Ariosto identification, but, aside from Mariacher (1968, 1975), his proposal did not find favor with subsequent critics.[9] The man portrayed in the London portrait bears little resemblance to the most reliable likeness of Ariosto— the woodcut by or after Titian illustrating the 1532 edition of the *Orlando Furioso*.[10] In addition, Ariosto, born in 1474, would seem too old to have sat for the London portrait at the probable time it was completed about 1520.

1. Gombosi (1937, 19:65) dated the painting c. 1515, as did Gould (1975, 185) and Mariacher (1975, 210) while Spahn (1932, pl. 59) preferred c. 1524. Rylands (1992, 201) opts for 1520–1525.

2. Vasari (Milanesi 1878–1885, 5 [1880]): 246–248. Dated 1516–1518 by Rylands (1992, 173–175, no. 32), this work employs the dynamic turning pose invented by Giorgione, to whom it is sometimes attributed. For the other portraits, see Rylands 1992, 225, no. 82; 226, no. 83; 227, no. 84; and 258, no. 95.

3. Compare Rylands 1992, 152–153, no. 8; and 208, no. 66, also in the National Gallery, London.

4. Rylands 1992, 176–177, no. 34; and 209–210, no. 67. In the case of Palma's *Adam and Eve* in Braunschweig (198–199, no. 55), the leafy tree was taken over with the figures from Dürer's engraving of the same subject.

5. Palma's *Young Shepherd with Pipes*, formerly in a private collection in Zürich (Rylands 1992, 179, no. 37), bears the same relation to Giorgione's *Boy with an Arrow* in Vienna, as does Titian's *Shepherd* at Hampton Court. Both works experiment with Giorgione's type of youthful male beauty, derived in turn from Leonardo.

6. In an interpretation of Giorgione's *Laura*, Helen A. Noë ("Messer Giacono en zijn 'Laura' Een dubbel portret van Giorgione?" *Nederlands Kunsthistorisch Jaarboek* 11 (1960), 25 [1–35]), taking into account the rosary, claimed that the laurel in the London picture symbolized faith and charity.

7. Carlo Ridolfi, *Le Maraviglie dell'Arte* (orig. ed. 1648), Detlev von Hadeln, ed. vol. 1 (Berlin, 1914), 162.

8. Rylands 1992, 201–202, no. 58.

9. Gould 1975, 185–187, no. 636.

10. David Rosand and Michelangelo Muraro, *Titian and the Venetian Woodcut* (Washington, 1976), 193–194, no. 41.

Provenance: Tomline Collection; in Paris by 1857, when transferred to canvas; purchased with the Beaucousin Collection for the National Gallery in 1860.

Selected References: Spahn 1932, 77, 151–152; Gombosi 1937, 19:65; Gould 1975 (reprinted 1987), 185–187; Pope-Hennessy 1966, 218; Mariacher 1968, 49–50, no. 12; Rylands 1992, 201–202, no. 58 (with full bibliography).

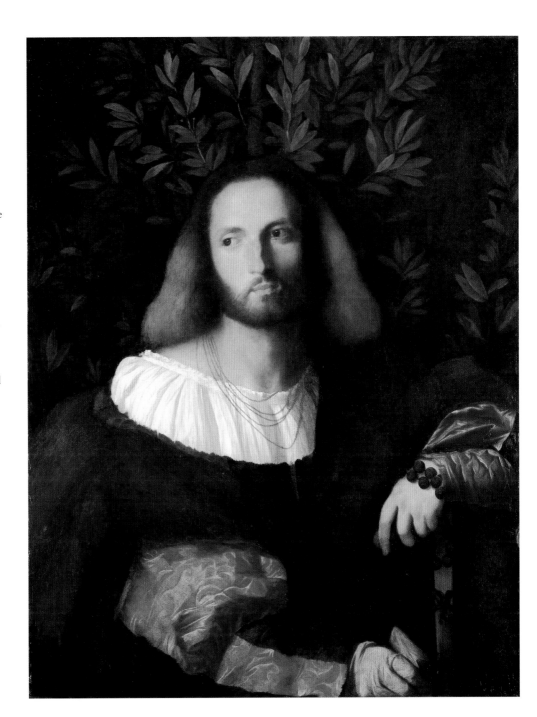

53

Titian

CONCERT

c. 1511/1512, oil on canvas
86.5 × 123.5 (34 1/16 × 48 5/8)
Galleria Palatina
di Palazzo Pitti, Florence

Though dismissed as one of the "stalest…controversies in the whole of Renaissance painting," the scholarly debate about who painted the *Concert*—Giorgione or Titian?—is actually quite revealing about the picture and its meaning.[1] Depicted in the new half-length format rapidly becoming popular for portraits, the young man in the center of the composition turns, while playing a keyboard instrument, to look over his shoulder at an older man holding a viola da gamba, while on the left a fashionably dressed youth gazes out at the viewer.[2] The picture is a study in contrasts, which have puzzled critics ever since 1648, when Ridolfi first mentioned the *Concert* as in Paolo del Sera's Collection in Venice.[3] Ridolfi attributed the painting to Giorgione and identified the central figure as an Augustinian friar. From his description, contrasting the clerical garb of the right-hand figure and the plumed hat of the one on the left, arose the odd notion that the protagonists were Calvin, Luther, and Catherine von Bore, the ex-nun whom Luther married in 1525. At the beginning of the nineteenth century, when the discrepancy in dates was recognized (Giorgione died in 1510), this colorful identification was abandoned in favor of the more plausible one of "three musicians."[4] Later in the century, the two leading scholars of early Italian painting, G. B. Cavalcaselle and Giovanni Morelli, disagreed about the *Concert,* which Cavalcaselle praised as Giorgione's finest work and which Morelli tentatively gave to the young Titian.[5] Cavalcaselle's view found considerable support, but it was Morelli's attribution that steadily gained credence, with authors repeat-

edly comparing the highly expressive keyboard player to the *Man with a Glove* (cat. 56).[6] Of particular interest in the debate is the way Giorgione's advocates focused on the left-hand figure, while those favoring Titian emphasized his companion.[7] One explanation for the incongruity between the left-hand and central figures was to regard them as having been painted, respectively, by Giorgione and Titian. Gronau first advanced the hypothesis of a collaboration between Giorgione and Titian in 1904, and though the share allotted to each artist varied slightly over the years, the idea that Giorgione began a picture finished by his colleague enjoyed a remarkable longevity, buttressed, no doubt, by analogy with the Dresden *Venus.*[8]

The conservation treatment of the *Concert* in 1976 altered the debate about its authorship and affected the identification of its subject.[9] The most dramatic change was the removal of a nine-inch strip of canvas added at the top, restoring the picture to its original dimensions and heightening the interaction between the figures. The fur-trimmed garment of the keyboard player turns out to contain white lead, moreover, and its color appears to be dark blue, not black, ruling out the identification of him as a friar. Another discovery arose from technical examination of the picture. In common with other Venetian works of the period, the *Concert* had been studied using x-rays as early as the 1930s.[10] The x-radiograph (fig. 1) showed that all of the picture, including the left-hand figure, was planned and painted at the same time, the differences having to do with the preparatory layers.[11] Thus, the *Concert*

appears to have been painted entirely by Titian about 1511/1512, contemporary with the Santo frescoes in Padua, the *Baptism* in the Capitoline Museum, Rome, and the Saint Mark altarpiece in the sacristy of Santa Maria della Salute, Venice, all works to which the Pitti picture has been compared.[12]

With the attribution question settled in favor of Titian, modern writers on the *Concert* have turned their attention to explicating its subject. Though the nineteenth-century English critic Walter Pater saw the picture's musical theme as the quintessence of Giorgione's art, subsequent scholars noted that a deep interest in musical theory and practice characterizes the entire period. All modern interpretations of the Pitti painting have sought to define its nature as an allegorical portrait in which the figures come together in a musical performance. At one level, of course, music-making was an effective means for integrating the figures in the new type of double or group portrait associated with Giorgione. Beyond this use as a compositional device, however, recent studies have stressed music as a thematic unifier in both the *Concert* and the so-called *Three Ages of Man* (see page 242, fig. 5), also in Palazzo Pitti.[13] The problem with this reading, in which music brings together men from youth to old age, is that, in the *Concert,* the figures in the center and on the left are both young, while the third, his brown hair tonsured, is middle-aged. More pertinent is Gentili's observation that the keyboard player's performance is interrupted by the cleric on the right, who, laying a

has shown that the paint of his cos-
tume extends under that of his com-
panion.[19] The painter was at pains to
contrast the artificiality and inertia of
the Giorgionesque type, as he saw it,
with the realism and expressive force
of the keyboard player, who seems to
embody Titian's own innate vitality.

265

hand on his companion's shoulder,
would represent the intrusion of real
time into the harmony of ideal time.[14]
If we substitute "world" for Gentili's
"time," the idea of an interrupted con-
cert seems valid and does not negate
Ballarin's emphasis on the spiritual
communion between the two musi-
cians, one playing and the other not.[15]
More recently, Joannides has plausibly
interpreted the *Concert* as a moraliz-
ing allegory, in which the stern-look-
ing cleric draws the keyboard player
away from the charms of music and
friendship, from self-indulgence to
self-discipline and denial.[16]

The Pitti painting appears to present
a contrast or opposition not between
music and music-making, but between
music's dual nature as both entertain-
ment and moral uplift. Making a
momentous choice, the protagonist in
the center of the picture turns away
from his worldly companion to cast a
rapturous gaze at the cleric, who

interrupts the player's performance
to remind him of music's true value.
An allegory of the spiritual power of
music, the *Concert* is also a double
portrait of the two musicians, whose
identities remain unknown. The indi-
vidualized features of the cultivated
aristocrat and the cleric contrast with
the generalized appearance of the
vapid youth in fancy dress on the left.
Detached from the other figures, the
youth with the plumed hat has always
provoked uncertainty and continues
to strike critics as an anomaly in the
composition.[17] Admittedly, his figure
has been damaged through overclean-
ing in the past, but even with his face
flattened and his features hardened,
he can still be evaluated as a type.
Intended, perhaps, to personify self-
indulgent pleasure and luxury, the
youth appears so exaggerated, so like
a caricature or parody of a Giorgion-
esque type, that E. H. Ramsden dis-
missed him as a fabrication by Titian's
seventeenth-century imitator Pietro
della Vecchia.[18] But the youth must
be Titian's own work, not a spurious
addition, as technical investigation

1. Cecil Gould, "Lorenzo Lotto and the
Double Portrait. Transformations of the
Della Torre Picture," *Saggi e Memorie
di Storia dell'Arte* 5 (1966), 50 (44–51).

2. For the identification of the keyboard
instrument as a "spinetta" or "clavi-
cembalo," see Mina Tieri, "Prezenze
Musicali nelle Opere di Tiziano Vecellio,"
in *Tiziano Cadorinus. Celebrazioni in
Onore di Tiziano. Pieve di Cadore 1576–
1976* (Vicenza, 1976), 170 (165–170).

3. Carlo Ridolfi, *Le Maraviglie dell'Arte*
(orig. ed. 1648), Detlev von Hadeln, ed.
2 vols. (Berlin, 1914), 1:99.

4. Gloria Chiarini, in Chiarini, 1978,
196–198.

5. See Crowe and Cavalcaselle 1912,
2:144; and Morelli 1883, 157.

6. See Crowe and Cavalcaselle 1912, 3:
note 1, 26–27. Even authors like Herbert
Cook (*Giorgione* [London, 1900], 49–52)
and Claude Philips (*Titian, a Study of his
Life and Work* [London, 1898], 61–62) who
gave the *Concert* to Giorgione, compared
the central figure to the Louvre portrait.

7. Titian's defenders were often plagued by
doubts about his authorship. See, among
others, Venturi 1928, 209–211.

8. Gronau 1904, 291. See also Giorgio
Castelfranco, "Note su Giorgione," *Bollet-
tino d'Arte*, 40, no. 4 (October–December
1955), 310, note 19 (298–310), and Beren-
son 1957, 185.

9. On the results of cleaning, see Gloria Chiarini in Chiarini, 1978, 203–204, 360–361; and Marco Chiarini, "Tre Dipinti Restaurati di Tiziano a Palazzo Pitti," in *Tiziano e Venezia*, Convegno Internazionale di Studi, Venice, 1976 (Verona, 1980), 293–294 (293–296).

10. A "shadowgraph" detail of the head of the central figure was published by Alan Burroughs (*Art Criticism from a Laboratory* [Boston, 1938], fig. 17), who described its brushwork as "light, thin, and feathery."

11. Chiarini 1978, 203–204. See also Marco Chiarini, "Tre dipinti restaurati," in *Tiziano e Venezia*, 1980, 293–294 (293–296). For different readings of the x-radiographs, see Ludovico Mucchi, *Caratteri radiografici della pittura di Giorgione*, vol. 3 of *I Tempi di Giorgione*, 3 vols., L. Puppi, P. Carpeggiani, and R. Maschio, eds. (Florence, 1978), 62–63; and Bert W. Meijer, Review of Chiarini 1978, in *Prospettiva* 19 (October 1979), 108 note 12 (104–109).

12. Charles Hope (Review of Chiarini 1978, in *The Burlington Magazine* 122, no. 932 [November 1980], 772) concluded that, after cleaning, the *Concert* "has emerged as a wholly autograph work, and any suggestion that Giorgione had a hand in it must surely be abandoned."

13. Patricia Egan, "'Concert' Scenes in Musical Paintings of the Italian Renaissance," *Journal of the American Musicological Society* 14, no. 2 (Summer 1961), 191 (184–195).

14. Gentili 1980, 43–44, and Gentili 1988, 67.

15. Ballarin 1993, 406–407. Less convincingly the author revives the notion that the two figures on the right represent the musicians Verdelot and Obrecht whose double portrait by Sebastiano del Piombo was praised by Vasari. The temptation to identify this known work with the Pitti picture also proved irresistible to E. H. Ramsden, *"Come take this Lute": A Quest for Identities in Italian Renaissance Portraiture* (Salisbury, 1983), 5–94.

16. Joannides 2001, 215–218.

17. Gronau (1904, 20–21) describes the figure as a "disturbing element."

18. Ramsden 1983, 49–52. Francesco Valcanover (1969, 95, no. 42) and Rodolfo Pallucchini (1969, 24–25, 241) both ascribed the figure to a Giorgione follower.

19. The costume in parts also shows Titian's characteristic handling. See Terisio Pignatti (1971, 120), who notes that the "little white shirt with pleats is in a good state of preservation, and its handling seems decidedly Titianesque." Costume expert Stella Mary Newton described the hat as "difficult to accept as Venetian except, perhaps, in the theatre" (*The Dress of the Venetians 1495–1525* [Aldershot, 1988], 44).

Provenance: Paolo del Sera, Venice, in 1648; acquired by Cardinal Leopoldo de' Medici in 1654; entered the Pitti in 1675.

Selected References: Morelli 1883, 157; Gronau 1904, 19–21, 291; Berenson 1906, 40; Venturi 1913, 149–150; Venturi 1928, 9: pt. 3, 209–211; Berenson 1932, 570; Berenson 1957, 1:185; Pallucchini 1969, 24–25, 241; Valcanover 1969, 95, no. 42; Wethey 1971, 91–92, no. 23; Chiarini 1978, 196–208, no. 54; Gentili 1980, 43–44 (40–48); Gentili 1988, 67 (60–79); Padovani 1990, 144–146, no. 3; Ballarin 1993, 403–407, no. 45; Gentili 1994, 91–92 (84–95), no. 1d; Guarino 1995, 244–245, no. 8; Joannides 2001, 215–218; Pedrocco 2001, 92, no. 23.

53

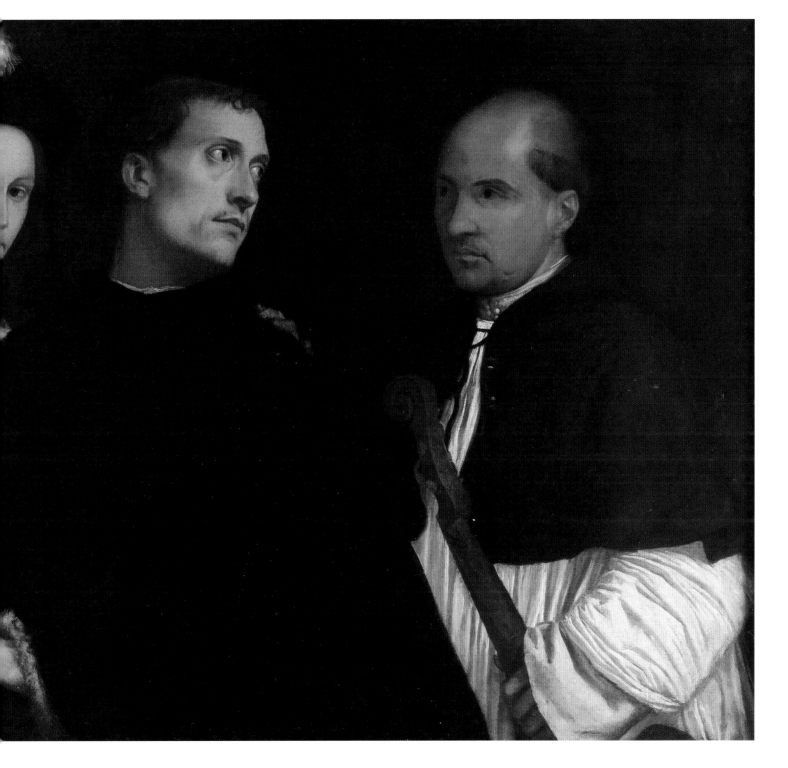

54

Giovanni Cariani

CONCERT

———

c. 1518, oil on canvas
92 × 130 (36 ¼ × 51 ³⁄₁₆)
National Gallery
of Art, Washington,
Bequest of Lore
Heinemann
in memory of her
husband, Dr. Rudolf J.
Heinemann

•

Washington only

Cariani's *Concert,* now in the National Gallery of Art, came to light only in the 1960s, when it was immediately hailed as a masterpiece. Born about 1485 near Bergamo, the westernmost of the Venetian mainland territories, Cariani was trained in Venice, possibly in Giovanni Bellini's workshop, and he was further influenced there by Giorgione, Titian, Sebastiano del Piombo, and Palma Vecchio. Cariani returned to live and work in his native city from 1517 to 1523 and again from 1528 to 1530; otherwise he was active in Venice until his death sometime after 1547. This pattern of alternating between two centers, one a sophisticated cultural capital and the other a provincial city tied to Milan, is reflected in Cariani's picture, featuring a singer accompanying himself on the lute, flanked by two companions. The oblong composition, with the figures shown half-length behind a ledge, derives from Giorgione, as do the two themes that Cariani combined in his painting. The subject of a young man and his teacher goes back to Giorgione's so-called *Three Ages of Man* (see page 242, fig. 5) in the Pitti Gallery, Florence. Cariani united this theme with the even more popular one of music-making, epitomized in Titian's *Concert* (cat. 53), also in Palazzo Pitti. The warm color in Cariani's picture — the green cloth draped over the ledge, the red garments and book, and the stunning red-and-pink hat worn by the musician, set off against a gray background — is also Venetian in origin.[1]

Cariani has interpreted his Venetian models in a highly realistic manner associated with his native Lombardy. The musician convincingly strums the lute, which is depicted accurately with six strings and eleven pegs.[2] Placed on the ledge near him are a crumpled cloth with which to wipe his hands and a small box containing a string. Like these functional objects and the musical instrument itself, the costumes, especially the fur-lined cloaks, are treated with the utmost attention to texture and detail. Not surprisingly, with so few dated works by the artist for comparison, this meticulously detailed Lombard treatment of a Venetian theme has been dated to different moments in Cariani's career. The authors of the standard monograph on the artist, Pallucchini and Rossi, dated it soon after his return to Bergamo in 1517.[3] Though at first of the same opinion, Ballarin subsequently changed his mind, favoring a dating to about 1510–1515, and his reconstruction of Cariani's early Venetian period to include the *Concert* has been followed in the most recent study of the artist.[4] The figures of the tutor and his charge do display a knowledge of portraits Titian painted in the years following Giorgione's death.[5] But the closest work within Cariani's own oeuvre dates from just after his return to Bergamo — the so-called *Pala di San Gottardo* in the Brera, of 1517–1518, in which Joseph stands out from his docile fellow saints, much like the animated lute player in the *Concert.*[6]

Any interpretation of Cariani's picture must proceed from the fact that it does not represent a vocal ensemble. With his head tilted back and lips parted, the lutenist appears to be singing, but his companions have no instruments and do not react to the musician's playing. This feature, which Cariani's *Concert* shares with other Venetian musical paintings, stands in contrast to Lorenzo Costa's *Concert* (fig. 1) of about 1490, in the National Gallery, London, which depicts three singers, one of whom accompanies himself on a lute, in a lively, informal manner.[7] The stringed instrument and open songbook resting on the table further specify the scene depicted as one in which all three figures are performing. But if the title of Cariani's picture is a misnomer, what does the painting actually represent?[8] According to Gentili, the singer/lutenist has resumed a performance interrupted by a broken string, and, with musical harmony restored, the man on the left is about to open his book.[9] The problem with this theory is that the figures flanking the musician do not appear to be singers: the youth on the right simply looks out at the viewer, as do similar figures in the works by Giorgione and Titian already mentioned, and the book held by the older man on the left could be a text on the theory or science of music, or indeed any academic subject, rather than a songbook. All three figures, to judge from their individualized features, must be portraits, though the sitters have yet to be identified. Most impressive is the corpulent musician, who bursts on the scene, separating the tutor from his aristocratic young pupil. Cariani had already depicted a Giorgionesque musician, playing a lute in a pastoral landscape, in a panel of about 1512/

1515 in Strasbourg.[10] The main figure
in the *Concert* departs sharply from
that conception: no longer idealized as
a melancholic, he has an overly large,
almost comic presence. In his bulk,
extravagant hat, and perhaps too-
passionate search for inspiration, the
musician in the Washington canvas,
in common with its realistic style,
would seem to be a critique of the ele-
vated type of musical picture Cariani
encountered in Venice. The solo per-
formance in the *Concert* posits the
everyday reality of music as a delight-
ful pastime and casts doubt on its
ability to transport listeners to a
higher sphere. This skeptical or satiri-
cal note goes beyond the realism of
the central figure in Titian's *Concert*
and shows that the type of musical
picture that originated with Giorgione
was undergoing further change in
the hands of another of his followers.

1. The combination of bright red and pink
was a favorite of the artist; compare the
figure of the high priest in his *Visitation*
in the Kunsthistorisches Museum, Vienna
(Pallucchini and Rossi 1983, pl. XXXIV).

2. About the construction and history
of the lute, centered in Venice in the early
sixteenth century, see Douglas Alton
Smith, *A History of the Lute from Antiq-
uity to the Renaissance* ([n.p.], 2002),
58–94.

3. Pallucchini and Rossi 1983, 125.

4. For his change of mind, see Ballarin
1993, 437–439. See also Zanchi and Caval-
leri 2001, 5, 19, where the picture is
wrongly stated to be in the Metropolitan
Museum, New York.

5. Pedrocco 2001, 94–95, nos. 24–27; and
103, nos. 38–39.

6. About the *Virgin and Child Enthroned
with Saints*, see Francesco Rossi in *Pinaco-
teca di Brera. Scuola Veneta* (Milan, 1990),
406–411, no. 209. Slightly later works by
Cariani, like the *Virgin and Child with a
Donor*, dated 1520, in the Accademia Car-
rara, Bergamo, or the *Resurrection*, of the
same date and also in the Brera (Palluc-
chini and Rossi 1983, respectively plates
XXI and XXIII), show the influence of Lotto,
in Bergamo after 1512.

7. Ranieri Varese, *Lorenzo Costa* (Milan,
1967), 25–26 and 71–72, no. 54.

8. For Cariani's paintings of musicians
in a landscape, see *Tiziano. Amor Sacro
e Amor Profano* (exh. cat., Palazzo delle
Esposizioni, Rome) (Milan, 1995),
256–258, nos. 23–25.

9. Gentili 1990, 65, and Gentili 1995,
93–95.

10. Pallucchini and Rossi 1983, 140–141,
no. 74, and pl. III.

Provenance: Sir Charles Reed Peers
(1868–1952), Chiselhampton House,
Stadhampton, Oxfordshire; Dr. and
Mrs. Rudolf Heinemann by 1962
to 1997, when bequeathed by Lore
Heinemann to the National Gallery
of Art.

Selected References: Pallucchini 1966,
87–97; Ballarin 1968, 244 (237–255);
Fomiciova 1979, 162 (159–164); Palluc-
chini and Rossi 1983, 40, 47–48 and
125, no. 46; Safarik 1984, 232 (230–
232); Gentili 1990, 65 (65–70); Camiz
1991, 215 (213–226); Ballarin 1993,
437–439, no. 64; Gentili 1995, 93–95
(82–105); Dal Pozzolo 1997, 8, 25
(5–37); Zanchi and Cavalleri 2001, 5,
19–21.

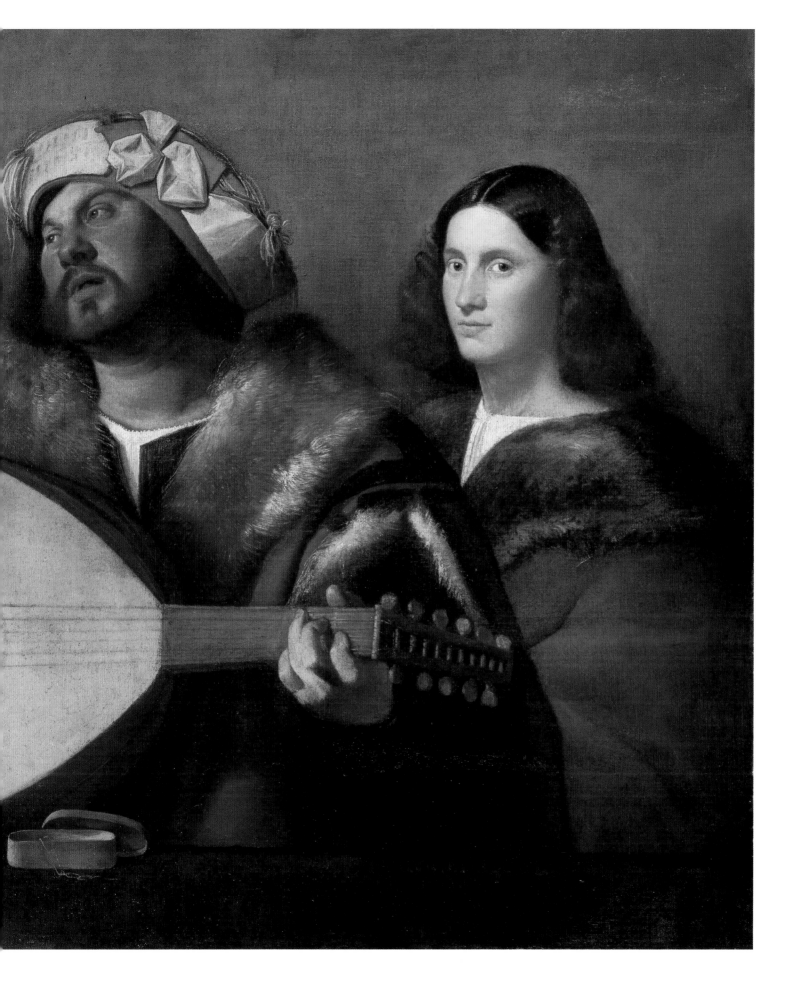

55

Sebastiano del Piombo

FERRY CARONDELET
AND HIS
SECRETARY

c. 1512/1513, oil on panel
112.5 × 87 (44 5/16 × 34 1/4)
Museo Thyssen-
Bornemisza, Madrid

Washington only

Long admired as a work by Raphael, this magnificent portrait was only recognized as Sebastiano's at the end of the nineteenth century.[1] The figure on the right was fancifully identified as the Florentine historian Guicciardini, but the principal sitter was known from the Latin inscription on the letter he holds to be Ferry Carondelet (1473–1528), archdeacon of Besançon, who served as the imperial envoy to the court of Pope Julius II in Bologna and in Rome from 1510 to 1513.[2] The sitter's motto NOSCE OPPORTUNITATEM is carved over the door behind him, and in the altarpiece Carondelet commissioned from Fra Bartolommeo for the cathedral of Besançon, the kneeling donor has the same features.[3] Unlike Sebastiano's *Man in Armor* (cat. 51), which originally included a page, the Thyssen picture is a true double portrait, in which both foreground figures are likenesses. In the brilliant concept for the painting, Carondelet holds a letter from the emperor and, ignoring the other correspondence on the table, dictates a reply to his secretary, who, pen in hand, looks up at his master. Carondelet, it appears, has been distracted by the viewer, at whom he glances impassively. The presence of the spectator is also acknowledged by the messenger in the background. The secretary's figure is cropped on the right, a distant echo of Giorgione's *Man in Armor* (page 241, fig. 4), and his pose is artfully adjusted to indicate his social inferiority.[4] No doubt at Carondelet's request, the portrait commemorates his diplomatic mission, but the idea for a double portrait, with one sitter subordinated to the

other, was probably the artist's. Sebastiano, according to Vasari, had previously painted a portrait of the composer Verdelot, together with the singer Obrecht, a now-lost work cited repeatedly in discussions of the Venetian double portrait.[5]

The Washington picture is datable between the late summer of 1511, when Sebastiano arrived in Rome, and the spring of 1513, when Carondelet was recalled to the Netherlands.[6] It is hard to believe that the Hartford and Madrid portraits could both have been completed in such a narrow space of time. The reason they differ in style and concept may be that the artist was responding to diverse sources of inspiration. The *Man in Armor* is so idealized in the Giorgionesque manner that its status as a commissioned portrait of an actual person might be doubted. The Madrid portrait may also have a Venetian source but of an altogether different type. Less well known than Giovanni Bellini's masterful portrayal of Leonardo Loredan (page 7, fig. 3) in the National Gallery, London, is the portrait he designed of the doge seated with his counselors or kinsmen at a table covered with an oriental carpet.[7] This work, signed and dated 1507 and now in the Gemäldegalerie, Berlin, is as rigidly symmetrical as Bellini's compositions of the Virgin and Child with saints, but the figure of the doge, raised above the others who turn toward him, and the motif of the carpet-covered table strewn with objects may lie behind Sebastiano's more dynamic solution to the problem of the group portrait. But it is the style of the Thyssen picture more than its composition that seems to require an explanation, as this is

the most richly detailed of all Sebastiano's portraits. The attention lavished on the costume and setting has reminded more than one scholar of Flemish painting, and Hirst has specifically compared the Carondelet double portrait to a Flemish example seen by Michiel in a Milanese private collection, representing two half-length figures—probably a merchant and his agent—going over accounts.[8] Michiel's description suggests a composition like Sebastiano's in which the sitters are shown engaged in an activity, with a table acting as a unifying device. Sebastiano's rendering of the carpet covering the table is inaccurate, again pointing to a visual representation rather than an actual carpet as the artist's model.[9]

With its wealth of descriptive detail worthy of Van Eyck, Sebastiano's portrait was doubtless calculated to appeal to his patron's taste. The part of the picture that looks Flemish—the group of Carondelet and his secretary working at a table—is separated from the background by a low curtain. Beyond lie a portico and a distant landscape, both of which recall the artist's previous work in Venice. The same combination occurs in the San Giovanni Crisostomo altarpiece, but a closer precedent for the row of Corinthian columns enclosing a dark interior is found in Sebastiano's very large canvas at Kingston Lacy, the *Judgment of Solomon*. In the portrait, the shadowy portico effectively frames Carondelet's head. On the right is a pastoral landscape, complete with stone and timber structures perched on a hill before a sunset;

1.

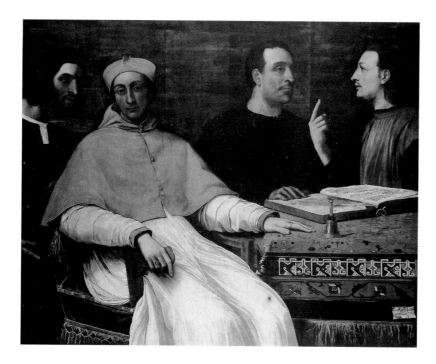

similar vignettes appear in Giogione's Castelfranco altarpiece and his *Three Philosophers* (cat. 30), completed by Sebastiano, according to Michiel, and in Titian's early *Pastoral Concert* (cat. 31).

Carondelet's is the last of the Roman portraits in which Sebastiano's Venetian heritage plays a major, if supporting, role. The painter subsequently adopted a more austere, pared-down manner for portraying high-born sitters of the calibre of Andrea Doria and Pope Clement VII. The transition from the Madrid picture to the rhetorical grandeur of Sebastiano's later portraits is marked by his *Cardinal Bandinello Sauli and Three Companions* (fig. 1) of 1516, in the National Gallery of Art. Here the format has been extended to an oblong rectangle and the motif of two men at a carpet-covered table is shifted to the right, flanked on the left by the cardinal,

seated in an armchair, and a fourth figure echoing the messenger behind Carondelet.[10] With the Venetian colonnade and landscape replaced by a curtain, attention now focuses on the protagonists rather than their setting but in a way that seems disjointed: the cardinal's figure, though three-quarter length, has to compete with those of his companions. The Washington picture may have been important for Raphael, particularly for his *Pope Leo X with His Nephews* of 1518, in the Uffizi. But it was Carondelet's portrait or some version of it that clearly influenced Titian's double portrait of Georges d'Armagnac, French ambassador to Venice, and his secretary, belonging to the Duke of Northumberland at Alnwick Castle.[11] And the appeal of Sebastiano's portrait extended beyond Titian to inspire Rubens' so-called *Four Philosophers* in the Pitti Gallery, in which a sunset landscape juxtaposed with a column figures prominently.[12]

1. Though Carondelet's portrait was labeled Raphael in the New Gallery exhibition in London in 1894, critics agreed, according to Constance Jocelyn Ffoulkes ("Le Espozioni d'Arte Italiana a Londra," *Archivio Storico dell'Arte* 7 [1894], 266–267 [249–268]), that it was by Sebastiano.

2. The inscription reads "Honorabilj devoto no/bis dilecto Ferrieco Ca/rodolet. Archidiacono/Bisuntino Consiliario/Et Comisario nro/In Urbe," (Mena 1995, 83): "To our esteemed and faithful Ferry Carondelet, archdeacon of Besançon and counselor and commissary in Rome."

3. See Hans Von der Gabelentz, *Fra Bartolommeo und die Florentiner Renaissance*, 2 vols. (Leipzig, 1922), 1:161–164.

4. On the basis of copies showing more of the figures and their setting, Lucco (1980, 103) deduced that the painting was cut down, but the panel actually has its original margins, at least on the right and along the bottom, where the gessoed edge is visible, as was kindly confirmed by Mar Borobia of the Thyssen Museum.

5. Hirst 1981, 93 note 13.

6. For Carondelet's mission in Italy see L. de la Brière, "Dépêches de Ferry Carondelet, Procureur en Cour de Rome (1510–1513)," in *Bulletin Historique et Philologique du Comité des Travaux Historiques et Scientifiques* (Paris, 1895–1896), 98–134.

7. Goffen 1989, 212–214 and fig. 159. A miniature with a half-length portrayal of Doge Vendramin and his secretary receiving a papal legate, attributed to Gentile Bellini, in the Boymans Museum, Rotterdam (Jürg Meyer zur Capellen, *Gentile Bellini* [Stuttgart, 1985], no. VII.2, 181–182 and fig. 174), also offers analogies with Sebastiano's picture.

8. See Pope-Hennessey 1966, 117–119; and Hirst 1981, 98 note 34. For Michiel's description, see Frimmel 1888, 54: "El quadretto a mezze figure, del patron che fa conto cun el fattor fo de man de Zuan Heic, credo Memelino, Ponentino, fatto nel 1440," in the house of Camillo or his father Nicolò Lampugnano. Van Eyck's picture or one like it seems to have inspired later group portraits by Petrus Christus, Massys, and others (Elisabeth Dhanens, *Hubert and Jan Van Eyck* [New York, 1980], 307–309), and one of these works, in Rome, could have been Sebastiano's source.

9. In agreement with published sources, Rosamund Mack has kindly observed that Sebastiano's carpet is a confused approximation of the Anatolian "small pattern Holbein" type most often represented in fifteenth- and sixteenth-century Italian paintings.

10. The carpet here, by contrast to the one in the Madrid portrait, is a highly accurate, detailed rendering of the so-called Lotto type, studied from an actual example, according to Rosamund Mack.

11. Michael Jaffé, "The Picture of the Secretary of Titian," *Burlington Magazine* 107, no. 756 (March 1966), 114–126, esp. 114, 117.

12. About this self-portrait of the artist, shown together with his brother and his teacher Lipsius, and its debt to Sebastiano, see Julius Müller Hofstede, "Peter Paul Rubens 1577–1640. Selbstbildnis und Selbstverständnis," in *Von Bruegel bis Rubens. Das Goldene Jahrhundert der flämischen Malerei*, Ekkehard Mai and Hans Vlieghe, eds. (exh. cat., Cologne, Antwerp, Vienna) (Cologne, 1992), 103–170, esp. 107.

Provenance: Ferry Carondelet; the Carondelet family; Earl of Arundel; Government of the United Netherlands; presented to Henry Bennett, Earl of Arlington; Duke of Grafton, Suffolk; acquired by Baron Thyssen-Bornemisza, Lugano, in 1934.

Selected References: Dussler 1942, 37–38 and 135, no. 32; Pallucchini 1944, 39–41, 159; Hendy 1964, 95–98; Pope-Hennessy 1966, 117–119; Heinemann 1969, 306–307, no. 281; Lucco 1980, 102–103, no. 35; Hirst 1981, 98–99; Maestros Antiguos 1987, 106–108; Mena 1995, 83–86, no. 1.

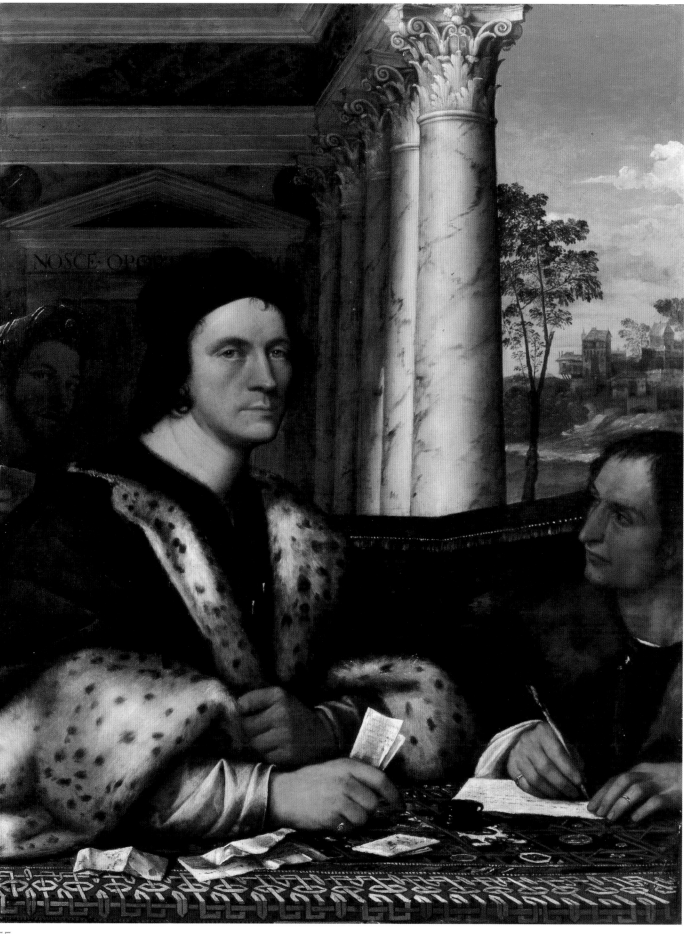

56

Titian

MAN WITH A GLOVE

c. 1523/1524, oil on canvas
100 × 89 (39⅜ × 35 1/16)
Musée du Louvre,
Departement
des Peintures, Paris

inscribed:
TICIANVS (lower right)

One of the best-known and loved of all Italian Renaissance portraits, the *Man with a Glove* belongs to a group of pictures of young men that Titian painted in the years around 1520. In these works the artist broke with the Giorgionesque manner of his youth, eliminating the parapet and extending the format from half- to three-quarter length, thereby distancing the sitter, showing more of his figure, and allotting a greater role to his hands.[1] A noteworthy feature of the group is that the young men portrayed nearly all wear crisp white shirts, black jackets, and gray gloves. Some of the costume elements appear in earlier, more richly colored portraits by Titian, like the *Man in a Red Cap* (page 242, fig. 6) in the Frick Collection, but the consistency of style, format, and dress in the later group, particularly the striking play of black, white, and gray against a uniform dark background, argues that Titian created most, if not all, of them for the same clientele at about the same time. The high ruffled shirt collar in the *Man with a Glove*, and in a similar portrait, once considered its pendant, also in the Louvre, indicates a date after 1520, when such collars came into fashion.[2] But whether this was in 1520 or 1524, the range of dates proposed for the *Man with a Glove*, is important for determining whether the sitter was a friend or associate of the artist or belonged to a new class of patrons, whether the sober dress was dictated by sumptuary laws or by fashion, and whether the picture originated in Venice or elsewhere.[3]

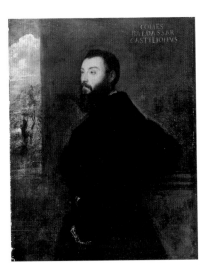

As with the other young men in black, the sitter in the *Man with a Glove* remains unknown. Hourticq attempted to identify the painting with a portrait of Girolamo Adorno that Titian sent as a gift to Federico Gonzaga, Marquis of Mantua, in 1527.[4] But subsequent critics noted that Adorno, a Genoese nobleman beloved by Federico who was sent as envoy of Charles V to Venice in December 1522, died there in March 1523 at the age of thirty-three or forty, while the man portrayed in the Louvre picture cannot be older than about twenty.[5] Rejecting Hourticq's proposal, Mayer favored Giambattista Malatesta, the Mantuan ambassador in Venice.[6] Malatesta did send a portrait by Titian to Federico in 1523, but the relevant correspondence fails to identify its subject. More recently Hope suggested that the portrait sent in 1523 represented a member of the Gonzaga family, namely Federico's younger brother Ferrante (1507–1557), who left for Spain in 1524, and he tentatively identified this work with the *Man with a Glove*, which Titian would have begun in Mantua and finished in Venice.[7] Objections

raised to this theory are that the subject of the Louvre portrait appears too old and too plainly dressed to be the sixteen-year-old Ferrante Gonzaga.[8]

Despite their differences, these proposals all agree in identifying the sitter as a friend, ambassador, or brother of Federico Gonzaga, and they all point to the Mantuan court in 1523. Titian's splendid portrait of Federico Gonzaga in the Prado, Madrid, must date from several years later, to judge from its style. But the artist's Mantuan connection goes back to 1523, when late in January he stopped for a few days on his way to Ferrara, where he was working for Federico's uncle Alfonso d'Este.[9] In Mantua Titian might have become acquainted with the most illustrious of Federico's courtiers, Baldassare Castiglione (1478–1529), then on a year-long absence from his duties as ambassador to the papal court. Or the artist and the diplomat could already have met in Venice, where Castiglione journeyed with his master in 1517. What is known for sure is that Castiglione accompanied Federico's mother, Isabella d'Este, to Venice for two weeks in late May and early June of 1523, and on that occasion visited Titian's studio.[10] It was probably then that Castiglione commissioned and sat for his portrait by the Venetian painter (fig. 1), now in the National Gallery of Ireland, Dublin.[11] Except for a bit of landscape background, this work conforms to the portrait type previously described: dressed in black, Castiglione strikes an elegant pose that brings to mind the book he was then completing, *Il Cortegiano*.

Titian saw Castiglione—or the sitter wished to be seen—as a paragon of courtly grace, but for much of his career, the diplomat toiled over what would become one of the most influential books of the period. Published by the Aldine Press in Venice in 1528, Castiglione's *Il Cortegiano* purportedly records discussions that took place at the court of Urbino in 1507, aimed at fashioning the perfect courtier. The author himself famously describes the book as a "portrait," and his speakers, among them Titian's friend Pietro Bembo, are, in fact, idealized portraits of actual courtiers.[12] As described by Count Canossa, the courtier should possess "nobilità, ingegno, e bella forma di persona e di visto" (nobility, talent, and beauty of person and countenance), qualities that must be accompanied by "grazia" (grace), which should make him "pleasing at first sight."[13] So endowed, the courtier impresses others, especially his prince, but he must do so discreetly, with "sprezzatura" (nonchalance), and "disinvoltura" (ease), avoiding affectation, above all, so as to appear natural.[14] Not only are the courtier's appearance and "actions, gestures, every movement" to be imbued with grace, his dress should also show an understated elegance. Clearly reflecting Castiglione's own view, another speaker prefers in sartorial matters "always to tend a little more toward the grave and sober rather than the foppish. Hence I think that black is more pleasing in clothing than any other color," specifically citing the Spanish fashion newly introduced into Italy.[15]

Comparison with Palma's *Poet* (cat. 52) of about the same date suggests that the *Man with a Glove* responds to the new courtly ideal of deportment and dress, which is projected in Castiglione's book and which Titian would have encountered during his stays in Ferrara, Mantua, and later Urbino.[16] Scholars have noted that the glove-holding gesture is similar in each case, but Titian has abandoned the symbolism and reverie of the Giorgionesque portrait in favor of a restraint and realism better suited to the requirements of the handsome young aristocrat who was his client.[17] Fashionably dressed in dark gray and black and nonchalantly resting his left arm on a stone block bearing the artist's signature, Titian's sitter is the epitome of courtly elegance. His air of nobility appears innate and does not depend on such trappings of wealth as his half-concealed gold chain and pendant. Likewise concealing his own artifice, Titian used the color scheme, pose, and costume to emphasize the young man's head, with its sensitive features and modestly averted glance, and his hands, with one glove removed to display a signet ring, whose now indecipherable coat of arms offers no clue to his identity. The image of a courtier in Titian's *Man with a Glove* is, like those of Castiglione's interlocutors, simultaneously real and ideal

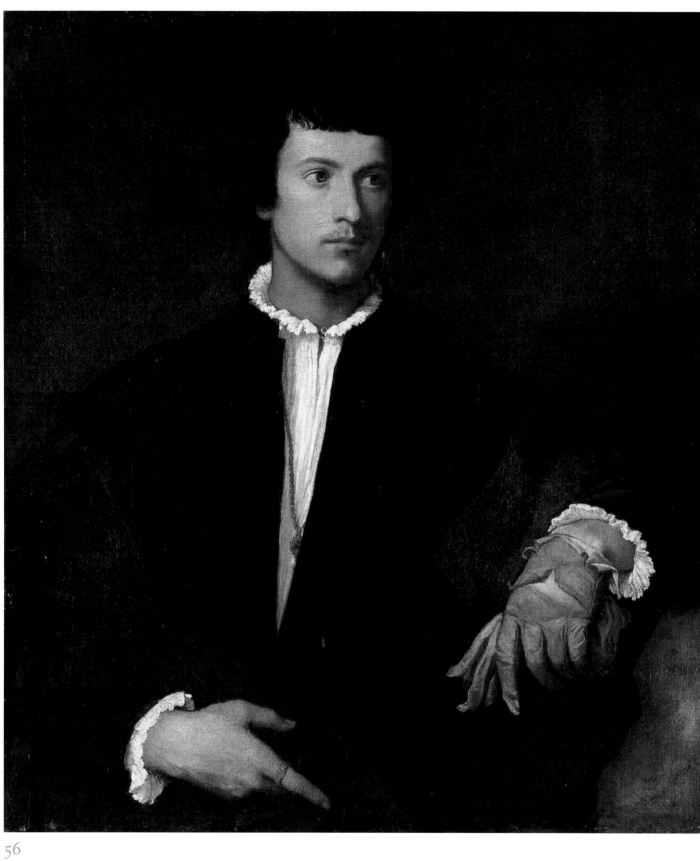

1. For the group, or more accurately series since they show a development, see Pallucchini 1969, 58–61 and 258–259; and Joannides 2001, 224–229.

2. For the second Louvre portrait, see Pedrocco 2001, 138, no. 74. About the costume see August L. Mayer, "Quelques Notes sur l'Oeuvre de Titien," *Gazette des Beaux-Arts* 20 (December 1938), 289–291 (289–308).

3. The Louvre picture has almost invariably been dated to the early 1520s, with some authors, like Habert (1993), favoring c. 1520, others like Wethey (1971), Rosand (1978), and Pignatti (1979), c. 1520–1522, and others still, like Valcanover (1969), Pallucchini (1969), and Hope (1980), c. 1523–1524.

4. Louis Hourticq, *La Jeunesse de Titien* (Paris, 1919), 202–203, 206–213. To recommend himself to Federico, Titian sent Adorno's portrait together with one he had done of Aretino, newly arrived in Venice.

5. Wethey 1971, 118, no. 64.

6. Mayer 1938, 289–291 (289–308).

7. Hope 1980, 64. Ferrante (or Ferdinando) Gonzaga, after a stint at the Spanish court from 1524 to 1527, became a trusted vassal of Charles v. What is known about his character (G. Brunelli in *Dizionario Biografico degli Italiani*, vol. 57 [2001], 734–744) and his later depictions, bald and bearded, as a military commander in a medal and life-size bronze statue by Leone Leoni (Giuseppe Amadei and Ercolano Marani, *I Gonzaga a Mantova* [Milan, 1975], figs. 81–82) are hard to reconcile with the young man in Titian's portrait.

8. Habert 1993, 425; and Falomir 2003, 358.

9. For Titian's early relations with Federico and his court, including the Adorno portrait of 1523, see Diane H. Bodart, *Tiziano e Federico II Gonzaga. Storia di un rapporto di committenza* (Rome, 1998), 35–40; and for his portrait of Federico, Zeitz 2000, 32–36.

10. Julia Cartwright, *The Perfect Courtier. Baldassare Castiglione. His Life and Letters, 1478–1529* (New York, 1927), 11, 92, 183–189.

11. See Pedrocco 2001, 138, no. 75.

12. For a variety of views on Castiglione's project, see *Castiglione. The Ideal and the Real in Renaissance Culture*, Robert W. Hanning and David Rosand, eds. (New Haven and London, 1983); and Baldassare Castiglione, *The Book of the Courtier*, Charles Singleton, trans., and Daniel Javitch, ed. (New Haven and London, 2002).

13. Castiglione 2002, 14 (book 1, chapter 14).

14. Castiglione 2002, 33 (book 1, chapter 27).

15. Castiglione 2002, 14 (book 2, chapter 27).

16. In progress for nearly twenty years, the text of the *Cortegiano* and the issues it raises were much discussed in cultural and intellectual circles to the extent that the author's first and second drafts, of 1514 and 1520 respectively, were even revised by colleagues, like Bembo, who figures prominently in the book.

17. See Hope 1980, 64; and Rylands 1992, 201–202.

Provenance: Gonzaga Collection, Mantua?; Eberhard Jabach, Paris, sold in 1671 to Louis XIV, Paris and Versailles.

Selected References: Pallucchini 1969, 1:60, 258–259; Valcanover 1969, 103, no. 114; Wethey 1971, 118, no. 64; Rosand 1978, 7; Pignatti 1979, 70, 161–162, no. 19; Hope 1980, 64–65; Habert 1990, 190–192, no. 17 (with full bibliography); Huse 1990, 247–248; Habert 1993, 424–425, no. 54 (with full bibliography); Joannides 2001, 224, 226; Pedrocco 2001, 137, no. 73; Falomir 2003, 357–358, no. 10.

57

Lorenzo Lotto

YOUNG MAN IN
HIS STUDY

c. 1526/1530, oil on canvas
98 × 111 (38 9/16 × 43 11/16)
Gallerie dell'
Accademia, Venice

Vienna only

If Titian excelled in every branch of painting, Lorenzo Lotto seems to have had a special affinity for portraiture so that his sitters appear vividly present centuries after he painted their images. From the beginning Lotto's ambitions as a portraitist went beyond likeness and characterization. To his penetrating portrayal of Bishop Rossi (cat. 46), he added an allegorical cover (cat. 47) that comments on the sitter's moral choices or values and, at the same time, reveals the artist's predilection for symbols and emblems. Completed during Lotto's early years in the Veneto, Rossi's portrait has a mainly Venetian frame of reference. In 1506, however, Lotto left for what became an extended stay in central Italy—in the Marches with a stint in Rome from 1509 to 1510—followed by a lengthy sojourn (1513–1525) in Bergamo, then under Venetian rule. During this period, the artist's style underwent a fundamental change as he responded to new visual experiences. Working in the Vatican Stanze, for example, Lotto encountered Raphael, whose formal and expressive language he attempted to incorporate in his own work. Equally important for Lotto's development as a portraitist was the example of Leonardo and his followers in Milan. The portraits Lotto painted in Bergamo reflect the influence of Raphael and Leonardo in the greater variety of pose, gesture, and expression they exhibit. But when Lotto came back to Venice after a two-decade absence in 1526, he faced a new challenge, for in the interim Titian not only had become the leading painter in the city but had virtually reinvented every category of por-

traiture, including the innovative new type of multifigure portrait (cat. 53) that was a Venetian specialty. From 1516 onwards, however, Titian worked increasingly for the northern Italian courts, first Ferrara and then Mantua and Urbino, leaving an opening in Venice for a portraitist of Lotto's calibre to assert himself.

How successfully Lotto filled the gap may be judged by the *Young Man in his Study*. This work has been grouped with two other portraits—the *Lady Named Lucretia* in the National Gallery, London, and the *Andrea Odoni*, dated 1527, in the Royal Collection at Hampton Court—which are generally regarded as the finest Lotto ever painted. All three could be compared in the Lotto exhibition in Washington, Bergamo, and Paris in 1997–1998.[1] Each work adopts the broad horizontal format used for double portraits but, in place of the second figure, includes a cloth-covered table on the right. The table is angled to the picture plane so that the sitter interacts with it, an innovation with respect to Sebastiano's portrait of Carondelet (cat. 55), where the table, like the earlier parapet, serves as a base. In Lotto's three portraits, the subjects are shown standing, not seated, and they turn to gaze and gesture emphatically at the viewer. The young man, his pale face and hands set off by the surrounding darkness, bends over the table in a highly unstable pose that is surely meant to reflect a restless, even precarious state of mind. Though fashionably dressed in black and white, Lotto's unknown sitter lacks the poise and self-assurance of Titian's *Man with a Glove* (cat. 56). Instead, he is glimpsed in the privacy of his study,

turning the pages of a large folio, which unlike the smaller books held by Catena's scholar or Palma's poet, appears to be a ledger or account book. Around the book is a profusion of objects that, encouraged by the adoption of the oblong format, have been incorporated in the portrait proper rather than a separate cover.

These symbolic objects have occasioned most of the commentary on the painting. On the right are a bundle of letters and an inkwell with writing instruments and on the left, an opened letter, a ring, and a pair of gloves, among scattered rose petals. A green lizard looks up at the young man. Behind him appear a box, possibly containing a keyboard instrument known as a virginal, and keys, and hanging on a rack, a hat and a hunting horn. Before asking what these objects mean in relation to the sitter, it is important to note that they are not simply a miscellany but are of different types: some, like the book, letters, and writing apparatus, are proper to a study while others, like the ring, gloves, and hat, are the young man's personal effects, and others still, like the lizard and the rose petals, can be understood only as symbols. In other words, the objects may or may not have a symbolic meaning, but, whether as accessories or attributes, they all serve to characterize the sitter. Earlier scholars attempted to decode the items displayed throughout the picture as alluding to an episode in the sitter's life when, disappointed in love or rejecting the pastimes of youth, he turned to more

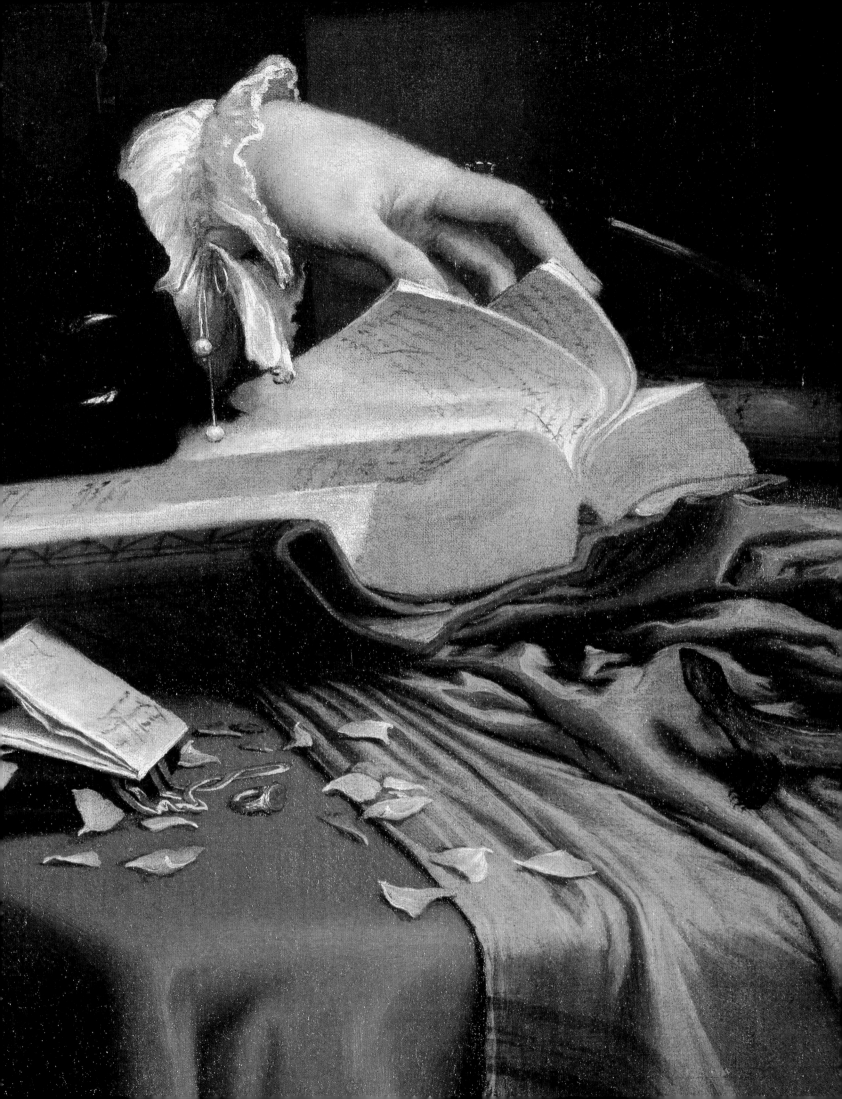

serious matters like study or business.[2] More recently, critics skeptical of this approach have preferred to regard the objects surrounding the sitter as signs of a more permanent disposition toward melancholy, caused perhaps by a failure in love.[3]

1. Humfrey 1997, 172–174, no. 32; 185–187, no. 38; and 161–164, no. 28.

2. For the most detailed iconographic interpretations, see Diana Wronski Galis, "Lorenzo Lotto. A Study of His Career and Character, with Particular Emphasis on His Emblematic and Hieroglyphic Works" (PhD. diss., Bryn Mawr College, 1997), 233–232; and Augusto Gentili, "Virtus e Voluptas nell'Opera di Lorenzo Lotto," in *Lorenzo Lotto*, Atti del Convegno Internazionale, Asolo, 1980, Vittorio Sgarbi and Pietro Zampetti, eds. (Treviso, 1981), 420–421 (415–424).

3. See Sheard, Humfrey, Beyer, and Lucco in the Selected References. As noted by several of these authors, after the cleaning of the picture for the exhibition of 1997, a dead bird and a lute that figured in earlier interpretations were no longer visible.

Provenance: Edoardo de Rovèr, Treviso, from whom acquired for the Accademia in 1930.

Selected References: Marconi 1962, 131–132, no. 209; Boehm 1985, 170, 172–174; Huse 1990, 243; Humfrey 1997, 172–174, no. 32 (with bibliography); Humfrey 1997a, 107–110; Sheard 1997, 47–48; Simon 1997, 34–36; Beyer 2002, 154–157; 34–36; Anderson 2004, 90; Lucco 2004, 81–82.

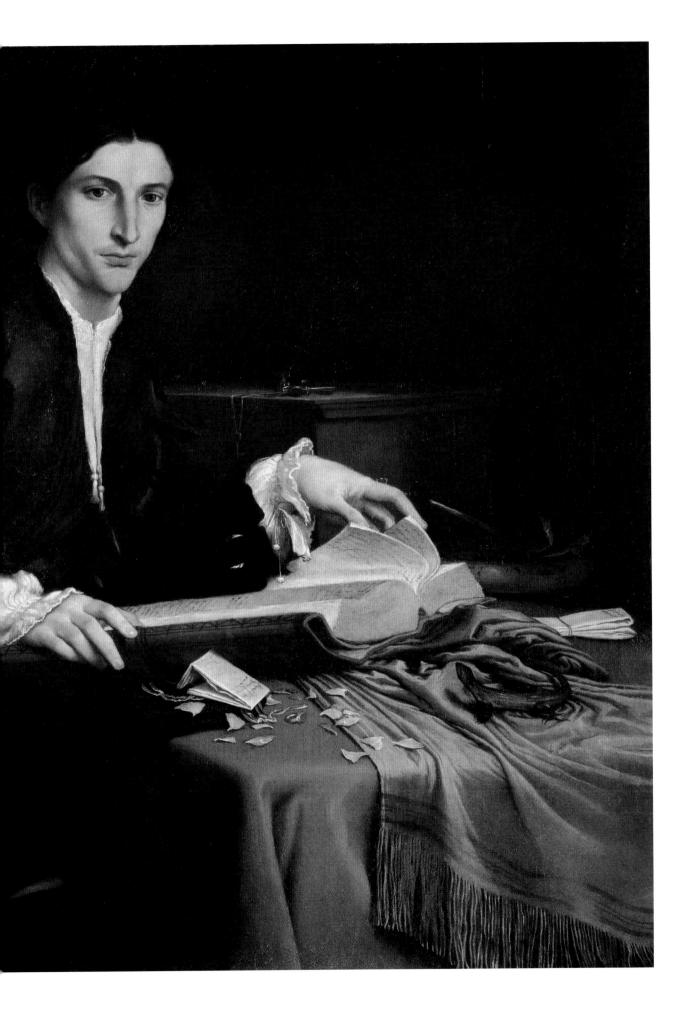

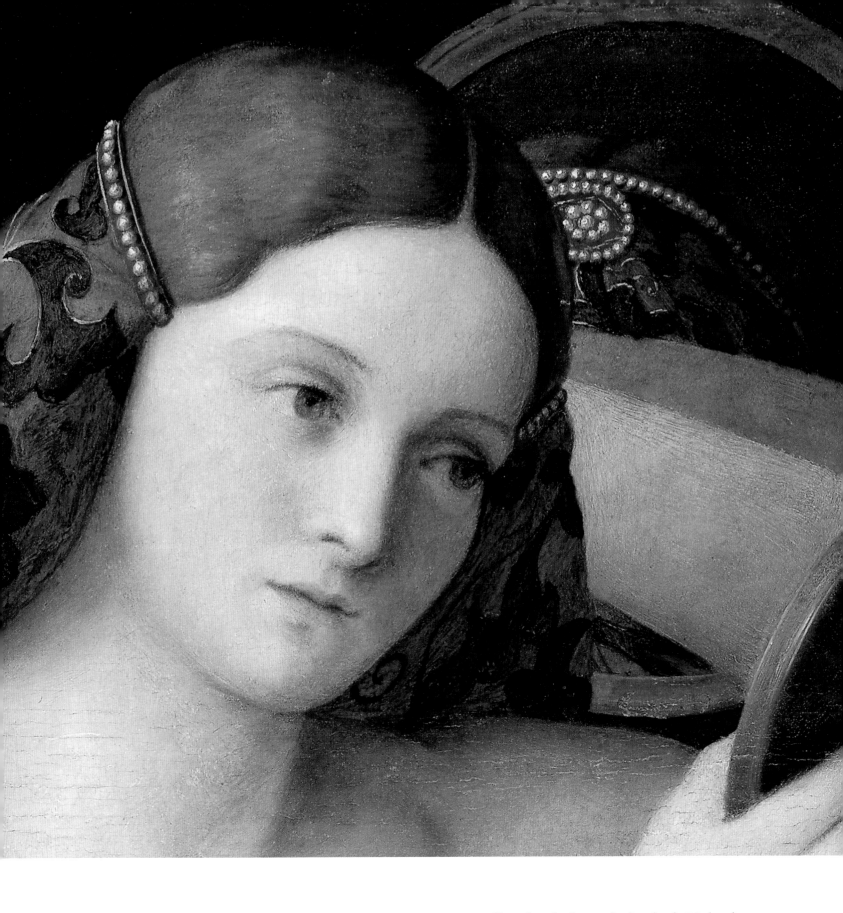

TECHNICAL STUDIES OF PAINTING METHODS * *Elke Oberthaler and Elizabeth Walmsley*

THE USE OF TECHNICAL EXAMINATION for art historical research has a long tradition. By the time the International Conference for the Study of Scientific Methods for the Examination and Preservation of Works of Art was held in Rome in 1930, x-radiography was already an established tool in the field.[1] One of the first attempts to explore its potential for the study of Venetian paintings was the 1932 article by Johannes Wilde, curator of the Gemäldegalerie at the Kunsthistorisches Museum, Vienna, about two paintings in the museum's collection: Giorgione's *Three Philosophers* (cat. 30) and Titian's *Gypsy Madonna* (cat. 2).[2] X-radiographs of the two pictures revealed that during the course of painting the compositions had been dramatically revised. With these insights into the artists' creative process, suggesting that Giorgione, Titian, and other Venetian painters developed their compositions directly on the canvas, Wilde and other early researchers hoped to resolve questions of attribution and subject matter. Wilde exchanged x-radiographs of these two paintings, as well as of Giovanni Bellini's *Lady with a Mirror* (cat. 41), with Alan Burroughs, curator at the Fogg Art Museum, Cambridge, Massachusetts. Burroughs' 1938 book, *Art Criticism from a Laboratory*, was the culmination of twelve years of compiling x-radiographs of paintings in both America and Europe.[3] A chapter on Giorgione and Titian summarized Burroughs' interpretation of their brushwork and working methods as illustrated by x-radiographs. Burroughs' views regarding the authorship of the *Three Philosophers*, the *Gypsy Madonna*, and Bellini and Titian's *Feast of the Gods* (cat. 32) varied in certain respects from Wilde's, demonstrating that the results of technical investigations are not objective, but require interpretation, and thus will always be open to revision.[4]

The use of underdrawing beneath the painted surface of a picture may be inferred from x-radiographs, but since the underdrawn lines cannot be visualized with this technique, infrared photography and infrared reflectography have now come to be used as the primary tools for investigating the graphic preparation in paintings. Infrared photography had been discussed at the 1930 Rome conference, but the first use of infrared reflectography to study Venetian paintings at the Kunsthistorisches Museum took place in 1989, when Charles Hope and J. R. J. van Asperen de Boer, inventor of the technique, discovered underdrawing in the *Three Philosophers*, the *Gypsy Madonna*, and the *Lady with a Mirror*.[5]

Since these pioneering studies, further investigations of underdrawing by Bellini, Giorgione, and Titian have been undertaken, as well as continued improvements in x-radiography and infrared imaging, particularly with the increased availability of inexpensive computers and software. The present exhibition provided an occasion for the Kunsthistorisches Museum and the National Gallery of Art to jointly assess the results of technical investigations of paintings from the two museums, focusing particularly on x-radiographs and infrared images, here referred to as technical photographs.

For this study, we chose, in addition to the pictures mentioned above, Giorgione's *Laura* (cat. 38) and his *Adoration of the Shepherds* (cat. 17), all paintings completed in the narrow span from about 1500 to 1515, with the goal of comparing the working methods of their creators at this important moment in the development of Venetian painting.

1.

Giovanni Bellini, *Lady with a Mirror* (cat. 41). Infrared reflectogram showing detail of underdrawing.

2.

Giovanni Bellini, *Virgin with the Blessing Child* (cat. 1). Infrared reflectogram showing detail of underdrawing.

Giovanni Bellini painted the *Lady with a Mirror* a year before his death at about the age of eighty. From their 1989 infrared examination of the picture, Hope and Van Asperen de Boer concluded that Bellini had followed traditional working methods, in which artists "worked out their compositions fully in advance, and used underdrawing as a means of recording the design on the gesso ground."[6] More recent technical investigations into Bellini's oeuvre have revealed that modifications in his working methods were made throughout his life. Examination of the *Lady with a Mirror* confirms Bellini's attention to contours and also reveals his innovative use of a textured, colored underpaint layer.

Although passages of faint black underdrawing are apparent to the eye, the infrared reflectogram captured in 2005 reveals the spare contour drawing more fully (fig. 1). The outer contours of the figure, defined in the underdrawing, were retained in the application of the paint layers. Although the major drapery folds were underdrawn, additional pleats and folds were added during the paint stage. In place of hatchmarked shadows, the underdrawing of the *Lady with a Mirror* includes several carefully outlined details, such as the drapery shadow beneath the woman's elbow, the line of her collarbone, and the swell of her shoulder, which were not modeled until the paint stage. The underdrawing of Bellini's *Virgin with the Blessing Child* (cat. 1) is remarkably similar both overall and in detail (fig. 2).[7] Much of the underdrawing in these two pictures, particularly the facial details and the outlines of the arms in the *Lady with a Mirror*, has a stilted quality peculiar to compositions transferred using "carbon paper" drawings, a technique in

the stippling, which includes areas of fleshtones covered by draperies, ends exactly at the boundaries of the fleshtones.[11] The juxtaposition of the almost marmoreal fleshtones against the stippled background of cloth and carpet was therefore an artistic choice made possible by the use of the slow-drying oil paint medium. The sculptural quality of the woman's body has been observed by previous authors, who have suggested that her pose is based on classical prototypes. The mirrors and the woman's reflection have also prompted them to interpret the painting in the context of the *paragone*.[12]

The textured underpaint layer also explains the broken appearance of the underdrawing for the red drapery on the ledge and the scored line for the window, which, unlike the underdrawing in the rest of the painting, seem to have been drawn on a roughened surface. Bellini used what appears to be a distinctive process of underdrawing. The underdrawing was first applied to the gesso and served as a guide for applying and texturing the gray underpaint in the background. Then, the folds in the lower left quadrant were (re)drawn on top of the textured layer. In the final stages of painting the picture, Bellini emphasized some of the contours—for example, the outline of the woman's elbows and the edge of the curtain—by reinforcing them with incised lines, possibly made with the end of a brush.[13] A compass was used to construct the round mirror, the outlines of which are both underdrawn and incised.[14] Thus, Bellini was able to retain the major contours of his composition through the entire painting process, a very different procedure than the one used by Titian in the *Gypsy Madonna*.

which a drawing, or an interleaved sheet of paper, is blackened with charcoal on the reverse, then incised through the front to transfer the necessary contours onto a prepared panel. In this way, a design can easily be duplicated. Some of the underdrawn lines, such as the contours of the lady's neck and shoulder, and the fingers of her right hand, have a more unrestrained feel. Perhaps the main contours were transferred from a cartoon and the rest of the underdrawing was developed freehand.[8]

While many of Bellini's paintings have fingerprints texturing the surface or the *imprimitura*, the *Lady with a Mirror* has a stippled texture made with a paintbrush in all areas but the figure.[9] This texture, very subtle and hardly apparent on the surface, is visualized more clearly in the x-radiograph (fig. 3), which indicates that the stippling was applied to an opaque, light gray underpaint beneath the paint layers.[10] Bellini must have underdrawn the main features of the composition before he textured the gray layer, because

3.

Giovanni Bellini, *Lady with a Mirror* (cat. 41). X-radiograph showing detail of texture in background.

Cat. 32 Giovanni Bellini and Titian: *Feast of the Gods*

In 1956, John Walker published a composite x-radiograph
(fig. 4) of the *Feast of the Gods* that revealed its original
appearance as finished by Bellini, with figures seated in front
of a forest with tree trunks extending across the entire width
of the picture.[15] Walker was thus able to modify Vasari's
claim that Titian completed Bellini's picture by demonstrat-
ing that the younger artist had actually repainted the left
side of a finished landscape. Walker also proposed that Titian
altered some of the figures by adding attributes and by
lowering the necklines of some of the nymphs and goddesses.
The presence of an intermediate landscape, seen on the left
side of the composite x-radiograph and consisting of a moun-

tain with architectural ruins, raised the possibility that
another artist had previously revised that part of the com-
position before Titian intervened. Burroughs, who had
already x-rayed the painting in 1930, focused on the sil-
houetting of the figures and trees, which he attributed to
an "outlined preparation."[16]

The most substantial investigation of Bellini's work-
ing methods in the painting was carried out by David
Bull and Joyce Plesters using the earlier x-radiographs, as
well as an infrared reflectogram and cross sections taken
during Bull's restoration of the painting begun in 1985.[17]
They reexamined the alterations to the figures that Walker
had attributed to Titian and found that they were made,
instead, by Bellini. Bull further substantiated earlier pro-
posals that Dosso Dossi was the author of the intermediate
landscape and the pheasant in the tree by finding parallels
in Dosso's painting technique. Operating under the same
assumption as Burroughs — namely, that Bellini must have
used an underdrawing for the complicated, multifigured
scene — Bull and Plesters made considerable effort to deter-
mine the nature of the underdrawing, but no evidence
of it was found using an infrared vidicon camera.[18] Later, a
second attempt to detect underdrawing was made using
transmitted infrared reflectography.[19] The "transmittogram"
(fig. 5) of the top left quadrant reveals outlines along the
tree trunks and intertwined branches. Instead of an under-
drawing of fine lines, as expected, the freely drawn outlines
are unusually wide and there are some brushy lines within
the tree trunks.[20] This surprising image highlights the
complexities of interpreting technical photographs. Do these
wide brushstrokes reinforce an underdrawing that is invi-
sible at these infrared wavelengths? Are the brushy lines
part of the underpaint stage? Or is this, indeed, Bellini's

4.

Giovanni Bellini and
Titian, *Feast of the Gods*
(cat. 32). Composite
x-radiograph.

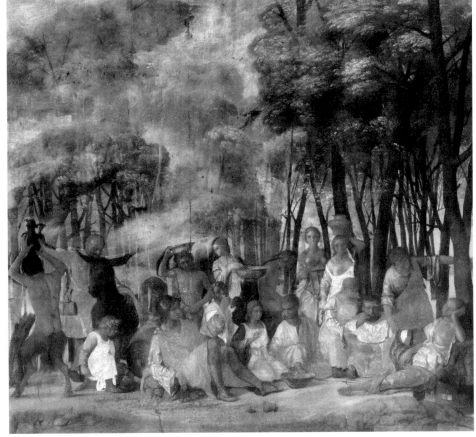

7.

Giorgione, *Portrait of a
Woman ("Laura")* (cat. 38).
Infrared reflectogram.

underdrawing, not made with a small paintbrush or quill
pen, but with a brush large enough to expedite covering a
large area of canvas with the bold forms of the tree trunks?
The picture was examined yet again several years later
using a platinum silicide infrared camera (fig. 6).[21] The
legibility of the infrared image increased, and several
branches in the tree canopy on the right side of the paint-
ing and a few additional tree trunks on the left side were
revealed. Most important, a compositional change was
found, disclosing the first position of Lotis' foot, finely
underdrawn to the left of the final version. The fine under-
drawing of the foot thus makes it more likely that the
wide brushstrokes in the trees were the reinforcement
of a first underdrawing.

Cat. 38 Giorgione: *Portrait of a Woman ("Laura")*

Giorgione's *Laura* was x-radiographed as part of the early
campaign by Wilde.[22] The original support, a fine canvas
glued to a fir panel, was cut down into an oval in the early
eighteenth century. Later in the century, ten pieces of oak
were added to regain the original rectangular format. The
painting's complex structure obscures the legibility of the
x-radiograph. But recently, the x-radiograph was digitally
enhanced and significant changes in the background were
revealed.[23]

Beginning in 1989, several attempts were made to
detect the presence of underdrawing using infrared re-
flectography.[24] The infrared reflectogram (fig. 7) captured
in 2004 again failed to reveal evidence of underdrawing.
Nonetheless, it allows compositional changes in the back-
ground, already known from Wilde's x-radiograph, to be
organized into a logical sequence.

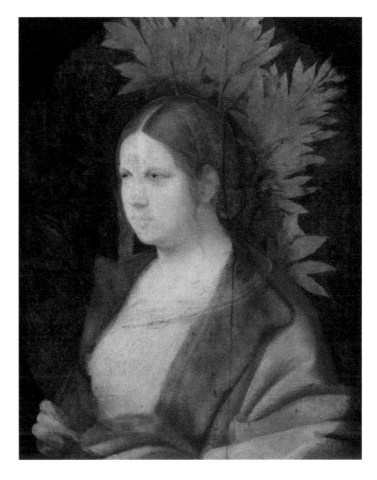

291

The laurel was included at the earliest stage: the
x-radiograph (fig. 8) shows an area for the leaves that was
left in reserve while a light-colored background was laid
in. The mass of leaves was much wider than in the finished
painting, and would have created a dense cluster around
Laura's head (fig. 9, dark gray). Cross sections indicate that
the background, at this stage, consisted of a pale blue sky
and perhaps a distant landscape. Then Giorgione reconsidered

5.

Giovanni Bellini and
Titian, *Feast of the Gods*
(cat. 32). Transmitted
infrared reflectogram
showing detail of top
left quadrant.

6.

Giovanni Bellini and
Titian, *Feast of the
Gods* (cat. 32). Infrared
reflectogram.

8.
Giorgione, *Portrait of a Woman ("Laura")* (cat. 38). X-radiograph.

9.
Giorgione, *Portrait of a Woman ("Laura")* (cat. 38). Diagram of changes in the laurel.

10.
Giorgione, *Three Philosophers* (cat. 30). Composite x-radiograph.

11.
Giorgione, *Three Philosophers* (cat. 30). Infrared reflectogram showing right side of painting.

292

8

9

the background; cross sections show a dark brown paint was used to block out the blue sky. This stage is shown in the infrared image (fig. 9, light gray): rather than a backdrop of leaves, there is a spray of leaves only on the right side of the painting, behind Laura's head. On the left side, the background was filled with a brushy application of dark paint, leaving an area in reserve for Laura's long side curls, but none for any leaves. The leaves on the left side are very faint in the infrared reflectogram because they were painted on top of the dark background paint, which means they were added next. In the final stage, Giorgione roughly merged the two earlier versions of the laurel behind Laura by adding leaves on the left side of the painting, on top of the dark background (fig. 9, black outlines). These changes indicate how Giorgione continued to develop the composition during the painting process, as noted long ago in the *Tempest* (page 44, fig. 3) and the *Three Philosophers*.

Changes, less dramatic than those in the background, were also found in the figure of Laura.[25] The infrared reflectogram and the x-radiograph reveal that adjustments were made to reduce the décolletage, while her features and hair remained unchanged. The white veil, as seen in the x-radiograph, was painted with sweeping brushstrokes that form a figure eight around her right breast. She may originally have worn a chemise instead of a veil. In a second stage, her left fur collar was narrower, exposing more of her bust; and the veil that took the place of a chemise wound around her breast and continued up to her shoulder. The infrared image shows a line indicating the original edge of the narrower collar. The wide, horizontal band of fur at the bottom of the picture, which truncates the décolletage, was added later by Giorgione.

10

11

As one of the few secure works in Giorgione's oeuvre, the
Three Philosophers has played a key role in the study
of his working methods, as reflected by the literature inter-
preting the x-radiographs (fig. 10). The first x-radiographs,
published in 1932 by Wilde, revealed extensive changes in
the composition.[26] Since then x-radiography has continued
to be used to clarify the still unresolved and much debated
question of the subject matter of the painting. In 1991, Hope
and Van Asperen de Boer published several infrared reflecto-
gram details with underdrawing that corresponds to the
earlier stages of the painting seen in the x-radiographs.[27]

The most important recent contribution made by tech-
nical study of the *Three Philosophers* is a new overall infrared
reflectogram (fig. 11) that was captured with the INOA scan-
ner in 2004.[28] It visualizes with great clarity an extensive
amount of underdrawing throughout the painting and forms
a touchstone for assessing Giorgione's underdrawing style
in the absence of such evidence from other secure works.

The underdrawing is complex and the style is not con-
sistent. The figures and most of the landscape features were
indicated in bold outlines using a large brush. They vary
from loosely drawn freehand to stiffer lines. The eyes of the
middle philosopher were shifted; in the infrared reflectogram,
the underdrawn lines reinforcing the second set of eyes are
much darker than the first. Diagonal hatchmarks are found
in his face (also faintly visible to the eye).[29] Above the older
philosopher, the outlines of the trees and bushes in the upper
right corner are underdrawn. The left side of this foliage
is underdrawn in a series of short, scalloped lines, almost
semicircles. The right side of the foliage and the tree trunk
(at the extreme right edge of the painting) have a hard-edged
outline, hinting at the use of a tracing or transfer technique.

Throughout the infrared reflectogram, the underdrawn lines do not register with equal strength because some of the lines are blocked by the paint layers; this depends on the pigments used and the number of paint layers on top. For example, the underdrawing in the middle philosopher is especially clear, because the paint is built up in thin layers that are transparent in this region of the infrared spectrum. It is even possible to differentiate between the stronger, darker lines for the neck and chin and the more fluent lines for the hatchmarks. In contrast, the paint used for the highlights of the red tunic cannot be penetrated and block parts of the underdrawing for the short hem in the earlier version.

Based on his interpretation of the x-radiographs, Wilde had proposed a first version of the *Three Philosophers* with headdresses worn by all three figures, a short tunic donned by the middle philosopher, and small buildings on a distant hill beyond the large tree trunks. As the x-radiographs show that these features had progressed beyond the underdrawing stage and had, at a minimum, been blocked in with paint, Wilde's assumption was that Giorgione had completed a first version, which he then revised to create the painting's present appearance, rather than making a succession of changes during the painting process. The most recent technical studies substantiate the latter, more complicated, working procedure, in which Giorgione experimented with a number of approaches to setting the figures in the landscape and several depictions of the foreground, middle, and far distance.[30]

Compositional changes apparent in the x-radiographs now can be reassessed, together with the underdrawing seen in the infrared reflectogram of 2004, to understand how the painting developed. Common elements include the small buildings in the distant landscape, the shorter tunic of the middle philosopher, and the headdress of the older philoso-pher and his earlier profiles. In the background, trees were added, then removed at different stages, perhaps to partially regain the open sky of the earliest versions; some of them are visible in the x-radiographs, others only in the infrared reflectogram. The foreground landscape was also revised in several stages. The figures were separated from the distant landscape by an additional hillock, at the level of the seated philosopher's shoulder. The hillock, though underdrawn, is not evident in x-radiographs. It may have been part of the underdrawing stage, or a late change during the elaboration of the present light green landscape next to the seated philosopher's hands. The middle, roughly hewn step was underdrawn with rounded corners. This shape was carried into the paint stage, and the sharp corner at the back was added on top. At the underdrawing stage, the standing figures' robes were longer, with the older philosopher's draperies underdrawn nearly to the bottom edge of the painting, and the middle philosopher's draperies extending to his toes. Even though the two left figures have multiple underdrawn attempts at locating their feet, the shorter length of the robes was determined by the time the paint was applied, as there are distinct boundaries in the x-radiograph. Other areas of fine underdrawing, such as the random lines in the seated philosopher's elbow, do not appear to correspond to any of the earlier compositions.

The middle philosopher's head underwent fewer changes than the others. There is a lower but abandoned position for the eyes in the underdrawing and an additional cloth covering his forehead beneath the turban, which is not underdrawn and was probably added later in the painting process. Between the first short tunic seen in the x-radiographs and the longer one seen in the finished painting, there is an underdrawn line slightly above his knees.

This may have been intermediate step in determining the length of the tunic, and a characteristic intermingling of underdrawing and painting in the picture. The profile of the older philosopher was underdrawn and painted, as seen in both the infrared reflectogram and x-radiographs. Another underdrawn line slightly to the right suggests a third profile.

The x-radiographs reveal a pentimento in the seated figure, where the light underpaint of the sky cuts through his face. From this, Hope and van Asperen de Boer suggested the possibility of an early paint stage with fewer trees and just the two standing figures.[31] However, evidence that all three figures could have been included at this early stage is provided by the new infrared reflectogram, which reveals traces of underdrawing in the seated philosopher's draperies. Moreover, the distinct boundaries of the paint application seen in the x-radiographs imply that Giorgione followed some sort of preliminary sketch for this figure. The x-radiographs also reveal a headdress, now hidden by his curly hair.

Cat. 17 Giorgione: *Adoration of the Shepherds* *("Allendale Nativity")*

Beginning in 1937, while the *Adoration of the Shepherds* was on the market, x-radiography (fig. 12) was seen as a tool to help resolve its attribution, whether to Bellini, Giorgione, Titian, or Sebastiano del Piombo.[32] By the time Jaynie Anderson discussed the infrared reflectogram (fig. 13), in her 1997 monograph, the painting was firmly attributed to Giorgione.[33]

Study of the x-radiograph of the *Adoration of the Shepherds* in conjunction with the infrared reflectogram shows how the composition evolved. The infrared reflectogram reveals that the contours of forms were underdrawn probably with a fine brush. In the figures, the most notable

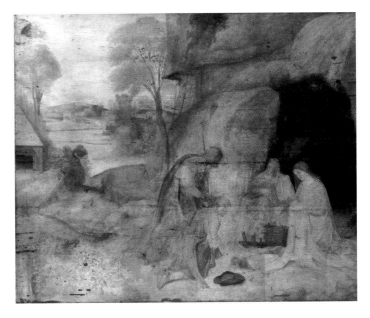

12.

Giorgione, *Adoration of*
the Shepherds ("Allendale
Nativity") (cat. 17).
Composite x-radiograph.

13.

Giorgione, *Adoration of*
the Shepherds ("Allendale
Nativity") (cat. 17).
Infrared reflectogram.

addition is a roughly sketched head just above the standing shepherd, presumably indicating his first position. There is an extensive use of hatching in the landscape: the rocks in the center of the picture have small areas of hatchmarks, while the large rock has hatchmarks that create an effect like that of a topographic map. The landscape was revised during both the underdrawing and paint stages. At the underdrawing stage, the rock face comprised large rounded forms. Brushstrokes in the upper right corner of the x-radiograph show that Giorgione began to lay in the curved forms, but then revised the profile. He extended the rock face to the left, making the forms more blocky. Areas for the large tree and small branches growing out of the rock were left in reserve while he laid in the sky. The infrared image shows that the rock face was extended to the left a second time, covering some already painted trees and part of the sky, thereby dividing the painting in half. This procedure finds parallels in the *Three Philosophers*, where small branches left in reserve were hidden when the rock face was enlarged. In the middle distance of the *Adoration of the Shepherds*, the pond was surrounded by rocks underdrawn with rounded shapes that became more blocky during the paint stage. A similar development is seen in the foreground of the *Three Philosophers*, where the rounded hillocks at the underdrawing stage became large slablike steps in the finished picture.

The *Adoration of the Shepherds* is the only composition by Giorgione that exists in two versions. The version in Vienna (cat. 18) was attributed to Giorgone very early. The painting is usually judged to be unfinished, but its damaged condition complicates this issue. Furthermore, the relationship between the two paintings has never been fully clarified: Did they emerge simultaneously? Is one a copy?[34] Superimposition of tracings of the paintings shows a close,

almost total, correspondence of the two compositions. Although underdrawing can barely be detected in the infrared reflectogram of the Vienna picture, a pentimento seen with infrared reflectography and x-radiography shows the tree on the left in the Vienna painting was originally very much like the one in Washington; this supports the idea that the two works emerged simultaneously.

Cat. 2 Titian: *Virgin and Child ("Gypsy Madonna")*

Technical investigation of the *Virgin and Child*, an early work by Titian, demonstrates how his approach differed from that of his former master Bellini.

Wilde's x-radiographs of the *Virgin and Child* revealed an earlier version of the composition, in which the Virgin was depicted with a different facial type and a downward glance to the left. Other changes, such as the diagonal line of the drapery across the Virgin's torso and the change in position of the Child's head, led Wilde to deduce a close relationship with Bellini's *Madonna with Christ Blessing* in Detroit, signed and dated 1509.[35] He used this observation to demonstrate how the young Titian moved away from Bellini to formulate his own artistic ideas. With the aid of infrared reflectography, Hope and Van Asperen de Boer in 1989 discovered passages of underdrawing in the head and right hand of the Virgin.[36] More recently, a technical study of the painting was undertaken in the context of a project, begun in 2003, to examine paintings by Titian at the Kunsthistorisches Museum.[37]

The infrared reflectogram captured in 2005 (fig. 14) revealed additional underdrawing, including a considerable amount in the body of the Christ child as well as in the drapery and hair of the Virgin. The underdrawing was

14.
Titian, *Virgin and Child*
("Gypsy Madonna")
(cat. 2). Infrared reflec-
togram.

hand. This means that Titian applied the underdrawing for the outstretched fingers, blocked them in with paint, covered them with the red drapery, and finally painted the second version.[38] The infrared reflectogram also clarifies the pentimenti in the x-radiographs of the Christ child's body.

The landscape, which does not seem to have been underdrawn, also underwent revisions during the paint stage. It is difficult to interpret the changes in the sky due to its damaged condition. The x-radiographs reveal changes in the profile of the distant landscape, with two hills close to the Virgin's shoulder and a horizontal line at the left edge that might be a lake. Close examination shows the intense blue paint used for the distant mountains lies beneath the green hills, stopping at the bushes and the seated man. The tree, now at the left edge, was at first painted further in the middle of the landscape.

Examination with a stereomicroscope confirms a working method that relied much less on an underdrawn contour drawing than the examples described above. The red underpaint of the Virgin's dress extends, not only beneath her hand, but also beneath her blue and the green draperies, as well as the stone ledge on which the Child stands. The gray and white stripes on the cloth of honor were painted on top of the green underpaint. It seems that, for Titian, the underdrawing in the painting merely suggested the main forms and served as a guide for continuing his work with the paintbrush.

apparently made with a fairly wide brush. The Virgin's face shows fluent underdrawn lines that correspond closely to the finished painting, except for two lines indicating the chin, the curls above her left eyebrow, and the changed outline of her head with indications of a bow previously noted by Wilde. Thin washes to indicate shadows in the Virgin's face and neck were applied at the underdrawing stage. However, the facial features in the first version are hard to distinguish in the infrared reflectogram.

The underdrawn contours, revealed by infrared reflectography, served as a guide for the first version of the picture, known from the x-radiographs. For example, the early version of the Virgin's right hand, with outstretched fingers, is documented in both the infrared reflectogram and the x-radiograph composite (fig. 15). Close examination of the paint surface reveals a red paint layer beneath the present

15.

Titian, *Virgin and Child* *("Gypsy Madonna")* (cat. 2). Composite x-radiograph.

For the Kunsthistorisches Museum paintings, x-radiography of the *Gypsy Madonna* and the *Laura* was conducted by the Painting Conservation Department, with digital composites by Thomas Ritter. X-radiography of the *Three Philosophers* was done by the Painting Conservation Department and digitized by Paolo Spezzani and reedited by Ritter. Infrared reflectography of the *Laura* and the *Three Philosophers* with the INOA InGaAs scanner was by Spezzani.[39] Infrared reflectography of the *Lady with a Mirror*, the *Gypsy Madonna*, and the *Adoration of the Shepherds* with an Indigo Alpha InGaAs camera configured to 1.5–1.7 microns was carried out by Monika Strolz, E. Walmsley, and Michael Eder, with the composite by Eder.

For the National Gallery of Art paintings, x-radiography was by Kristin Casaletto. Infrared reflectography of the *Feast of the Gods* and the *Adoration of the Shepherds* was carried out with a Kodak 310-21x PtSi camera configured to 1.5–2.0 microns. Image capture of the *Feast of the Gods* was by J. K. Delaney, C. Fletcher, C. Metzger, and Walmsley, with the composite by Fletcher. Image capture and composite of the *Adoration of the Shepherds* was by Walmsley. Transmitted infrared reflectography of the *Feast of the Gods* was captured with a Hamamatsu vidicon camera with N2606 tube and Kodak Wratten 87A filter, with images on a Techtronix monitor. Image capture was by Metzger, P. Decristofaro, and Casaletto, with a digital composite of 35mm negatives by Walmsley.

With the exception of the infrared reflectograms of the *Virgin with the Blessing Child* and the *Adoration of the Shepherds*, and the x-radiographs of the *Feast of the Gods*, the *Adoration of the Shepherds*, the *Three Philosophers*, and the *Laura*, the technical photographs of the works discussed are published here for the first time.

1. Rome 1930, 162–170; Stout 1964, 126; Burroughs 1938, vii–x; Wolters 1938; Bridgman 1964; Posse 1931; Wilde 1931; Rothschild 1932.

2. Wilde 1932.

3. See also Spronk 1996; Keyser 1999; Bewer 2001.

4. See also Anderson 1997, 83; Luber 2005, 4.

5. Hope and Van Asperen de Boer 1991.

6. Hope and Van Asperen de Boer 1991, 135.

7. Zanolini 1986, 24; Olivari 2001, 38–44.

8. On methods used by Venetian painters to duplicate compositions, see Vasari/ Maclehose 1907, 215, 231; Spezzani 1992, 50–51; Galassi 1998; Bambach 1999, 338; Goffen and Nepi Scirè 2000, 82; Falomir 2003; Kasl 2004. A privately owned copy of the *Lady with a Mirror*, sometimes given to Giovanni Bellini and/ or Vincenzo Catena and reproduced in Bernardini 1995, 177 and 242–243, is similar in size and coloring, but there are slight variations in the landscape and it lacks the *cartellino* and vase. Interestingly, these elements were not underdrawn in the Vienna painting.

9. On fingerprints in Venetian paintings, see Vasari/Maclehose 1907, 231; Zanolini 1986; Fletcher and Skipsey 1991, 7; Dunkerton, Foister, and Penny 1999, 219; Dunkerton 2004, 315–316, note 66.

10. Bellini occasionally used a gray *imprimitura* according to Merrifield 1849, ccxcv–ccxcvi. Cross sections from the *Lady with a Mirror* analyzed by Martina Grießer, head of the Kunsthistorisches Museum Scientific Department, reveal a slight variation in the gray color beneath the draperies as compared to the flesh-tones. This suggests the use of an under-paint layer beneath specific areas, rather than an *imprimitura* applied over the entire surface. See also Dunkerton and Spring 1998.

11. This appears to be an unusual technique, since previous cross section analysis has found that Bellini executed the underdrawing directly on the gesso unless an *imprimitura* was present, in which case it was applied on top of this layer; see Lazzarini 1983, 134–155; Lucas and Plesters 1978, 39.

12. Fletcher 1990, 173; Goffen 1991, 194 and 196.

13. These incised lines are dark in the x-radiographs, and, moreover, have a uniform width and appear to have been drawn. There are additional dark contour lines in the x-radiographs. But, when the painting's surface is examined, they have a different appearance. Some lines seem to be the result of the artist following the underdrawing accurately and not allowing the local color to overlap the boundaries. Other lines seemed to have formed during the drying process, due to different shrinkage rates in the various colors as a result of the different amounts of oil required to bind the pigments.

14. The compass point, which was used twice, is located to the right of the woman's forehead. The outlines of the round mirror are dark in the x-radiographs, an indication that they were made into the paint layer while the paint was still wet.

15. Walker (1956) published x-radiographs taken in 1947.

16. Burroughs 1938, 112.

17. Bull and Plesters 1990; Brown 1993; Bull 1993; Plesters 1993.

18. Bull and Plesters 1990, 58–59 and fig. 20.

19. In the usual method of capturing infrared reflectograms, an infrared camera is set up in front of a painting, with photoflood lights positioned so light reflects off the painting's surface. For transmitted infrared reflectography, the lights are positioned behind, so light is transmitted through the painting.

20. In a photograph of the *Madonna of the Meadow* (page 59, fig. 3) taken during transfer, a similar brushiness at an early stage of the painting process is seen in the tree at the right edge; see Ruhemann 1968, 155–162, figs. 42–45.

21. The camera was generously donated to the National Gallery of Art by Eastman Kodak. Walmsley et al. 1994, fig. 8; Metzger et al. 1995, pl. 88.

300

22. Wilde 1931, 91–102; Ballarin 1993, 724–729.

23. The corner spandrels, including most of Laura's hand, are modern reconstructions following an old copy. See Oberthaler 2004 for the full results of the technical study of the painting.

24. Hope and Van Asperen de Boer 1991 (presented at conference in 1989); Katie Crawford Luber and Sylvia Ferino-Pagden (unpublished report, 1989, in the conservation files of the Kunsthistorisches Museum, Vienna); Paolo Spezzani, using the INOA scanner, produced the infrared image reproduced here.

25. A dark line that curves below Laura's throat is barely visible as a pentimento on the paint surface. It is also faint in the infrared reflectogram, but registers more strongly in the infrared photograph; see Hornig 1987, 32. One possible explanation comes from the often-cited comparison of the *Laura* with Albrecht Dürer's *Portrait of a Venetian Lady* (Kunsthistorisches Museum,

Vienna), painted one year earlier. Dürer's lady, also in three-quarter view, wears a similar hairstyle with long side curls and a more modest costume. Her necklace is recalled by the curved line of that in the *Laura*, but if intended as a placemark for a necklace, the idea was abandoned before the individual jewels were painted. Another possibility is that Giorgione considered clothing Laura in a round-necked dress, such as the one in his painting of *Judith with the Head of Holofernes* (State Hermitage Museum, St. Petersburg), but the x-radiograph reveals no evidence of reworking in this area, which shows little modeling, at any rate, in the thickly painted fleshtones.

26. The x-radiographs were made in 1931.

27. Hope and Van Asperen de Boer 1991.

28. The infrared reflectogram was captured in Venice, after the exhibition *Giorgione: Le maravaglie dell'arte* and before the painting returned to Vienna for the exhibition *Giorgione. Mythos und Enigma*. This infrared reflectogram was displayed with the x-radiograph composite, full-size, in the Vienna exhibition. An overall infrared vidicon composite by Manfred Shreiner and the x-radiograph composite, digitized by Paolo Spezzani from x-radiographs taken in 1977, were published in the exhibition catalogue, together with a technical analysis; see Oberthaler 2004.

29. Hope and Van Asperen de Boer 1991, 130, characterized the diagonal hatchmarks as a Quattrocento technique.

30. See also Steinberg and Wylie 1990, 70–77.

31. Though Hope and Van Asperen de Boer 1991, 130, commented dubiously that the "seated philosopher has probably the best claim to be the work of Sebastiano," Oberthaler 2004 firmly concluded that the figure was the work of Giorgione.

32. Morassi 1942; Mucchi 1978, 30–31; Brown 1979, 28–29; Strehlke 2003.

33. Anderson 1997, 109–114.

34. See Jaynie Anderson's entry in Ferino-Pagden and Nepi Scirè 2004, 173–175.

35. Technical photographs show that the figures' contours were underdrawn with a brush and retained through the paint layers with only very minor revisions. The painting was examined in the studio through the generosity of Alfred Ackerman, Paul Cooney, and Barbara Heller at The Detroit Institute of Arts.

36. Hope and Van Asperen de Boer 1991, 131.

37. This project is headed by Sylvia Ferino-Pagden and is funded by the Fond zur Förderung der wissenschaftlichen Forschung (FWF) of Austria.

38. This technique was found also in the Pesaro altarpiece and the *Bacchus and Ariadne*.

39. Materazzi, Pezzati, and Poggi 2002.

VENETIAN "COLORE": ARTISTS AT THE INTERSECTION
OF TECHNOLOGY AND HISTORY * *Barbara H. Berrie and Louisa C. Matthew*

IN THE EARLY YEARS of the sixteenth century, Venice was a great cosmopolitan center, admired for the creative energy of its artisans and the dazzling array of goods in its shops. The city's artisan trades were at the heart of an entrepreneurial and artistic boom that had begun during the last third of the fifteenth century, when Venice became the nexus of the nascent printing industry, and its artisans made important advances in glass manufacturing, ceramic production, and textile dyeing.[1] From this milieu emerged the painters who also contributed to the city's prosperity and reputation for innovation. The most renowned of these artists were termed "figurers" (easel painters) by their guild, of which they were the most prestigious members.[2] The pictures of these figurers constitute the majority of the painted works that have survived, and they form the basis for most of the historical and scientific analyses of materials and painting techniques used in Venice. The number of extant paintings suggests that production increased significantly from 1480 to 1530, as did the invention of subjects and formats. We are now learning that the painters also applied their creative talents to the selection of pigments and painting techniques.

Venetian Renaissance painters have been admired as colorists since their own time, a reputation that is justly deserved. Yet they were, in fact, part of a larger "industry of color," which provided them with a wider variety of pigments and new ideas for their application than may have been available elsewhere on the Italian peninsula. This industry encompassed all the members of the Venetian painters' guild—including decorators of masks, furniture, books, playing cards, textiles, and leather—who significantly outnumbered the figurers. Dyers, glassmakers, glass painters, and potters, not to mention terrazzo floor makers and house plasterers, were also part of this industry of color, as were the pigment manufacturers and the *vendecolori* (color sellers). These *vendecolori* were the retail specialists who sold colorants and related supplies from their shops (and apparently dabbled in import and export at the wholesale level as well).[3] This profession, unique to Venice at the time, would not become established elsewhere until the second half of the sixteenth century. Throughout the rest of Italy and northern Europe, generalist apothecaries sold painters' supplies, which constituted only a small part of their business. The Venetian color sellers, as specialists in colorants and the materials used to extract, process, and apply them, must have played a significant role in stimulating experimentation in the selection and uses of color, as well as in fostering communication among the variety of artists and artisans who patronized their establishments.

Recent archival research and scientific analysis have added much to our knowledge of how color was produced, used, and valued in Renaissance Venice. Numerous documents establishing the identity and business practices of the color sellers—most significantly, inventories of their shops—have been discovered in the state archives in Venice.[4] These inventories, examined in conjunction with other types of documents, suggest that as the sixteenth century progressed, the color sellers introduced an increasingly wide variety of pigments. They may also have assumed more responsibility for processing pigments and other materials, such as varnish, from the painters' workshops.[5] Documents show that the color sellers also sold materials to other artisans who used colorants, specifically, dyers, glassmakers, and glass painters.[6] The color sellers' shops were meeting places where information on new materials and new uses for familiar materials were exchanged by various artisans, who may have also discussed the tastes and preferences of customers. Ample

evidence exists to show that artists and agents from throughout northern and central Italy traveled to Venice to obtain painting materials, and the existence of the color sellers provides a more complete explanation for these trips.[7]

At the same time, scientific analysis of paintings has expanded our knowledge of how the Venetian painters worked and what materials they used.[8] Microscopy and instrumental analysis of paint cross sections have revealed that by about 1500 the painters were using an exceptionally wide range of pigments, measured by varieties of hue and grades of refinement. This selection and variety was certainly made available by the *vendecolori*, who were operating in the city by the 1490s. New results from analysis of the colorants and additives employed by Venetian painters also show that they added unusual pigments to their palettes. Some of these materials were employed by artisans working in other industries, and many were available from the color sellers, as known from their inventories. Cross sections also reveal that painters began to use materials in innovative ways. Venetian artists, for example, were at the forefront of underpainting with variously colored paints. They began to use bright white, pink, or gray primings to modulate the color of their work and novel mixtures of colors—such as red lakes mixed with copper green glazes, and orange mixed with blue paint—to make subtle changes in hue and tone. Certainly the exploration of the potential of the oil medium, which the Venetian figurers adopted with exceptional enthusiasm in the third quarter of the fifteenth century, was another catalyst for incorporating novel materials and techniques into their painting. Thus, the congruence of new painting methods and the availability of new materials became a potent source of innovation. Painting with oil encouraged artists to use the technique called glazing, that is, superimposing layers of partially transparent or translucent mixtures of pigment together with oil. Each layer acts like stained glass, altering the appearance of, but not obscuring, the layer below it, to produce striking and sometimes novel effects based on color and light.

Red and yellow lake pigments were among the most effective colorants for producing transparent and translucent paint in the Renaissance. The lakes were made from dyes such as madder, brazilwood, or fustic, which were rendered insoluble and suitable for painting usually by reaction with alum (aluminum potassium sulfate) or precipitated onto chalk or finely divided white earth. The importing and manufacturing trades in Venice provided many dyes, and Venice became renowned for its high-quality red lakes.[9] In the account book of the Venetian painter Lorenzo Lotto, in entries dating to the early 1540s, the cost of kermes lake was exceeded only by ultramarine and gold, and was four times more costly than any other color.[10] The glazing technique encouraged layering, not only of translucent mixtures, but also of scumbles of opaque paint. The paint could include several layers of different hues, sometimes alternating between the transparent and the opaque. Artists even began to change the color entirely from one layer to the next, painting pink or red under glazes of ultramarine, as seen, for example, in the Virgin's mantle (fig. 1) in the *Adoration of the Shepherds ("Allendale Nativity")* (cat. 17) and the nymph's blue dress in the *Feast of the Gods* (cat. 32). Clearly these techniques were intended to increase the variety, range, and richness of colors achievable on the surface of a panel or a canvas.

Striking examples of the use of the glazing technique can be found in Venetian painting in the first decades of the sixteenth century. Cima da Conegliano painted some of the

1.

Giorgione, *Adoration of the Shepherds* (cat. 17). Cross section from the Virgin's mantle showing deep red underpaint, saturated blue made from ultramarine, and a purplish glaze.

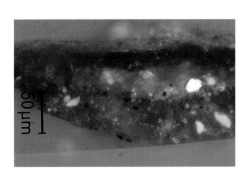

2.

Cima da Conegliano, *Incredulity of Saint Thomas*, National Gallery, London. Cross section from green drapery; viewed with transmitted light, multiple layers of transparent glaze paint can be seen.

304

draperies in his *Incredulity of Saint Thomas* (National Gallery, London), a large altarpiece of 1502 to 1504, using a complex, multilayered structure of alternating layers of opaque and transparent paint (fig. 2). These layers are mostly green, but sandwiched in between is a thin red glaze that would have muted the intensity of that color in certain areas.[11] Lotto also exploited the glazing method to depict richly colored red fabric. In his *Saint Catherine* of 1522 (National Gallery of Art, Washington), the saint wears a luminous scarlet dress. A cross section shows that the artist painted five thin layers of glaze over pink paint mixed from lead white and vermilion (fig. 3). The structure of the underlying layers of paint is not orderly. A very thin layer of red glaze separates two opaque layers of pink paint. A remarkably similar structure of opaque light red paint with transparent glazes is also present in the work of Bellini and the young Titian.[12]

Lotto's glazes were prepared in an unconventional way. He used two red lake pigments, one prepared from madder root, a colorant more frequently found on the palette of Northern artists, and another made from kermes.[13] Lotto was working with subtle changes in color by using two different transparent red pigments; he was also improving the working properties of his paint through the addition of a large proportion of finely ground sand to these pigments.[14] This is a remarkable innovation. Some sixteenth-century writers on artists' practice advocated the addition of travertine or chalk to red lakes to give the paint body and to decrease drying time (and chalk is present in Bellini's red lake paint used for the *Feast of the Gods*). Although glass has been found in red lakes in Umbrian and Florentine paintings, sand appears to have been a unique addition. Pulverized sand, used for glassmaking, was an abundant commodity in Venice,[15] and Lotto may have found the material at a color seller's shop.[16]

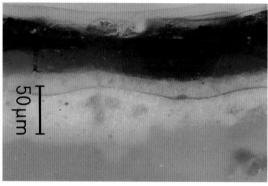

3a

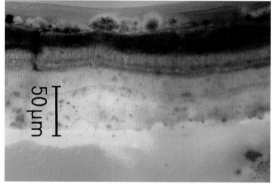

3b

4

3.

Lorenzo Lotto, *Saint Catherine*, National Gallery of Art, Washington. Cross section sample from a dark fold in the red dress (bottom left-hand corner). A. Reflected light. B. Fluorescence, which shows that the dark red glaze is formed by five layers of transparent red paint.

4.

Giovanni Bellini and Titian, *Feast of the Gods* (cat. 32). This cross section is from a dark green space between the nymph with a jar on her head and the tree to her left. The top layer of green paint may have been applied by Bellini or Titian, but the layers below that are certainly by Bellini. The blue paint is that of the sky just above the horizon. It was blended from azurite, lead white, and a small proportion of an orange pigment that is a glassy lead antimonate.

He would have used it in place of chalk or glass, presumably seeking the same results, namely, to promote drying and provide exceptional transparency to the paint.

Lotto's account book, with its addendum of his expenses for art, provides fascinating evidence of how a painter used pigments that were originally intended for artisans and artists working in other media.[17] Lotto noted his acquisition of *zalolin da vazari* (potter's yellow), the name of which suggests a frit, or partially fused glaze, of the sort used by artisans who painted ceramic ware and glass.

In the late fifteenth and early sixteenth centuries, Venice was the Western world's center of glass production; the expertise of its glassmakers was unmatched, although much copied. Venice was also, contemporaneously, the source for much ceramic ware that was decorated with figural designs.[18] The frits were applied as paints, often in a resin or oil-based binder. After application of the painted decoration, a piece of glass or pottery would have been refired and the frit pigments in the paint would have vitrified.

A deep orange is among the most typical colors for early sixteenth-century majolica. The yellow and orange glazes can be made from a variety of compounds of lead, tin, and/or antimony. While there are few known sixteenth-century references to antimony yellows, they are included in Cipriano Piccolpasso's treatise on the potter's art, published in 1548.[19] Furthermore, x-ray fluorescence analysis of early sixteenth-century majolica has confirmed that this compound was used to paint ceramics.[20] Orange-yellow pigments made from lead and antimony have been found in Lotto's paintings, but it is only now that we are finding that some of these antimony yellows are glassy and have the characteristics of a potter's color, and hence may be Lotto's *zalolin da vazari*.[21] Bellini used a very similar deep yellow pigment

mixed in a small proportion into an azurite sky paint at the horizon (fig. 4) in the *Feast of the Gods*. Elemental analysis showed these particles are a silicate with a little zinc, iron, and antimony (fig. 5) and in chemical composition are closely related to the kinds of materials called *zalolin da vazari*. The addition of orange-yellow to the blue paint shows the artist's masterful command of the laws of color mixing.[22]

Paul Hills noted the aesthetic link between oranges on majolica and the oranges in works of Bellini and his contemporaries.[23] The occurrence in paint of the deep yellow antimonal glassy pigment, one that is associated with the technology of ceramic decoration, may be a reflection of artists' desire to use the deep yellow color of the glazes in their work and, indeed, the brilliant yellow and orange draperies of their figures are a hallmark of the expanding palette of Venetian painters about 1500. Artists painted the oranges and deep yellows using mixtures of yellow and red pigments—lead-tin yellows, litharge, minium, vermilion, and organic lakes—more often than they used the antimonal

5.

The energy dispersive spectrum of the yellow-orange particles in the sample of sky shown in fig. 4. The particles contain silicon, potassium, zinc, lead, and antimony, and have a composition similar to that of the glassy frits used to decorate majolica.

yellows of the ceramicists. Two sulfides of arsenic, the yellow orpiment and the reddish-orange realgar, provided orange tones and were widely used on the Venetian palette beginning about 1500, although Bellini had begun to use orpiment as early as the 1470s.[24] The intense orange-red color used by Titian for the fluttering drapery of a bacchante in his *Bacchus and Ariadne* (National Gallery, London) was painted with orpiment. Bellini used orpiment mixed with red lake for Silenus' tunic (fig. 6) and for Apollo's garb in the *Feast of the Gods.*[25] Cinquecento Venetian painters continued to use orpiment and realgar so regularly that Giovanni Paolo Lomazzo, in his 1584 treatise on painting, referred to orpiment, which he described as "the color of gold," as "the alchemy of Venetian painters."[26]

The coloristic effects achieved by painters of the Venetian Renaissance arose not only from the addition of new colorants, but also from the purity and grade of pigments available. Some mineral pigments apparently arrived in Venice already ground and graded, as evident from the commerce in azurite that came from German-speaking territories and Hungary.[27] In Giorgione's *Adoration of the Shepherds* (cat. 17), the painter appears to have exploited the availability of many grades and variations of colorants. As with Titian, notably in his *Bacchus and Ariadne,* Giorgione used mixtures of pigments of exceptional quality. On the other hand, his layering is not as complex as that of his contemporaries, and his sensitive color schemes were achieved more by using paints made from expensive and highly graded colorants. The rich brown color of a shepherd's wool cloak was painted not with an earth, but with a mixture of earths and the more expensive brilliant red pigment vermilion, and his tattered shirt was painted with azurite. This latter pigment is common, but for Giorgione's work the unusual

6.

Giovanni Bellini and Titian, *Feast of the Gods* (cat. 32). The cross section is from a shadowed part of Silenus' robe. The deep orange-colored paint is prepared from a mixture of the arsenical sulfide pigment, orpiment, and a red lake.

7.

Giorgione, *Adoration of the Shepherds* (cat. 17). A photomicrograph of the sleeve of the kneeling shepherd. The homogeneity and purity of the particles of the blue pigment azurite in this sample is remarkable. The small, consistently sized particles give a paint of a turquoise hue.

subtle blue-green shade depends on the use of a thoroughly refined and graded product that has homogeneous particles (fig. 7). The consistency of the particle size is remarkable and would likely have been difficult to achieve in a painter's workshop. Despite the fact that certain pigments were traditionally processed and synthesized in painters' workshops, the color sellers' inventories suggest that they, as specialists, assumed more and more responsibility for creating ready-to-use pigments.[28] Furthermore, as specialists, they would have carried a wide range of hues and grades to satisfy an equally wide range of customers, from the painter of wooden boxes to a Giorgione or Titian who painted canvases for wealthy patrons and the Church.

Scientific analysis and historical research are not only confirming the reputation of Venetian Renaissance painters as skilled colorists, but also their participation in a larger industry of color that afforded them opportunities to experiment with new materials and techniques. At the center of this industry were the color sellers; their establishments were meeting places, where information about familiar materials and new ones could be shared among the trades.[29] Different substances — vegetable or mineral, imported or manufactured locally — were used in different ways depending on the needs of particular trades. These trades were not "closed shops" that looked only to the traditional knowledge passed down through the apprenticeship system of each specialty. Artisans were learning from other trades within the industry of color, and the painters are a case in point, borrowing materials, techniques, and coloristic effects from potters, dyers, and glassmakers, and taking every advantage of the presence of the *vendecolori*, the color specialists whose expertise and entrepreneurship were unique to Venice during the first half of the sixteenth century.

The authors' work was supported jointly by a Samuel H. Kress Paired Fellowship at the Center for Advanced Study in the Visual Arts and by the Gladys Krieble Delmas Foundation (LCM).

1. For artisans in Venice, see Richard MacKenney, *Tradesmen and Traders. The World of the Guilds in Venice and Europe, ca. 1250–ca. 1650* (London, 1987). For dyeing and the silk trade, see Luca Molà, *The Silk Industry of Renaissance Venice* (Baltimore and London, 2000). For descriptions of the glass industry, see W. Patrick McCray, *Glassmaking in Venice: The Fragile Craft* (Aldershot, 1999); Marco Verità, "Some Technical Aspects of Ancient Venetian Glass," in *Technique et science: Les arts du verre. Actes du colloque de Namur* (Namur, 1991), 57–67; and Luigi Zecchin,

Vetro e vetrai di Murano, 3 vols. (Venice, 1987–1990). For the painters, see Matthew 2002 and Louisa C. Matthew and Barbara H. Berrie, *"Memoria de colori che bisognino torre a Vinetia*: Venice as a Centre for the Purchase of Painters' Colours," in *Trade in Painters' Materials: Markets and Commerce in Europe to 1700*, Joanna Cannon, Jo Kirby, and Susie Nash, eds., London, forthcoming.

2. The figurers constituted only one sector of the painters' guild and were outnumbered by other types of painters; Favaro 1975.

3. For the profession of *vendecolori* in Venice, see Matthew 2002; the first date associated with the profession is 1493.

4. Four inventories of Venetian color sellers have been found, ranging in date from 1534 to 1594. See Krischel 2002 for a transcription and annotation of the 1594 inventory. See Matthew 2002 and Matthew and Berrie, forthcoming, cited in note 1, for discussion of the other three inventories.

5. Matthew and Berrie, forthcoming. Some pigments had always been purchased ready-to-use, as the Tuscan Cennino Cennini mentions in his manual on painters' techniques dating to the late fourteenth century; Cennini 1982.

6. Matthew and Berrie, forthcoming. These contacts are documented, but we hypothesize that many other trades used the shops given the large amounts of materials available and the variety.

7. Matthew and Berrie, forthcoming.

8. There have been significant studies on the painting techniques and materials used by Cinquecento Venetian artists. The reader is referred to the following articles and the citations therein: Allan Braham, Martin Wyld, and Joyce Plesters, "Bellini's 'The Blood of the Redeemer,'" *National Gallery Technical Bulletin* 2 (1978), 11–24; Bull and Plesters 1990; Elisa Campani et al., "Giorgione's Materials and Painting Technique: Scientific Investigation of Three Paintings," in Ferino-Pagden and Nepi Sciré 2004; Lorenzo Lazzarini, "Il colore nei pittori veneziani tra il 1480 e il 1580," *Bolletino d'arte* suppl. 5, (1985), 135–144; Lorenzo Lazzarini, "Lo studio stratigrafico della pala di Castelfranco e di altre opere contemporanee," in *Giorgione: La pala di Castelfranco Veneto*, Lorenzo Lazzarini et al., eds. (Milan, 1978), 45–59. Lorenzo Lazzarini et al., "Pittura veneziana: Materiali, techniche, restauri," *Bollettino d'arte* 5 (1983), 133–166; and Arthur Lucas

and Joyce Plesters, "Titian's 'Bacchus and Ariadne,'" *National Gallery Technical Bulletin* 2 (1978), 25–48; Jill Dunkerton and Marika Spring, "The Technique and Materials of Titian's Early Paintings in the National Gallery," in *Titian. Jacopo Pesaro Being Presented by Pope Alexander VI to Saint Peter*, Koninklijk Museum voor Schone Kunsten Antwerp, *Restoration* 3, no. 1 (2003), 9–21.

9. The importance of the dyeing trade in Venice at this time is evident by the first printed treatise in Italian on dyeing. It was published in Venice in 1548 and contains scores of recipes. Gioanventura Rosetti, *Plictho de l'arte de tentori* (Venice, 1548), trans. Sidney M. Edelstein and Hector C. Borghetty (Cambridge, Mass., 1969). For the dyeing of textiles in Venice, see also Molà 2000.

10. Quoted in Jo Kirby, "The Price of Quality: Factors Influencing the Cost of Pigments," in *Revaluing Renaissance Art*, Gabriele Neher and Rupert Shepherd, eds. (Aldershot, 2000), note 45, 32.

11. Jill Dunkerton and Ashok Roy, "The Technique and Restoration of Cima's 'The Incredulity of S. Thomas,'" *National Gallery Technical Bulletin* 10 (1986), 4–27.

12. The Bellini painting is the *Feast of the Gods*—see Bull and Plesters 1990 (the pink drapery of nymph)— and the Titian is *Jacopo Pesaro Being Presented by Pope Alexander VI to Saint Peter*, for which see Hélène Dubois and Arie Wallert, "Titian's Painting Technique," in *Titian. Jacopo Pesaro Being Presented by Pope Alexander VI to Saint Peter*, Koninklijk Museum voor Schone Kunsten Antwerp, *Restoration* 3, no. 1 (2003), 22–37.

13. Jill Dunkerton, Nicholas Penny, and Ashok Roy, "Two Paintings by Lorenzo Lotto at the National Gallery," *National Gallery Technical Bulletin* 19 (1998), 52–63. Madder is found more rarely in sixteenth-century Italian paintings than in German and Northern examples. See Robert Chenciner, *Madder Red: A History of Luxury and Trade* (Richmond, Surrey, 2000), 325–

327. Kermes appears more than once in the 1534 inventory, for which see Matthew 2002. There are many more recipes in the *Plictho* (1548), cited at note 9, for dyeing with kermes or brazilwood than dyeing with madder.

14. Barbara H. Berrie and Louisa C. Matthew, "Material Innovation and Artistic Invention: New Materials and New Colors in Renaissance Venetian Paintings," in *Scientific Examination of Art. Modern Techniques in Conservation and Analysis* (Washington, 2005), 12–26.

15. Finely ground quartz was the main raw material for the glassmaking industry. The glassmaker Antonio Neri describes the work up of the material from white peebles, called Tarso, thus: "si pesti minutamente in polvere in pile di pietra…che il Tarso sia pestato fine come farina, di maniera che tutto passi per staccio fitto." In Antonio Neri, *L'arte vetraria, distinta in libri sette* (Florence, 1612), 4.

16. Krischel has speculated that "sabbion da ore" is listed in the 1594 inventory of a color seller's shop (Krischel 2002).

Krischel has speculated that it is the finely ground sand used in hourglasses (personal communication).

17. Zampetti 1969 and Grimaldi and Sordi 2003.

18. The volume of majolica produced in Venice may be underestimated today in light of the renown of the towns of Faenza and Castel Durante. Ronald Lightbown and Alan Caiger-Smith, *The Three Books of the Potter's Art. A Facsimile of "I tre libri dell'arte de Vasaio" by Cipriano Piccolpasso*, vol. 2 (London, 1980), 81.

19. Lightbown and Caiger-Smith 1980, 2: xxiii.

20. See Giovanna Bandini et al., "Studio sulle decorazioni policrome mediante fluorescenza X di alcune maioliche rinascimentali ritrovate in Roma," *Faenza* 83, 4–6 (1997), 235–252. Two recipes for antimonal yellow glass were given by Darduin in a treatise on glassmaking written in the seventeenth century, but containing some recipes thought to date as early as the 1520s:

"A far smalto zallo in corpo in altro modo bellissimo. Piglia antimonio lire quindici, piombo brusado (da quelli dalli colori) lire trentadoi, tuccia d'Alessandria (dalli droghieri) lire tre, calcina bianca lire vinti: missia ogni cosa insieme, poi fuori, pestala e tamisala, e ritornala in fornello per hore dodeci. Etc…" and "Smalto giallo opaco bellissimo. Si calcina in fornello, per 12 ore, una miscela formata da: antimonio, libbre 15, ossiso di piombo (che si trova dai negozianti di colori), libbre 32, tuzia d' Alessandria (Che si acquista nelle drogherie), libbre 3, calce Bianca (di piombo e stagno), libbre 20 etc etc." This is recipe 56 in Luigi Zecchin, ed., *Il ricettario Darduin. Un codice vetrario del seicento trascritto e commentato* (Venice, 1986), 138.

21. Ashok Roy and Barbara H. Berrie, "A New Lead-based Yellow in the Seventeenth Century," in *Painting Techniques. History, Materials and Studio Practice*, Con-

tributions to the Dublin Congress, International Institute for Conservation, 7–11 September 1998, Ashok Roy and Perry Smith, eds. (London, 1998), 160–165; yellow pigments that contain lead, tin, and antimony were found in frescoes by Raphael in his *Loggia di Psiche* (Rome, 1517); see Claudio Seccaroni and Pietro Moioli, *Fluorescenza X* (Florence, 2002), 50–51.

22. Mixing the complementary color into the paint—in this example, orange-yellow into blue (and in other cases red into green)—mutes the intensity of the color without dulling it. The so-called laws of color mixing were not codified until the nineteenth century, most clearly by Michel Eugène Chevreul, *De la loi du contraste simultané des couleurs* (Paris, 1839).

23. Hills 1999, 146–150.

24. One of the earliest occurrences of orpiment in a panel painting is in Bellini's *Pesaro Altarpiece*, dated to 1474, for which see Maria Laurenzi Tabasso, "Le indagini scientifiche," in *La pala ricostituita*, Maria Rosaria Valazzi, ed. (Venice, 1988).

25. Lucas and Plesters 1978.

26. Giovanni Paolo Lomazzo, *Trattato dell'arte della pittura*, reprint ed., 1965 (Milan, 1584), 191. The 1534 color seller's inventory contains multiple listings for orpiment, as does the 1594 inventory, where different types are clearly described.

27. Andreas Burmester and Christoph Krekel, "The Relationship between Albrecht Dürer's Palette and Fifteenth/Sixteenth-Century Pharmacy Price Lists: The Use of Azurite and Ultramarine," in *Painting Techniques: History, Materials and Studio Practice*, Ashok Roy and Perry Smith, eds. (London, 1998), 101–105.

28. This is discussed more specifically in Matthew and Berrie, forthcoming.

29. For a wider discussion of artisans and technology in the sixteenth century, see Paolo Rossi, *Philosophy, Technology, and the Arts in the Early Modern Era* (New York, 1970).

Agosti 2005
Agosti, Barbara. "Vittoria Colonna e il culto della Maddalena (tra Tiziano e Michelangelo)." In Ragionieri 2005, 71–81.

Agostini and Allegri 1978
Agostini, Grazia, and Ettore Allegri, eds. *Tiziano nelle Gallerie fiorentine* (exh. cat., Palazzo Pitti, Florence). Florence, 1978.

Aikema 1994
Aikema, Bernard. "Titian's Mary Magdalen in the Palazzo Pitti: An Ambiguous Painting and Its Critics." *Journal of the Warburg and Courtauld Institutes* 57 (1994), 48–59.

Aikema 2003
Aikema, Bernard. "Giorgione: i rapporti con il nord e una nuova lettura della 'Vecchia' e della 'Tempesta.'" In Nepi Scirè and Rossi 2003, 73–89.

Aikema 2004
Aikema, Bernard. "Giorgione und seine Verbindung zum Norden. Neue Interpretationen zur 'Vecchia' und zur 'Tempesta.'" In Ferino-Pagden and Nepi Scirè 2004, 85–103.

Aikema and Brown 1999
Aikema, Bernard, and Beverly Louise Brown. *Renaissance Venice and the North: Crosscurrents in the Time of Dürer, Bellini, and Titian* (exh. cat., Palazzo Grassi, Venice). London and Milan, 1999.

Alizeri 1847
Alizeri, Federico. *Guida artistica per la Città di Genova.* Vol. 2. Genoa, 1847.

Altan 1772
Altan, F. "Del vario stato della pittura in Friuli." *Nuova Raccolta di Opuscoli Scientifici e Filologici* 4 (1772), 1–29.

Ames-Lewis and Rogers 1998
Ames-Lewis, Francis, and Mary Rogers. *Concepts of Beauty in Renaissance Art.* Aldershot, England, and Brookfield, Vermont, 1998.

Anderson 1978
Anderson, Jaynie. "L'opera di Giorgione." In *Giorgione. Guida alla mostra: i tempi di Giorgione.* P. Carpeggiani, ed. Florence, 1978, 37–73.

Anderson 1979
Anderson, Jaynie. "L'année Giorgione." *Revue de l'Art* 43 (1979), 83–90, 153–158.

Anderson 1979a
Anderson, Jaynie. "A Further Inventory of Gabriel Vendramin's Collection." *The Burlington Magazine* 121 (1979), 639–648.

Anderson 1979b
Anderson, Jaynie. "The Giorgionesque Portrait: From Likeness to Allegory." In *Giorgione* 1979, 153–158.

Anderson 1993
Anderson, Jaynie. "The Provenance of Bellini's Feast of the Gods and a New/Old Interpretation." In *Titian 500* 1993, 264–287.

Anderson 1996
See Anderson 1997.

Anderson 1997
Anderson, Jaynie. *Giorgione: The Painter of Poetic Brevity.* New York, 1997; French ed. 1996.

Anderson 2004
Anderson, Jaynie. "Bittersweet Love: Giorgione's Portraits of Masculine Friendship." In *Italians in Australia, Studies in Renaissance and Baroque Art.* David R. Marshall, ed. Melbourne and Florence, 2004, 87–94.

Anderson 2004a
Anderson, Jaynie. In Ferino-Pagden and Nepi Scirè 2004, 173–175.

Anzelewsky 1971
Anzelewsky, Fedja. *Albrecht Dürer: das malerische Werk.* Berlin, 1971.

Arasse 1981
Arasse, Daniel. "Lorenzo Lotto dans ses bizarreries: le peintre et l'iconographe." In *Lorenzo Lotto. Atti del convegno internazionale di studi per il v centenario della nascita.* Pietro Zampetti and Vittorio Sgarbi, eds. Teviso, 1981, 365–382.

Arasse 1991
Arasse, Daniel. "Giovanni Bellini et la mythologie de Noé." *Venezia Cinquecento. Studi di storia dell'arte e della cultura* 1 (1991), 157–183.

Arnolds 1959
Arnolds, G. "Dürer's 'Opus Quinque Dierum.'" In *Festschrift Friedrich Winkler.* Berlin, 1959, 187–190.

Arslan 1956
Arslan, Edoardo. *Vicenza: Le Chiese.* Rome, 1956.

Art 2002
Art in the Making: Underdrawings in Renaissance Paintings. David Bomford, ed. New Haven and London, 2002.

Athanasius 1989
Sant'Atanasio. *La vita di Antonio. Lettere—Regola.* S. Di Meglio, ed. Padua, 1989.

Attardi 1993
Attardi, Luisa. "Jacopo Nigreti, dit Palma Vecchio." In *Le Siècle de Titien* 1993, 433–434.

Avagnina and Girotto 1996
Avagnina, Maria Elisa, and Maria Beatrice Girotto. Entry in *Restituzioni '96.* Cittadella, 1996, 80–89.

Babelon 1950
Babelon, J. *Titien.* Paris, 1950.

Baldarini et al. 1761
Baldarini, P., O. Arnaldi, and L. Vecchi. *Descrizione… di Vicenza.* 2 vols. Vicenza, 1761.

Baldass 1955
Baldass, Ludwig. "Die Tat des Giorgione." *Jahrbuch der Kunsthistorisches Sammlungen in Wien* 51 (1955), 103–144.

Baldass 1957
Baldass, Ludwig. "Tizian im Banne Giorgiones." *Jahrbuch der Kunsthistorisches Sammlungen in Wien* 53 (1957), 101–156.

Baldass 1961
Baldass, Ludwig. "Zur Erforschung des 'Giorgionismo' bei den Generationsgenossen Titians." *Jahrbuch der Kunsthistorischen Sammlungen in Wien* 57, no. 180 (1961), 69–88.

Baldass and Heinz 1964
See Baldass and Heinz 1965.

312

Baldass and Heinz 1965
Baldass, Ludwig, and Günther Heinz. *Giorgione.* London, 1965; German ed. Vienna and Munich, 1964.

Ballarin 1966
Ballarin, Alessandro. *Gerolamo Savoldo.* Milan, 1966.

Ballarin 1968
Ballarin, Alessandro. "Pittura veneziana nei musei di Budapest, Prague, Dijon e Venezia." *Arte Veneta* 22 (1968), 244 (237–255).

Ballarin 1968a
Ballarin, Alessandro. *Tiziano.* Florence, 1968.

Ballarin 1979
Ballarin, Alessandro. "Una nuova prospettiva su Giorgione: La ritrattistica degli anni 1500–1503." In *Giorgione 1979,* 227–252.

Ballarin 1980
Ballarin, Alessandro. "Tiziano prima del Fondaco dei Tedeschi." In *Tiziano e Venezia. Atti del convegno internazionale di studi, Venezia 1976.* Vicenza, 1980, 493–499.

Ballarin 1981
Ballarin, Alessandro. "Giorgione: per un nuovo catalogo e una nuova cronologia." In *Giorgione e la cultura veneta tra '400 e '500. Mito, allegoria, analisi iconologia.* Rome, 1981, 26–30.

Ballarin 1983
Ballarin, Alessandro. "Giorgione e la Compagnia degli Amici: Il 'Doppio Ritratto' Ludovisi." In F. Zeri, ed. *Storia dell'arte italiana.* Vol. 3, pt. 5. Turin, 1983, 479–541.

Ballarin 1993
Ballarin, Alessandro. In *Le Siècle de Titien* 1993: "Une nouvelle perspective sur Giorgione: les portraits des années 1500–1503," 281–294, 307–309, 316–320, (La Vecchia) 320–324, (Laura) 332–337, 392–400, 403–407, 437–439.

Ballarin 1995
Ballarin, Alessandro. *Dosso Dossi. La pittura a Ferrara negli anni del ducato di Alfonso I.* A. Pattanaro and V. Romani, eds., with the assistance of S. Momesso and G. Pacchioni. 2 vols. Cittadella, 1995.

Ballarin 2002
Ballarin, Alessandro. *Il Camerino delle pitture di Alfonso I.* 4 vols. Padua, 2002.

Bambach 1999
Bambach, Carmen C. *Drawing and Painting in the Italian Renaissance Workshop: Theory and Practice, 1300–1600.* Cambridge, 1999.

Banti and Boschetto 1953
Banti, Anna, and Antonio Boschetto. *Lorenzo Lotto.* Florence, 1953.

Baranski 1988
Baranski, Zygmunt G. "Relazione conclusiva. Da storia a metafora: letteratura italiana e arti figurative." In *Letteratura italiana e arti figurative. Atti del XII convegno dell'Associazione internazionale per gli studi di lingua e letteratura italiana.* Antonio Franceschetti, ed. Vol. 1. Florence, 1988, 207–225.

Barzaghi 1980
Barzaghi, Antonio. *Donne o cortigiane? La prostituzione a Venezia documenti di costume dal XVI al XVIII secolo.* Verona, 1980.

Battilotti and Franco 1978
Battilotti, Donata, and Maria Theresa Franco. "Regesti di committenti e dei primi collezionisti di Giorgione." *Antichità viva* 18, nos. 4–5 (1978), 58–86.

Battisti 1960
Battisti, Eugenio. *Rinascimento e Barocco.* Turin, 1960.

Battisti 1962
Battisti, Eugenio. "Il Cima e il significato storico delle sue immagini." *La Provincia di Treviso* 5, nos. 4–5 (1962), 25–30.

Battisti 1970
Battisti, E. *Hochrenaissance und Manierismus.* Baden-Baden, 1970.

Battisti 1994
Battisti, Eugenio. "Quel che non c'è in Giorgione." In *Giorgione 1994,* 236–258.

Begni Redona 1990
Begni Redona, P. V. "I Dipinti." In *Giovanni Gerolamo Savoldo 1990,* 93–191.

Béguin 1981
Béguin, Sylvie. "A propos des peintures de Lorenzo Lotto au Louvre." In Zampetti and Sgarbi 1981, 99–105.

Béguin 1993
Béguin, Sylvie. "Lorenzo Lotto et Venise." In *Le Siècle de Titien* 1993, 539–544.

Belting 2001
Belting, H. "Exil in Arkadien. Giorgiones Tempesta in neuer Sicht." In *Meisterwerke der Malerei. Von Rogier van der Weyden bis Andy Warhol.* R. Brandt, ed. Leipzig, 2001, 45–68.

Benkard 1907
Benkard, Ernst. *Die Venezianische Frühzeit des Sebastiano del Piombo.* Frankfurt, 1907.

Benzi 1982
Benzi, Fabio. "Un disegno di Giorgione a Londra e il 'Concerto campestre' del Louvre." *Arte veneta* 36 (1982), 183–187.

Berenson 1894
Berenson, Bernard. *The Venetian Painters of the Renaissance: With an Index to Their Works.* New York and London, 1894 (also 1897, 1901, 1906).

Berenson 1895
Berenson, Bernard. *Lorenzo Lotto.* New York and London, 1895.

Berenson 1897
See Berenson 1894.

Berenson 1897a
Berenson, Bernard. *The Central Italian Painters of the Renaissance.* New York, 1897.

Berenson 1901
See Berenson 1894.

Berenson 1901a
Berenson, Bernard. *The Study and Criticism of Italian Art.* London, 1901 and 1903.

Berenson 1903
See Berenson 1901a.

Berenson 1906
See Berenson 1894.

Berenson 1907
Berenson, Bernard. *The North Italian Painters of the Renaissance.* New York and London, 1907.

Berenson 1916
Berenson, Bernard. *Venetian Painting in America: The Fifteenth Century.* London, 1916.

Berenson 1919
Berenson, Bernard. *Dipinti veneziani in America: con 111 tavole fuori testo.* Milan, 1919.

Berenson 1932
Berenson, Bernard. *Italian Pictures of the Renaissance.* Oxford, 1932; Italian ed. Milan, 1936.

Berenson 1936
See Berenson 1932.

Berenson 1954
Berenson, Bernard. "Notes on Giorgione." *Arte Veneta* 8 (1954), 145–152.

Berenson 1955
Berenson, Bernard. *Lotto.* 3d Italian ed. Louisa Vertova, ed. Milan, 1955.

Berenson 1957
Berenson, Bernard. *Italian Pictures of the Renaissance. Venetian School.* 2 vols. London, 1957.

Berenson 1968
Berenson, Bernard. *Italian Pictures of the Renaissance: Central and North Italian Schools.* London, 1968.

Bergamo 2001
Bergamo: L'Altra Venezia (exh. cat., Accademia Carrara, Bergamo). Milan, 2001.

Bernardini 1908
Bernardini, Giorgio. *Sebastiano del Piombo*. Bergamo, 1908.

Bernardini 1995
Bernardini, Maria Grazia, ed. *Tiziano Vecellio. Amor Sacro e Amor Profano* (exh. cat., Galeria Borghese, Rome). Rome, 1995.

Bertotti Scamozzi 1761
Bertotti Scamozzi, O. *Il Forestiere istruito…di Vicenza*. Vicenza, 1761.

Beschreibendes Verzeichnis 1904
Beschreibendes Verzeichnis der Gemälde im Kaiser Friedrich Museum. 5th ed. Berlin, 1904.

Bestor 2003
Bestor, Jane Fair. "Titian's Portrait of Laura Eustochia: The Decorum of Female Beauty and the Motif of the Black Page." *Renaissance Studies* 17 (2003), 628–673.

Bettarini and Barocchi 1966–1987
Bettarini, Rosanna, and Paola Barocchi, eds. *Le Vite de' più eccellenti Pittori, Scultori e Architettori di Giorgio Vasari*. (Orig. pub. 1550; 2d rev. ed. 1568). 6 vols. Florence, 1966–1987.

Bewer 2001
Bewer, Francesca G. "Technical Research and the Care of Works of Art at the Fogg Art Museum (1900 to 1950)." In *Past Practice—Future Prospects. The British Museum Occasional Papers* no. 145. Andrew Oddy and Sandra Smith, eds. London, 2001, 13–18.

Beyer 2002
Beyer, Andreas. *Das Porträt in der Malerai*. Munich, 2002.

Białostocki 1952
Białostocki, Jan. "Warszawskie leonardiana." *Biuletyn Historii Sztuki* 14 (1952), 10–15.

Białostocki 1959
Białostocki, Jan. "'Opus Quinque Dierum': Dürer's *Christ among the Doctors* and Its Sources." *Journal of the Warburg and Courtauld Institutes* 22 (1959), 17–34.

Białostocki and Skubiszewska 1979
Białostocki, Jan, and M. Skubiszewska. *Malarstwo francuskie, niderlandzkie, wloskie do 1600*. Warsaw, 1979.

Białostocki and Walicki 1955
Białostocki, Jan, and M. Walicki. *Malerstwo Europejskie w zbiorach polskich 1300–1800*. Krakow, 1955.

Biancale 1914
Biancale, M. "Giovanni Battista Moroni e i pittori bresciani." *L'Arte* (1914), 289–300.

Bober and Rubinstein 1986
Bober, Phyllis Pray, and Ruth Rubenstein. *Renaissance Artists and Antique Sculpture. A Handbook of Sources*. London. 1986.

Boccardo and Magnani 1987
Boccardo, Piero, and Lauro Magnani. "La committenza." In *Il Palazzo e l'Università di Genova*. Genoa, 1987, 47–88.

Bode 1886
Bode, Wilhelm von. "Aus Österreichischen Galerien." *Repertorium für Kunstwissenschaft* (1886), 309.

Bode 1890
Bode, Wilhelm von. "Un maestro anonimo dell'antica scuola lombarda (il Pseudo Boccaccino)." *Archivio Storico dell'Arte* (1890), 193–195.

Boehm 1985
Boehm, Gottfried. *Bildnis und Individuum. Über den Ursprung der Porträtmalerei in der italienischen Renaissance*. Munich, 1985, 170, 172–174.

Boehn 1908
Boehn, Max von. *Giorgione und Palma Vecchio*. Bielefeld and Leipzig, 1908.

Boesten-Stengel 1990
Boesten-Stengel, A. "Albrecht Dürers 'Zwîljhriger Jesu unter den Schriftgelehrten' den Sammlung Thyssen Bornemisza, Lugano: Bilderfindung und prestezza." *Idea* 9 (1990), 43–66.

Bomford 2002
Bomford, David, ed. *Art in the Making: Underdrawing in Renaissance Paintings*. London, 2002.

Bonario 1974
Bonario, B. "Marco Basaiti: A Study of the Venetian Painter and a Catalogue of His Works." PhD diss., University of Michigan, 1974.

Bonicatti 1964
Bonicatti, Maurizio. "Per la formazione di Paris Bordon." *Bolletino d'Arte* 49 (1964), 249–251.

Bonicatti 1964a
Bonicatti, Maurizio. *Aspetti dell'umanesimo nella pittura veneta dal 1455 al 1515*. Rome, 1964.

Bonnet 1996
Bonnet, Jacques. *Lorenzo Lotto*. Paris, 1996.

Bonomi 1886
Bonomi, Giuseppe M. *Il quadri di Tiziano della famiglia Martinengo-Colleoni*. Bergamo, 1886.

Bora 1998
Bora, Giulio. "Giovanni Agostino da Lodi: attivo dal 1495 circa al 1520 circa." In *I leonardeschi: l'eredità di Leonardo in Lombardia*. Milan, 1998, 93–120.

Borean and Mason 2002
Borean, Linda, and Stefania Mason. "Cristoforo Orsetti e i suoi quadri di 'perfetta mano.'" In *Figure di collezionisti a Venezia tra Cinque e Seicento*. Linda Borean and Stefania Mason, eds. Udine, 2002, 119–157.

Borenius 1913
Borenius, Tancred. *A Catalogue of the Paintings at Doughty House, Richmond & Elsewhere in the Collection of Sir Frederick Cook*. Vol. 1. Italian Paintings. London, 1913.

Borenius 1914
Borenius, Tancred. *Catalogue of Italian Pictures at 16, South Street, Park Lane, London and Buckhurst in Sussex: Collected by Robert and Evelyn Benson*. London, 1914.

Borenius 1923
Borenius, Tancred. *The Picture Gallery of Andrea Vendramin*. London, 1923.

Borromeo 1625
Borromeo, Federico. *Musaeum Bibliothecae Ambrosianae*. Milan, 1625.

Boschetto 1963
Boschetto, Antonio. *Giovan Gerolamo Savoldo*. Milan, 1963.

Boschini 1676
Boschini, Marco. *I Gioieli pittoreschi…della Città di Vicenza*. Venice, 1676.

Bossaglia 1963
Bossaglia, Rossana. "La pittura bresciana del Cinquecento: i maggiori e i loro scolari." In *Storia di Brescia, vol. 2. La dominazione veneta (1426–1575)*. Brescia, 1963.

Bossaglia 1985
Bossaglia, Rossana. "Problemi aperti sul Savoldo." In *Giovanni Gerolamo Savoldo pittore bresciano: atti del convegno (Brescia 21–22 maggio 1983)*. G. Panazza, ed. Brescia, 1985, 9–12.

Bottari 1963
Bottari, Stefano. *Tutta la pittura di Giovanni Bellini*. 2 vols. Milan, 1963.

314

Botteon and Aliprandi 1893
Botteon, Vincenzo, and Antonio Aliprandi. *Intorno alla vita e alle opere di Giovanni Battista Cima.* Conegliano, 1893.

Botti 1891
Botti, G. *Catalogo delle R. R. Gallerie di Venezia.* Venice, 1891.

Bowron 2004
Bowron, Edgar Peters. In *Renaissance to Rococo. Masterpieces from the Wadsworth Atheneum Museum of Art.* Eric Zafran, ed. New Haven and London, 2004.

Braham 1974
Braham, Alan. "A Reappraisal of 'The Introduction of the Cult of Cybele at Rome' by Mantegna." *The Burlington Magazine* 115 (1974), 457–463.

Brendel 1955
Brendel, Otto J. "Borrowings from Ancient Art in Titian." *The Art Bulletin* 37 (1955), 113–125.

Bridgman 1964
Bridgman, Charles F. "The Amazing Patent on the Radiography of Paintings." *Studies in Conservation* 9 (1964), 135–139.

Brion 1971
Brion, Marcel. *Titien.* Paris, 1971.

Brizio 1964
Brizio, Anna Maria. "Lotto." In *Enciclopedia universale dell'arte.* Vol. 8. Venice and Rome, 1964.

Brockwell 1932
Brockwell, Maurice W. *Abridged Catalogue of the Pictures at Doughty House, Richmond, Surrey, in the Collection of Sir Herbert Cook.* London, 1932.

Brown 1974
Brown, Clifford M. "Andrea Mantegna and the Cornaro of Venice." *The Burlington Magazine* 116 (1974), 101–103.

Brown 1979
Brown, David Alan. *Berenson and the Connoisseurship of Italian Painting: A Handbook to the Exhibition* (exh. cat., National Gallery of Art, Washington). Baltimore, 1979.

Brown 1980
Brown, David Alan. "Italian School. xv–xvi Centuries." In *Small Paintings of the Masters.* Leslie Shore, ed. 3 vols. New York, 1980. Vol. 1, nos. 82–106.

Brown 1987
Brown, David Alan. *Andrea Solario.* Milan, 1987.

Brown 1992
Brown, David Alan. "Il Cenacolo di Leonardo: la prima eco a Venezia." In *Leonardo and Venice* 1992, 85–96.

Brown 1993
Brown, David Alan. "The Pentimenti in *The Feast of the Gods.*" In *Titian 500* 1993, 288–299.

Brown 1997
Brown, David Alan. In Brown, Humfrey, and Lucco 1997.

Brown 1999
Brown, Beverly Louise. Entries in *Rinascimento* 1999, 444–445, 454–455.

Brown 2001
Brown, David Alan, ed. *Virtue and Beauty. Leonardo's Ginevra de' Benci and Renaissance Portraits of Women* (exh. cat., National Gallery of Art, Washington). Washington, 2001.

Brown 2002
Brown, Jonathan. "Artistic Relations between Spain and England 1604–1655." In *Sale of the Century* 2002, 41–68.

Brown 2003
Brown, David Alan. In *Italian Paintings of the Fifteenth Century. National Gallery of Art, Washington.* Washington and New York, 2003.

Brown 2004
Brown, David Alan. In Ferino-Pagden and Nepi Scirè 2004, 170–172.

Brown, Humfrey, and Lucco 1997
Brown, David Alan, Peter Humfrey, and Mauro Lucco. *Lorenzo Lotto: Rediscovered Master of the Renaissance* (exh. cat., National Gallery of Art, Washington). New Haven and London, 1997.

Buckley 1977
Buckley, Elizabeth Trimble. "Poesia muta: allegory ad pastoral in the early paintings of Titian." PhD diss., University of California, 1977.

Bull 1993
Bull, David. "*The Feast of the Gods:* Conservation and Investigation." In *Titian 500* 1993, 366–373.

Bull and Plesters 1990
Bull, David, and Joyce Plesters. "*The Feast of the Gods*": *Conservation, Examination, and Interpretation.* Studies in the History of Art 40. National Gallery of Art. Washington, 1990.

Burckhardt 1860
Burckhardt, Jacob. *Die Cultur der Renaissance in Italien. Ein Versuch von Jacob Burckhardt.* Basel, 1860; English ed. *The Civilization of the Renaissance in Italy.* Vienna, New York, and Oxford, 1937.

Burckhardt 1898
Burckhardt, Jacob. *Beiträge zur Kunstgeschichte von Italien: das Altarbild—das Porträt in der Malerei—die Sammler.* (Orig. pub. Basel, 1898). In *Jacob Burckhardt Werke. Kritische Gesamtausgabe.* Vol. 6. Munich, 2000; Italian ed. *L'arte italiana del rinascimento: i collezionisti.* M. Ghelardi and S. Müller, eds. Venice, 1995.

Burckhardt 1905
Burckhardt, Rudolf. *Cima da Conegliano.* Leipzig, 1905.

Burroughs 1938
Burroughs, Alan. *Art Criticism from a Laboratory.* Boston, 1938.

Bury 1989
Bury, Michael. "The *Triumph of Christ*, after Titian." *Burlington Magazine* 131 (1989), 188–197.

Cadogan 1991
Cadogan, Jean K. In *Wadsworth Atheneum Paintings II. Italy and Spain. Fourteenth through Nineteenth Centuries.* Jean Cadogan, ed. Hartford, 1991.

Calvesi 1970
Calvesi, Maurizio. "La 'morte di bacio.' Saggio sull'ermetismo di Giorgione." *Storia dell'Arte* 7/8 (1970), 179–233.

Calvesi 1979
Calvesi, Maurizio. "Il tema della Sapienza nei 'Tre Filosofi.'" In *Giorgione* 1979, 83–90.

Camiz 1991
Camiz, Franca Trinchieri. "Music and Painting in Cardinal Del Monte's Household." *Metropolitan Museum Journal* 26 (1991), 215 (213–226).

Campori 1870
Campori, Giuseppe. *Raccolta di Cataloghi ed Inventarii inediti.* Modena, 1870.

Campori 1874
Campori, Giuseppe. "Tiziano e gli Estensi." *Nuova Antologia* 27 (1874), 581–620.

Cannon-Brookes 1977
Cannon-Brookes, Peter. *The Cornbury Park Bellini.* Birmingham, 1977.

Canova 1964
See Mariani Canova 1964.

[Cantalamessa] 1914
[Cantalamessa, G.] "R. Galleria Borghese. Acquisti e Doni." *Bollettino d'Arte* suppl. (1914), 91.

Capelli 1951
Capelli, U. "Nota al Savoldo giovane." *Emporium* (1951), 13–24.

Caroli 1975
Caroli, Flavio. *Lorenzo Lotto.* Florence, 1975.

Caroselli 1983
Caroselli, Susan Lyons. "A Portrait Bust of Caterina Cornaro by Tullio Lombardo." *Bulletin of the Detroit Institute of Arts* 61 (1983), 47–57.

Carratù 2001
Carratù, Tullia. Entry in *Titian to Tiepolo. Three Centuries of Italian Art* (exh. cat., National Gallery of Australia, Melbourne). Milan, 2001, 68–69, no. 9.

Casagrande di Villaviera 1968
Casagrande di Villaviera, Rita. *La Cortigiana veneziana del Cinquecento.* Milan, 1968.

Castelfranco 1955
Castelfranco, Giorgio. "Note su Giorgione." *Bollettino d'Arte* 40 (1955), 298–310.

Catalogue 1765
Catalogue des tableaux de la Galerie Electorale a Dresde. Jean Antoine Riedel and Chrêtien Frederic Wenzel. Dresden, 1765.

Cecchini 2000
Cecchini, Isabella. *Quadri e commercio a Venezia durante il Seicento. uno studio sul mercato dell'arte.* Venice, 2000.

Chambers and Pullan 1992
Chambers, David, and Brian Pullan, with Jennifer Fletcher, eds. *Venice, A Documentary History.* Cambridge, 1992.

Chiarini 1978
Chiarini, Gloria. In *Tiziano nelle Gallerie Fiorentine* (exh. cat., Palazzo Pitti, Florence). Florence, 1978, 196–208, no. 54.

Chojnacki 2000
Chojnacki, Stanley. *Women and Men in Renaissance Venice: Twelve Essays on Patrician Society.* Baltimore, 2000.

Chojnacki 2003
Chojnacki, Stanley. "Identity and Ideology in Renaissance Venice. The Third Serrata." In *The History and Civilization of an Italian State 1297–1797.* John Martin and Dennis Romano, eds. Baltimore, 2003, 263–284.

Christiansen 1985
Christiansen, Keith. "Giovanni Gerolamo Savoldo." In *The Age of Caravaggio* (exh. cat., Metropolitan Museum of Art, New York). New York and Milan, 1985.

Christiansen 1998
Christiansen, Keith. "The View from Italy." In *From Van Eyck to Bruegel. Early Netherlandish Painting in the Metropolitan Museum of Art.* M. W. Ainsworth and K. Christiansen, eds. New York, 1998, 39–61.

Christiansen 2004
Christiansen, Keith. "Giovanni Bellini and the Practice of Devotional Painting." In *Giovanni Bellini and the Art of Devotion.* Ronda Kasl, ed. (exh. cat., Indianapolis Museum of Art, Indianapolis). Indianapolis, 2004, 7–57; Italian ed. Venice, 2004, 123–153.

Cima 1962
Cima da Conegliano. Luigi Menegazzi, ed. (exh. cat., Palazzo dei Trecento, Treviso). Venice, 1962.

Clark 1958
Clark, Kenneth. *Leonardo da Vinci, überarbeitete ausgabe.* Harmondsworth, 1958.

Clark 1969
Clark, Kenneth. *Civilization, A Personal View.* London, 1969.

Claut 1986
Claut, Sergio. "All'ombra di Tiziano. Contributo per Girolamo Denti." *Antichità Viva* 25, nos. 5–6 (1986).

Cogliati Arano 1992
Cogliati Arano, Luisa. In *Leonardo and Venice* 1992, 326, cat. 62.

Cohen 1980
Cohen, Charles. *The Drawings of Giovanni Antonio da Pordenone.* Florence, 1980.

Cohen 1996
Cohen, Charles. *The Art of Giovanni Antonio da Pordenone. Between Dialect and Language.* 2 vols. Cambridge, 1996.

Colantuono 1991
Colantuono, Anthony. "*Dies Alcyoniae:* The Invention of Bellini's *Feast of the Gods.*" *Art Bulletin* 73 (1991), 237–256.

Coletti 1936
Coletti, Luigi. "Girolamo da Treviso il giovane." *La Critica d'Arte* (1936), 172–180.

Coletti 1953
Coletti, Luigi. *Lotto.* Bergamo, 1953.

Coletti 1955
Coletti, Luigi. *Tutta la pittura di Giorgione.* Milan, 1955; English ed. New York, 1962.

Coletti 1959
Coletti, Luigi. *Cima da Conegliano.* Venice, 1959.

Collins Baker 1923
Collins Baker, C. H. "Catena at Trafalgar Square." *The Burlington Magazine* (1923), 239–245.

Coltellacci, Reho, and Lattanzi 1981
Coltellacci, S., I. Reho, and M. Lattanzi. "Problemi di iconologia delle immagini sacre. Venezia c. 1490–1510." In *Giorgione* 1981, 97–112.

Cook 1900
Cook, Herbert. *Giorgione.* (Orig. pub. 1900). 2d ed. London, 1907.

Cook 1902
Cook, Herbert. "Pitture italiane esposte a Burlington House." *L'Arte* (1902), 114–122.

Cook 1912
Cook, Herbert. *Reviews and Appreciations of Some Old Italian Masters.* London, 1912.

Cook 1915
Cook, Herbert. *The Portrait of Caterina Cornaro (Finished by Titian).* London, 1915.

Cortesi Bosco 1992
Cortesi Bosco, Francesca. "'Divina vigilia': il sonno vigilante dell'Anima nel dipinto di Lorenzo Lotto K291 della National Gallery di Washington." *Notizie da Palazzo Albani* 21 (1992), 25–49.

Cottrell 2000
Cottrell, Philip. "Bonifacio's Enterprise. Bonifacio de' Pitati and Venetian Painting." PhD diss., University of St. Andrews, 2000.

Cranston 2000
Cranston, Jodi. *The Poetics of Portraiture in the Italian Renaissance.* Cambridge, 2000.

Cropper 1986
Cropper, Elizabeth. "The Beauty of Woman: Problems in the Rhetoric of Renaissance Portraiture." In *Rewriting the Renaissance. The Discourse of Sexual Difference in Early Modern Europe.* Margaret W. Ferguson et al., eds. Chicago, 1986, 175–190, 335–359.

Cropper 1995
Cropper, Elizabeth. "The Place of Beauty in the High Renaissance and Its Displacement in the History of Art." In *Place and Displacement in the Renaissance.* Alvin Vos, ed. Binghamton, NY, 1995, 159–205.

Crowe and Cavalcaselle 1871
Crowe, Joseph Archer, and Giovanni Battista Cavalcaselle. *A History of Painting in North Italy.* 2 vols. London, 1871.

Crowe and Cavalcaselle 1877
Crowe, Joseph Archer, and Giovanni Battista Cavalcaselle. *Titian: His Life and Times.* 2 vols. London, 1877; Italian ed. Florence, 1877–1878.

Crowe and Cavalcaselle 1878
See Crowe and Cavalcaselle 1877.

Crowe and Cavalcaselle 1912
See Crowe and Cavalcaselle 1871. Tancred Borenius, ed. Rev. ed. 3 vols. London, 1912.

D'Achiardi 1908
D'Achiardi, Pietro. *Sebastiano del Piombo.* Rome, 1908.

316

D'Achiardi 1912
D'Achiardi, Pietro. "Nuovi acquisti della R. Galleria Borghese." *Bollettino d'Arte* (3 March 1912), 92–93.

Dal Pozzo 1718
Dal Pozzo, Bartolomeo. *Vite de' Pittori Veronesi.* Verona, 1718.

Dal Pozzolo 1992
Dal Pozzolo, Enrico Maria. "Laura tra Polia e Berenice di Lorenzo Lotto." *Artibus et Historiae* 25 (1992), 103–127.

Dal Pozzolo 1993
Dal Pozzolo, Enrico Maria. "Il lauro di Laura e delle 'maritate venetiane.'" In *Mitteilungen des Kunsthistorischen Institutes in Florenz* 37 (1993), 257–292.

Dal Pozzolo 1997
Dal Pozzolo, Enrico Maria. "Tra Cariani e Rocco Marconi." *Venezia Cinquecento* 13 (1997), 8, 25 (5–37).

de Grummond 1975
de Grummond, Nancy Thomson. "vv and Related Inscriptions in Giorgione, Titian, and Dürer." *The Art Bulletin* 57 (1975), 346–356.

De Rinaldis 1798
De Rinaldis, G. *Della Pittura Friulana. Saggio Storico.* Udine, 1798.

De Rinaldis 1935
De Rinaldis, A. *La R. Galleria Borghese in Roma.* Rome, 1935.

De Vecchi 1990
De Vecchi, Pierluigi. "Die Mimesis im Spiegel." In Passamani 1990, 63–70.

Del Bravo 1987
Del Bravo, Carlo. "Giorgione." *Medioevo e Rinascimento* 1. Bari, 1987, 243–244.

Dell'Acqua 1955
Dell'Acqua, Gian Alberto. *Tiziano.* Milan, 1955.

Dell'Acqua 1992
Dell'Acqua, Gian Alberto. "La galleria federiciana e gli incrementi del tardo Seicento." In *Storia dell'Ambrosiana: il Seicento.* Milan, 1992, 297–334.

Della Pergola 1950
Della Pergola, Paola. *La Galleria Borghese.* Roma, 1950.

Della Pergola 1955
Della Pergola, Paola. *Galleria Borghese: I Dipinti.* 2 vols. Rome, 1955.

Della Pergola 1955
Della Pergola, Paola. *Giorgione.* Milan, 1955.

Demus 1973
Demus, Klaus. *Verzeichnis der Gemälde. Kunsthistorisches Museum, Wien.* Vienna, 1973.

Di Maniago 1819
Di Maniago, F. *Storia delle Belle Arti Friulane.* Venice, 1819.

Dionisotti 1987
Dionisotti, Carlo. "Giorgione e la letteratura di corte." In *La letteratura, la rappresentazione, la musica al tempo e nei luoghi di Giorgione.* M. Muraro, ed. Rome, 1987, 11–15. Reprinted in *Appunti su arti e lettere.* Milan, 1995, 111–116.

Dolce 1557
See Roskill 1968.

Dolce 1557a
Dolce, Lodovico. *Dialogo della pittura, intitolato l'Aretino.* Venice, 1557. In *Trattati d'arte del Cinquecento.* P. Barocchi, ed. Vol. 1. Bari, 1960, 143–206.

Douglas-Pennant 1902
Douglas-Pennant, Alice. *Catalogue of the Pictures at Penrhyn Castle and Mortimer House in 1901.* Privately printed, 1902.

Douglas-Scott 1996
Douglas-Scott, Michael. "Giovanni Bellini's *Madonna and Child with Two Saints and a Donor* at Birmingham: A Proposal." *Venezia Cinquecento* 6, no. 11 (1996), 5–21.

Dülberg 1990
Dülberg, Angelica. *Privatporträts. Geschichte und Ikonologie einer Gattung im 15. und 16. Jahrhundert.* Berlin, 1990.

Dunkerton 1994
Dunkerton, Jill. "Developments in Colour and Texture in Venetian Painting of the Early 16th Century." In *New Interpretations of Venetian Renaissance Painting.* Francis Ames-Lewis, ed. London 1994, 63–75.

Dunkerton 1999
Dunkerton, Jill. "Nord e Sud: tecniche pittoriche nella Venezia rinascimentale." In *Rinascimento* 1999, 92–103.

Dunkerton 2002
Dunkerton, Jill. "Giorgione." In *Art* 2002, 136–143.

Dunkerton 2003
Dunkerton, Jill. "Titian at Work. Titian's Painting Technique." In *Titian* 2003, 45–59.

Dunkerton 2004
Dunkerton, Jill. "Bellini's Technique." In Humfrey 2004, 195–225.

Dunkerton, Foister, and Penny 1999
Dunkerton, Jill, Susan Foister, and Nicholas Penny. *Dürer to Veronese: Sixteenth-Century Painting in the National Gallery.* London, 1999.

Dunkerton and Penny 1995
Dunkerton, Jill, and Nicholas Penny. "'Noli me tangere.' Londra, The National Gallery." In *Tiziano* 1995, 364–368.

Dunkerton and Plazzotta 2002
Dunkerton, Jill, and Plazzotta. "Drawing and Design in Italian Renaissance Painting." In *Art* 2002, 53–79.

Dunkerton and Spring 1998
Dunkerton, Jill, and Marika Spring. "The Development of Coloured Surfaces in Sixteenth-Century Italy." In *Painting Techniques: History, Materials and Studio Practice.* London, 1998, 120–130.

Dussler 1935
Dussler, Luitpold. *Giovanni Bellini, von Luitpold Dussler.* Frankfurt, 1935.

Dussler 1942
Dussler, Luitpold. *Sebastiano del Piombo.* Basel, 1942.

Dussler 1949
Dussler, Luitpold. *Giovanni Bellini.* Vienna, 1949.

Dussler 1956
Dussler, Luitpold. "Die Giorgione-Ausstellung in Venice." *Kunstchronik* 9 (1956), 1–5.

Ebert-Schifferer 1990
Ebert-Schifferer, Sybille. "Il Savoldo e il Nord: un processo di appropriazion." In *Giovanni Gerolamo Savoldo* 1990, 71–77.

Echols 1994
Echols, Robert. "Cima and the Theme of Saint Jerome in the Wilderness." *Venezia Cinquecento* 8 (1994), 47–69.

Egan 1959
Egan, Patricia. "Poesia and the Fête Champêtre." *The Art Bulletin* 41 (1959), 103–113.

Ekserdjian 1988
Ekserdjian, David. "Palma Vecchio, A Young Woman (La Bella)." In *Old Master Paintings from the Thyssen-Bornemisza Collection* (exh. cat., Royal Academy of Arts, London). MaryAnne Stevens, ed. Milan and London, 1988.

Ekserdjian 1997
Ekserdjian, David. "Lorenzo Lotto's Virgin and Child with St. Onophrius and St. Ignatius of Antioch." *Journal of the Warburg and Courtauld Institutes* 60 (1997), 251–253.

Engerth 1881
Engerth, E. R. von. *Kunsthistorische Sammlungen des Allerhöchsten Kaiserhauses, Gemälde. Beschreibendes Verzeichniss I: Italienische, spanische und französische Schulen.* Vienna, 1881.

Exhibition 1894-1895
Exhibition of Venetian Art (exh. cat., The New Gallery). London, 1894–1895.

Exhibition 1930
Exhibition of Italian Art. London, 1930.

Falchetti 1969
Falchetti, Antonia. *La Pinacoteca Ambrosiana.* Vicenza, 1969.

Falomir 2003
Falomir, Miguel, ed. *Tiziano* (exh. cat., Museo del Prado, Madrid). Madrid, 2003.

Federici 1803
Federici, D. *Memorie trevigiane sulle opere di disegno.* 2 vols. Venice, 1803.

Fehl 1957
Fehl, Philipp. "The Hidden Genre: A Study of the *Concert Champêtre* in the Louvre." *Journal of Aesthetics and Art Criticism* 16 (1957), 135–159.

Fehl 1974
Fehl, Philipp. "The Worship of Bacchus and Venus in Bellini's and Titian's Bacchanals for Alfonso d'Este." Studies in the History of Art 6. National Gallery of Art. Washington, 1974, 42–55.

Ferino-Pagden 1997
Ferino-Pagden, Sylvia. *Vittoria Colonna: Dichterin und Muse Michelangelos* (exh. cat., Kunsthistorisches Museum, Vienna). Vienna, 1997.

Ferino-Pagden and Nepi Scirè 2004
Ferino-Pagden, Sylvia, and Giovanna Nepi Scirè, eds. *Giorgione. Myth and Enigma* (exh. cat., Kunsthistorisches Museum, Vienna). Milan, 2004.

Ffoulkes 1888
Ffoulkes, Constance Jocelyn. *Handbook of the Italian Schools in the Dresden Gallery.* London, 1888.

Ffoulkes 1895
Ffoulkes, Constance Jocelyn. "L'esposizione dell'arte veneta a Londra." *Archivio Storico dell' Arte* 1 (1895), 254–256.

Finocchi Ghersi 2003
Finocchi Ghersi, Lorenzo. *I quattro secoli della pittura veneziana.* Venice, 2003.

Fiocco 1939
Fiocco, Giuseppe. *Giovanni Antonio da Pordenone.* Venice, 1939.

Fiocco 1941
Fiocco, Giuseppe. *Giorgione.* Bergamo, 1941 and 1948.

Fiocco 1947
Fiocco, Giuseppe. "Pitture veneziane ignote al Museo di Varsavia." *Arte Veneta* (1947), 276–283.

Fiocco 1948
See Fiocco 1941.

Fiocco 1956
Fiocco, Giuseppe. "The Flemish Influence in the Art of Gerolamo Savoldo." *The Connoisseur* (1956), 166–167.

Fiorenza 2001
Fiorenza, Giancarlo. "Pandolfo Collenuccio's Specchio d'Esopo and the Portrait of the Courtier." *I Tatti Studies. Essays in the Renaissance* 9 (2001), 63–87.

Fischer 1974
Fischer, Ernst. "Orpheus and Calais, on the Subject of Giorgione's *Concert Champêtre.*" In *Liber Amicorum, Karel G. Boon.* Amsterdam, 1974, 71–77.

Fletcher 1973
Fletcher, Jennifer. "Marcantonio Michiel's Collection." *Journal of the Warburg and Courtauld Institutes* 36 (1973), 382–385.

Fletcher 1989
Fletcher, J. "Bernardo Bembo and Leonardo's Portrait of Ginevra de' Benci." In *The Burlington Magazine* 131, no. 1041 (December 1989), 811–816.

Fletcher 1990
Fletcher, Jennifer M. "Harpies, Venus, and Giovanni Bellini's Classical Mirror: Some Fifteenth-Century Venetian Painters Responses to the Antique." *Venezia e l'archeologia: un importante capitolo nella storia del gusto dell'antico nella cultura artistica veneziana. (Congresso internazionale, Venezia, 25–29 maggio 1988). Rivista di Archeologia, Supplementi 7.* Gustavo Traversi and Irene Favoretto, eds. Rome, 1990, 170–176.

Fletcher and Skipsey 1991
Fletcher, Jennifer, and David Skipsey. "Death in Venice: Giovanni Bellini and the Assassination of St. Peter Martyr." *Apollo* 133, no. 347 (January 1991), 4–9.

Fogolari 1935
Fogolari, Gino. *Mostra di Tiziano: catalogo delle opere.* Venice, 1935.

Fomiciova 1977
Fomiciova, T. "Lo sviluppo compositivo della Venere allo specchio con gli amorini nell'opera di Tiziano e la copia dell'eremitage." *Arte Veneta* 31 (1977), 195–199.

Fomiciova 1979
Fomiciova, Tamara. "Giorgione e la Formazione della Pittura di Genere nell'Arte Veneziano del XVI secolo." In *Giorgione* 1979, 159–164.

Foratti 1912
Foratti, A. *Note su Jacopo Palma il Vecchio.* Padua, 1912.

Fornari Schianchi 1997
Fornari Schianchi, Lucia. *Galleria nazionale di Parma. Catalogo delle opere dall'Antico al cinquecento.* Milan, 1997.

Fornari Schianchi 2005
Fornari Schianchi, Lucia. "Il restauro della Sacra Conversazione Magnani Rocca." In *Tiziano. Restauri, Tecniche, Programmi, Prospettive.* Giuseppe Pavanello, ed. Venice, 2005, 59–71.

Fornoni 1880
Fornoni, E. *Notizie biografiche su Palma Vecchio.* Bergamo, 1886.

Förster 1878
Förster, E. *Geschichte der italienischen Kunst.* Vol. 5. Leipzig, 1878.

Fortini Brown 1988
Fortini Brown, Patricia. *Venetian Narrative Painting in the Age of Carpaccio.* New Haven and London, 1988.

Fossaluzza 1984
Fossaluzza, Giorgio. "Codice diplomatico bordoniano." In *Paris Bordon* 1984, 115–140.

Fossaluzza and Manzato 1987
Fossaluzza, Giorgio, and Eugenio Manzato, eds. *Paris Bordon e il suo Tempo: Atti del Convegno Internazionale di Studi.* Treviso, 1987.

Frangi 1986
Frangi, Francesco. "Giovanni Girolamo Savoldo." In *Pittura del Cinquecento a Brescia.* Mina Gregorim, ed. Milan, 1986.

Frangi 1988
Frangi, Francesco. "Savoldo Giovanni Girolamo." In *La Pittura in Italia. Il Cinquecento.* Milan, 1988, 833–834.

Frangi 1992
Frangi, Francesco. *Savoldo.* Florence, 1992.

Frangi 1993
Frangi, Francesco. "Giovan Gerolamo Savoldo." In *Le Siècle de Titien* 1993, 449–450.

Fredericksen and Zeri 1972
Fredericksen, Burton B., and Federico Zeri. *Census of Pre-Nineteenth-Century Italian Paintings in North American Public Collections.* Cambridge, 1972.

Freedberg 1961
Freedberg, Sydney J. *Painting of the High Renaissance in Rome and Florence.* 2 vols. Cambridge, Mass., 1961.

Freedberg 1975
Freedberg, Sydney J. *Painting in Italy 1500 to 1600.* (Orig. pub. 1971). Rev. ed. Harmondsworth, 1975.

318

Freedberg 1988
Freedberg, Sydney J. *La Pittura in Italia dal 1500 al 1600*. Bologna, 1988.

Freedberg 1993
Freedberg, Sydney J. "The Attribution of the Allendale *Nativity*." In *Titian 500* 1993, 51–71.

Freedberg 1994
Freedberg, Sydney J. "The 'Benson Holy Family': A Reconsideration." In *Hommage à Michel Laclotte: études sur la peinture du Moyen Age et de la Renaissance*. Paris, 1994, 329–340.

Freedman 1987
Freedman, Luba. "The Schiavona: Titian's Response to the Paragone between Painting and Sculpture." *Arte veneta* 41 (1987), 31–40.

Friedländer 1955
Friedländer, Walter. *Caravaggio Studies*. Princeton, 1955.

Friedmann 1980
Friedmann, Herbert. *A Bestiary for St. Jerome: Animal Symbolism in European Religious Art*. Washington, 1980.

Frimmel 1888
Frimmel, Theodor von, ed. *Der Anonimo Morelliano: Marcanton Michiel's Notizia d'opere del disegno*. Vienna, 1888.

Frimmel 1913
Frimmel, Theodor von. *Lexikon der Wiener Gemäldesammlungen*. Munich, 1913.

Frizzoni 1890
Frizzoni, Gustavo. "La raccolta Galliera in Genova." *Archivio Storico dell'Arte* 3 (1890), 119–126.

Fry 1900
Fry, Roger E. *Giovanni Bellini*. London, 1900.

Fry 1901
Fry, Roger E. *Giovanni Bellini*. London, 1901.

Fry 1909
Fry, Roger E. "On a Picture Attributed to Giorgione." *The Burlington Magazine* (1909), 6–9.

Fry 1912
Fry, Roger E. "Exhibition of Pictures of the Early Venetian School at the Burlington Fine Arts Club, III." *The Burlington Magazine* (1912), 95–96.

Furlan 1988
Furlan, Caterina. *Il Pordenone*. Milan, 1988.

Galassi 1998
Galassi, Maria Clelia. "La produzione 'seriale' nella bottega di Giovanni Bellini indagini sulle due Madonne del Museo del Castelvecchio." *Verona illustrata* 11 (1998), 3–11, figs. 1–17.

Galassi 1998a
Galassi, Maria Clelia. *Il disegno svelato: Progetto e immagine della pittura italiana del primo Rinascimento*. Nuoro, 1998.

Galis 1977
Galis, Diana Wronski. "Lorenzo Lotto: A Study of His Career and Character with Particular Emphasis on His Emblematic and Hieroglyphic Works." PhD diss., Bryn Mawr College, 1977.

Gallina 1954
Gallina, L. *Giovanni Cariani: (materiale per uno studio)*. Bergamo, 1954.

Gamba 1937
Gamba, Carlo. *Giovanni Bellini*. Milan, 1937.

Gamba 1939
Gamba, Carlo. "Pittori bresciani del Rinascimento: Gian Girolamo Savoldo." *Emporium* (1939), 373–388.

Gamba 1954
Gamba, Carlo. "Il mio Giorgione." *Arte Veneta* 8 (1954), 172–177.

Garas 1964
Garas, Klára. "Giorgione et giorgionisme au XVIIᵉ siècle, I." *Bulletin du Musée Hongrois des Beaux-Arts* 25 (1964), 51–80.

Garas 1966
Garas, Klára. "Giorgione et giorgionisme au XVIIᵉ siècle, III." *Bulletin du Musées Hongrois des Beaux-Arts* 28 (1966), 69–93.

Garas 1967
Garas, Klara. "Die Enstehung der Galerie des Erzherzogs Leopold Wilhelm." *Jahrbuch der kunsthistorischen Sammlungen in Wien* 63 (1967), 39–80.

***Gemäldegalerie* 1991**
Die Gemäldegalerie des Kunsthistorischen Museums in Wien: Verzeichnis der Gemälde. S. Ferino-Pagden, W. Prohaska, and K. Schutz, eds. Vienna, 1991.

***Genius of Venice* 1983**
Genius of Venice. Charles Hope and Jane Martineau, eds. (exh. cat., Royal Academy of Arts, London). London, 1983.

Gentili 1980
Gentili, Augusto. *Da Tiziano a Tiziano. Mito e allegoria nella cultura veneziana del Cinquecento*. 1st ed. Rome, 1980; 2d ed. Rome, 1988.

Gentili 1981
Gentili, Augusto. "Per la dimitizzazione di Giorgione: Documenti, ipotesi, provocazione." In *Giorgione e la cultura veneta*. Venice, 1981.

Gentili 1985
Gentili, Augusto. *I Giardini di Contemplazione: Lorenzo Lotto 1503/1512*. Rome, 1985.

Gentili 1988
See Gentili 1980.

Gentili 1990
Gentili, Augusto. "Savoldo, il ritratto e l'allegorie musicale." In *Giovanni Gerolamo Savoldo tra Foppa, Giorgione, e Caravaggio*. Milan, 1990, 65 (65–70).

Gentili 1991
Gentili, Augusto. "Giovanni Bellini, la bottega, I quadri di devozione." *Venezia Cinquecento* 1, no. 2 (1991), 27–60.

Gentili 1994
Gentili, Augusto. "La tematica musicale nella cultura figurativa di Venezia, ca. 1500–1515." In *I Tempi di Giorgione*. Ruggero Maschio, ed. Rome, 1994, 84–95.

Gentili 1994a
Gentili, Augusto. "Smontando e rimontando le costruzioni simboliche delle pale d'altare." *Venezia Cinquecento* 8 (1994), 71–92.

Gentili 1995
Gentili, Augusto. "Amore e amorose persone: tra miti ovidiani, allegorie musicali, celebrazioni matrimoniali." In *Tiziano* 1995, 82–105.

Gentili 2000
Gentili, Augusto, ed. "Atti del Convegno Internazionale di Studi su Lorenzo Lotto." *Venezia Cinquecento* 10, nos. 19–20 (2000).

Gentili 2000a
Gentili, Augusto. "Giorgio da Castelfranco, detto Giorgione." In *Dizionario Biografico degli Italiani*. Vol. 55. Rome, 2000, 350–361.

Gentili 2004
Gentili, Augusto. "Bellini and Landscape." In Humfrey 2004, 167–181.

Gentili 2006
Gentili, Augusto. "A proposito di Giorgione: aspirazioni, esiti e limiti dell'iconologia." In *Giorgione Symposium Act*, the forthcoming volume of the proceedings of the Giorgione conference in Vienna, 2004. Turnhout, 2006, 93–104.

Gibbons 1965
Gibbons, Felton. "Practices in Giovanni Bellini's Workshop." *Pantheon* 23 (1965), 146–155.

Gibbons 1978
Gibbons, Felton. "Giorgione's Humanism in the *Tempesta* and the *Three Philosophers*." *Antichità Viva* 17, no. 4/5 (1978), 12–36.

Gilbert 1945
Gilbert, Creighton E. "Milan and Savoldo." *The Art Bulletin* (1945), 124–138.

Gilbert 1952
Gilbert, Creighton E. "Per i Savoldo visti dal Vasari." In *Studi vasariani. Atti del Convegno Internazionale per il IV centenario della prima edizione delle "Vite" del Vasari. Firenze, Palazzo Strozzi, 16–19 settembre 1950.* Florence, 1952, 146–152.

Gilbert 1955
Gilbert, Creighton E. *The Works of Girolamo Savoldo.* New York, 1955.

Gilbert 1980
Gilbert, Creighton E. "Some Findings on Early Works of Titian." *The Art Bulletin* (1980), 36–75.

Gilbert 1983
Gilbert, Creighton E. "Giovanni Girolamo Savoldo." In *Genius of Venice* 1983, 202–206.

Gilbert 1986
Gilbert, Creighton E. *The Works of Girolamo Savoldo.* New York, 1986.

Gilbert 1991
Gilbert, Creighton E. "Newly Discovered Paintings by Savoldo in Relation to Their Patronage." *Arte Lombarda* 96–97 (1991), 29–46.

Gilbert 2003
Gilbert, Creighton E. "Savoldo's *Death of Peter Martyr*." *Arte documento* 17/19 (2003), 290–293.

Giorgione **1978**
Giorgione a Venezia (exh. cat., Gallerie dell'Accademia, Venice). Milan, 1978.

Giorgione **1979**
Giorgione. Atti del Convegno Internazionale di studio per il quinto centenario della nascita (Castelfranco Veneto, 1978). Castelfranco Veneto, 1979.

Giorgione **1981**
Giorgione e la cultura veneta tra '400 e '500. Rome, 1981.

Giorgione **1994**
I tempi di Giorgione. Ruggero Maschio, ed. Rome, 1994.

Giorgione **2004**
See Ferino-Pagden and Nepi Scirè 2004.

Giorgione **2006**
Giorgione Symposium Acts. Forthcoming volume of the proceedings of the Giorgione conference in Vienna, 2004. Sylvia Ferino-Pagden, ed. Turnhout, 2006.

Gioseffi 1979
Gioseffi, D. "Giorgione e la pittura tonale." In *Giorgione* 1979, 91–98.

Giovanni Bellini a Milano **1986**
Giovanni Bellini a Milano. Milan, 1986.

Giovanni Gerolamo Savoldo **1990**
Giovanni Gerolamo Savoldo (exh. cat., Monastero di Santa Giulia, Brescia). Milan, 1990.

Gli Uffizi **1979**
Gli Uffizi. Catalogo Generale. Florence, 1979.

Goffen 1989
Goffen, Rona. *Giovanni Bellini.* New Haven and London, 1989.

Goffen 1991
Goffen, Rona. "Bellini's Nude with Mirror." *Venezia cinquecento* 1, no. 2 (1991), 185–199.

Goffen 1993
Goffen, Rona. "Titian's Sacred and Profane Love: Individuality and Sexuality in a Renaissance Marriage Picture." In *Titian 500* 1993, 121–144.

Goffen 1997
Goffen, Rona. *Titian's Women.* New Haven and London, 1997.

Goffen 2002
Goffen, Rona. *Renaissance Rivals: Michelangelo, Leonardo, Raphael, and Titian.* New Haven and London, 2002.

Goffen and Nepi Scirè 2000
Goffen, Rona, and Giovanna Nepi Scirè, eds. *Il color ritrovato: Bellini a Venezia* (exh. cat., Gallerie dell'Accademia, Venice). Venice, 2000.

Gombosi 1932
Gombosi, György. "Palma Jacopo, gen. Palma il Vecchio." In U. Thieme and F. Becker. *Allgemeines Lexikon der Bildenden Künstler von der Antike bis zur Gegenwart.* Vol. 26. Leipzig, 1932, 172–176.

Gombosi 1937
Gombosi, György. *Palma Vecchio. Des Meister Gemälde und Zeichnungen.* Stuttgart and Berlin, 1937.

Gombrich 1948, 1978 ed.
Gombrich, Ernst. *Tobiolo e l'angelo.* 1948. Reprinted in *Immagini simboliche. Studi sull'arte del Rinascimento.* Turin, 1978, 39–45.

Goodman-Soellner 1983
Goodman-Soellner, Elise. "Poetic Interpretations of the 'Lady at Her Toilette' Theme in Sixteenth-Century Painting." *The Sixteenth Century Journal* 14 (1983), 426–442.

Götz-Mohr 1987
Götz-Mohr, Brita von. *Individuum und soziale Norm. Studien zum italienischen Frauenbildnis des 16. Jahrhunderts.* Europäische Hochschulschriften Reihe XXVIII. Vol. 72. Frankfurt, 1987.

Gould 1958
Gould, Cecil. "A Famous Titian Restored." *The Burlington Magazine* (1958), 44–48.

Gould 1959
Gould, Cecil. *The Sixteenth-Century Italian Schools.* London, 1959.

Gould 1961
Gould, Cecil. "New Light on Titian's 'Schiavona' Portrait." *The Burlington Magazine* 103 (1961), 335–340.

Gould 1969
Gould, Cecil. *The Studio of Alfonso d'Este and Titian's "Bacchus and Ariadne": A Re-Examination of the Chronology of the Bacchanals and of the Evolution of One of Them.* London, 1969.

Gould 1975
Gould, Cecil. *The Sixteenth-Century Italian Schools.* National Gallery, London, 1975. 2d rev. ed. 1987.

Grave 2004
Grave, Johannes. *Landschaften der Meditation. Giovanni Bellinis Assoziationsräume.* Freiburg im Breisgau, 2004.

Gregori 1986
Gregori, Mina. "Riflessioni sulla pittura bresciana della prima metà del Cinquecento." In *Pittura del Cinquecento a Brescia.* Mina Gregori, ed. Milan, 1986, 9–16.

Grignani 1973
Grignani, M. A. "Badoer, Filenio, Pizio: un trio bucolico a Venezia." In *Studi di Filologia e di Letteratura Italiana offerti a Carlo Dionisotti.* Milan and Naples, 1973, 77–115.

Gronau 1895
Gronau, Georg. "Correspondance d'Angleterre: l'Art venitien a Londres, à propos de l'exposition de la New Gallery." *Gazette des Beaux-Arts* (1895), 247–264.

Gronau 1900
Gronau, Georg. *Tizian.* Berlin, 1900.

Gronau 1904
Gronau, Georg. *Titian.* London and New York, 1904.

Gronau 1908
Gronau, Georg. "Kritische Studien zu Giorgione." *Repertorium für Kunstwissenschaft* 31 (1908).

Gronau 1921
Gronau, Georg. "Giorgione." In U. Thieme and F. Becker. *Allgemeines Lexikon der Bildenden Künstler von der Antike bis zur Gegenwart.* Vol. 14. Leipzig, 1921, 86–90.

Gronau 1928
Gronau, Georg. *Spätwerke des Giovanni Bellini.* Strassburg, 1928.

320

Gronau 1930
Gronau, Georg. *Giovanni Bellini: des Meisters Gemälde in 207 Abbildungen.* Stuttgart and Berlin, 1930.

Gruber 2004
Gruber, Gerlinde. Entry in *Transalpinum* (exh. cat., Kunsthistorisches Museum, Vienna; National Gallery, Warsaw; National Gallery, Gdansk). Olszanica, 2004.

Gualandi 1844-1856
Gualandi, Michelangelo. *Nuova raccolta di lettere sulla pittura, scultura ed architettura scritte da i piu celebri personaggi dei secole XV a XIX, con note ed illustrazioni di Michelangelo Gualandi in aggiunta a quella data in luce da Mons. Giovanni G. Bottari e dal Ticozzi.* Bologna, 1844–1856.

Guarino 1995
Guarino, Sergio. "'Noli me tangere.'" In *Tiziano 1995,* 245–246.

Guidoni 1999
Guidoni, Enrico. *Giorgione. Opere e significati.* Rome, 1999.

Guillaume 1980
Guillaume, Marguerite. *Peintures Italiennes: catalogue raisonné du Musée des Beaux-Arts de Dijon.* Dijon, 1980.

Guthmüller 1994
Guthmüller, Bodo. "Nicht länger schweigen: Moderata Fontes Dialog, il merito delle donne." In *Die Frau in der Renaissance.* Paul Gerhard Schmidt, ed. Wiesbaden, 1994, 157–177.

Habert 1990
Habert, Jean. In *Titian 1990.*

Habert 1993
Habert, Jean. In *Le Siècle de Titien 1993.*

Hadeln 1912
Hadeln, Detlev von. "Catena, Vincenzo di Biagio." In U. Thieme and F. Becker. *Allgemeines Lexikon der Bildenden Künstler von der Antike bis zur Gegenwart.* Vol. 6. Leipzig, 1912, 182–183.

Hadeln 1925
Hadeln, Detlev von. "Notes on Savoldo." *Art in America* (1925), 72–82.

Haitowsky 1990
Haitowsky, D. "Giorgione's 'Trial of Moses': A New Look." *Jewish Art* 16 (1990), 20–29.

Hammer-Tugendhat 1989
Hammer-Tugendhat, Daniela. "Jan van Eyck—Autonomisierung des Aktbildes und Geschlechterdifferenz." *Kritische Berichte* 3 (1989), 78–100.

Hartlaub 1942
Hartlaub, Gustav. "Die Spiegelbilder des Giovanni Bellini." *Pantheon* 129–130 (1942), 235–241.

Hartlaub 1951
Hartlaub, Gustav Friedrich. *Zauber des Spiegels: Geschichte und Bedeutung des Spiegels in der Kunst.* München, 1951.

Hartt 1970
Hartt, Frederick. *A History of Italian Renaissance Art: Painting, Sculpture, Architecture.* London, 1970.

Haskell 1971
Haskell, Francis. "Giorgione's Concert Champêtre and Its Admirers." *Journal of the Royal Society for the Encouragement of Arts, Manufacturers and Commerce* (1971), 543–555.

Haskell 1989
Haskell, F. "Charles 1's Collection of Pictures." In *The Late King's Goods. Collections, Possessions and Patronage of Charles 1 in the Light of the Commonwealth Sale Inventories.* A. McGregor, ed. London and Oxford, 1989, 203–231.

Heimbürger 1999
Heimbürger, Minna. *Dürer e Venezia. Influssi di Albrecht Dürer sulla Pittura Veneta del primo Cinquecento.* Rome, 1999.

Heinemann 1962
Heinemann, Fritz. *Giovanni Bellini e i Belliniani.* 3 vols. Venice and Hildesheim, 1962.

Heinemann 1969
Heinemann, Rudolf. *The Thyssen-Bornemisza Collection.* Castagnola, 1969.

Heinemann 1991
Heinemann, Fritz. *Giovanni Bellini e i Belliniani.* Vol. 3. Hildesheim, Zürich, and New York, 1991.

Held 1961
Held, Julius. "Flora, Goddess and Courtesan." In *De Artibus Opuscula XL: Essays in Honor of Erwin Panofsky.* Millard Meiss, ed. New York, 1961, 201–218.

Helke 1999
Helke, G. "Giorgione. Maler des Paragone." *Jahrbuch des Kunsthistorischen Museums* 1 (1999), 11–79.

Helke 2002/2003
Helke, Gabriele. "Lorenzo Lottos Spiegel im Dienst von Paragone und Religion." *Jahrbuch des Kunsthistorischen Museums* 45 (2002/2003), 77–120.

Hendy 1964
Hendy, Philip. *Some Italian Renaissance Pictures in the Thyssen-Bornemisza Collection.* Lugano-Castagnola, 1964, 95–96.

Hendy and Goldscheider 1945
Hendy, Philip, and Ludwig Goldscheider. *Giovanni Bellini.* Oxford, 1945.

Hermanin 1933
Hermanin, Federico. *Il Mito di Giorgione.* Spoleto, 1933.

Hetzer 1920
Hetzer, Theodor. *Die früher Gemälde des Tizian: eine stilkritische Untersuchung.* Basel, 1920.

Hetzer 1926
Hetzer, Theodor. "Vecellio, Tiziano." 1926. In U. Thieme and F. Becker. *Allgemeines Lexikon der Bildenden Künstler von der Antike bis zur Gegenwart.* Vol. 34. Leipzig, 1940, 158–172.

Hills 1999
Hills, Paul. *Venetian Colour: Marble, Mosaic, Painting, and Glass, 1250–1550.* New Haven, 1999.

Hirsch and Shapley 1960
Hirsch, Richard, and Fern Rusk Shapley. *Gothic to Baroque in Sculpture, Drawings, Prints: Allentown Art Museum.* Allentown, 1960.

Hirst 1981
Hirst, Michael. *Sebastiano del Piombo.* Oxford, 1981.

Hirst and Mayr 1997
Hirst, Michael, and Gudula Mayr. "Michelangelo, Pontormo und das Noli me tangere für Vittoria Colonna." In Ferino-Pagden 1997, 335–344.

Hirt 1830
Hirt, A. L. *Kunstbemerkungen auf einer Reise über Wittenberg und Meißen nach Dresden und Prag.* Berlin, 1830.

Hochmann 2004
Hochmann, Michel. *Venise et Rome 1500–1600. Deux Écoles de Peinture et leurs Échanges.* Geneva, 2004.

Hofer 1946
Hofer, P. *Die italienische Landschaft im 16. Jahrhundert: erster Teil: Die Schulen und Meister; I/II Venedig und Verona.* Bern, 1946.

Holberton 1987
Holberton, Paul. "The Choice of Texts for the Camerino Pictures." In *Bacchanals by Titian and Rubens.* Görel Cavalli-Björkman, ed. Stockholm, 1987, 57–66.

Holberton 1993
Holberton, Paul. "The *Pastorale* or *Fête Champêtre* in the Early Sixteenth Century." In *Titian 500* 1993, 245–262.

Holberton 1994
Holberton, Paul. "Varieties of Giorgionismo." In *New Interpretation of Venetian Renaissance Painting.* Francis Ames-Lewis, ed. London, 1994, 31–41.

Holberton 2003
Holberton, Paul. "To Loosen the Tongue of Mute Poetry: Giorgione's Self-Portrait as 'David' as a Paragone Demonstration." In *Poetry on Art. Renaissance to Romanticism*. Thomas Frangenberg, ed. Donington, Lincolnshire, 2003, 29–47.

Holberton 2006
Holberton, Paul. "Giorgione's *sfumato*." In *Giorgione Symposium Act*, the forthcoming volume of the proceedings of the Giorgione conference in Vienna, 2004. Turnhout, 2006, 43–57.

Holmes 1914
Holmes, C. J. "La Schianova, by Titian." *The Burlington Magazine* 26 (1914), 15–16.

Holmes 1923
Holmes, C. "Giorgione Problems at Trafalgar Square." *The Burlington Magazine* (1923), 169–181, 230–239.

Holmes 1929
Holmes, C. *The National Gallery Catalogue*. London, 1929.

Hope 1971
Hope, Charles. "The 'Camerino d'Alabastro' of Alfonso d'Este—I." *The Burlington Magazine* 113, no. 824 (November 1971), 641–650.

Hope 1971a
Hope, Charles. "The 'Camerino d'Alabastro' of Alfonso d'Este—II." *The Burlington Magazine* 113, no. 825 (December 1971), 712–721.

Hope 1980
Hope, Charles. *Titian*. London and New York, 1980.

Hope 1987
Hope, Charles. "The Camerino d'Alabastro: A Reconsideration of the Evidence." In *Bacchanals by Titian and Rubens*. Görel Cavalli-Björkman, ed. Stockholm, 1987, 25–42.

Hope 1993
Hope, Charles. "The Early Biographies of Titian." In *Titian 500* 1993, 167–197.

Hope 2003
Hope, Charles. Review of Titian exhibition at Museo del Prado. *The Burlington Magazine* 145 (2003), 740–742.

Hope 2004
Hope, Charles. "Giorgione's Fortuna critica." In Ferino-Pagden and Nepi Scirè 2004, 41–55.

Hope and Martineau 1983
Hope, Charles, and Jane Martineau, eds. *Genius of Venice* (exh. cat., Royal Academy of Arts, London). London, 1983.

Hope and Van Asperen de Boer 1991
Hope, Charles, and J. R. J. Van Asperen de Boer. "Underdrawings by Giorgione and His Circle." In *Le Dessin sous-jacent dans la Peinture*. Hélène Verougstraete-Marcq and Roger Van Schoute, eds. Louvain, 1991, 127–140.

Hörnig 1975
Hörnig, Christian. Review of Huse 1972. *Kunstchronik* 28 (1975), 454.

Hörnig 1976
Hörnig, H. "Giorgiones Spätwerk." *Annali della Scuola Normale Superiore di Pisa* 3 (1976), 877–927.

Hörnig 1987
Hörnig, Christian. *Giorgiones Spätwerk*. Munich, 1987.

Hours 1955
Hours, Magdeleine. "Examen sommaire fait au laboratoire d'études scientifiques de la peinture du Musée du Louvre sur le tableau de Giorgione: *Le Concert Champêtre*." *Bollettino d'arte* 40 (1955), 310.

Hours 1964
Hours, Magdeleine. *Les secrets des chefs-d'œuvres*. Paris, 1964.

Hours 1976
Hours, Magdeleine. "Contributions à l'étude de quelques œuvres du Titien." *Laboratoire de Recherche des Musées de France, Annales* (1976), 30–33.

Hourticq 1919
Hourticq, Louis. *La Jeunesse de Titien*. Paris, 1919.

Hübner 1880
Hübner, J. *Verzeichniss der Koniglichen Gemalde-Gallerie zu Dresden*. Dresden, 1880.

Humfrey 1982
Humfrey, Peter. "Cima da Conegliano a Parma." *Saggi e Memorie di Storia dell'Arte* 13 (1982), 35–46.

Humfrey 1983
Humfrey, Peter. *Cima da Conegliano*. Cambridge, 1983.

Humfrey 1986
Humfrey, Peter. "Some Additions to the Cima Catalogue." *Arte Veneta* 40 (1986), 154–156.

Humfrey 1990
Humfrey, Peter. *La Pittura Veneta del Rinascimento a Brera*. Florence, 1990.

Humfrey 1991
Humfrey, Peter. "Two Lost St. Jerome Altarpieces by Giovanni Bellini." *Venezia Cinquecento* 1, no. 2 (1991), 109–117.

Humfrey 1993
Humfrey, Peter. *The Altarpiece in Renaissance Venice*. New Haven and London, 1993.

Humfrey 1995
Humfrey, Peter. *Painting in Renaissance Venice*. New Haven and London, 1995.

Humfrey 1997
Humfrey, Peter. *Lorenzo Lotto*. New Haven and London, 1997.

Humfrey 1997a
Humfrey, Peter. In Brown, Humfrey, and Lucco 1997, 161–164, no. 28; 172–174, no. 32; and 185–187, no. 38.

Humfrey 2003
Humfrey, Peter. "The Patron and Early Provenance of Titian's *Three Ages of Man*." *The Burlington Magazine* (2003), 787–791.

Humfrey 2004
Humfrey, Peter, ed. *The Cambridge Companion to Giovanni Bellini*. Cambridge and New York, 2004.

Huse 1972
Huse, Norbert. *Sudien zu Giovanni Bellini*. Berlin, 1972.

Huse 1990
See Huse and Wolters 1986.

Huse and Wolters 1986
Huse, Norbert, and Wolfgang Wolters. *Venedig. Die Kunst der Renaissance*. Munich, 1986; English ed. *The Art of Renaissance Venice. Architecture, Sculpture and Painting, 1460–1590*. Edmund Jephcott, trans. Chicago and London, 1990.

Iamurri 2001
Iamurri, Laura. "Questo bellissimo quadro ha una lunga storia. Note sulla vendita della *Schiavona* di Tiziano." *Ricerche di storia dell'arte* 73 (2001), 49–55.

Il gioco 1990
Il gioco dell'Amore: Le cortigiane di Venezia dal Trecento al Settecento (exh. cat., Casinò Municipale Ca' Vendramin Calergi, Venice). Milan, 1990.

Il Pordenone 1984
Il Pordenone. Caterina Furlan, ed. (exh. cat., Villa Manin, Passeriano, and church of San Francesco, Pordenone). Milan, 1984.

Ingenhoff-Danhäuser 1984
Ingenhoff-Danhäuser, Monika. *Maria Magdalena: Heilige und Sünderin in der italienischen Renaissance. Studien zur Ikonographie der Heiligen von Leonardo bis Tizian*. Tübingen, 1984.

Inventarium 1659
Inventarium aller unndt jeder Ihrer hochfürstlichen Durchleücht Herrn Leopoldt Wilhelmen…zue Wienn vorhandenen Mahllereyen… Fürstl. Schwarzenbergsches Centralarchiv. Krumau. (Comp. 1659). Pub. in A. von Berger. *Jahrbuch der Kunsthistorischen Sammlungen des Allerhöchsten Kaiserhauses* 1 (1883), 46–177.

322

Jacobsen 1896
Jacobsen, Emil. "Le Gallerie Brignole-Sale Deferrari in Genova." *Archivio Storico dell'Arte.* 2d series. Vol. 2 (1896), 88–129.

Jacobsen 1974
Jacobsen, M. A. "Savoldo and Northern Art." *The Art Bulletin* (1974), 530–534.

Jaffé 2003
Jaffé, David, ed. *Titian* (exh. cat., National Gallery, London). London, 2003.

Jaubert 1994
Jaubert, Alain. *Souvenir d'Arcadie. Le Concert champêtre, Tiziano Vecellio.* Paris 1994, film.

Joannides 1990
Joannides, Paul. "Savoldo: Minimalist Refinement." Review of *Giovanni Gerolamo Savoldo 1990. Apollo* 132, no. 341 (1990), 56–57.

Joannides 1991
Joannides, Paul. "Titian's *Daphnis and Chloe.* A Search for the Subject of a Familiar Masterpiece." *Apollo* (1991), 374–382.

Joannides 1992
Joannides, Paul. "Titian's *Judith* and Its Context. The Iconography of Decapitation." *Apollo* 361 (1992), 163–170.

Joannides 1994
Joannides, Paul. "Two Topics in the Early Work of Titian." *Apollo* (1994), 17–27.

Joannides 2001
Joannides, Paul. *Titian to 1518. The Assumption of Genius.* New Haven and London, 2001.

Joannides 2004
Joannides, Paul. "Titian and Michelangelo/Michelangelo and Titian." In Meilman 2004, 121–145.

Jones 1993
Jones, Pamela M. *Federico Borromeo and the Ambrosiana. Art Patronage and Reform in Seventeenth-Century Milan.* Cambridge, 1993.

Joost-Gaugièr 1999
Joost-Gaugièr, Christiane. "The Mute Poetry of the *Fête Champêtre:* Titian's Memorial to Giorgione." *Gazette des Beaux-Arts* 133 (1999), 1–13.

Jungblut 1967
Jungblut, Renate. *Hyeronimus Darstellung und Verherung eines Kirchenvaters.* Bamberg, 1967.

Junkerman 1988
Junkerman, Anne Christine. "Bellisima Donna: An Interdisciplinary Study of Venetian Sensuous Half-Length Images of the Early Sixteenth Century." PhD diss., University of California, Berkeley, 1988.

Junkerman 1993
Junkerman, A. C. "The Lady and the Laurel. Gender and the Meaning in Giorgione." *Oxford Art Journal* 16 (1993), 49–58.

Justi 1908
Justi, Ludwig. *Giorgione.* 2 vols. Berlin, 1908.

Justi 1926
Justi, Ludwig. *Giorgione.* Berlin, 1926.

Justi 1955
Justi, L. *Meisterwerke der Dresdner Galerie, ausgestellt in der National-Galerie, Anregungen zu genauem Betrachten.* Berlin, 1955.

Kasl 2004
Kasl, Ronda, ed. *Giovanni Bellini and the Art of Devotion.* Indianapolis, 2004.

Keller 1960
Keller, H. *Die Kunstlandschaften Italiens.* Munich, 1960.

Kelso 1978
Kelso, Ruth. *Doctrine for the Lady in the Renaissance.* Urbana, 1978.

Keyser 1999
Keyser, Barbara Whitney. "Technical Studies and Visual Values: Conservation and Connoisseurship at the Fogg Museum 1990–1950." In *12th Triennial Meeting. Lyon, France. ICOM Committee for Conservation 1.* Janet Bridgeland, ed. 1999, 172–176.

Kilian 2004
Kilian, J. "Giovanni Battista Cima da Conegliano." In *Transalpinum* 2004, 92–93.

Klauner 1958
Klauner, F. "Venezianische Landschaftsdarstellung von Jacopo Bellini bis Tizian." *Jahrbuch der Kunsthistorischen Sammlungen in Wien* 54, no. 167 (1958), 121–150.

Klauner 1960
Klauner, Friderike. *Katalog der Gemäldegalerie. 1. Italiener, Spanier, Franzosen, Engländer.* Vienna, 1960.

Klauner 1979
Klauner, F. "Über die Wertschätzung Giorgiones." In *Giorgione. Atti del Convegno internazionale di studio per il quinto centenario della nascita. Castelfranco Veneto, 1978.* Castelfranco Veneto, 1979, 263–267.

Klein 1967
Klein, Robert. "Die Bibliothek von Mirandola un das Giorgione zugeschrieene 'Concert Champêtre.'" *Zeitschrift für Kunstgeshichte* 30 (1967), 199–206. Reprinted in Klein. *La forme et l'intelligible.* Paris, 1970, 193–203.

Knox 1978
Knox, George. "The Camerino of Francesco Corner." *Arte veneta* 32 (1978), 79–84.

Kodera 2003
Kodera, Sergius. "Masculine/Feminine. The Concept of Matter in Leone Ebreo's Dialoghi d'amore or the Difficult Question: Who's on Top." *Zeitsprünge* 7 (2003), 4, 481–517.

Koortbojian and Webb 1993
Koortbojian, Michael, and Ruth Webb. "Isabella d'Este's Philostratus." *Journal of the Warburg and Courtauld Institutes* 56 (1993), 260–267.

Koreny 1999
Koreny, Fritz. "Venice and Dürer." In Aikema and Brown 1999, 240–249.

Krafft 1849
Krafft, Albrecht. *Verzeichnis der kais.kön. Gemälde-Gallerie im Belvedere zu Wien.* 3d ed. Vienna, 1849.

Krafft 1854
Krafft, Albrecht. *Historisch-kritischer Katalog der k. k. Gemälde-Gallerie im Belvedere zu Wien, 1. Abteilung: Italienische Schulen.* Vienna, 1854.

Krumrine 1981
Krumrine, Mary Louise. "Alcune osservazioni sulle radiografie del 'Concerto campestre.'" *Antichità viva* 3 (1981), 5–10.

Laclotte 1993
Laclotte, Michel. "Vincenzo Catena." In *Le Siècle de Titien* 1993, 274.

Laclotte 2005
Laclotte, Michel. *Splendeur de Venise 1500–1600. Peintures et dessins des collections publiques françaises* (exh. cat., Musée des Beaux-Arts de Bordeaux). Paris, 2005.

Laing 1995
Laing, Alastair. *In Trust for the Nation. Paintings from National Trust Houses.* London, 1995.

Langton Douglas 1950
Langton Douglas, R. "Some Early Works by Giorgione." *Art Quarterly* (1950), 23–33.

Lanzi 1808
Lanzi, Luigi. *Storia Pittorica della Italia.* (Orig. pub. 1808). M. Capucci, ed. Vol. 2. Florence, 1970.

Lattanzi 1983
Lattanzi, M. "Il tema del San Girolamo nell'eremo e Lorenzo Lotto." In *San Girolamo* 1983, 56–58.

Lauber 2002
Lauber, Rosella. "Per un ritratto di Gabriele Vendramin. Nuovi contributi." In *Figure di collezionisti a Venezia tra Cinque e Seicento.* Linda Borean and Stefania Mason, eds. Udine, 2002, 25–75.

Lazzarini 1983
Lazzarini, Lorenzo. "Il colore nei pittori veneziani tra il 1480 e il 1580." *Studi veneziani. Supplemento no. 5 del Bollettino d'arte* (1983), 135–144.

Le Ceneri 2004
Le Ceneri violette di Giorgione. Natura e Maniera tra Tiziano e Caravaggio (exh. cat., Palazzo Te, Mantua). Milan, 2004.

Le Siècle de Titien 1993
Le Siècle de Titien. L'Âge d'Or de la Peinture à Venise (exh. cat., Grand Palais, Paris). Paris, 1993.

[Lechi-Panazza] 1939
[Lechi, Fausto, and Gaetano Panazza.] *La pittura bresciana del Rinascimento* (exh. cat., Palazzo Tosio-Martinengo, Bergamo]. Bergamo, 1939.

Lehninger 1782
Lehninger, J. A. *Description de la ville de Dresde, de ce qu'elle contient de plus remarquable et de ses environs.* Dresden, 1782.

Leonardo and Venice 1992
Leonardo and Venice (exh. cat., Palazzo Grassi, Venice). Milan, 1992.

Leopold Wilhelm 1659
See *Inventarium 1659.*

Lépicié 1754
Lépicié, François-Bernard. *Catalogue raisonné des tableaux du Roy avec un abrégé de la vie des peintres.* Paris, 1754, 2, 46.

Lermolieff 1890
Lermolieff, Ivan. *Die Galerie Borghese und Doria Panfili in Rom.* Leipzig, 1890.

Lermolieff 1893
Lermolieff, Ivan. *Die Galerie zu Berlin.* Leipzig, 1893.

Levey 1961
Levey, Michael. "Minor Aspects of Dürer's Interest in Venetian Art." *The Burlington Magazine* (1961), 511–513.

Liberali 1981
Liberali, Giuseppe. "Gli inventari delle suppellettili del vescovo Bernardo de Rossi, nell'episcopio di Treviso (1506–1524)." In Zampetti and Sgarbi 1981, 73–92.

Lippincott 1990
Lippincott, Kristen. "The Genesis and Significance of the Fifteenth-Century Italian *Impresa.*" In *Chivalry in the Renaissance.* Sydney Anglo, ed. Woodbridge, England, 1990, 49–76.

Locatelli 1890
Locatelli, P. *Notizie intorno a Giacomo Palma il Vecchio ed alle sue pitture.* Bergamo, 1890.

Lomazzo 1584
Lomazzo, Giovan Paolo. *Trattato dell'arte della pittura, scoltura et architectura.* Milan, 1584. In Giovan Paolo Lomazzo. *Scritti sulle arti.* R. P. Ciardi, ed. Florence, 1973.

London Old Masters 1870
Exhibition of Works of the Old Masters. Winter Exhibition (exh. cat., Royal Academy, London). London, 1870.

Longhi 1926
Longhi, Roberto. "Precisioni nelle Gallerie Italiane. La Galleria Borghese." *Vita Artistica* (1926). Reprinted in *Edizione delle opere complete di Roberto Longhi. II. Saggi e Ricerche, 1925–1928.* Florence, 1967, 265–366.

Longhi 1927
Longhi, Roberto. "Due dipinti inediti di Gian Girolamo Savoldo." *Vita Artistica* (1927), 72–75. Reprinted in *Edizione delle opere complete di Roberto Longhi. II. Saggi e Ricerche, 1925–1928.* Florence, 1967, 149–155.

Longhi 1929
Longhi, Roberto. "Quesiti caravaggeschi. II: i precedenti." *Pinacotheca* (1929), 258–320. Reprinted in *Edizione delle opere complete di Roberto Longh. IV. "Me pinxit" e quesiti caravaggeschi.* Florence, 1968, 97–143.

Longhi 1934
Longhi, Roberto. *Officina Ferrarese 1934.* Florence, 1956.

Longhi 1946
Longhi, Roberto. *Viatico per cinque secoli di pittura veneziana.* Florence, 1946.

Luber 2005
Luber, Katherine Crawford. *Albrecht Dürer and the Venetian Renaissance.* Cambridge, 2005.

Lucas and Plesters 1978
Lucas, Arthur, and Joyce Plesters. "Titian's Bacchus and Ariadne." *National Gallery Technical Bulletin* 2 (1978), 25–47.

Lucco 1974
Lucco, Mauro. "Marco Basaiti." PhD diss. 2 vols. University of Bologna, 1974, 2, 96–97.

Lucco 1975
Lucco, Mauro. "Pordenone a Venezia." *Paragone* 309 (1975), 3–38.

Lucco 1980
Lucco, Mauro. *L'opera completa di Sebastiano del Piombo.* Milan, 1980.

Lucco 1981
Lucco, Mauro. "La giovinezza del Pordenone (nuove riflessioni su vecchi studi)." In *Giornata di studio sul Pordenone.* P. Ceschi Lavagetto, ed. Piacenza, 1981, 26–42.

Lucco 1988
Lucco, Mauro. "Giovanni Agostino da Lodi nella cultura veneta dei primi del Cinquecento." In *Cena in Emmaus. Giovanni Agostino da Lodi.* Finarte, sale 641. Milan, 1988.

Lucco 1988a
Lucco, Mauro. "Basaiti, Marco." In *La pittura in Italia: il Cinquecento.* G. Briganti, ed. Milan, 1988, 638.

Lucco 1990
Lucco, Mauro. "Savoldo." Review of *Giovanni Gerolamo Savoldo* 1990. *Osservatorio delle arti* 5 (1990), 88–93.

Lucco 1993
Lucco, Mauro. "A l'occasion de la redécouverte d'un tableau du musée des Beaux-Arts, nouveau regard sur l'oeuvre de Marco Basaiti." *Bulletin des musées et monuments Lyonnais* 1 (1993), 3–38.

Lucco 1994
Lucco, Mauro. "Review of *Palma Vecchio, by Philip Rylands.*" *The Burlington Magazine* 136 (1994), 32–33.

Lucco 1995
Lucco, Mauro. *Giorgione.* Milan, 1995.

Lucco 1996
Lucco, Mauro. "Venezia: 1500–1540." In Lucco 1996–1999, 13–146.

Lucco 1996a
Lucco, Mauro. "Sebastiano del Piombo." In *The Dictionary of Art* 28 (1996), 331–336.

Lucco 1996-1999
Lucco, Mauro, ed. *La Pittura nel Veneto: Il Cinquecento.* 3 vols. Milan, 1996–1999.

Lucco 1999
Lucco, Mauro. "Basaiti Marco." In Lucco 1996–1999, 1268.

Lucco 2001
Lucco, Mauro. "Andrea Previtali." In *Bergamo, l'altra Venezia.* Francesco Rossi, ed. (exh. cat., Accademia Carrara, Bergamo). Milan, 2001, 104–145.

Lucco 2004
Lucco, Mauro. "Lorenzo Lotto and the Interpretation of Venetian Sixteenth-Century Portraits." In *Italians in Australia, Studies in Renaissance and Baroque Art.* David R. Marshall, ed. Melbourne and Florence, 2004, 81–82 (69–86).

Lucco 2004a
Lucco, Mauro. "Pittura veneta a Carpi al tempo di Alberto Pio." In *Alberto III e Rodolfo Pio da Carpi Collezionisti e mecenati.* Carpi, 2004, 258–267.

Luchs 1995
Luchs, Alison. *Tullio Lombardo and Ideal Portrait Sculpture in Renaissance Venice, 1490–1530.* Cambridge, 1995.

Ludwig 1905
Ludwig, G. "Archivalische Beiträge zur Geschichte der Venezianischen Malerei. Zuan Gerolamo Savoldo." *Jahrbuch der Königlich Preussischen Kunstsammlungen* 26 (1905), 117–123.

Luigini 1974
Luigini, Federico. *Il Libro della bella donna, Introduzione e note a cura di Luigi Pascasio.* Verona, 1974.

Luzio 1888
Luzio, Alessandro. "Isabella d'Este e due quadri di Giorgione." *Archivio Storico del l'Arte* (1888), 47.

***Maestros Antiguos* 1987**
Maestros Antiguos de la Coleccion Thyssen-Bornemisza (exh. cat., Real Accademia de Bella Artes de San Fernando). Madrid, 1987, 106–108, no. 34.

Magugliani 1970
Magugliani, Lodovico. *Introduzione a Giorgione ed alla pittura veneziana del Rinascimento.* Milan, 1970.

Malaguzzi Valeri 1908
Malaguzzi Valeri, Francesco. *Catalogo della R. Pinacoteca di Brera.* Bergamo, 1908.

Malaguzzi Valeri 1912
Malaguzzi Valeri, Francesco. "Chi è lo 'Pseudo-Boccaccino?'" *Rassegna d'Arte* (1912), 99–100.

Malvolti 1774
Malvolti, Francesco Maria. *Catalogo delle migliori pitture esistenti nella città e territorio di Conegliano.* (Orig. pub. 1774.) Luigi Menegazzi, ed. Treviso, 1964.

Manca 1993
Manca, Joseph. "What is Ferrarese about Bellini's *Feast of the Gods.*" In *Titian 500* 1993, 300–313.

Mantese 1964
Mantese, Giovanni. *Memorie Storiche della Chiesa Vicentina (1404–1563).* Vol. 3, pt. 2. Vicenza, 1964.

Marconi 1962
Marconi, Sandra Moshini. *Gallerie dell' Accademia di Venezia. Opera d'Arte del Secolo XVI.* Venice, 1962, 131–132, no. 209.

Marek 1987
Marek, Michaela. "Trying to Look at Paintings with Contemporary Eyes. Titian's *Feast of Venus* and *Andrians* Reconsidered." In *Bacchanals by Titian and Rubens.* Görel Cavalli-Björkman, ed. Stockholm, 1987, 67–72.

Mariacher 1968
Mariacher, Giovanni. *Palma il Vecchio.* Milan, 1968.

Mariacher 1975
Mariacher, Giovanni. "Jacopo Negretti detto Palma il Vecchio." In *Pittori Bergamaschi dal XIII al XIX Secolo. Il Cinquecento.* Vol. 1. Bergamo, 1975, 210 (169–243), no. 31.

Mariani Canova 1964
Mariani Canova, Giordana. *Paris Bordon.* Venice, 1964.

Mariani Canova 1975
Mariani Canova, Giordana. *L'Opera Completa del Lotto.* Milan, 1975.

Marini 1963
Marini, R. "Cima da Conegliano e la sua problematica." *Emporium* (1963), 147–158.

Martin 1995
Martin, Andrew John. *Savoldos sogenanntes "Bildnis des Gaston de Foix."* Zum Problem des Paragone in der Kunst und Kunsttheorie der italienischen Renaissance. Sigmaringen, 1995.

Martin and Manikowska 1999
Martin, S. C., and E. Manikowska. "Cima da Conegliano." In *Rinascimento* 1999, 294–295.

Mascherpa 1980
Mascherpa, Giorgio. *Invito a Lorenzo Lotto.* Milan, 1980.

Mascherpa 1981
Mascherpa, Giorgio. "Il Lotto, il Palma (Le vite parallele e le patrie scambiate)." *Serina a Palma il Vecchio nel quinto centenario della nascita 1480/1980: studi e ricerche in occasione del restauro dei polittici di Serina.* Serina, 1981, 13–26.

Mason 2003
Mason, Stefania. "'Di mano di questo maestro pocchissime sono le cose che si vedono' Giorgione nel collezionismo veneziano." In Nepi Scirè and Rossi 2003, 63–71.

Mason 2004
Mason, Stefania. "'Man findet von diesem Meister ja nur wenige Dinge.' Giorgione und der venezianische Sammlerkreis." In Ferino-Pagden and Nepi Scirè 2004, 33–39.

Materazzi, Pezzati, and Poggi 2002
Materazzi, Marzia, Luca Pezzati, and Pasquale Poggi. "Infrared Reflectography and the INOA High Resolution Scanner." In Carl Brandon Strehlke with Cecilia Frosinini. *The Panel Paintings of Masolino and Masaccio: The Role of Technique.* Milan, 2002.

Mather 1936
Mather, Frank Jewett. *Venetian Painters.* New York, 1936.

Mazza 1934
Mazza, E. "Palma il Vecchio." *Rivista di Bergamo* 12 (1934), 195–199.

Mechel 1783
Mechel, Christian von. *Verzeichniss der Gemälde der K. K. Bilder Gallerie in Wien.* Vienna, 1783; French ed. Basel, 1784.

Meijer 1976
Meijer, Bert. "A Sheet with Drapery Studies by Palma Vecchio." *The Burlington Magazine* 118 (1976), 768.

Meijer 1999
Meijer, Bert W. In *Rinascimento* 1999, 516.

Meilman 2004
Meilman, Patricia, ed. *Cambridge Companion to Titian.* Cambridge, 2004.

Meiss 1974
Meiss, Millard. "Scholarship and Penitence in the Early Renaissance: The Image of St. Jerome." *Pantheon* (1974), 134–140.

Mellencamp 1969
Mellencamp, Emma H. "A Note on the Costume of Titian's Flora." *The Art Bulletin* 51 (1969), 174–177.

Meller 1962
Meller, Peter. "La cultura humanistica del Cima." *La Provincia di Treviso* 5, nos. 4–5 (1962), 20–24.

Meller 1979
Meller, Peter. "La 'Madre di Giorgione.'" In *Giorgione* 1979, 9–18.

Meller 1981
Meller, Peter. "I tre filosofi di Giorgione." In *Giorgione e l'umanesimo veneziano.* Florence, 1981, 1:227–247.

Mena 1995
Mena, Marqués, B. Manuela, and Fernando Benito Domenech. *Sebastiano del Piombo y España* (exh. cat., Museo del Prado, Madrid). Madrid, 1995.

Menegazzi 1962
Menegazzi, Luigi. *Cima da Conegliano* (exh. cat., Palazzo dei Trecento, Treviso). Venice, 1962.

Menegazzi 1981
Menegazzi, Luigi. *Cima da Conegliano.* Treviso, 1981.

Menz and Walther 1968
Menz, H., and A. Walther. *Gemäldegalerie Dresden: alte Meister*. Dresden, 1968.

Merrifield 1849
Merrifield, Mary Philadelphia. *Original Treatises on the Arts of Painting*. (Orig. pub. 1849.) New York, 1967.

Metzger et al. 1995
Metzger, Catherine, et al. "A Platinum Silicide Camera Applied in the Study of Underdrawings." In *Le Dessin sous-jacent dans le peinture, Colloque 10 (September 1993): Le dessin sous-jacent dans le processus de creation*. Hélène Verougstraete-Marq and Roger van Schoute, eds. (1995), 195–200, pls. 86–88.

Meyer 1886
Meyer, Julius. "Das Frauenbildnis des Sebastiano del Piombo aus Schloss Blenheim." *Jahrbuch der königlich preussischen Kunstsammlungen* 7 (1886), 58–72.

Mezzatesta 1975
Mezzatesta, Michael. "'Dreaming Hercules': A Note on Hercules Iconography and North Italian Classicism c. 1500." *Marsyas. Studies in the History of Art* 18 (1975–1976), 17–19.

Michalski 1932
Michalski, Ernst. *Die Bedeutung der ästhetischen Grenze für die Methode der Kunstgeschichte*. Berlin, 1932.

Michiel *Notes*
See Frimmel 1888.

Milanesi 1878-1885
Le Vite de' più eccellenti pittori, scultori ed architettori da Giorgio Vasari. Gaetano Milanesi, ed. 9 vols. Florence, 1878–1885.

Molmenti 1927-1929
Molmenti, Pompeo. *La Storia di Venezia nella vita privata*. 7th ed. Bergamo, 1927–1929.

Momesso 1997
Momesso, Sergio. "Sezioni sottili per l'inizio di Marco Basaiti." *Prospettiva* 87–88 (July–October 1997), 14–41.

Mommsen 1953
Mommsen, Theodor. "Petrarch and the Story of the Choice of Hercules." *Journal of the Warburg and Courtauld Institutes* 16, no. 3–4 (1953), 178–192.

Monneret de Villard 1904
Monneret de Villard, Ugo. *Giorgione da Castelfranco*. Bergamo, 1904.

Morassi 1930
Morassi, Antonio. "La mostra d'arte italiana a Londra." *Emporium* (1930), 131–157.

Morassi 1942
Morassi, Antonio. *Giorgione*. Milan, 1942.

Morassi 1946
Morassi, Antonio. "Inediti veneziani nelle quadrerie genovesi." *Emporium* (1946).

Morassi 1946a
Morassi, Antonio. "Il Tiziano di Casa Balbi." *Emporium* 103 (1946), 207–228.

Morassi 1953
Morassi, Antonio. "The Lotto Exhibition in Venice." *The Burlington Magazine* 95 (1953), 290–298.

Morassi 1954
Morassi, Antonio. "Esordi di Tiziano." *Arte Veneta* (1954), 178–198.

Morassi 1955
Morassi, Antonio. "Un disegno e un dipinto sconosciuti di Giorgione." *Emporium* 4 (1955), 146–149.

Morassi 1964
Morassi, Antonio. *Tiziano*. Milan, 1964.

Morassi 1967
Morassi, Antonio. "Giorgione." In *Rinascimento europeo e Rinascimento veneziano*. V. Branca, ed. Florence, 1967, 187–208.

Morelli 1880
Morelli, Giovanni. *Italian Painters: The Galleries of Munich and Dresden*. (Orig. pub. 1880.) London, 1893.

Morelli 1883
Morelli, Giovanni. *Italian Masters in German Galleries. A Critical Essay on the Italian Pictures in the Galleries of Munich, Dresden, Berlin*. Louise M. Richter, trans. (Orig. German ed., 1880.) London, 1883.

Morelli 1890
Morelli, Giovanni. *Kunstkritische Studien über italienische Malerei: die Galerien Borghese und Doria Panfili in Rom*. Leipzig, 1890.

Morelli 1891
Morelli, Giovanni. *Kunstkritische Studien über italienische Malerei: die Galerien zu München und Dresden*. Leipzig, 1891.

Morelli 1892
Morelli, Giovanni. *Italian Painters, Critical Studies of Their Works. The Borghese and Doria-Pamfili Galleries in Rome*. London, 1892.

Morelli 1893
Morelli, Giovanni. *Italian Painters, Critical Studies of Their Works. The Galleries of Munich and Dresden*. Constance Jocelyn Ffoulkes, trans. London, 1893.

Morelli 1897
Morelli, Giovanni. *Della pittura italiana: studii storico critici: le Gallerie Borghese e Doria Pamphilj in Roma*. Milan, 1897.

Morelli 1991
Morelli, Giovanni. *Della pittura italiana: studii storico-critici: le gallerie Borghese e Doria-Pamphili in Roma*. Jaynie Anderson, ed. Milan, 1991.

Moro 1989
Moro, F. "Giovanni Agostino da Lodi ovvero l'Agostino di Bramantino: appunti per un unico percorso." *Paragone* 40, no. 473 (1989), 23–61.

Moro 1992
Moro, F. "The Allentown Nativity: Giorgione to Agostino and Vice Versa." *Accademia Leonardi Vinci* 5 (1992), 52–57.

Moschini 1949
Moschini, Vittorio. "'La Vecchia' di Giorgione nel suo aspetto genuino." *Arte Veneta* 3 (1949), 180–182.

Moschini Marconi 1955
Moschini Marconi, Sandra. *Gallerie dell'Accademia di Venezia. Catalogo. Opere d'arte dei secoli XIV e XV*. Venice, 1955.

Moschini Marconi 1962
Moschini Marconi, Sandra. *Gallerie dell'Accademia di Venezia. Opere d'arte del secolo XVI*. Venice, 1962.

Moschini Marconi 1978
Moschini Marconi, Sandra. "Giorgione. La vecchia." In *Giorgione* 1978, 143–147.

Mucchi 1978
Mucchi, Ludovico. *Caratteri radiografici della pittura di Giorgione*. Florence, 1978.

Muraro 1976-1986
Muraro, Maria Teresa. "La Festa a Venezia e le sue manifestazioni rappresentative: le compagnie della calza e le *momarie*." In *Storia della cultura veneta*. G. Arnaldi and M. P. Stocchi, eds. 6 vols. Vicenza, 1976–1986. Vol. 3, pt. 3, 315–341.

Muraro 1977
Muraro, Michelangelo. "Tiziano pittore ufficiale della Serenissima." In *Tiziano* 1977, 83–100.

Muraro 1979
Muraro, Michelangelo. "Giorgione e la civiltà delle ville venete." In *Giorgione* 1979, 171–180.

Murates 1973
Murates, Harry. "Personifications of Laughter and Drunken Sleep in Titian's *Andrians*." *The Burlington Magazine* 115, no. 845 (August 1973), 518–525.

***National Gallery* 1973**
National Gallery. Illustrated General Catalogue. London, 1973. 2d rev. ed. 1986.

Nepi Scirè 1987
Nepi Scirè, Giovanna. "Giorgione. La vecchia." In *Restauri alle Gallerie dell' Accademia*. Quaderni della Soprintendenza ai Beni Artistici e Storici di Venezia 13. Venice, 1987, 22–29.

326

Nepi Scirè 1988
Nepi Scirè, Giovanna. *Renaissance in Venice* (exh. cat., Art Gallery of South Wales, Sidney-Brisbane). Rome, 1988, cat. 16.

Nepi Scirè 1991
Nepi Scirè, Giovanna. *I capolavori dell'arte veneziana. Le Gallerie dell'Accademia.* Venice, 1991.

Nepi Scirè 1992
Nepi Scirè, Giovanna. "Giorgione. La vecchia." In *Leonardo and Venice* 1992, 328–329.

Nepi Scirè 1998
Nepi Scirè, Giovanna. *Gallerie dell'Accademia di Venezia.* Milan, 1998.

Nepi Scirè 2003
Nepi Scirè, Giovanna. "La Vecchia." In Nepi Scirè and Rossi 2003, 162–167.

Nepi Scirè 2004
Nepi Scirè, Giovanna. "La Vecchia (Alte Frau)." In Ferino-Pagden and Nepi Scirè 2004, 219–223.

Nepi Scirè and Rossi 2003
Nepi Scirè, Giovanna, and Sandra Rossi, eds. *Giorgione: "le maraviglie dell'arte"* (exh. cat., Gallerie dell'Accademia, Venice). Venice, 2003.

Nepi Scirè and Valcanover 1985
Nepi Scirè, Giovanna, and Francesco Valcanover. *Gallerie dell'Accademia di Venezia.* Milan, 1985.

Nicco Fasola 1940
Nicco Fasola, G. "Lineamenti del Savoldo." *L'Arte* 11, no. 2 (1940), 51–81.

Nicodemi 1925
Nicodemi, G. *Gerolamo Romanino.* Brescia, 1925.

Nieuwenhuys 1843
Nieuwenhuys, C. J. *Description de la Galerie des Tableaux de S. M. Le Roi des Pays-Bas.* Brussels, 1843.

Noë 1960
Noë, Helen A. "Messer Giacomo en zijn 'Laura.'" *Nederlands Kunsthistorisch Jaarboek* 11 (1960), 1–35.

Nova 1990
Nova, A. "Brescia and Frankfurt: Savoldo." *The Burlington Magazine* 132 (1990), 431–434.

Nova 2003
Nova, Alessandro. "Paragone-Debatte und gemalte Teorie in der Zeit Cellinis." In *Benvenuto Cellini: Kunst und Kunsttheorie im 16. Jahrhundert.* Alessandro Nova and Anna Schreurs, eds. Cologne, 2003, 183–202.

Oberhuber 1976
Oberhuber, Konrad. *Disegni di Tiziano e della sua cerchia.* Vicenza, 1976.

Oberhuber 1979
Oberhuber, Konrad. "Giorgione and the Graphic Arts of His Time." In *Giorgione* 1979, 313–320.

Oberthaler 2004
Oberthaler, Elke. "On Technique, Condition and Interpretation of Five Paintings by Giorgione and His Circle." In Ferino-Pagden and Nepi Scirè 2004, 267–276.

Olivari 1990
Olivari, Mariolina. *Giovanni Bellini.* Florence, 1990.

Olivari 2001
Olivari, Mariolina. "Tecnica pittorica e disegno preparatorio in Giovanni Bellini e Mario Basaiti." In Duilio Bertani. *Oltre il visibile: Indagini riflettografiche.* Milan, 2001, 30–50.

Oretti
Oretti, Marcello. *Le Pitture che si ammirono nelli Palaggi e Case de' Nobili della Città di Bologna.* (18th-century manuscript.) Emilia Calabi and Daniela Kelescian, eds. Bologna, 1984.

Paccanelli 1999
Giacomo Carrara (1714–1796) e il collezionismo d'arte a Bergamo. Saggi, fonti, documenti. Rossana Paccanelli, M. G. Recanati, and F. Rossi, eds. Bergamo, 1999.

Pächt 2002
Pächt, Otto. *Venezianische Malerei des 15. Jahrhunderts: die Bellinis und Mantegna.* Margareta Vyoral-Tschapka and Michael Pächt, eds. Munich, 2002.

Padovani 1990
Padovani, Serena. In *Titian* 1990, 144–146, no. 3.

Pagnotta 1997
Pagnotta, Laura. *Bartolomeo Veneto. L'Opera Completa.* Florence, 1997.

Pagnotta 2002
Pagnotta, Laura. *The Portraits of Bartolomeo Veneto* (exh. cat., Timken Museum of Art, San Diego). San Diego, 2002.

Pallucchini 1944
Pallucchini, Rodolfo. *Sebastian Viniziano.* Milan, 1944.

Pallucchini 1944a
Pallucchini, Rodolfo. *La pittura veneziana del Cinquecento.* 2 vols. Novara, 1944.

Pallucchini 1949
Pallucchini, Rodolfo. *Giovanni Bellini: catalogo illustrato della mostra.* Venice, 1949.

Pallucchini 1949a
Pallucchini, Rodolfo. "Un nuovo Giorgione a Oxford." *Arte Veneta* (1949), 178–180.

Pallucchini 1953
Pallucchini, Rodolfo. *Tiziano.* Bologna, 1953.

Pallucchini 1955
Pallucchini, Rodolfo. *Giorgione.* Milan, 1955.

Pallucchini 1959
Pallucchini, Rodolfo. *Giovanni Bellini.* Milan, 1959.

Pallucchini 1962
Pallucchini, Rodolfo. "Appunti alla mostra di Cima da Conegliano." *Arte Veneta* (1962), 221–228.

Pallucchini 1966
Pallucchini, Rodolfo. "Due Concerti Bergamaschi del Cinquecento." *Arte Veneta* 20 (1966), 87–97.

Pallucchini 1966a
Pallucchini, Rudolfo. *Sebastiano del Piombo.* Milan, 1967.

Pallucchini 1969
Pallucchini, Rodolfo. *Tiziano.* 2 vols. Florence, 1969.

Pallucchini 1977
Pallucchini, Rodolfo. *Profilo di Tiziano.* Florence, 1977.

Pallucchini 1981
Pallucchini, Rodolfo, ed. *Giorgione e l'Umanesimo veneziano.* 2 vols. Florence, 1981.

Pallucchini and Rossi 1983
Pallucchini, Rodolfo, and Francesco Rossi. *Giovanni Cariani.* Bergamo, 1983.

Panazza 1985
Panazza, Gaetano. "Conclusione del convegno." In *Giovanni Gerolamo Savoldo pittore bresciano: atti del convegno (Brescia 21–22 maggio 1983).* Gaetano Panazza, ed. Brescia, 1985, 177–183.

Panazza 1990
Panazza, Gaetano. "Gian Gerolamo Savoldo: quesiti risolti e problemi insoluti." In *Giovanni Gerolamo Savoldo* 1990, 26–37.

Panofsky 1969
Panofsky, Erwin. *Problems in Titian, Mostly Iconographic.* New York and London, 1969.

Papetti 1992
Papetti, S. "Il ruolo di Giulio Cantalamessa nell'incremento delle raccolte veneziane e romane: l'acquisto del 'Tobiolo e l'angelo' del Savoldo per la Galleria Borghese." *Paragone* 493–495 (1992), 137–146.

Paris 1995
Paris, Jean. *L'atelier Bellini.* Paris, 1995.

Paris Bordon 1984
Paris Bordon (exh. cat., Palazzo dei Trecento, Treviso). Milan, 1984.

Parronchi 1977
Parronchi, A. "La prospettiva a Venezia tra Quattro e Cinquecento." *Prospettiva* 9 (April 1977), 7–16.

Parronchi 1989
Parronchi, A. *Giorgione e Raffaello*. Bologna, 1989.

Paschini 1926-1927
Paschini, P. "Le collezioni archeologiche dei prelati Grimani del Cinquecento." In *Atti della Pontificia Accademia Romana di Archeologia*. 3d series. Rendiconti, 1926–1927, 149–190.

Passamani 1990
Passamani, Bruno, ed. *Giovanni Gerolamo Savoldo tra Foppa, Giorgione e Caravaggio* (exh. cat., Monastero di Santa Giulia, Brescia; and Schirn Kunsthalle, Frankfurt). Milan, 1990.

Passavant 1833
Passavant, Johann David. *Kunstreise durch England und Belgien, nebst einem Bericht über den Bau des Domthurms zu Frankfurt am Main*. Frankfurt, 1833.

Pastoral 1992
The Pastoral Landscape. John Dixon Hunt, ed. Studies in the History of Art 36. National Gallery of Art. Washington, 1992.

Pattanaro 1993
Pattanaro, Alessandra. In *Le Siècle de Titien* 1993.

Pedretti 1978
Pedretti, Carlo. "Leonardo a Venezia." In *Giorgione: Guida alla Mostra. I Tempi di Giorgione*. Paolo Carpeggiani, ed. (exh. cat., Castelfranco Veneto). Florence, 1978, 84–85.

Pedretti 1979
Pedretti, Carlo. "Ancora sul rapporto Giorgione—Leonardo e l'origine del ritratto di spalla." In *Giorgione* 1979, 181–185.

Pedrocco 1990
Pedrocco, F. "L'iconografia delle cortigiane." In *Il gioco dell'amore: Le cortigiane di Venezia dal Trecento al Settecento* (exh. cat., Casinò municipale Ca'Vendramin Calergi, Venice). Milan, 1990, 81–92.

Pedrocco 2000
See Pedrocco 2001.

Pedrocco 2001
Pedrocco, Filippo. *Titian. The Complete Paintings*. London and New York, 2001; German ed. Munich, 2000.

Penny 1990
Penny, Nicholas. "La notte nella pittura veneziana tra Bellini ed Elsheimer." In *Italia al chiaro di luna: la notte nella pittura italiana 1550–1850*. R. M. Letts, ed. (exh. cat., Accademia Italiana delle Arti e delle Arti Applicati, London). Rome, 1990, 21–44.

Penny 2003
Penny, Nicholas. "'Noli me tangere.'" In *Titian* 2003, 86–87. Spanish ed. Madrid, 2003, 148–149.

Pérez Sanchez 1987
Pérez Sanchez, Alfonso E. "La Bacanal y la oftenda a la Diosa de Los Amores Museo del Prado." In *Rubens copista de Tiziano* (exh. cat., Museo Nacional del Prado, Madrid). Madrid, 1987, 27–36.

Perissa Torrini 1993
Perissa Torrini, Annalisa. *Giorgione. Catalogo completo dei dipinti*. Florence, 1993.

Perissa Torrini 2004
Perissa Torrini, Annalisa. "Documents and Sources." In Ferino-Pagden and Nepi Scirè 2004, 21–30.

Periti 2005
Periti, Giancarla. "Correggio, Prati, e l'Ecce Homo: Nouvi intrecci intorno a problemi di devozione nella Parma rinacimentale." In *Emilia e Marche nel Rinascimento: l'Identità Visiva della 'Periferia.'* Giancarlo Periti, ed. Bergamo, 2005.

Petrarca 2002
Petrarca, Francesco. *Canzoniere, Triumphe, verstreute Gedichte*. H. Grote, ed. K. Förster and H. Grote, trans. Düsseldorf and Zürich, 2002.

Phillips 1893
Phillips, Claude. "L'Exposition des Maitres anciens à la Royal Academy." *Gazette des Beaux-Arts* (1893), 221–237.

Phillips 1897
Phillips, Claude. *The Earlier Work of Titian*. London, 1897.

Phillips 1909
Phillips, Claude. "Some Figures by Giorgione(?)" *The Burlington Magazine* (1909), 331–337.

Phillips 1937
Phillips, Duncan. *The Leadership of Giorgione*. Washington, 1937.

Pigler 1968
Pigler, Anton. *Katalog der Galerie Alter Meister: Budapest*. Tübingen, 1968.

Pignatti 1953
Pignatti, Terisio, ed. *Lorenzo Lotto*. Verona, 1953.

Pignatti 1955
Pignatti, Terisio. *Giorgione*. Milan, 1955.

Pignatti 1969
Pignatti, Terisio. *Giorgione*. Venice, 1969. 2d ed. Venice and Milan, 1978; English ed. London, 1971.

Pignatti 1969a
Pignatti, Terisio. *L'opera completa di Giovanni Bellini detto Giambellino*. Milan, 1969; English ed. London, 1971.

Pignatti 1971
See Pignatti 1969.

Pignatti 1973
Pignatti, Terisio. "The Relationship between German and Venetian Painting in the Late Quattrocento and Early Cinquecento." In *Renaissance Venice*. John Hale, ed. London, 1973, 244–273.

Pignatti 1978a
See Pignatti 1969.

Pignatti 1978b
Pignatti, Terisio. "Gli inizi di Giorgione." In *Giorgione* 1978, 7–14.

Pignatti 1978c
Pignatti, Terisio. "Giorgione e Tiziano." In *Tiziano e il Manierismo europeo*. Rodolfo Pallucchini, ed. Florence, 1978, 29–41.

Pignatti 1979
Pignatti, Terisio. *The Golden Century of Venetian Painting* (exh. cat., Los Angeles County Museum of Art). Los Angeles, 1979.

Pignatti 1981
Pignatti, Terisio. "Il primo Giorgione." In *Giorgione* 1981, 9–11.

Pignatti 1981a
Pignatti, Terisio. "Il 'corpus' pittorico di Giorgione." In Pallucchini 1981. Vol. 1, 131–159.

Pignatti 1983
Pignatti, Terisio. "Gli inizi di Lorenzo Lotto." *Ateneo Veneto* 21 (1983), 175–183.

Pignatti 1990
Pignatti, Terisio. "Giorgione e Tiziano." In *Tiziano* (exh. cat., Palazzo ducale, Venice). Venice, 1990, 68–76.

Pignatti and Pedrocco 1999
Pignatti, Terisio, and Filippo Pedrocco. *Giorgione*. New York and Milan, 1999.

Pinacoteca di Brera 1990
Pinacoteca di Brera. Scuola Veneta. Milan, 1990.

Pincus 2004
Pincus, Deborah. "Bellini and Sculpture." In Humfrey 2004, 122–142.

Pino 1548
Pino, Paolo. *Dialogo di pittura*. Venice, 1548. E. Camesasca, ed. Milan, 1954.

Pita Andrade and Borobia Guerrero 1992
Pita Andrade, José Manuel, and Maria del Mar Borobia Guerriero. *Maestros Antiguos del Museo Thyssen-Bornemisza*. Madrid, 1992.

Plesters 1993
Plesters, Joyce. "Examination of Giovanni Bellini's *Feast of the Gods*: A Summary and Interpretation of the Results." In *Titian 500* 1993, 374–391.

Plesters and Lazzarini 1976
Plesters, Joyce, and Lorenzo Lazzarini. "Preliminary Observations on the Technique and Materials of Tintoretto." In *Conservation and Restoration of Pictorial Art*. Norman Bromelle and Perry Smith, eds. London and Boston, 1976, 7–26, frontispiece.

Pochat 1973
Pochat, Götz. *Figur und Landschaft*. Berlin and New York, 1973.

328

Pochat 1985
Pochat, Götz. "Two Allegories by Lorenzo Lotto and Petrarchism in Venice around 1500." *Word & Image* 1 (1985), 2–15.

Pochat 2002
Pochat, Götz. "I Tre Filosofi di Giorgione alla luce della filosofia naturale del suo tempo." In *Lezioni di metodo. Studi in onore di Lionello Puppi*. Loredana Olivato and Giuseppe Barbieri, eds. Venice, 2002, 185–196.

Pope-Hennessy 1966
Pope-Hennessy, John. *The Portrait in the Renaissance.* London and New York, 1966.

Popham and Pouncey 1950
Popham, A. E., and P. Pouncey. *Italian Drawings: 14th and 15th Centuries.* 2 vols. London, 1950.

Posse 1924
Posse, Hans. *Meisterwerke der staatlichen Gemälde-galerie in Dresden.* Munich, 1924.

Posse 1931
Posse, Hans. "Die Rekonstruktion der Venus mit dem Cupid von Giorgione." *Jahrbuch der Preußischen Kunstsammlungen* 52 (1931), 29ff.

Pozzi 1981
Pozzi, Giovanni. "Il ritratto della Donna nella Poesia d'Inizio Cinquecento e la Pittura di Giorgione." In Pallucchini 1981, 309–341.

Preliminary Catalogue 1941
Preliminary Catalogue. National Gallery of Art. Washington, 1941.

Previtali 1980
Previtali, Giovanni. "Da Antonello da Messina a Jacopo d'Antonello. I. La data del Cristo Benedicente della National Gallery di Londra." *Prospettiva* 20 (1980), 27–34.

Propping 1892
Propping, Friedrich. "Die künstlerische Laufbahn des Sebastiano del Piombo bis zum Tode Raffaels." PhD diss., Leipzig, 1892.

Pujmanová 1986
Pujmanová, Olga. *Italské Gotické a Renesanční Obrazy.* Prague, 1987.

Quattrini 2002
Quattrini, Cristina. *Giovanni Agostino da Lodi e Marco d'Oggiono: quadri a due mani da Santa Maria della Pace a Milano* (exh. cat., Pinacoteca di Brera, Milan). Milan, 2002.

Quondam 1989
Quondam, Amedeo. "Il naso di Laura." In *Il ritratto e la Memoria, Materiali.* Vol. 1. Augusto Gentili, ed. Rome, 1989, 9–44.

Quondam 1995
Quondam, Amedeo. "Sull'orlo della bella fontana. Tipologie del discorso erotico nel primo Cinquecento." In *Tiziano* 1995, 65–81.

Radar 2001
Radar, Edmond. "Le moment du portrait chez Giorgione." *Arte documento* 15 (2001), 91–95.

Ragionieri 2005
Ragionieri, Pina, ed. *Vittoria Colonna e Michelangelo* (exh. cat., Florence Casa Buonarroti). Florence, 2005.

Ratti 1766
Ratti, Carlo Giuseppe. *Instruzione di quanto può vedersi di più bello in Genova.* 1st ed. 1761; 2d ed. Genoa, 1766.

Ravà 1920
Ravà, Aldo. "Il 'camerino delle antigaglie' di Gabriele Vendramin." *Nuovo Archivio Veneto* 22 (1920), 77–78, 155–179.

Rearick 1977
Rearick, W. Roger. "Titian's Drawings, 1510–1512." In *Tiziano* 1977, 173–185.

Rearick 1979
Rearick, W. Roger. "Chi fu il maestro di Tiziano?" In *Giorgione* 1979, 187–193.

Rearick 1984
Rearick, W. Roger. "Observations on the Venetian Cinquecento in the Light of the Royal Academy Exhibition." *Artibus et Historiae* 9 (1984) 59–75.

Rearick 1987
Rearick, W. Roger. "The Drawings of Paris Bordon." In Fossaluzza and Manzato 1987, 47–63.

Rearick 1992
Rearick, W. Roger. "From Arcady to the Barnyard." In *Pastoral* 1992, 137–159.

Rearick 1994
Rearick, W. Roger. "La pittura veneta ai tempi di Giorgione." In *Giorgione* 1994, 9–15.

Rearick 2001
Rearick, W. Roger. *Il disegno veneziano del Cinquecento.* Milan, 2001.

Reinecke 2003
Reinecke, Brigitte. *Eros und Tod, Zur Bildlichkeit von Femininität in den halbfigurigen Judith-Darstellungen im Venedig des 16. Jahrhunderts.* Weimar, 2003.

Rice 1985
Rice, E. F. *Saint Jerome in the Renaissance.* Baltimore and London, 1985.

Richter 1910
Richter, J. P. *The Mond Collection: An Appreciation, with Numerous Illustrations in Photogravure and Halftone.* London, 1910.

Richter 1934
Richter, G. M. "The Problem of the Noli Me Tangere." *The Burlington Magazine* (1934), 4–16.

Richter 1937
Richter, G. M. *Giorgio da Castelfranco Called Giorgione.* Chicago, 1937.

Richter 1942
Richter, G. M. "Lost and Rediscovered Works by Giorgione I–II." *Art in America* 30 (1942), 141–157, 211–224.

Ricketts 1910
Ricketts, Charles. *Titian.* London, 1910.

Ridolfi 1648
Ridolfi, Carlo. *Le Maraviglie dell'Arte.* (Orig. pub. Venice, 1648). Detlev von Hadeln, ed. Vol. 1. Berlin, 1914.

Rinascimento 1999
Il Rinascimento a Venezia e la pittura del Nord ai tempi di Bellini, Dürer, Tiziano. Bernard Aikema and Beverly Louise Brown, eds. (exh. cat., Palazzo Grassi, Venice). Milan, 1999.

Ringbom 1965
Ringbom, Sixten. *Icon to Narrative: The Rise of the Dramatic Close-Up in 15th Century Devotional Painting.* Abo, 1965; Doornspijk, 1984.

Ringbom 1984
See Ringbom 1965.

Rizzi 1978
Rizzi, A. "Giovanni Antonio Pordenone." In *Giorgione* 1978.

Robertson 1954
Robertson, Giles. *Vincenzo Catena.* Edinburgh, 1954.

Robertson 1955
Robertson, Giles. "The Giorgione Exhibition in Venice." *The Burlington Magazine* (1955), 272–277.

Robertson 1968
Robertson, Giles. *Giovanni Bellini.* Oxford, 1968.

Robertson 1979
Robertson, Martin. "A Possible Classical Echo in Bellini." *The Burlington Magazine* 121 (1979), 650–653.

Robertson 1979a
Robertson, Giles. "Giorgione e Leonardo." In *Giorgione* 1979, 195–199.

Robertson 1983
Robertson, Giles. "Vincenzo Catena." In *Genius of Venice* 1983, 167.

Rogers 1988
Rogers, Mary. "'The Decorum of Women's Beauty': Trissino, Firenzuola, Luigini and the Representation of Women in Sixteenth-Century Painting." *Renaissance Studies* 2 (1988) 47–88.

Rogers 1994
Rogers, Mary. "Reading the Female Body in Venetian Renaissance Art." In *New Interpretation of Venetian Renaissance Paintings*. Francis Ames Lewis, ed. London, 1994, 77–90.

Romanelli 1997
Romanelli, Giandomenico, ed. *Venice: Art and Architecture*. 2 vols. Cologne, 1997.

Romani 1993
Romani, Vittoria. "Tiziano Vecellio, dit Titien. Flore." In *Le Siècle de Titien* 1993, 415–417, no. 49.

Rome 1930
Anon. "Conclusions Adopted by the International Conference for the Study of Scientific Methods for the Examination and Preservation of Works of Art, Rome, October 13th to 17th, 1930." *Mouseion* 13–14, nos. 1–2 (1931). Suppl., 162–170.

Rosand 1978
Rosand, David. *Titian*. New York, 1978.

Rosand 1983
Rosand, David. "The Portrait, the Courtier and Death." In *Castiglione: The Ideal and the Real in Renaissance Culture*. Robert W. Hanning and David Rosand, eds. New Haven and London, 1983, 91–129.

Rosand 1988
Rosand, David. "Giorgione, Venice, and the Pastoral Vision." In *Places of Delight. The Pastoral Landscape*. R. Cafritz, L. Gowing, and D. Rosand, eds. (exh. cat., The Phillips Collection and National Gallery of Art, Washington). London, 1988, 20–81.

Rosand 1992
Rosand, David. "Pastoral Topoi: On the Construction of Meaning in Landscape." In *Pastoral* 1992, 161–177.

Rosenhauer 1980
Rosenauer, Artur. "Vincenzo Catena: eine Musikerdarstellung von 1529." *Artibus et historiae* 2 (1980), 29–41.

Rosenthal 1992
Rosenthal, Margaret F. *The Honest Courtesan: Veronica Franco, Citizen and Writer in Sixteenth-Century Venice*. Chicago, 1992.

Roskill 1968
Roskill, Mark W. *Dolce's Aretino and Venetian Art Theory of the Cinquecento*. New York, 1968.

Roskill 1976
Roskill, Mark W. *What Is Art History?* London, 1976.

Rossi 1981
Rossi, F. "Bergamo e Palma il Vecchio: un rapporto dialettic." In *Serina a Palma il Vecchio nel Quinto Centenario della nascita, 1480–1980: studi e ricerche in occasione del restauro dei polittici di Serina*. Serina, 1981, 27–46.

Rossi 1988
Rossi, Francesco. *Accademia Carrara. Bergamo. Catalogo dei dipinti sec. XV–XVI*. Bergamo, 1988.

Rossi and Rovetta 1997
Rossi, Marco, and Alessandro Rovetta. *La Pinacoteca Ambrosiana*. Milan, 1997.

Rothschild 1932
Rothschild, Eugen von. "Tizians *Kirschenmadonna*." *Belvedere* 11 (1932), 107–114.

Rowlands 1966
Rowlands, John. "Two Unknown Works by Palma Vecchio." *Pantheon* 24 (1966), 372–377.

Ruhemann 1968
Ruhemann, Helmut. *The Cleaning of Paintings: Problems and Potentialities*. London, 1968.

Rumor 1907
Rumor, Sebastiano. *La Vergine del Palma il Vecchio in Santo Stefano di Vicenza*. Vicenza, 1907.

Rupprich 1956
Rupprich, Hans. *Dürer Schriftlicher Nachlass*. Vol. 1. Berlin, 1956.

Russo 1987
Russo, D. *Saint Jérôme en Italie: étude d'iconographie et de spiritualité (XIIIe–XVIe siècle)*. Paris, 1987.

Rylands 1988
Rylands, Philip. *Palma II Vecchio, L'opera completa*. Milan, 1988.

Rylands 1992
Rylands, Philip. *Palma Vecchio*. Cambridge, 1992.

Rylands 2001
Rylands, Philip. "Palma Vecchio. Ritratto di donna detta 'La Bella.'" In *Bergamo* 2001, 188–189.

Sachs 1940
Sachs, Curt. *The History of Musical Instruments*. New York, 1940; Italian ed. Milan, 1996.

Safarik 1979
Safarik, Eduard A. "Catena, Vincenzo." In *Dizionario Biografico degli Italiani*. Vol. 22. Rome, 1979, 325–328.

Safarik 1984
Safarik, Eduard A. "Una monografie su Giovanni Cariani e un contributo alla conoscinza del suo primo periodo." *Arte Veneta* 38 (1984), 232 (230–232).

***Sale of the Century* 2002**
Sale of the Century. Artistic Relations between Spain and Great Britain, 1604–1655. Jonathan Brown and John Elliott, eds. New Haven and London, 2002.

Salvini 1961
Salvini, Roberto. "Giorgione: un ritratto e molti problemi." *Pantheon* (1961), 226–239.

Salvini 1978
Salvini, Roberto. "Leonardo, i Fiamminghi e la cronologia di Giorgione." *Arte Veneta* 32 (1978), 92–99.

***San Girolamo* 1983**
Il San Girolamo di Lorenzo Lotto a Castel Sant'Angelo. Bruno Contardi and Augusto Gentili, eds. Rome, 1983.

Sander 2004
Sander, Jochen. *Italienische Gemälde im Städel 1330–1550. Oberitalien, die Marken und Rom*. Mainz am Rhein, 2004.

Sangiorgi 1933
Sangiorgi, Giorgio. "Scoperta di un'opera di Giorgione." *Rassegna italiana* 12, no. 186 (1933), 1–5.

Santagostino 1671
Santagostino, Agostino. *L'Immortalità e Gloria del Pennello*. (Orig. pub. 1671). Marco Bona Castellotti, ed. Milan, 1980.

Santore 1988
Santore, Cathy. "Julia Lombardo, 'Somtuosa Meretrize': A Portrait by Property." *Renaissance Quarterly* 41 (1988), 44–83.

Santore 1990
Santore, Cathy. "La Bella, the Painted Venetian Beauty in Renaissance Art and Society." PhD diss., New York University, 1990.

Santore 2000
Santore, Cathy. "Picture versus Portrait." *Source* 19, no. 3 (2000), 16–21.

Santos 1657
Santos, Fray Francisco de los. *Descripción breve del Monasterio de El Escorial*. Madrid, 1657.

Sassu 2004
Sassu, Giovanni. *Giorgione*. Milan, 2004.

Scarpa 1991
Scarpa, Pietro. "Vittore Carpaccio: identificazioni e proposte, I." *Arte Documento* 5 (1991), 60–69.

Schäpers 1997 (1994)
Schäpers, Petra. *Die Junge Frau bei der Toilette. Ein Bildthema im venezianischen Cinquecento*. Bochumer Schriften für Kunstgeschichte 21. Frankfurt am Main, 1997 (PhD diss., Bochum, 1994).

Schleier 1975
Schleier, Erich. "Bildnis einer Römerin. Um 1512/13." In Henning Bock, ed. *Gemäldegalerie Berlin, Staatliche Museen Preussischer Kulturbesitz, Katalog der ausgestellten Gemälde des 13.–18. Jahrhunderts*. Berlin and Dahlem, 1975, 322.

330

Schleier 1998
Schleier, Erich. "Sebastiano Luciani, genannt del Piombo. Bildnis einer Römerin. Um 1513." In Jan Kelch, ed. *Gemäldegalerie Berlin. 200 Meisterwerke, Staatliche Museen zu Berlin, Preussischer Kulturbesitz*. Berlin, 1998.

Schlosser 1924
Schlosser, J. Von. *Die Kunstliteratur*. Vienna, 1924.

Schmidt 1904
Schmidt, Wilhelm. "Zu Giorgione." *Repertorium für Kunstwissenschaft* 27 (1904), 160.

Schmitter 1997
Schmitter, Monika Anne. "The Display of Distinction: Art Collecting and Social Status in Early Sixteenth Century Venice." PhD. diss., University of Michigan, 1997.

Schmitter 2004
Schmitter, Monika Anne. "'Virtuous Riches': The Bricolage of *Cittadini* Identities in Early-Sixteenth Century Venice." *Renaissance Quarterly* 57, no. 3 (Fall 2004), 908–969.

Schröer-Trambowsky 2002
Schröer-Trambowsky, Susanne. "Art. Giorgione. 'Knabe mit Pfeil.'" In *Venezia! Kunst aus venezianischen Palästen: Sammlungsgeschichte Venedigs vom 13. bis 19. Jahrhundert* (exh. cat., Kunst- und Ausstellungshalle der BRD, Bonn). Bonn, 2002, 159.

Schubring 1916
Schubring, F. "Zwei Bilder der Parissage von J. Palma in der Dresdner Galerie." *Mitteilungen aus den Sächsischen Kunstsammlungen* (1916), 28–34.

Schütz 2004
Schütz, Karl. "Dürer in Venice. A Few Comments on the Relationship between German and Venetian Painting around 1505." In Ferino-Pagden and Nepi Scirè 2004, 105–109.

Serenissima **1999**
Serenissima: światło Wenecji: dzieła mistrzów weneckich XIV–XVIII wieku ze zbiorów Muzeum Narodowego w Warszawie w świetle nowych badań technologicznych, historycznych i prac konserwatorskich. G. Bastek and G. Janczarski, eds. Warsaw, 1999, 118–129.

Settis 1978
Settis, Salvatore. *"La Tempesta" interpretata: Giorgione. I committenti, il soggetto*. Torino, 1978; English ed. Chicago, 1990.

Settis 2006
Settis, Salvatore. "Esercizi di stile: una Vecchia e un Bambino." In *Giorgione Symposium Act*, the forthcoming volume of the proceedings of the Giorgione conference in Vienna, 2004. Turnhout, 2006, 28–33.

Settis and Toracca 1998
Settis, Salvatore, and Donatella Toracca. *La Libreria Piccolomini nel Duomo di Siena*. Modena, 1998.

Sgarbi 1977
Sgarbi, Vittorio. "Pier Maria Pennacchi e Lorenzo Lotto." *Prospettiva* 10 (July 1977), 39–50.

Sgarbi 1981
Sgarbi, Vittorio. "Ricognizione del catalogo di Giorgione: con proposte per la sua formazione e per l'opera della maturità." In *Giorgione* 1981, 31–34.

Sgarbi 1984
Sgarbi, Vittorio. "Savoldo tra Giorgione e Caravaggio: l'Annunciata di San Domenico di Castello a Venezia." *Paragone* 409 (1984), 62–69.

Shapley 1955
Shapley, Fern Rusk. *Catalogue of the Italian Paintings. National Gallery of Art*. Washington, 1955.

Shapley 1960
Shapley, Fern Rusk. *Early Italian Painting in the National Gallery of Art*. Washington, 1960.

Shapley 1968
Shapley, Fern Rusk. *Paintings from the Samuel H. Kress Collection: Italian Schools, XV–XVI Century*. London, 1968.

Shapley 1979
Shapley, Fern Rusk. *Catalogue of the Italian Paintings*. 2 vols. National Gallery of Art, Washington, 1979.

Sheard 1993
Sheard, Wendy Stedman. "Antonio Lombardo's Reliefs for Alfonso d'Este's Studio di Marmi: Their Significance and Impact on Titian." In *Titian 500* 1993, 315–357.

Sheard 1997
Sheard, Wendy Stedman. "The Portraits." In Brown, Humfrey, and Lucco 1997, 43–51.

Shearman 1992
Shearman, John. *Only Connect…Art and the Spectator in the Italian Renaissance*. Washington, 1992, 108–148.

Simon 1997
Simon, Patricia. "Homosociality and Erotics in Italian Renaissance Portraiture." In *Portraiture. Facing the Subject*. Joanna Woodall, ed. Manchester and New York, 1997, 29–51.

Simonetti 1986
Simonetti, Simonetta. "Profilo di Bonifacio de' Pitati." *Saggi e Memorie di Storia dell'Arte* 15 (1986), 85–133.

Simonetto 2001
Simonetto, L. "Giovanni Agostino da Lodi." In *Dizionario Biografico degli Italiani*. Vol. 56. Rome, 2001.

Singer 1913
Singer, H. W. *Die Meisterwerke der Königl. Gemälde-Galerie zu Dresden: 350 Kunstdrucke nach den Originalgemälden*. Munich 1913.

Sokolowski 1882
Sokolowski, M. *Wystawa orbazów dawnych mistrzów*. Krakow, 1882.

Spahn 1932
Spahn, Anna Maria. *Palma Vecchio*. Leipzig, 1932.

Spezzani 1992
Spezzani, Paolo. *Riflettoscopia e indagini non distruttive: Pittura e grafica (Quaderni del restauro 11)*. Milan, 1992.

Sponza 1994
Sponza, Sandro. "Il restauro della pala di Costantino ed Elena ai piedi della Croce in San Giovanni in Bragora: osservazioni e appunti." *Venezia Cinquecento* 8 (1994), 127–143.

Spronk 1996
Spronk, Ron. "The Early Years of Conservation at the Fogg Art Museum: Four Pioneers." *Harvard University Art Museums Review* 6, no. 1 (1996), 1–12.

Sricchia Santoro 1998
Sricchia Santoro, Fiorella. *Il Cinquecento: l'arte del Rinascimento*. Milan, 1998.

Steinberg 1993
Steinberg, Arthur. "Blurred Boundaries, Opulent Nature, and Sensuous Flesh: Changing Technological Styles in Venetian Painting; 1480–1520." In *Titian 500* 1993, 199–220.

Steinberg and Wylie 1990
Steinberg, Arthur, and Jonathan Wylie. "Counterfeiting Nature: Artistic Innovation and Cultural Crisis in Renaissance Venice." *Comparative Studies in Society and History* 32, no. 1 (January 1990), 54–88.

Storffer 1733
Storffer, Ferdinand. *Gemaltes Inventarium der Aufstellung der Gemäldegalerie in der Stallburg*. Vol. 3. Vienna, 1733.

Stout 1964
Stout, George L. "Thirty Years of Conservation in the Arts: A Summary of Remarks to the IIC American Group in New York, June 1963." *Studies in Conservation* 9, no. 4 (November 1964), 126–128.

Strehlke 2003
Strehlke, Carl Brandon. "Changing Perceptions about the Conservation of Early Italian Paintings and Its Usefulness to Art Historical Research." In *Early Italian Paintings: Approaches to Conservation (Proceedings of a Symposium at the Yale University Art Gallery April 2002).* Patricia Sherwin Garland, ed. New Haven and London, 2003, 132–145.

Suida 1931
Suida, Wilhelm. "Zum Werke des Palma Vecchio." *Belvedere* (1931), 135–142.

Suida 1933
Suida, Wilhelm. *Tizian.* Zürich and Leipzig, 1933.

Suida 1934–1935
Suida, Wilhelm. "Studien zu Palma." *Belvedere* 12, nos. 5–6 (1934–1935), 85–101.

Suida 1935
Suida, Wilhelm. "Savoldo, Giovanni Girolamo." In U. Thieme and F. Becker. *Allgemeines Lexikon der Bildenden Künstler von der Antike bis zur Gegenwart.* Vol. 29. Leipzig, 1935, 510–512.

Suida 1935a
Suida, Wilhelm E. "Giorgione. Nouvelles attributions." *Gazette des Beaux-Arts* 14 (1935), 75–94.

Suida 1937
Suida, Wilhelm. "Giovanni Girolamo Savoldo." *Pantheon* 19 (1937), 48–56.

Suida 1951
Suida, Wilhelm Emil. *Paintings and Sculpture from the Kress Collection Acquired by the Samuel H. Kress Foundation 1945–1951* (exh. cat., National Gallery of Art, Washington). Washington, 1951.

Suida 1954
Suida, Wilhelm. "Spigolature giorgionesche." *Arte Veneta* (1954), 153–166.

Suida 1956
Suida, Wilhelm E. "Pittori lombardi del Rinascimento, I: lo Pseudo-Boccaccino." *Arte Lombarda* (1956), 89–93.

Suida 1956a
Suida, Wilhelm Emil. "Giorgione in American Museums." *The Art Quarterly* 19 (1956), 145–152.

Swerdlow 1967
Swerdlow, Noel. "Musica Dicitur A Moys, Quod Est Aqua." *Journal of the American Musicological Society* 20 (1967), 3–9.

Tassi 1793
Tassi, Francesco Maria. *Vite de' Pittori, Scultori e Architetti Bergamaschi.* Vol. 1. Bergamo, 1793.

Tempestini 1992
Tempestini, Anchise. *Giovanni Bellini. Catalogo completo dei dipinti.* Florence, 1992.

Tempestini 1996–1999
Tempestini, Anchise. "La *Sacra Conversazione* nella pittura veneta dal 1500 al 1516." In Lucco 1996–1999, 3:939–1,014.

Tempestini 1997
Tempestini, Anchise. *Giovanni Bellini.* Milan, 1997.

Tempestini 1998
Tempestini, Anchise. *Bellini e Belliniani in Romagna.* Florence, 1998.

Tempestini 1999
Tempestini, Anchise. *Giovanni Bellini.* New York, 1999.

Tempestini 2000
Tempestini, Anchise. *Giovanni Bellini.* Milan, 2000.

Tempestini 2004
Tempestini, Anchise. "Bellini and His Collaborators." In Humfrey 2004, 256–271.

Teniers 1660
Teniers, David. *Theatrum Pictorium.* Antwerp, 1660, pl. 207, engraved by Quirin Boel.

Thausing 1876
Thausing, M. *Dürer: Geschichte seines Lebens und seiner Kunst.* Leipzig, 1876.

Theatrum Pictorium 1659
Theatrum Pictorium. Brussels, 1659.

Tietze 1936
Tietze, Hans. *Tizian.* 2 vols. Vienna, 1936.

Tietze 1950
Tietze, Hans. *Titian. The Paintings and Drawings.* 2d rev. ed. London, 1950.

Tietze and Tietze-Conrat 1944
Tietze, Hans, and Erica Tietze-Conrat. *The Drawings of Venetian Painters in the 15th and 16th Centuries.* New York, 1944.

Tietze and Tietze-Conrat 1949
Tietze, Hans, and Erica Tietze-Conrat. "The Allendale Nativity in the National Gallery." *The Art Bulletin* (1949), 11–20.

Tietze-Conrat 1948
Tietze-Conrat, Erica. "An Unpublished *Madonna* by Giovanni Bellini and the Problem of Replicas in His Shop." *Gazette des Beaux-Arts* 33 (June 1948), 379–382.

Timken 1996
Timken Museum of Art: European Works of Art, American Paintings and Russian Icons in the Putnam Foundation Collection. San Diego, 1996.

Titian 1990
Titian: Prince of Painters (exh. cat., Palazzo Ducale, Venice, and National Gallery of Art, Washington). Washington, 1990.

Titian 1993
See *Le Siècle de Titien* 1993.

Titian 2003
Titian. David Jaffe, ed. (exh. cat., National Gallery, London). London, 2003.

Titian 500 1993
Titian 500. Joseph Manca, ed. Studies in the History of Art 45. National Gallery of Art. Washington, 1993.

Tiziano 1977
Tiziano nel quarto centenario della sua morte, 1576–1976. Venice, 1977.

Tiziano 1995
Tiziano. Amor Sacro e Amor Profano. Maria Grazia Bernardini, ed. (exh. cat., Palazzo delle Esposizioni, Rome). Milan, 1995.

Toffolo 1987
Toffolo, Stefano. *Antichi strumenti veneziani. 1500–1800: quattro secoli di liuteria e cembalaria.* Venice, 1987.

Torrini 1993
See Perissa Torrini 1993.

Tosini Pizzetti 2001
Tosini Pizzetti, Simona, ed. *Fondazione Magnani-Rocca: Catalogo Generale.* Florence, 2001.

Transalpinum 2004
Transalpinum: From Giorgione and Dürer to Titian and Rubens. Dorota Folga-Januszewska and Antoni Ziemba, eds. Warsaw, 2004.

Tressider 1992
Tressider, Warren. "A Borrowing from the Antique in Giovanni Bellini's *Continence of Scipio.*" *The Burlington Magazine* 134 (1992), 660–662.

Tschmelitsch 1975
Tschmelitsch, Günther. *Zorzo, genannt Giorgione: der Genius und sein Bannkreis.* Vienna, 1975.

Tsuij 1979
Tsuij, Shigeru. "La 'nocte' di Giorgione." In *Giorgione* 1979, 293–297.

Unger 1865
Unger, M. *Kritische Forschungen im Gebiete der Malerei alter und neuester Kunst.* Leipzig, 1865.

Valcanover 1960
Valcanover, Francesco. *Tutta la pittura di Tiziano.* Milan, 1960.

Valcanover 1969
Valcanover, Francesco. *L'Opera Completa di Tiziano.* Milan, 1969.

Valcanover 1999
Valcanover, Francesco. *Tiziano.* Florence, 1999.

Valentiner 1923
Valentiner, Wilhelm R. *Paintings in the Collection of Joseph Widener at Lynnewood Hall.* Elkins Park, Penn., 1923 (unpaginated).

332

Van der Sman 1986
Van der Sman, Gert Jan. "Uno studio iconologico sull'*Endimione dormiente* e sul *Giudizio di Mida* di Cima da Conegliano. Pittura, poesia e musica nel primo Cinquecento." *Storia dell' Arte* 58 (1986), 197–203.

van Marle 1935
van Marle, Raimond. *The Development of the Italian Schools of Painting.* Vol. 17. The Hague, 1935.

van Marle 1936
van Marle, Raimond. *The Development of the Italian Schools of Painting.* Vol. 18. The Hague, 1936.

van Os et al. 1978
van Os, Henk, et al. *The Early Venetian Paintings in Holland.* Maarsden, 1978.

Vasari 1568 (2d rev. ed.; orig. pub. 1560)
See Milanesi 1878–1885 or Bettarini and Barocchi 1966–1987.

Vasari/Maclehose 1907
Vasari, Giorgio. *Vasari on Technique.* Louisa S. Maclehose, trans. London, 1907.

***Venice* 1992**
Leonardo and Venice. Pietro Marani and Giovanna Nepi Scirè, eds. (exh. cat., Palazzo Grassi, Venice). Milan, 1992.

Venturi 1888
Venturi, Adolfo. "Nuovi documenti su Leonardo da Vinci." *Archivio Storico dell'Arte* (1888), 45–46.

Venturi 1907
Venturi, Lionello. *Le Origini della Pittura Veneziana.* Venice, 1907.

Venturi 1913
Venturi, Lionello. *Giorgione e il Giorgionismo.* Milan, 1913.

Venturi 1915
Venturi, Adolfo. *Storia dell'Arte Italiana. La Pittura del Quattrocento.* Vol. 7, pt. 4. Milan, 1915.

Venturi 1924
Venturi, Adolfo. *L'arte a San Girolamo.* Milan, 1924.

Venturi 1927
Venturi, Adolfo. *Studi dal vero attraverso le raccolte artistiche d'Europa.* Milan, 1927.

Venturi 1928
Venturi, Adolfo. *Storia dell'Arte Italiana. La Pittura del Cinquecento.* Vol. 9, pt. 3. Milan 1928.

Venturi 1954
Venturi, Lionello. *Giorgione.* Rome, 1954.

Venturi 1958
Venturi, Lionello. "Giorgione." In *Enciclopedia Universale dell'Arte.* Vol. vi. Venice and Rome, 1958.

Verheyen 1968
Verheyen, E. "Der Sinngehalt von Giorgiones 'Laura.'" In *Pantheon* 26 (1968), 220–227.

Vescovo 1992
Vescovo, Piermario. "'Col tempo': l'allegoria e l'ultima verità del ritratto." *Eidos* 10 (1992), 47–61.

Volle 2005
Volle, Nathalie. "Titien, *Le concert champêtre* et *La Vénus du Pardo*." In *Tiziano. Restauri, Tecniche, Programmi, Prospettive.* Giuseppe Pavanello, ed. Venice, 2005, 37–57.

Volpe 1963
Volpe, Carlo. *Giorgione.* Milan, 1963.

Volpe 1975
Volpe, Carlo. "Il 'Cristo portacroce' di Vienna al Pordenone." *Paragone* 309 (1975), 100–103.

Volpe and Lucco 1980
Volpe, Carlo, and Mauro Lucco. *L'opera completa di Sebastiano del Piombo.* Milan, 1980.

von der Bercken 1927
von der Bercken, Erich. *Die Malerei der Früh- und Hoch-Renaissance in Oberitalien.* Munich, 1927.

Von Hadeln 1908
Von Hadeln, Detlev. "Die Werke Vincenzo Catenas." *Monatshefte für Kunstwissenschaft* 1, no. 2 (1908), 1,080–1,091.

Waagen 1837-1839
Waagen, Gustav F. *Kunstwerke und Künstler in England und Paris.* 3 vols. Berlin, 1837–1839.

Waagen 1838
See Waagen 1837–1839.

Walker 1956
Walker, John. *Bellini and Titian at Ferrara.* London and New York, 1956.

Walmsley et al. 1994
Walmsley, E., et al. "Improved Visualization of Underdrawings with Solid-State Detectors Operating in the Infrared." *Studies in Conservation* 39, no. 4 (November 1994), 217–231.

Waltham 1963
Major Masters of the Renaissance. Creighton Gilbert, ed. The Rose Art Museum, Brandeis University. Waltham, Mass., 1963.

Walther 1978
Walther, A. *Tizian.* Leipzig, 1978.

Washington 1985
European Paintings: An Illustrated Catalogue. National Gallery of Art. Washington, 1985.

Waterhouse 1952
Waterhouse, Ellis. "Paintings from Venice for Seventeenth-Century England: Some Records of a Forgotten Transaction." *Italian Studies* 7 (1952), 1–23.

Waterhouse 1974
Waterhouse, Ellis. *Giorgione.* Glasgow, 1974.

Webb 1992
Webb, Ruth Helen. *The Transmission of the "Eikones" of Philostratus and the Development of Ekphrasis from Late Antiquity to the Renaissance.* London, 1992.

Westphal 1931
Westphal, Dorothee. *Bonifazio Veronese.* Munich, 1931.

Wethey 1969
Wethey, Harold E. *The Paintings of Titian I: The Religious Paintings.* London, 1969.

Wethey 1969-1975
Wethey, Harold E. *The Paintings of Titian.* 3 vols. London, 1969–1975.

Wethey 1971
Wethey, Harold E. *The Paintings of Titian II: The Portraits.* London, 1971.

Wethey 1975
Wethey, Harold E. *The Paintings of Titian III: The Mythological and Historical Paintings.* London, 1975.

Wethey 1987
Wethey, Harold E. *Titian and His Drawings.* Princeton, 1987.

Wiebel 1988
Wiebel, C. *Askese und Endlichkeitsdemut in der italienischen Renaissance: ikonologische Studien zum Bild des heiligen Hieronymus.* Weinheim, 1988.

Wilde 1928
Wilde, Johannes. "Die Zigeunermadonna." *Katalog der Gemäldegalerie.* Kunsthistorisches Museum Wien. Vienna, 1928, 228.

Wilde 1930
Wilde, Johannes. "Wiedergefundene Gemälde aus der Sammlung Erzhrezog Leopold Wilhelms." *Jahrbuch der Kunsthistorischen Sammlungen in Wien* 4 (1930), 248–249.

Wilde 1931
Wilde, Johannes. "L'Examen des tableaux à l'Institut Holzknecht de Vienne." *Mouseion* 16, no. 4 (1931), 18–25.

Wilde 1931a
Wilde, Johannes. "Ein unbeachtetes Werk Giorgiones." In *Jahrbuch der Preussischen Kunstsammlungen* 52, 1931, 91–102.

Wilde 1932
Wilde, Johannes. "Röntgen-aufnahmen der *Drei Philosophen* Giorgiones und der *Zigeunermadonna* Tizians." *Jahrbuch der Kunsthistorischen Sammlungen in Wien* 6 (1932), 141–154.

Wilde 1933
Wilde, Johannes. "Die Probleme von Domenico Mancini." *Jahrbuch der Kunsthistorischen Sammlungen in Wien* (1933), 97–135.

Wilde 1934
Wilde, Johannes. "Über einige venezianische Frauenbildnisse der Renaissance." In *Hommage à Alexis Petrovics*. Budapest, 1934, 206–212.

Wilde 1938
Wilde, Johannes. *Katalog Kunsthistorisches Museum.* Vienna, 1938.

Wilde 1974
Wilde, Joannes. *Venetian Art from Bellini to Titian.* Oxford, 1974.

Wilson 2001
Wilson, Carolyn C. *St. Joseph in Italian Renaissance Society and Art.* Philadelphia, 2001.

Wilson 2004
Wilson, Carolyn C. "Invention, Devotion and the Requirements of Patrons: Titian and the New Cult of St. Joseph." In Meilman 2004, 75–94.

Wilson 2004a
Wilson, Carolyn C. "Giovanni Bellini and the 'Modern Manner.'" In Humfrey 2004, 95–121.

Wind 1948
Wind, Edgar. *Bellini's "Feast of the Gods"; A Study in Venetian Humanism.* Cambridge, Mass., 1948.

Wind 1969
Wind, Edgar. *Giorgione's "Tempesta" with Comments on Giorgione's Poetic Allegories.* Oxford, 1969.

Winzinger 1966
Winzinger, Franz. "Albrecht Dürer in Rome." *Pantheon* (1966), 283–287.

Woermann 1887
Woermann, K. *Katalog der Königlichen Gemäldegalerie zu Dresden.* Dresden, 1887.

Wölfflin 1920
Wölfflin, Heinrich. "Dürer und Cima da Conegliano." *Kunstwanderer* (December 1920), 137.

Wolters 1938
Wolters, Christian. *Die Bedeutung der Gemäldedurchleuchtung mit Röntgenstrahlen für die Kunstgeschichte.* Frankfurt, 1938.

Zampetti 1953
Zampetti, Pietro. *Mostra di Lorenzo Lotto: Catalogo Ufficiale.* Venice, 1953.

Zampetti 1955
Zampetti, Pietro. *Giorgione e i Giorgioneschi* (exh. cat., Palazzo Ducale, Venice). Venice, 1955.

Zampetti 1968
Zampetti, Pietro. *L'Opera completa di Giorgione.* Milan, 1968.

Zampetti *postille* 1955
Zampetti, Pietro. "Postille alla mostra di Giorgione." *Arte Veneta* 9 (1955), 54–70.

Zampetti and Sgarbi 1981
Zampetti, Pietro, and Vittorio Sgarbi, eds. *Lorenzo Lotto. Atti del convegno internazionale di studi per il v centenario dell nascita.* Treviso, 1981.

Zanchi and Cavalleri 2001
Zanchi, Mauro, and Simmetta Cavalleri. *Giovanni Cariani. Il Giorgionesco del Realismo Terragno.* Clusone, 2001.

Zanolini 1986
Zanolini, Paola. "La Madonna con Bambino Benedicente." *Giovanni Bellini a Milano.* Milan, 1986, 19–26.

Zeitz 2000
Zeitz, Lisa. *Tizian, Teurer Freund. Tizian und Federico Gonzaga. Kunstpatronage in Mantua im 16. Jahrhundert.* Petersburg, 2000.

Zeri 1973
Zeri, Federico, with the assistance of Elizabeth E. Gardner. *Italian Paintings. A Catalogue of the Collection of the Metropolitan Museum of Art. Venetian School.* New York, 1973.

Ziemba 2004
Ziemba, Antoni. "Between the Storia and the Devotional Image. Religious Paintings in the 15th and 16th Centuries." In *Transalpinum* 2004, 79–81.

334

Page ii: cat. 31

Pages iv–v: cat. 17

Page vi: cat. 2

Page viii: cat. 23

Pages xvi–1, 14–15, 38–39: Details of Jacopo de' Barbari, *View of Venice*, National Gallery of Art, Rosenwald Collection; Photographed by Ricardo Blanc.

Pages 54–55: cat. 3

Pages 98–99: cat. 24

Pages 146–147: cat. 32

Pages 188–189: cat. 43

Pages 236–237: cat. 53

Page 285: cat. 41

Page 301: cat. 30

Every effort has been made to locate the copyright holders for the photographs used in this book. Any omissions will be corrected in subsequent editions.

Pages xiv–xv
© The Cleveland Museum of Art.

Pages 3–9
Figs. 1, 4, and 5: Scala/Art Resource, NY; *fig. 2:* Erich Lessing/Art Resource, NY.

Pages 23–34
Fig. 4: Library of Congress; *fig. 11:* Alinari/Art Resource, NY; *fig. 12:* Courtauld Institute of Art.

Pages 41–49
Figs. 1, 3, 8, 9, and 10: © Museum-Francesco Turio Bohm-Venice (Foto Vasari, Rome); *fig. 2:* Bibliotheca Hertziana, Rome; *figs. 4 and 5:* Erich Lessing/Art Resource, NY; *fig. 6:* Photograph © National Gallery in Prague 2005; *fig. 7:* Scala/Art Resource, NY.

Catalogue Plates
Cat. 1: Under license from Italian Ministry for Cultural Goods and Activities; *cats. 2, 15, 18, 30, 35, 38, 41, 49:* Kunsthistorisches Museum, Gemäldegalerie, Vienna; *cats. 3 and 24:* 2005 © Galleria Borghese—Foto Vasari, Rome, photographed by Foto Vasari Rome; *cat. 4:* Foto Prisma; *cat. 5:* Birmingham Museums and Art Gallery; *cats. 6, 25, and 57:* Erich Less-

ing/Art Resource, NY, photographed by Erich Lessing; *cats. 7, 33, and 34:* All Rights Reserved © Museo Nacional Del Prado—Madrid; *cat. 8:* Foto © Ufficio Arte Sacra e Beni Culturali—Diocesi di Concordia—Pordenone; *cat. 9:* Ufficio per I beni culturali della diocese di Vicenza; *cat. 10:* Scala, Florence; *cat. 12:* Copyrights Biblioteca Ambrosiana Auth. No F 128/05; *cat. 13:* Nicola Restauri Restauro Opere d'Arte; *cat 14:* Bergamo, Accademia Carrara, Nr. 117; *cat. 16:* Foto Piotr Ligier, photographed by Piotr Ligier; *cats. 17, 22, 28, 32, 37, 40, 47, 48, 54:* photographed at the National Gallery of Art, Washington, by Bob Grove, Jose A. Naranjo, Lyle Peterzell, and Greg Williams; *cat. 19:* Photograph © 1983 The Metropolitan Museum of Art; *cat. 20:* Allentown Art Museum; *cats. 21, 29, 45, and 52:* © 2006 The National Gallery, London; *cat. 23:* Timken Museum of Art, San Diego; *cats. 26 and 27:* Galleria Nazionale, Parma; *cat. 31:* © Centre de Recherche et de Restauration des Musées de France; *cat. 36:* © Musée des Beaux-Arts de Dijon, photographed by Hugo Maertens; *cat. 39:* Cameraphoto Arte, Venice/Art Resource; *cats. 42 and 53:* Foto © Paolo Tosi/Su concessione del Ministero per I Beni e le Attività Culturali, photographed by Paolo Tosi; *cat. 43:* Staatliche Museen zu

Berlin, Gemäldegalerie, photographed by Foto Jörg P. Anders, Berlin; *cats. 44 and 55:* © Museo Thyssen-Bornemisza. Madrid; *cat. 46:* Foto Vasari, Rome, photographed by Foto Vasari Rome; *cat. 50:* Palazzo Venezia, Rome; *cat. 51:* Wadsworth Atheneum Museum of Art, Hartford, CT; *cat. 56:* Réunion des Musées Nationaux/Art Resource, NY, photographed by R. G. Ojeda.

Pages 57, 60
Figs. 1 and 4: © Museum-Francesco Turio Bohm-Venice (Foto Vasari, Rome); *fig. 5:* Erich Lessing/Art Resource, NY.

Page 83
Cat. 7, fig. 1: Derechos reservados © Museo Nacional del Prado, Madrid.

Pages 101–105
Figs. 1 and 3: © Museum-Francesco Turio Bohm-Venice (Foto Vasari, Rome); *fig. 5:* © NTPL/Derrick E. Witty.

Pages 149, 151
Fig. 1: RMN/Art Resource, NY, photographed by Rene-Gabriel Ojeda; *fig. 2:* © Museum-Francesco Turio Bohm-Venice (Foto Vasari, Rome).

Pages 152–169
Cat. 26, fig. 1: Studio Fotografico Paolo Tosi, Florence; *cat. 29, fig. 1:* National Gallery of Art, Washington, Gift of W. G. Russell Allen; *cat. 31, figs. 1 and 2:* Centre de Recherche et de Restauration des Musées de France.

Page 193
Fig. 6: RMN/Art Resource, NY, photographed by J. G. Berizzi.

Pages 208–232
Cat. 38, fig. 1: Derechos reservados © Museo Nacional del Prado, Madrid; *cat. 39, fig. 1:* 2005 © Galleria Accademia Venezia-Ph. Turio Bohm/Foto Vasari; *cat. 45, fig. 1:* Scala/Art Resource, NY.

Pages 239–242
Fig. 1: RMN/Art Resource, NY, photographed by J. G. Berizzi; *fig. 2:* Bildarchiv Preussischer Kulturbesitz/Art Resource, NY, photographed by Joerg P. Anders; *fig. 5:* © Museum-Francesco Turio Bohm-Venice (Foto Vasari, Rome).

Page 304
Fig. 2: Photographed by Ashok Roy

$42.90 3-30-07